THE SPECTER AND THE SPECULATIVE

THE SPECTER AND THE SPECULATIVE

AFTERLIVES AND ARCHIVES IN THE AFRICAN DIASPORA

EDITED BY
MAE G. HENDERSON, JEANNE SCHEPER, AND GENE MELTON II

RUTGERS UNIVERSITY PRESS
NEW BRUNSWICK, CAMDEN, AND NEWARK,
NEW JERSEY LONDON AND OXFORD

Rutgers University Press is a department of Rutgers, The State University of New Jersey, one of the leading public research universities in the nation. By publishing worldwide, it furthers the University's mission of dedication to excellence in teaching, scholarship, research, and clinical care.

Library of Congress Cataloging-in-Publication Data

Names: Henderson, Mae, editor. | Scheper, Jeanne, 1967– editor. | Melton, Gene, II, editor.

Title: The specter and the speculative : afterlives and archives in the African diaspora / edited by Mae G. Henderson, Jeanne Scheper, Gene Melton II.

Other titles: Afterlives and archives in the African diaspora

Description: New Brunswick, NJ : Rutgers University Press, [2024] | Includes bibliographical references and index.

Identifiers: LCCN 2023044585 | ISBN 9781978834064 (paperback) | ISBN 9781978834071 (hardcover) | ISBN 9781978834088 (epub) | ISBN 9781978834101 (pdf)

Subjects: LCSH: African Americans in popular culture. | African Americans—Race identity—History. | African Americans—Violence against—History. | Future life. | Collective memory—United States. | United States—Race relations—History. | BISAC: LITERARY CRITICISM / American / African American & Black | SOCIAL SCIENCE / Ethnic Studies / American / African American & Black Studies

Classification: LCC E185.625 .S697 2024 | DDC 973/.0496073—dc23/eng/20231122

LC record available at https://lccn.loc.gov/2023044585

A British Cataloging-in-Publication record for this book is available from the British Library.

This collection copyright © 2024 by Rutgers, The State University of New Jersey
Individual chapters copyright © 2024 in the names of their authors

All rights reserved

No part of this book may be reproduced or utilized in any form or by any means, electronic or mechanical, or by any information storage and retrieval system, without written permission from the publisher. Please contact Rutgers University Press, 106 Somerset Street, New Brunswick, NJ 08901. The only exception to this prohibition is "fair use" as defined by U.S. copyright law.

References to internet websites (URLs) were accurate at the time of writing. Neither the author nor Rutgers University Press is responsible for URLs that may have expired or changed since the manuscript was prepared.

♾ The paper used in this publication meets the requirements of the American National Standard for Information Sciences—Permanence of Paper for Printed Library Materials, ANSI Z39.48-1992.

rutgersuniversitypress.org

Toni Morrison, now among the Ancestors,
never let us forget what we should always remember:
Black Lives Matter!

CONTENTS

Introduction 1
Mae G. Henderson, Jeanne Scheper, and Gene Melton II

PART I
Watery Unrest: Trauma and Diaspora 21

ONE
Relayed Trauma and the Spectral Oceanic Archive in M. NourbeSe Philip's *Zong!* 23
Diana Arterian

TWO
"STEP IN STEP IN / HUR-RY! HUR-RY!": Diaspora, Trauma, and "Rep & Rev"
in Suzan-Lori Parks's *Venus* 51
Christopher Giroux

THREE
Yoruba Visions of the Afterlife in Phyllis Alesia Perry's *Stigmata* 70
Stella Setka

PART II
Raising the Dead: Black Sonic Imaginaries 85

FOUR
The Sonic Afterlives of Hester's Scream: The Reverberating Aesthetic of
Black Women's Pain in the Black Nationalist Imagination from
Slavery to Black Lives Matter 87
Meina Yates-Richard

FIVE
Mumia Abu-Jamal and Harriet Jacobs: Sound, Spectrality,
and the Counternarrative 104
Luis Omar Ceniceros

SIX
Forbidding Mourning: Disrupted Sites of Memory
and the Tupac Shakur Hologram 121
Danielle Fuentes Morgan

CONTENTS

PART III
Spectral Technologies of Hip-Hop 135

SEVEN
The Afterlife in Audio, Apparel, and Art: Hip-Hop, Mourning,
and the Posthumous 137
Shamika Ann Mitchell

EIGHT
Dreaming of *Life After Death* When You're *Ready to Die*: Notorious B.I.G.
and the Sonic Potentialities of Black Afterlife 156
Andrew R. Belton

NINE
"We Ain't Even Really Rappin', We Just Letting Our Dead Homies
Tell Stories for Us": Kendrick Lamar, Radical Popular Hip-Hop, and
the Specters of Slavery and Its Afterlife 169
Kim White

PART IV
The Posthumous and the Posthuman 185

TEN
DNA as Cultural Memory: Posthumanism in Octavia Butler's *Fledgling*
and Nnedi Okorafor's *The Book of Phoenix* 187
Sheila Smith McKoy

ELEVEN
Ghosts of Traumatic Cultural Memory: Haunting, Posthumanism, and Animism in Daniel Black's
The Sacred Place and Bernice L. McFadden's *Gathering of Waters* 200
Pekka Kilpeläinen

TWELVE
Africa in Horror Cinema: A Critical Survey 215
Fernando Gabriel Pagnoni Berns, Emiliano Aguilar, and Juan Ignacio Juvé

PART V
"In the Wake": Racial Mourning and Memorialization 231

THIRTEEN
Mapping Loss as Performative Research in Ralph Lemon's *Come home Charley Patton* 233
Kajsa K. Henry

FOURTEEN
Remembering and Resurrecting Bad N---s and Dark Villains:
Walking with the Ghosts That Ain't Gone 246
McKinley E. Melton

FIFTEEN
Mourning Trayvon Martin: Elegiac Responsibility in Claudia Rankine's *Citizen:
An American Lyric* 262
Emily Ruth Rutter

CONTENTS

Coda: *Post Vitam Amicitiae*, or the Afterlife of a Friendship 277
Mae G. Henderson

Acknowledgments 287
Selected Bibliography 289
Notes on Contributors 303
Index 307

PUBLISHER'S NOTE

This book contains several instances of the word n-----. Rutgers University Press does not condone usage of this word and does not reprint it without careful thought. In this instance, the word is used in quoted and source materials.

THE SPECTER AND THE SPECULATIVE

INTRODUCTION

MAE G. HENDERSON, JEANNE SCHEPER, AND GENE MELTON II

Black afterlives are animated by a stubborn refusal to forget and to *be forgotten*.

—Ruha Benjamin, "Black Afterlives Matter"

The past is misperceived in terms of sheer absence or utter annihilation. Something of the past always remains, if only as a haunting presence or symptomatic revenant.

—Dominick LaCapra, *Writing Trauma, Writing History*

Even ghosts can teach us a thing or two.

—Randall Kenan, "Letter from North Carolina: Learning from Ghosts of the Civil War"

Let us begin with a ghost story.

In 1913, when Silent Sam, the statue of a "student Confederate soldier," a gift of the Daughters of the Confederacy, was installed on the campus of the University of North Carolina at Chapel Hill (where two of the editors have had academic affiliations), alumnus Julian Shakespeare Carr noted the following in his dedication speech:

> I trust I may be pardoned for one allusion, howbeit it is rather personal. One hundred yards from where we stand, less than ninety days perhaps after my return from Appomattox, I horse-whipped a negro wench until her skirts hung in shreds, because upon the streets of this quiet village she had publicly insulted and maligned a Southern lady, and then rushed for protection to these University buildings where was stationed a garrison of 100 Federal soldiers. I performed the pleasing duty in the immediate presence of the entire garrison, and for thirty nights afterwards slept with a double-barrel shot gun under my head.[1]

This rather startling confession, poignant testimony to what scholar Camille Owens has described as "black suffering, white enjoyment,"[2] speaks even more pointedly to what scholar Ruha Benjamin argues to be the "vampiric" relationship between "white vitality" and "black

demise."[3] Carr's unapologetic invocation of the unidentified Black woman whom he "horse-whipped until her skirts hung in shreds," however, reminds the contemporary reader of the physically proximate violence on which the institution of slavery was founded as well as the deliberate erasure of voices and careless effacement of identities that, in effect, left an archive marked by blank pages and unrecorded lives because the enslaved were relegated to the status of property and commodity.

More recently, this monument to the afterlife of the Confederacy on a campus serving the descendants of those who were free and those who were enslaved during the antebellum and Civil War periods of United States history has met with controversy. Like Carr, some constituencies championed Silent Sam's place at the portals of the main entrance onto the campus. Indeed, Carr's dedicatory oration betrays the underlying investments that continue to prop up Silent Sam (and other Confederate monuments), even into the twenty-first century, in order to memorialize, defend, and maintain "the welfare of the Anglo Saxon race."[4] Moreover, in the self-valorization of his own role as a Confederate veteran who served the "Lost Cause" as a young man, Carr waxes poetic about the "pleasing duty" of preserving "the purest strain of the Anglo Saxon . . . to be found" in the US South. Carr's nostalgic recollection, with its flowery rhetoric, is a notable example in a tradition of forged histories that constitute an archive of false memories and memorials of the Old South, which Adam H. Domby has eloquently captured in his aptly titled study *The False Cause: Fraud, Fabrication, and White Supremacy in Confederate Memory*. Exploring "the connection between lies, historical memory, and white supremacy," Domby argues that "[t]he collective historical memory propagated by Carr and other Confederate veterans—called the 'Lost Cause' narrative—celebrated the Confederacy and its soldiers despite their defeat on the battlefield."[5] Reflecting on "[t]he devastating interplay of white supremacy and false memories of the past during the late nineteenth and early twentieth centuries," Domby examines

> . . . how white supremacy, fraud, and fabricated memories have fundamentally shaped how Americans, especially white southerners, recalled the past. Lies and falsehoods influenced American understandings of . . . the nature of slavery, and the role of racism in American history. Moreover, at the turn of the twentieth century, a Lost Cause narrative celebrating white supremacy became a crucial rhetorical tool for white North Carolinians in their efforts to justify segregation, disenfranchisement, and racial discrimination. . . . The invented narratives propagated during the Jim Crow era not only continue to exist but still serve to perpetuate racial inequality.[6]

Challenging the legacy of the "invented narrative" put forth by Carr, other members of the UNC-Chapel Hill student body and the community protested the presence of the statue. As tensions escalated, protesters toppled the statue (in concert with similar decolonizing actions occurring from the United States to the United Kingdom, France, South Africa, and elsewhere), an outcome that not only led to the resignation of the university's chancellor but also continues to garner debate and discussion around the meaning and function of such monuments. In response to the removal of Silent Sam and the notably lingering support of the statue by some in the community, the Raleigh *News and Observer* ran a political cartoon by Dwayne Powell

INTRODUCTION

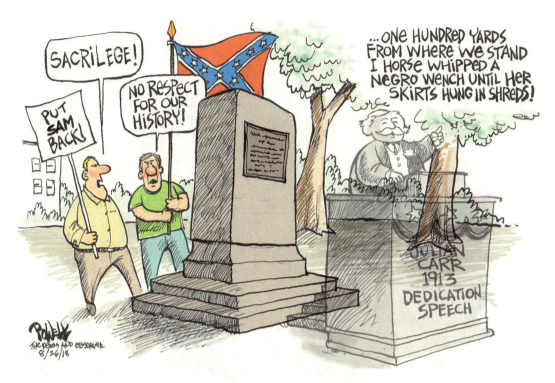

Figure I.1. Cartoon by Dwayne Powell published in the Raleigh, North Carolina, *News and Observer*, August 26, 2018. Under license from *The News & Observer*. © 2018 McClatchy. All rights reserved.

that juxtaposed the current champions of Silent Sam with the specter of Carr delivering his dedication speech (see figure I.1).

This monument was erected to honor "sons of the university" who fought for the Confederacy; however, in his public dedication on this solemn occasion, Carr recounts a personal sadistic memory (revisited in the political cartoon in figure I.1, even at the risk of replicating the violence of the original speech) that invokes the subjection of Black female flesh. The unidentified Black woman is not depicted in this cartoon; rather, she is invoked as an absent presence haunting the scene. In its representation of supporters of Silent Sam, this cartoon forces us to reckon with the "official" history of the Confederacy and "the war of 1861–65" in which young men answered "the call of their country."[7] The cartoon disrupts this historical idealization of the "Lost Cause" by invoking, as a spectral haunting, Carr's speech—itself disinterred from the university archives in 2009 by Domby (who, at the time, was a graduate student at UNC-Chapel Hill).[8] Despite her literal absence from the cartoon and from Carr's anonymous invocation, it is the sublime specter of the unnamed Black woman who ultimately topples the controlling historical narrative. Thus, the challenge for the contemporary scholar is multifold: how to expose the erasures of the sexual violence and subjection produced by slavery; how to topple the monumental alibis erected to misrepresent that past; how to approach an archive of absented figures; and, finally, how to creatively and imaginatively make space in the archives for these unrecorded lives.

3

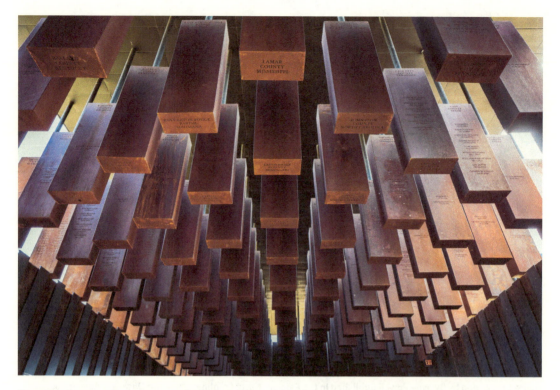

Figure I.2. Hanging steel columns at the National Memorial for Peace and Justice in Montgomery, Alabama. Photograph © Audra Melton. Reprinted by permission of Audra Melton and the Equal Justice Initiative.

Efforts to mark the absent presence of the victims of lynching in the United States and bear further witness to the trauma of racial terror in the nation have driven recent projects, from lauren woods's participatory inter-media monument and interactive sound sculpture *American Monument* documenting police brutality through Freedom of Information Act requests to the multiple installations featured in the long-anticipated National Museum of African American History and Culture in Washington, DC. Moreover, at the National Memorial for Peace and Justice in Montgomery, Alabama, this lingering legacy of the African Diaspora is given dramatic monumentalization in the landscape.[9] Victims of lynching are represented in an installation of eight hundred hanging steel columns, which are not only monumental reminders of the means by which most of these individuals were murdered but also spectacular testaments to each life—an archive of suspended animation (see figure I.2).

The juxtaposition of these memorials—the one enshrining slavery and the "Lost Cause" of the Confederacy and the others memorializing the victims of what has been called the "peculiar institution," as well as its afterlives—not only speaks to the contested narratives of southern slavery and the politics of public memory but also demonstrates how these shadow histories, in myriad manifestations, continue to haunt and envelop the contemporary cultural imaginary. And, notably, it is the afterlife of slavery and, in particular, Black afterlife in the American South, that informs the recent practice of "ghost tourism" or "thanatourism," which has emerged as a contemporary form of travel or leisure activity in several cities and towns in

INTRODUCTION

the southeastern United States. In her fascinating study of "dark tourism," Tiya Miles examines this popular practice in selected sites in Charleston, Savannah, New Orleans, and St. Francisville, Louisiana, showing how, through its appropriation and commodification, the notion of Black antebellum afterlife in the American South continues to haunt the contemporary American imaginary.[10] Arguably, this proliferation of haunted plantations, ghostly manors, and spooky cemeteries (centers and sites of chilling and exotic stories of love, lust, betrayal, torture, and death) continues a tradition long associated with haunted British castles populated by resident ghosts (abandoned children, weeping mothers, betrayed and vengeful lovers), all of which form a United Kingdom magical mystery heritage tour for avid history buffs and paranormal enthusiasts.

But the present preoccupation with the afterlife has a long and illustrious place in popular culture and social history; indeed, the belief in the afterlife has preoccupied philosophers and theologians from time immemorial, from the Egyptians and ancient Greeks to the Zoroastrians and Muslims, and from the Hindustani and Buddhists to the Hebrews and Christians. This dualist concept has existed virtually throughout human history, and continues to dominate the historical, theological, and popular imaginary. Its perduring persistence has led not only to the popularity of "dark tours" along southern heritage highways and byways but also to the emergence of Afterlife Studies, along with a slew of films, television shows, graphic novels, music videos, computer games, social media, avant-garde fiction, personal memoirs, and other entertainment vehicles focused on exploring events such as near-death episodes, out-of-body experiences, ghostly hauntings, precognition, clairvoyance, extrasensory perception, and other such paranormal phenomena. Popular culture and media representation are rife with potent images signifying the return of the (un)dead, the Zombie Apocalypse, vampire slayers and ghost hunters, angels and demons, and "God" and "Devil" figures—who often meddle in human affairs and battle over the destiny of humankind. Whatever the manifestations, the concept of the afterlife, or the continuation of existence after the extinction of biological human life, populates religious, historical, scholarly, and popular culture.

The concept of the afterlife that we engage here is meant to invoke the symbolic presence of life after death, or life after life, as it were—a notion that bespeaks an abiding presence that transcends temporal and spatial boundaries and divides. More specifically, our invocation of the afterlife presupposes a relationship of continuity between past, present, and future articulations of cultural, historical, and literary texts and performances of the African Diaspora. And it is notable that historically and culturally, the concept of the afterlife, in the form of ancestral reverence, healing, and intervention into the personal and communal lives of descendants, is nowhere more evident than in African and diasporic African religious beliefs and practices, including Santeria (Cuba), Candomblé (Brazil), Vodun (Haiti), and Obeah (Jamaica, Trinidad and Tobago, and the Bahamas).

Our purpose is to demonstrate how, when certain contemporary and historical figures and figurations circulate transhistorically and transculturally, they generate what critic Felicia McCarren describes as continuing and accrued "use value" created or re-created through a revalorization that is achieved by way of cultural displacement, historical recontextualization, and formal redeployment (into, for instance, different genres or venues).[11] Such a notion of the afterlife reconceptualizes and reframes historic, literary, cultural, and mythic texts and performances in ways that are diverse and divergent, conflicting and captivating, reflecting the

ability of critical hindsight and foresight to recycle the past in order to (re)imagine a present and future—and, in so doing, produce often liberating (but sometimes repressive) reenactments of events and figurations. Such reiterations function as guarantors of the afterlife by opening spaces for fresh—and even rogue—readings, producing meanings both in excess of and, at times, in deficit to their original articulations; restoring lost or repressed significance; and, as often as not, annexing meanings that reconstruct or deconstruct intentionality. What seems evident, whatever the reclamation or appropriation, however, is the excavation or production of layers and shades of often buried or eroded meanings that potentially erupt to expand or give new life to the cultural/historical artifact or event in the contemporary symbolic economy. To invoke a geologic analogy, just as rock formations get recrystallized or sedimented under physical heat and pressure, so do cultural formations, under critical stress and cultural critique, get tilted, bent, reshaped, or otherwise metamorphosed.

Unlike the metaphysical and materialist concepts of the afterlife embracing a sense of spiritual life after death or even reincarnated life after life, this volume's vision of the afterlife invokes a cultural and symbolic economy that is in dialectical interplay with the idea of the "useable past." If the useable past suggests a construction of past events or articulations that helps us to understand how we become who we are through an understanding of history and tradition, we suggest here that the afterlife also serves as a construction for understanding who we will become. The afterlife thus helps us to understand how past and present forms evolve or expand into present and future forms of collective and individual existence through cultural critique and critical stress. The symbolic afterlife proposed here not only assimilates or appropriates the past but also seeks to explore how present or past sites and situations can serve often radically different, unpredictable, or unimagined forms of articulation and critique. The narrative arc of the present volume, then, bends forward, releasing enthralling and often elusive meanings and insights not always evident in the originary forms and structures taken up by the individual essays. The afterlife, as we conceptualize it, allows for paradigmatic shifts, creative and critical transformations, unruly encounters, contradictory engagements, and capricious, often mutable, relations defining the de-formations and re-formations between the "life" and "afterlife" of various cultural and historical artifacts and articulations. Thus, like more traditional conceptions of the afterlife in which the soul or spirit transcends or survives the body's physical death, the notion of afterlife that we espouse here presumes that the value, meaning, purpose, or affect of a cultural performance or literary construction is neither diminished nor lost when reframed or rearticulated in a subsequent text, context, or location, even one in which prevailing social and cultural values and norms have undergone significant and even unpredictable shifts. In the instance of the cultural or symbolic afterlife, continuity—that is to say, afterlife—is maintained not so much through re-embodiment or reincarnation as it is through multiple subsequent, often diverse and contradictory, critical and performative re-articulations and even dis-articulations. The present volume focuses neither on a materialist nor even a spiritualist resurrection, but rather on a symbolic re-creation in a culture and context often far removed from the site of the original articulations or events. Symbolic afterlife, in other words, does not reproduce a simulacrum of the original; nor is it meant to produce a kind of critical cryonics that seeks to preserve the deceased body. Our conception of a critical afterlife thus seeks neither to revive the old corpse nor restore it to health, but rather to infuse the original

INTRODUCTION

body with new and vibrant meaning, form, and value in a contemporary or future critical context.

AFTERLIVES AND ARCHIVES IN THE AFRICAN DIASPORA

> I am interested in how we imagine ways of knowing that past, in excess of the fictions of the archive . . . I am interested, too, in the ways we recognize the many manifestations of that fiction and that excess, that past not yet past, in the present.
>
> —Christina Sharpe, *In the Wake: On Blackness and Being*

Contemporary critical concepts such as Saidiya Hartman's "the afterlife of slavery"[12] and Michelle Alexander's "the new Jim Crow"[13] evoke structures of dehumanization and anti-Black racism that shaped nineteenth- and twentieth-century political and economic institutions. Drawing these terms from the past into the present by design powerfully marks and rearticulates truths about the very systems that produce the conditions of Black life. The temporal and geographic arc of these terms—the "spark" across the then and the now—foregrounds this point: that these structures are contiguous and persistent. Such conceptual phrases put to rest the idea that there is now a post-apartheid, "born free" generation in South Africa, or that we have entered a new era in the United States defined by a "post-racial" or post–civil rights trajectory in which some imagined liberal progress machine has finally reached the end of its long march to freedom.[14] Rather, formulations such as these capture the intersectional and systemic critique that teaches how racial antagonisms of the present—whether embodied in the carceral state, police violence, environmental racism, or media distortions—are apparitional, haunting continuities of systems of racial capital.

Despite the invocation of "after" that the term "afterlives" in our title evokes, the adherence of one term to the other supersedes any easy notion that the past is left behind. This rhetorical compounding alchemically breathes relentless "life" into the persistent conditions of social death, an unwelcome recurring resuscitation. Conditions of captivity, slavery, social death, "thingification," such salient phrases teach, are neither new nor antiquated. They are, rather, fiercely and repeatedly rearticulated, revived, never quite dead. For some scholars, this insight captures the hauntological conditions of the now: the specter requiring critical speculation. For others, recycling the past offers the promise of a tactical mode of survival, the making of possibilities out of hopelessly impure and inadequate resources. The ethical and archival challenge that confronts each contributor to this anthology or, indeed, anyone examining such afterlives, echoes the conundrum Saidiya Hartman poses in her essay "Venus in Two Acts": "How does one revisit the scene of subjection without replicating the grammar of violence?"[15]

Diaspora is movement. Its archives are subject to an ebb and flow of temporal and geographic afterlives and, as these essays demonstrate, present absences. The archives of the African Diaspora may be found in the circulation of living fragments of cultural production, in the mobile expression of embodied knowledges, in the linked fates of social histories, in the sonic memories that Sankofa-like reach backward and forward, producing flights of memory and lines of kinship and connection out of the violent disruptions of slavery and colonialism. Diaspora is an entanglement of loss and traces that tether Black people to motherlands across seas and

7

generations. The sentimentality, however, that evocations of agency or origins or pasts or forms of resistance might activate can be troubling. Archives are fraught with the dangers of romance, lies, sentimentality, and nostalgia—although we take up the possibility of a *critical sentimentality*.[16] In which case, diasporic archives are those places, spaces, moments, effects and affects that become not only repositories but also sites of cultural production that generate afterlives. And, as such, the essays in *The Specter and the Speculative: Afterlives and Archives in the African Diaspora* become expansive propositions that allow for the possibilities of imagined and prospective pasts, futures, and communities. Archives, thus reconfigured, invite a politics of invention and fabulation that offer a critical form of epistemology and knowledge production for marginalized and subjugated peoples.[17]

When thought of conventionally as repositories, archives become places for the deposit and storage of artifacts and official documents, often closed and sometimes hermetically sealed receptacles for records, objects, and effects, many torn in unacknowledged ways from their originary contexts, presented as unmediated, and therefore rendered static icons serving the "memorializing needs of those in power."[18] If the archive is a reliquary, or repository of relics, where fragments and objects are kept, then the question is: To what end are these artifacts retained? Or, if kept as *memento mori*, or reminders of death, what spiritual or political ends do the archives re-member or re-constitute? Yet, against these images of official entombment—often of a state-sponsored past—there exists another set of counter-discourses and practices of "archival memory," described by Diana Taylor as the "repertoire":[19] that ephemeral collection of embodied practices and ways of knowing and knowledge transmission that has been long repressed and delegitimized, but which is nonetheless necessary to the survival of marginalized and erased subjects. Moving beyond the materiality of objects and artifacts, we find ourselves asking in what ways are archives actually receptacles of affect or performative possibilities for speaking the new or conjuring the missing—a space of the specter and the speculative?

The theoretical turn to the repertoire that Taylor maps is meant to de-territorialize the archive and demonstrate, in her classic work on the Americas, that "[t]he performance of the prohibitions seems as ubiquitous and continuous as the outlawed practices themselves."[20] This performative possibility has also become an axiom of queer studies. Within the rhetoric of law, prohibition, and legal cases, in other words, we find traces of another set of histories, an outlaw world, a commodity that speaks (the enslaved person), the afterlives of those who, as Audre Lorde writes, "were never meant to survive,"[21] or even to be recorded, certainly not to exist and persist into the future. The archive, then, becomes a battleground of epistemes, a subjunctive space of longing, and an insurgent space of counternarrativity.

Each of the chapters in *The Specter and the Speculative* grapples with its own particular "archives of violence," from eighteenth-century court documents related to the trial concerning the murder of Africans on board the slave ship *Zong* to elegiac collections of hip-hop in which "dead homies" persist through the sonic technologies of posthumous performance. This volume must seek, as Hartman implores, "to do more than recount the violence that deposited these traces in the archive."[22] It may come as no surprise that that doing "more" looks different in each of these essays—as the authors pursue their own paths in their theoretical "mining of the museum."[23]

These archives are necessarily haunted in ways that insist on the presence of the past, or what Jeanne Scheper names the "past tense future" of objects of study—that is to say, how objects perform in their own historical moment and then perform again as they are laid to (un)rest in the

8

INTRODUCTION

archive, and then again as they are animated, persisting beyond the institutional logics of the "collections" that would contain them, to produce and perform *afterlives*.[24] Sometimes those afterlives are composed through (re-)citation, rendering new cultural productions, as when Ralph Lemon's Black dancing body becomes a multilayered site of memory in *Come home Charley Patton* or when Suzan-Lori Parks's *Venus* resurrects Sara (Saartjie) Baartman and puts her in conversation with live theater audiences. But there is also something "unruly" about these afterlives, as when Tupac Shakur appears as a posthumous hologram, producing an uncanny direct encounter with the dead. Trying to make sense of such moments, the contributors to this volume write from the space and perspective of antecedents and ancestors, engaging in techniques of knowing that press on Western conceptions of knowledge. Using tools of invention and methods of "critical fabulation,"[25] these authors sometimes engage in "speculative fictions" or "recombinant narratives,"[26] and, at other times, in Black, queer, or against-the-grain archival practices, demonstrating that afterlives can produce imagined futures that cede ground to the dead and the living dead.

In "Venus in Two Acts," Saidiya Hartman describes wrestling with "the unspeakable and the unknown" in the archive of Atlantic slavery, of engaging a story that she "preferred not to tell or was unable to tell,"[27] while fearing the dangers of yet another salvific narrative.[28] This cautionary tale warns against the fabrication of a witness and the temptation "to fill in the gaps and to provide closure where there is none."[29] Hartman's work should thus unsettle critics, prompting them to question whether their own imagined impulses of "bearing witness" can save them from the ethical dilemmas posed by the official archive. Deeply undergirding any discussion of the archives, then, is the ability and willingness to interrogate one's own ethical relationship to the material under examination, which, once more, returns us to Hartman's injunction against subjecting "the dead to new dangers and to a second order of violence."[30]

THIS VOLUME, THIS ARCHIVE

As I understand it, a history of the present strives to illuminate the intimacy of our experience with the lives of the dead, to write our *now* as it is interrupted by this *past*, and to imagine a *free state*, not as the time before captivity or slavery, but rather as the anticipated future. . . .

—Saidiya Hartman, "Venus in Two Acts"

The essays in *The Specter and the Speculative* have been selected and arranged to promote new critical conversations on how historical subjects, texts, performances, and rituals within the African Diaspora are refashioned, reanimated, and rearticulated, as well as parodied, nostalgized, and defamiliarized, to establish afterlives for Black Atlantic identities and narratives. Accordingly, these essays explore how—as transnational and transhistorical sites of memory—particular textual, visual, sonic, or embodied performances circulate and imagine anew the meanings of prior cultural and textual narratives and articulations liberated from their originary context. As part of the dialogue advanced by this volume, individual essays seek to examine how historical and literary performances—in addition to film, drama, music, dance, and material culture—thus

9

revitalized, transcend, and speak across temporal and spatial boundaries not only to reinstate traditional meanings but also to motivate fresh commentary and critique. Notably, as these selected essays demonstrate, such creative productions play an increasingly critical role as alternative archival repositories, or what Jean Christophe Cloutier refers to as "shadow archives." Cloutier argues that the novel, in particular, remains a critical alternative historical site of preservation due to the erasure of Black experience from institutional sites of memory.[31] As editors, we have deliberately gone beyond the focus on traditional sites of memory to include a range of creative and expressive forms of cultural production—represented in the voices of new and emergent, as well as established, scholars across a spectrum of artistic approaches and disciplinarities—that can offer further insight into underexplored aspects of afterlives and archives in the African Diaspora.

Part I, "Watery Unrest: Trauma and Diaspora," opens with poet-scholar Diana Arterian's "Relayed Trauma and the Spectral Oceanic Archive in M. NourbeSe Philip's *Zong!*" Drawing on the notion of "relayed trauma," Arterian considers how Caribbean-Canadian poet M. NourbeSe Philip works through the secondary trauma associated with her personal engagement with *Gregson v. Gilbert*, the court transcript detailing the 1793 massacre, during the Middle Passage, of 142 West Africans on the slave ship *Zong*. In her "anti-narrative lament,"[32] Philip wreaks poetic havoc and vengeance in the act of deconstructing the official narrative, literally breaking apart the words on the page and refashioning the court record as a kind of forensic tombstone. Like Shakespeare's Caliban, Philip appropriates the colonizer's language with the precise intent of undoing its violence. Arterian demonstrates how Philip, as lawyer and poet, subjects *Gregson v. Gilbert* to a vigorous poetic cross-examination in order to gain knowledge otherwise lost to the watery grave of the Atlantic. Arterian concludes that *Zong!*—an exemplar of traumatic textuality, as both product and vessel of relayed trauma—evinces in its concrete form, deconstructed language, and diasporic relationality, an act of epistemic violence that Philip visits upon the past in order to produce a Black afterlife for the descendants of the African Diaspora.

Further exploring the contours of relayed trauma, in "'STEP IN STEP IN / HUR-RY! HUR-RY!': Diaspora and Trauma as 'Rep & Rev' in Suzan-Lori Parks's *Venus*," Christopher Giroux focuses our attention on Parks's summoning of Sara (Saartjie) Baartman, the Khoi Khoi woman who was displayed in Europe as the entertainment "oddity" known as the Venus Hottentot when she was alive and then, after her death, preserved as a human specimen in Paris's *Musée de l'Homme*. Parks's *Venus* was written before Baartman's remains were repatriated in 2002—as a result of international debate and protest—to her South African homeland for burial almost two hundred years after her death. According to Giroux, Parks's play not only constitutes a call for justice on Baartman's behalf but also serves as a vehicle through which audiences are interpellated into the trauma of the African Diaspora on both sides of the Atlantic. Such a recognition of the African Diaspora as site and source of trauma—the aftereffects of which can still be felt—Giroux concludes, positions Parks's *Venus* as an enactment of "Rep & Rev," her theory of traumatic repetition. Through the various ways in which the play creates discomfort and dislocation by breaking the fourth wall, looping histories, and using *mis-en-abyme*, present-day reading and viewing audiences are forced to reckon with the trauma of colonialism and its afterlives.

Working through the effects of intergenerational trauma and the African Diaspora, Stella Setka examines in a contemporary neo-slave narrative the Yoruba concept of matrilineal reincarnation, or *Yetunde*, as an interface between the slave past and post-slavery African American

identity. In "Yoruba Visions of the Afterlife in Phyllis Alesia Perry's *Stigmata*," Setka argues, the novelist adapts the Yoruba notion of the *Yetunde* to frame the corporeal and emotional connection that the protagonist, Lizzie, shares with her female ancestors. In its transgression of geographical and temporal boundaries, *Stigmata* highlights the inextricable ties between past and present, demonstrating how the painful consequences of slavery's legacy continue to reverberate within the lived conditions of present generations. Setka notes, however, that the consciousness that Lizzie shares with her foremothers is more than just a conduit for memory; it also provides the protagonist with the tools necessary to begin working through the weight of historical trauma. Setka concludes that Perry, by infusing her novel with a Yoruba understanding of the connections between the afterlife of the ancestors and the world of the living, rejects the primacy of Western—specifically Christian—ontologies, while insisting on a reappraisal of the slave past within the framework of a non-Western epistemology.

Part II, "Raising the Dead: Black Sonic Imaginaries," begins with an essay that considers how maternal song has been a point of origin and inflection for formations of Black nationalist ideology throughout the history of Black liberation movements—from abolition to Black Power to #BlackLivesMatter. In "The Sonic Afterlives of Hester's Scream: The Reverberating Aesthetic of Black Women's Pain in the Black Nationalist Imagination from Slavery to Black Lives Matter," Meina Yates-Richard examines how the mother's scream becomes critical in sounding a warning against communal danger and in voicing a politics of raising the dead. By tracing a different lineage, one of intracommunal gendered muting and "sonic-social silencing," Yates-Richard demonstrates how, repeatedly, Black women's soundings are uttered only to be muted and subsumed as a maternal sacrifice in the service of Black male imaginaries of freedom and self-making. She interrogates mutings and aporias within Black liberatory movements that at once require Black women's screams and labors, while discursively excluding women through ritual silencing. Closely reading Fredrick Douglass's *Narrative*, Ralph Ellison's *Invisible Man*, and Toni Morrison's *Song of Solomon*, Yates-Richard traces the "echoes forward" from Aunt Hester's scream to Black women's suffering and protest in the Black Lives Matter movement. She argues for the importance of Black women's soundings and the significance of their "continuous echoes" as reverberating testimony that moves across time and space. It is not a matter of simply recognizing what has been repressed, Yates-Richard contends, but recognizing Black women's sonic repertoire as the grounds for liberation, leadership, and freedom.

Similarly tracing a sonic archive that travels from slavery to the present, Luis Omar Ceniceros reinscribes former death row inmate Mumia Abu-Jamal's recordings as multimedia postmodern neo-slave narratives. In "Mumia Abu-Jamal and Harriet Jacobs: Sound, Spectrality, and Counternarrative," Ceniceros examines how Abu-Jamal locates his body of work on a continuum of sonic resistance within conditions of Black enslavement and confinement. By tracing commodity mysticism from the Atlantic Slave Trade to the United States prison-industrial complex, specifically through a Derridean lens, Ceniceros argues, the specter becomes fully realized in postmodernism, or the cultural logic of late capitalism. Ceniceros demonstrates how Abu-Jamal refigures his nineteenth-century antecedent, the enslaved woman Harriet Jacobs, as a specter who speaks from the margins, raising her voice from the dead space within the interstices of history. Drawing on Sharon Holland's concept of "raising the dead" as a framework, Ceniceros examines how Abu-Jamal makes voices become audible from beyond the grave and beyond carceral captivity. From within the prison-house of celebrity culture to the ephemeral dreamhouse of

Apple's iTunes digital superstore, he argues, Abu-Jamal's free-to-download library constitutes an act of radical insurgency. Despite a capitalist corporate stranglehold on media, Ceniceros maintains, Abu-Jamal creates a transtemporal archive in which to voice a counternarrative of Black resistance and revolution by and for the poor, the excluded, the powerless.

Concluding this section on the sonic echoes and reverberations of the dead that inform the Black radical tradition is Danielle Fuentes Morgan's "Forbidding Mourning: Disrupted Sites of Memory and the Tupac Shakur Hologram," a cautionary tale about the relentless commodification of Black bodies—even after death. In this essay, Morgan examines Tupac Shakur's 2012 posthumous appearance at the Coachella music festival in the form of a hologram projection—literally light and mirrors—for a young, increasingly wealthy, and elite audience. For Morgan, the creation of this visually stunning performance constitutes a troubling reminder of the insistent and unrelenting commodification of celebrity, evoking what Coco Fusco elsewhere describes as "all the feelings of the uncanny that direct encounters with the dead often produce."[33] The mimesis of his appearance and iconic mannerisms, Morgan notes, thus turns the fiercely independent rapper into a mere facsimile. Morgan argues that the audience's refusal to mourn, in effect, undermines Black subjectivity. According to Morgan, the hologram reduces Tupac Shakur to something quantifiable, to the sum of his parts, thus demonstrating simultaneously the inherent worth and worthlessness of transient commodities. Recognizing that this reduction is nothing new (as Black bodies have been commodified since slavery), she concludes that the holographic commodification of Tupac Shakur's performance of Black masculinity, in practice, denies him the space of memory and memorialization. In the hologram, he is rendered a virtual celebrity specter, valuable only in a performance and performativity that frames and fashions social norms while he is conspicuously consumed. The extraction of value and the reduction to commodity constitute the conditions of slavery and Black social death writ materially across Black bodies and wrought immaterially across Black afterlives. Thus, Morgan's essay interrogates the notion that ghosts are not always enlisted in the service of resistance—even ghosts can be commodified.

Elaborating on the spectral archives of popular culture, Part III, "Spectral Technologies of Hip-Hop," turns to other ghostly matters. In "The Afterlife in Audio, Apparel, and Art: Hip-Hop, Mourning, and the Posthumous," Shamika Ann Mitchell examines practices of musical and visual mourning within hip-hop culture. She proposes that acts of remembering the departed and memorializing the fallen should be read in the context of diasporic African rituals of mourning: libation, elegy and dirge, and invocation (aka the "shout-out"). Hip-hop originated as and continues to be a culture of resistance to institutional oppression, socioeconomic struggle, and systemic violence. Mitchell demonstrates how, within this community, the music that emanates from grief, mourning, and loss becomes a form of collective memorialization, evoking the legacies of those whose lives have been claimed by state violence, street aggression, natural causes, or accidents. According to Mitchell, these individuals retain an afterlife through song lyrics, music videos, fashion design, and visual art. Distinctive among the forms of communal mourning that Mitchell examines is the "audio obituary," lyrics in which the artists contemplate their mortality in music that is most typically released posthumously. She concludes with an examination of how music survives as auto-sonic testimony to the young Black and Latino men whose lives are thus self-memorialized.

In the next essay, "Dreaming of *Life After Death* When You're *Ready to Die*: Notorious B.I.G. and the Sonic Potentialities of Black Afterlife," Andrew R. Belton considers the self-consciously

INTRODUCTION

imitative incorporation and recombination of modern recorded sounds to create a "reality effect" that leaves listeners haunted by unexpected eavesdropping. Examining the emcee's dream of a post-human sonic escape from the fears of biological and social death, Belton listens for how each album imagines alternative modes of being made possible by/in sound production. Belton analyzes how Notorious B.I.G. and Sean "P. Diddy" Combs use twentieth-century sound technologies to extend the reach of Black life in the face of extreme historic violence and in resistance to the political assault on the Black body in America. He further explores how this sonic afterlife reverberates in the posthumous release of *Life after Death*. For Belton, the emcee works to recognize the full innovation of modern sound, which lies in its ability to effectively separate the voice (as sonic specter) from the body (in all its organic vulnerability). He demonstrates how Notorious B.I.G. builds on the twentieth-century fantasy of the post-human, who, aided by technology, no longer is beholden to the precarious nature of a strictly biological existence. As such, Belton asks how, and to what effect, Notorious B.I.G.'s original use and deployment of sound technologies and creation of a sonic spectral presence fashioned, for him, a Black afterlife.

In the final essay of this section on spectral technologies in hip-hop, "'We ain't even really rappin', we just letting our dead homies tell stories for us': Kendrick Lamar, Radical Popular Hip-Hop, and the Specters of Slavery and Its Afterlife," Kim White suggests that commercial hip-hop's more recent renunciation of its original critical vocation embracing a militant communal aesthetic is challenged by rapper Kendrick Lamar's exorcism of the specters of resistant Black life in hip-hop. Reading Derrida's concept of the specter alongside Frank Wilderson's notion of the "grammar and ghosts" of diasporic African art, White draws on Afropessimism and postmodernism to consider the indispensability of ghosts to critiques of anti-Black violence by analyzing Lamar's staging of a conversation with the dead rapper Tupac Shakur. She describes this spectral Black aesthetic as key to challenging the persistence of racism in a putatively post-racialist era. Through a reading of Lamar's first three albums, in concert with the concepts of "Black rage" and "racial melancholia," White concludes that Lamar's music takes up the struggle of creating a just(ified) response to anti-Black violence, even if his music alone cannot stand in for the revolution needed to bring about structural change. Thus, White foregrounds how Lamar's much-feted political pop constructs, in the dead zone between the narrative of Black success and the tragedy of Black genocide, what Fred Moten and Stefano Harney call the emancipatory potential of the "undercommons."

Part IV, "The Posthumous and the Posthuman," begins with Sheila Smith McKoy's "DNA as Cultural Memory: Posthumanism in Octavia Butler's *Fledgling* and Nnedi Okorafor's *The Book of Phoenix*." Smith McKoy explores the transgenerational cultural worlds navigated by the protagonists of these novels in which the germ seed of humanity—African DNA—enables individual, human, and cultural survival through the creation of the "posthuman." In order to fully grapple with the social and scientific complexity of these texts, Smith McKoy takes an interdisciplinary approach to analyzing how these novels position the reader in the midst of two powerful, contingent intersections: life/death and memory/history. She explores how Butler and Okorafor envision contemporary medical experimentation as the afterlife of the Western eugenics movement and the medical plantation. This genealogy, Smith McKoy argues, has had a profound impact on Afrofuturist and Africanfuturist literature, especially in texts written by and about Black women, whose bodies have most often been sites where biopower intersects with the history and practice of Western medicine. Thus, Smith McKoy examines how *Fledgling* and *The Book of Phoenix* expose biopower at work in human-based scientific research,

13

MAE G. HENDERSON, JEANNE SCHEPER, AND GENE MELTON II

concluding that Butler and Okorafor present posthuman survival as fundamentally linked to genetic and cultural memory.

The literary treatment of cultural memory and the posthuman is also explored in Pekka Kilpeläinen's "Ghosts of Traumatic Cultural Memory: Haunting, Posthumanism, and Animism in Daniel Black's *The Sacred Place* and Bernice L. McFadden's *Gathering of Waters*." Kilpeläinen argues that ghosts in contemporary African American fiction may be read as spectral personifications of the past, emblems of histories that have been marginalized and repressed, yet collectively recalled, as traumatic cultural memory travels transgenerationally. Drawing on Paul Gilroy's theory of the Black Atlantic as the counterculture of modernity, Kilpeläinen reads how spectrality and haunting trouble the dominant cultural memory in *The Sacred Place* and *Gathering of Waters*. Both of these novels critically return to the historical murder of Emmett Till, interrogating racism and white supremacy through their fictional (re-)narrativization and (re-)negotiation of this haunting cultural memory. Kilpeläinen asserts that Black and McFadden use animism and posthumanism to disrupt received, white supremacist versions of the "human," which are exclusive of Black life as well as other sentient beings and life-forms. According to Kilpeläinen, each novel takes a "posthumanist turn" and a "spectral turn," participating in the contemporary move toward posthumanist Black countermodernity. Kilpeläinen concludes that these texts differently use haunting, animism, and posthumanism to construct counternarratives of Western modernity through their depiction of the supernatural and the spectral as quintessential parts of everyday reality.

As the final essay in this section demonstrates, before the posthumous and the posthuman were to become critical presences in contemporary African American prose fiction, these themes of racialized Otherness and boundaries of the human emerged in early twentieth-century Hollywood horror films. Indeed, as Cedric Robinson notes, "[t]he appearance of moving pictures coincides with Jim Crow and the development of American national identity."[34] Motion pictures, therefore, offered a new and innovative venue for disseminating well-entrenched nineteenth-century racial constructs, aligning them in the white cultural imaginary with similarly stereotypical visions of "primitive" Africa. In "Africa in Horror Cinema: A Critical Survey," Fernando Gabriel Pagnoni Berns, Emiliano Aguilar, and Juan Ignacio Juvé draw on the Freudian dialectic between repression and oppression to examine how images of Africa and Africans function allegorically to embody and mask Western social anxieties figured in the monstrous and disruptive Other in Western horror film. Pagnoni Berns et al. argue that African landscapes and backdrops, codified through the filter of horror, are subject to shifting (mis)interpretations, ranging from clearly regressive representations to those with more nuanced valences. Presenting a critical overview of Africa in the archive of horror cinema, the authors trace the shifts in celluloid visions of the "Dark Continent" from early twentieth-century films, such as *West of Zanzibar* (and its remake *Kongo*), *Son of Ingagi*, and the all-but-forgotten *The Vampire's Ghost*, to late-twentieth century films, such as *The Stick* and *Dust Devil*. Over time, Pagnoni Berns et al. conclude, the earlier cinematic depictions of Africa as the dark mirror of civilization give way to more contemporary images of Africa as coproducer of its own dialectical identity.

Part V, "'In the Wake': Racial Mourning and Memorialization," begins with Kajsa K. Henry's essay, "Mapping Loss as Performative Research in Ralph Lemon's *Come home Charley Patton*." According to Henry, Lemon's travels to the US South chart the tensions of these geographies of homespace permeated by Jim Crow violence. These sites become the ritual grounds of performance

INTRODUCTION

for the Black dancer to produce an alternative archive of embodied counter-memory. Lemon's performances, Henry asserts, move against the absences and silences promoted by southern landscapes drenched with racialized violence often sutured over by everyday life. Drawn to spaces where forgetting seems to overcome remembering—where, in Lemon's words, "returning is about what's not there anymore"—the dancer searches for the remains left behind. Henry explores Lemon's use of a performative language of loss in his choreography to rescue the "Buck dance" from its toxic historical connotations. Henry further examines how Lemon rearticulates the "Buck dance" through another choreographic research project on "living room dances." Thus, through performative research, Lemon creates an embodied archive from the remains of the history and memory of subjection written on the Black male body. It is the pursuit of these remains, Henry argues, that binds Lemon, the audience, and the afterlife of the past together. In Lemon's projects, then, dance becomes a repertoire of collective counter-memory in the wake of histories and legacies of racialized violence.

In the next essay in this section, "Remembering and Resurrecting Bad N---s and Dark Villains: Walking with the Ghosts That Ain't Gone," McKinley E. Melton examines the afterlives of racialized violence in the poetic eulogies of three poets: Frank X Walker's "Turn Me Loose: The Unghosting of Medgar Evers," Gwendolyn Brooks's "A Bronzeville Mother Loiters in Mississippi. Meanwhile, a Mississippi Mother Burns Bacon," and Dominique Christina's "For Emmett Till." Melton demonstrates how Walker's and Brooks's poetic eulogies contribute to the "unghosting" of Medgar Evers and Emmett Till, respectively, while also strategically and critically incorporating the voices of the unrepentant homicidal white supremacists, Byron De La Beckworth, the man who assassinated Evers, and Carolyn Bryant, the woman whose false allegation was the catalyst for Till's brutal murder. Walker and Brooks challenge the trope of the "Dark Villain," historically attached to Black male bodies, by using mourning and critical archival practices to resurrect Evers and Till and to proclaim their right to be remembered in their full humanity. Like Walker and Brooks before her, Melton suggests, Christina resists despondency by deploying the meditative power of mourning to rescript and reclaim the narrative that Black lives matter. Thus, Melton argues, these three poets craft words of remembrance and reckoning that not only mourn but also carry forward the work of racial justice in the wake of systemic losses and state-sanctioned murders of key figures in the Civil Rights Movement.

In "Mourning Trayvon Martin: Elegiac Responsibility in Claudia Rankine's *Citizen: An American Lyric,*" the final essay in this section on racial mourning and memorialization, Emily Ruth Rutter examines Rankine's contribution to an African American elegy tradition. Locating Rankine's book-length collection of lyric essays, *Citizen,* within an elegiac economy, Rutter argues that Trayvon Martin's death is an occasion not only for lamentation and consolation, but also for rethinking the current sociopolitical landscape in which many of the ideologies that justified *de jure* segregation remain entrenched. Rutter explores a subgenre within the elegiac tradition that she calls the "Trayvon Martin poem," which marks a new era in the long marriage of poetic and sociopolitical protest, one in which Black bodies and the rights of citizenship are at stake. She considers how Rankine's reconfiguration of the elegiac mode serves to redress the nation's failure to value or protect the lives of its citizens of color and to transform the loss of an individual into the imperative for collective, interracial mourning. Rutter proposes that Rankine places on the reader the onus to make the afterlives of Trayvon Martin and other victims of state-sanctioned violence meaningful by recognizing their full rights of citizenship.

15

"BLACK AFTERLIVES MATTER"

#SayHerName

If biological reproduction begets life, then social reproduction begets afterlives.

—Ruha Benjamin, "Black Afterlives Matter"

What I'm going to say to you is that I'm here representing the mothers who are not heard. I am here representing the mothers who have lost children as we go on about our daily lives. When the cameras and lights are gone, our babies are dead. So I'm going to ask you here today to wake up. Wake up. By a show of hands, can any of you tell me the other six women who died in jail in July 2015 along with Sandra Bland? That is a problem. You all are among *the walking dead*, and I am so glad that I have come out from among you. I heard about Trayvon, I heard about all the shootings, and it did not bother me until it hit my daughter. I was *walking dead* just like you until Sandra Bland died in a jail cell in Texas.

—Geneva Reed-Veal [Sandra Bland's mother], addressing a
Congressional Caucus on Black Women and Girls

Citing the incalculable loss of and cost to Black lives due to state-sanctioned police violence, scholar Ruha Benjamin references the testimony of Geneva Reed-Veal,[35] mother of Sandra Bland, the twenty-eight-year-old African American woman who was stopped by a state trooper on a minor traffic violation in Waller, Texas, in 2015, subsequently taken to jail, and found hanged three days later in the county prison. Addressing a Congressional Caucus on Black Women and Girls, Reed-Veal urged the nation to "wake up . . . [w]ake up" from the zombie-like complacency of the "*walking dead*" and take responsibility for "lost children" and "dead babies." Benjamin aptly perceives this maternal testimony as a rallying cry and call to action: "[W]e witness how waking up *after death* is a call for solidarity and an insistence that Black Afterlives Matter."[36] It is precisely the invocation of the recently departed and slain dead—from Tamir Rice to Trayvon Martin, Eric Garner to Freddie Gray, Michael Brown to George Floyd, Sandra Bland to Breonna Taylor, Deshawnda Sanchez to Tony McDade, and the many other names we dare not forget—that awakens consciousness ("Say Her Name"), vivifies a desire for justice ("No Justice, No Peace"), and (re)animates a struggle for fundamental social change ("Black Lives Matter"). In this instance, the powerful response to the death of civil rights advocate and Black Lives Matter activist, Sandra Bland, along with the tragic and needless deaths of countless Black children, men, and women, sparked a national and international call for collective action and mass mobilization.

Reed-Veal's reiterated supplication to "wake up" inevitably calls to mind the Black vernacular expression, "stay woke"—an imperative currently associated with Black Lives Matter, that has, in recent years, assumed widespread currency among younger generations of African Americans. Broadly translated as "stay vigilant, remain watchful, pay attention"—especially to issues of racial justice—it also suggests the political and social "awakening" defining an afterlife that emerges, as Benjamin argues, "after death." Hashtag signifiers like #SayHerName are forms of social media memorials, public invocations, and rituals of mourning that simultaneously

INTRODUCTION

constitute calls to action and give rise to an awakened social consciousness and collective political movement. In alignment with this tradition of resistance, *The Specter and the Speculative* engages particularly with the linkages between the concepts of "wokefulness," the ancestors, death, and the afterlife. As Benjamin observes, these intersections "[trouble] the line between the biological living and dead by calling forth spiritual practices of ancestral communication, now taking new forms via social media, yet retaining key features of African diasporic tradition."[37] In other words, it is the synchrony of ancestral practices and contemporary media technology that galvanizes the struggle and gives promise to the goal of redressing the past and refashioning the future.

Even as the United States stages confrontations with its tragic historical legacy of institutional, structural, and systemic racism—ranging from peaceful protestations to the forcible removal of Confederate monuments—it is part of a larger global reckoning with slavery, colonialism, and racial regimes. Great Britain, for example, finds itself reawakened, tossed into the throes of social upheaval, and pushed toward what London artist Marc Quinn describes as a "global tipping point."[38] Quinn's creation of a sculpture memorializing British Black Lives Matter activist, Jen Reid, was inspired by the real-life raised-arm and clinched-fisted image of Reid, who climbed and mounted the deserted plinth that had held the controversial statue of seventeenth-century slave trader Edward Colston, toppled by civil rights protestors and thrown into the Floating Harbor in Bristol, England (see figure I.3).[39] Commemorated by the installation of a large bronze statue in 1895, Colston was honored as one of the Town Fathers for his great philanthropy to

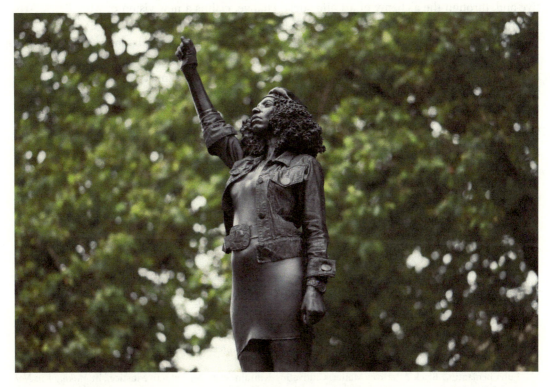

Figure I.3. *Surge of Power*, Marc Quinn's statue of Jen Reid installed on the plinth where a statue of Edward Colston once stood in Bristol, England. Photograph by Matthew Horwood via Getty Images.

17

the city of Bristol, funded by wealth he had accumulated as an executive in the Royal African [Slave] Company. It is not without some historical irony that Colston, reduced to symbolic effigy, was rather unceremoniously dumped into the very same harbor into which his Royal African Company had transported "black gold" on ships plying the triangulated transatlantic slave route.

And although Quinn's statue of Reid was removed by city officials in less than twenty-four hours, its significance resides in the memorialization of a counter-history that jeopardizes the legitimacy of popular and more authorized monumental representations of British history. Like the dedication of Silent Sam, the UNC-Chapel Hill statue commemorating the service of young Confederate recruits, the erection of the statue commemorating the slave trader functioned to efface the counternarrative of Black lives whose degradation, dispossession, and death helped to ensure what Cedric Robinson describes as the "forgeries of memory and meaning" that naturalize the terms of power and privileged whiteness.[40] How wonderful it would be to imagine that the anonymous slave woman in Carr's narrative is given symbolic embodiment, or an afterlife—in a journey through time into the present and through space across the Atlantic—in Quinn's statue, aptly titled "Surge of Power." No matter that it now sits in a museum in Bristol, in search of a future home. The Black Lives Matter subject, Jen Reid, monumentalized in memory and black resin, symbolically answers the call of the ancestors' "longing for home." Reversing Hartman's configuration, then, "insurgent nostalgia" gives way to insurgency (a "surge of power"), and the "imagination [that] transformed the space of captivity into one inhabited by the revenants of a disremembered past" is displaced by an image of empowerment that dislocates the official narrative and, through the alchemy of art and social change, claims a new vision of what Black Arts theorist and practitioner Larry Neal hails as "a liberated future."[41]

But it is Hartman's notion of the slave's severance from family, home, country, and past—her haunting existential homelessness—to which we must finally respond. For against this notion of profound loss, so linked with the fate of becoming property, we must juxtapose what scholar Zhaleh Boyd calls "ancestral co-presences"[42] and what Hartman describes as the "ancestral landscape."[43] These spiritual kinfolk—those who have departed before us—are the ancestors who continue to exercise "claim[s] on the present and demand us to imagine a future in which the afterlife of slavery has ended."[44] It is they who continue "to [animate] our desire for a liberated future," the commitment to continue the struggle for social transformation, and it is to them that we owe the debt of memory.[45] If we are willing to acknowledge these subjugated histories, then we open ourselves to liberating hauntologies.

NOTES

1. Julian S. Carr, "Unveiling of Confederate Monument at University. June 2, 1913," in the Julian Shakespeare Carr Papers #141, Southern Historical Collection, The Wilson Library, University of North Carolina at Chapel Hill. Historian Hilary N. Green's transcription of this speech is available online: https://hgreen.people.ua.edu /transcription-carr-speech.html.
2. Camille Owens, "Tom Wiggins's Sensorium: Black Suffering, White Enjoyment, and the Un-ending Antebellum Family" (lecture, Critical Encounters: Conversations in American Studies, Public Humanities, Yale University, New Haven, CT, November 20, 2019).
3. Ruha Benjamin, "Black Afterlives Matter: Cultivating Kinfulness as Reproductive Justice," in *Making Kin Not Population: Reconceiving Generations*, edited by Adele E. Clarke and Donna Haraway (Chicago: Prickly Paradigm Press, 2018), 41.

INTRODUCTION

4. Carr, "Unveiling of Confederate Monument at University. June 2, 1913."

5. Adam H. Domby, *The False Cause: Fraud, Fabrication, and White Supremacy in Confederate Memory* (Charlottesville: University of Virginia Press, 2020), 3.

6. Domby, *The False Cause*, 3.

7. Inscribed on one of the bronze plaques attached to the pedestal on which Silent Sam stood was the following legend: "To the sons of the university who entered the war of 1861–65 in answer to the call of their country and whose lives taught the lesson of their great commander that duty is the sublimest word in the English language."

8. See Dan Dickison, "History Professor Is Toppling an Ideology," *The College Today: The Official News Site of the College of Charleston*, January 16, 2020, https://today.cofc.edu/2020/01/16/silent-sam-adam-domby/; Adam Domby, "Why Silent Sam Was Built: A Historian's Perspective," *Daily Tar Heel*, January 20, 2011, https://www.dailytarheel.com/article/2011/01/why_silent_sam_was_built_a_historians_perspective; and Domby, *The False Cause*, 2 and 176 n. 3.

9. On lauren woods's *American Monument*, see: https://beallcenter.uci.edu/exhibitions/american-monument. Websites are also available for the National Museum of African American History and Culture (https://nmaahc.si.edu/) and the National Memorial for Peace and Justice (https://museumandmemorial.eji.org/memorial).

10. Tiya Miles, *Tales from the Haunted South: Dark Tourism and Memories of Slavery from the Civil War Era* (Chapel Hill: University of North Carolina Press, 2015).

11. Felicia McCarren, "The Use-Value of 'Josephine Baker,'" *S & F Online* 6, nos. 1–2 (2007/2008), accessed November 18, 2020, http://sfonline.barnard.edu/baker/mccarren_01.htm.

12. Saidiya Hartman, *Lose Your Mother: A Journey Along the Atlantic Slave Route* (New York: Farrar, Straus and Giroux, 2007), 6.

13. Michelle Alexander, *The New Jim Crow: Mass Incarceration in the Age of Colorblindness* (New York: New Press, 2011).

14. Tiffany Willoughby-Herard, "The Trial of Andrew Zondo: Defending Black Children/Criticizing the Racial State," American Studies Association, November 10, 2018.

15. Saidiya Hartman, "Venus in Two Acts," *Small Axe: A Caribbean Journal of Criticism* 26 (2008): 4.

16. See Lauren Berlant, "The Female Woman: Fanny Fern and the Form of Sentiment," *American Literary History* 3, no. 3 (1991): 434.

17. See Hartman on "critical fabulation" ("Venus in Two Acts," 11).

18. Diana Taylor, *The Archive and the Repertoire: Performing Cultural Memory in the Americas* (Durham, NC: Duke University Press, 2003), 17.

19. Taylor, *The Archive and the Repertoire*, 19, 20.

20. Taylor, *The Archive and the Repertoire*, 43.

21. Audre Lorde, "Litany for Survival," in *The Black Unicorn* (New York: Norton, 1978), 32.

22. Hartman, "Venus in Two Acts," 2 and 8.

23. Fred Wilson, Leslie King-Hammond, and Ira Berlin, *Mining the Museum: An Installation* (Baltimore, MD: Contemporary Museum of Art, 1994).

24. Jeanne Scheper, *Moving Performances: Divas, Iconicity, and Remembering the Modern Stage* (New Brunswick, NJ: Rutgers University Press, 2016), 160.

25. Hartman, "Venus in Two Acts," 11.

26. Hartman, "Venus in Two Acts," 12. She notes her source as: "The notion of recombinant narrative is borrowed from Stan Douglass, but I was introduced to the idea by NourbeSe Philip's unpublished essay" (n. 37).

27. Hartman, "Venus in Two Acts," 5.

28. Hartman, "Venus in Two Acts," 8.

29. Hartman, "Venus in Two Acts," 8.

30. Hartman, "Venus in Two Acts," 5.

31. See Jean Christophe Cloutier, *Shadow Archives: The Lifecycles of African American Literature* (New York: Columbia University Press, 2019).

32. We have borrowed this phrase from the description of *Zong!* that appears on M. NourbeSe Philip's website: https://www.nourbese.com/poetry/zong-3/.

33. Coco Fusco, "Better Yet When Dead," *Coco Fusco*, accessed December 5, 2015, http://www.thing.net/~cocofusco/subpages/performances/performancepage/subpages/betteryetwhendead/betteryetwhendead.html.
34. See Cedric J. Robinson, *Forgeries of Memory and Meaning: Blacks and the Regimes of Race in American Theater and Film before World War II* (Chapel Hill: University of North Carolina Press, 2007): "Racial constructs predate the arrival of moving pictures, and thus the representations of race and ethnicity (as well as gender) were transferred from the stage, literature, and popular culture. . . . The appearance of moving pictures coincides with Jim Crow and the development of American national identity in the midst of dramatic demographic and economic changes" (xv).
35. Geneva Reed-Veal, address to Congressional Caucus on Black Women and Girls, quoted in Benjamin, "Black Afterlives Matter," 46; emphasis in original.
36. Benjamin, "Black Afterlives Matter," 46.
37. Benjamin, "Black Afterlives Matter," 47.
38. Marc Quinn, quoted in Colin Dwyer, "Black Lives Matter Monument Replaces Statue of Slave Trader in England," *NPR*, July 15, 2020, https://www.npr.org/sections/live-updates-protests-for-racial-justice/2020/07/15/891329005/monument-to-black-lives-matter-protester-replaces-slave-trader-in-bristol.
39. See Dwyer, "Black Lives Matter Monument Replaces Statue of Slave Trader in England." See also "Jen Reid: Bristol Black Lives Matter Statue Removed," *BBC News*, July 16, 2020, https://www.bbc.com/news/uk-england-bristol-53427014.
40. Robinson, *Forgeries of Memory and Meaning*, xiv.
41. Saidiya V. Hartman, *Scenes of Subjection: Terror, Slavery, and Self-Making in Nineteenth-Century America* (New York: Oxford University Press, 1997), 72, and "Venus in Two Acts," 13. See also Larry Neal's *Visions of a Liberated Future: Black Arts Movement Writings* (New York: Basic Books, 1989).
42. Zhaleh Boyd, cited in Benjamin, "Black Afterlives Matter," 46.
43. Hartman, *Scenes of Subjection*, 72.
44. Hartman, *Lose Your Mother*, 13.
45. Hartman, *Lose Your Mother*, 13.

PART I

WATERY UNREST

Trauma and Diaspora

ONE

RELAYED TRAUMA AND THE SPECTRAL OCEANIC ARCHIVE IN M. NOURBESE PHILIP'S *ZONG!*

DIANA ARTERIAN

Let the groans and cries of the murdered, and the cruel slavery of the Africans tell!

—Quobna Ottobah Cugoano

History was not dead for me, as the postmodernists urge. I wanted a chance to rewrite it.

—M. NourbeSe Philip

In the vastness of the ocean, bodies can be hidden, redacted, lost without a trace. The bodies that line the ocean floor receive no proper burial and thus cannot be properly mourned and put to rest: the desire of the living to acknowledge and show respect for the dead, and to reckon with the grief of personal and communal loss, remains unfulfilled down through the generations haunted by the ghosts of the unceremoniously dead consigned to the anonymity of mass watery graves. For many precolonial West Africans, death was understood as a journey of the soul to meet and reunite with the ancestors.[1]

The ocean in the Middle Passage, for countless souls a watery sepulcher, continues to haunt writers from the African Diaspora, whose efforts to construct a final resting place for these lost souls in language seems forever elusive. In *Saltwater Slavery*, Stephanie Smallwood explains that the forced migration of the Middle Passage was "something akin to death": "[O]ut of sight of any land, enslaved Africans commenced a march through time and space that stretched their own systems of reckoning to the limits."[2] The "stretched systems of reckoning" constitute the site of originary trauma—but, while stretched, they are not broken. Reckoning will come later to the African Diaspora through generational relay. While the abuse and absolute objectification of the Atlantic African's body began on the shore, it continued at sea.[3] The destruction of the enslaved person as subject and the brutality in that desubjectification via the treatment of that person as a fungible commodity (yet one that requires chains[4]), a "desired object: an African body fully alienated and available for exploitation in the American marketplace."[5] Thus, this annihilation of the West African subject in this sepulchral, aquatic archive defines the Middle Passage. The ocean serves simultaneously as a cypher and a place that destroyed most elements of identity for the enslaved people and their future ancestors. Dionne Brand calls the Middle Passage "the door of no return," writing, "I cannot go back to where I came from. It no longer exists . . . That one door transformed us into bodies emptied of being, bodies emptied of self-interpretation,

23

DIANA ARTERIAN

into which new interpretations could be placed."[6] Édouard Glissant describes this portal as the "abyss."[7] Others dub it "a spatial continuum."[8] Claudia Rankine writes, "[I]f you let in the excess emotion you will recall the Atlantic Ocean breaking on our heads."[9] As we shall see, M. NourbeSe Philip considers the oceanic archive "a genealogy of Silence/s."[10]

The Trinidadian–Canadian poet M. NourbeSe Philip explains that she used a five-hundred-word court document from 1783 concerning the massacre of 142 West Africans during the Middle Passage because "the case is the tombstone, the one public marker of those Africans on board."[11] In this essay, I consider Philip's remarkable collection *Zong!*, in which she not only appropriates from this forensic tombstone but attempts to break it apart in order to gain knowledge otherwise lost. The many places of intersection between Philip's experience of relayed trauma regarding the *Zong* massacre[12] and her subsequent creative production of *Zong!* are central to this essay. Ultimately *Zong!* acts as both product and vessel of relayed trauma, evinced in its form, language, and relationality as a text and performance. While most scholars focus on the specificity of Philip's process or politics or consider *Zong!* in the lineage of Caribbean writers, my hope is to address these points while focusing primarily on how her traumatic experience informed her decisions while producing the collection.

The normative approach to the archive overwhelmingly circumscribes the suffering and violence that defined the Middle Passage because the archive is composed of the voices of the slavers who enacted the brutality, rather than those who were subjected to it. Even when abolitionists sought information regarding the Middle Passage to aid their cause, they consulted logbooks and testimonies from slavers and slave ship crews.[13] When we subscribe to notions of a tangible archive, we often allow those who harmed, who held power, and whose voices dominated over the oppressed to continue to define the narrative. As Walter Benjamin cautions, "There is no document of civilization which is not at the same time a document of barbarism. And just as such a document is not free of barbarism, barbarism taints also the manner in which it was transmitted from one owner to another."[14] To access subjugated testimonies of trauma will require other means of reception—a relay, or haunting.[15] The slavers, the captain, the crew are all long dead, yet the ghosts of the murdered enslaved people continue to haunt. As M. Jacqui Alexander writes, "In the realm of the secular, the material is conceived of as tangible while the spiritual is either nonexistent or invisible. In the realm of the sacred, however, the invisible constitutes its presence by provocation of sorts, by provoking our attention."[16] Philip accesses these subjugated stories through her imagination of hundreds of enslaved persons on the *Zong* slave ship killed by the captain's orders in 1781. The cover of *Zong!* offers just such a provocation: "As told to the author by Setaey Adamu Boateng"—a ghost.

I want to consider these ghosts, these hauntings, through the lens of "relayed trauma." While potentially communal, relayed trauma focuses primarily on one's personal experience in response to the trauma(s) of others, and without the normative connection of family or community as a requirement. Relayed trauma requires intimacy but allows for that intimacy to exist beyond bloodlines and across time. Relayed trauma can be mediated by other affiliations. Physical proximity, even in time-space, is not essential. The conditions for relayed trauma necessitate an event that goes beyond the everyday distressing experience that provokes empathy. While the power of empathic feeling and behavior are important and can link us to past events, for the receiver of relayed trauma there is more at stake. Trauma can be relayed directly and through channels other

24

than empathy, including trauma within bloodlines, but also those traumas that continue to ripple out as secondary traumas relating to earlier generations (even when they are potentially outside of one's direct ancestry). Such relayed or secondary trauma possesses the potential to shape personal trajectories, inform present lives, and comprehend the current moment.

People traumatized through relayed information can feel a sense of powerlessness, even when the traumatic happening is far away and/or took place long ago. Because of this spatial and/or temporal distance, those receiving relayed trauma are, most often, limited in their capacity to shield the person(s) experiencing the trauma firsthand.

In the case of the Middle Passage, relayed trauma plays a significant role in the lives of the descendants of enslaved people, so much so it informs their identities. The relayed trauma often determines an individual's trajectory on a fundamental level. In *Zong!* relayed traumas haunt the African Diaspora, and the poem emphasizes experiences of subjugation and conveys them to people who were not witnesses to them. For the characters in *Zong!* and their author and her audiences, the discord between the effect the events have over their lives and their inability to respond is palpable. Thus, I consider how, in *Zong!*, Philip explores the intersection of trauma and poetry in bringing relayed trauma to the surface of the oceanic archive. As someone from Trinidad and Tobago, a place with its own history of connection to the Atlantic slave trade, Philip reckons with events to which she feels both affective ties and temporal distance. Her trauma is not experienced firsthand. Rather, trauma is relayed to her when she learns about these traumatic histories, and the temporal distance does not allow her to prevent what happened in the past.

Philip's book *Zong!* attempts to see through "the door of no return" using a court document as the keyhole through which to peer. It is through appropriation of that brief text and (ultimately) sustained interaction with the ghosts of the *Zong* slave ship massacre that Philip is able to engage and document her relayed trauma. When working on *Zong!*, Philip traveled to a former slave port in Ghana and communicated with local elders and a priest concerning the events of the *Zong* massacre and her book in progress.

> None of my ancestors could have been among those thrown overboard, one elder offers. If that were the case, he continues, I would not be there . . . I have never entertained the thought that I may have had a personal connection to the *Zong*, nor have I ever sought to understand why this story has chosen me. Fundamentally, I don't think it matters, but his comment is still disconcerting.[17]

The "disconcerting" aspect of the elder's comments is the signification of blood as a site of connection. His rationale is that, without that blood connection, Philip has only an indirect claim to the *Zong* massacre and trauma. In fact, having direct blood ties to those on the *Zong* is not required for Philip's relayed trauma or for her taking up of the creative, reparative work of *Zong!* The trauma has "chosen her" through relay. Even further, Philip's daughter later reminds her that there could have been people killed on the *Zong* whose children survived—and to whom Philip may be related.[18] Nonetheless, the *Zong* and the events surrounding that ship are emblematic of the brutality of the "one-way route of terror,"[19] to which Philip is directly connected as a member of the African Diaspora—particularly as a person from the Caribbean.

DIANA ARTERIAN

Direct hereditary connection to those who are victims of trauma, as we have seen, is not necessary to receive that traumatic knowledge. As a Black diasporic woman moving through the world whose ancestors survived the Middle Passage, Philip's contemporary life intersects with the traumas of the *Zong* massacre. She is making no grand claims about the *Zong* and her direct linkage to it, but rather positions herself as an ethical subject who is listening and witnessing. As Emmanuel Levinas states,

> An ethical significance of a past which concerns me, which 'has to do with' me, which is 'my business' outside all reminiscence, all retention, all representation, all reference to a recalled present. A significance in ethics of a pure past irreducible to my present, and thus, of an originating past. An originating significance of an immemorial past, in terms of responsibility for the other man. My unintentional participation in the history of humanity, in the past of others which has something to do with me.[20]

Further, Philip's legal training gives her expertise for analyzing the events of the *Zong* massacre and the nuances of the subsequent court case. Her experiences as a Black Caribbean-Canadian woman writer shape the form of her poetic engagement. The ghosts hailed her, and, blood ties or no, Philip took heed and interpellated their imperative through *Zong!* While Philip insists, "I [don't] want or even care to link myself to the *Zong*," it is the case that the traumas chose her.[21] Whether she has genetic kinship to those shackled and/or killed on the *Zong*, Philip recognizes those murders as a trauma relayed to her.

THE OCEANIC ARCHIVE OF THE *ZONG*

The events on the *Zong* and the legal battle that followed are largely considered to have precipitated the end of England's engagement in the Atlantic slave trade, as the world power outlawed chattel slavery in its colonies not long after. The Liverpool-based *Zong*[22] departed Cape Coast Castle (modern Ghana) overloaded with 442 West Africans. The *Zong* was almost twice as overburdened as the famous *Brookes*, the illustrated cross-section of which is one of the most enduring images of the Atlantic slave trade.[23] Upon arriving in the Caribbean, the *Zong* crew caught sight of Jamaica, took it for Saint-Dominique, a colony of French enemies, and decided to continue despite being low on water reserves.[24] However, they also feared that many of the enslaved people on board would die of thirst before the *Zong*'s arrival in Jamaica—meaning, for the slavers, fewer people to sell upon arrival and a subsequent loss of profits. In addition, those who did survive would be worth little at auction because of their diminished physical states. Thus, the ill captain, Luke Collingwood, called for the crew to throw some of the West Africans into the Atlantic, explaining, "[I]f the slaves died a natural death, it would be at the loss of the owners of the ship; but if they were *thrown alive into the sea, it would be the loss of the underwriters*."[25]

Every experienced slave ship owner insured his "goods" against loss, seizure, or theft. Collingwood's grotesque and contradictory racial calculus was in keeping with the law of the time mandating that enslaved people who died by "natural means"—including suicide—lost their monetary value with no recompense to the ship's owners (versus, say, if they were stolen).[26] Collingwood conjoined this legal practice with another, stating that insurance claims may be made on

26

RELAYED TRAUMA AND THE SPECTRAL OCEANIC ARCHIVE

any cargo the captain of a ship in dire straits must lose ("jettison") in order to reduce weight and gain speed necessary to ensure the overall safety of those remaining on board. Thus, according to the conjunction of these two laws, as Ian Baucom writes, "[D]rowning the slaves . . . was not so much murdering them as securing the existence of their monetary value" for the ship's owners.[27] Thus, on November 2, 1781, the *Zong's* crew threw fifty-four women and children from the ship's windows, one at a time, into the Atlantic. The crew drowned forty-two men from the quarter deck on December 1. According to later testimony,

> One of the Africans spoke some English, and told Kelsall (then no longer first mate) that the people shackled below decks were murmuring on Account of the Fact of those who had been drowned . . . they begged they might be suffered to live and they would not ask for either Meat or Water but could live without either till they arrived at their determined port.[28]

It then rained, filling several depleted water barrels. Despite the enslaved people's pleas and the replenished supply of fresh water, a third group of thirty-eight were drowned by the crew, and ten more jumped overboard of their own volition. The reasoning of the captain here is uncertain; perhaps he intended to utilize the ship's provisions to keep the remaining enslaved people in good health so that they would earn more money on the auction block. All told, 143 West Africans were pushed or dove into the Atlantic. One managed to scramble back on board through a porthole. Despite the murders around them of over a quarter of the people put on the ship at Cape Coast Castle, still 238 survived. Yet, the *Zong* arrived at Black River, Jamaica, on December 22, with only 208 living West Africans aboard ship.[29]

Baucom explains that the *Zong* "was not an aberration, not some wildly exceptional event."[30] The crew murdered enslaved persons by drowning them if enemy ships were near, or the slave ship was operating illegally and in danger of being discovered. The *Zong's* story is exceptional for what happened after the massacre, namely, the legal pursuit of insurance money. While some information on the initial legal exchanges regarding the *Zong* massacre is spotty, we know the ship's owners attempted to collect £30 for each murdered West African based on the insurance they secured prior to the *Zong's* departure from Cape Coast Castle.[31] The insurance company, however, denied them that £3990,[32] and the slavers subsequently took the company to court, where a jury of their countrymen agreed they should be paid the full amount. There is no official documentation of the case up to this point; it is only when the insurance company (represented by Gilbert) attempts to appeal this decision that anything appears in the archive: a two-page court holding stating that the insurance company had the right to have their case heard again (*Gregson v. Gilbert*).

This record of the court case is Philip's primary source for *Zong!* The ghosts of these events also begin to engage her, as her reading of the document brings their traumas into the present. The court decision is, on the whole, highly disturbing. The first sentence alone—"This is an action on a policy of insurance"—demonstrates the degree to which humans are subject to shocking forms of commodification.[33] In this case, human lives were turned into fungible commodities that could be converted into insurable assets whose cash value could be recovered, allowing profit to be extracted even in death. As Baucom writes, "It's hard to remember that, as a legal matter, the *Zong* was not a murder case."[34] The entirety of the court's decision is a macabre work of

27

linguistic gymnastics designed to avoid the dead as dead. Murder as a criminal offense is not invoked; rather, loss of life is summoned merely as burden of proof: "Every particular circumstance of this averment need not be proved. In an indictment for murder it is not necessary to prove each particular circumstance."[35]

The whole of the *Zong* massacre as a legal act, and others like it, hinges on the terrible reality that in the law, as in the minds of the slavers, one might as well have dropped barrels into the sea. This conversion from human to object was not entirely viable, even for those who endorsed such acts of brutality. Solicitor-general John Lee, representing the *Zong*'s owners, states at one point that the enslaved people "*are goods and property: whether right or wrong, we have nothing to do with it. This property—the human creatures if you will*—have been thrown overboard."[36] This bizarre verbal choreography—saying "goods," then "human creatures"—captures that tension present in the total objectification and destruction of the enslaved human subject. As James Walvin writes, "[The slave system] was a concept which from the first contained an obvious contradiction: how could a human being be a thing?"[37] And, I will add, how can a thing require chains to avoid its self-destruction and/or insurrection?

Baucom compellingly takes objectification to its ends, asking: *how can a human being be money?* He writes:

> that the money forms of the trans-Atlantic slave trade could attach themselves not only to the slaves who reached the markets of the Caribbean alive but also to those drowned along the way; that a sufficiently credible imagination could see in a drowned slave a still existent, guaranteed, and exchangeable form of currency; that a British court could hold the majesty of the law to endorse *this* act of the imagination; that the attorneys for William Gregson and his partners could convince a jury that by throwing 132 of the *Zong*'s less desirable slaves into the sea Captain Collingwood had not so much murdered a company of his fellows as hurried them into money, is also, as we shall see, unsurprising—perhaps even the inevitable consequence of that epistemological revolution . . . which had permitted Britain's capital houses to convert "their" slaves into paper money.[38]

I quote Baucom extensively here because his accretive list compounds information with remarkable impact, describing the extent to which the enslaved West African's identity as a human was obliterated, transformed explicitly into the entity desired by those who participated in and benefited from that destruction and objectification—no matter the amount of brutality, death, and stretch of the imagination it required. That desire for profit was so strong as to empty people of their humanity, and equate a human corpse at the bottom of the Atlantic to money gained. *Gregson v. Gilbert* illustrates this obscenity fully. As Philip explains, "[T]his two-page account . . . squeezed out the lives that were at the heart of this case."[39] There were no people here, only goods and value attached to those goods—human agency is attributed only to the slavers as claimants of lost funds.

There are many nonlegal documents regarding the *Zong* case, including those of British abolitionists who successfully publicized the terrible details for the British public.[40] Despite her ability to draw on these additional documents in *Zong!*, Philip chose to engage solely with *Gregson v. Gilbert*.[41] Stef Craps makes the point that "the traumas sustained by the formerly colonized and enslaved are collective in nature and impossible to locate in an event that took place at a

RELAYED TRAUMA AND THE SPECTRAL OCEANIC ARCHIVE

Zong! #7

Figure 1.1. M. NourbeSe Philip's *"Zong! #7."* First published by Wesleyan University Press, 2008, Middleton, CT; reprinted by permission of M. NourbeSe Philip.

first:

the when

the which

the who

the were

the throwing

overboard

the be

come apprehended

exist did not

<div style="text-align:center">Wemusa Ilesanmi Nayo Odai</div>

singular, historically specific moment in time."[42] The documentation of the *Zong* case thoroughly represents the Atlantic slave trade and its horrors. Philip's use of *Gregson v. Gilbert* is thus an apt point of entry into an otherwise potentially elusive and vast system of oppression. The legal aspect provided, for Philip, a foothold into the conditions of the Atlantic slave trade. Consequently, she writes, "I turned . . . to the law: certain, objective, and predictable, it would cut through the emotions like a laser to seal off vessels oozing sadness, anger, and despair."[43] Deploying the techniques of "concrete poetry," Philip enacts a straightforward erasure of *Gregson v. Gilbert* in the fragment *"Zong! #7,"* apparently excising emotion (see figure 1.1).[44] Through the eccentric layout of *"Zong! #7,"* Philip seeks to tilt the focus of the investigation toward the slavers who committed the murders rather than toward the insurance claims. A former lawyer herself, Philip recognizes the function of the legal system here, ostensibly the most objective method of approach—even in regards to something as emotionally chaotic as relayed trauma. Her

DIANA ARTERIAN

recognition of the law as a vital archive is thus, in part, why the *Zong* traumas found their way to her, and why she began the disturbing work of researching the event.

LANGUAGE, LINEAGE, AND THE ARCHIVE

Philip's use of *Gregson v. Gilbert*, an extant document within the colonial archive, is particularly germane when considering the etymology of "archive" itself. Derrida observes that *arkeion* was a residence of a caretaker of sorts with subsequent societal power to "make or represent the law."[45] Thus, with this system in place, "these documents in effect speak the law: they recall the law and call on or impose the law."[46] This power is, like all systems of power, one that disregards methods different than its own for knowing and containing knowledge. There is little regard for alternative means of passing on wisdom, largely due to the potential of those means to subvert what the archive represents (often hegemonic entities). As Diana Taylor writes in *The Archive and the Repertoire*, essentially since the Conquest there has been a long and exacting project of delegitimizing and eradicating often Indigenous methods of transmitting knowledge, such as oral traditions of storytelling or embodied practices of dance.[47] Philip similarly writes, "the written archive, the historical archive has, more often than not, been scripted by those who were integrally connected to the European project of terror and dehumanization of the Other."[48] This colonial enterprise is twofold: establishing and protecting knowledge and law that is largely obscured from the colonized population, and simultaneously othering that population and undermining colonized people's own methods of preserving knowledge. Taylor argues, "The dominance of language and writing has come to stand for *meaning* itself."[49] And this conception of meaning is, of course, most explicitly beneficial for those who possess the power to impose official spoken and written languages through colonial oppression. The colonial archive preserves, records, and orders "official" knowledge while actively redacting the knowledges of subjugated populations. As Akira Lippit explains, this process produces the "shadow" or "anarchive," which "represents an impossible task of the [official] archive: to protect the secret. . . . It is an archive that, in the very archival task of preserving, seeks to repress, efface."[50] In *Situated Testimonies*, Laurie Jo Sears describes the archive as "a site of exclusion, haunting, and lack."[51] Such critical understandings of the archive as an institutional site of power inform my reading of Philip's poetic exhumation of *Gregson v. Gilbert*. Philip explains that her process of "fracturing" the oppressive language of the archival text for her poetry "allow[ed] what I knew was locked in there to emerge; it led me to another archive—the liquid archive of water."[52] Further, this fracturing allows for the recovery of "a memory . . . buried *without legal burial place*," what Nicholas Abraham and Maria Torok describe as that which resides in "a sealed-off psychic place, a crypt in the ego."[53] Alexander asks, "What is the threat that certain memory poses?"[54] Philip, in her creation of *Zong!*, attempts to resurrect the memory entombed in this extralegal oceanic archive.[55]

Philip's engagement with the court document's language was the key to accessing the alternative archive regarding the *Zong* massacre. Philip notes a kinship between legal discourse and poetry, as they "both share an inexorable concern with language—the 'right' use of the 'right' words, phrases or even marks of punctuation; precision of expression is the goal shared by both." Yet, as she states, the stakes for the former are much higher.[56] This precision in legal writing is

RELAYED TRAUMA AND THE SPECTRAL OCEANIC ARCHIVE

an element of why the *Gregson v. Gilbert* document is so horrifying. It was carefully thought through and articulated such that the human victims were demonstrably redacted. As Jenny Edkins writes, "Language does not just name things that are already there in the world. Language divides up the world in particular ways to produce for every social grouping what it calls 'reality.'"[57] The reality *Gregson v. Gilbert* "divided up" involved few individuals with agency and scant options for survival for the enslaved. And, overall, there are notably very few verbs in the whole document.[58] Instead, as Baucom has pointed out in *Specters of the Atlantic: Financial Capital, Slavery, and the Philosophy of History*, what is noteworthy in the court case is that one of the most frequently used terms throughout is a noun: "Necessity."[59] Citing from *Gregson v. Gilbert*, Baucom demonstrates how, in the court case, this term pivots from a discussion of ethics to one of goods: "'a perilous Necessity,' 'an absolute Necessity,' an 'actual Necessity,' 'an inviolable Necessity,' 'an indispensable Necessity,' 'an extreme Necessity,' 'an inevitable Necessity.'"[60] As Philip writes, "The language in which those events [on the *Zong*] took place promulgated the non-being of African peoples, and I distrust its order, which hides disorder."[61] In terms of Philip's experience of relayed trauma, this distrust is a particularly radical move. The tools by which she interrogates her experience, Philip recognizes, are always already compromised: first, through a language deployed by those exacting brutality; and, second, by way of a legal tradition that authorizes a Eurocentric subjectivity that she seeks to disrupt and dismantle.

Philip grapples with English as the language of the colonial oppressor, as well as her own native tongue. She explains, "As with most writers, an issue chooses you—in my case it was language."[62] Throughout her body of work, the conundrum of language recurs repeatedly, largely because of the irreconcilable fact that, as Philip puts it in *Zong!*, the English she speaks and writes also "merely served to articulate the non-being of the African, over and above her primary function as chattel and unit of production."[63] Thus, the archive constituted by *Gregson v. Gilbert* functions as both the source of the originary trauma and the means by which Philip excavates the relayed trauma of the events that took place on the *Zong!* Because of the precise and powerful reach of the legal system, *Gregson v. Gilbert* demonstrates institutional oppression and constitutes the core of Philip's relayed trauma. Documentation of the case aptly captures the depth of processes of desubjectification that reduce human beings to commodities with a starkness that cannot be adequately conveyed by the secondary literature. *Gregson v. Gilbert*'s ability to set legal precedent, and its success in doing so, has enormous societal weight. Further, *Gregson v. Gilbert* becomes the site where Philip continues her interrogation of the English language and the means by which, in this case, it was deployed with such legal facility as to disguise the murders and make the *Zong* events about lost cargo and insurable profits. Philip's focus on the intricate displays of language in the *Gregson v. Gilbert* document's "hid[ing] disorder" renders this "public marker" of the *Zong* events traumatically personal.

The lineage of Western poetic forms that push back against language is a long one, and many critics link Philip to these movements. Philip, however, not only questions those associations but complicates the description of her work as "postmodern." She writes, "you have to understand that the Caribbean was postmodern before the term was coined: Multiple discourses—fragmentation—we've been doing this ever since; we just haven't applied that name to it."[64] Philip does claim a tenuous connection to the 1970s Language Poets, in that she "question[s] the assumed transparency of language and, therefore, employ[s] similar strategies to reveal the hidden agendas of language."[65] Yet, ultimately, Philip avoids the lyric first-person speaker, thereby strategically

31

DIANA ARTERIAN

decentering the self in her work. Writing against the Romantic Wordsworthian notion of the primacy of the poetic self, Philip asks:

> Why should anyone care how the "I" that is me feels, or how it recollects my emotions in tranquility? Without the mantle of authority—**who** gives me such authority—whiteness? Maleness? Europeanness? Without the mantle of authority what is the lyric voice? We seldom think of the lyric voice as one of authority . . . but it is, with the weight of tradition behind it, even in its sometimes critical stance against society or the state.[66]

Thus, according to Philip, the colonizing history of the lyric provides no space for postcolonial Black experiences and relayed traumas. The notion of the lyrical self derives from the Eurocentric delimiting of identity to a singular, stable, coherent construct. In contrast, Philip ponders the multivalence of Caribbean postmodern identity: "Is the polyvocular the natural voicedness of women? Of Blacks? Is it because our sense of self is constituted of so many representations—the gaps, the silences between those selves—the many selves presented to us as African or woman?"[67] Polyvocality, one of the defining motifs in *Zong!*, destabilizes the Eurocentric poetic self, with the many voices breaking the common structure of the "I" who is telling the "you/reader" something of value.[68] *Gregson v. Gilbert* is a colonialist structure, a monolithically hegemonic text—a Western epistemological conceit that Philip exposes and deconstructs using the polyvocality of *Zong!*

With this court ruling, Philip certainly has located a representation of institutional hegemony, and through *Zong!* she attempts to bear witness to and recover the pain and deaths obfuscated by the official archive. Philip brings readers of *Zong!* along with her as she reckons with *Gregson v. Gilbert* and with the fact that English, a language that would have been inscrutable to those harmed and destroyed by it, was used in the courtroom to objectify enslaved people and on board the ship to command them to jump to their deaths.[69] Benjamin argues that the "historical materialist . . . disassociates himself from [the documents of civilization and barbarism] as far as possible" in order to "brush history against the grain."[70] Like Benjamin, Philip underscores the brutality of the archive but approaches the barbaric document with passionate proximity. Thus, the violence of Philip's engagement with *Gregson v. Gilbert* is a "Necessity." She writes, "At times it feels as if I am getting revenge on 'this fuck-mother motherfucking language' of the colonizer . . . bringing chaos into the language or, perhaps more accurately, revealing the chaos that is already there."[71] Those in the West (and where the West/European powers have invaded and colonized) are led to believe that the law and other such institutions create order. For Philip, however, this pretense is a façade hiding the turmoil that cultivates the disparity between the empowered and the subjugated—a dichotomy that undergirds generations of relayed trauma. As Glissant elaborates, "Those who dominate benefit from chaos; those who are oppressed are exasperated by it."[72] Understood in these terms, Philip's *Zong!* attempts to reveal the chaos embedded within the structures of order and the oppression it imposes. If the violence on the *Zong* produced the court document, it is the violence of the archive that generates Philip's acts of literary violence that produce *Zong!*—what Philip calls "a poetics of the unsayable."[73]

As it progresses, the text of *Zong!* becomes increasingly graphic and fragmented. The book-length poem is composed increasingly of sounds and syllables rather than full words—opening with

the straightforward erasure of *Gregson v. Gilbert* (as in figure 1.1) and concluding with a literally vanishing, ostensibly cryptic text. Through this process, Philip explains, "For the first time in my writing life, I felt, this is my language—the grunts, moans, utterances, pauses, sounds, and silences. I feel that now in a powerful sense."[74] This technique likely provided the poet with remarkable relief, as it allows her the space to create a linguistic identity that has defined her art—that which "chose her." But such a strategy fails to offer a site of closure. Clearly derived from relayed trauma, the form of *Zong!* is fraught with emotional cost. As Philip reflects, "This language of limp and wound. Of the fragment. And, in its fragmentation and brokenness the fragment becomes mine. Becomes me. Is me."[75] With its apparent linguistic embodiment of her identity and its reckoning with relayed trauma through creative production, *Zong!* was a particularly difficult book to bring into being. Philip ultimately grapples not only with the events surrounding the *Zong* but with the oppressions of colonialist language and law—and how that archive shapes her current identity. And in *Zong!* this relayed trauma is manifest in the poetic form.

TO PROCESS, IN FORM

In an interview, Philip states, "[T]his is what *Zong!* is attempting: to find a form to bear this story which can't be told, which must be told, but through not telling."[76] Philip's ideas concerning the limitations of colonial language and her technique of "not telling" generate the forms of *Zong!* Caribbean poet Kamau Brathwaite writes, "It was in language that the slave was perhaps most successfully imprisoned by his master, and it was in his (mis-)use of it that he most effectively rebelled."[77] Philip manages to escape from the "prison-house of language,"[78] but "(mis-)use" is too demure a term for the violence of her poetic rebellion against the hegemony of colonial language. Writing about her insurrectionary approach to the *Gregson v. Gilbert* document, Philip unflinchingly asserts, "I mutilate the text as the fabric of African life and lives of these men, women and children were mutilated . . . I murder the text, literally cutting it to pieces . . . throwing articles, prepositions, conjunctions overboard, jettisoning adverbs."[79] Her strong words here describe *Zong!* as an act of vengeance, recognizing that the poem's form functions as a means to destroy the textual corpus—a manifestation of institutional and linguistic oppression—in retribution for the dead. Philip reports that she exacts this textual violence "until my hands bloodied, from so much killing and cutting, reach into the stinking, eviscerated innards." Further, she explains that, as an augur reads viscera, she "reads the untold story that tells itself by not telling."[80] Thus, Philip's literary violence interrogates the social violence by making the text illegible, turning what is affectively incomprehensible into something unreadable but ultimately knowable, creating what Lippit describes as "a visibility born from annihilation."[81] Philip chooses not to appropriate the conventions of a Western poetic tradition because, as she explains, "To 'write' about what happened in a logical, linear way is to do a second violence."[82] In the back matter of *Zong!*, in the section called "Notanda," Philip repeats the enigmatic injunction that this is a "story that cannot but must be told," echoing the powerful refrain that concludes Toni Morrison's *Beloved* ("It was not a story to pass on.").[83]

The violent act of creation that is *Zong!* represents Philip's desire to reckon with the originary violence that is manifest in *Gregson v. Gilbert*. Throughout *Zong!*, the incessant repetition and

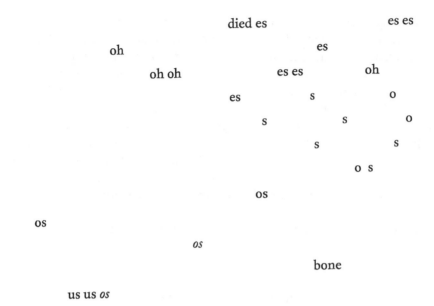

Figure 1.2. Excerpt from the "Sal" section of *Zong!* First published by Wesleyan University Press, 2008, Middleton, CT; reprinted by permission of M. NourbeSe Philip.

wordplay produce alternative meanings and create a third interpretation of the court document. One of the most compelling instances of this linguistic violence is in the section "Sal," immediately following the speaker's description of a woman's drowning (see figure 1.2). Let us begin with "es / oh / es," which is of course the international distress signal S.O.S., or "save our souls," but this wordplay transforms into *os* (bone)—"save us *os* / salve / and save / our souls."[84] This linguistic interplay continues the dance between "save" and "salve" until the words elide into "salve the slav / e *salve* to / sin *salve* / slave *salve*," the italics of *salve* calling attention to the shift from an emollient to the Latin term simultaneously signifying greeting and parting.[85] With a shifting of letters, we move between rescuing and aiding (save / salve) then, with italicization, we get a hail/farewell—all within close proximity to "slave." Through shuffling or expunging of a single letter, with repetition, Philip produces a multitude of meanings. This linguistic fracturing empowered Philip, who writes that it "was my engagement with language . . . helped me to understand how the fragment can resonate and have great power. For those of us who often have nothing but fragments of our original cultures, this was revelatory."[86] Thus, in *Zong!*, Philip constructs an apt form—increasing fragmentation and repetition—to illustrate the violence and rupture of the slave trade and colonialism and the lingering fragmentation of kinship and culture that wends its way through time as relayed trauma.

Traumatic events often result in fragmented memory and knowledge. Of her impulse for repetition, Philip writes that "those of us who have been victims—and sometimes perpetrators—made manifest in our continued need to go over the same material time and time again, trying to find answers, trying to come up with different understandings of what this experience has been all about."[87] For Philip, the violent rebellion inherent to repetition and wordplay—"(mis-)use" of the language—enables the reader to access the meaning that has been effaced by colonialism. As Jenny Edkins writes of political violence, "Abuse by the state, the fatherland, like abuse by the

RELAYED TRAUMA AND THE SPECTRAL OCEANIC ARCHIVE

father within the family, cannot be spoken in language, since language comes from and belongs to the family and the community."[88] As Philip notes time and again, the *Zong* massacre is an untellable event, a trauma that seems to have no meaning or logic by which to comprehend its horrors. Philip grapples with the relayed trauma that she experienced upon encountering *Gregson v. Gilbert*. What she found in this archive was a narrative so painful that, for Phillip, recounting it necessitated breaking through the constraints of normative grammar.[89] Philip states, "I teeter between accepting the irrationality of the event and the fundamental human impulse to make meaning from phenomena around us."[90] Thus, her poetic violence produces a text that generally overwhelms the space of the page with (in)comprehensible snippets that are few and far between (see figure 1.3). By literally dissecting and reconnecting bodies of words, Philip succeeds in excavating silenced voices precisely through the fragmentation and reassembling of the primary source material in *Gregson v. Gilbert*. As Erin M. Fehskens writes, "Instead of apprehending the *Zong* in *any* space, the massacre and attempts at representing it inhabit *every* space."[91] In an interview with Patricia Saunders, Philip reflects that, "in fragmenting the words, the stories locked in DNA of those words are released."[92]

The absences in *Zong!*, the white spaces on the page in particular, inscribe powerful meanings; they are the silences that whirl around the repeated and fragmented words. As poet and scholar Evie Shockley writes, "[T]he most important things happening in that poem [*Zong!*] are happening in the spaces between the words and word clusters."[93] Philip herself explains that "each cluster of words is seeking the space or the silence above. And this creates a number of alternatives for meaning and reading . . . the text becomes an aesthetic translation of the physical containment, the legal containment that marked our arrival in this part of the world."[94] The white space, the silences, surround the text. Absences define meaning or, at the very least, limit its possibilities. In "Multiple Registers of Silence in M. NourbeSe Philip's *Zong!*," Katie Eichorn writes that "any account of slavery . . . requires one to pay even greater attention to silence, both as something discursively produced and as something that can and does function as speech or at least as an audible interruption."[95] Who silences and who is silenced are key to Philip's rearticulation of the events in *Zong!* For Philip, then, silence itself tells a compelling story. Silence invokes the presence of those whose voices are omitted from the official archive. Through the blank spaces on the page, Philip constructs a counter-archive of expressive silences, a space for those voices otherwise redacted in the official archive. Turning inward, *Zong!* invites subjective contemplation of the significances of such silences. As Shockley elaborates, Philip

> not only reconstruct[s] a sense of the speechlessness (in effect) of the passengers in the hold, but also . . . demonstrate[s] to the rest of us that even when we believe we have freedom to use whatever words we wish to use, that we have the entire lexicon . . . at our disposal . . . much of the language we work with is already preselected and limited, by fashion, by cultural norms—by systems that shape us such as gender and race—by what's acceptable. By order, logic, and rationality.[96]

What Shockley suggests here, then, is that the logic and assumptions underlying the construction of the legal document itself directly define its reception and limit our capacity to understand the events of the *Zong* massacre. By their "(mis-)use of language," Philip's fragmentation and

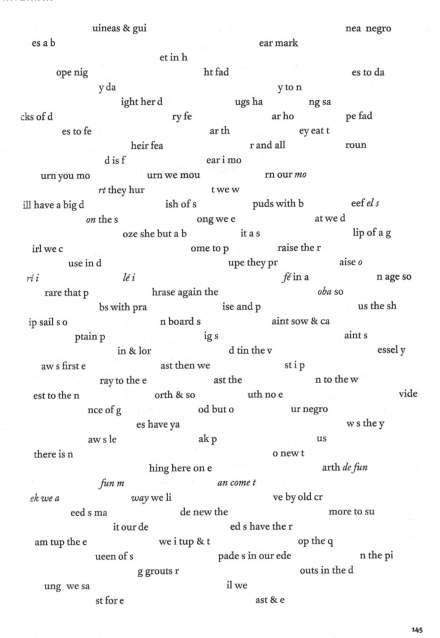

Figure 1.3. Page 145 of *Zong!* First published by Wesleyan University Press, 2008, Middleton, CT; reprinted by permission of M. NourbeSe Philip.

repetition thus challenge and resist complicity in the structure that made possible the massacre and its subsequent legal rationalization.

Philip's method of engagement with language in *Zong!* resonates with Glissant's concept of relationality, "in which each and every identity is extended through a relationship with the other."[97] A creolization occurs here. Not only is she a poet/medium, embodying creative

RELAYED TRAUMA AND THE SPECTRAL OCEANIC ARCHIVE

retribution, but Philip recognizes that, in enacting violence upon a hegemonic archive in order to be the arbiter of information, there is an overlap between her acts and those of the colonizer. Glissant describes "flash agents" as "relay agents who are in tune with the implicit violence of contacts between cultures and the lightning speed of techniques of relation."[98] Not only is Philip "in tune" with such violence, but with the production of *Zong!*, she herself takes up the tools of violence, turning them against the instruments of power. And perhaps not without some irony, she likens herself to Captain Collingwood embarking on a slaver's journey.[99] Her task, as she perceives it, is to tarry between the account archived by the perpetrators and the relayed traumas of the ghosts of the victims of the *Zong*. She reckons with her complicated role as a poet of violence thusly:

> In simultaneously censoring the activity of the reported text while conjuring the presence of excised Africans, as well as their humanity, I become both censor and magician... I replicate the censorial activity of the law, which determines which facts should or should not become evidence; what is allowed into the record and what is or is not. As magician, however, I conjure the infinite(ive) of to be of the "negroes" on board the *Zong*.[100]

Just as Glissant explains in his concept of root identity (imperialism, law, myth) versus relational identity (chaotic relations between cultures), Philip understands that she must wrestle with her uncomfortable position in the dichotomy between colonizer and colonized.

While *Zong!* privileges the ghosts of the West Africans on board the ship, it also incorporates the presence of the crew and the existence of British slave law. In the third section, "Ventus" (Latin for "wind"[101]), an entirely different font appears, disrupting the typeset words with a handwritten, cursive query addressing a beloved named "Ruth" (see figure 1.4).[102] Throughout "Ventus," typescript and cursive are juxtaposed, and this juxtaposition implies that the cursive text is taken from a crewmember's letter. In one instance, for example, the bits of cursive can be reconstructed to read: "my fri / end i p / en this to y / ou since y / ou are my f / riend...."[103] These epistolary fragments are vexing for Philip, who explains, in an interview, that the cursive is indeed "a white Euro male voice, who is confronting his own actions and responsibility in this horrific event, and ordinarily I would never have been interested in that voice, and for good reason. [At times] I would think, 'shut the fuck up already, we've heard enough about and from

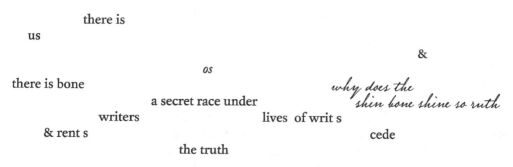

Figure 1.4. Excerpt from the "Ventus" section of *Zong!* First published by Wesleyan University Press, 2008, Middleton, CT; reprinted by permission of M. NourbeSe Philip.

DIANA ARTERIAN

you!'"[104] Yet Philip allowed that voice to remain ("this is what was surfacing in the text"[105]), thus heeding the imperative to include traumas that were relayed to her from the archive, no matter the source. In not censoring the voices of the slaver, Philip engages the chaotic relations between cultures described by Glissant.

Thus, while Philip has little investment in the "white Euro male" experience, its representation plays a role in her understanding of her own relayed trauma. The archival source, in addition to the traumatic events, is cause for horror and revulsion here. Yet the violence on the *Zong* inextricably links slaver and slave to one another, an entanglement that defines the trauma Philip shares with the reader. The fragmented form ultimately is Philip's means of conveying the complexity of the trauma through the representation of multivocality implicit in Glissant's notion of relational poetics. Philip writes, "[*Zong!*] is all about words being in relationship to each other. Words creating spaces to allow other words to breathe. Colonialism was not about this kind of Relationship. It was rather about power—power over."[106] Thus, while present, the slaver's voice remains on Philip's terms—fragmented and surrounded by the silences representing the ghosts of the *Zong* and the generational traumas that they relay.

"AS TOLD TO": SPECTRAL INTERVENTIONS

Zong! feels unearthly. And it is not simply because, as the cover declares, the story is "as told to the author by Setaey Adamu Boateng," a spectral voice, but also because Philip's particular poetic use of language both destabilizes and defamiliarizes the archive.[107] Signifying on the conventions of the nineteenth-century American slave narrative, the title of Philip's work foregrounds the instrumental role that haunting plays in the transmission of traumatic knowledge. She reflects, "When I think of *Zong!* nothing is very clear in the work. The images are fleeting, it's almost as if you can't pin them down, as if they're ghosts."[108] Raw data of death tolls gives us little insight into the particular traumas of the Middle Passage. On this point, Smallwood writes, "A great deal has been learned from the data on mortality aboard the slave ship, but overall numbers—and our interpretation of them—correspond only loosely to the ways African captives experienced and understood shipboard mortality."[109] Considered alongside the facts and raw data of the *Zong* massacre and the Atlantic slave trade as a whole, ghostly presences and spectral transmission of traumatic knowledges become alternative means of gaining access to submerged, oceanic archives. The documentation to which we do have quick and easy access in the official archive is scratched into parchment by those who profited from and enacted the Atlantic slave trade—slavers, ship crewmembers, and auctioneers. As Taylor writes, "from the sixteenth century onward, scholars have complained about the lack of valid sources."[110] The danger here, of course, is that those whose voices have been redacted, silenced, and ignored as a "valid source" still remain largely unknown. Hegemonic history continues to repeat itself without reckoning.[111] Philip, however, makes an intervention in that cycle. While repeatedly insisting that *Zong!* is the "story that cannot be told," Philip nevertheless pushes against that apparent injunction through creative production and ghostly encounter. Otherwise, if something is deemed "unspeakable," then, as Edkins writes, "we are excused from further inquiry."[112] If we adhere solely to the knowledge contained within the normative archive, we reinforce and risk the continuing dominance of that hegemonic narrative. Focusing specifically on empirical data to the exclusion of other ways of knowing, we miss

RELAYED TRAUMA AND THE SPECTRAL OCEANIC ARCHIVE

the submerged narratives that bear witness to the traumatic realities that harmed and killed innumerable people. As Kathleen Brogan writes, "Historical meaning and ethnic identity are established through the process of haunting."[113] If we are willing to accept that history and the past are not the same, we must simultaneously accept the ghost as a source of knowledge.

Thus, while I recognize the value of Derrida's idea that "there is no witness for the witness"—that some traumas simply cannot be claimed and understood by another—I push back at his assumption that "there is *never* a witness for the witness"[114] for it simultaneously assumes that one: those traumas can and will remain illegible to others, and two: ghosts cannot select witnesses of their deaths and concealed experiences for relay. Agamben agrees with Derrida in part, describing the "lacunae" within testimony by survivors of deadly encounters. He writes, "The survivors speak in their stead, by proxy, as pseudo-witnesses; they bear witness to a missing testimony. And yet to speak here of proxy makes no sense; the drowned have nothing to say, nor do they have instructions or memories to be transmitted."[115] These drowned have a good deal to say, as Philip illustrates, and—especially considering her feeling that she was being pushed to write certain voices—in specific ways.[116] Since the cover and frontmatter of *Zong!* present the book "[a]s told to the author by Setaey Adamu Boateng," this poem is thus framed as a haunting to whose dictates Philip surrenders in order to grapple with the traumatic knowledge the ghosts decide to relay to her.

Avery Gordon calls for a shifting of interrogation from "How can we be accountable to people who seemingly have not counted in the historical record?" to "How are we accountable for the people who do the counting?"[117] To dismiss the possibility of ghostly encounters is to heed the hegemonic approach to the world as dictated by patriarchal and colonial powers. It is to quash the notion that those harmed and killed by those same powers have absolutely no means of recourse, of relay. This ascribes more power to hegemony than it deserves, and undermines the ability of the spirit after it is relieved of the pressure and oppression hegemony imposed upon it when it was in a body. As M. Jacqui Alexander notes, "The dead do not like to be forgotten."[118] Indeed it is clear that they are disruptive (or inspiring or healing) when it seems they are neglected in cultural memory. Edkins writes, "What has been forgotten—subjugated knowledges—like the memory of past traumas, returns to haunt the structures of power that instigated the violence in the first place. Trauma is that which refuses to take its place in history as done or finished with."[119] This definition of trauma is simultaneously one of the most expansive yet precise I have encountered. It contains the vast cultural traumas as well as the personal—and implies the spectral response (refusal of closure) and the agency of those after trauma marks them in some way and/or precipitates their deaths. The desire to continue the dialog with the living, to relay the knowledge their traumas contain as potentially protective, gives insight into the current moment, if nothing else. As Grace M. Cho writes, "When an unspeakable or uncertain history . . . takes the form of a 'ghost,' it searches for bodies through which to speak. In this way, the ghost is distributed across the time-space of diaspora."[120] This ghostly relay of traumatic knowledge is vital to comprehending present-day social systems through which the living move and endure and which have come to be understood as the afterlives of slavery.

Traumas of the past, otherwise unknown in their particulars (numbers of dead, sure—but experience or "a reality that exceeds facts,"[121] not really) can shine a light on present subjugations and the systems in place to maintain that position in the world. Otherwise, as poet and scholar Alice Ostriker writes, "silence is surrender"[122]—in this case, to the status quo, the

ignorance of the past, and all that is required for hegemonic powers to remain in their locations of dominance. These revelations are not benign to the recipient of traumatic relay. As Brogan notes, "The ghost gives body to memory, while reminding us that remembering is not a simple or even safe act."[123] For Philip this was in the encounter with a single word, a description in a sales book otherwise filled with "negroe man" or "negroe woman" in which she finds several "Negroe girl (meagre)." Philip writes, "This description leaves me shaken—I want to weep. I leave the photocopied sheet of the ledges sitting in my old typewriter for days. I cannot approach the work for several days."[124] This is the moment of collapsed identity (no names, only monetary value of thirty pounds sterling[125])—yet "meagre" gives us something, gave Philip something. This ledger entry is a trace of the crossing and the trauma as scannable upon the girl's body. The ghost punctures, similarly. As Abraham and Torok note, "It is memory entombed in a fast and secure place, awaiting resurrection."[126] The resurrected memory of the ghost reveals the interiority of an event or situation otherwise obscured in the archive. Flouting the laws of time and space with an urgency—even if the relayed knowledge harms ("I want to weep"), the ghost is ultimately acting in order to provoke the attention of the haunted subject and to invite a comprehension of events and their impact on the people involved that goes beyond their reduction in the archive to ledger entries. Alexander explains this cross-temporal communication as follows:

> Spirit energy both travels in Time and travels differently through linear time, so that there is no distance between space and time that it is unable to navigate. Thus, linear time does not exist because energy simply does not obey the human idiom. What in human idiom is understood as past, present, and future are calibrated into moments in which mind and Spirit encounter the energy of a dangerous memory, a second's glimpse of an entire life . . . all penetrating the web of interactive energies made manifest.[127]

It is through death that the specter can cast off the "human idiom" of time and move freely, encountering those with whom it hopes to initiate contact, relay knowledge. The ghosts of subjugated persons are able to locate an agency otherwise denied them in life. As the poet Morgan Parker recently stated, "[L]inear time isn't real. It's bullshit, and it's white nonsense."[128] Ghosts exploit this fact. The impact trauma often has on those who sustain it—breaking the acceptance of chronological time, fearing the present safe state is the past site of danger, the difficulty of recalling the event(s) in sequential order—feeds into the issue of what is considered a "valid" archival source, as Taylor describes.

Those who endure and die from traumatic experiences are often the people whose identities are subjugated by hegemonic powers throughout history. Those who survive these traumas and attempt to testify or relay them often struggle to do so in ways acknowledged by those who maintain the normative archive. This points to why, in part, Philip's forms throughout *Zong!* push against the lyrical, against the narrative. She is attempting to document an "untellable" event through the ghosts' voices spilling onto the page. She writes, "*Zong!* is hauntological; it is a work of haunting, a wake of sorts, where the specters of the dead make themselves present."[129] *Zong!* places itself within the lacunae of knowledge regarding the *Zong* event—as just one of thousands of similar deadly traumas throughout the years of the Atlantic slave trade. As Philip reminds us, "The only reason why we have a record is because of insurance [law]."[130] Philip's attention to this

RELAYED TRAUMA AND THE SPECTRAL OCEANIC ARCHIVE

record as a poet and lawyer informs her deep distrust of it. When the specters begin to speak, Philip transcribes their experiences and breaks and fights traditional form in an attempt to contain the uncontainable, tell the untellable, and write the unwritable. She explains, "[I]t is so instinctive, this need to impose meaning."[131] Yet despite her best efforts to fight meaning, form, and narrative, portions of *Zong!* indeed include traceable narrative. Two ghosts, in particular, relay their traumas, and Philip allows room for their stories, identities, and specificity. Their chronology.

One of these is the "white Euro male voice" that provokes Philip to think "shut the fuck up already, we've heard enough about and from you!"[132]—which she nevertheless includes because it is the ghostly information coming to her, ostensibly provoking insight that she might otherwise miss. This unnamed crewmember's narrative is intertwined with a West African on board named Wale, and manifests itself in "Ferrum" (iron). The events culminate with Wale asking the crewmember to write a letter to his wife, Sade. It ends with Wale's suicide.[133] "Ferrum" is largely from the perspective of that crewmember[134] to his beloved Ruth (as mentioned earlier) or his interior voice, recording his observations of a life of an enslaved person on the *Zong* (Wale), and describing Wale and Sade's life together and eventual kidnapping in West Africa. In large part this involves descriptions of the crewmembers' meals and prayers—but also the massacre themselves: "wa / ter / to se / cure our pro / fit we th / row them to res / cue our for / tunes . . . to se / cure their re / scue the / y fall o / ver bo / ard to pre / serve our profit"; "t / his story i / s not mi / ine to t / ell tell i / t i m / ust it was on / ly trade after a / ll." While this is the rationale of the captain and British law, the crewmember does see it differently: "it was a c / ase of m / urder i te / ll you"[135] His villainy not so clear, Philip creates space for the troubled slave ship crewmember to speak, too.

Throughout "Ferrum," the crewmember tells of Wale and Sade's love, their child (Ade), attempts to evade capture, and eventual seizure—Sade apparently in the hands of Ruth,[136] with Wale on the *Zong*. The powerful and often disorienting section ends with Wale approaching the crewmember: "i see yo / u to wri / te a / ll ti / me me wa / le you wr / ite for m / e," which the man does.[137] The letter reads, "de / ar sade you b / e my queen e / ver me i mi / ss you & a / de al / l my lif / e."[138] Wale then eats the letter to Sade and says "*sa / de fé / mi i / fá if / á if o / nly ifá*" and leaps into the Atlantic.[139] This is perhaps best translated from Yoruba as (roughly): "Sade loves me, Ifá Ifá if only Ifá."[140] The script can do nothing, the text can go nowhere on a ship in the Atlantic—certainly not to an enslaved woman in England who cannot read English. The desperation to create a message, to make feeling legible was so urgent to Wale—yet his recognition of the impossibility for that message to be accessible to the woman to whom it is addressed is crushing, causing his suicide.

The act of ingesting the hegemonic text, the feelings made legible by hegemonic methods, destroys Wale. His love lost, his identity collapsed, the oppressor's language in his mouth, Yoruba on his tongue, he chooses death. After Wale jumps into the sea, the crewmember states, "i ca / ll his na / me & f / all too t / o my on / ce my noo / nce queen of the ni / ger the sa / ble o / ne *nig / ra afra*."[141] The crewmember dies then, too, calling from the water or perhaps merely in his mind, as Wale expresses himself similarly: "*sa / d / e oh ye ye* afr / i / ca oh." The section's final words come from an omniscient: "o / ver & o / ver the *o / ba* s / o / b / s"[142] "Oba" is Yoruba for king, and the statement that the oba is crying or sobbing is a recurring motif in *Zong!* Here, it points to Wale and Sade calling one another king and queen. Weeping and death define this series

41

of pieces. Words on paper mean nothing to enslaved people on an isolated ship. Words are the means of slavers' attempt to legitimize brutality and murder, of West Africans' destruction. Distrust the words, exterminate them. You will have greater success relaying your pain and trauma after death than in life. The horror of this truth, coupled with the horrors of the daily reality on the ship, are enough to send Wale to suicide. By Western literary standards and concepts of narrative, this is one of the more "legible" threads of *Zong!*—a narrative a reader can likely trace. Considering Philip's ethos for the text, this fact has its complication for me in that it reveals the appeal narrative has to me, how I grasp for it when it comes in *Zong!*, even from the voice of the oppressor. While *Zong!* often fights specific meaning, it is experiential—focused on producing feeling rather than fixed comprehension. This is largely in the most important element of the text's existence, which this "Ferrum" section points to explicitly if one is self-reflective: the reader. As Quéma writes, "The poem makes the Ancestors manifest, but this manifestation cannot occur without the work that is expected from readers."[143]

READERS' ROLES

By the end, the incessant fragmentation progresses to the margins of *Zong!*'s large pages. The poem is visually overwhelming, resisting the common conventions of written literature. Thus, for some readers, when first encountering *Zong!*, the impulse is to snap it shut.[144] In "The Archive and Affective Memory in M. NourbeSe Philip's *Zong!*," Jenny Sharpe explains that, "[b]y refusing the logic of language and narrative, Philip's poems present a problem for the reader."[145] Philip actively works to present the poem as a critique of the history of the Atlantic slave trade and its illogics in order to engage readers who may otherwise remain willfully ignorant of the legacies of racial capital. As Philip explains, "I have never set out to be difficult in my work . . . I understand that when someone looks at a page of *Zong!*, they may wonder what to do with it."[146] Yet Philip is quick to add that "[d]ifficulty is supposed to be the preserve of the white, European male. Not the Black female."[147] *Zong!*'s fragmentation, breaking down of language, and illegibility constitute a form of traumatic textuality meant to embody the horrors of the experience of the Middle Passage. Thus, some readers' dismissal of *Zong!* as too difficult or illegible misses the need for a book such as *Zong!* to exist and be read—despite readerly discomfort. The experience of reading *Zong!* is not meant to be easy. The difficulty of the text also embodies the experience of relayed trauma in coming to terms with the archive of *Gregson v. Gilbert*. Readers of *Zong!* become witnesses, although positioned differently in relation to these subjugated histories. Philip generously offers the reader a window into her own process of coming to terms with relayed trauma. Thus, white readers are confronted with their own histories and must acknowledge their own complicity in the perpetuation of trauma.

Ultimately *Zong!* functions as a dialogic text, demanding readerly participation in the production of meaning. Philip explains that her intention is for the reader to become a "cocreator" along with her: "The form accomplishes that by allowing the reader certain options on how to read, and it is in the process of making choices to read that the reader becomes cocreator."[148] At times, the form is so fragmented that readers must choose how to reorder or reassemble the words as the eye scans the page. In her essay "*Zong!*'s 'Should We?': Questioning the Ethical Representation of Trauma," Veronica Austin discusses the impact of this readerly "cocreation" and its

subjective meaning-making: "Philip's text sets up a contradictory necessity: readers are positioned at once to have to do more work, thereby potentially to assert more power over the text and the historical event it represents and to have that position of power denied."[149] *Zong!*'s fragmented language is thus intended to create a sense of dislocation, dissociation, and displacement that imbricates the reader in an affective experience not dissimilar to that of the originary traumatic event.

In the "Notanda" section of the book, Philip writes about the difficulty of engaging with *Gregson v. Gilbert*: "In the discomfort and disturbance created by the poetic text, I am forced to make meaning from apparently disparate elements—in so doing I implicate myself. The risk—contamination—lies in piecing together the story that cannot be told."[150] Thus, the human impulse to comprehend, to make meaning or sense from something entirely senseless, to create poetic narrative from an untellable story, leads to Philip's sense of self-implication, which extends to her readers as well. She continues, "[S]ince we have to work to complete the events, we all become implicated in, if not contaminated by, this activity."[151] In trying to piece together the fragments of this untold story, we come closer to our own imbrication in this untellable story. By placing "Notanda," her statement of aesthetic methods, at the end of the book (rather than at the beginning), Philip avoids alerting the reader of the fragmented journey that is *Zong!*

Philip's challenging poetic form is Glissant's relational poetics writ large: "This is not a passive participation. Passivity plays no part in Relation."[152] *Zong!* embodies chaotic expression, but also the requirement of deep connectivity—even if readers are connecting to a trauma outside their heritage or ancestral experience, even if these ghosts are not theirs. *Zong!* demands that readers participate in the trauma's relay—that is, they are challenged to encounter it through implication and feeling rather than passive reading and logical apprehension. It is through dialogic engagement with this painful chaos that readerly connectivity through "shared knowledge" takes place.[153]

Philip produces a text that requires the reader to engage untellable knowledge—or not to engage at all. In other words, *Zong!* does not do that work for readers. Readers must choose. Philip writes,

> The not-telling of this particular story is in the fragmentation and mutilation of the text, forcing the eye to track across the page in an attempt to wrest meaning from words gone astray . . . The resulting abbreviated, disjunctive, almost non-sensical style of the poems demands a corresponding effort on the part of the reader to 'make sense' of an event that eludes understanding, perhaps permanently.[154]

By filling the gaps, by providing meaning to meaningless brutality, what Philip calls "anti-meaning,"[155] readers become active participants in not only the poem but also the history it confronts. Ideally, *Zong!* illuminates the implications of this interactive reading. Readers are then enmeshed within Glissant's chaotic connectivity between people, and the relayed trauma the poem conveys.

Relayed trauma and Glissant's theory of "Relation" are perhaps most fully realized during some of Philip's public presentations of *Zong!*, in which she invites audience participation in the act of performance. Disseminating handouts, Philip assigns audience members different roles, turns off the lights, and directs them to shout various lines in the dark while holding candles or

flashlights to their pages. The audience members stand as a group, speaking the ghostly words of *Zong!*, creating a communal, spectral, and immersive experience.[156] Who is who, who bears what role or identity, is not so simple here. At one recent event, Philip submerged written questions from some audience members in a bottle of water. She explained that these submerged questions symbolized those audience members being drowned in the water. And then she invited other members of the audience to extract a question and read it as if it were their own.[157] The use of water as a means of destruction (the paper will eventually deteriorate), as well as a location for inquiry, is a powerful one, directly linking the performance to Philip's idea of the oceanic archive. The polyvocality is immersive, as different audience members speak from the voices from the *Zong*. No one voice is clear enough to distinguish from the others, which makes explicit the idea that each person's place is in the chaos of Relation. Each audience member plays a role in the relay of this collective trauma. The specificity of the role (whether crew, enslaved Atlantic African, none of the above) does not matter. What matters is the active participation. As Fred D'Aguiar writes at the end of his novel *Feeding the Ghosts*, "The *Zong* is on the high seas. Men, women and children are thrown overboard by the captain and his crew. One of them is me. One of them is you. One of them is doing the throwing, the other is being thrown. I'm not sure who is who, you or I . . . There is only the fact of the *Zong*."[158]

In the final section of *Zong!*, "Ebora" (underwater spirits), Philip stacks words directly on top of one another, presenting grey text that is indeed at times illegible. *Zong!* may appear to be an ordeal for its reader, as it ranges from legible to fully illegible text through fragmentation, erasure, and palimpsest.[159] Pages are often visually overwhelming, requiring active readerly choices that Philip has organized to invite the reader to examine their own imbrication in the histories and systems that led to the *Zong* massacre. In the afterword, Philip documents her own experience of relayed trauma in encountering *Gregson v. Gilbert* and chronicles the aesthetic method guiding her creative production and her decision to solicit the readers' engagement. *Zong!* invites dialogic performance in order to narrate the untellable. *Zong!* has remained dynamic, powerful, and informative—a space of collective reckoning with relayed trauma.

NOTES

Quotations from M. NourbeSe Philip's *Zong!*, first published by Wesleyan University Press, 2008, Middleton, CT, are reprinted by permission of M. NourbeSe Philip.

1. Stephanie E. Smallwood, *Saltwater Slavery: A Middle Passage from Africa to American Diaspora* (Cambridge, MA: Harvard University Press, 2009), 58–59. Smallwood also writes, "In some Atlantic African communities it was believed that persons who departed in this way did in fact return but traveled not on the metaphysical plane of the ancestors but rather, transmuted as wine and gunpowder, on the material plane of commodities—an idea suggesting that the special violence of commodification produced not only social death, but more ominous still a kind of total annihilation of the human subject" (*Saltwater Slavery*, 61).
2. Smallwood, *Saltwater Slavery*, 59, 131.
3. Hortense J. Spillers argues this point similarly in her essay "Mama's Baby, Papa's Maybe: An American Grammar Book" (*Diacritics* 17, no. 2 [1987]: 72).
4. Smallwood writes, "Traders and masters alike confronted the universal contradiction inherent in the idea of human beings as property; conceding that a slave had a will, in order to better devise means to control it, was not an acknowledgment of the slave's personhood" (*Saltwater Slavery*, 182). James Walvin cites the contradiction of

RELAYED TRAUMA AND THE SPECTRAL OCEANIC ARCHIVE

chains as well, writing, "chains represented both the fearful apprehension of the enslaver *and* the ubiquitous, resistant defiance of the enslaved" (*The* Zong: *A Massacre, the Law and the End of Slavery* [New Haven, CT: Yale University Press, 2011], 37).

5. Smallwood, *Saltwater Slavery*, 122.

6. Dionne Brand, *A Map to the Door of No Return: Notes to Belonging* (Toronto: Doubleday Canada, 2001), 90, 93. Édouard Glissant addresses this fact in regards to Jewish diasporic populations who, while dispersed and largely apart from their place of origin, "maintained their Judaism, they had not been transformed into *anything else*" (*Caribbean Discourse: Selected Essays*, trans. J. Michael Dash [Charlottesville: University of Virginia Press, 1989], 17). James Walvin, in *Black Ivory*, writes, "No other slave system was so regulated and determined by the question of race. No other slave system forcibly removed so many people and scattered them across such vast distances—and for such wonderful returns to the slave-owning class" (*Black Ivory: A History of British Slavery* [London: HarperCollins, 1992], xii).

7. Édouard Glissant, *Poetics of Relation*, trans. Betsy Wing (Ann Arbor: University of Michigan Press, 1997), 6–8. The "abyss" for Glissant is the ship's hold as well as the ocean it sails over, the unbearable depths of that despair: "[I]n actual fact the abyss is tautology: the entire ocean, the entire sea gently collapsing in the end into the pleasures of sand, make one vast beginning, but a beginning whose time is marked by these balls and chains gone green" (*Poetics of Relation*, 6).

8. Maria Diedrich, Henry Louis Gates, Jr., and Carl Pedersen. "The Middle Passage between History and Fiction: Introductory Remarks," in *Black Imagination and the Middle Passage*, ed. Maria Diedrich, Henry Louis Gates, Jr., and Carl Pedersen (New York: Oxford University Press, 1999), 8.

9. Claudia Rankine, *Citizen: An American Lyric* (Minneapolis, MN: Graywolf Press, 2015), 73.

10. M. NourbeSe Philip, *A Genealogy of Resistance: And Other Essays* (Toronto: Mercury Press, 1997), 13.

11. M. NourbeSe Philip, *Zong!* (Middletown, CT: Wesleyan University Press, 2008), 194.

12. Ian Baucom takes issue with the violent events on the *Zong* ship being dubbed "a massacre" rather than multiple massacres of each West African slave thrown overboard (*Specters of the Atlantic: Finance Capital, Slavery, and the Philosophy of History* [Durham, NC: Duke University Press, 2005], 130).

13. Françoise Charras, "Landings: Robert Hayden's and Kamau Braithwaite's Poetic Renderings of the Middle Passage in Comparative Perspective," ed. John Louis Gates, Jr., and Carl Pedersen, in *Black Imagination and the Middle Passage*, ed. Maria Diedrich (New York: Oxford University Press, 1999), 58. Walvin writes, "Each slave landed in the Americas with his or her own unique memory of enslavement. A mere handful left an account of their experiences, though we know a great deal from the accounts of their tormentors" (*Black Ivory*, 33).

14. Walter Benjamin, *Illuminations*, trans. Harry Zohn (New York: Harcourt, Brace & World, 1968), 256.

15. Saidiya Hartman, in an interview with Patricia Saunders, notes on the archive and her book *Lose Your Mother*, "The nature of the archive, and/or the absence of captive Africans as subjects in the discourse of slavery, and the absence that haunts the physical spaces of confinement made writing the book seem impossible. How does one write about a history that is this encounter with nothing; or write about a past that has been obliterated so that even traces aren't left. That entails more than a critique of the archive. This absence or loss was a window onto the enormity of violence that characterized the process of captivity and enslavements" (Saunders, "Fugitive Dreams of Diaspora: Conversations with Saidiya Hartman," *Anthurium: A Caribbean Studies Journal* 6, no. 1 [2008]: article 7, 4).

16. M. Jacqui Alexander, *Pedagogies of Crossing: Meditations on Feminism, Sexual Politics, Memory, and the Sacred* (Durham, NC: Duke University Press, 2005), 307.

17. Philip, *Zong!*, 202.

18. Philip, *Zong!*, 202.

19. Smallwood, *Saltwater Slavery*, 6.

20. Emmanuel Levinas, *Entre Nous: On Thinking-of-the-Other*, trans. Michael B. Smith and Barbara Harshav (New York: Columbia University Press, 1998), 150.

21. Philip, *Zong!*, 202.

22. Liverpool was a major hub of the Atlantic slave trade for a century, with roughly five thousand voyages embarked from the city from 1690–1807 (Walvin, *The* Zong, 21). The *Zong* was formerly the Dutch *Zorg* or "Care," captured by England and renamed (Walvin, *The* Zong, 69).

DIANA ARTERIAN

23. Walvin, *The* Zong, 27–28. The common ratio of a British slave ship was 1.75 enslaved people per ship's tonnage capacity. The *Brookes* was 2.3 enslaved people per ton—the *Zong* was 4.0 enslaved people per ton. As Smallwood explains, "Because human beings were treated as inhuman objects, the number of bodies stowed aboard a ship was limited only by the physical dimensions and configuration of those bodies" (*Saltwater Slavery*, 68).

24. Walvin, *The* Zong, 92. While I lean heavily on Walvin's text, it has a pat, foreboding tone, laden with rhetorical questions that give it the feel of a "whodunit" crime novel. Ultimately Walvin's many questions remain unanswered—the ill Captain Luke Collingwood died in Jamaica, the First Mate James Kelsall never testified in person, and Robert Stubbs (generally regarded as a duplicitous man who was a civilian passenger serving as first mate at some point during the voyage) was the only person to testify in court (Walvin, *The* Zong, 86–87). The *Zong*'s logbook went missing by the time of the trial (Baucom, *Specters of the Atlantic*, 127). Baucom also provides a description of the events, though not as thoroughly (*Specters of the Atlantic*, 129).

25. Walvin, *Black Ivory*, 15; emphasis in original.

26. "The insurer takes upon himself the risk of the loss, capture, and death of slaves, or any unavoidable accident to them: but natural death is always understood to be excepted:—by natural death is meant, not only when the captive destroys himself through despair, which often happens: but when slaves are killed, or thrown into the sea in order to quell an insurrection on their part, then the insurers must answer" (qtd. in Walvin, *The* Zong, 112).

27. Baucom, *Specters of the Atlantic*, 8.

28. Walvin, *The* Zong, 157. In the normative archive, this is the closest we have to testimony from a West African who was aboard the *Zong*.

29. Walvin, *The* Zong, 99. The crew was in a sorry state themselves. Former First Mate Kelsall "found himself unable to perform any further duties aboard ship," Captain Collingwood "became 'delirious' after the last slave was drowned and had to be relieved of his command" (Baucom, *Specters of the Atlantic*, 131).

30. Baucom, *Specters of the Atlantic*, 109.

31. This was the Gregson slave-trading syndicate that included James Aspinall, George Case, Edward Wilson, and William, James, and John Gregson. "[William Gregson] was either primary or secondary investor in 177 voyages which carried 60,669 slaves, of whom 51,082 survived the middle passage . . . Nine thousand, nine hundred and fourteen of the human beings taken aboard ships Gregson either owned or co-owned did not reach the Americas alive" (Baucom, *Specters of the Atlantic*, 49).

32. This is through some rough math on my end. Presumably this number is what they were after—there is no extant documentation on the exact monetary figures in this case. It does seem that the ten West Africans who took their own lives did not "count" as lost goods, as their deaths were "natural," precluding them from Gregson's claim. The man who successfully returned to the ship, also, seems to not be included. The numbers are slippery, ranging from 150 to 130 dead, depending.

33. Qtd. in Philip, *Zong!*, 210.

34. Baucom, *Specters of the Atlantic*, 96. Abolitionists Olaudah Equiano (a former enslaved person) and Granville Sharp did indeed attempt to create a murder case from the *Zong* massacre, but to no avail.

35. Qtd. in Philip, *Zong!*, 211.

36. Walvin, *Black Ivory*, 17; emphasis in original.

37. Walvin, *Black Ivory*, 17.

38. Baucom, *Specters of the Atlantic*, 92–93.

39. Patricia Saunders, "Defending the Dead, Confronting the Archive: A Conversation with M. NourbeSe Philip," *Small Axe: A Caribbean Journal of Criticism* 26 (2008): 66. I quote from this conversation extensively—Philip and Saunders' dialog is a remarkable one and is hugely valuable in understanding the depths of Philip's thinking while creating *Zong!*

40. Walvin, *The* Zong, 2, 180.

41. Philip, *Zong!*, 194.

42. Stef Craps, *Postcolonial Witnessing: Trauma out of Bounds* (New York: Palgrave Macmillan, 2013), 63.

43. Philip, *Zong!*, 191.

44. Philip, *Zong!*, 15.

45. Derrida, *Archive Fever: A Freudian Impression*, trans. by Eric Prenowitz (Chicago: University of Chicago Press, 1996), 2.

46. Derrida, *Archive Fever*, 2.

47. Diana Taylor, *The Archive and the Repertoire: Performing Cultural Memory in the Americas* (Durham, NC: Duke University Press, 2003), 18. This book is largely about performance in contemporary and ancient Latinx cultures, but the idea of the archive's function most certainly still applies across many spaces.

48. M. NourbeSe Philip, Antwi Phanuel, and Austen Veronica, "Cocreation in an Uncertain World," *Jacket2*, September 17, 2013.

49. Taylor, *The Archive and the Repertoire*, 25.

50. Akira Mizuta Lippit, *Atomic Light: (Shadow Optics)* (Minneapolis: University of Minnesota Press, 2005), 11.

51. Laurie Jo Sears, *Situated Testimonies: Dread and Enchantment in an Indonesian Literary Archive* (Honolulu: University of Hawai'i Press, 2013), 2. While this book is about the Dutch Indies and Indonesian literature, specifically, I find this description of the archive still applies to my argument.

52. Philip, Phanuel, and Veronica, "Cocreation in an Uncertain World."

53. Nicolas Abraham and Maria Torok, *The Shell and the Kernel: Renewals of Psychoanalysis*, trans. Nicholas T. Rand (Chicago: University of Chicago Press, 1994), 141.

54. Alexander, *Pedagogies of Crossing*, 294.

55. Abraham and Torok, *The Shell and the Kernel*, 141.

56. Philip, *Zong!*, 191. Philip is not the only thinker who puts forth this connection. Jahan Ramazani writes that poetry "resembles the law in its precision, narratives, and . . . rhetoric," yet can "unlock silences and disclose what has been legally suppressed; to retell narratives that include their own counternarratives; to restore a multidimensionality to the past, even when arguing with an almost legal purposiveness, for the dignity and worth of a humanity that the law had rendered invisible" (*Poetry and Its Others: News, Prayer, Song, and the Dialogue of Genres* [Chicago: University of Chicago Press, 2013], 59.).

57. Jenny Edkins, *Trauma and the Memory of Politics* (Cambridge: Cambridge University Press, 2003), 11.

58. Dawn Lundy Martin and Lisa Sewell, "The Language of Trauma: Faith and Atheism in M. NourbeSe Philip's Poetry," in *Eleven More American Women Poets in the 21st Century: Poetics Across North America*, Vol. 3 of *American Poets in the 21st Century*, ed. Claudia Rankine and Lisa Sewell (Middletown, CT: Wesleyan University Press, 2012), 3:302.

59. Baucom, *Specters of the Atlantic*, 136.

60. Baucom, *Specters of the Atlantic*, 136.

61. Philip, *Zong!*, 197.

62. Philip, *Zong!*, 131.

63. Philip, *Zong!*, 47.

64. Kristen Mahlis, "A Poet of Place: An Interview with M. NourbeSe Philip," *Callaloo* 27, no. 3 (2004): 688–689. This is similarly stated in Philip's *A Genealogy of Resistance*, 128–129.

65. Philip, *Zong!*, 197. The Language poetry movement is often associated with Lyn Hejinian, Charles Bernstein, and Barrett Watten

66. Philip, *A Genealogy of Resistance*, 124. Bolded emphasis in original.

67. Philip, *A Genealogy of Resistance*, 115. While this is a quotation about her book *She tries her tongue, her silence softly breaks* (Middletown, CT: Wesleyan University Press, 2015), the concept still applies.

68. Philip's *Zong!* is clearly in conversation with Amiri Baraka's short play *Slave Ship*, which also uses polyvocality, nonlingual speech, and definitions of Yoruba terms in the back matter of the text (Amiri Baraka, *Slave Ship: A Historical Pageant*, in *The Motion of History and Other Plays* [New York: William Morrow, 1978], 129–150).

69. Anne Quéma, "M. NourbeSe Philip's *Zong!*: Metaphors, Laws, and Fugues of Justice," *Journal of Law and Society* 43, no. 1 (2016): 102.

70. This is in the Benjaminian sense. Walter Benjamin writes, "There is no document of civilization which is not at the same time a document of barbarism. And just as such a document is not free of barbarism, barbarism taints also the manner in which it was transmitted from one owner to another. A historical materialist therefore disassociates himself from it as far as possible. He regards it as his task to brush history against the grain" (*Illuminations*, 256–257).

71. Philip, *Zong!*, 205.

72. Glissant, *Poetics of Relation*, 141.

73. M. NourbeSe Philip, "Wor(l)ds Interrupted," *Jacket2*, September 13, 2013.

DIANA ARTERIAN

74. Mahlis, "A Poet of Place," 688–689. This is similarly stated in *A Genealogy of Resistance*, 71, 128–129.

75. Philip, *Zong!*, 205.

76. Saunders, "Defending the Dead," 72.

77. Kamau Brathwaite, *The Development of Creole Society in Jamaica, 1770–1820* (Kingston, Jamaica: Ian Randle, 2005), 237.

78. Fredric Jameson, *The Prison-House of Language: A Critical Account of Structuralism and Russian Formalism* (Princeton, NJ: Princeton University Press, 1975).

79. Philip, *Zong!*, 193.

80. Philip, *Zong!*, 193–194.

81. Lippit, *Atomic Light*, 48.

82. Philip, *Genealogy of Resistance*, 116. This is also on *She tries her tongue*, but again applies to *Zong!*

83. Philip, *Zong!*, 196.

84. Philip, *Zong!*, 63.

85. Philip, *Zong!*, 63.

86. M. NourbeSe Philip, "Nasrin and NourbeSe," in *Bla_K: Essays and Interviews*, 340.

87. Saunders, "Defending the Dead," 74.

88. Edkins, *Trauma and the Memory of Politics*, 17.

89. This produced even further access to pain for Philip. She explains, "There were things that came out of the text, phrases like 'nig, nig, nog,' and so on, that made me feel nauseous as they would surface. It was very distressing, but it was part of the story—I could flinch, but I could not turn away from it" (Saunders, "Defending the Dead," 75).

90. Philip, *Zong!*, 198.

91. Erin M. Fehskens, "Accounts Unpaid, Accounts Untold: M. NourbeSe Philip's *Zong!* and the Catalogue," *Callaloo* 35, no. 2 (2012): 410; emphasis in original.

92. Saunders, "Defending the Dead," 73.

93. Philip, "Interview with an Empire," in *Bla_K: Essays and Interviews*, 67.

94. Saunders, "Defending the Dead," 73.

95. Katie Eichorn, "Multiple Registers of Silence in M. NourbeSe Philip's *Zong!*," *Xcp: Cross-Cultural Poetics* 23 (2010): 34.

96. Evie Shockley, "Going Overboard: African American Poetic Innovation and the Middle Passage," *Contemporary Literature* 52, no. 4 (2011): 811.

97. Glissant, *Poetics of Relation*, 11.

98. Glissant, *Poetics of Relation*, 166.

99. Philip, *Zong!*, 191.

100. Philip, *Zong!*, 199.

101. The body of *Zong!* is divided into six sections: "Os" (bone), "Sal" (salt), "Ventus" (wind), "Ratio" (reason or central reason for a legal decision), "Ferrum" (iron), and "Ẹbọra" (underwater spirits). Each term is Latin, save for "Ẹbọra," which is Yoruba. Philip writes, "I chose Latin to emphasize the connection with the law, which is steeped in Latin expressions, and, also to reference the fact that Latin is the father tongue in Europe" (*Zong!*, 209). Each section's title represents a major element of the *Zong* massacre. Diana Leong explains these titles "are drawn from a word bank comprised of the case and what poet Evie Shockley refers to as 'imperfect anagrams' or new words derived from words in the case" ("The Salt Bones: *Zong!* and an Ecology of Thirst," *Interdisciplinary Studies in Literature and Environment* 23, no. 4 [2016]: 800.)

102. Philip, *Zong!*, 80.

103. Philip, *Zong!*, 147.

104. Saunders, "Defending the Dead," 75.

105. Saunders, "Defending the Dead," 75.

106. Philip, "Nasrin and NourbeSe," 338.

107. See Russian formalist Viktor Shklovsky's 1917 essay "Art, as Device," most recently translated in *Poetics Today* 36, no. 3 (2015): 151–174.

108. Saunders, "Defending the Dead," 69.

RELAYED TRAUMA AND THE SPECTRAL OCEANIC ARCHIVE

109. Smallwood, *Saltwater Slavery*, 137.
110. Taylor, *The Archive and the Repertoire*, 34.
111. I recognize in the case of the *Zong* massacre and British involvement in the Atlantic slave trade, there *was* reckoning, in a sense, without the involvement of ghostly contact. And while the *Zong* events precipitated those important actions by abolitionists, there is still a lack of information about the specificity of the brutality for those who may need to access it most—members of the African Diaspora, but also Anglos who are connected in one way or another to the slave trade.
112. Edkins, *Trauma and the Memory of Politics*, 176.
113. Kathleen Brogan, *Cultural Haunting: Ghosts and Ethnicity in Recent American Literature* (Charlottesville: University of Viriginia Press, 1998), 18.
114. Jacques Derrida, "'A Self-Unsealing Poetic Text': Poetics and Politics of Witnessing," trans. Rachel Bowlby, in *Revenge of the Aesthetic: The Place of Literature in Theory Today*, ed. Michael P. Clark (Berkeley: University of California Press, 2000), 195. Emphasis mine.
115. Giorgio Agamben, *Remnants of Auschwitz: The Witness and the Archive*, trans. Daniel Heller-Roazen (New York: Zone Books, 2000), 34.
116. Saunders, "Defending the Dead," 75.
117. Gordon, *Ghostly Matters*, 187–188.
118. Alexander, *Pedagogies of Crossing*, 59.
119. Edkins, *Trauma and the Memory of Politics*, 59.
120. Grace M. Cho, *Haunting the Korean Diaspora: Shame, Secrecy, and the Forgotten War* (Minneapolis: University of Minnesota Press, 2008), 40. While Cho is describing the experience of the Korean diaspora and the American-Korean War, it still applies to the phenomenon I am attempting to describe.
121. Edkins, *Trauma and the Memory of Politics*, 177.
122. Alice Ostriker, "Beyond Confession: The Poetics of Postmodern Witness," in *After Confession: Poetry as Autobiography*, ed. K. Sontag (Saint Paul, MN: Graywolf Press, 2001), 319.
123. Brogan, *Cultural Haunting*, 29.
124. Philip, *Zong!*, 194.
125. Philip, *Zong!*, 194.
126. Abraham and Torok, *The Shell and the Kernel*, 141.
127. Alexander, *Pedagogies of Crossing*, 309–310.
128. Rachel Zucker, "Commonplace: Conversations with Poets (and Other People), Episode 23: Morgan Parker," March 15, 2017.
129. Philip, *Zong!*, 201.
130. Philip, *Zong!*, 191. Text was originally italicized, denoting it is from a journal written during the production of the manuscript. In correspondence with the editors of the present volume, Philip asked that "law" be added to this quotation to clarify the phrasing.
131. Philip, *Zong!*, 194.
132. Saunders, "Defending the Dead," 75.
133. "Ferrum" is, to Philip, her most accomplished section of *Zong!* She writes, "We are trying to find the words to express what happened. But there are no words, there is no language for it. The closest I came to it was in the last book, 'Ferrum,' where language disintegrates and degrades into sounds expressing that which cannot be expressed" (Saunders, "Defending the Dead," 74).
134. At times it seems to shift to an omniscient or Wale himself: "i am h / am h / am i am a / m i a / m cur / se o / f go / d by g / od" (Philip, *Zong!*, 133). While the "Ruth" figure is referenced prior to "Ferrum," this section addresses her most explicitly and consistently.
135. Philip, *Zong!*, 164. The crewmember is no saint—his writing includes fantasies of raping female West Africans.
136. "i ma / ke y /ou a g / ift de / ar ru / th of th / is she ne / gro her na / me is sa / de i cal l / her di / do u / se her as y / ou w / ill" (Philip, *Zong!*, 151).
137. Philip, *Zong!*, 172.
138. Philip, *Zong!*, 172.
139. Philip, *Zong!*, 172.

DIANA ARTERIAN

140. In the glossary to *Zong!*, Philip notes that ifà (rather than ifá) means "divination" (184). In correspondence with the editors of the present volume, Philip explained why she prefers that "*sa / de fé / mi i / fá if / á* if o / nly *ifá*" be translated as "Sade loves me, Ifá Ifá if only Ifá":

> While I have translated Ifá to mean "divination" in the glossary, that should actually be "divination system." Ifá is, in fact, an umbrella word under which shelter a number of practices including the divination system, as well as a religio-spiritual practice known as Orisa, which in turn contains a corpus of oral literature—the odus or verses referring to divinations as well as conduct and behaviour in life. The use of Ifá is akin to the way the word Tao/Dao is used in English. It is not translated.

141. Philip, *Zong!*, 173. "Nigra" is Latin for a Black woman, "afra" for female African (Philip, *Zong!*, 183).
142. Philip, *Zong!*, 173.
143. Quéma, "M. NourbeSe Philip's *Zong!*," 104.
144. Sina Queyras writes, "I realize several things at once: this will not be an easy read; this will be a journey . . . There is also a vague sense of unease: I may not be the right reader for this book" ("On Encountering *Zong!*," *Influency Salon*, no. 1 [2010]).
145. Jenny Sharpe, "The Archive and Affective Memory in M. NourbeSe Philip's *Zong!*," *Interventions: International Journal of Postcolonial Studies*, vol. 16 (2014): 473.
146. Philip, Phanuel, and Veronica, "Cocreation in an Uncertain World."
147. Philip, Phanuel, and Veronica, "Cocreation in an Uncertain World."
148. Philip, Phanuel, and Veronica, "Cocreation in an Uncertain World."
149. Austen, Veronica J., "*Zong!*'s 'Should We?': Questioning the Ethical Representation of Trauma," *ESC: English Studies in Canada* 37, no. 3–4 (2011): 66.
150. Philip, *Zong!*, 198.
151. Philip, *Zong!*, 198.
152. Glissant, *Poetics of Relation*, 137.
153. As Glissant notes, "Relation is not made up of things that are foreign but of shared knowledge" (*Poetics of Relation*, 8). This is specifically about the "abyss" of the Middle Passage and the subsequent shared knowledge of the African Diaspora, but it applies here. He writes, "This experience of the abyss can now be said to be the best element of exchange" for its producing "knowledge of the Whole, greater from having been at the abyss and freeing knowledge of Relation within the Whole" (*Poetics of Relation*, 8).
154. Philip, *Zong!*, 198.
155. Philip, *Zong!*, 201.
156. Philip has also done durational readings, collaborated with choreographers, dancers, musicians, and other artists to create specific events with the *Zong!* text. See, for example, "Zong!Readings&Performances2013 15," *YouTube*, December 8, 2015, https://www.youtube.com/watch?v=zLlUFzrhyAg.
157. Philip, "&NOW Keynote: M. NourbeSe Philip," California Institute of the Arts, Valencia, March 28, 2015.
158. Fred D'Aguiar, *Feeding the Ghosts* (Hopewell, NJ: Ecco Press, 1999), 229–230.
159. Philip, *Zong!*, 176–182. The final section of *Zong!*, "Ebora" (underwater spirits), involves grey text that is indeed at times illegible due to Philip stacking words directly on top of one another. "Silence is . . . not a product of an absence, not even an absence of freedom, but rather silence appears as an unspeakable presence in the final section" (Eichorn, "Multiple Registers of Silence," 37).

TWO

"STEP IN STEP IN / HUR-RY! HUR-RY!"

Diaspora, Trauma, and "Rep & Rev" in Suzan-Lori Parks's Venus

CHRISTOPHER GIROUX

The call of "STEP IN STEP IN / HUR-RY! HUR-RY!" from Suzan-Lori Parks's 1996 play *Venus* is an urgent cry for reckoning with histories of racialized trauma. The urgency of this call is linked to the larger set of conditions in which the protagonist of *Venus* finds herself—one that echoes the historical realities confronted by peoples of the African Diaspora. In an autobiographical note at the end of *Venus*, Parks recounts eavesdropping on a cocktail party conversation about "the woman called the Hottentot Venus": "As I was listening, bells started going off in my head and I knew this Saartjie Baartman woman was going to end up in a play of mine. She was a woman with a remarkable bottom, a woman with a past, and that got me interested in her."[1] Baartman, a South African Khoi Khoi woman from the Eastern Cape, was brought from her homeland to England in 1810. Despite gaps in the historical record, and even though the slave trade had been abolished by statute in England by the time Baartman arrived, evidence suggests that she spent much of her time in Europe in figurative if not literal bondage—objectified, dehumanized, disempowered, sexualized, and othered.[2] Displayed in London entertainment venues as an oddity and featured in the popular press as a curiosity, Baartman was at the same time sought after as an object of pseudo-scientific study by Georges Cuvier, who used her to develop his ideas of the missing link between animal and human in the theory of human evolution—or, as T. Denean Sharpley-Whiting puts it, "the crucial step between humanity, that is, Europeans, and animals."[3] Baartman not only stands as a reminder that the configurations of diaspora involved physical separation from a geographic homeland but also represents the instrumentalization of bodies in this era to imagine the distinction between "primitive" Africa and "civilized" Europe. Eventually, Baartman's body parts (brain, genitalia, and skeleton) were exhibited posthumously throughout the nineteenth and twentieth centuries as a "scientific" specimen. Both her literal remains and a full-scale cast of her body had been displayed in Paris's *Muséum de l'Histoire Naturelle* from 1816 to 1937, when these "artifacts" were moved to the *Musée de l'Homme*, constructed for the Paris International Exposition of 1937.[4]

In this essay, I examine Parks's play as a tale of trauma eliciting what Dominick LaCapra describes as "empathic unsettlement" across temporalities (and, I would add, geographies—as in the African Diaspora).[5] Although Baartman lived before the invention of the modern camera, her image was "captured" in the nineteenth century (with great artistic license) by illustrators of the day and published in various periodicals. Her singular story inspired the contemporaneous *La Vénus hottentote, ou haine aux Françaises* (*Hottentot Venus, or Hatred of*

French Women), a popular 1814 French vaudeville production. In the twentieth and twenty-first centuries, artists and scholars (in addition to Parks) who have been inspired by Baartman include novelist Barbara Chase-Riboud; poets Elizabeth Alexander and Diana Ferrus; filmmakers Zola Maseko and Abdellatif Kechiche; performance artists Coco Fusco, Guillermo Gómez-Peña, Renée Green, Tracey Rose, and Penny Siopis; and scholars Zine Magubane, Carla Williams, and Deborah Willis, among others. These writers, filmmakers, performance artists, scholars, and critics have been drawn to Baartman's story not as a case study and spectacular curiosity, as was the case in the nineteenth century, but rather as a narrative for unpacking the politics of race, gender, colonialism, and nationhood.[6] In retelling Baartman's story, these later engagements have produced new historiographies and critical biographies with a focus on the ethics of representation at the intersections of scientific racism, gender, sexuality, and aesthetics.[7] For scholar Nicholas Hudson, "The spectacle of the 'Hottentot Venus'" is one that takes place "both on stage and on the dissecting table . . . and could therefore be treated as either a freak-show or scientific specimen."[8] Indeed, in the late twentieth century, public scrutiny continued to surround Baartman as she emerged at the center of an international movement seeking recognition of indigenous personhood in the context of academic inquiry. Under pressure from activists and newly elected Nelson Mandela, the French ultimately passed legislation that expedited the repatriation of Baartman's remains to her native South Africa in 2002.[9]

At the time of publication of Parks's play, Baartman's remains were still in the *Musée de l'Homme* collection. Parks's postmodern interpretation of the life and experiences of the Venus Hottentot was conceived as a drama of past and present bondage, a cautionary tale of the afterlife of slavery and colonialism that has continued to haunt the cultural imaginary. The contemporary preoccupation with Baartman represents an attempt to grapple with the persistence of systemic racial and social inequalities, along with an expanding recognition of the social and cultural trauma linking the African Diaspora with the conditions of the slave trade and colonial subjectivity. Parks's award-winning play[10] recognizes that the slave trade involved not only US slavery but what Paul Gilroy describes as the Black Atlantic,[11] and *Venus* interweaves temporalities and geographies by incorporating the contemporary audiences into the stage directions of her historical drama. Parks's work therefore adroitly articulates the relationship between individual emotional anguish and the collective experiences of loss of identity and lack of belonging, which result in historical and secondary trauma. Parks's focus is not on those sites of racial terror and trauma more familiar in mainstream cultural representations, such as the Middle Passage, the auction block, the lynch mob, or the peculiar institution of slavery as it was perpetrated and perpetuated in the United States in the 1800s after the international slave importation was abolished. Rather, *Venus* depicts the ways in which the legacies of slavery and colonialism and their aftereffects on the African Diaspora persist as contemporary experiences of racialized trauma. The term "trauma" can be overused in popular media, and it has been linked to Parks's oeuvre. Witnessing and wounding, reworking and recovering are concepts central to trauma theory that have been applied to Parks's writings on childhood, family, and American history by scholars such as Stacie McCormick and Christine Woodworth.[12] Here, however, I argue for exploring the meaning of trauma in a sense at once broader and more specific as I analyze Parks's *Venus* and how the play addresses the effects of historical and secondary trauma resulting from the individual experience and the collective memory of slavery and displacement.

According to Shoshana Felman and Dori Laub's *Testimony: Crises of Witnessing in Literature, Psychoanalysis, and History*, which recounts the teaching of Holocaust texts in a graduate seminar, individuals need not necessarily directly experience a traumatic event to feel its impact; they merely need be witness to an event for it to be traumatizing.[13] It is crucial, though, to acknowledge the problematic nature of the concept of traumatic transference. In *Writing Trauma, Writing History*, LaCapra introduces the concept of "structural trauma" and elaborates on the nuances of *lack* and *loss*: "[T]he historical past is the scene of losses that may be narrated as well as of specific possibilities that may conceivably be reactivated, reconfigured, and transformed in the present or future."[14] Although he acknowledges the possibility of foundational trauma, citing apartheid, bondage, and the Holocaust as examples of trauma that can shape collective identities, LaCapra questions the validity of surrogate victimhood,[15] explaining that "[t]he role of empathy and empathic unsettlement in the attentive secondary witness does not entail this identity; it involves a kind of virtual experience through which one puts oneself in the other's position while recognizing the difference of that position and hence not taking the other's place."[16] He admits, though, that empathic unsettlement is "a desirable affective dimension of inquiry" that can lead to moments of progress.[17] With these distinctions in mind, I argue that, in Parks's rendition, Baartman's narrative stands as a tale of trauma that invites empathic unsettlement, recognizes the "coexistence of temporalities,"[18] and bridges geographies, offering audiences a new means of inquiry into the afterlife of racialized trauma. Parks's play stages for contemporary audiences the immediacy of *historical* trauma as opposed to the more foundational notions associated with *structural* trauma.[19] Parks uses audience participation to explore historical trauma as it is experienced both individually and collectively. Continuing to focus on historical trauma characteristic of much of her oeuvre,[20] Parks affectively, politically, and ethically stages the life and afterlife of Sara Baartman.

Because Parks takes artistic liberties with the details of Baartman's life, which are, in any case, not entirely known to scholars, her project should be viewed not merely as historical fiction, but rather as an invitation to audiences to respond both critically and empathically to the events unfolding onstage. Parks aims to make the historical and fictive experiences of Baartman a living reality for contemporary audiences, many of whom have never considered the losses felt by the descendants of enslaved people or their own imbrication in those histories and their aftereffects. And even though universalizing individual experience and presuming that it is representative of a larger group of people can pose a danger,[21] LaCapra notes that "the secondary witness (including the historian) who resists full identification and the dubious appropriation of the status of victim through vicarious or surrogate victimage may nonetheless undergo empathic unsettlement or even muted trauma."[22] Parks's *Venus* complexly challenges audiences to be both empathic and critically distant witnesses. Aligning herself as playwright with the "resurrectionist" (and not with his former incarnation as "gravedigger"), Parks seeks to honor and restore to the archive a useable, albeit traumatizing, past.

"STEP IN STEP IN" TO *VENUS*

Venus begins with an overture announcing The Venus's death ("I regret to inform you that thuh Venus Hottentot iz dead. / . . . / There wont b inny show tonite."[23]) and closes with the same

CHRISTOPHER GIROUX

refrain at the beginning of the epilogue ("I regret to inform you that thuh Venus Hottentot iz dead. / . . . / There wont b inny show tonite."[24]). It is therefore in both the overture and the epilogue that the characters directly break the fourth wall in an interpellation that conflates the play's contemporary audiences with its historically contemporaneous audiences. Thus, the end is in the beginning, and what transpires in between is based on what Parks describes as *"History, Memory, Dis-Memory, Remembering, Dismembering, Love, Distance, Time, a Show."*[25] Speaking as a specter and a spectacle, The Venus engages other characters on the stage and addresses the members of the audience, who learn during that first encounter that the lead character is speaking from beyond the grave.[26] Placed on display as an entertaining spectacle of black female hypersexuality and a didactic exemplum of primitive animality, The Venus relates a story framed by complex dialogic devices that work to unsettle audiences by subverting linear plot development with its circularity and complicating perspective through its introduction of competing and clashing voices. Parks's audiences thus quickly realize that *Venus* will not follow conventional forms of dramaturgy, thereby challenging any official reiteration of events shaping the traumatizing life experiences of this most singular and controversial historical character.

After the opening, *Venus* unfolds, for the most part, in chronological fashion (even though the play is structured by a scene reversal that begins with Scene 31 and ends with Scene 1). Parks's protagonist is introduced to the audience while still in South Africa, where she works as a serving girl in the early 1800s. Promising fame and fortune, two brothers coerce her to travel to England where she will be featured as an African Dancing Princess. Once in England, Parks's protagonist is sold to The Mother-Showman, the owner of a traveling "freak show," and is displayed as the troupe's ninth Wonder of the World. Christened "The Venus Hottentot," Parks's heroine is known, as other characters in the play comment, for "[a]n ass to write home about"[27] and for "not wearin uh scrap / hidin only thuh privates that lipped inner lap."[28] A profitable and popular draw to this traveling circus—her success stemming from English society's exoticization and sexual fetishization of the Other—The Venus essentially becomes enslaved by The Mother-Showman. The Venus is eventually summoned to appear in the British courts (as was the case for the real Baartman, who appeared before the Court of the King's Bench), and, due to her testimony, she is allowed to remain in England. Rather than return home no better off than when she left, The Venus opts to stay with The Mother-Showman until The Baron Docteur, who claims to have fallen in love with The Venus, buys her "freedom." Although he showers her with material gifts, his love is tainted by professional ambition: he wants to examine The Venus's genitalia and, through publishing his scientific findings, gain his own fame and fortune. His career goals and his concern for his personal and professional reputation appear to overshadow his professed love for The Venus, whom he keeps closeted, allowing her to see and to be seen only by himself and the other anatomists whom he is training. In response to her repeated inquiries regarding the medical meaning of "maceration,"[29] The Baron Docteur translates this as "lunch" or "after lunch" to mislead or allay The Venus's fears, hiding from her his real intent for her postmortem dissection. He further coerces her into having two abortions. The Baron Docteur then yields to the pressures of The Grade-School Chum and other scientists and imprisons The Venus when she falls ill. As the Negro Resurrectionist notes, Parks's heroine dies of exposure to the elements, lack of appropriate clothing, and the cold-heartedness of European society. Parks's characters reveal a historical fact, that Baartman's measurements were indeed retaken after death and then molds of her body were made, preserved, and years later displayed in the *Musée de*

54

"STEP IN STEP IN / HUR-RY! HUR-RY!"

l'Homme. While Parks's audiences do not witness the postmortem dissection and display of her body, these events are narrated by The Negro Resurrectionist at the end of the play. Parks's *Venus* is a critical response not only to Baartman's display in life but also to the afterlife of her specularization through the desecration and exhibition of her remains in the museum of ethnography.

Parks's *Venus* reminds audiences of the triangulations of the Atlantic slave trade—involving the Americas, Africa, and Europe. Only the first scene in *Venus* occurs in Africa, and, significantly, it is the only one in which the character is referred to by her name. While she is referenced as "Saartjie," or Dutch for "Little Sarah," by the two brothers as they lay out their plans to exploit Baartman as a source of income, the stage directions hereafter refer to her as merely "The Girl." When addressed directly, she simply remains "Girl" or "GIRL!"[30] The erasure of her name by these two men not only denies Baartman personhood and humanity, but also renders her instrumental to their schemes for profit and power: The Mans Brother exploits her sexually and variously uses her to manipulate other family members (threatening that he will marry beneath himself—a Hottentot!).[31] Although the play unfolds outside of the time of the Middle Passage or the traditional southern settings linked to slavery in the United States, Parks's protagonist endures degradation, sexual violation, and the theft of name and identity—experiences that audiences will recognize as identical to the traumas inflicted on enslaved women in the Americas.

Although she was not officially chattel, Baartman's abjection is equivalent to that of the enslaved. Throughout most of the first scene, Baartman remains on her hands and knees scrubbing "a vast tile floor," while the two brothers plot and scheme her exploitation, pointing out spots she has missed.[32] When the two brothers are not barking orders about the floor's cleanliness, they are ordering her to dance so as to assess her value and potential as an entertainment spectacle or "Freak Act."[33] Further evidence of her subservience and captivity occurs when she asks if she can stop dancing, and The Mans Brother decrees that she must dance faster. The only time she is truly engaged in conversation or dialogue with the brothers occurs when they seek to lure or seduce her into traveling to England under their sponsorship.[34]

Although this African scene from Parks's tale of "a commodified black body"[35] is the place where our protagonist is allegedly most free, there is dispute about whether Baartman came willingly to England or was coerced because she entered into a contract.[36] In Parks's fictionalization, the imagery of this opening scene becomes highly symbolic: Baartman ultimately appears in the play addicted not to alcohol per the historical record but to chocolate, the latter becoming a vehicle by which to interrogate colonialism, consumption, and love.[37] Baartman also worked as an indentured servant in South Africa, but was sold as chattel after the death of her parents; Baartman's Dutch name "Saartjie" signals the settler colonial history of South Africa, while her position as a laborer and object of sexual exploitation highlights her lack of power and agency. Baartman's Khoi Khoi or Gonaqua name remains unknown.[38] The Venus, like the historical Baartman, is symbolically stripped of her aboriginal identity and agonizes about returning to Africa without having made her name and fortune.[39]

Racial violence, sexual subjugation, and separation from kin, all defining features of slavery, mark the life of the historical and fictionalized Baartman, and thus Parks's *Venus* reminds audiences that the traumas experienced by diasporic Africans are complex because slavery and colonialism are interwoven, exceeding temporal and spatial boundaries. Critical understandings of trauma map paths toward healing and the achievement of social and psychic integration. Trauma, literally Greek for "wound," is an unchosen break with a previous way of life and sense

of safety and belonging. Recovery from trauma and healing involve, as LaCapra suggests, the prospect of a future return to a prior existence. Individuals who have experienced trauma must learn to integrate traumatic memories, dreams, and flashbacks into narrative memory. Encountering a sense of traumatic displacement or dispossession in their new land, diasporic peoples and their descendants often desire a return to the homeland, a place signifying belonging and integration. As William Safran notes in the premiere issue of *Diaspora*, "Some diasporas persist—and their members do not go 'home'—because there is no homeland to which to return; because although a homeland may exist, it is not a welcoming place with which they can identify politically, ideologically, or socially."[40] However, for Baartman, no originary home, or prelapsarian state, exists; her desires remain forever out of reach.

Ultimately, Parks's protagonist must confront the painful recognition that homelands, like hostlands, are often mythical,[41] and that "the notion of 'return' . . . is often an eschatological or utopian projection in response to a present dystopia."[42] Tiffany Ruby Patterson and Robin D. G. Kelley argue that "[a]s a process, [diaspora] is constantly being remade through movement, migration, and travel, as well as imagined through thought, cultural production, and political struggle. . . . [A]s a condition, it is directly tied to the process by which it is being made and remade."[43] Baartman's experiences both in Europe and in Africa are marked by objectification and disempowerment in terms of class, race, and sex. The play ends with The Venus imploring the audience to "love" her. Named, with irony, after the Roman goddess of love, The Venus futilely seeks the love that eludes her in both homeland and hostland. Parks's play, however, seeks to provide an empathic embrace and restore a literary and historical place for Baartman in the archive. She is, to draw on Patterson and Kelley, an embodiment of diaspora, as both process and condition. Like diaspora, trauma can be both process and condition: past and present, event and response, wounding and healing, knowing and not knowing, and—as we shall see—mimesis and antimimesis.

As noted previously, at the time of *Venus*'s debut in 1996, Baartman's remains were still on display at the *Musée de l'Homme*. This strange afterlife echoes the play's depiction of the displacement Baartman must have felt while alive. Both The Venus and The Negro Resurrectionist urge audiences to visit "her" at the site of her posthumous captivity and exile in France. As a victim of trauma, diaspora, and the trauma of the diaspora, this subject/object of desire nevertheless remains, in the landscape of the play, estranged from past (homeland) and present (hostland).

Despite the Africa scene, the main action takes place in England and France (and arguably, Germany, the site of The Baron Docteur's lecture in Tübingen, as well as the United States, evoked by the song that one of the Wonders of the World dedicates to the ladies of New York[44]), broadening accounts of colonialism and slavery beyond those of the US South. These particular settings of *Venus* reinforce the insight that the slave trade was not just about bondage—and the time and place of that bondage—but also about the larger cultural conditions that perpetuate racial domination. As we know from historical and more recent experiences of racial violence, these dynamics have been handed down, much as trauma can be handed down, from generation to generation.[45] Trauma theory is thus critical to understanding the historical legacies of slavery and the diaspora.[46]

The Venus experiences tragedy after tragedy and loss after loss, but her response to these events is not always predictable. She is apparently moved from tears ("'[B]ut no one ever noticed that her face was streamed with tears'"[47]) to protest ("I'll set up shop and show myself. / Be my own Boss make my own mint."[48]). When The Mother-Showman threatens her with rape via the drunks

in a nearby bar, The Venus can quietly admit that she has already been abused, molested, and assaulted by these men.[49] When brought to the British courts and given the chance to return to her home country, The Venus asks to remain in England. And while some critics view Parks's representation of The Venus's appeal as an example of complicity in her own bondage,[50] Parks seems to suggest that her social positioning as "Other" renders her destitute and disempowered, subject to cajolery and manipulation by those who exploit her desire for love and self-empowerment (even at the risk of self-commodification). Seeking to come to terms with her de facto sexual bondage and the erasure of her rights, Parks's Venus would seem to experience moments of dissociation and denial in her public and personal life.

The Africa scene and The Venus's subjection by The Man and The Mans Brother are foundational moments of trauma in the play and, by extension, function as a metaphor for diasporic trauma. Although critics and audiences may argue that The Venus does not experience repression or deal with memory lapses, flashbacks, or fugue states,[51] Parks's protagonist resurrects a traumatic past that culminates in her death, an event that opens and closes the play. In *Venus*, as in real life, trauma involves and is resolved by reliving past moments of horror and terror, and, in the process, learning to organize those memories into an integrated narrative.

The bondage and sexual exploitation that The Venus experiences with The Man and The Mans Brother in the opening scenes are symbolically reiterated when she arrives in London and is handed over to The Mother-Showman, who promotes her as a "Wild Female Jungle Creature. Of singular anatomy."[52] Prancing and performing before a gawking public ("Take a look at one for just a penny and a half / you can gawk as long as you like."[53]), she is pronounced to be one of the "9 lowest links in Gods Great Bein Chain,"[54] "[t]he very lowest rung on Our Lords Great Evolutionary Ladder."[55] Taken to court ostensibly by abolitionists concerned for her legal protection, she must perform before the court in fulfillment of the writ of *habeas corpus*.[56] *Venus* is a play where the protagonist's body is indeed shown in various venues: the circus theater, the court theater, and even the medical theater. When her freedom is allegedly purchased by The Baron Docteur, he too puts her on display before the anatomists he is training and ultimately the larger scientific community. An object of the public, legal, and medical gaze, The Venus is habitually confined to, by, and in metaphoric and literal cages, chains, and other enclosures.

In addition to these tropic iterations of confinement, Parks deploys a series of formal and structural devices throughout *Venus* to mime the symptomatic and formal properties of trauma. I will argue here that Parks's dramaturgy—her use of repetition, reiteration, rehearsal, and doubling—reinforces her strategy of emphasizing the intergenerational transference of trauma and, crucially, revealing the role of witnessing in the process of healing and recovery.

Typical of formal reiterations in the play are the following: Each chorus includes eight members who often speak in unison, frequently repeating lines and passages that comment on the play's action. Chorus members engage repeatedly in mocking refrain and laughter.[57] The Negro Resurrectionist (whose very name references repetition in the form of returning one from the dead) sometimes delivers monologues where he simply counts down the scenes.[58] Multiple individuals at The Venus's trial maintain that they are "unavailable for comment."[59] Throughout the play, The Venus's physical measurements are ritually rehearsed as if to underscore her status as specimen. Significantly, these reiterations, repetitions, and rehearsals in *Venus* are examples of the "Jazz esthetic" that Parks calls "Repetition and Revision," or "Rep & Rev," a concept she elaborates in her essay "From *Elements of Style*."

CHRISTOPHER GIROUX

Parks describes her theory of "Rep & Rev" as "a literal incorporation of the past," which shapes the "theatrical experience":

> I am working to create a dramatic text that departs from the traditional linear narrative style to look and sound more like a musical score . . . a structure which creates a drama of accumulation. . . . Characters refigure their words and through a refiguring of language show us that they are experiencing their situation anew. . . . The concept of repetition and revision is one which breaks from the text we are told to write. . . . The accumulated weight of the repetition [is] a residue that, like city dust, stays with us. . . . Repetition and revision is integral part of the African and African American literary and oral traditions. . . . [60]

The reiterations, repetitions, and rehearsals that permeate the play position *Venus* as a text that is deeply engaged with diaspora and trauma as process and condition. As Ruth Leys maintains, "[F]rom the beginning trauma was understood as an experience that immersed the victim in the traumatic scene so profoundly that it precluded the kind of specular distance necessary for cognitive knowledge of what had happened. The subject was fundamentally 'altered' . . . because it was 'other.'"[61] While the reliving of these events in *Venus* is indeed an "incorporation of the past" into the present, this reliving is also about repetition with revision, which Parks identifies as essential to her "Jazz esthetic." It is, in Leys's terms, a repetition with revision that is both mimetic and antimimetic.[62] For traumatized individuals, a relived, or mimetic, event is no longer the same event; it becomes a new event. It is (re)figured and (re)experienced by individuals who are, over time, subject to change. Even when (or if) the traumatized event is (re)encountered by the psyche, each time individuals (re)engage with the memory, they (re)live or (re)enact the event from a different standpoint in time. Because overcoming trauma entails creating change, assuming agency, and facilitating healing, recovery is an ongoing process moving individuals toward a future in which the traumatizing past event is more fully integrated into the present through narrative. Ideally, it is this process that keeps "the dignity of truth alive."[63] Healing and integration frequently require personal testimony. Diasporic peoples are thus often engaged in a quest to articulate, voice, and validate the experiences of raced and gendered violence and the trauma of othering.[64] In *Venus*, Parks addresses trauma and diaspora through her "Jazz esthetic" theory of "Rep & Rev"—an aesthetic of dramatic mimesis that formally replicates the compulsive repetitions associated with individual responses to trauma but also allows for movement toward revision, or antimimesis, and collective healing.

Parks employs additional formal devices both to mime the properties of trauma and appeal to contemporary audiences to give ethical witness to the histories and legacies of colonialism, slavery, and the African Diaspora. Another significant device deployed in *Venus* is doubling, a dramatic technique that is not only symbolic and practical (in terms of financing, production costs, and casting), but also relevant to the notions of trauma and mimesis. The Venus and Negro Resurrectionist are the only actors, per the stage directions, who have a single role assigned to them (although various names are attributed to The Venus, and The Negro Resurrectionist also functions as jailer and narrator). As in many plays that rely on doubling to advance, symbolically and formally, a work's thematics, this device in *Venus* enables audiences to draw connections between characters and situations: The actor doubling as The Man and The Baron Docteur enacts in both roles sexist and racist exploitation of The Venus, just as the one actor who

"STEP IN STEP IN / HUR-RY! HUR-RY!"

plays The Mans Brother, The Mother-Showman, and The Grade-School Chum replicates derogatory and demeaning attitudes toward The Venus. Similarly, the eight-member Chorus performs multiple roles, including the 8 Human Wonders, the Spectators, the Court, and the 8 Anatomists. In "Choral Compassion: *In the Blood* and *Venus*," Harvey Young reminds us of the link between the general population and The Chorus in ancient drama:

> To attend a play and to witness the actions of the chorus was to watch your neighbors play the role of members of the community but 'onstage' and before an audience. . . . More than merely assuming the vantage point of the always seen/scened chorus, audience members could enter the narrative vicariously through the chorus. The citizens in the stands could become the citizen on the stage.[65]

Parks's goal is to position present-day citizens as witnesses to The Venus's plight while simultaneously rendering readers and viewers as participants through a process of traumatic transference. As Judith Herman notes, three participants are actually involved within any human-made trauma: the perpetrator of the trauma, the victim, and the witness, who in watching a moment of trauma unfold or who in listening to a description of a traumatizing act must align with either perpetrator or victim.[66] In *Venus*, Parks challenges audiences to become witnesses and to reflect on their own positionality as "members of the community"—represented by the Chorus (e.g., Young's average citizens)—who alternately mock and sympathize with The Venus, speak on her behalf as abolitionists in the British courts, or who gawk and poke her at the circus sideshow. Do they leave at intermission or stay for The Baron Docteur's clinical recitation of her measurements? Given that the actress portraying The Venus is typically seen on stage in a padded costume and often on literal and figurative pedestals, and given that we know the exact degrees to which she turns (so that spectators can see her entire body and profile[67]), Parks's audiences are literally positioned, time and again, in the roles of voyeur or spectator. Notably, Anne Fausto-Sterling refused to reprint any historical illustrations of Baartman—even as cultural artifacts—in order not to perpetuate her visualized other-ing in scholarship.[68] In Parks's play, however, The Venus's prosthetic posterior becomes a device by which the audience is confronted with the ethical dilemma of how to approach the spectacle of the black female body.

Returning to the formal device of doubling, Parks's play *Venus* embeds another play, *For the Love of Venus*, which is itself a repetition of the 1814 French vaudeville production, *La Vénus hottentote, ou haine aux Françaises*,[69] creating a *mis-en-abyme*, or double-mirroring effect with one play inside another play inside another play. *For the Love of Venus* appears at intervals throughout *Venus*, providing further ironic commentary on Parks's use of hypertheatricality and simulation to produce a critique of spectacle. Performances of The Chorus appear in excerpts from *For the Love of Venus*. In these performances, for example, a bride, who laments that her groom has fallen out of love with her and is, instead, infatuated with The Venus, engages in subterfuge—dressing up as The Venus—to win back her fiancé. The 1814 vaudeville production similarly involves a white French woman, Amelia, who schemes to attract the attentions of a man, who has sworn off white French females as potential mates. Amelia changes his mind, just as Parks's bride changes her groom's mind, by masquerading as The Venus.[70] In neither text does a Hottentot ever appear. The onstage audience watching *For the Love of Venus* is composed, in various combinations, of The Baron Docteur, The Venus, and The Negro Resurrectionist.

59

CHRISTOPHER GIROUX

Their reactions are largely what theater audiences are meant to measure themselves against. Audiences are invited to watch either with the studied silence of disinterest and apathy, or with the intense indignation of shock and outrage, as do The Venus and Negro Resurrectionist. Alternatively, audiences may applaud wildly, as do The Baron Docteur and Chorus.[71] Audiences are spectators, but—in terms of trauma theory—are more properly witnesses to the traumatic events taking place on stage. Parks invites audience participation in order to facilitate their reflection on how they might position themselves within this drama. Parks's play is thus designed to create empathic unsettlement among members of the audience so that they leave the theater pondering a set of ethical questions related to trauma and diaspora: With whom does one align oneself in relation to past atrocities? Further, with whom does one align oneself when confronted with present-day instances of police brutality, systemic racism, or institutional discrimination on the nightly news?

STEP BACK STEP BACK FROM BAARTMAN

Some critics, as noted earlier, and audiences refuse to see The Venus as a tragic figure confronting historical trauma; rather, they view her as a figure of pathos, and even complicity. I turn, however, to Kai T. Erikson's notion that continuous exposure to poverty, discrimination, fear, and corruption, along with unsafe environmental conditions, can lead to trauma.[72] In her play, Parks renders her subject a victim of historical trauma—a response that can, nonetheless, be handed down from generation to generation—resulting from ongoing conditions of deprivation and degradation. Parks, then, links contemporary cycles of poverty, violence, and exploitation to the historical traumas of slavery, racism, and the diaspora as emblematized by her protagonist. This idea of generational trauma and the afterlives of slavery is echoed by other scholars, such as Paul Farmer, who writes out of his experience of field work in Haiti that "large-scale forces [can] crystallize into the sharp, hard surfaces of individual suffering. Such suffering is structured by historically given (and often economically driven) processes and forces that conspire—whether through routine, ritual, or as is more commonly the case, these hard surfaces—to constrain agency. For many, . . . life choices are structured by racism, sexism, political violence, *and* grinding poverty."[73] Parks's play, then, is meant to foster a recognition of that trauma in *Venus* and *confront* her present-day audiences with an ethical charge regarding the conditions of its perpetuation. If the character Venus and the diasporic historical traumas she represents are not ones with which contemporary audiences can immediately identify, these traumas constitute the conditions that Parks invites critics and spectators to acknowledge intellectually and experience emotionally.

Given the frame provided by the play's overture and the closing scene—in which The Venus returns from death and breaks the fourth wall—Parks's play should be understood as Brechtian in nature, a performance meant to make the present-day viewer, like the viewer of epic theater, think, "I'd have never thought it—That's not the way—That's extraordinary, hardly believable— It's got to stop—The sufferings of this man appal [sic] me, because they are unnecessary—That's great art, nothing obvious in it—I laugh when they weep, I weep when they laugh."[74] This Brechtian alienation would seem to inform Parks's commitment to "empathic unsettlement," in which the audience is able to establish a relationship of both empathy with and critical distance from the

60

events unfolding on stage. For Parks, this unsettlement and critical consciousness constitute part of an invitation to the audience to engage ethically with structures of oppression while bearing witness to historical trauma since, as Laurie Vickroy argues, "Traumatic experience can inspire not only a loss of self-confidence, but also a loss of confidence in the social and cultural structures that are supposed to create order and safety."[75] The trauma that audiences witness on stage has the potential to produce secondary trauma, but it is important for Parks that, while viewer-participants experience empathic unsettlement, they resist the appropriation of The Venus's trauma. Numbering her scenes backward to create a kind of time reversal, Parks prompts their repeated announcements (as in a vaudeville show) to create opportunities for the audience to be simultaneously drawn into the story and experience critical distance through "Brechtian alienation." Audiences are not counting down with excitement to a moment of exhilaration but to a finale that leads inevitably to a death sentence—the goal here is not pleasure, but destruction. Moreover, given that *Venus* is a play, it is meant to be performed again and again, fashioned to be repeated and revised. Like the experience of reliving a traumatic event, the play's repetition provides a temporal break, offering the audience an opportunity to reflect on past horrors and terrors attached not only to the protagonist but to the historical record. In a play that is, at times, intentionally nonlinear and self-referential, Parks actively works to empathically unsettle her audiences; she strives to disorient by compelling audiences to relive a shared public history of colonialism, slavery, and diaspora. The fact that her plot concerns an historical event—set in multiple countries, geographies, and landscapes—issues a moral challenge to those American audience members who disclaim responsibility for atrocities occurring in other times and places. In contrast, Parks reminds audiences that the aftermath and afterlife of colonialism, slavery, and diaspora remain present-day realities. The Venus's legacy of alienation, unsettlement, and abuse is ours; like Shylock and the Venetians to whom he addresses his speech, The Venus also bleeds; she, too, is speaking to and for us.[76]

Further, Parks strives to draw contemporary audiences into the performance, unsettling them by using anachronisms and other elements associated with experiences of trauma and diaspora. Even though the story primarily takes place in the 1800s, there are characters who invoke the experience of "jet lag"[77] and whose speech is marked by additionally anachronistic discourse. At one point, using language that audiences would associate with twentieth-century jargon, Parks's Chorus exclaims: "Good God. Golly. Lookie-Lookie-Look-at-her. / Ooh-la-la. What-a-find. Hubba-hubba-hubba."[78] Elsewhere, The Chorus considers, *à la* Mama Rose in *Gypsy*, "'Everythings coming up roses'" as a possible greeting for The Venus, while also remarking that she's "bit the big one."[79] By incorporating these playfully anachronistic references, Parks signals to audiences that The Venus's condition is not simply historical but also contemporary in its relevance. If, as Parks argues in "From *Elements of Style*," "[l]anguage is a physical act"—with "thuh" and "the" conveying a marked difference[80]—then her incorporation of contemporary phrases and references woven, albeit anachronistically, into *Venus* should engender opportunities for reflection on the connections between the present day,[81] demonstrating, as Vickroy argues, that trauma texts provide "not only human understanding but also a critical evaluative process that encourages resistance and change in the future."[82] This anachronistic movement between past, present, and future reinforces the larger thematic address by *Venus*, reminding audiences that trauma and diaspora are not simply relegated to the past but retain their traumatic potential to affect the present.

Parks makes it difficult for audiences to miss the implications of this contemporary language by incorporating lines specifically addressing readers and viewers as interactive participants in a dialogic theatrical experience. This participation likewise moves audiences directly into the realm of trauma, particularly the tension between action, agency, and passiveness that characterizes this condition. Various scholars remind us that trauma robs individuals of conscious control.[83] As individuals relive a traumatic event, the event is often forced on them; this gap or wound breaks into and upon their consciousness, robbing them of agency. They are removed from the present moment as the past intrudes on it, and because *Venus* is a text that actively makes connections between past and present, audiences can find themselves in a precarious situation. Removed from the onstage events, interactive audiences are nonetheless part of the performance insofar as they are invited to collaborate in the production of the meaning. Thus, in plays such as *Venus*, where the fourth wall is broken, audience participation necessarily results in the co-production of meaning—a meaning that becomes contingent with each performance. This contingency and unpredictability in the production of meaning renders a gap that represents what trauma scholar Cathy Caruth would call a delayed truth.[84]

The breaking of the fourth wall, a device employed throughout *Venus*, occurs most noticeably in the opening lines, the intermission, and the ending, all of which are moments specifically concerned with audience members' exit from or entry into the "real" world. The overture of *Venus*, for example, opens with The Negro Resurrectionist and the other characters introducing themselves and one another to acclimate viewers to the time and setting of the play. Further, The Mother-Showman's spiel to drum up business applies to both spectators in the play and to Parks's theater audiences, and, notably, this doubling of spectatorship extends to the excerpts from *For the Love of Venus*, the embedded play. Additionally, during the intermission, a time traditionally reserved as a break for audiences, the play unexpectedly continues. The primary speaker, The Baron Docteur, encourages audiences to visit the lobby or facilities if needed, declaring to the playgoers that he will just speak louder for the benefit of those who have temporarily left the performance.[85] The drama concludes with Parks's protagonist speaking in supplication to the audience, in what The Negro Resurrectionist deems "A Scene of Love." The Venus directly implores the audience, "*Kiss me Kiss me Kiss me Kiss.*"[86]

This final cry ("*Kiss me Kiss me Kiss me Kiss.*") echoes the repetition, doubling, and direct audience appeal that break the fourth wall—formal properties that permeate the play. Ending the play with this desperate entreaty firmly conflates the world of the play and the real world of audience members. Here, Shoshana Felman's comments on Claude Lanzmann's *Shoah* resonate with the historical trauma of colonialism, slavery, and diaspora as depicted in *Venus*:

> Memory is conjured up essentially in order to *address* another, to impress upon a listener, to *appeal* to a community. To testify is always, metaphorically, to take the witness stand, or to take the possibility of the witness insofar as the narrative account of the witness is at once engaged in an appeal and bound by an oath. To testify is thus not merely to narrate but to commit oneself, and to commit the narrative, to others: to *take responsibility*—in speech—for history or for the truth of an occurrence. . . . [87]

Parks uses this form of address to speak doubly both within the play and directly to the audience, emphasizing the audience's role as witness to the testimony and history of The Venus. She

appeals to the audience to take responsibility for The Venus's bondage in recognition that these forms of subjugation and states of unfreedom persist as the afterlives of slavery. Parks's manipulation of time and her focus on repetition and revision is not exclusive to *Venus*, but is characteristic of her other plays as well. As she notes in "From *Elements of Style*," "History is time that won't quit."[88] She might well have added that unresolved trauma is an afterlife that won't quit.

As a play focused on the trauma of the diaspora, *Venus* makes knowledge of diaspora—including its erased affect—a reality for those audiences who are distanced from diasporic trauma. That distance may be a product of time, geography, ignorance, and/or evasion. In *Venus*, Parks communicates Baartman's history and condition to audiences in order to challenge them to take responsibility for this legacy and, further, to accept responsibility for the injustices endured by The Venus and those diasporic subjects she represents. These injustices should be seen as referencing the audiences' own personal experiences with and/or role in perpetuating systemic racism. *Venus* has become recognized by literary critics as a trauma text that offers "a means of recovering cultural memories and traditions of groups often neglected or suppressed by mainstream culture."[89] Parks thus recognizes that, as Dori Laub and Nanette C. Auerhahn explain, "[i]t is in the nature of trauma to elude our knowledge, because of both defence and deficit. The knowledge of trauma is fiercely defended against, for it can be a momentous, threatening, cognitive and affective task, involving an unjaundiced appraisal of events and our own injuries, failures, conflicts and losses."[90] Parks's audiences must engage in that "unjaundiced appraisal" to create, in the words of Erikson, "a *changed sense of self* and a *changed way of relating to others* but [also] a changed *worldview*."[91] This thinking about change directly relates to the flashback that is so closely linked to trauma—a flashback signifying an event that is, as Caruth notes, placeless. The traumatized self is traumatized because the subject was unable to process that event when it happened.[92] Thus, this gap between temporalities and change is critical to understanding *Venus*, particularly if Parks's audiences are indeed the individuals who are empathically unsettled. Caruth describes this state of "unclaimed experience" as follows:

> The experience of trauma, the fact of latency, would thus seem to consist, not in the forgetting of a reality that can hence never be fully known, but in an inherent latency within the experience itself. . . . The historical power of the trauma is not just that the experience is repeated after its forgetting, but that it is only and through its inherent forgetting that it is first experienced at all."[93]

That Parks keeps her focus not only on The Venus as the traumatized individual but also on her audience members reinforces the notion that present-day readers and spectators are also essential actors to The Venus. Audiences are drawn into diasporic time that does not quit in order to take responsibility for the trauma of then and now.

"HISTORY IS TIME THAT WON'T QUIT"

In her classic work, *Borderlands/La Frontera: The New Mestiza*, Gloria Anzaldúa describes the border as "*una herida abierta* [an open wound] . . . where the Third World grates against the First and bleeds. And before a scab forms, it hemorrhages again, the lifeblood of two worlds merging

CHRISTOPHER GIROUX

to form a third country—a border culture.'"[94] Conjuring up the idea of homelands and host-lands in her study of "borderlands," Anzaldúa evokes the image of a physical wound. Parks's *Venus* similarly reminds audiences that diaspora is a space marked by the woundings of colonialism, slavery, and racial subjugation, traumas that can be internalized and collectivized, and that can move beyond the borders of one's body and one's lifespan. Recognizing that trauma is both trans-historical and cultural wounding, artists like Parks seek multiple ways of offering hope for healing, reconciliation, or unity.[95] The healing demands, as Caruth argues, a "listening [and response] to the address of another."[96] In confronting trauma, Parks holds audiences account-able as witnesses who are made to acknowledge the afterlife of trauma in the present—and that acknowledgment has the potential to forge rememory.

In the last lines The Venus speaks before she dies, she implores The Negro Resurrectionist not to look at her.[97] The spectacularizing gaze is still at work. In the next scene, which essen-tially serves as an epilogue, The Venus resumes talking, but this time to other characters and to the theater audience. As we have seen, Parks gives her protagonist the concluding line, "*Kiss* me *Kiss* me *Kiss* me *Kiss*," which The Negro Resurrectionist introduces, prefacing it as a scene of love, in a play where erotic love is on display but philia is missing. Close attention to the speeches immediately preceding these lines reveals that this display addresses urgent tensions between objectification, attraction, death, and life:

THE CHORUS OF THE 8 HUMAN WONDERS

Turn uhway
dont look
cover yr face
cover yr eyes

ALL

Drum Drum Drum Drum.
Hur-ry Hur-ry Step in Step in.
(*Rest*)
Thuh Venus Hottentot iz dead.

THE VENUS

Tail end of the tale for there must be uh end
is that Venus, Black Goddess, was shameless, she sinned or else
completely unknowing thuh Godfearin ways, she stood
showing her ass off in her iron cage.
When Death met Love Death deathd Love
and left Love tuh rot

64

"STEP IN STEP IN / HUR-RY! HUR-RY!"

au naturel end for thuh Miss Hottentot.
Loves soul, which was tidy, hides in heaven, yes thats it
Loves corpse stands on show in museum. Please
visit.[98]

That The Venus speaks the last lengthy passage is significant, for her words echo, in an example of Parks's theory of Rep & Rev, the last lines of the Overture, which are spoken, not by The Venus, but by The Negro Resurrectionist:

Tail end of our tale for there must be an end
is that Venus, Black Goddess, was shameless she sinned or else
completely unknowing of r godfearin ways she stood
totally naked in her iron cage.
She gaind fortune and fame by not wearin a scrap
hidin only the privates lippin down from her lap.
When Death met her Death deathd her and left her to rot
au naturel end for our Hottentot.
And rot yes she would have right down to the bone
had not The Docteur put her corpse in his home.
Sheed a soul which iz mounted on Satans warm wall
while her flesh has been pickled in Sciences Hall.[99]

The difference in the articulation of these two passages, by different speakers with disparate designs, is central to understanding how the denouement of Parks's drama embodies her intentionality. The Negro Resurrectionist, our narrator, often uses the first-person plural to describe The Venus—he and the audience own and must own up to her condition. Additionally, both The Venus and The Negro Resurrectionist speak of the soul, an entity beyond the physical body, but in The Venus's version, even though her corpse remains in a cage, her soul, her psyche in trauma terms, remains free. It is "tidy" and in a better place. Considered within the framework of trauma theory, she is able to tell her tale, and therefore through narrativization transcend her original conditions of subjugation. Thus, as a vital healing work in the world, Parks confronts the legacy of the African Diaspora, the conditions of slavery and unfreedom, and invites audiences to challenge the forgeries of memory that have absolved them from ethical engagements with and responsibility for the afterlives of colonialism and slavery. "History," after all, as Parks reminds us, "is time that just won't quit."

NOTES

1. Suzan-Lori Parks, "About Suzan-Lori Parks," in *Venus* (New York: Theatre Communications Group, 1997), 166.
2. Slavery in England would not be abolished until the Slavery Abolition Act in 1833.
3. T. Denean Sharpley-Whiting, *Black Venus: Sexualized Savages, Primal Fears, and Primitive Narratives in French* (Durham, NC: Duke University Press, 1999), 17.
4. Clifton Crais and Pamela Scully, *Sara Baartman and the Hottentot Venus: A Ghost Story and a Biography* (Princeton, NJ: Princeton University Press, 2009), 2.

CHRISTOPHER GIROUX

5. Dominick LaCapra, *Writing Trauma, Writing History* (Baltimore, MD: Johns Hopkins University Press, 2001), 47, 78.
6. Robin Mitchell, "Another Means of Understanding the Gaze: Sarah Bartmann in the Development of Nineteenth-Century French National Identity," in *Black Venus 2010: They Called Her "Hottentot,"* ed. Deborah Willis (Philadelphia: Temple University Press, 2010), 32–46.
7. See Crais and Scully, *Sara Baartman and the Hottentot Venus*; and Chris Dunton, "Sara Baartman and the Ethics of Representation," *Research in African Literatures* 46, no. 2 (2015): 32–51.
8. Nicholas Hudson, "The 'Hottentot Venus,' Sexuality, and the Changing Aesthetics of Race, 1650–1850," *Mosaic* 40, no. 1 (2008): 23.
9. Rachel Holmes, *The Hottentot Venus: The Life and Death of Saartjie Baartman: Born 1789–Buried 2002* (London: Bloomsbury, 2007), 169–170.
10. In 1995–1996, *Venus* won two OBIE Awards.
11. Paul Gilroy, *The Black Atlantic: Modernity and Double Consciousness* (Cambridge, MA: Harvard University Press, 1993).
12. Stacie McCormick, "Witnessing and Wounding in Suzan-Lori Parks's *Venus*," *MELUS* 39, no. 2 (2014), 188–207; and Christine Woodworth, "Parks and the Traumas of Childhood," in *Suzan-Lori Parks: Essays on the Plays and Other Works*, ed. Philip C. Kolin (Jefferson, NC: McFarland, 2010), 140–155.
13. Shoshana Felman and Dori Laub, *Testimony: Crises of Witnessing in Literature, Psychoanalysis, and History* (New York: Routledge, 1991).
14. LaCapra, *Writing Trauma, Writing History*, 49.
15. LaCapra, *Writing Trauma, Writing History*, 78–81.
16. LaCapra, *Writing Trauma, Writing History*, 78.
17. LaCapra, *Writing Trauma, Writing History*, 78.
18. Sheila Lloyd, "Sara Baartman and the 'Inclusive Exclusions' of Neoliberalism," *Meridians* 11, no. 2 (2013): 230.
19. According to LaCapra, "Everyone is subject to structural trauma. But, with respect to historical trauma and its representation, the distinction among victims, perpetrators, and bystanders is crucial." Continuing, LaCapra explains, "[H]istorical trauma is related to particular events that do indeed involve losses" (*Writing Trauma, Writing History*, 79, 80).
20. Consider Parks's *The America Play* (in *The America Play and Other Works* [New York: Theatre Communications Group, 1995]) with its Great Hole of History, the impact of the past on her characters' current situations as in *Topdog/Underdog* (New York: Theatre Communications Group, 2001), the Lincoln impersonators that appear in both *The America Play* and *Topdog/Underdog*, and her preoccupation with American history (literary and otherwise) in *In the Blood* (from *The Red Letter Plays* [New York: Theatre Communications Group, 2001]) and *Father Comes Home from the Wars Parts 1, 2 & 3* (New York: Theatre Communications Group, 2015). Connections to American literary history and the idea of digging up the past also occur in her novel *Getting Mother's Body* (New York: Random House, 2003). For discussions of Parks's focus on history, see, for example, Heidi J. Holder's "Strange Legacy: The History" in *Suzan-Lori Parks: A Casebook*, ed. Kevin J. Wetmore, Jr., and Alycia Smith Howard (New York: Routledge, 2007), 18–28; and various essays in Jennifer Larson's *Understanding Suzan-Lori Parks* (Columbia: University of South Carolina Press, 2012).
21. Parks herself has argued against the danger of assuming that there is one consistent Black experience in "An Equation for Black People Onstage" (in *The America Play and Other Works*, 21).
22. LaCapra, *Writing Trauma, Writing History*, 71.
23. Parks, *Venus*, Overture.3.
24. Parks, *Venus*, Epilogue.160.
25. Parks, "About Suzan-Lori Parks," 166.
26. Parks, *Venus*, Overture.3.
27. Parks, *Venus*, Overture.7.
28. Parks, *Venus*, Overture.8.
29. As The Negro Resurrectionist says, "'A process performed on the subject after the subject's death. The subjects body parts are soaked in a chemical solution to separate the flesh from the bones so that the bones may be measured with greater accuracy'" (Parks, *Venus*, 12.120).
30. Parks, *Venus*, 31.13.

"STEP IN STEP IN / HUR-RY! HUR-RY!"

31. Parks, *Venus*, 31.13 and 30.23.
32. Parks, *Venus*, 31.10.
33. Parks, *Venus*, 31.12.
34. Parks, *Venus*, 31.10-18.
35. Philip C. Kolin, "Puck's Magic Mojo: The Achievements of Suzan-Lori Parks," in *Suzan-Lori Parks: Essays on the Plays and Other Works*, ed. Philip C. Kolin (Jefferson, NC: McFarland, 2010), 15.
36. Crais and Scully, *Sara Baartman and the Hottentot Venus*, 54–57; Holmes, *The Hottentot Venus*, 45–53.
37. Parks, *Venus*, 3.155–156.
38. Crais and Scully, *Sara Baartman and the Hottentot Venus*, 10.
39. Parks, *Venus*, 20I.75.
40. William Safran, "Diasporas in Modern Societies: Myths of Homeland and Return," *Diaspora* 1, no. 1 (1991): 91.
41. Safran, "Diasporas in Modern Societies, 81, 86.
42. James Clifford, *Routes: Travel and Translation in the Late Twentieth Century* (Cambridge, MA: Harvard University Press, 1997), 248.
43. Tiffany Ruby Patterson and Robin D. G. Kelley, "Unfinished Migrations: Reflections on the African Diaspora and the Making of the Modern World," *African Studies Review* 43, no. 1 (2000): 20.
44. Parks, *Venus*, 16.91–99.
45. Dori Laub, "The Empty Circle: Children of Survivors and the Limits of Reconstruction," *Journal of the American Psychoanalytic Association* 46, no. 2 (1998): 507–529.
46. Kirby Farrell, *Post-traumatic Culture: Injury and Interpretation in the Nineties* (Baltimore, MD: Johns Hopkins University Press, 1998), 21–26; Ruth Leys, *Trauma: A Genealogy* (Chicago: University of Chicago Press, 2000); Lawrence J. Kirmayer, "Landscapes of Memory: Trauma, Narrative, and Dissociation," in *Tense Past: Cultural Essays in Trauma and Memory*, ed. Paul Antze and Michael Lambek (New York: Routledge, 1996), 173–198; Michael Lambek, "The Past Imperfect: Remembering as Moral Practice," in *Tense Past, Cultural Essays in Trauma and Memory*, ed. Paul Antze and Michael Lambek (New York: Routledge, 1996), 235–254.
47. Parks, *Venus*, 24.47.
48. Parks, *Venus*, 22.55.
49. Parks, *Venus*, 24.47 and 22.56–57.
50. For discussions of this alleged complicity, see Ben Brantley, "Of an Erotic Freak Show and the Lesson Therein," *New York Times*, May 3, 1996; Robert Brustein, "Resident Theater Hopes," *New Republic*, May 20, 1996, 28–30; Stephen Lucasi, "Saartjie's Speech and the Sounds of National Identification," *Mosaic* 42, no. 2 (2009): 171; Jean Young, "The Re-Objectification and Re-Commodification of Saartjie Baartman in Suzan-Lori Parks's *Venus*," *African American Review* 31, no. 4 (1997): 699–708; Jennifer Larson, "'Deliberate Calculation' in Money, Sex, and Black Plays: *Venus*," in her *Understanding Suzan-Lori Parks* (Columbia: University of South Carolina Press, 2012), 26–39.
51. Dori Laub and Nanette C. Auerhahn, "Knowing and Not Knowing Massive Psychic Trauma," *The International Journal of Psychoanalysis* 74, no. 2 (1993), 287–302.
52. Parks, *Venus*, Overture.5.
53. Parks, *Venus*, 28.31.
54. Parks, *Venus*, 28.31.
55. Parks, *Venus*, 24.45.
56. Parks, *Venus*, 20B.64–65.
57. Parks, *Venus*, 24.47, 20J.7.
58. Parks, *Venus*, 25.77, 15.77.
59. Parks, *Venus*, 20D.66, 20H.71, and 20I.74.
60. Parks, "From *Elements of Style*," in *The America Play*, 9–10.
61. Leys, *Trauma: A Genealogy*, 9.
62. Leys, *Trauma: A Genealogy*.
63. Nora Strejilevich, "Testimony: Beyond the Language of Truth," *Human Rights Quarterly* 28, no. 3 (2006): 713.
64. Sandra Jackson-Opoku, "Out Beyond Our Borders: Literary Travelers of the TransDiaspora," in *The New African Diaspora*, ed. Isidore Okepwho and Nikiru Nzegqu (Bloomington: Indiana University Press, 2009), 9.

CHRISTOPHER GIROUX

65. Harvey Young, "Choral Compassion: *In the Blood* and *Venus*," in *Suzan-Lori Parks: A Casebook,* ed. Kevin J. Wetmore, Jr., and Alycia Smith-Howard (New York: Routledge, 2007), 30–31.
66. Judith Lewis Herman, *Trauma and Recovery* (New York: Basic Books, 1997), 7.
67. Parks, *Venus*, Overture.1–2.
68. Anna Fausto-Sterling, "Gender, Race, and Nation: The Comparative Anatomy of 'Hottentot' Women in Europe, 1815–1817," in *Deviant Bodies: Critical Perspectives on Difference in Science and Popular Culture*, ed. Jennifer Terry and Jacqueline Urla (Bloomington: Indiana University Press, 1995), 19.
69. Marie-Emmanuel-Guillaume-Marguerite Théaulon, Armand Dartois, and Brasier, *La Vénus hottentote, ou haine aux Françaises,* in *Black Venus: Sexualized Savages, Primal Fears, and Primitive Narratives in French,* ed. T. Denean Sharpley-Whiting (Durham, NC: Duke University Press, 1999), 127–164.
70. Théaulon, Dartois, and Brasier, *La Vénus hottentote, ou haine aux Françaises,* 149–161; Parks, *Venus*, 8.132–134, 4.153–154.
71. Parks, *Venus*, 29.25–27, 26.39, 23.48–49, 11.121–123, 4.153–154.
72. Kai T. Erikson, *A New Species of Trouble: Explorations in Disaster, Trauma, and Community* (New York: Norton, 1994).
73. Paul Farmer, "On Suffering and Structural Violence: A View from Below," in *Violence in War and Peace: An Anthology*, ed. Nancy Scheper-Hughes and Philippe Bourgois (Malden, MA: Blackwell Publishing, 2004), 282. Farrell calls these the "cumulative" effects of trauma (*Post-traumatic Culture*, 3).
74. Bertolt Brecht, *Brecht on Theatre: The Development of an Aesthetic,* ed. and trans. John Willett (New York: Hill and Wang, 1964), 71.
75. Laurie Vickroy, *Trauma and Survival in Contemporary Fiction* (Charlottesville: University of Virginia Press, 2002), 13.
76. See William Shakespeare, *The Merchant of Venice*, in *The Riverside Shakespeare*, ed. G. Blakemore Evans (Boston: Houghton Mifflin, 1974), 3.1.65.
77. Parks, *Venus*, 16.99 and 30.21.
78. Parks, *Venus*, Overture.6.
79. Parks, *Venus*, 30.190.
80. Parks, *The America Play and Other Works*, 11–12.
81. In discussing Parks's inventive use of language throughout her work, Kolin argues she has created a "language of the fragmented, the dispossessed, the disjointed"; it is, he writes in a more specific discussion of characters from Parks's *Imperceptible Mutabilities*, a "language of absence . . . of the displaced" ("Puck's Magic Mojo," 16). These descriptors are just as often used when discussing trauma.
82. Vickroy, *Trauma and Survival in Contemporary Fiction*, 223.
83. Laub and Auerhahn, "Knowing and Not Knowing," 288; Cathy Caruth, *Unclaimed Experience: Trauma, Narrative, History* (Baltimore, MD: Johns Hopkins University Press, 1996), 61; Kirmayer, "Landscapes of Memory," 179; Vickroy, *Trauma and Survival in Contemporary Fiction*, 170.
84. Caruth, *Unclaimed Experience*, 4.
85. Parks, *Venus*, 16.92.
86. Parks, *Venus*, 1.162.
87. Shoshana Felman, "From 'The Return of the Voice: Claude Lanzmann's *Shoah*," in *The Claims of Literature: A Shoshana Felman Reader*, ed. Emily Sun, Eyal Peretz, and Ulrich Baer (New York: Fordham, 2007), 295.
88. Parks, *The America Play and Other Works*, 15.
89. Vickroy, *Trauma and Survival in Contemporary Fiction*, 172.
90. Laub and Auerhahn, "Knowing and Not Knowing," 288.
91. Kai Erikson, "Notes on Trauma and Community," in *Trauma: Explorations in Memory*, ed. Cathy Caruth (Baltimore, MD: The Johns Hopkins University Press, 1995), 194.
92. Caruth, "Introduction to Part II: 'Recapturing the Past,'" in *Trauma: Explorations in Memory*, ed. Cathy Caruth (Baltimore, MD: The Johns Hopkins University Press, 1995), 153.
93. Caruth, *Unclaimed Experience*, 17.
94. Gloria Anzaldúa, *Borderlands/La Frontera: The New Mestiza* (San Francisco: Aunt Lute Books, 1987), 3. See also Smadar Lavie and Ted Swedenburg, "Introduction: Displacement, Diaspora, and Geographies of Identity," in

"STEP IN STEP IN / HUR-RY! HUR-RY!"

Displacement, Diaspora, and Geographies of Identity, ed. Smadar Lavie and Ted Swedenburg (Durham, NC: Duke University Press, 1996), 14–15.

95. Farrell, *Post-traumatic Culture*, 1–33.
96. Caruth, *Unclaimed Experience*, 9.
97. Parks, *Venus*, 2.159.
98. Parks, *Venus*, 1.161.
99. Parks, *Venus*, Overture.8–9.

THREE

YORUBA VISIONS OF THE AFTERLIFE IN PHYLLIS ALESIA PERRY'S *STIGMATA*

STELLA SETKA

This is the hand of my mother, she says. And of my grandmother. Petals of the same flower. Your life is many lives.

—Phyllis Alesia Perry, *Stigmata*

In *Black Subjects: Identity Formation in the Contemporary Narrative of Slavery*, Arlene R. Keizer argues that writers of the African Diaspora have turned toward "slavery as a touchstone for present-day meditations on the formation of black subjectivity."[1] In the Americas, where Black history was "submerged under the totalizing narrative of Western history until very recently,"[2] neo-slave narratives have become a literary form through which writers of African descent are making attempts to reclaim "a true sense of [the] time and identity" of the Black diasporic subject.[3] What many have neglected to note, however, is the pervasive influence of African cosmologies in many of these texts. Writers such as Phyllis Alesia Perry, Toni Morrison, Octavia Butler, and J. California Cooper, among others, have constructed texts in which recollections of the slave past are imbricated with references to African spiritual traditions.

This essay examines Phyllis Alesia Perry's *Stigmata*, a neo-slave narrative in which the Yoruba concept of matrilineal reincarnation, or *Yetunde*, serves as an interface between the slave past and post-slavery African American identity.[4] Specifically, the novel adapts the Yoruba notion of the *Yetunde* to frame the corporeal and emotional connection that the protagonist, Lizzie, shares with her female ancestors. In its transgression of geographical and temporal boundaries, the novel highlights the inextricable ties between past and present and demonstrates how the painful consequences of slavery's legacy reverberate today. However, the consciousness that Lizzie shares with her foremothers is more than just a conduit for memory; it also provides her with the tools necessary to begin working through the weight of historical trauma. By infusing her novel with a Yoruba understanding of the connections between the afterlife of ancestors and the world of the living, Perry not only rejects the primacy of Western, specifically Christian, ontologies but also insists that a reappraisal of the slave past be framed within a non-Western cultural context.

Stigmata is just one in a number of contemporary African American texts that have turned to African understandings of the afterlife—and the fluid connection between past and present generations that those cosmologies envision—as a means of facilitating a more intimate connection with history. That Africanisms abound in contemporary African American novels that

YORUBA VISIONS OF THE AFTERLIFE

contend with the slave past is a testament to the persistence of the African Diasporic heritage. Henry Louis Gates, Jr., explains how African belief systems and traditions evolved in the African Diaspora:

> Slavery in the New World, a veritable seething cauldron of cross-cultural cultural contact, however, did serve to create a dynamic of exchange and revision among previously isolated Black African cultures on a scale unprecedented in African history. Inadvertently, African slavery in the New World satisfied the preconditions for the emergence of a new African culture, a truly Pan-African culture fashioned as a colorful weave of linguistic, institutional, metaphysical, and formal threads.[5]

This Pan-African culture that Gates describes accounts for the variety of Africanisms that can be traced in contemporary African American narratives that look to the past. Like Perry's novel, Gayl Jones's *Corregidora* (1975) invites readers to experience the trauma of history through the experiences of a contemporary protagonist who shares a consciousness with her slave ancestors in a manner suggestive of Yoruba reincarnation beliefs. Other texts, such as Julie Dash's *Daughters of the Dust* (1997) and J. California Cooper's *Family* (1991), draw from Kongo cosmology to narrate the slave experience from the perspectives of ancestral spirits who provide readers access to the experience of multiple generations in African American history. Similarly, Octavia Butler's *Kindred* (1978) uses the Igbo ogbanje figure—with its ability to travel between the worlds of the living and the dead—to reinterpret the complexities of Black identity in post-Civil Rights America and to explore the means by which both Blacks and non-Blacks can remember and feel history. In this, *Kindred* anticipates projects like Butler's own *Wild Seed* (1980), Tananarive Due's *The Between* (1996), and John Edgar Wideman's *The Cattle Killing* (1997), which creatively repurpose the ontological peculiarity of the ogbanje figure to negotiate questions of race, gender, subjectivity, and historical memory. Works such as Paule Marshall's *Praisesong for the Widow* (1983), Gloria Naylor's *Mama Day* (1988), and August Wilson's *The Piano Lesson* (1990) engage African beliefs in the ancestor figure to reaffirm connections to African American cultural values and traditions that have been forgotten or suppressed by post-slavery generations.[6]

For these authors, contemporary Black subjectivity is imagined in conversation with the legacy of slavery and visions of the afterlife that suggest an African, rather than Christian, worldview, "evok[ing] Afro-diasporic ways of knowing that were suppressed by Enlightenment rationality."[7] Gates specifically roots these ways of knowing in traditional African cosmologies: "Violently and radically abstracted from their civilizations, these Africans nevertheless carried within them to the Western hemisphere aspects of their cultures that were meaningful, that could not be obliterated, and that they chose, by acts of will, not to forget: their music, . . . their myths, their institutional structures, their metaphysical systems of order."[8] Echoing Wole Soyinka, Gates goes further to argue that prominent among the belief systems that were transmitted and readapted in the New World was Yoruba cosmology and its òrìṣà. In its adaptation by African American writers such as Perry and Jones, the Yoruba world view, and specifically its vision of intrafamilial reincarnation, has been reshaped to fit uniquely American contexts and hermeneutical purposes. That it is increasingly found in narratives touched by slavery reflects a desire on the part of African American writers to syncretize their African heritage with the distinctive

71

experience of American slavery and to reconcile the historical silences that it wrought with the need to feel the past.

Much of *Stigmata*'s critical attention has centered on its unique approach to the neo-slave narrative. Critics such as Lisa Long, Camille Passalacqua, Lisa Woolfork, and Corinne Duboin have added to our understanding of the text's experimentation with temporal and physical boundaries as engaging with the broader historical reclamation work of the neo-slave narrative.[9] This discourse is valuable for the way that it highlights the text's efforts to convey the brutal corporeal reality of enslavement. However, no scholarship to date has explored the connection between the novel's temporal experiment and Perry's interest in Yoruba ontological traditions, nor have scholars noted the way that Perry mobilizes those traditions as a way of re-forming lost ancestral histories and imagining a future in which working through a cultural trauma like slavery is possible.[10] Indeed, Perry explains that her novel was inspired by a desire to counteract America's inability to face the traumatic impact of the past by only looking at recorded historical knowledge. She continues:

> We don't really deal with the emotional effects of [slavery]. We don't deal with the way they affect subsequent generations. . . . we inherit other people's pain, other people's prejudices, we inherit other people's versions of history. The only way I feel that you can really get out of this is to be emotional about it. . . . Getting emotional about it takes you some place no one wants to go.[11]

The risk of not facing the "legacies of our past," Perry argues, causes it to "always come back." Here, Perry articulates her concern that American culture's refusal to confront history in an emotional way inevitably precipitates its traumatic return. Fearing the repetition of this trauma, Perry not only recasts the slave narrative as means of confronting the truth of slavery's traumatic legacy but also writes to "deal with [her] fears about that past . . . fears that somehow the past is going to become [her] present or future."[12] To prevent the possibility of repeating history, then, Perry prompts her readers to respond emotionally to the fact of slavery by staging a fictional return to some of the most brutal moments of that event. *Yetunde* reincarnation permits this return, "creat[ing] confidence in life" by not only overcoming death but also creating possibilities for working through trauma and thus ensuring "that life is not interrupted, but goes on."[13] The driving force of *Stigmata* can therefore be interpreted as a dual imperative: first, to preserve the memory of the trauma so that it can be addressed and thus enable healing and, second, to signal that one path toward healing may reside in recognizing and understanding the hidden or disguised African worldviews that have sustained Americans of the African Diaspora all along.

Stigmata presents a complicated tapestry of personal and familial memories of a violent slave history, beginning with Lizzie DuBose's therapy session at an Atlanta psychiatric hospital in 1994. We learn from this session that Lizzie had been committed by her parents fourteen years earlier after they interpreted certain bodily injuries—manacle-like wounds—to be a suicide attempt prompted by an unusual fascination with her matrilineal inheritance: a diary chronicling the slave experiences of her great-great-grandmother, Ayo, and a quilt crafted by her grandmother, Grace. The more elusive aspects of that inheritance—which Lizzie is determined to conceal— are the vivid memories passed down by these ancestors, memories that send her into trance-like states and leave her emotionally and physically scarred.

YORUBA VISIONS OF THE AFTERLIFE

When asked why Ayo's reincarnation plays such a central role in Lizzie's narrative, Perry explains that her return "was her (Ayo's) way of making herself known, of making herself known to herself. It was her way of remembering who she was. I didn't know this as I was writing; I didn't plan any kind of 'message' to be part of the book. Ayo's motivations were only clear to me after the fact, when I looked at her story and said, 'Ah, that's what that was all about.'"[14] And just as Ayo revealed her motivations to Perry as the author was writing her painful tale, so too does she reveal her purpose to the readers as they follow Lizzie's experience. In this way, Lizzie's inherited memories become a point of entry through which readers in the present day can gain access to a felt experience of slavery, an experience that is rendered even more painful for readers because of Lizzie's resistance to her foremothers' memories. Indeed, *Stigmata* is as much about Lizzie's efforts to reconcile history and memory as it is about the brutality of Ayo's and Grace's experiences of slavery. Lizzie's struggle to come to terms with this ancestral past can be charted as a path toward the cultivation of an integrated consciousness. If the impetus behind Grace and Ayo's return signifies the imperative to remember the past, Lizzie's acceptance of both women's memories preserves the integrity of their experiences while at the same time enabling her to work through the traumatic experiences she has inherited.

The novel features a progression from fragmentation to integrated consciousness in three stages: the first focuses on Lizzie's resistance to the intrusion of her *Yetunde* consciousnesses, which is signified by the memories of Ayo and Grace and the transcriptions of those traumatic memories on her body. Lizzie's resistance to these memories propels her into a state of liminal consciousness. The second stage examines the processes by which she attempts to negotiate these memories and work through her own response to the traumatic experiences of her foremothers. The final stage demonstrates Lizzie's own personal healing and achievement of an integrated consciousness. Ultimately, Lizzie's struggle to integrate her ancestors' memories with her life in the present resonates as a call for readers to remember and bear witness to slavery and its lasting impact in American culture.

Central to this drama is the *Yetunde* reincarnation that begins with Ayo, who is identified by Perry as belonging to "the Yoruba people" and who is, in many ways, the driving force of the text.[15] Indeed, Lizzie, like her grandmother Grace before her, finds her destiny shaped both by the influence of Ayo's presence in her life and the painful memories of the slave experience that she carries with her. Although reincarnated in her descendants, Ayo retains her own distinct personality. John S. Mbiti confirms the authenticity of this type of ancestral connection, noting that while "[b]elief in reincarnation is reported among many African societies," it is only a "partial reincarnation in the sense that only some human features or characteristics of the living-dead are said to be 'reborn' in some children. This happens chiefly in the circle of one's family and relatives. The living-dead who has been reincarnated continues, however, to have his separate existence and does not cease to be."[16] Thus, it is important to understand that the reincarnation referenced in *Stigmata* is not that which is traditionally understood by Western culture as a full rebirth. Anthony N. O. Ekwunife cautions that "the English word—reincarnation . . . does not fit and cannot fit into the [West African] experience of the phenomenon."[17] Instead, Ekwunife suggests, the experience of reincarnation in the African sense is better translated as "coming back to the world, not necessarily being born again."[18] Babatunde Lawal goes further to note that for the Yoruba, "death is not the end of life," but rather a state of "dematerialization."[19] The soul may elect to remain in a spiritual state in the afterlife or choose to "make periodic returns

73

to the earth through reincarnation," often in the body of a descendant who shares the same gender.[20]

Inherent in this type of reincarnation is the idea that it extends a family's—or a people's—collective consciousness through multiple generations. William Bascom notes that "[t]he Yoruba believe in reincarnation and in multiple souls. The most important soul is the ancestral guardian soul . . . which is associated with a person's head, his destiny, and reincarnation."[21] Thus, an integrated consciousness is "intricately merged with the spirit" of the ancestor and constitutes "the essence, energy, expression, and experience of the black spirit (or being) in the form of awareness, knowing, comprehension, and existing. It is that which allows African people to reflect, respond, project, and create from, before, and beyond the time of their individual experience."[22] This awareness is most powerfully realized in the novel when Lizzie accepts the powerful influence of Ayo and Grace's spirits, acknowledging, "This is my life. These people belong to me. . . . it's like they've always been there, trying to make me hear them."[23] Through Ayo in particular, Lizzie accesses distant memories of Africa and the nameless foremother, "the full-brown woman," who gave Ayo life.

While acceptance of ancestral knowledge is crucial to Lizzie's identity formation in the present, the weight of the past and the pain of her ancestors' memories initially proves too much to bear. "'I don't know how to stop it,'" Lizzie cries, anguished by the fact that her engagement with the multiple consciousnesses of her foremothers is quite beyond her control: "Ayo paces back and forth inside my head. Restless and yearning, impatient for me to remember all. But Grace holds our secrets just beyond my view, eagerly teases me with imminent revelations. She's there now, insisting that I listen to her."[24] In a conversation with her great-aunt Eva, she admits: "'I can't get away . . . It follows me. . . . The past. Wherever I go.'"[25] Eva gently corrects her false understanding of historical linearity, explaining to Lizzie that "'The past . . . is a circle. If you walk long enough, you catch up with yourself,'" and then gently tells her "you done already been here."[26] Beyond implying that history—and the traumas it carries with it—is capable of repeating itself, Eva also indicates that the women Lizzie channels in her trance-like states represent reincarnated beings who have repeated the life cycle to share their wisdom with her.[27] In this, Eva reflects an "African comprehension of life and time [that] is oriented towards the past" while at the same time accepting the fact of Ayo's and Grace's reincarnation in Lizzie, which "direct thoughts to the future."[28] However, because Lizzie cannot reconcile the impact of the past with the reality of her present-day existence, she is paralyzed by this ancestral legacy and therefore exists uncomfortably between denial and belief.

Because she is resistant to the presence of her foremothers, Lizzie occupies a liminal space for much of the novel, in a troubled middle ground between the two poles of consciousness: that of her own independent psyche and the integrated psyche that Ayo and Grace wish to form with her.[29] Lizzie's traumatic experience of the movement from a fragmented to an integrated consciousness can be described as a period of liminality; indeed, the shadowy specters of liminal spaces permeate the text. Just after receiving her "keys to the past"—Joy's journal and Grace's quilt—Lizzie experiences a strange sense of sleeplessness, which she recalls as marking "the start of things."[30] "If you don't sleep," she continues wryly, "you think and have conversations with yourself that, in the morning, are startling."[31] The period that she describes—that curious state just between wakefulness and sleep—is in itself a liminal state, and marks her entry into a liminal consciousness: that very night, Lizzie meets Ayo for the first time. With Lizzie serving as

YORUBA VISIONS OF THE AFTERLIFE

our proxy, Ayo's memories draw us into the painful and unsettling world of the past and ask us to become witnesses to the horrors of slavery.

Further, Lizzie, like Grace and Ayo before her, is an adolescent when she first begins to experience the traumas of slavery, and adolescence, the transitional threshold between childhood and adulthood, is in itself traditionally acknowledged to be a liminal period. As the text tells us, Ayo is fourteen when she is taken captive and experiences the Middle Passage, and it is primarily the memory of this experience—the liminality of being caught between Africa and America—that she elects to pass on to her descendants. Joy's journal attests to the liminality of her mother's experience: "*She once told me that Ayo got los when she crossed the water. Bessie kinda took over. She had to think like her not like Ayo from Afraca.*"[32] Similarly, Grace and Lizzie lose themselves to the memories of this experience and the enslavement that followed. Lizzie, speaking for herself as well as for Grace, tells us that, despite her efforts to control the visions, "Ayo is there, reminding us who we are. And we can't stop the sea from rolling beneath us and we can't stop the fear. The chains go on over our skin, no matter how much we holler."[33] In *A Sunday in June*, *Stigmata*'s prequel, Grace reflects that because of these intrusive memories, which arise unpredictably, "It had been years . . . since she'd slept through the night. Not since she held those diary pages in her hands. Not since the girl in the blue dress [Ayo] had led her down the road. A door had opened for her that day."[34] The door to which Grace refers here is symbolic of the threshold that she crossed into the space of liminal consciousness. Just as Ayo is trapped by the institution of slavery, and just as Grace is captivated by her second-hand experience of that horror, so too is Lizzie held captive by the legacy of trauma that they collectively pass on to her. Gradually, because she cannot control her increasingly frequent lapses into ancestral memories, Lizzie is forced to negotiate the world of Western psychiatry, which seeks to deny the validity of her reincarnation and ultimately forces her to adopt a new kind of Du Boisian double-consciousness.

Paradoxically, the novel stages Lizzie's entry into the second phase of integrated consciousness not in the middle of the text, but at its beginning. The first chapter of the novel describes Lizzie's final psychiatric session and functions as a prologue to the tale that follows. She answers her pyschiatrist's questions with practiced, cursory responses, and silently notes, "I've polished my story of redemption and restored mental health—the one responsible for my impending freedom—to such a shine that I've dazzled . . . everyone."[35] "All it took," she adds, "was fourteen years and some well-acted moments of sanity."[36] In addition to holding her captive, Lizzie's connection to the past silences her as well, so much so that to speak only condemns her in the eyes of others as a madwoman. As a result, she is forced to pretend that she has been "cured" of the past; however, as she thinks to herself when exiting the psychiatrist's office, "there is no cure for what I've got."[37] Here, the text argues that the psychiatric system, though perhaps equipped to address individual traumas, refuses to acknowledge either the possibility of inherited or cultural traumas or alternate, non-Western ontologies and thus cannot begin to theorize a means by which traumatized subjects can negotiate the trauma that they have inherited from their ancestors. Thus, when Lizzie leaves the office, she is aware that she must find her own way to learn to cope with her shared consciousness, which she does by seeking a community of empathetic witnesses and by testifying through art, namely quilting, painting, and writing.

Perry's privileging of Yoruba ontology over Western ideology reflects Channette Romero's assertion that "Contemporary novels by women of color explore the relationship of people of color's temporalities to mainstream Euro American notions of time in an effort to prompt their

readers to consider how concepts of temporality relate to ideology."[38] As Vine Deloria, Jr., argues, this exploration is crucial to the recovery of non-white histories and identities because "Western European identity involves the assumption that time proceeds in a linear fashion; further it assumes that at a particular point in the unraveling of this sequence, the peoples of Western Europe became the guardians of the world."[39] By framing Lizzie's experience of reincarnation—and the physical exposure to slavery this unique brand of reincarnation allows—within the context of Western psychiatric culture, *Stigmata* challenges readers to become more aware of "the ideologies associated with divergent worldviews, ideologies that the linear concept of time works to elide."[40] Thus, the text not only underscores the inextricable, though often forgotten, connections between the slave past and the shape of present-day America but also challenges the ideologies—both religious and scientific—that have historically justified the existence and perpetuation of slavery in America and that seek to negate ontologies that fail to square with Western belief systems.

However, the psychiatric industry is significant for another reason as well: because readers encounter the novel from Lizzie's point of view, they bear witness to her traumatic experiences from her perspective as they occur. This shared subject position makes it difficult for even a dissenting reader to accept clinical misdiagnoses of Lizzie's condition. Readers know, for example, that the bloody wounds on Lizzie's wrists are not the product of self-mutilation but are rather evidence of the manacles that Ayo bore on her wrists a century earlier. By positioning Lizzie in a tug-of-war between the Yoruba and Western beliefs—and between a past that compels her to remember and a present that wants her to forget—the novel implicates readers as witnesses to her traumatic ordeal. Although what Lizzie tells her audience defies Western logic, readers nevertheless accept and trust her story. As a result, readers become bound to Lizzie in the way that she is bound to her ancestors; that is, while they may be resistant to what she has to say, and while they may be unfamiliar with the Yoruba worldview to which her shared consciousness has exposed them, they have nevertheless been confronted with alternate ways of understanding the past. Thus, *Stigmata* can be read as Lizzie's testimony of her personal ordeal and a testament to her newly integrated consciousness, a living document that includes the voices of Grace and Ayo as well. And while the text is rooted in the past, its effects "belong to both the present and the future—to the living readers whose post-traumatic responsibilities are both retrospective and prospective."[41] As a living document that elides the distance between past and present, the novel calls on readers to recognize the long reach of history into the contemporary moment and to resist the amnesia brought on by the passage of time. And the only way to resist this amnesia, the text suggests, is to keep the past alive by sharing its stories and lessons with others.

Communicating her inherited memories of the past to others is instrumental to Lizzie's ability to achieve an integrated consciousness. Often discouraged by the disapproval of her parents and the community, Lizzie struggles to work through her traumatic legacy on her own; however, she is not without support. Chief among her champions is Eva, Grace's sister, who recognizes Lizzie's experience as legitimate and offers her guidance when she needs it most. When Lizzie confesses that she is not sure that she "know[s] how" to take control of her experiences, Eva assures her that she has the strength to work through the trauma she has inherited: "'. . . when something needs doing, you don't let it go. . . . That's why you're here now. Because you left something unfinished. . . . You won't feel right until you take care of it. . . . Find a way."[42] Her advice to Lizzie resonates with that of Willow Davidson to Grace in *A Sunday in June*. Although

YORUBA VISIONS OF THE AFTERLIFE

she was Ayo's closest friend, Willow is distrusted by Ayo's descendants because of her designation as an "ole root woman" whose adherence to her tribal traditions poses a challenge to the growing popularity of evangelical Christianity among members of their community.[43] Despite the disapproval of the community, Willow persists in advising Grace to give herself over to a state of shared consciousness with Ayo, saying: "'Set some time aside to listen to her. Next time she speaks, if you can, just stop what you doin' and sit down and let her come and see what's what. . . . Unless you know what she come back for you won't know how to send her on her way.'"[44] Both Eva and Willow recognize the need of the reincarnated beings to impart their knowledge of suffering to a new generation so that it can be acknowledged and remembered. Further, in their encouragement of Lizzie and Grace, these women also function as symbols of resistance to Western ideology and midwives for the reemergence of reincarnation beliefs not only in the lives of the characters but also in the imagination of the contemporary reader.

Gradually, Lizzie does find a way to negotiate both her trauma and those of the women who have come before her. Ironically, the means by which she works through her trauma—bearing witness through cathartic endeavors like quilting, painting, and speaking—are methods prescribed by her psychiatrists. In fact, one psychiatrist, a Dr. Cremick, suggests that she draw, which he describes as "a different kind of communication."[45] And although artistic therapeutic methods eventually help her to make sense of the past and achieve an integrated consciousness, the fact that her psychiatrists consistently misdiagnose her only makes her feel more alone. On the whole, they interpret her flashbacks of the Middle Passage as "'super-sensitive dream disturbances'"[46] and the "voices" of Ayo and Grace as evidence of schizophrenia.[47] Ultimately, Lizzie struggles under the care of her psychiatrists because they are unwilling to validate her experiences; the notion of *Yetunde* reincarnation—and the weight of traumatic history that this particular form of reincarnation carries with it—is beyond their context for understanding. There are, however, other characters in the text that function as empathetic listeners: not only Aunt Eva, who sees reflected in Lizzie the experiences of her own sister, but also Lizzie's cousin, Ruth, whose ability to literally feel the "searing pain" renders her a truly empathetic witness to Lizzie's trauma.[48]

The character who is perhaps the most crucial supporter of Lizzie on her journey toward an integrated consciousness is her lover, Anthony Paul. A "printer and sometime artist,"[49] Anthony Paul shares Lizzie's creativity and encourages her in her experimentation with the artistic media, like quilting and painting, that she uses to illustrate her ancestral past. However, Lizzie is afraid of the effect that her multiple consciousnesses might have on her lover. She warns Anthony Paul: "Once you get inside my body, you may want to get inside my head. . . . things happen to people when they make love. You gotta realize you'll begin to know me, and I'm not talking about the biblical sense."[50] His response—"I already know you, old woman"—startles Lizzie, who has not yet confided in him the story of her past lives and memories. When Lizzie asks him who he is, he offers another startling reply: "I'm just someone who loves you."[51] After making love, Lizzie recalls Grace's longing for her husband, George, in the distant, lonely world of a northern city and recollects Grace's firm belief that she "Couldn't go back to George and make him do what he would have had to do."[52] When Lizzie makes love to Anthony Paul a second time, she becomes "more sure than ever that [she has] loved him before."[53] As though sensing her growing certainty about their past life connection, Anthony Paul valorizes her suspicions by whispering: "Don't ever leave me again." However, what stands as confirmation for Lizzie are words of admonishment for

77

STELLA SETKA

Grace, presumably from George, who has returned to reclaim his lost love in a future life. Thus, while Passalacqua argues that Anthony Paul's "possible alternate identity is ambiguous,"[54] it is clear in this context that Lizzie's first encounter with Anthony Paul doubles as the bittersweet reunion of Grace and George.

Moreover, the novel goes on to suggest that the connection between Anthony Paul and Lizzie may extend beyond Grace and George's relationship into Ayo's lifetime. This is confirmed for Lizzie when she uncovers one of Anthony Paul's canvases to reveal the following scene: the image of a girl emerging from "a swirl of water—the ocean, obviously, in the midst of a storm. A girl-woman walking into the unknown. In the distance, the waves toss a ship. She is obviously nude underneath a cloth that is wrapped around the waist of her slight body. She has her back to us—a back crisscrossed with a lacy pattern of scars" that resemble Lizzie's own scars.[55] Observing Lizzie's recognition of her own face reflected in that of the girl's in the painting, Anthony Paul asks, "It is you . . . isn't it?"[56] When Lizzie answers in the affirmative, Anthony Paul attempts to explain their connection: "I don't remember where the image came from. A dream maybe?" Anthony Paul's "dream" is in fact a memory of a previous life, one that is explained by Grace as she recounts one of Ayo's painful memories of a boy she encountered on the Middle Passage:

> . . . we were there at the rail. And they brought somebody. A boy. . . . They take him and haul up. . . . And he didn't scream. He didn't even whimper. He just looked up at the sky as if he were giving a prayer of thanks. And then . . . then they just hung him over the side of the boat and let him go. . . . I watched him fall. . . . As I watched, he looked at me, inviting like. I wanted to go. I wanted to go down there with him through the doorway to heaven.[57]

The perspective of the painting—the view of Ayo's sad face—seems to reflect this lost boy's point of view, and while Anthony Paul struggles to accept the fact of his own reincarnation, he nevertheless acknowledges that he shares a deep, lasting bond with Lizzie.

The validity of this suspected bond is valorized at the close of the novel, when we learn that Anthony Paul's painting has a counterpart—a painting by Lizzie of a similar scene—that predates their meeting: "A dark naked shape drifts toward the vortex. The red spiral moves, rises to meet it. Small legs and arms fly out in a confused jumble, needing something solid but finding nothing to cling to."[58] As Stefanie Sievers argues, "In addition to emphasizing the closeness between Anthony and Lizzie, this final textual moment combines Ayo's, Grace's, and Lizzie's lives in having their narratives structurally overlap: Lizzie is hearing Grace talk to a friend about standing on a slave ship, while she, in 1988, is painting the picture of 'a brown girl standing at the rail.'"[59] Perhaps even more important is the way that this final scene enables us to assign a deeper significance to Anthony Paul's painting: it confirms for Lizzie, beyond a doubt, that the visions she has are not "dreams," but are past-life flashbacks shared—whether he accepts it or not—by Anthony Paul.[60] Thus, for Lizzie, her relationship with Anthony Paul is of the utmost importance because it further validates her recollection of shared past experiences and helps her come to terms with the continued existence of her reincarnated foremothers. Further, it offers the possibility that what has been lost by the moment of traumatic rupture may be retrieved if only one remains open to alternate ontological possibilities. In this sense, the novel's view of the afterlife offers a sense of hope that counters the dominant Christian narrative. Rather than reuniting in death, Perry suggests, those who have been lost in history may somehow be reunited in the world of the living.

YORUBA VISIONS OF THE AFTERLIFE

Although her (re)union with Anthony Paul provides Lizzie with a sense of emotional and psychic ballast, she must still contend with the challenge of integrating the intrusive and often painful traumatic memories of Ayo and Grace into her own consciousness. She begins by turning to the tool with which Ayo bore witness—and thus attempted to work through—her personal experience of slavery. Just before her death at the turn of the century, Ayo commands her daughter, Joy, to transcribe the oral testimony of her capture in Africa and subsequent enslavement in America. The journal passages, which do not tell Ayo's story in a linear way, are prefaced by Ayo's oral declaration of self-hood and the dedication of her testimony:

I am Ayo. I remember.
This is for those whose bones lay sleepin in the heart of mother ocean for those who tomorrows I never know who groaned and died in that dark damp aside a me. You rite this daughter for me and for them.[61]

Ayo insists that her daughter "rite" her testimony by transcribing her oral testimony. If read as a homonym, the word "rite" takes on three distinct but intertwined meanings. Interpreted as Joy's misspelling of the word "write," Ayo's command to her daughter is simply the explicit instruction to transcribe her story, both for herself as a ritual of healing and for "them" (presumably her descendants) as a record of their ancestral past.

The other possible interpretations of Ayo's command to "rite" are its homonymic counterparts, "right" and "rite," the first of which reflects the survivalist response of the post-slavery Black community, and the second of which shores up the interpretation of Ayo's diary as a site of intergenerational memory. For Joy, to "right" Ayo's trauma means that to commit it to paper is essentially to "right" history: "The tellin' of it lifted a burden from her after she was old."[62] Joy regards her mother's written slave testimony as something that is privately therapeutic but "ain't nothin' to dwell on."[63] Conversely, for Ayo, to "rite" the history renders the act of testifying to the past—the act of rememory—a ritual to be reenacted through successive generations to prevent the past from being forgotten. The "rite" to which Ayo refers also anticipates her own reincarnation in her descendants. As Sundermeier notes, reincarnation represents a cultural continuity that is established "ritually" to ensure both the return of the individual and the survival of the community.[64] Thus, unbeknownst to her, Joy performs a "rite" in multiple senses: she records the testimony of her mother and she gives birth to Ayo's first reincarnated descendant, Grace.

The ritual of bearing witness to Ayo's slave testimony is continued by Grace, who carries on her grandmother's legacy by crafting a quilt that, like Ayo's diary, functions as a way to remember and transmit the slave past. Further, like the diary, the quilt tells Ayo's story in a nonlinear way, "transmitting and transgressing the bounds of dominant history" and therefore enabling each quilter—first Grace, then Lizzie—to "rite" themselves into the family history. Like Ayo's diary, the story sewn onto Grace's quilt is nonlinear, "jumbled,"[65] and reflects the simultaneity of past and present experiences and memories. This layout, for Lizzie, reflects her newly adopted Yoruba worldview that "the world seems to move in cycles."[66] While Woolfork argues that the text "imagines the quilt as therapy and narrative release,"[67] I go further to suggest that the act of quilting represents a form of healing that moves even beyond a therapeutic understanding of working through: it also functions for Lizzie as a site where integrated consciousness is realized. Indeed, it is through the act of quilting that Lizzie is able to achieve some sense of resolution

79

and begin the process of learning to live with the emotional and physical manifestations of her ancestral slave past.

Lizzie also recognizes that the layout of Grace's quilt, like the one she creates herself, reflects Ayo's Yoruba worldview of life as a continuity that continues beyond death, the sense that *We are forever. Here at the bottom of heaven we live in the circle. We back and gone and back again.*[68] This view of the life cycle and the universe as circular is emphasized by Mbiti in *Introduction to African Religion*, who notes that in many African religions, "circles are used as symbols of the continuity of the universe. They are the symbols of eternity, of unendingness, of continuity."[69] Lizzie's acceptance of her foremothers' memories helps her achieve an integrated consciousness, which is evidenced when she declares, "'I am the circle! The circle stands before you!'"[70] By acknowledging the significance of the memories that Grace and Ayo impart to her, Lizzie also implicitly embraces the African religious principle that explains the connection that she shares with her foremothers, the notion that "human life does not terminate at the death of the individual, but continues beyond death."[71] Lizzie thus not only extends their tales of horror in making a quilt but also adds herself to the chain of witnesses, creating a quilt that incorporates her story as well.

By the time she is released from psychiatric care, Lizzie has not only accepted the shared presences of Ayo and Grace and the memories that they carry with them but also recognizes the cosmological significance of their return: "I think that Ayo reincarnated as Grace and Grace reincarnated as me."[72] Despite the fact that she still carries the scars of history, Lizzie no longer fears the painful flashes of the past imparted to her by Ayo and Grace. Rather, she has come to terms with the past and her role as memory-bearer. She declares:

> I am free, I remember. These things can't hurt me anymore. The story on those diary pages belongs to me, but they don't own me. My memories live somewhere spacious now; the airless chamber of horrors has melted into the ground. I guess psychotherapy, psychiatry and long-term residential treatment really cured me of something. Cured me of fear. Made me live with every part of myself every day. Cured me of the certainty that I was lost.[73]

Thus, it is through the act of accepting and remembering the past—confronting it directly by exercising therapeutic tools, such as bearing witness and quilting, instead of avoiding it—that Lizzie is liberated from her fear. Instead of denying the connection she shares with Ayo and Grace, Lizzie integrates their memories with her own experience of the world. Lizzie acknowledges her acceptance when she declares that "I'm in the past. Yes, it's a part of me. But I can't get stuck there."[74] This sense of self-acceptance gives her the courage to refuse the labels that others try to assign her: "just because I know you think I'm crazy doesn't mean *I* think I'm crazy."[75] Instead of being weighed down by history, she moves forward into the future by carrying the past with her and expressing it through her art, telling Ayo's story by taking up a "brush to paint a gray ship and a brown girl standing at the rail,"[76] or designing "pictures" for the quilt that "so obviously tell Grace's story."[77] Just as the reader pieces together the fragments of Grace and Ayo's narratives to make sense of the story, so Lizzie pieces their stories together to narrativize their traumas, bearing witness to history in a way that brings together the shards of Grace and Ayo's collective pasts to create a whole where only traces of memory existed.

It is important to note that Lizzie succeeds where Grace failed; although Grace accepted the fact of her connection to Ayo and, like Lizzie, quilted Ayo's story, Grace was unable to

YORUBA VISIONS OF THE AFTERLIFE

balance her own life with Ayo's memories. As we learn in *Stigmata*'s prequel, Grace's decision to leave her husband George and children behind in Alabama stemmed from her hope that Ayo would stop transmitting painful memories of slavery to her. Just prior to her departure, Grace confesses to Eva her belief that distance from the South will cause Ayo's intrusive memories to cease: "Maybe if I go away from this place, she'll stay here."[78] George's reaction to her final "fit" of memory convinces her that she must leave or risk destroying the lives of those she loves; she recovers to find him "staring . . . so scairt, so scairt" and declares that she "never want[s] to see that look on his face again."[79] However, Grace is unable to find reprieve from Ayo and the painful memories she carries, and therefore never returns to her family home.

As though to explain her reasoning as well as to prevent Lizzie from committing the same mistake, Grace transports her descendant to the moment of that fateful fit. When Lizzie regains consciousness, she mistakes the man soothing her for Grace's husband George; at this moment, Lizzie's consciousness fuses with Grace's, who thinks that George has "come back now that [she] can be forgiven."[80] As she is carried away by Son Jackson, a family friend, Lizzie sees the apparition of Grace, "standing beside her house, her body bunched up in a protective stance."[81] Grace's protective posture signifies both her unwillingness to allow Lizzie to fail as she did and her desire to communicate to Lizzie the importance of integrating Ayo's consciousness with her own rather than trying to run away, to avoid quietly assimilating at the cost of losing one's connection to one's ancestral narrative. By sharing memories of her own past with Lizzie, Grace makes it clear that instead of fully accepting the fact that she shares a consciousness with Ayo, she tried to avoid it altogether by severing all ties to the past. Lizzie herself comes to this conclusion and confides in Anthony Paul that "'Grace had to leave her home and her family because Ayo's memories became too much for her to handle.'"[82] Gradually, Lizzie acknowledges that she, like Grace, is "superimposed" on Ayo.[83] In admitting this, Lizzie accepts her integrated consciousness, recognizing that her foremothers' memories are "more than memory, they're events."[84] And unlike Grace, who was too afraid to share her connection to the past with others, Lizzie gradually summons the courage to emphatically assert her reincarnated identity to those who, like Anthony Paul, are willing to listen: "'I know, *I know*, who I am.'"[85] In so doing, Lizzie is able to communicate her emotional, felt connection to the past.

Stigmata re-forms the past by inscribing history on the body and psyche of a present-day subject. In so doing, the text transcends the boundaries—considered sacrosanct in the Western imagination—that separate past from present and ancestor from descendant. By utilizing the ontology of matrilineal reincarnation as a foundation for its neo-slave tale, *Stigmata* connects Yoruba spiritual traditions to an African American context not only to reinstate its traditional meanings but also to inspire readers to recognize the syncretism that it is enacting. Perry herself has emphasized the value of acknowledging those in the African American community who "subscribe to belief systems outside the mainstream. A lot of those beliefs are based on African American spirituality that's inherited from African ancestors and from other traditions."[86] And Perry believes that for the contemporary African American community, as for the characters in her novel, "beliefs exist side by side. You would go to a root doctor, an herbalist, you might get a charm, you would go to church on Sunday, and you would believe that the spirits were talking to you." The pervasive influence of African cosmologies in the work of African American authors like Perry signals the continued resonance of Africanisms within the African American

81

STELLA SETKA

community and emphasizes the value of turning to these Africanisms as keys for decoding the messages embedded in their narratives of the past.

NOTES

This essay first appeared, in slightly different form, in Stella Setka, "'The Circle Stands before You': Reincarnation and Traumatic Memory in Phyllis Alesia Perry's *Stigmata*" in *MFS: Modern Fiction Studies* 68, no. 3 (Fall 2022): 482-505. Published by Johns Hopkins University Press. Copyright 2022 Purdue University.

1. Arlene R. Keizer, *Black Subjects: Identity Formation in the Contemporary Narrative of Slavery* (Ithaca, NY: Cornell University Press, 2004), 4.
2. Keizer, *Black Subjects*, 5.
3. Édouard Glissant, "History, Time, Identity," in *Caribbean Discourse: Selected Essays*, ed. J. Michael Dash (Charlottesville: University of Virginia Press, 1989), 93.
4. *Yetunde* translates as "Mother comes back." There are two types of reincarnation in Yoruba cosmology. As Babatunde Lawal explains, one type "occurs when a dead ancestor is believed to have been reborn in the same family," indicating its return in the child either through physical resemblance, similarities in behavior, or "through dreams in which the ancestor tells someone in the family that he [or she] has returned" ("The Living Dead: Art and Immortality among the Yoruba of Nigeria," *Africa: Journal of the International African Institute* 47, no. 1 [1977]: 51).
5. Henry Louis Gates, Jr., *The Signifying Monkey: A Theory of African American Literary Criticism* (1988; New York: Oxford University Press, 2014), 4.
6. Gayl Jones, *Corregidora* (New York: Random House, 1975); Julie Dash, dir., *Daughters of the Dust* (Kino International, 1991); J. California Cooper, *Family* (New York: Doubleday, 1991); Octavia Butler, *Kindred* (New York: Doubleday, 1978); Octavia Butler, *Wild Seed* (New York: Doubleday, 1980); Tananarive Due, *The Between* (New York: HarperCollins, 1996); John Edgar Wideman, *The Cattle Killing* (Boston: Houghton Mifflin, 1996); Paule Marshall, *Praisesong for the Widow* (New York: Putnam, 1983); Gloria Naylor, *Mama Day* (New York: Ticknor and Fields, 1988); and August Wilson, *The Piano Lesson* (New York: Plume, 1990).
7. Madhu Dubey and Elizabeth Swanson Goldberg, "New Frontiers, Cross-Currents and Convergences: Emerging Cultural Paradigms," *The Cambridge History of African American Literature*, ed. Maryemma Graham and Jerry W. Ward, Jr. (Cambridge: Cambridge University Press, 2011), 602.
8. Gates, *The Signifying Monkey*, 3–4.
9. Lisa A. Long, Camille Passalacqua, and Lisa Woolfork address the significance of trauma and embodiment in the novel. Long, drawing on the work of trauma theorist Cathy Caruth, argues that Perry and author Octavia Butler utilize "the intimacy and immediacy of their protagonists' pain as strategies to obscure the distance of a traumatic history" ("A Relative Pain: The Rape of History in Octavia Butler's *Kindred* and Phyllis Alesia Perry's *Stigmata*," *College English* 64, no. 4 [2009]: 462). Woolfork, by contrast, employs "a distinctly African American trauma theory" that attends equally to mind and body, arguing that what she terms as "bodily epistemology" functions as a representational strategy that uses the body of a present-day protagonist to register the traumatic slave past" (*Embodying American Slavery in Contemporary Culture* [Urbana: University of Illinois Press, 2009], 2). Passalacqua links *Stigmata*'s use of embodiment to that which is evidenced in novels such as *Corregidora* and *Kindred*, while Kinitra Brooks has advanced our understanding of the way that the text's unique engagement with slave history raises questions about post-slavery identity construction (Passalacqua, "Witnessing to Heal the Self in Gayl Jones's *Corregidora* and Phyllis Alesia Perry's *Stigmata*," *MELUS* 35, no. 4 [2010]: 139–163; and Brooks, "Maternal Inheritances: Trinity Formations and Constructing Self-Identities in *Stigmata* and *Louisiana*," *FEMSPEC* 12, no. 2 [2012]: 17–46). Further, the work of Venetria Patton and Éva Tettenborn has revealed how African concepts of time and the ancestor figure in the novel. However, neither Patton nor Tettenborn connects *Stigmata* to Yoruba reincarnation beliefs; both of their interpretations instead use the Kongo cosmogram as a lens through which to interpret the novel (Patton, *The Grasp That Reaches Beyond the Grave: The Ancestral Call in Black Women's Texts* [Albany: SUNY Press, 2013]; and Tettenborn, "Africana Concepts of the Ancestor and Time in Phyllis Alesia Perry's *Stigmata* and *A Sunday in June*," *Obsidian* 12, no. 1 [2011]: 94–109). Although these readings are useful in the sense that they encourage us to read the novel in

YORUBA VISIONS OF THE AFTERLIFE

the context of the African Diaspora, they are not supported by Perry herself, who imagines her characters as rooted in the Yoruba, rather than Kongolese, culture.

10. Here, I rely on A. Timothy Spaulding's understanding of "re-forming" as a means by which writers recalibrate our understanding of African American history "by depicting a more complex, nuanced view of black identity in the context of American slavery" (*Re-Forming the Past: History, the Fantastic, and the Postmodern Slave Narrative* [Columbus: The Ohio State University Press, 2005], 4).

11. Qtd. in Corinne Duboin, "Confronting the Specters of the Past, Writing the Legacy of Pain: An Interview with Phyllis Alesia Perry," *The Mississippi Quarterly* 62, nos. 3/4 (2009): 636.

12. Qtd. in Duboin, "Confronting the Specters of the Past," 636.

13. Theo Sundermeier, "Soul, Self—Reincarnation: African Perspectives," in *Self, Soul, and Body in Religious Experience*, ed. Albert I. Baumgarten, Jan Assmann, and Guy G. Stroumsa (Leiden, The Netherlands: Brill, 1998), 21.

14. Phyllis Alesia Perry, "Email Interview with Phyllis Alesia Perry," by Stella Setka, June 21, 2012.

15. Perry, "Email."

16. John S. Mbiti, *African Religions and Philosophy* (New York: Praeger, 1969), 164.

17. Anthony Nwoye Okechukwu Ekwunife, *Meaning and Function of the "Ino Uwa" (Reincarnation) in Igbo Traditional Religious Culture* (Onitsha, Nigeria: Spiritan Publications, 1999), 20.

18. Ekwunife, *Meaning and Function of the "Ino Uwa,"* 20.

19. Lawal, "The Living Dead," 51.

20. "Such children are called Babátúndé (Father comes again) or Yétúndé (Mother comes back) if they are of the same sex as a recently deceased relation. In these instances, the soul of the dead is believed to have returned to the earth to start a new life in a new physical body" (Lawal, "The Living Dead," 51).

21. William Russell Bascom, *Sixteen Cowries: Yoruba Divination from Africa to the New World* (Bloomington: Indiana University Press, 1980), 33.

22. Wade W. Nobles, "Consciousness," *Encyclopedia of Black Studies*, ed. Molefi Kete Asante and Ama Mazama (Thousand Oaks: Sage, 2005), 199.

23. Perry, *Stigmata*, 139.

24. Perry, *Stigmata*, 165–166.

25. Perry, *Stigmata*, 116.

26. Perry, *Stigmata*, 117.

27. Perry, *Stigmata*, 117.

28. Sundermeier, "Soul, Self—Reincarnation," 22.

29. Lizzie's fragmented state calls to mind the sociological concept of liminality, which is an intermediary stage in a rite of passage consisting of separation, liminality, and reintegration. Also described as "crises rituals," rites of passage mark the transition from "one phase of life or . . . status to another," and concern "not only the individuals on whom they are centered, but also mark changes in the relationships of all people connected with them" (T. O. Ranger and Isaria Kimbambo, *The Historical Study of African Religion* [Berkeley: University of California Press, 1972], 179). Of crucial importance in this transitional process is the liminal state, the period between the phases of separation and reintegration, during which the individual is "structurally, if not physically, invisible" (Ranger and Kimbambo, *The Historical Study of African Religion*, 179). Moreover, the liminal period can function as "a realm of pure possibility whence novel configurations of ideas and relations may arise" (Ranger and Kimbambo, *The Historical Study of African Religion*, 180).

30. Perry, *Stigmata*, 14.

31. Perry, *Stigmata*, 14.

32. Perry, *Stigmata*, 52; emphasis in original.

33. Perry, *Stigmata*, 57.

34. Phyllis Alesia Perry, *A Sunday in June* (New York: Hyperion), 62–63.

35. Perry, *Stigmata*, 5.

36. Perry, *Stigmata*, 6.

37. Perry, *Stigmata*, 7.

38. Channette Romero, *Activism and the American Novel: Religion and Resistance in Fiction by Women of Color* (Charlottesville: University of Virginia Press, 2012), 59.

STELLA SETKA

39. Vine Deloria, Jr., *God Is Red: A Native View of Religion* (1973; New York: Putnam, 2003), 63.
40. Romero, *Activism and the American Novel*, 59.
41. Nancy K. Miller and Jason Tougaw, "Introduction: Extremities," in *Extremities: Trauma, Testimony, and Community*, ed. Nancy K. Miller and Jason Tougaw (Chicago: University of Illinois Press, 2002), 7.
42. Perry, *Stigmata*, 49.
43. Perry, *A Sunday in June*, 23.
44. Perry, *A Sunday in June*, 260.
45. Perry, *Stigmata*, 164.
46. Perry, *Stigmata*, 140.
47. Perry, *Stigmata*, 139.
48. Perry, *Stigmata*, 88.
49. Perry, *Stigmata*, 128.
50. Perry, *Stigmata*, 130.
51. Perry, *Stigmata*, 131.
52. Perry, *Stigmata*, 131.
53. Perry, *Stigmata*, 132.
54. Passalacqua, "Witnessing to Heal the Self," 154.
55. Perry, *Stigmata*, 148.
56. Perry, *Stigmata*, 149.
57. Perry, *Stigmata*, 234; emphasis in original.
58. Perry, *Stigmata*, 234.
59. Stefanie Sievers, "Embodied Memories—Sharable Stories? The Legacies of Slavery as a Problem of Representation in Phyllis Alesia Perry's Stigmata," in *Monuments of the Black Atlantic: Slavery and Memory*, ed. Joanne M. Braxton and Maria I. Diedrich (Münster: LIT Verlag, 2004), 137.
60. Perry, *Stigmata*, 149.
61. Perry, *Stigmata*, 7; emphasis in original.
62. Perry, *A Sunday in June*, 30.
63. Perry, *A Sunday in June*, 30.
64. Sundermeier, "Soul, Self—Reincarnation," 21.
65. Perry, *Stigmata*, 69.
66. Perry, *Stigmata*, 93.
67. Woolfork, *Embodying American Slavery in Contemporary Culture*, 48.
68. Perry, *Stigmata*, 7; emphasis in original.
69. John S. Mbiti, *Introduction to African Religion*. 2nd ed. (New York: Waveland Press, 2015), 37.
70. Perry, *Stigmata*, 94.
71. Mbiti, *Introduction to African Religion*, 75.
72. Perry, *Stigmata*, 181.
73. Perry, *Stigmata*, 46–47.
74. Perry, *Stigmata*, 223.
75. Perry, *Stigmata*, 67.
76. Perry, *Stigmata*, 235.
77. Perry, *Stigmata*, 169.
78. Perry, *A Sunday in June*, 318.
79. Perry, *A Sunday in June*, 319.
80. Perry, *Stigmata*, 126.
81. Perry, *Stigmata*, 127.
82. Perry, *Stigmata*, 181.
83. Perry, *Stigmata*, 138.
84. Perry, *Stigmata*, 139.
85. Perry, *Stigmata*, 182.
86. Qtd. in Duboin, "Confronting the Specters of the Past," 643.

PART II

RAISING THE DEAD

Black Sonic Imaginaries

FOUR

THE SONIC AFTERLIVES OF HESTER'S SCREAM

The Reverberating Aesthetic of Black Women's Pain in the Black Nationalist Imagination from Slavery to Black Lives Matter

MEINA YATES-RICHARD

In "An Afterword" to *Black Fire* (1968), Larry Neal enjoins America to "Listen to James Brown scream," a sonic utterance that he marks as a "surging new sound" that holds the potential to liberate the Black community. Neal's statement suggests a crucial relationship between sound, communal experience, and liberation ideology in African diasporic culture.[1] Neal marks Brown's scream as representative of Black experience in a manner that subsumes the sounds of the "Supremes," thereby enacting a gendered muting that I argue is pervasive within the imaginative construction of Black liberation ideologies.[2] From the time of slavery, Black women's sounds and cries have been both utilized by and suppressed within diasporic imaginings of freedom in order to forward Black males as representative of communal struggle, and to instate these men as the models for, and heirs to, freedom. Within several Black nationalist frameworks, the gendered sublimation of feminine sounds of protest and pain manifests in masculinist attempts to abrogate Black women's maternal and sonic labors. In this way, Black male figures are established as testis to communal experiences. Frederick Douglass's amplification and suppression of Aunt Hester's scream within his 1845 *Narrative* enacts a profound sounding and silencing that haunts the African diaspora even today.[3] The *Narrative* stands as an ur-text that continues to influence how liberation is conceived in the diaspora, as it shaped the imaginative contours of US Black masculinity and freedom. As such, Douglass's treatment of Black women, most prominently Hester, proves endemic within masculinist Black nationalist concepts of freedom.[4] This essay (re)turns to the Black maternal body's sounds as sites of traumatic testimony and the mediation of identities in Black nationalist ideologies in order to track the persistence of this peculiar sonic-social silencing from Douglass's *Narrative* through the #BlackLivesMatter movement. Investigating the core of Black nationalism, we find that the New World Black mother's soundings are necessary to formulate Black nationalist ideologies, though her cries are muted in the masculinist imagination.

Forwarding the ideal of an autonomous male witness within Black male–authored nationalist texts, maternal acts become abrogated through *thefts of the umbilical* performed by Black men who enact their own metaphorical rebirthings through proxy wombs and the sounds of Black women's pain. These men lay claim to subjective autonomy and the authority to represent the Black community, thereby minimizing the presence and labors of Black women. The lionized status of Black masculinity in nationalist contexts obscures how Black women's maternal sounds

engender community, testimony, and subjectivity. This disavowal of the maternal at the core of Black testimony, subjectivity, and liberation ideology reaches a critical juncture during the late 1960s, when Black male authority was discursively amplified in radical Black movements in America. The "Black Nationalist" rhetoric of this historical moment publicly silences Black women, while requiring their psychic, physical, and maternal labors offsite. This gendered suppression, however, is not unique to the Black Power moment. Instead, this moment reveals long-standing practices of maternal denial and abandonment that place Black women within the discursive margins of various Black nationalist and liberation ideologies—practices that extend well into contemporary activist frameworks.

Narrative of the Life of Frederick Douglass, An American Slave (1845), *Invisible Man* (1952), and *Song of Solomon* (1977) all mark maternal song and sound as fundamental to Black nationalist ideologies.[5] In each of these texts, Black women's songs engender communal connection, and their cries of pain inform community members of danger. However, masculinist Black nationalisms push maternal bearers of song and sound to the peripheries, effecting a "split between sound and source."[6] While Frederick Douglass is not commonly understood as a Black nationalist sympathizer in the context of his 1845 *Narrative*, here I position him as a Black nationalist figure because his *Narrative* models exceptionalist, representative, Black masculinism, and maternal disavowal that prove endemic to future Black nationalist ideologies. Extending the analysis of Douglass's silencing of Black women, I examine *Invisible Man*'s approximations of the womb and appropriations of Black women's sounds as constitutive aspects of the text's Black nationalism. *Song of Solomon* offers a sustained critical engagement with the historical continuity of maternal sacrifice within Black nationalist discourses that allows us to see how the #BlackLivesMatter Movement, as a mode of public political engagement in the Black nationalist tradition, inadvertently reproduces these sacrificial tendencies.

Douglass laments the "destructive loss of the natural mother" by enslaved children, intimating that slavery negates kinship bonds.[7] He reinforces this claim by revealing that his biological mother has been replaced by other maternal figures. Aunt Hester emerges as the most important maternal figure in the *Narrative*. Hester's cries inaugurate Douglass into knowledge of his own enslavement. However, he refuses to linger in the resonant impact of Hester's scream. Rather, Douglass (re)presents his attainment of subjectivity as the result of his physical confrontation with Covey, which reflects his attempt to formulate a narrative of slavery's traumas that centers only his experiences. Douglass insists that the estranging effects of slavery render him completely without family, yet the *Narrative* belies this fact. He resides with his grandmother as a child, is cared for by Hester, and lives with an Aunt and Sister (all of whom are silent save Hester's cries). Hester's scream testifies to her personal injuries while also sounding a warning to young Douglass that inaugurates him into knowledge of his condition. Hester's scream, then, must be textually managed by creating measures of psychic and physical distance. Because he conceives of freedom as male autonomy, Douglass "forsakes 'familial or communal postures,'" by narratively distancing himself from and silencing Black women.[8] Hester and other maternal figures must be left behind in order for Douglass to attain freedom.

Hester's voice is the *only* Black woman's voice represented in the text and is manifested in a nonlinguistic cry as opposed to dialogue. Douglass's mother and grandmother remain silent, haunting presences, and other slave women suffer in silence. Douglass acts as witness by reporting the atrocities these women endure, but in a manner that further abjects Black women by

THE SONIC AFTERLIVES OF HESTER'S SCREAM

presenting them as mute objects.[9] Once Hester's scream performs its task in the text, Black women's sounds are silenced in a manner that suggests that they are unnecessary to crafting Douglass's testimony. Hester's cries "awaken" Douglass to the horrors of enslavement, and (re)birth him into the knowledge of his own bondage.[10] Her "heart-rending shrieks" stand in the text as dissipating echoes of Douglass's formative experience as opposed to an opportunity for the reader to truly bear witness to Hester's scream.[11] Once Douglass comes into knowledge of his own enslavement, the cries are no longer reported.

Douglass analogizes Hester's scream to the cry of a laboring mother. He writes of her cry as "the blood stained gate, the entrance to the hell of slavery, through which [he must] pass" into knowledge of his bondage.[12] His choice to represent Hester's scream as a gate also mandates her abandonment. Presumably in order to claim an active manhood, Douglass must leave her behind. His mother's death and grandmother's banishment to the fringes of the plantation and *the text* propose the necessity of male unfettering from female influence as prerequisite to the attainment of freedom. Hester's muffled scream proves endemic to the masculinist constructs of freedom on which the Black nationalist tradition comes to rest. It enables Douglass's testimony by sounding a warning even while attesting to the brutalities that Hester personally endures. Importantly, in slave narratives, Black women's cries of pain metonymically represent communal suffering, rendering the maternal body and its cries as the locus of Black communal testimony.[13] The continuity of this trope is evident throughout the body of African American literature, but less attention is given to the wresting of representative power from Black women in order to center Black men as archetypes of Black personhood, and thereby models for the attainment of freedom.[14] Following his rebirth through Hester's scream, Douglass silences Black women in the text to enact a narrative containment that forwards idealized Black masculinity as the basis for freedom. However, the resonance of Hester's cries produces a *reverberating aesthetic of Black women's pain*, a literary resonance that both shapes and exceeds the parameters of the text proper.

The *Narrative* does not explicitly name maternal sound as fundamental to Douglass's testimonial practice, yet Hester's cries provide an imaginative acoustic record for future replay and recall, shaping his testimony to enslavement, as well as his ideal of freedom. Douglass writes: "It was the first of a long series of such outrages, of which I was doomed to be a *witness* and a participant."[15] The traumatic scene of Hester's beating/rape so deeply affects Douglass that he echoes the experience two paragraphs later, more clearly stating his own sense of endangerment. In the midst of this narrative echo, Douglass enacts his (re)birth into bondage. He writes, "I hid myself in a closet, and dared not venture out till long after the bloody transaction was over."[16] Douglass's doubled recall of Hester's scream amplifies her cry as a primary motif of the text, but in a manner that *also* signals Douglass's personal vulnerability. The echoed scream reveals Douglass's fear of the possibility of sharing Hester's fate. Hester's cries, then, must be silenced in order to mitigate Douglass's own sense of vulnerability. In the closet, Douglass (re)mediates his relationship to the Black maternal body. The closet, as a built environment, displaces the *natural* womb, and is marked as a site of safety insofar as it places a barrier both between Douglass and the lash, and between Douglass and Hester's body. This recourse to the built environment signals Douglass's first step toward physical and psychic detachment from his maternal forebears, a paradigm that marks the construction of the *Narrative* as a document. Douglass (re)constructs womb space in a manner that comes to mark itself as a signal trope that echoes in tandem with sounds of Black women's pain in Black male authors' nationalist imaginings, evidenced most masterfully in Ralph Ellison's *Invisible Man*.

89

Invisible Man's series of appropriative and constructive acts surrounding the anatomy of the womb belie anxieties about the possibility of autonomous Black male subjectivity, as well as the possibilities for Black communal liberation. The unnamed protagonist's multiple attempts to claim an identity within a racist society present themselves as a series of "becomings." Notably, the protagonist's multiple attempts at becoming are framed, like Douglass's awakening, through textual metaphors of rebirth, shoring up maternal sounds and presences even as the text attempts to suppress their import and impact. The connection between the Black maternal body, the sounds it produces, and Black male freedom comprises an important aspect of Invisible Man's conceptual framing, provoking a reading of the text that takes this into account. Black women acoustically frame the discourse of the text.

Ellison's protagonist struggles to formulate a usable Black nationalism that affirms his rightful place within America. Oscillating between uncovering and recovering Black maternal figures, Invisible Man produces *subterranean maternity* that echoes Douglass's Narrative, revealing both an investment in and an anxiety regarding maternal soundings. Ellison presents Black female figures as peripheral while using their sounds to negotiate the protagonist's identity, which enables the erasure of Black women. Black women in Invisible Man produce sounds and songs that (re)birth the protagonist into different spheres of consciousness, and symbolically perform maternal labors for him and the community at large. From the "old singer" and the "beautiful girl" with the "mother's" voice in the Prologue, to the "thin brown girl" at the college, to Mary Rambo's "contralto" voice, to his grandmother's song, to the blues singer in the riot scene, Invisible Man's pages resonate with the songs and cries of Black women. The prologue marks maternal sound as the protagonist's means of grappling with questions of freedom. Hearing Louis Armstrong's "What Did I Do to Be So Black and Blue" engenders his descent into the "lower levels" of his consciousness and American history.[17] During his descent, the protagonist encounters a "singer of the spirituals" who has given birth to her master's sons, as well as *a beautiful girl . . . pleading in a voice like [his] mother's.*[18] The record's breaks disseminate the maternal voice in order to transmit Black communal histories, and establish the role of Black women's sounds as fundamental to Black men's imaginings of freedom.

Maternal voices echo throughout the prologue in a manner that signals the sexual abuses visited upon Black women during slavery. The "old singer" has birthed her master's children, while the "*beautiful girl . . . [stands] before a group of slaveowners who bid for her naked body.*"[19] These sexually imperiled Black women's "pleading[s]" and "moans" (re)sound Hester's screams, and enable the protagonist to "discover unrecognized compulsions of . . . being."[20] The sounds of Black women inaugurate him into a new realm of knowledge, even though he remains "incapable" of acting in response to the demands their cries imbed within the "familiar music."[21] This incapacity to act echoes in the protagonist's disclaiming of responsibility: "To whom can I be responsible, and why should I be, when you refuse to see me . . . Responsibility rests upon recognition."[22] He addresses his demands for social "recognition" necessary to prompt his sense of "responsibility" to an amorphous "you" that reproduces the slave narrative's mode of address in tandem with its paradigmatic use of Black maternal sounds. Ellison's deployment of slave narrative generic commonplaces ally the protagonist's experiences with those of the enslaved Black male seeking freedom, and unwittingly reveals the manner in which Black men's desires for social recognition allow them to mitigate responsibilities to or for Black women.

THE SONIC AFTERLIVES OF HESTER'S SCREAM

In order to contemplate freedom or subjectivity, the text insists that one grapple with the materiality of *Black maternal sonority*. Maternal sounds and songs (re)birth the protagonist into different spheres of consciousness. His experiences at the hospital after becoming injured at work in a paint factory provide the most salient example of this narrative construct. "Cramped" into fetal position within a machine approximating the womb, he relies on acoustic information to make sense of his surroundings: "I listened intensely, aware of the form and movement of sentences and grasping the now subtle rhythmical differences between progressions of sound that questioned and those that made a statement. But still their meanings were lost in the vast whiteness in which I myself was lost."[23] He wonders, "Where did my body end. . . . ? No sounds beyond the sluggish inner roar of blood. I couldn't open my eyes. I seemed to exist in some other dimension."[24]

His state of helplessness while suspended within the box, and his inability to decipher or communicate in language, index the fetal stage of development nearing birth. The doctor's written queries call to the fore issues of familial legitimacy and legacy, national belonging, and racial identity. Because "the condition of the . . . mother 'is forever entailed on all her remotest posterity,'"[25] the simple questions "WHO ARE YOU," and "WHAT IS YOUR MOTHER'S NAME" alternately provoke terror, excitement, and resistance.[26] The protagonist muses that perhaps he is "just this blackness and bewilderment and pain."[27] The machine in which he finds himself trapped provides acoustic accompaniment to the doctor's questions. When asked about his mother, the protagonist associates Black motherhood with the sound of a scream: "*Mother*, who *was* my mother? Mother, the one who screams when you suffer—but who? This was stupid, you always knew your mother's name. Who was it that screamed? Mother? But the scream came from the machine. A machine my mother? . . . Clearly, I was out of my head."[28]

Like Douglass, the narrator represents Black maternity through a scream. The scream functions as an acoustic marker that (re)sounds chattel slavery's annulment of kinship ties. The resonant scream locates lost maternity in Black women's sounds of pain. This moment recalls both Douglass's Aunt Hester, identified through her "heart-rending shrieks," as well as the "singer" and "beautiful girl" from the novel's prologue.[29] Ellison's protagonist realizes that the mother's scream "came from the machine," which leads him to question "A machine my mother?"[30]

Though the protagonist quickly dismisses this possibility, stating, "Clearly, I was out of my head," his query is worth considering. Machine-as-mother is predicated upon the "thingification" of Black life instantiated by the systematic denial of personhood under the regime of chattel slavery.[31] Slavery institutionally reduced the Black body to its instrumental capacities, codified Black maternity as the manufacture of laboring bodies, and constructed Black maternal milk and care as extractable commodities.[32] The mother-machine dynamic is forcefully underscored by the protagonist's experience of being reborn from within the bowels of the factory hospital: "I . . . looked down to see one of the physicians pull the chord which was attached to the stomach node. . . . I recoiled inwardly as though the cord were a part of me."[33] The removal of the stomach node signifies the manner in which slavery disabled Black maternity, and thereby Black knowledge of self. The protagonist's abortive rebirth occurs within the matrix of Black maternal sound and a constructed womb, obliquely echoing Douglass's experience of rebirth from the closet awash in the sounds of Hester's cries. This scene also marks a theft of the umbilical in the protagonist's conflation of maternal presence and sound with bondage, and in his desire to disconnect from the formative soundings of his maternal forebears in his pursuit of freedom.

MEINA YATES-RICHARD

Preceding this experience, his grandmother's song *awakens* him. Her song marks the first time he "saw the hounds chasing black men in stripes and chains," wedding her memory both to song and to Black male bondage.[34] The song awakens the protagonist and memorializes the bound men prior to the protagonist ordaining the mother as she "who screams when you suffer," exposing these distinct maternal soundings as transitory spaces for gestating Black male identities.[35] Here, maternal screams, as in the slave narrative, represent collective suffering. However, in order to mitigate Black women's representative power, the protagonist must cross their screams' thresholds and leave them behind. (Re)constructed womb-spaces in the laboratory hospital and his underground dwelling displace maternal bodies to reduce Black women to resounding screams that engender Black male *self-making*. "The music became a distinct wail of female pain" immediately prior to the protagonist's encounter with the inquisitive doctor, echoing Douglass's encounter with Hester's scream.[36] Similarly, the "glass and metal float[ing] above the protagonist" recall Douglass's *closeting* in a proxy womb.[37]

In this scene, Black maternity is abstracted in a manner that physically absents the Black woman while echoing her voice. The cold, white machine in which he has been forcibly placed dislocates the protagonist's maternal figures, relegating the process of rebirth to authoritative white male figures. While Ellison's protagonist is (re)connected to communal history through the memory of his grandmother's song and a maternal scream, his rebirth is predicated on Black women's material absence. The sound/source split engenders his next becoming. While the constructed womb signifies how whiteness estranges the Black male from his mother-figures, Black maternal screams and songs usher the protagonist into different, if still stunted, phases of self-consciousness.

The protagonist emerges from the subway on Lenox avenue, assessing his surroundings "with . . . infant's eyes," unable to stand on his own.[38] He faints, only to be awakened by "the big dark woman['s] . . . husky-voiced contralto" inquiring about his well-being.[39] Mary Rambo insists that she will "*take care of* [*him*]," a statement that, in tandem with her contralto voice, marks her as one of the text's substitute maternal figures.[40] Mary acts as "a stable, familiar force like something out of [the] past which kept [him] from whirling off into some unknown."[41] He finds "living with her pleasant except for her constant talk about . . . responsibility" to the Black community.[42] Mary's voice and home provide protective structures that allow him to further develop his sense of personhood. While inhabiting the womb-like safety of Mary's home, he makes a speech that engenders a significant shift. Having been observed during the speech by Jack, a leader of the "Brotherhood," the protagonist receives a job offer that will change the course of his life. "The odor of Mary's cabbage" makes him consider that he doesn't "even know how much . . . [he] owe[s] her."[43] As Mary sings "a troubled song" in her "clear and untroubled" voice, he comes to a "calm sense of [his] indebtedness" that propels him to act on Jack's offer.[44]

When Jack mandates that he move from Mary's house as a condition of his employment, the protagonist wonders, "why should it be . . . that the very job which might make it possible for me to do some of the things which [Mary] expected of me required that I leave her?"[45] He notes the necessity of his estrangement from this maternal figure, as well as the Harlem community, as prerequisite for his (externally) appointed role as community leader. After attempting to repay Mary's kindnesses with a "hundred dollar bill," he takes his leave without warning that he won't return.[46] Ellison writes, "Mary was singing something sad and serene . . . as I opened the door. . . . then took the faintly perfumed paper from my wallet. . . . and took a long, hard look at my new

92

THE SONIC AFTERLIVES OF HESTER'S SCREAM

Brotherhood name."[47] Mary's "sad and serene" song, like the "old singer's . . . moan," the screaming mother/machine, and the "grandmother's song," ushers the protagonist into a different sphere, and actualizes the reverberating aesthetic of Black women's pain that structures the text. He believes that both his subjective autonomy and authority to represent the community *require* his detachment, which reflects his investment in a masculinist *freedom-from* Black women.

The "compulsions" that propel the protagonist into liberation activism inhere in Black women's sounds, but these women's cries and songs come to be sublimated in the interests of a more masculinist framework for attaining freedom. We see evidence of this dynamic and its echoing relationship to #BlackLivesMatter in that the novel's most organized public protest responds to Todd Clifton's murder, and that, likewise, the Harlem riot ensues from the murder of a young male soldier. Hence, the most visible and vocal protests center on Black men as those most harmed by racial violence, and on males as the imagined subjects of Black freedom. This masculinist construction of Black liberation requires distance from Black women.[48] While Ellison's triangulation of white men, Black men, and white women in *Invisible Man* attempts to shift focus to Black men's bodies as sites of traumatic injury in America; it also works to vacate Black women from the contemplation of American freedom and democracy, even as the text itself repeatedly calls up their bodies and their cries to mediate Black male and American identities. It is precisely this slippage that renders the Black maternal body and its sounds as ciphers through which Black male freedom is actualized.

Ellison marks the protagonist as Douglass's heir during his tenure at the Brotherhood. He receives a portrait of the "great man" from Brother Tarp, who urges him to "look at him" as the model for Black male leadership.[49] The protagonist ponders Douglass's rise to national acclaim as a man who "talked his way from slavery to a government ministry."[50] He thinks, "something of the kind is happening to me," underscoring his identification with Douglass while also claiming "escape" as requisite to his ability to "bec[o]me . . . [and] define . . . himself."[51] The young orator never questions whom Douglass left behind.

Even while *Invisible Man* attempts to critique America's systemic abuses of Black women rooted in the nation's history of chattel slavery, the novel itself utilizes Black women's maternal labors, songs, and sounds of pain to engender the protagonist's shifts into various spheres of consciousness. The text both reflects a continuation of this problematic gendered paradigm inherited from Douglass and presages the reduction of Black women to procreative and caregiving roles in 1960s nationalisms. The Harlem riot scene critiques America's rampant abuses of Black women yet refuses an opportunity to identify maternal power and authority as central to the politics of Black nationalism.

Black women's collective focus on survival leads them to steal food during the chaos of the riot. When Dupre prepares to burn the tenement in which he lives, a pregnant woman, her "belly heavy and high," begs him not to follow through with his plan.[52] Thinking only of the loss of his own child, he states, "I bet a man ain't no more go'n be *born* in there."[53] Dupre's willingness to sacrifice both the pregnant mother and her unborn child offers a critical assessment of Black male leaders. However critical of the more militant forms of Black nationalism's misuse of Black women this moment appears, Ellison's portrayal of the text's most visible Black woman undercuts his critique. "Excessive to Ellison's reconstitution of a poetics of suffering necessary to refigure the Black body as the embodiment of an American national identity," the blues singer on the milk wagon brings the novel's underground Black maternal figures emphatically to the

93

fore.[54] If the Prologue marks the "old singer" as she who *birthed the nation*, then the blues singer exposes radical liberatory possibilities for the Black community, and its own failure to recognize Black women as the source of these possibilities—a missed opportunity. Ellison writes:

> And I saw a crowd of men running up pulling a Borden's milk wagon, on top of which . . . a huge woman wearing a gingham pinafore sat drinking beer from a barrel which sat before her. . . . she . . . threw back her head and shouted passionately in a full-throated voice of blues singer's timbre. . . . Free Beer!!—sloshing the dipper of beer around.
>
> We stepped aside, amazed, as she bowed graciously from side to side like a tipsy fat lady in a circus parade, the dipper like a gravy spoon in her enormous hand. Then she laughed and drank deeply while reaching over nonchalantly with her free hand to send quart after quart of milk crashing into the street. And all the time the men running with the wagon over the debris. Around me there were shouts of laughter and disapproval.[55]

The blues singer's wasteful acts discursively marginalize her. Shuttling this figure to the margins exposes *Invisible Man*'s obsessive processes of revealing Black maternal figures only to leave them behind. While Ellison may attempt to "reposition the role of the black female within . . . the national imaginary," presenting a strategically costumed grotesque who recalls the aesthetics of the plantation mitigates her song's importance.[56] The blueswoman echoes Mary Rambo's gifts of home and sustenance to the struggling protagonist by offering "Free Beer" in tandem with her song. Tossing milk from the Borden's wagon, the blueswoman literally feeds the streets, reflecting the manner in which slavery rerouted Black maternal milk from the community, and used this milk to nourish America's exploitative capitalist structure. Significantly, "kerosene" carried by Dupre's men "splashed into the spilt milk," suggesting that communal acts of gendered marginalization and silencing taint this milk as well.[57]

Ellison offers a trenchant critique of some of the most pernicious aspects of Black nationalism through making visible the manner in which women and children become sacrificed to men's desires to wipe out the past. Sadly, the protagonist reproduces some of the most troubling aspects of Black nationalist ideology in exercising his desire to "speak for" the Black community.[58] Like Douglass, Ellison amplifies, then sublimates, Black maternal presence and sounds in a manner that undercuts his critique. Tellingly, the blues singer's appearance reveals the radical possibilities attending the powerful "mammy" stereotype of Black female fecundity and plenitude, only to suppress them. The comic staging of the blues singer problematically echoes America's gross misrepresentations of Black maternal care. While all of the novel's women perform maternal acts, the blues singer provokes shame. However, all of the novel's maternal figures, whether virtuous or grotesque, suffer the same fate—abandonment.

Ellison ultimately exposes that neither the Black community's, nor the nation's, ethical obligations to Black mothers will be met. Even as the text marks Black maternal sound as the locus of Black/national identity, it muffles its own claims. The protagonist's inability to recall his mother's name, his abandonment of Mary Rambo, Dupre's burning of the tenement against Lottie's protest, and the disapproval directed at the blues singer make apparent the gendered inequities in Black communal duty. Ellison's text reaches an aporia in its inability to articulate responsibilities to, or for, Black women. Instead, the text consistently uses, and then marginalizes, Black maternal figures and their sounds to engender the protagonist's endless becomings, echoing a

THE SONIC AFTERLIVES OF HESTER'S SCREAM

fundamental problem within Black nationalist thought. The imperative to center Black men as the sole active agents of Black liberatory politics requires the simultaneous use and denial of the maternal aspects of Black womanhood. The Black male nationalist subject utilizes gifts of sustenance, sound, and song, only to move swiftly beyond maternal influence. He walks, alone, into the future. *Invisible Man* begs this question without fully addressing it: What is the Black woman's place in the "future" of America or Black nationalism? *Song of Solomon* solemnly answers: she will be sacrificed.

Song of Solomon serves as a feminist engagement with the historical trajectory of masculinist Black nationalist ideologies that exposes the manner in which *freedom* came to be constructed as male autonomy through the abandonment of Black women. Importantly, women's maternal labors, songs, and sounds of pain comprise the discursive matrix of Black male "becoming." Morrison uncovers a genealogy of Black female sacrifice by representing the historical continuity of the interlocking relationship between Black women, their songs and sounds, and Black nationalist ideologies through the character Pilate. Pilate, as song-bearer, embodies the link between past and present that enables Milkman's "ironic quest" to understand his family's history.[59] However, she has no access to her song's meaning and, along with other women, becomes sacrificed to male imperatives.

Pilate's consistent singing marks her as a reservoir for cultural heritage. The song as metonym for Black culture posits an understanding of memory that runs counter to, yet enables the fleshing out of the *historical record*. Morrison constructs Pilate's song as an echoing aural palimpsest that acts as "the key.... that transforms [Milkman's] search for gold into an acknowledgement of his heritage."[60] Pilate's "powerful contralto" voice signifies home and safety for her male kin, echoing Mary Rambo's voice both in form and in purpose, while also serving as a bridge that connects past and future generations.[61] Her song presents an enigma to Milkman and signifies nothing to his friend Guitar. These two men represent the competing ideologies of 1960s cultural and revolutionary nationalisms. Pilate "symbolically . . . exists as a merger between Milkman's cultural nationalist characteristics and Guitar's revolutionary militancy."[62] However, the symbolic merger between these competing nationalisms proves untenable because her sacrifice proves constitutive to their ideological foundations.

Pilate's offering of song provides insufficient cultural nourishment for her family or the community at large because it is incomplete. While the lyrics "cotton balls to choke me . . . Buckra's arms to yoke me" evoke Black suffering and connect the community to its past, Pilate does not have the full text of the song.[63] She can neither identify her grandfather Solomon, whom the song memorializes, nor grasp the fact that she sings her grandmother Ryna's blues. Tellingly, the incompleteness of Pilate's song results from the command handed down by her father Macon Sr. in her dreams: "Sing."[64] Interpreted as a directive to lift her voice, the perceived command actually represents her father's yearning for her long-dead mother. He is the center of his haunting discourse. Papa's hauntings expose narcissistic aspects of masculinist Black nationalisms.

After his wife Sing dies in labor, Macon forbids speaking her name. Macon Sr. disallows the mother's name in a futile attempt to reverse slavery's denial of Black paternal authority. This ban exposes the long history of maternal disavowal in masculinist Black nationalisms that seek to concretize the "rights of patriarchal privilege."[65] Macon's attempt to build a patrilineal inheritance refutes inheritance of the "condition of the mother" by silencing and erasing maternal presence, while seeking to affirm Black male civic acceptability.[66] Morrison exposes how the

95

MEINA YATES-RICHARD

assimilationist politics of mastery of (white male citizenship as) form constructs acts of Black male exemplarity as representative of and thereby fundamentally tethered to the fate of the Black community. This is evidenced by Macon Sr.'s mythic status in Danbury, an echo of Douglass's lionized status as exemplary Black male within the historical trajectory of Black nationalist thought. Macon Sr., however, is "shot. . . . Five feet into the air," and his children nevertheless inherit the "condition" of his mother Ryna—they are *left behind*.[67]

Bereft of her mother's name, Pilate "Sing['s]" a song for which she has no text. Her missing navel signifies how suppressing the "heritage of the mother" undergirds Black (masculinist) nationalist ideology.[68] Macon reminisces that "the absence of [Pilate's] navel . . . convinced people that she . . . had never . . . been connected to a reliable source of human nourishment."[69] Instead, "once the . . . lifeline was cut, the cord stump . . . left no trace of having ever existed"—a physical indicator of disallowing Sing's name, and thereby abstracting her to a womb.[70] Unaware that her mother is song itself, Pilate nevertheless positions Sing (song) as the necessary interstice between past and future. Maternal song echoes throughout the text, reaching both forward and backward in time and space. Milkman's desire to record the song countermands the diffuse linkages to his history embodied in Pilate and her singing daughters. In turn, these women are sacrificed to Milkman's desire for *self*-knowledge, ironically mediated through Pilate's song and Hagar's body.

The distinctly gendered division of labor *Song of Solomon* presents—Pilate as song-bearer and Milkman as interpreter—suggests that the synthesis of these forms of labor may engender communal healing. However, the text of the song reveals rather than sutures a source of communal fracture by exposing Solomon's annulment of familial responsibility in the face of his desire to fly "home." Ryna's perpetual "crying in a ditch" resonates throughout the song and the land as evidence of Solomon's abandonment.[71] In a stunning echo of Hester's scream as an acoustic monument to Douglass's attainment of freedom, Ryna's wail becomes a vessel for Solomon's memorialization as opposed to testament to her own pain. The sounds of the sacrificed mother render the Black man free to "fly off."[72] Milkman negotiates his subjectivity through the song, rendering Pilate the vessel of his becoming. Despite acknowledgement of whom Solomon "[left] behind" and the irremediable pain it caused, Pilate's sacrifice remains necessary for Milkman to take flight.[73] Milkman takes Pilate to Virginia to bury her father's bones, where she inters her father atop Solomon's Leap, placing her mother's snuffbox containing her own name in the grave, thereby reconnecting the fractured family. However, Guitar's distrust has led him to hunt Milkman, and he fires the single shot that takes Pilate's life.

In her final moments, Pilate asks Milkman to "Sing. . . . for [her]."[74] Tellingly, Milkman *speaks* "the words without the least bit of a tune," as he enters Pilate into the text of the song. He occludes her given name, calling her "Sugargirl" instead.[75] These actions seem to outwardly affirm Milkman's "love" for Pilate, as he muses that "she could fly . . . without ever leaving the ground."[76] However, the necessity of Pilate's *grounding* and Milkman's denial of her name undercuts his homage. Pilate's life ends at the very site of her maternal ancestor's abandonment. She is sacrificed like Ryna and Sing before her. Pilate's flying "without ever leaving the ground" constitutes her body as the ground from which Milkman can take flight. His leap from beside Pilate's lifeless body renders him "as bright and fleet as a lodestar."[77] Pilate's demise culminates Milkman's paternal inheritance in his ability to take flight. Through her death, Milkman is reborn. "Lodestar" signifies a directive or tenet that navigates a course of action. Morrison thereby reveals that

maternal sacrifice comprises the *ground*, the problematic historical guiding principle, of *all* Black nationalist ideologies.

Morrison's text exposes, through its engagement with maternal sounds and songs, the historical continuity of the abandonment of Black women as a constitutive feature of Black nationalist ideologies. The novel uncovers the lost and silenced mothers in Pilate's song to reveal the continuous (re)production of maternal sacrifice at the core of masculinist Black nationalisms, evidenced by the fact that Pilate is cut down at the site of her grandmother's abandonment. Her name—like those of her foremothers—is also stricken from the historical record. Morrison thereby critiques the masculinist construct of *freedom-from* Black mothers at the core of Black nationalist ideologies that mandates these women's sacrifice. Pilate's death and Milkman's impending embrace in "the killing arms of his brother" Guitar sound a grim warning that the masculinist desire for complete autonomy assures only destruction.[78] *Song of Solomon*'s disturbing ending both offers a jarring counterpoint, and forces a return, to its opening epigraph. Morrison writes, "*The fathers may soar / And the children may know their names.*" "*And*" suggests that *soaring* need not equate with *flying-off*—that Black men may exercise subjective autonomy "*And*" attain *freedom-with* the "*children*," who "*may know their*" fathers' and their own names, as well as the names of their mothers, whose songs and cries birth these possibilities into existence.

Morrison's trenchant critique of the persistent use and disavowal of Black maternal sonority in Black liberation praxis provides a crucial entry point for the interrogation of contemporary activist movements. In particular, the #BlackLivesMatter movement offers a current example of liberation activism in the African diaspora that illuminates the problematic continuance of the muting and marginalization of Black women succeeding these women's sonic agitations that foment liberatory action. In this way #BlackLivesMatter actualizes the sonic afterlife of Hester's scream, both by revealing how Black women's sounds—particularly cries of maternal pain—are leveraged in the creation of Black liberation activist movements, and how the implicit masculinist biases of Black nationalist frameworks suppress these feminine soundings in the interests of centering Black men.

"NOT YOUR MAMA'S CIVIL RIGHTS MOVEMENT": MATERNAL SUPPRESSION AS A BLACK NATIONALIST IMPERATIVE

In 2013 three Black queer women—Alicia Garza, Patrice Cullors, and Opal Tometi—coined the hashtag that (re)birthed Black liberation activism into the twenty-first century.[79] Coalescing first around the acquittal of George Zimmerman for the murder of unarmed Florida teenager Trayvon Martin, the #BlackLivesMatter movement was designed to protest the continued disposability of Black life in the Americas, as well as to transcend "the narrow nationalism that can be prevalent within some Black communities, which . . . keep [sic] straight cis Black men in the front of the movement while our sisters, queer and trans and disabled folk take up roles in the background or not at all. . . . It centers those that have been marginalized within Black liberation movements."[80] While centering those typically silenced in traditional Black nationalist liberation movements and centering Black feminist politics were among the founding goals of #BlackLivesMatter, its leaders were initially forced back to the very margins of the liberation discourse they sought to expand in a saddening echo of Douglass's suppression of Hester's cry,

97

and the silencing of Black women in 1960s activist circles. By 2016, Shaun King and Deray McKesson, two Black-identified men, had emerged as the movement's most recognizable representatives.[81] It begged the question, then, as to *whose* #BlackLivesMatter(ed) when Black men like Trayvon Martin, Mike Brown, Eric Garner, and Freddie Gray become canonized as the movement's martyrs, serving as the primary (arguably sole) focus of popular public protest actions. Women like Rekia Boyd, Mia Hall, Alexia Christian, Shelly Frey, and young Ayana Stanley-Jones—all victims of state-sanctioned or extrajudicial violence comparable to the aforementioned men—slipped quickly from public consciousness. Opal Tometi states, "Being Black . . . women . . . within these movements tends to equal invisibility."[82] Tometi's comment, while directly engaging with the erasure of Black women's labors in social justice activism, sadly proves equally applicable to women as the targets of racialized violence.

Kaavya Asoka reminds us that Black women "are targeted in the same ways as men—shootings, police stops, racial profiling. They also experience police violence in distinctly gendered ways. . . . Yet such cases have failed to mold our analysis of . . . police violence, nor have they drawn equal public attention or outrage."[83] Marcia Chatelain ruminates that "historically, movements for racial justice have often framed the question of equality as one that can be answered by black men."[84] Additionally, as Keeanga-Yamahtta Taylor cogently observes, while "Black women have always been susceptible to violence from the police and criminal justice system, where organizing and struggle have emerged, they have, for the most part, had a male face."[85] I want to further suggest that #BlackLivesMatter's marginalization of its founding women; the movement's use of Sabrina Fulton's, Lesley McSpadden's, and Esaw Garner's cries of mourning as means to illuminate back male suffering; and the lackluster public responses to acts of brutality against Black women mark the continuance of gendered inequities within Black nationalist liberation ideologies, echoing Douglass's problematic suppression of Hester's scream. While Black women's voices are used to disseminate communal knowledge, and their cries of pain frequently serve as the impetus for liberation activism, Black women are regarded as neither the authors, nor the subjects of liberation activism in the Black nationalist tradition. As Taylor notes, protests form around "mothers and other women in the lives of the (typically male) victims" of police violence, "but the activism has been seen as male-led and organized."[86] The disavowal of Black maternal figures that plagues Douglass's *Narrative* echoes forward into contemporary claims that the current models for Black social justice activism, which eschew traditional politics of Black respectability associated with the Civil Rights Movement in favor of what its authors deem more radical action, "ain't your Mama's civil rights movement."[87] This playful, seemingly innocuous slogan actually probes deeply into the painful marginalization of Black maternal figures (and Black women more broadly) in diasporic liberation activism, as well as obliquely links the failures of the Civil Rights Movement to the presence of Black mothers and their ability to tether the community to the degraded past. This claim also reveals the longstanding preoccupation in Black activist circles with muting Black maternal figures—a paradigm rooted in Douglass's suppression of Hester's scream—that allows Black men to stand as those most injured by racism, and therefore the subjects most in need of institutional recognition and redress.[88] This preoccupation resounds the fundamental aporia within Black liberatory movements that at once requires Black women's screams and labors (maternal and otherwise) and discursively excludes women from the realm of active participation in these movements through ritual silencing. The Black woman, then, may cry, but she may neither lead nor testify. In this way, we are able to see the manner in which the

discursive distancing of Black males from Black women in the Black nationalist tradition works to mark liberation activism as always-already not the purview of Black women, although Black liberation has always been and will always rightfully be our "Mama's . . . movement."

Black liberation activist movements from abolitionism to the long Civil Rights Movement, to the Black Power Movement, to the #BlackLivesMatter movement, have all implicitly or explicitly addressed testimonies of Black trauma to the state in their appeals to the wider public consciousness. The state's continuous refusal to recognize the historical source of Black injury, as well as institutional racism's ability to reproduce and transform itself in the face of the purported death of Jim Crow and the dawn of post-racial America, enables a profound denial of the manner in which Black people continue to be systemically marginalized and injured. The continuance of state-sanctioned and state-supported violence against black people in the twenty-first century echoes and extends legacies of racialized violence in the form of lynching as part and parcel of US identity—one that is persistently denied and covered over with narratives of Black inferiority, Black pathology, and Black people's unwillingness to integrate themselves into the body politic as productive citizens. Historically, these narratives have been persistently met with Black people's counternarratives of Black humanity and exceptionality, Black people's thrift, virtue, and work ethic, beginning with legal petitions and the slave narrative tradition. However, these beautifully worded narrative testimonies as appeals for the recognition of Black humanity, along with demands for the recognition of Black people's foundational roles in the imagining and creation of Western democratic capitalism, have only been marginally heeded. These counternarratives are readily enfolded into the dominant narratives of oppression by marking the (typically) male testis as singular and exceptional, effectively divorcing this narrator from the concerns or the fate of the larger community. These pleas for equality, because they are tethered to Black male exemplarity, problematically excise a critical demographic from their imaginings of freedom—Black women.

From the time of slavery, Black liberation activism in the United States (most prominently through various forms of Black nationalism) has persistently hailed Black women, and benefited from their sonic, maternal, intellectual, and bodily labors, only to silence and sublimate these women in the interests of centering Black men as the representatives of Black liberation. This problematic cycle of suppressing Black women finds its literary roots in the slave narrative tradition, wherein Black maternal figures' cries come to mark the ineffable aspects of slave experience. This narrative collapse of the enslaved maternal figure and her sounds of pain, the state of bondage, and the ineffable, lead to her marginalization and silencing within the construction of Black liberation ideologies even as she serves as the locus of Black subjectivity and diasporic testimony. She is the unacknowledged ground of Black liberation politics. Representative authority has been persistently wrested from Black maternal figures, effectively silencing their testimony while positioning Black males as authoritative testis to diasporic experience, a paradigm prominently displayed in Douglass's *Narrative* through the management of Hester's screams. This vested interest in male representatives constitutes Black men as both the subject in need of institutional recognition and redress and the emblem of Black freedom, as freedom comes to be constructed as freedom-from Black women. Black women are thereby reduced generationally to wailing mothers (and aunts and sisters) "who scream [sic] when [black men] suffer," indexing not only the perpetuity of Black maternal loss but also how these women's soundings are compressed into testimonies to Black male injury, rather than their own.[89]

In December 2014, a new movement entitled #SayHerName was launched by the African American Policy Forum and the Center for Intersectionality and Social Policy Studies to amplify Black (cisgender and transgender) women's experiences within an anti-police brutality, Black liberation activist framework.[90] The necessity of the #SayHerName movement in and of itself comprises a powerful testimony to how Black women's traumatic experiences continue to go unheard, and how justice and freedom continue to be conceptualized in Black liberation movements as the sole provenance of Black males. While #BlackLivesMatter undertook an intersectional approach to "identify" and address all "the places in which Black life is cut short"—one that sought to "consciously resist [sic] the mistakes of the previous movement, especially the classism and sexism that all too often shaped the direction of older civil rights and feminist struggles"—the movement itself has fallen prey to some of the very same gendered inequities it seeks to resist.[91] As opposed to being seen as a "bottom-up, collaboratively organized movement," #BLM is often characterized as "'leaderless'"—perhaps as a consequence of Black women's civic erasure when participating in broad-based social justice movements.[92] Charlene Carruthers, an organizer with the Black Youth Project 100 notes that "all too often black women and girls, black LGBTQ folks, are left on the sidelines. And if we're going to be serious about liberation we have to include all black people."[93]

Toni Morrison reminds us in *Song of Solomon* that any liberation project that does not include the entire Black community as a body, or that requires us to silence our mother's and sister's names, simply perpetuates (gendered) intracommunal violence that ultimately aids in the Black community's destruction. While Morrison's text sounds a grim warning about the echoing history of Black nationalism, it also points toward a critical recovery of the Black mother in liberation activism, and urges us to heed her songs and sounds, as opposed to silencing and erasing her. These echoing aural palimpsests that operate to forge connections across time, space, and place that engender community may also work in the same manner to forge connections across class, gender, and sexual identities. As palimpsests, these maternal sounds hold the latent potential to echo and (re)form themselves in order to address the exigencies of their moments of articulation, traveling across distances absent even the hope of recognition, to engender heightened receptivity and permeability to the sounds of Black testimony.[94] In so doing, Black women's songs and cries will sound the depths of Western history and experience to provide the routes and roots of connectivity and intersubjectivity that resonate on social, political, affective, and even ecological levels. We can no longer afford to deny that these soundings and their continuous echoes produce a reverberating testimony that insists on the urgency of actualizing Black freedom (for all) as our rightful cultural inheritance, "*handed by* . . . the mother."[95]

NOTES

This essay has appeared, in somewhat different form, in Meina Yates-Richard, "'WHAT IS YOUR MOTHER'S NAME?': Maternal Disavowal and the Reverberating Aesthetic of Black Women's Pain in Black Nationalist Literature," *American Literature* 88, no. 3 (2016), 477–507. Copyright © 2016, Duke University Press. All rights reserved. Republished by permission of the copyright holder and the Publisher (www.dukeupress.edu).

1. Larry Neal, "An Afterword: And Shine Swam On," in *Black Fire: An Anthology of Afro-American Writing*, ed. LeRoi Jones and Larry Neal (New York: William Morrow, 1968), 631–656.
2. Neal, "An Afterword," 653.

THE SONIC AFTERLIVES OF HESTER'S SCREAM

3. Frederick Douglass, *Narrative of the Life of Frederick Douglass, an American Slave: Written by Himself* (1845; Oxford: Oxford University Press, 1999).

4. I want to note here that I am forwarding a more capacious understanding of Black nationalism, while at the same time not wishing to suggest that all Black liberation activism is "Black nationalist." However, I do want to consider the ways in which Douglass (who neither publicly identified with, nor promoted Black nationalism at the time of the 1845 *Narrative*) profoundly shaped masculinist understandings of Black nationalism, and how, in large part, Douglass's *Narrative* set up a gendered paradigm of silencing Black women in order to instate Black men as communal representatives and the subjects of freedom to the exclusion of Black women, most prominently figured as mothers and maternal substitutes.

5. Ralph Ellison, *Invisible Man* (1952; New York: Vintage, 1995); and Toni Morrison, *Song of Solomon* (1977; New York: Vintage, 2004).

6. Alexander Weheliye, *Phonographies: Grooves in Sonic Afro-Modernity* (Durham, NC: Duke University Press, 2005), 7.

7. Hortense Spillers, "Mama's Baby, Papa's Maybe: An American Grammar Book," in *Black, White, and In Color: Essays on American Literature and Culture*, by Hortense Spillers (Chicago: University of Chicago Press, 2003), 221.

8. William Andrews, *To Tell a Free Story: The First Century of Afro-American Autobiography, 1760–1865* (Chicago: University of Chicago Press, 1986), 238.

9. In *Narrative of the Life*, Douglass presents the following women and the traumas they endured in the text, but does not give them voice: his sister, aunt, and Henny (53), Henny's abuse (56), Caroline the "breeder" (61), Sandy's free wife (66), and his wife Anna Murray who "shouldered one part of the baggage" (95). Frances Smith Foster argues in "'In Respect to Females . . .': Differences in the Depiction of Women by Male and Female Narrators" that the male-authored slave narrative "refers to slave women en masse . . . and presents slave women primarily as examples of the extremes of the depravity [of] slaveholders . . . and . . . the degradation to which black men, through their inability to protect, were forced" (*Black American Literature Forum* 15, no. 2 [1981]: 66).

10. Douglass, *Narrative of the Life*, 18.

11. Douglass, *Narrative of the Life*, 18.

12. Douglass, *Narrative of the Life*, 18.

13. William Andrews asserts that "male slave narrators [gave] voice to [slave women's] suffering," but in a manner that portrayed the inevitability of their status as "sexual victim[s]" (*To Tell a Free Story*, 241).

14. Mae G. Henderson notes the "power of . . . sonance" in the "African American literary tradition" in *Speaking in Tongues and Dancing Diaspora: Black Women Writing and Performing* (Oxford: Oxford University Press, 2014), 2. Henderson indicates that particular "tropes" involving female sonority in black women's writing "become instrumental to securing freedom from slavery, reconstituting damaged and fractured subjectivities, and reconstructing personal narratives and communal histories" (*Speaking in Tongues*, 2). While my work draws from the tradition that Henderson so aptly describes, this piece seeks to understand the specific workings of black maternal sonority in the black nationalist tradition of liberatory activism and politics.

15. Douglass, *Narrative of the Life*, 18; emphasis added.

16. Douglass, *Narrative of the Life*, 18.

17. Ellison, *Invisible Man*, 8.

18. Ellison, *Invisible Man*, 9; emphasis in original.

19. Ellison, *Invisible Man*, 9; emphasis in original.

20. Ellison, *Invisible Man*, 13.

21. Ellison, *Invisible Man*, 20.

22. Ellison, *Invisible Man*, 15.

23. Ellison, *Invisible Man*, 235, 238.

24. Ellison, *Invisible Man*, 238.

25. Spillers, "Mama's Baby, Papa's Maybe," 219.

26. Ellison, *Invisible Man*, 239–240.

27. Ellison, *Invisible Man*, 240.

28. Ellison, *Invisible Man*, 240; emphasis in original.

29. Douglass, *Narrative of the Life*, 19.
30. Ellison, *Invisible Man*, 240.
31. Aimé Césaire, *Discourse on Colonialism* (1955; New York: Monthly Review Press, 2001), 42.
32. Saidiya Hartman notes that under slavery Black women became mired within a model of "reproductive extraction that enabled reproduction of human biological commodities in black women's wombs." See "The Belly of the World: A Note on Black Women's Labors," *Souls* 18, no. 1 (2016): 166.
33. Ellison, *Invisible Man*, 243–244.
34. Ellison, *Invisible Man*, 234.
35. Ellison, *Invisible Man*, 240.
36. Ellison, *Invisible Man*, 235.
37. Ellison, *Invisible Man*, 235.
38. Ellison, *Invisible Man*, 251.
39. Ellison, *Invisible Man*, 251.
40. Ellison, *Invisible Man*, 258; emphasis in original.
41. Ellison, *Invisible Man*, 258.
42. Ellison, *Invisible Man*, 258; emphasis in original.
43. Ellison, *Invisible Man*, 296.
44. Ellison, *Invisible Man*, 297.
45. Ellison, *Invisible Man*, 315.
46. Ellison, *Invisible Man*, 325.
47. Ellison, *Invisible Man*, 327.
48. Ellison's portrayal of Trueblood as the Black male most intimately connected to (and allied with in his song-making abilities) Black women as an atavistic, potentially pathological character suggests that the inability to leave/cleave one's relationship with Black women stymies black male progress. Trueblood is rewarded by whites for his accidental incestuous behaviors that provoke the Black community's shame. Though this article does not have the space to ruminate upon this character and his relationship to Black nationalism at length, I want to suggest that the collapsing of incest, Black maternity, songs/sounds, and shame are also evidence of the paradigm of maternal disavowal that I have outlined above.
49. Ellison, *Invisible Man*, 378.
50. Ellison, *Invisible Man*, 381.
51. Ellison, *Invisible Man*, 381.
52. Ellison, *Invisible Man*, 547.
53. Ellison, *Invisible Man*, 545.
54. Nicole Waligora-Davis, "Riotous Discontent: Ralph Ellison's 'Birth of a Nation,'" *Modern Fiction Studies* 50, no. 2 (2004): 401.
55. Ellison, *Invisible Man*, 544–545.
56. Waligora-Davis, "Riotous Discontent," 406.
57. Ellison, *Invisible Man*, 545.
58. Ellison, *Invisible Man*, 581.
59. Cheryl Wall, "Resounding *Souls*: Du Bois and the African American Literary Tradition," *Public Culture* 17, no. 2 (2005): 219.
60. Gay Wilentz, "Civilizations Underneath: African Heritage as Cultural Discourse in Toni Morrison's *Song of Solomon*," *African American Review* 26, no. 1 (1992): 63.
61. Morrison, *Song of Solomon*, 6.
62. Kalenda Eaton, *Womanism, Literature, and the Transformation of the Black Community 1965–1980* (New York: Routledge, 2007).
63. Morrison, *Song of Solomon*, 303.
64. Morrison, *Song of Solomon*, 208.
65. Spillers, "Mama's Baby, Papa's Maybe," 233.
66. Spillers, "Mama's Baby, Papa's Maybe," 219.
67. Morrison, *Song of Solomon*, 52.
68. Spillers, "Mama's Baby, Papa's Maybe," 228.

THE SONIC AFTERLIVES OF HESTER'S SCREAM

69. Morrison, *Song of Solomon*, 27–28.
70. Morrison, *Song of Solomon*, 28.
71. Morrison, *Song of Solomon*, 323.
72. Morrison, *Song of Solomon*, 208.
73. Morrison, *Song of Solomon*, 328.
74. Morrison, *Song of Solomon*, 336.
75. Morrison, *Song of Solomon*, 336.
76. Morrison, *Song of Solomon*, 336.
77. Morrison, *Song of Solomon*, 337.
78. Morrison, *Song of Solomon*, 337.
79. Movement for Black Lives cofounder Alicia Garza first used the phrase "Black lives matter" in a Facebook post in July of 2013 to express the collective grief and disappointment felt within Black communities due to the acquittal of George Zimmerman. Garza's words were later economized in hashtag form by fellow cofounder Patrice Cullors. See Jelani Cobb, "The Matter of Black Lives," *The New Yorker*, March 6, 2016, https://www .newyorker.com/magazine/2016/03/14/where-is-black-lives-matter-headed; and Monica Anderson, "The Hashtag #BlackLivesMatter Emerges: Social Activism on Twitter," *Pew Research Center*, August 15, 2016, https:// www.pewresearch.org/internet/2016/08/15/the-hashtag-blacklivesmatter-emerges-social-activism-on -twitter/. In 2021, Cullors resigned from the Black Lives Matter Global Network Foundation.
80. Alicia Garza, "A Herstory of the #BlackLivesMatter Movement," *the feminist wire*, October 7, 2014.
81. The terrain of BLM activism has changed profoundly since 2016. While remaining a notable public figure, King has been mired in controversies concerning his racial identity, his fundraising activities, and his activist ethics. While still a prominent public voice associated with BLM, McKesson has since founded Campaign Zero, an organization focused explicitly on policy interventions aimed at reducing police violence. Arguably, these two men leveraged their association with the movement to propel themselves into celebrity status, thereby obscuring the movement's founders and some of its founding aims.
82. Garza, "A Herstory of the #BlackLivesMatter Movement."
83. Marcia Chatelain and Kaavya Asoka, "Women and Black Lives Matter: An Interview with Marcia Chatelain," *Dissent* 63, no. 3 (2015): 54.
84. Chatelain and Asoka, "Women and Black Lives Matter," 57.
85. Keeanga-Yamahtta Taylor, *From #BlackLivesMatter to Black Liberation* (Chicago: Haymarket Books, 2016), 164.
86. Taylor, *From #BlackLivesMatter to Black Liberation*, 164.
87. Percy Green II, Robin D. G. Kelley, Tef Poe, George Lipsitz, Jamala Rogers, and Elizabeth Hinton, "Generations of Struggle: St. Louis from Civil Rights to Black Lives Matter," *Transitions* 119 (2016): 10. The slogan is attributed not to Black Lives Matter, but to an associated organization, Hands Up United.
88. Marcia Chatelain posits that "from the abolitionist movement to the civil rights movement, many . . . key issues were framed around concerns that racial injustice harmed masculinity" (Chatelain and Asoka, "Women and Black Lives Matter," 57).
89. Ellison, *Invisible Man*, 240.
90. See: https://www.aapf.org/sayhername.
91. Chatelain and Asoka, "Women and Black Lives Matter," 59.
92. Chatelain and Asoka, "Women and Black Lives Matter," 59.
93. Katherine Mirani, "Nurturing Black Youth Activism," *Chicago Reporter*, October 6, 2014 (quoted in Taylor, *From #BlackLivesMatter to Black Liberation*).
94. Here, I mention heightened receptivity as akin to both AnaLouise Keating's construct of "raw openness" (*New Perspectives on Gloria E. Anzaldúa* [New York: Palgrave Macmillan, 2005]) that mandates subjective permeability, and to Nelle Morton's "depth hearing," as a modality of interaction in which "hearing evokes speech" (*The Journey Is Home* [Boston: Beacon Press, 1985]). Affective permeability and the practice of depth hearing suggest the possibilities of (re)hearing these Black women's soundings as part and parcel of the communal pursuit of freedom, and as testaments to their own injury—a means of enacting *empathetic listening* (Mae G. Henderson, *Speaking in Tongues*) as a key component of liberation activism that does not allow for the gendered silencing endemic to black nationalism.
95. Spillers, "Mama's Baby, Papa's Maybe," 228.

103

FIVE

MUMIA ABU-JAMAL AND HARRIET JACOBS

Sound, Spectrality, and the Counternarrative

LUIS OMAR CENICEROS

Indeed, censorship is the offspring of a power relation, for the powerful have an intrinsic interest in silencing the expressions of discontent by the powerless . . . the ultimate form of censorship—death!

—Abu-Jamal, *All Things Censored*

Here in morgue-like holding pens of Pennsylvania's penitentiaries, "life" literally sentences one to imprisonment for the length of one's natural lifespan, with no possibility of parole. "Life" is thus but a grim metaphor for death, for only death releases one from its shackles. "Life," it might be said, is merely slow death.

—Abu-Jamal, *Death Blossoms: Reflections from a Prisoner of Conscience*

Amid a continuous firestorm of controversy, Mumia Abu-Jamal, after thirty years of incarceration, no longer faces the death penalty. During a press conference held on December 7, 2011, Philadelphia district attorney Seth Williams officially stated that his office would no longer pursue the death penalty in the case of Mumia Abu-Jamal. Abu-Jamal's thirty-year-long struggle between preserving his life and state-sanctioned death is a battle fought not only in the arena of legal trials and appeals but also in the narration of the United States, where the master/slave dynamic of racial control forces people of color into spaces of confinement. For Abu-Jamal, his incarceration is indicative of an ever-pervasive capitalist power structure that in the past has, in the present is, and in the future will control designated groups of made marginalized masses in order that preeminent capitalist beneficiaries preserve elite status over those excluded, oppressed, and exploited masses. Within this framework, Abu-Jamal creates and characterizes his narrative as a continuum of Black enslavement.

Abu-Jamal's work transcends autobiography and becomes creative expression—calling to the past and amplifying forward—a constructed narrative that mimics and mirrors constructions found in the traditional slave narrative, while incorporating contemporary considerations and aesthetics, thereby forming a synthesis: a newer imaginatively artistic way of looking at the past in the present. Therefore, the United States prison-industrial complex doubles as metaphor and, simultaneously, a collection of literal and spatial institutions of racial control for capitalist

exploitation. While some have resisted a direct correlation between the material conditions of (un)life aboard Atlantic slave ships and day-to-day plantation life during the establishment of an independent United States throughout the eighteenth and nineteenth centuries to the material conditions of prison life in the twentieth and twenty-first centuries, nevertheless, the intentional design and symbolic significance between Atlantic slave trade/plantation economy and the United States prison/detention center industry reveal an entwined racial capitalism and economic determinism. It is this revelation that premises Abu-Jamal's creative intervention as a voice writing and orally articulating the wrongs perpetuated by moneyed ultra-rich power elites and their capitalistic structures that mechanistically function to preserve their financial intercsts and their power—from the past to the present into the future.

As the United States prison-industrial complex expands, and the prison program attempts to transform persons of color into non-persons, as Abu-Jamal astutely observes, a "dark, repressive trend in the business field known as 'corrections' is sweeping the United States, and it bodes ill both for the captives and for the communities from which they were captured."[1] Furthermore, within the space of prison as part of United States racial and social control, African Americans continue to create narratives of slavery. Enacting a "postmodernism of resistance,"[2] Abu-Jamal creates a neo-slave narrative, writing within and against postmodernism to challenge and dismantle the United States capitalist power-structure. From the Atlantic slave trade to the United States prison-industrial complex, from Quobna Ottobah Cugoano to Mumia Abu-Jamal, the slave narrative exists both as a critique of oppressive State powers and as a collective affirmation of Black interiority and embodied subjectivity.

In order to combat the United States prison-industrial complex, or what could be characterized as the intersection of the Atlantic slave trade and the Arcades, a more grotesquely perfect form of capitalism growing from out of its own head, Abu-Jamal engages in a call-and-response through a reverberation in time to call back those named and unnamed slaves, murdered and slowly murdered, into the now-time of the present—a body count of accountability, the voices of the dead echoed in Abu-Jamal.

In a world where the poor are rendered powerless, and the ultra-rich, by virtue of amassing *ungodly* amounts of wealth, have the financial means to determine the appointments of government offices and how that poser-government should operate, the disenfranchised, the discarded, the destroyed are forced into a state of perpetual living-death. Moreover, Abu-Jamal writes from within a more corporeal space of living-death; in this, his positionality is identical to his antecedent Harriet Jacobs. Abu-Jamal embraces a specifically Black postmodern aesthetic and critical thought to conceptualize and express the experiences of Black prisoner-slaves, physically confined to a cell, imprisoned within a still greater prison of institutional injustice—enslaved by a racist capitalist power structure that on the world stage champions universal democracy and freedom—this falsified construct fabricated by illusionary pretense to mystify capitalist utopia—but Jacobs and Abu-Jamal tell a different story, from out of their tombs, they voice their narrative—from out of death row, Abu-Jamal voices a multimedia postmodern neo-slave narrative.

Harriet Jacobs's aforementioned nineteenth-century slave narrative—*Incidents in the Life of a Slave Girl Written by Herself*—is an antecedent to Abu-Jamal's postmodern neo-slave narrative; a direct parallel between both authors is evident when considering their spatial confinement or corporeal physical imprisonment within a greater ideational and institutional socio-civic

LUIS OMAR CENICEROS

imprisonment. Their methodology in negotiating their own physical imprisonment and slave status within an overarching schemata of exploitation and capitalist ideology is transformed into literature and literary device. According to Jean Fagan Yellin, "Jacobs's achievement was the transformation of herself into a literary subject in and through the creation of her narrator, Linda Brent"[3]; Jacobs is not Linda Brent, and yet Linda Brent is Harriet Jacobs. From Jacobs's nineteenth-century "living grave" to Abu-Jamal's twentieth-/twenty-first-century "morgue-like holding pens," their slave narratives double as a struggle for personal liberation, as well as a representational work that comments on and resists the material conditions of antidemocratic oppression and capitalist exploitation.

In a 1996 interview, Abu-Jamal tells Allen Hougland that the "reality is that my book [*Live from Death Row*] is a toned-down, stripped, barebones, objective version of reality . . . of what I've seen, what I've smelt, the bodies. . . . If I wrote pure stream of consciousness, no publisher would publish it, and any reader would say it's fiction."[4] Abu-Jamal's position as slave narrator is unique, and in terms of postmodern aestheticism, he is self-aware of writing as a prisoner-slave in a real-time narrative of enslavement, in that way a meta-slave-narrative.

Although *Live from Death Row* is intrinsically informed by traditional slave narrative conventions and literary devices, Abu-Jamal's postmodern neo-slave narrative transposes and reconstitutes a revolutionary adaptation of traditional literary presentations of slave narrative. Corresponding to A. Timothy Spaulding's postmodern slave narratives, which "use elements of the fantastic to occupy the past, the present, and in some cases, the future simultaneously,"[5] Abu-Jamal circumvents the official State record of history by presenting his mostly autobiographical narrative in an unconventional nonlinear (Black) postmodern style.

Premised on the logic of chattel slavery, the "absence of known genealogies can be taken as a defining feature and subject of most slave narratives . . . which is why so many of these narratives begin with the words . . . 'I was born.'"[6] The most radical cogitation that firmly differentiates Abu-Jamal's narrative from the traditional slave narrative and positions itself as postmodern text is the antithetical beginning of *Live from Death Row*: "Don't tell me about the valley of the shadow of death. I live there."[7] Before John E. Wideman's introduction, before page one of the prisoner-slave narrative, the reader is confronted by Abu-Jamal—living in death. Subverting the reader's expectations about autobiographical slave narratives (usually written from a position of relative freedom), Abu-Jamal is always already dead. Abu-Jamal disrupts ordered time and undermines the customary, "I was born," foreshadowing the conclusion of his particular slave narrative—not freedom but death. Abu-Jamal's slave narrative does not end with relative freedom but with death: "I am en route to the Police Administration Building, presumably on the way to die."[8] Abu-Jamal is the representative slave narrative of the unjustly branded fugitive slave captured and sent to die. Abu-Jamal's postmodern neo-slave narrative is the slave story told, not from a position of relative achieved freedom, but in chronologically fragmented sketches, voiced by the dead: live from death row.

Abu-Jamal speaking from a position of death empowers and mobilizes his voice, specifically in conjunction with his more impressionistic and experimental postmodern text *Death Blossoms*. However, as this relates to contemporary renditions and fictionalized constructions of slave narrative, Abu-Jamal, in constructing literary text, uses death as a means to amplify his message and recuperate his subjectivity and agency. Teetering between life and death, Abu-Jamal becomes

a representational voice, through artistic expression, for the marginalized masses that face socio-civic, political, economic, and corporeal death.

Whereas traditional slave narratives are a single narrative collected as a book, usually written from a position of relative freedom, or an expounding additional commentary on a former state of physical enslavement, Abu-Jamal's postmodern neo-slave narrative is in-process, a slave narrative diary an audience reads as a work in-development. Abu-Jamal's postmodern neo-slave narrative is not a line segment, bookended by socially convenient endings reassuring a distancing readership public—an ending that indirectly doubles as projected absolution and an expedient pardon for the United States; rather, Abu-Jamal's slave narrative in-process is an infinite line, forever running across a slave past anchored in the Middle Passage—a boundless abyss—an infinite line projecting into a dystopic future of continuous capitalist domination, a compression of slave past, present, and future without end. There is no Hollywood ending. This slave narrative ends when the global capitalist power structure that has perpetuated enslavement for hundreds of years is defeated. Abu-Jamal's slave narrative is a multimedia postmodern neo-slave narrative that appropriates any and all means to articulate and voice a challenge against the capitalist enslavement of those victimized masses that were and are being broken to build global capitalist imperialism.

In the final section of *Live from Death Row*, the only section throughout the narrative without a date, entitled "Philly Daze: An Impressionistic Memoir," Abu-Jamal echoes the same conceptualization of slavery as memory—as a fluid, omni-temporal/atemporal, all-time/timeless, narrative of African(-American) enslavement and confinement—as does Caryl Phillips in the prologue and epilogue of *Crossing the River*:

> The "I love you" echoes like feedback, booming like a thousand voices, and faces join the calming cacophony: wife, mother, children, old faces from down south, older faces from—Africa? Faces, loving, warm, and dark, rushing, racing, roaring past. Consciousness returns to find me cuffed, my breath sweet with the heavy metallic taste of blood, in darkness. [. . .] I recall my father's old face with wonder at its clarity, considering his death twenty years before. I am en route to the Police Administrations Building, presumably on the way to die.[9]

This flash-memoir at the end of *Live from Death Row* anticipates the strong postmodern presentation of *Death Blossoms*. *Live from Death Row*, Abu-Jamal's first collected slave narrative, ends not with freedom but with Abu-Jamal on his way to death; as such, the continuation of his slave experience is premised on death, adopting a more postmodern stylistic aesthetic to express *Death Blossoms*. As Abu-Jamal inches closer to death, deeper into living-death, Abu-Jamal enters disordered time, to where *Death Blossoms*'s anti-form becomes its form—the continuation of his conclusion to *Live from Death Row*.

Abu-Jamal's postmodern neo-slave narrative continued to evolve into *Death Blossoms: Reflections from a Prisoner of Conscience*, where the reader is thrust into the psychic mindscape of a Black prisoner-slave's interiority; vexed and volatile, *Death Blossoms* is an a-local narrative traveling beyond the mappable world, or rather, is a narrative traversed across that space—*teetering on the brink between life and death*—that every slave is forced into by ever-evolving multifaceted

slaveocracies. Although Abu-Jamal's follow-up to *Live from Death Row* is not exclusively stream of consciousness, *Death Blossoms* embraces a more creative postmodern presentation.

Abu-Jamal's dedication "To those who come before / To those who are to come / I dedicate this shield," suggests that *Death Blossoms*'s creative thematization begins where the most experimental sketch in *Live from Death Row* ends; more precisely, the final sketch at the end of his first postmodern neo-slave narrative—"Philly Daze"—showcases Abu-Jamal's narrative as transtemporal, as well as expressly showcasing Abu-Jamal's bi-local disembodied embodiment, and ultimately ends with Abu-Jamal "en route . . . presumably on the way to die."[10] This final entry in *Live from Death Row* is dateless, seemingly a moment that is perpetually (re)lived by Abu-Jamal—the night of his arrest. Where the traditional slave narrative ends from the narrator's achieved or positioned state of relative freedom, *Live from Death Row* concludes with Abu-Jamal on his way to die—toward a state of enslaved slow death. What the reader discovers in *Death Blossoms* is that Abu-Jamal is in Phase II, which is death row within death row as determined by the state officially setting a date for execution. With a date to die, Abu-Jamal comes to embody living-death, and to his credit and devotion to revolution, readers are allowed a glimpse into the netherworld buried beneath citadels fortifying United States capitalism and racist ideologies.

Death Blossoms does not adhere to a strict structural presentation and rarely is it circumscribed to specific dates; however, this is not to suggest formlessness, but rather, that the structure of Abu-Jamal's postmodern neo-slave narrative is not based on chronological storytelling or even plot-driving narrative. *Death Blossoms* utilizes short essays, vignettes, sketches, poetry ("Miracles" and "Untitled"), and—unique within the postmodern neo-slave narrative—graphics that become artistic installations embedded throughout the text. These images are not so much supplementary materials like photographs or drawings that lend visual aids, but rather function as artistic pieces in themselves. *Death Blossoms* is a postmodern neo-slave narrative because the form is as much the narrative as the narrative storytelling of Abu-Jamal is slave narrative. *Death Blossoms* incorporates postmodern storytelling by utilizing postmodern presentational aesthetics and mixed media. Genre-meshing is one aspect, but in addition, and like Jean-Michel Basquiat's language-based visual art, Abu-Jamal interweaves graphic and text to present an aesthetically postmodern neo-slave narrative.

The conflict between nature and postmodern *second nature* is a central theme in "The Spider." Abu-Jamal's narrativity constructs a modern parable through the use of "Ancient African and West Indian folklore" within his narrative.[11] In other words, Abu-Jamal contemporizes a "famous Ghanian tale," while the traditional referent is transposed to a contemporary super-max prison.[12] Despite spatial alienation as the result of prison architecture—despite postmodernity denaturalizing space—a spider spins her web within a death row prison cell: Norman called, "in a deep stage-whisper," to "Mu," in a "voice heavy and strangely conspiratorial," and tells Mu about a "mama spider" that was making her home in Norman's cell—"out of her own body!"[13] Abu-Jamal discerns the ubiquitous predominance of nature even within spatially constructed denaturalizing uniformity: "With a quiet, unwitting bravado that defied the State's most stringent efforts to quarantine [Norman], spiders had moved in and built webs in the dark corner under his sink."[14] In an interlude, Abu-Jamal tells the tale of Anansi, wherein the "spider whispers, 'It is I, Anansi'" to an antelope.[15] As with the antelope, Anansi (Nature) does not forget Norman, and in "a concrete tomb erected to smother men to death, she was a tiny marvelous reflection of life . . . Nature

amid the unnatural."[16] "The Spider" could be considered the most interactive graphic display in *Death Blossoms*.

Bleeding, or trans-positioning, into the following page, a graphic of a spider (about proportionate scale to any small spider) is just off the final sentences of the page at the page's bottom right corner. The tiny spider graphic then becomes a subjective long shot bleeding into the subsequent page, which when turned becomes a subjective extreme close-up as the exact graphic is magnified to a double-page spread. We then become Norman "who spent hours watching."[17] We take on his perspective, catch sight of a tiny spider, and then proceed to move in closer to admire Anansi as she spins a home out of her own body from her "miraculous silken thread."[18] As Abu-Jamal closes with the sentence "Nature amid the unnatural," a picture of a leaf overlaps the page break, thus breaking the border between "The Spider" and "The Fall." Not only does the picture visually pop by breaking the border but it locks the two entries together, informing one another. "The Fall" then describes how the "earth like an old woman, prepares for death" as all "the markers of death gather around her like a storm";[19] however, beneath that "fallowed earth lies a mighty heart athrob with life; that life lives within life, and goes forever on."[20] In the same way Anansi as nature challenges postmodern *second nature*, Abu-Jamal must challenge state-sanctioned death by reaffirming life within a space of slow death.

Abu-Jamal prolongs life through symbiotic simulation: the content and presentation of *Death Blossoms* is an exercise in meditation. *Death Blossoms* simulates prolonging life by slowing down living by way of art as device. The reader must meditate on Abu-Jamal's reflections and is forced to look deeper and engage this postmodern neo-slave narrative at a more cerebral level; it holds us, making it uncomfortable for the reader expecting a plot-driven narrative with a satisfactory conclusion—not with Abu-Jamal's *Death Blossoms*. Abu-Jamal upsets any predisposed expectations an audience—more comfortable with a story of escape—would have about slave narratives. The past is the present, as Abu-Jamal rearticulates slavery and disturbs a United States post-racial mindset that is comfortably situated in the twenty-first century, psychosocially far removed from the increasingly de-historicized United States (American) involvement in the Atlantic slave trade and institutional slavery.

According to Jacques Derrida, "the origin of exchange-value is the birth of capital. Of mysticism and the secret."[21] More generally, Derrida states that "Humanity is but a collection or series of ghosts."[22] Derrida makes this statement in accord with a discussion on a "history of ghosts," wherein Marx uses Feuerbach's "ordinary theology" and "speculative theology" to explain it.[23] Derrida reconciles these two specific theorized types of theologies to conceptualize what he terms "sensuous-non-sensuous." Derrida continues by describing how ghosts are thereby produced through the "incarnation of spirit."[24] Where Derrida complicates this sociocultural phenomenon is by advancing Marx's theoretical framework and illustrations of exchange-value and commodity mysticism.

With abstract equivalency and exchange-value facilitating social relations between the labor of individuals and those that control the labor of others, and more importantly, facilitating the social relationship between products and the values assigned to those products, a "commodity is therefore a mysterious thing."[25] Because of the social relationality of exchange-value, as Marx determines, use-value, at best, increasingly becomes incidental. If we think about the New York Stock Exchange, materially there is no practical use-value for any stock—rather the stock is the

LUIS OMAR CENICEROS

representation of money or future monies that are transtemporal and immaterial. This is hyper-realized in postmodernity; however, these basic principles are based on commodities altering the perceivable material and natural world.

The example used first by Marx, then advanced by Derrida, is of the wooden table that "continues to be that common everyday thing, wood"; however, because of social relations and exchange-value, "so soon as [the wooden table] steps forth as a commodity, it is changed into something transcendent."[26] With this in mind, Derrida suggests that we see what is unseen; in other words, while seeing the table as a wooden table derived from nature with the use-value of a table, one must simultaneously see that this wooden table has an inseparable abstract form within and without the materiality of the would-be-used wooden table: "So as to prepare us to see this invisibility, to see without seeing, thus to think the body without body of this invisible-visibility—the ghost is already taking shape. . . ."[27] Social relations then dictate that, socioculturally, the commodity is abstracted exchange-value corporealized in a state of material de-materialization.

Returning to Derrida's notion that "Humanity is but a collection or series of ghosts," I would propose that some are more ghostlike than others, when considering commodity's ghostlike "visible-invisib[ility]"[28]—or abstracted corporeality. The theorized ghost image evokes a literal and consequently gruesome response when applying Derrida's framework to the commodity sale of Africans throughout and across the Atlantic and Africans/African Americans within United States–instituted slavery. Derrida's framework reveals this phenomenon when applied to a reading of Harriet Jacobs's nineteenth-century slave narrative.

In Harriet Jacobs's *Incidents in the Life of a Slave Girl*, Dr. Flint posts "the following advertisement" in search of *his* runaway slave Linda Brent (Harriet Jacobs):

$300 Reward! Five feet four inches high. Dark eyes, and black hair inclined to curl; but it can be made straight. . . . All persons are forbidden under penalty of law to harbor or employ said slave. $150 will be given to whoever takes her in the state, and $300 if taken out of the state and delivered to me, or lodged in jail.[29]

Contextually directly correlated to Derrida's concept of commodity's visible-invisibility, Jacobs is the abstract equivalent to three hundred US dollars—*the ghost is already taking shape.*

Obviously, there are practical reasons for Dr. Flint to physically describe Jacobs, but this is symptomatic of capitalist sociocultural logic and is only the affirmation of the reification and commodification of Jacobs, so that within this one advertisement, Jacobs is compressed into a body with abstracted exchange value. Jacobs is sensuous-non-sensuous—both a dark-eyed girl and, depending on where her five-foot-four frame is hiding, the exchange value of one hundred and fifty US dollars or three hundred US dollars. For Dr. Flint, this is a property issue, as well as an interstate commerce issue.

Whereas the wooden table, "the ordinary, sensuous thing is transfigured, it becomes someone, it assumes a figure,"[30] the process is inverted for African/African American slaves, who are reified and commodified, relegating them to the status of non-person. There is direct similitude between the spectral wooden table and Jacobs's daughter: on learning that Mr. Sands has sent Ellen away, Mrs. Flint "pronounced" to Mrs. Sands's sister that it was "just as much stealing as it would be for him to come and take a piece of furniture out of her parlor . . . the children were

her property."[31] Social relations within this slaveocracy determine the perception with which Mrs. Flint (among most, more generally) perceives a Black child to be the abstract equivalent to antebellum parlor furniture. Mrs. Flint only sees the embodied spectrality of *her* property's exchange value.

In opposition to this divisive capitalist sociocultural logic, Jacobs parries an argument that substantiates the exploited, labored, and brutalized bodies of slaves, an argument charged against the ideological promise of United States democracy and utopic capitalism. The death of Jacobs's father is a critical point, early in her narrative, that informs her critique of bodily reductionism versus embodied significance found throughout her narrative. Jacobs rejects the master class's capitalist sociocultural and political logic within which a slave's labored body is simultaneously commodity with the abstracted equivalency to property. Jacobs continually emphasizes death, using it as a counterargument to dismantle abstract equivalent notions that perceive persons relative to price and property exchange value alone.

Jacobs describes burying "a dear little friend," and hearing her little friend's "mother sob" as Jacobs "turns away from the grave."[32] Soon thereafter, Jacobs is told by her grandmother that Jacobs's father has died. Despite thinking she "should be allowed" to visit her "father's house the next morning," Jacobs is instead "ordered to go for flowers" so that her "mistress's house might be decorated for an evening party."[33] At the crux of this incident is the chasm between the privileged master class and the Black slave class, where the privileged class is ignorant to the irony of ordering Jacobs to collect flowers—not for ritualistic and intimate honoring of the dead—but rather, for vainglorious socialite convention. The sardonic irony, however, is not lost on Jacobs: "I spent the day gathering flowers and weaving them into festoons, while the dead body of my father was lying within a mile of me. What cared my owners for that? he was merely a piece of property."[34] To the capitalist master class, Jacobs's father is worth only what his slave labor can produce and his net worth after purchasable exchange.

Contrary to this capitalist logic, and anticipating Abu-Jamal's efforts, Jacobs recuperates the dead to challenge the capitalist system of oppression, reappropriating dead space to revitalize slaves both dead and those living-dead. Jacobs supplants her master's evening party by, however delayed, participating in the burial ritual of her father: "The next day I followed his remains to a humble grave beside that of my dear mother. There were those who knew my father's worth, and respected his memory."[35] Jacobs revaluates her father—but counter to the capitalist logic of commodity/capital monetary exchange-value; Jacobs instead injects memory in re-historicizing her father, and in respect to memory that exists outside of price points and market determination, Jacobs makes exclusive, private, and intimate her father's worth known only by those select few and not based on more general social relations that calculate exchange value to determine abstract equivalency.

Furthermore, even abstract equivalency can be ruptured from within by those that are perceived through a lens of capitalist logic as commodity—as having visible-invisibility. Jacobs's use of the paranormal and supernatural in the background of her narrative heightens the gothic trope of "the poor captive in her dungeon,"[36] while her deployment of death and the revenant converts commodity mysticism into phantasmic haunting. For example, Mr. Litch, an especially sadistic planter, whose last words were, "I am going to hell; bury my money with me,"[37] is a slave master who is an institution unto himself. Mr. Litch had wealth enough to operate above the law, having his own "jail and whipping post on his grounds."[38] Jacobs goes on to describe the "interment" of

two slaves Mr. Litch clubbed to death as that of a "dog's burial"; moreover, murder "was so common on his plantation that he feared to be alone after nightfall. He might have believed in ghosts."[39] A character like Mr. Litch who has fetishized money, so much so that he would seek to have capitalist mysticism follow him into hell, must be the very same character who fetishizes the commodified Black body of the slaves he tortures; as such, "[v]arious were the punishments resorted to."[40] However, once Mr. Litch no longer possesses power over corporeal labored bodies, Mr. Litch becomes threatened by Black slave disembodiment. Despite being an institution unto himself, Mr. Litch (and his capitalist logic that perceives Black slaves as commodity with inherent exchange value), is disoriented by the specters of slaves he has murdered: the ghosts that haunt Mr. Litch are the revenants of those murdered slaves, disrupting the comfortable social relationality of the capitalist market.

In parallel effect, Jacobs specifically attacks utopic notions of slavery—capitalism—notably in "Fear of Insurrection": "Not far from this time Nat Turner's insurrection broke out; and the news threw our town into great commotion. Strange that they should be alarmed, when their slaves were so 'contented and happy'! But so it was."[41] Throughout Jacobs's narrative, dead slave bodies provide a constant challenge to utopic interpretations of slavery and capitalism; but one figure becomes hyper-phantasmic, turning commodity mysticism into revolutionary agency—Nat Turner. Black slaves are in a complex position; in that, they occupy a double placement as commodity while labor. As Derrida explains, the commodity—the sensuous-non-sensuous "Thing"—is the "contradiction of automatic autonomy, mechanical freedom, technical life . . . a stiff and mechanical doll whose dance obeys the technical rigidity of a program";[42] so, although capitalist sociocultural logic has produced commodity mysticism by way of exchange value, that mystical commodity is nevertheless an "automaton" that "mimes the living. The thing is neither dead nor alive, it is dead and alive at the same time."[43] The capitalist slaveocracy, therefore, has no obligation to respect or acknowledge the sovereignty of a commodified automaton that is devoid of interiority because the slavish "artifactual body" is in a state of living-death and must always obey the "technical rigidity of a program."[44] However, in the case of Nat Turner, when that already phantasmatized commodity exercises agency and attempts to discomfit the establishment, such a commodity becomes a terrorizing poltergeist.

Turner turns commodity mysticism against itself in the form of abstract terror. The darkness then becomes especially threatening while Turner escapes capture; it is not until the "capture of Turner" that the "wrath of the slaveholders was somewhat appeased."[45] When the power structure regains control over Turner's Black body, its ability to subject Turner to physical mutilation as punishment serves as a collective catharsis to mollify collective anxieties and reestablish the capitalistic sociocultural norm. Dr. Flint characterizes these capitalistic sociocultural anxieties when Jacobs exercises her agency; Jacobs, like the figure of Turner, reappropriates darkness and is able to gain mobility by accessing margins. Even before she enters her "prison," alone in her "cell, where no eye but God's could see her,"[46] Jacobs gains accessibility by effectively dematerializing—appropriating spectrality—despite remaining bodily: "For there to be a ghost, there must be a return to the body, but to a body that is more abstracted than ever."[47] Using visible-invisibility, Jacobs becomes a ghost figure that possesses person and space—disembodied embodiment.

Concealment and the night are important practical and elemental tropes throughout Jacobs's narrative. For example, Jacobs and her grandmother visit Benjamin in jail at "midnight"

in "disguise";[48] in "The Flight," Jacobs escapes at "half past twelve" and describes the night as "so intensely dark" that the "darkness bewildered" her.[49] Even though Jacobs is initially bewildered by intense darkness, she becomes more amerced in darkness and is aided by it. As Jacobs moves from one hiding place to another, using the local swamps at one point, she even adopts cross-dressing by donning "sailor's clothes" and performing a "rickety" sailor walk.[50] As a Black female slave, oversexualized in the eyes of her slave master Dr. Flint, Jacobs finds relief from any threat to her female slave body, even if just momentarily, by defusing the psychosocial hyper-sexualization of Black female slaves to the point that the "father" of her "children came so near that" she "brushed against his arm; but he had no idea who" she was.[51] Jacobs avails herself of night, darkness, and the margins of normativity to enact mobility.

> Jacobs's dematerialization and manipulation of spatiality facilitates a spectral gaze: in order to inhabit even where one is not, to haunt all places at the same time, to be *atopic* (mad and non-localizable) not only is it necessary to see from behind the visor, to see without being seen by whoever makes himself or herself seen (me, us), it is also necessary to speak. And to hear voices.[52]

Spectrality becomes advantageous for Jacobs; her non-localization conjuring trickery deceives Dr. Flint as it preserves bodily well-being and creates corporeal liberation: "in order to make him believe that I was in New York, I resolved to write him a letter dated from that place";[53] another letter "that fell into his hands, was dated from Canada."[54] Jacobs's spatial multiplicity and spectrality directly "enabled" her "to slip down into the storeroom more frequently" where she "could stand upright, and move [her] limbs more freely" now that Dr. Flint "seldom spoke" of her, due to Dr. Flint's inability to physically locate and re-enslave Jacobs.[55]

Resulting from this additional freedom through mobility, Jacobs is able to arrange a night meeting with her daughter Ellen, before Ellen is sent away. Like the importance Jacobs places on her father's memory, Jacobs had "a great desire" that Ellen "should look upon her" so that Ellen "might take" Jacobs's "image with her in her memory."[56] In order to spare Ellen from seeing the "wretched hiding-place" and having to be brought to Jacobs's "dungeon," Jacobs arranges to meet in the increasingly available storeroom.[57] After having "slipped through a trap-door," Jacobs expresses a need "to see her and talk with her, that she might remember" Jacobs.[58] It is in the darkness of night, and in the secrecy of intimate knowledge that Ellen is capable of seeing the apparition of her mother—a specter, a bodily abstraction. In effect, Jacobs is a supernatural specter, and because of Ellen's innate connection to her mother, Ellen has intimate and privileged knowledge about Jacobs's secret; therefore, Ellen, within this space, can converse with the dead—with the bodily apparition of Jacobs, a slave.

This visible-invisibility creates a dilemma since Jacobs must continue her elusiveness, while remaining cautious of her slave status as laboring commodity. In other words, Jacobs must remain a shadow and not allow her reappropriation of visible-invisibility to revert back to commodity exchange-value or monetary-based abstract equivalency. It is a crisis for Jacobs who seeks to be a reverent image in the memory of Ellen without surrendering her concealment and re-endangering her body as she evades re-enslavement: "I took her in my arms and told her I was a slave, and that was the reason she must never say she had seen me."[59] Because Jacobs is a slave—a

sensuous-non-sensuous commodity—her exchange value, her visible-invisibility, must not be re-seen by the master class of the capitalist power structure. With that consideration, Jacobs must remain physically confined to a "garret" of "only nine feet long and seven wide" with no "admission for either light or air."[60] However physically constrained, Jacobs retains agency and affirms a delocalized and theoretical mobility. As Michelle Burnham asserts, Jacobs's "'loophole of retreat' thus provides a strategic site for concealment even as it masks its own location";[61] Burnham continues: "This spatial loophole becomes . . . a means of escape from slavery . . . her manipulation of textual loopholes in dominant discourse allows her narrative to escape."[62] Notwithstanding a "wretched hiding-place" with "no room to toss and turn,"[63] Jacobs's "loophole operation allows for sites and performances of resistance within any discursive structure."[64] Analogously, the "morgue-like holding pens" become a site and performance of resistance for Abu-Jamal.[65]

Abu-Jamal, in "Books and the State," refers to Ray Bradbury's *Fahrenheit 451*—a novel about "a futuristic society in which books are banned," and "*subversives*—people who read books . . . keep books hidden in attics, in basements, and behind false walls."[66] As an exclamation, the text is bookended by a graphic formed out of Heinrich Heine's name and his quotation, "WHEN THEY BURN BOOKS, IT WON'T BE LONG BEFORE THEY BEGIN TO BURN PEOPLE."[67] The graphic, one can deduce, is a swastika divided in half (the other half off the page). There is a direct symbolic relation between a swastika and fascism, so much so that the reader mentally completes the symbolic image—this is contingent on making the connection between the fascist State and censorship. Abu-Jamal makes the reader an active reader, a participatory reader who recognizes fascism through image-induced recall, which recognizes fascism in State-willed censorship. Two separate highlighted sets of words (black background with white lettering, as opposed to black lettering on white page) are conjoined by Abu-Jamal as an emphatic statement of resistance—"the State" and "You cannot kill a book"—as if to directly promulgate that the fascist State cannot kill a book, and in a more conceptual reading, the word *book*, relative to Heine's quotation, doubles as *person*.

In other words, the oppressive State cannot kill a personal narrative. Abu-Jamal empowers *Death Blossoms* by having the final words in this section read, "You cannot kill a book," as a distemporal epitaph to his impending state-sanctioned execution and death. Abu-Jamal's postmodern neo-slave narrative, therefore, transcends death, distorting space-time considerations by speaking from a dislocating position of life-death. Abu-Jamal ruptures capitalist abstract equivalency and market exchange value mysticism by introducing sensuous subversive books as having a super-sensuous-non-sensuous form that represents revolutionary personal narratives of resistance. Jacobs literally and theoretically represents the subversive books—"hidden in attics, in basements, and behind false walls."[68] Jacobs dematerializes into a disembodied voice that speaks in the shadows, through walls and cracks. Jacobs, then, becomes a specter that sonically haunts places and spaces, thus reclaiming agency. Reappropriating visible-invisibility, Jacobs is a whisper that is both a-local and trans-local—both nowhere and anywhere; this circum-advantageous dynamic grants Jacobs accessibility to privileged communications and surveillant optical perspective. Jacobs, while hiding in an upstairs room in the unnamed mistress's home, could "lie perfectly concealed, and command a view of the street through which Dr. Flint passed to his office."[69] Whereas earlier in the narrative Dr. Flint espies and stalks Jacobs's enslaved female body, Jacobs now assumes oversight of Dr. Flint's movement.

After fashioning a loophole, "about an inch long and an inch broad," Jacobs is able to access privileged communications: "Southerners have the habit of stopping and talking in the streets, and I heard many conversations not intended to meet my ears."[70] Jacobs, in a sense, is also characterized as a benevolent specter intervening and guarding the well-being of her children. An intuitive connection between Jacobs and her children nevertheless endures: "I heard the merry laugh of children, and presently two sweet little faces were looking up at me, as though they knew I was there."[71] This familial bond transcends the material circumstance, which is also exemplified in the relationship between Jacobs and Aunt Nancy.

Earlier in the narrative, at the unnamed mistress's house, Betty tends to and helps to conceal Jacobs, at one point concealing her in a "shallow bed" beneath a "plank in the floor" in the kitchen.[72] However, Aunt Nancy, because of a very specific trauma and assault on her reproductive system and feminine identification, develops into a surrogate mother to Jacobs in what contextually could be read as a double-space of womb and tomb—her living-dead garret that represents slow death by physical decrepitude, while simultaneously representing a birth-way to the promise of a new life free from slavery.

Chapter XXVIII is titled "Aunt Nancy" and is the only chapter precisely named after a character. Jacobs provides readers with the narrative backstory of Aunt Nancy. As a direct causal link between Aunt Nancy being forced to sleep at the entry floor of Mrs. Flint's door, in order to serve Mrs. Flint during her pregnancy and subsequently to care for Mrs. Flint's baby afterwards, Aunt Nancy gave "premature birth to six children";[73] moreover, "toiling all day, and being deprived of rest at night, completely broke down her constitution."[74] Dr. Flint even "declared it impossible" that Aunt Nancy "could ever become the mother of a living child."[75] In fact, as Jacobs notes, Aunt Nancy "afterward had two feeble babies" both dying shortly after birth: "I well remember her patient sorrow as she held the last dead baby in her arms."[76] Aunt Nancy's stillbirths and born-dying babies are generally emblematic of slavery's assault on labored Black female bodies, but, more specifically to Jacobs's narrative, are emblematic of Jacobs's status as an always-already living-dead slave.

Jacobs represents a redemptive opportunity for Aunt Nancy to undermine the de-naturalizing effects of slavery, which "completely broke down her constitution," by literally nourishing Jacobs with sustenance, and more conceptually, swaddling Jacobs as she provides encouragement toward a new life beyond enslavement: "When my friends tried to discourage me from running away, she always encouraged me . . . she sent word never to yield."[77] Jacobs becomes a double for Aunt Nancy's "last dead baby in her arms." Jacobs is like a specter of her dead children, and because of Aunt Nancy's traumatic experience encountering death with all eight of her miscarriages and stillbirths, Aunt Nancy, like Ellen, is able to converse with the apparitional Jacobs, while entombed in the very structure of the places Jacobs haunts.

So that Jacobs could gauge Dr. Flint's reaction to her letters dated from New York, Jacobs "told" her "plan to aunt Nancy" as Jacobs "whispered it to her through a crack, and she whispered back":[78] "to haunt all places . . . not only is it necessary to see from behind the visor . . . it is also necessary to speak. And to hear voices."[79] Jacobs is the maturing specter of Aunt Nancy's could-have-been legacy that Aunt Nancy was forcefully deprived of ever having. Therefore, Aunt Nancy's line, "I could die happy if I could only see you and the children free," lends itself to a more metaphysical reading; Aunt Nancy, "old" with "not long to live," nestles Jacobs among "the children"—Jacobs's children specifically, and more generally, all current and future slave children.

Jacobs, while "shut up" in her "dark cell," would often "kneel down to listen to her words of consolation, whispered through a crack";[80] however, Aunt Nancy would become "very ill"—Jacobs meanwhile had been in her "cell six years."[81] In Jacobs's estimation, Aunt Nancy "had been slowly murdered," and when Jacobs heard uncle Philip state that Aunt Nancy had died, Jacobs's "little cell seemed whirling round."[82] Jacobs then rebukes Mrs. Flint's melodramatic performance, at the funeral service, by proclaiming a counternarrative, a "chapter of wrongs and sufferings," to challenge the supposedly benevolent "patriarchal institution" of slavery:

> *We* could have told them a different story. . . . We could also have told them of a poor, blighted young creature, shut up in a living grave for years. . . . All this, and much more, I thought of, as I sat at my loophole, waiting for the family to return from the grave; sometimes weeping, sometimes falling asleep dreaming strange dreams of the dead and the living.[83]

It is in this very space described by Jacobs almost two hundred years ago, "shut-up in a living grave for years . . . dreaming strange dreams of the dead and the living," that Abu-Jamal's *Death Blossoms* exists—articulating a revolutionary counternarrative to challenge the prevailing utopic discourses of capitalism in all its forms from institutional American slavery to the United States prison-industrial complex.

In line with Sharon Patricia Holland's concept of "raising the dead," the voices from beyond the grave become audible, communicating their story from dead space. Unlike the common model of the margin, which situates margins outside and away from the nation-state, Holland places "this marginal space on the inside, not as an entity from without but as an entity from within—a nation" and formulates a "theory of marginalized existence that more adequately describes the devastating experience of being 'outside' [US] culture."[84] It is through this marginal space that "writers, artists, and critics . . . are raising the dead, allowing them to speak and providing them with the agency of physical bodies in order to tell the story of a death-in-life."[85] In the case of prisoners of color, the marginalized space of death is not only a creative trope to discuss living-deadness, but, in their case, the marginalized dead space is quite literally a physical construct, and theoretically it is "outside" United States citizenship, societal heteronormativity, and the body politic, but, exactly as Holland proposes, the prison ideology and corrections hegemony are "inside," because they are important apparatuses and a discursive necessity when establishing sociopolitical positionality and when (re)constructing citizenship and personhood.

Like Jacobs, who raises the dead by devoting an entire chapter and its title to an especially necromantical character in Aunt Nancy, Abu-Jamal echoes Jacobs's devastation and sentiment in "Mother-loss." In similar expressions, for Jacobs, "the death of this kind relative was an inexpressible sorrow,"[86] while for Abu-Jamal, with his mother having died while he "was imprisoned, it was like a lightning bolt to the soul."[87] Abu-Jamal's mother, whom he describes as having "[d]eep rivers of loving strength" flowing through her, had died of emphysema—"her sweet presence, her wise counsel, was gone forever."[88] Although Jacobs's confinement was physically self-imposed, theoretically, Jacobs and Abu-Jamal are nevertheless imprisoned by overarching oppressive State powers; Jacobs must remain concealed in order "to avoid the tortures that would be inflicted on her if she ventured to come out and look on the face of her departed friend."[89] Abu-Jamal laments being imprisoned and thereby deprived of the opportunity to grieve the loss of his mother in ritual

practice: "To know one's mother dead, yet remain imprisoned! To imagine her lifeless form while held in shackles! To crush the hope of ever again embracing she who birthed me!";[90] this closing paragraph resounds a collapsing explodent of living-dead space: Abu-Jamal efficaciously compresses death and imprisonment to where neither can conceptually escape the other.

However, despite Abu-Jamal expressing his frustration at losing his mother while imprisoned, and not having physical accessibility to his dead mother, Abu-Jamal, nevertheless, raises the dead exactly how Jacobs raises Aunt Nancy from the dead. Abu-Jamal inserts a haunting image of his mother in "Mother-loss." The image is especially haunting because of its presentation in stippling (similar to pointillism); Abu-Jamal's mother's image is either a photograph converted to stippling or a portrait-rendition in stippling. Because stippling is a technique that uses dots to compose a larger image, the effect visually is that Abu-Jamal's mother appears apparitional—in a state of dematerialized materialization. The image of Abu-Jamal's mother inserted into his reflection re-enlivens her, as it memorializes her, forever a part of Abu-Jamal's postmodern neo-slave narrative.

In "God-talk on Phase II," Abu-Jamal further complicates God by framing a Socratic dialogue of sorts between "Mu" and "Scott." Abu-Jamal sets the scene by beginning with "ON DEATH'S BRINK, men begin to see things they've perhaps never seen before."[91] On Phase II, "sounds from the six death warrant cells are muffled," as "[m]en on the 'Faze' spend their precious hours . . . talking and learning about each other, their depths, their heights, their human uniqueness."[92] It is "midnight," Abu-Jamal writes, when Mu and Scott are discussing black holes, outer space, Einstein, Hawking, sci-fi movies and fiction, mother earth, "Mama—God."[93] There is a resurfacing of night conversations between the living-dead, as is found in *Incidents in the Life of a Slave Girl*; the trope of voices speaking from out of a cell or living grave is identical in both Jacobs's slave narrative and Abu-Jamal's postmodern neo-slave narrative, and to key off a phrase used by Ashraf Rushdy,[94] these slaves *survive by orality*; despite being on Phase II with death warrants signed, the call-and-response of prisoner-slaves Mu and Scott bilaterally reaffirm one another, and the "men talk on—hour after hour, late into the night, early into morn. Days, hours away from a date with death, they finally see each other. They see the miracles of life, the miracles of each other."[95] Essentially, through call-and-response from different cells, these prisoner-slaves are surviving by orality, edifying one another by recognizing the embodied significance of each other, and recognizing individual interiority and personhood in a shared collective subjectivity.

What immediately follows, then, is "Meditations on the Cross," not by Abu-Jamal, but by "Rufus, a slave."[96] Abu-Jamal's inclusion of Rufus's poem demonstrates a continuous communal slave narrative, where within Abu-Jamal's *Death Blossoms*, Abu-Jamal can raise the dead, by providing a place in his narrative for the voice of Rufus to rearticulate his own meditation on slavery. Within the structure of *Death Blossoms*, the dead can speak, as we see when Abu-Jamal brilliantly blends his voice into Rufus's: the final line in "God-talk on Phase II" reads "They see the miracles of life, the miracles of each other," which is followed by the first words in "Meditations on the Cross," which are, "Lawd, Lawd, I look at you and see."[97] The two lines run together, because the title of the poem is set six lines into the poem, so that the title spreads horizontally across the poem, visually structured as a cross, and thus creating an uninterrupted flow from Abu-Jamal's words within a contemporary death row prison cell to the words of Rufus, a slave. The *many-tongued chorus*[98] is a vehicle for the voices of Abu-Jamal and Rufus to speak together against the oppressive capitalist State—the dead rise together.

LUIS OMAR CENICEROS

From marginalized dead space, the dead then can speak, rupturing restrictive temporal constraints and forcing ruptures throughout the living's canonically *official* United States historical fabric. To challenge the dominant white heteronormative nation-state, the imprisoned living-dead are "writing from no-man's land" with the intent "to acquire voice through writing in a way that liberates the spirit and frees the soul."[99] Through the use of writing, prisoners bring themselves into being by re-recognizing their discarded personhood and interiority. Carol E. Henderson suggests that writing is a process of reembodying both a material and discursive Black body:

> Writers must reclaim that [disempowered body] *discursively* in order to facilitate a counter-discourse that *re*conceptualizes the meanings of literal and figurative bodies within certain predetermined social structures. It is the gap between these two categories that allows for the possibility of speaking a counter-discourse of the body—a body disfigured by the toxins of racism.[100]

To rupture the dominant discourse is to recuperate the historical and material racialized body that has been denied representation, recognition, and rights.

In closing, I would like to asseverate a contemporary parallel to the nineteenth-century slave narrative: the contemporary prisoner-slave narrative expressed as postmodern neo-slave narrative. Mumia Abu-Jamal raises the dead by writing himself into being and historicizes a slave past to contextualize his prisoner-slave narrative as a postmodern neo-slave narrative that critiques and challenges United States capitalism and white heteronormativity. Analogous to nineteenth-century slave narratives, Abu-Jamal's literature and recordings re-manifest the brutalized communal Black body by forcing it into the light of United States sociopolitical consciousness, as a psychosocial counterattack to necro ideological constructs.[101] *Death Blossoms* is not readily accessible—contrary to twenty-first-century micro-compressed information disseminated through emerging social media. *Death Blossoms* is an existential meditation; it is meant to be experienced—not consumed. *Death Blossoms* ruptures any convenient notions that seek to de-historicize American slavery as some fading distant past, irrelevant to a *post-racial* United States. Rather, *Death Blossoms* is an especially spectral postmodern neo-slave narrative that talks back from living-dead space to challenge global capitalist exploitation and oppression.

NOTES

1. Abu-Jamal, Mumia, *Death Blossoms: Reflections from a Prisoner of Conscience* (Cambridge, MA: South End Press, 1996), 73.
2. bell hooks, "Postmodern Blackness," in *Postmodern American Fiction: A Norton Anthology*, ed. Paula Geyh, Fred G. Leebron, and Andrew Levy (New York: Norton, 1998), 630.
3. Jean Fagan Yellin, "Introduction," in *Incidents in the Life of a Slave Girl Written by Herself* (Cambridge, MA: The Belknap Press of Harvard University Press, 2009), xx.
4. Abu-Jamal, *Death Blossoms*, 149.
5. A. Timothy Spaulding, *Re-forming the Past: History, the Fantastic, and the Postmodern Slave Narrative*. (Columbus: The Ohio State University Press, 2005), 5.
6. Robert S. Levine, "The Slave Narrative and the Revolutionary Tradition of American Autobiography," in *The Cambridge Companion to the African American Slave Narrative*, ed. Audrey Fisch (Cambridge: Cambridge University Press, 2007), 106.

7. Mumia Abu-Jamal, *Live from Death Row* (New York: HarperCollins, 2002), xv.
8. Abu-Jamal, *Live from Death Row*, 165.
9. Abu-Jamal, *Live from Death Row*, 165.
10. Abu-Jamal, *Live from Death Row*, 165.
11. Abu-Jamal, *Death Blossoms*, 78.
12. Abu-Jamal, *Death Blossoms*, 77.
13. Abu-Jamal, *Death Blossoms*, 77–78.
14. Abu-Jamal, *Death Blossoms*, 77.
15. Abu-Jamal, *Death Blossoms*, 78.
16. Abu-Jamal, *Death Blossoms*, 78–80.
17. Abu-Jamal, *Death Blossoms*, 77.
18. Abu-Jamal, *Death Blossoms*, 77.
19. Abu-Jamal, *Death Blossoms*, 81.
20. Abu-Jamal, *Death Blossoms*, 81.
21. Jacques Derrida, *Specters of Marx: The State of the Debt, the Working of Mourning and the New International*, trans. Peggy Kamuf (New York: Routledge Classics, 1994), 184.
22. Derrida, *Specters of Marx*, 172.
23. Derrida, *Specters of Marx*, 183.
24. Derrida, *Specters of Marx*, 158.
25. Karl Marx, *Capital* (Oxford: Oxford University Press, 2008), 43.
26. Marx, *Capital*, 42.
27. Derrida, *Specters of Marx*, 187.
28. Derrida, *Specters of Marx*, 173.
29. Harriet Jacobs, *Incidents in the Life of a Slave Girl Written by Herself* (New York: Modern Library, 2004), 242.
30. Derrida, *Specters of Marx*, 188.
31. Jacobs, *Incidents in the Life of a Slave Girl*, 295.
32. Jacobs, *Incidents in the Life of a Slave Girl*, 137.
33. Jacobs, *Incidents in the Life of a Slave Girl*, 137.
34. Jacobs, *Incidents in the Life of a Slave Girl*, 137.
35. Jacobs, *Incidents in the Life of a Slave Girl*, 137.
36. Jacobs, *Incidents in the Life of a Slave Girl*, 286.
37. Jacobs, *Incidents in the Life of a Slave Girl*, 182.
38. Jacobs, *Incidents in the Life of a Slave Girl*, 181.
39. Jacobs, *Incidents in the Life of a Slave Girl*, 182.
40. Jacobs, *Incidents in the Life of a Slave Girl*, 181.
41. Jacobs, *Incidents in the Life of a Slave Girl*, 202.
42. Derrida, *Specters of Marx*, 192.
43. Derrida, *Specters of Marx*, 192.
44. Derrida, *Specters of Marx*, 192.
45. Jacobs, *Incidents in the Life of a Slave Girl*, 207.
46. Jacobs, *Incidents in the Life of a Slave Girl*, 286.
47. Derrida, *Specters of Marx*, 157.
48. Jacobs, *Incidents in the Life of a Slave Girl*, 152.
49. Jacobs, *Incidents in the Life of a Slave Girl*, 240.
50. Jacobs, *Incidents in the Life of a Slave Girl*, 259.
51. Jacobs, *Incidents in the Life of a Slave Girl*, 261.
52. Derrida, *Specters of Marx*, 168–169.
53. Jacobs, *Incidents in the Life of a Slave Girl*, 279.
54. Jacobs, *Incidents in the Life of a Slave Girl*, 296.
55. Jacobs, *Incidents in the Life of a Slave Girl*, 296.
56. Jacobs, *Incidents in the Life of a Slave Girl*, 292.
57. Jacobs, *Incidents in the Life of a Slave Girl*, 292.

58. Jacobs, *Incidents in the Life of a Slave Girl*, 293.
59. Jacobs, *Incidents in the Life of a Slave Girl*, 294.
60. Jacobs, *Incidents in the Life of a Slave Girl*, 262.
61. Michelle Burnham, *Captivity and Sentiment: Cultural Exchange in American Literature, 1682–1861* (Hanover, NH: University Press of New England, 1997), 149.
62. Burnham, *Captivity and Sentiment*, 149.
63. Jacobs, *Incidents in the Life of a Slave Girl*, 270–271.
64. Burnham, *Captivity and Sentiment*, 149.
65. Abu-Jamal, *Death Blossoms*, 40.
66. Abu-Jamal, *Death Blossoms*, 4.
67. Abu-Jamal, *Death Blossoms*, 5.
68. Abu-Jamal, *Death Blossoms*, 4.
69. Jacobs, *Incidents in the Life of a Slave Girl*, 246.
70. Jacobs, *Incidents in the Life of a Slave Girl*, 264–265.
71. Jacobs, *Incidents in the Life of a Slave Girl*, 264.
72. Jacobs, *Incidents in the Life of a Slave Girl*, 249.
73. Jacobs, *Incidents in the Life of a Slave Girl*, 299.
74. Jacobs, *Incidents in the Life of a Slave Girl*, 299.
75. Jacobs, *Incidents in the Life of a Slave Girl*, 299.
76. Jacobs, *Incidents in the Life of a Slave Girl*, 299.
77. Jacobs, *Incidents in the Life of a Slave Girl*, 299.
78. Jacobs, *Incidents in the Life of a Slave Girl*, 280.
79. Derrida, *Specters of Marx*, 168–169.
80. Jacobs, *Incidents in the Life of a Slave Girl*, 299.
81. Jacobs, *Incidents in the Life of a Slave Girl*, 300.
82. Jacobs, *Incidents in the Life of a Slave Girl*, 301.
83. Jacobs, *Incidents in the Life of a Slave Girl*, 302–303.
84. Sharon Patricia Holland, *Raising the Dead: Readings of Death and (Black) Subjectivity* (Durham, NC: Duke University Press, 2000), 5.
85. Holland, *Raising the Dead*, 4.
86. Jacobs, *Incidents in the Life of a Slave Girl*, 301.
87. Abu-Jamal, *Death Blossoms*, 90.
88. Abu-Jamal, *Death Blossoms*, 90.
89. Jacobs, *Incidents in the Life of a Slave Girl*, 303.
90. Abu-Jamal, *Death Blossoms*, 90.
91. Abu-Jamal, *Death Blossoms*, 101.
92. Abu-Jamal, *Death Blossoms*, 101–102.
93. Abu-Jamal, *Death Blossoms*, 104.
94. Ashraf Rushdy, *Neo-Slave Narratives: Studies in the Social Logic of a Literary Form* (New York: Oxford University Press, 1999).
95. Abu-Jamal, *Death Blossoms*, 106.
96. Abu-Jamal, *Death Blossoms*, 107.
97. Abu-Jamal, *Death Blossoms*, 106–107.
98. Caryl Phillips, *Crossing the River* (New York: Vintage Books, 1995).
99. Carol E. Henderson, "Writing from No Man's Land: The Black Man's Quest for Freedom from Behind the Walls," in *From the Plantation to the Prison: African-American Confinement Literature*, ed. Tara T. Green (Macon, GA: Mercer University Press, 2008), 21.
100. Henderson, "Writing from No Man's Land," 13.
101. Russ Castronovo, *Necro Citizenship: Death, Eroticism, and the Public Sphere in the Nineteenth-Century United States* (Durham, NC: Duke University Press, 2001).

SIX

FORBIDDING MOURNING

Disrupted Sites of Memory and the Tupac Shakur Hologram

DANIELLE FUENTES MORGAN

The Coachella Valley Music and Arts Festival is a yearly multiday outdoor concert and festival featuring some of the biggest contemporary musical acts. Located in Indio, California, Coachella draws thousands of attendees each year, notably celebrities and socialites, interested in bearing witness to the calculated and heavily commercialized spectacle. While music and artistic expression are ostensibly centered, much of the appeal of Coachella is that it allows audience members the opportunity to participate in a "scene." It is a space to be publicly seen while performing engagement with a particular countercultural (although heavily commercialized) aesthetic. However, in 2012, the anticipated experience of the Coachella Music Festival was shifted in ways that continue to reverberate throughout popular culture. During a scheduled performance by rappers Snoop Dogg and Dr. Dre, the music shifted and began to build ominously. Suddenly, it seemed, famed California rapper Tupac Shakur slowly emerged from the bottom of the stage. Dressed in the quintessential garb of a rapper who came to prominence in the 1990s, he is shirtless, the phrase "THUG LIFE" arched across his stomach conspicuously, a weighty chain with a large, sparkling cross swinging as he swayed rhythmically, almost like a metronome. His sagging jeans were cinched with a thick brown belt to reveal a sliver of his underwear. Tupac hadn't aged a day since the mid-1990s. His muscles glistened and his voice seemed to boom through the microphone as he performed energetically—first solo, then alongside Snoop Dogg. And while the performance itself is entertaining and edgy, vulgar, and charismatic, its most prominent characteristic remains its unacknowledged ghastly nature. Tupac Shakur was shot and killed in 1996—his presence there was an aberration contrived from technology. What is especially interesting here is that, throughout the performance, his death and apparent reincarnation are never explicitly mentioned, seeming to indicate an investment in the appearance and persona of Shakur stripped from any significant context or historicism.

Shakur began by performing his hit, "Hail Mary," a song filled with imagery surrounding violence and death—including Shakur's riffing on his own imagined death. He sing-raps to the audience in the chorus, "What do we have here, now? / Do you wanna ride or die?" The audience tittered excitedly with nervous enthusiasm, perhaps unsure what this question really means when posed from beyond the grave by a specter. Shakur here was a hologram projection, "Pepper's Ghost"—literally light, smoke, and mirrors—for an audience of children of the wealthy elite.[1] The performance evoked what Coco Fusco has described as "all the feelings of the uncanny that direct encounters with the dead often produce."[2] Although visually stunning, it is a troubling

reminder of the insistent and unrelenting commodification of celebrity. In this particular instance, hologram creators AV Concepts proudly note that this resurrection was constructed not from stock footage but from newly designed imagery based on his movements while alive. It is a mimesis of his appearance and most iconic mannerisms, thus turning the fiercely independent rapper into a mere facsimile or simulacrum and disallowing grief as it disrupts even physical form as a site of memory. This hologram is a compilation of images and movements that seem to signal and signify the idea of Tupac Shakur. Yet in the process of this creation, something new and explicitly commercial emerges as Shakur's autonomously performed personality becomes capital itself. Indeed, it is this commodification of his mannerisms and physicality that is so problematic. It is expressly not an image of the living but a ghastly postmortem composite—a re-memory that refuses even a traditional assumption of respite in death. As a result, Blackness—or, more specifically in this case where the physicality of form no longer exists—a Blackness that can be located in the idea of Shakur's celebrity as a public representation of Black masculinity—becomes publicly quantifiable as the distinction between the person and celebrity is disallowed through the overt forbidding of mourning. In this sense, this hologram is a mere collection of movements and iconized phrases, in stark contrast to the whole, nuanced person—this is a collection of and itemization of traits, deliberately quantifiable and quantified. Utilizing what I identify as a refusal of Black subjectivity by disallowing the process of mourning, together with an expansion of Karl Marx's ideas of commodification and fetishism, I argue that this hologram reduces Tupac Shakur—both the lived individual and the persona—to something quantifiable, to the sum of his parts, thus demonstrating simultaneously inherent worth and worthlessness connected to the transient value of commodities. This reduction is nothing new as Black bodies have been commodified since slavery, and, in many cases, there has been an acute disavowal of Black sentience as a (sub)conscious outcome of the slave trade and this commodification of Black bodies. However, what is particularly damning about the promulgation of this hologram is the way that it commodifies a particular performance of Black masculinity by exerting control over it. Instead of introducing Tupac Shakur within the space of memory and memorialization, he is instead rendered a celebrity specter of virtuality—valuable only in performance and performativity and its ability to frame and reshape social norms as he is conspicuously consumed.

Toward the beginning of this Coachella performance, Shakur shouts out "Coachella," an especially surreal moment since there is no prior recording of his ever saying the phrase before—the Coachella Music Festival was not established until 1999, three years after his death. This calculated "utterance" is meant to signal for audiences the authenticity of a moment that is implicitly couched in the impossible. Although Shakur stood on stage silently nodding and then addressing Dr. Dre and Snoop Dogg, it is this moment—the sound of his voice in direct acknowledgment of his new audience—that receives the loudest and most fervent response from spectators. Why, then, even in the face of the visualization of Tupac Shakur is the aural component the most significant? It is this marriage of sound and image that legitimizes the celebrity of Shakur, but to consider the ramifications of this commodification of Tupac's celebrity after his death we must first consider the significance of his celebrity during his life. Not only were his records successful but he also had a burgeoning acting career, starring in the films *Juice*, *Poetic Justice*, and *Above the Rim* and a guest appearance as the frequently referenced character, Piccolo, in an episode of *A Different World*. Shakur was one of the first rappers to receive mainstream fame in addition to mainstream notoriety. His multifaceted background—a child of the Black Panthers, a student of

theater and ballet—offered authenticity and an aesthetic with roots in spoken word, jazz, and communal performance. That Shakur was confident, intelligent, attractive, and well-versed in Black history and historicity made him especially impactful in the sphere of Black cultural production. As Regina Arnold rightly notes, "[I]nserting an iconic and politically-charged singer, whose work in the 1990s redefined rap as a site of counterhegemonic speech, into a benign entertainment context, permanently and inevitably changes the symbolic weight of his oeuvre."[3] Presenting Shakur bereft of his impact in Black cultural reification damages the legacy of a man who intended himself to be more than simply an entertainer in the popular sphere.

The posthumous appearance of Tupac Shakur at the 2012 Coachella music festival, while certainly a well-executed spectacle, was simultaneously a horrifying reminder of the insistent commodification of celebrity. It reminds of Fred Astaire dancing with a vacuum cleaner long after his death, or our national obsession with what we imagine would be Abraham Lincoln's or John F. Kennedy's opinions on the state of United States politics today, and whether or not they would fall down straight, era-specific party lines. Indeed, we've taken this interest to the extent that Lincoln has even been resurrected as a vampire-hunting superhero. The process of turning an individual into a celebrity seems often to evoke and awaken desires that recontextualize the person through a lens of immortality, marked in a worshipful society that desires the paradigm of celebrity-as-ideal as a frame. Yet, more than in the past, contemporary celebrity speaks to an ability to be packaged and reproduced to serve the capitalist inclination.[4] Celebrities are forged into the idols of a secular society. It is why they are the best and most-sought spokespersons for anything commodifiable—celebrities are both the sellers and the sold product, the commodifier and the commodity. So the appearance of Shakur at Coachella is not necessarily surprising because we anticipate and demand the use of celebrity in this space—appropriate or not— infinitely, because the idea of celebrity lends itself to the idea of value where celebrities become the personification of what is valued. This is particularly true in a venue like Coachella, where much of the appeal for audience members is the expectation of celebrities participating as both spectators and performers. However, in the case of Shakur, it is damaging appropriation of this portrayal of Black masculinity—a portrayal that is predicated on autonomy and a disallowance of being owned—within the commodification of celebrity, particularly given Shakur's own self-structured and self-determined identity.

What is perhaps most striking about the insistent commodification of the image and performative prowess of Tupac Shakur is that it operates as a refusal of sorrow, a denial of the right to mourn and gain closure through the mourning. Indeed, it is a tacit rearticulation of the understanding of Black life as fraught, and as always already impending death, that facilitates this sense of recurring and consistent trauma. Dagmawi Woubshet's *Calendar of Loss: Race, Sexuality, and Mourning in the Early Era of AIDS* powerfully discusses the affective nature of Black mourning within the context of the compounding losses of AIDS in the United States and Ethiopia, and although Woubshet is addressing a distinct space and time, I would like to use his description of anticipatory loss to further examine the concerns about grief and subjectivity raised by the creation of this hologram. Most important in this discussion is the sense of forbidding mourning— that if *subjects* are afforded the right to mourn, then Blackness is compulsively rendered *object*, objectified, and abject through the refusal to allow this mourning. Woubshet writes, "There is a striking temporal difference between the two models of loss [mourning and melancholia], since the anticipation of death, as well as its passing, frame the calendar of Black mourning. From

founding genres like [N]egro spirituals to contemporary forms like hip-hop, the canon of Black arts and letters sounds a mourning of unremitting loss."[5] Woubshet is right to trace the trajectory of Negro spirituals to hip-hop in their deliberate framing of communal, continual mourning. Within this canon of "unremitting loss," these forms articulate a sense not only of the preeminence of death itself but that closure and relief are in a future place and time not of this world—that there is a "Balm in Gilead" or that a chariot is "coming for to carry me home" is echoed in unexpected ways when Bone Thugs-n-Harmony sing, "See you at the crossroads / so you won't be lonely . . . Livin' in a hateful world / sending me straight to heaven."[6] These songs underscore the idea that catharsis cannot be found in the natural world because the trauma of loss is not only prevalent but also because it is recurrent and your own life is likewise at stake.

Woubshet continues:

What underwrites black mourning—what [Karla] Holloway calls 'black death,' [Fred] Moten 'black mo'nin',' and [Abdul] JanMohamed the 'death-bound subject'—is a nonnormative, temporal relationship to death, which reiterates a death date that is time-bound, as opposed to one deferred to an open-ended future. Given the persistence of death in black life, black culture is imbued with an anticipatory sense of loss, recalibrating the calendar of mourning to record past and prospective losses in a single grammar of loss.[7]

Indeed, one of the recurrent motifs surrounding the murder of Shakur was the disbelief in the occurrence and the simultaneous sense of the inevitability of his death. This anticipation of loss was reflected by Shakur himself in the video for "I Ain't Mad At Cha," in which he imagines his own murder by gunfire and his performance in heaven surrounded by other Black musical legends, or lyrics like "Gotta sleep with my piece, an extra clip beside my dresser / Word to God, I've been ready to die since I was born" in the posthumously released "Open Fire."[8] Shakur's public life and persona were framed by his understanding of anticipatory mourning and loss, and this reading helps to explain why he has been elevated as an urban prophet in death. It could be then that the celebrity ideal, its utility, and its use-value are, at least in part, determined by the social sphere out of which the celebrity emerges. In *Celebrity Society*, Robert van Krieken explains, "The idea of celebrity is by definition individualistic—the more communal the sense of self is, the less response there will be attaching recognition and esteem to particular individuals, and the more individualistic social and cultural life is, the more likely it is that it will generate a more expansive network of celebrities."[9] If this is true, then the utility of Shakur's celebrity might be located in his ability to perform as an autonomous individual while still remarking on and, in some ways, even embracing life transience and the fraught status of Black life in America. Shakur's efforts to unite an articulation of the Black interior with a more public conception of Black identity reveal the significance of his legacy. Indeed, Shakur seemed to represent a microcosm of a possible Black identity formation, and that his life was ended and reanimated, separate from his explicit desires, seems to signify a broader problematizing of the position of Blackness in the popular realm. This deeper consideration of Shakur's celebrity and its potential utility is underscored when this hologram is viewed as emblematic of the insistent fetishization of Shakur's visual image and performed persona. Within this frame of the commodification of the object, the fetishization of Shakur and a certain performance of Black masculinity serves to dismantle anxieties surrounding the Black phallus. Marx describes fetishism as "attach[ing] itself to the

FORBIDDING MOURNING

products of labour, so soon as they are produced as commodities, and which is therefore inseparable from the production of commodities."[10] In this sense, it is this performance of Black masculinity, seen as inseparable from the persona of Shakur, that becomes fetishized and essentialized in its figuration. The irony here is that it is his seeming autonomy that framed his masculinity, and yet it is this same appearance of autonomous masculinity that becomes the commodity after his death.

Michele Wallace argues, "In the context of mass culture, the image of the black is larger than life. Historically, the body and the face of the black have posed no obstacle whatsoever to an unrelenting and generally contemptuous objectification. And yet, until recently, there has been no position within or outside American visual culture from which one could conceptualize the African American as a subject."[11] Indeed, it is in the present era, post–Civil Rights Movement, after ostensible "de jure equality," that this idea of African American subjectivity is so harshly refused because the lines demarcating marginalization must be reinscribed in different and often insidious ways.[12] This is not to say that fetishization, even as it is problematic and problematized, cannot be a space for ironic empowerment that disrupts notions of subservience by opening up a space for play within the Black interior and identity formation. Perhaps then, if the object retains its autonomy within the process of fetishization and can determine and calculate its own audience, this fetishization can impact actualization and subjectivity through a wry understanding of personhood that acknowledges the oppressor's reductive understanding of one's self while simultaneously refusing the oppressive nature of the image by choosing to embrace it. For Shakur, even if he took control of his own image of violent Black masculinity in life, in this process of pseudo-reincarnation, he loses the potential for autonomous choice and selection and is once again reduced to mere object.

Karl Marx may not have anticipated human beings themselves as commodifiable in this ghastly way, but it is critical to think about the production and reception of this hologram as reflecting— literally and figuratively—a compulsive desire to turn individuals into things, objects, and ideas of quantifiable value as related to the potential utility of commodification based on race, gender, class, and audience. Indeed, it is what Marx describes as the use value, exchange value, and the price of this hologram that has broader implications for celebrity and Black masculinity. To this end, the concerns I address about the production of the Tupac Shakur hologram and the commodification of celebrity and of Blackness take their root in the interstices of discussions about Marxism and these aforementioned mourning subjectivities. This hologram and its reception highlight unexpected ruptures in traditional discourses surrounding the political utility of personhood and the risks when even the ideas of autonomy and community may be commodified. In *Cultural Melancholy: Readings of Race, Impossible Mourning, and African American Ritual*, Jermaine Singleton offers, "Melancholy is part of the process of becoming a racialized subject—which is to say that the disavowal of social loss is what it means to be a racial subject in the world. The relations are necessarily unstable. Racial melancholy establishes itself in relation to the racial melancholy of another subject."[13] It is the "disavowal of social loss" and the structural performance of "racial melancholy" that are especially salient for the analysis of the Tupac Shakur hologram. The process of becoming the other—specifically, in the case of commodification, of becoming abject and displaced—requires that the subject refuse any substantive empathy as it gazes on the object. The other must be rendered entirely different and alien from that subject, and therein merit no substantive compassion, or the process of dehumanization will

125

DANIELLE FUENTES MORGAN

fail. This performance at Coachella makes manifest this potential as it presents itself as an imprecise tribute while ultimately stripping Shakur and his initial, *intended* audience of autonomy or the right to collective grief. Instead, the risk is that grief gets replaced by a sense of detached frivolity for audience members who were too young to remember Shakur as he was or to have participated in mourning him—or who were certainly not expecting Coachella to be reframed as a site for potential mourning—alienating and marginalizing those who have a place within the rites of mourning. It is meant, perhaps, to conjure a sense of vague nostalgia, but even this nostalgia is stripped of historical specificity or even the rites of melancholy and so it may ring false. What might it mean to lose the right to melancholy while witnessing a new context for the *appearance* of memory and memorialization? By presenting Shakur in this form, intentionally or not, he loses his humanity as he is rendered a commodity, and commodities are engineered to entice as large an audience of consumers as possible, no matter their initial intention, form, or content. If, as Justin A. Williams argues, "In post-mortem sampling, authenticity can be claimed through the use of the recorded sound or image, and its framing through recontextualisation," that this new context has implied validity when significantly stripped of its historical and political significance is troubling and has serious implications for the commodification of Blackness.[14] In the case of the Tupac Shakur hologram, it is not simply that Blackness is rendered a commodity, but that the commodity is meant to stand in for a lived experience of not only Blackness but of individual Black people. While Shakur himself may have participated actively in the commodification of his own image as stand-in for Blackness during his life, the implications are particularly troubling when the commodification is outside of his explicit choosing.

It can then be useful to return to Marxist critiques of capitalism insofar as they may lend themselves to a more overtly racialized adaptation, in which race itself is offered up in the creation of not only the racial subject but the racialized, commodified object. Marx's *Capital: A Critique of Political Economy* offers a foundation for these possibilities. Marx argues that materials become commodities once their utility is altered. He notes, "The form of wood, for instance, is altered, by making a table out of it. Yet for all that the table continues to be that common every-day thing, wood. But, so soon as it steps forth as a commodity, it is changed into something transcendent. It not only stands with its feet on the ground, but, in relation to other commodities, it stands on its head, and evolves out of its wooden brain grotesque ideas, far more wonderful than 'table-turning' ever was."[15] Similarly, Shakur is both reduced from his form as living breathing human being while he is also magnified to the mythic by his existence as hologram. While this simultaneity seems initially incompatible, Marx's assertion that a shifting of form to commodity results in transcendence demonstrates how this might be. Marx provides an interesting critique, then, because of a potential connection with a treatment of mourning. If the *appearance* of mourning is a mode of feigned behavior turned itself into a commodity, as it is in the case of this hologram, is the denial of closure and consolation part and parcel to commodification?

Marx continues by explaining, "Could commodities themselves speak, they would say: Our use-value may be a thing that interests men. It is no part of us as objects. What, however, does belong to us as objects, is our value."[16] However, in this case, the commodity certainly once *could* speak and is intentionally muted and stripped of its context. In this way, its value is conflated with its use-value and thus is equivocated to its position as the object. For Shakur, in life, he was insistent on determining his own portrayal and performance and was deliberate in defining his value on his own terms, but his role as postmortem celebrity commodity reframes and shifts the

126

value. As a result, the notion of celebrity *becomes* tantamount to the celebrity person and persona as marked by its other-determined use-value. Robert van Krieken addresses the utility of the idea of celebrity, writing, "Celebrity should not be understood as distinct from 'real' achievement, so that one is *either* a hero *or* a celebrity. In reality, the two are combined in some way, so that every celebrity lies somewhere on a spectrum combining achievement or talent, and what can be called the 'surplus value' of celebrity, or the 'celebrity effect'—that is, the independent value of 'well-knownness.'"[17] It is the surplus value of celebrity that ultimately determines its perceived use-value and highlights the particular utility of celebrity. In this sense, celebrity is not frivolous or incidental—instead, in many cases it acts as cause for consumption, even postmortem, for its representativeness of or aberration from current societal norms and, in ways that work intentionally to reframe future norms and expectations of social behavior. For the racialized object, this possibility has deep repercussions.

It is unsurprising that the first prominent and incredibly public reincarnation of this kind is of a Black male celebrity, and one who touted the "thug life" and a very specific performance of self-determined Black masculinity. Aimé J. Ellis explains in *If We Must Die*, "As peculiar as it might seem, the thug life affords these young men the opportunity to choose death or, more precisely, what social anthropologist Michael Taussig calls 'the space of death' to carve out an exhilarating racial and social identity that offers a gratifying if only fleeting and illusory sense of control and strength."[18] At the time of the shooting that took his life, many fans remained optimistic that Shakur would survive. Indeed, he had been shot before and survived—he was robbed and shot five times in the lobby of a recording studio in Manhattan—so certainly he could survive again, as though one result logically follows the other. Of course, this rationalization proved false— and, for some, it was only the publication of Shakur's autopsy and postmortem photographs that offered a degree of proof. Still, this belief not only indicates that Shakur's masculine persona was so prevalent that his fans began to believe it made him nearly supernatural. Perhaps even more significantly, it seemed to indicate that this supernaturality was a necessary condition of his persona. Thus, if the thug life not only acknowledges the inescapability of death but also unflinchingly anticipates it, Shakur's survival only solidified his position as transcendent icon—a persona only intensified by the incessant release of posthumous albums and samples.[19] Nicole Fleetwood articulates the potential problems of the icon as racialized figure:

> While the icon carries the trace of godlikeness, to render a subject as Black within various histories and discursive traditions means literally and symbolically to denigrate: to blacken, disparage, belittle. The verb *to denigrate*, with its Latin origins and roots in light/dark metaphors, means not only "to blacken" but also "to defame," "to discredit." To denigrate is a castigation in which darkness is associated with incivility, evil, mystery, and the subhuman. Racial iconicity hinges on a relationship between veneration and denigration and this twinning shapes the visual production and reception of Black American icons. The racial icon as both a venerated and denigrated figure serves a resonating function as a visual embodiment of American history and as proof of the supremacy of American democracy.[20]

This tension between veneration and denigration is heightened if we consider that this impulse toward iconography is driven by the insistence of commodification, where veneration emerges through replication and denigration through control. In the case of Shakur, the

desire to center this particular performance of self-determined Blackness as noteworthy and representative while simultaneously denying it rights to autonomy underscores the position of the racial Object, "iconized" or otherwise, within the frame of the trajectory of American history—even as it is rearticulated as stripped from its original context and historicity.

What then does it mean when Shakur *is* killed but resurrected in 2012 against his presumed will or perhaps even against his own articulated desire? This re-presentation of Tupac Shakur sends a disturbing message, and one that has ramifications beyond the legacy of the man himself. Not only does it indicate that there is a desire to continue to commodify celebrity eternally, but the specific demonstration of a desire to take ownership of a performance of Blackness—of the very idea of Blackness as it is often presented and understood within mainstream publics—but to take ownership of it and become its puppet master. It seems then that use-value has increased after his murder—his posthumous album sales are astronomical, even prior to 2012's rejuvenated interest in his life with the creation of the hologram. Shakur's murder is to this day unsolved, and no significant leads have been found or followed.[21] Criticism has been levied at the Las Vegas Police Department and the FBI that there is little interest in bringing the murderers of a seemingly menacing Black man to justice, regardless of how famous, how "iconic," he may be. As such, Shakur's death never provided the closure for his family, his fans, or even for the man himself. The unsolved nature of Shakur's death disallows much of the comfort associated with images of the dead securely "resting in peace." This feeling of incompletion is substantively enhanced by the hologram that not only reincarnates the man but brings him back in a completely new form. This new image purports to be the same as the old image but ultimately acts as an uncanny memorialization that refuses memory-making—the appearance of this man-made memorial replaces the original, removing its uniqueness and actualization by stripping it down to reproducible parts in performance. The creators thereby quantify Black masculinity and strip Shakur of his autonomy in its performance. In this way, the Tupac Shakur hologram permits the unapologetic fetishization of both celebrity and Black masculinity, indicating that even death itself is no respite from commodification. In fact, we see that Black death may be even more at risk of this grotesque fetishization than the always already commodified Black life.

What this Coachella appearance shows instead of an authentic memorialization is the shadow without the substance, an articulation of the content of Black masculinity as Shakur performed it bereft of the critical context, and Shakur's background is particularly significant to a full understanding not only of his significance in the 1990s but of his legacy. Both of his parents were members of the Black Panther Party, and Shakur's mother, the late Afeni Shakur, was pregnant with him while imprisoned as a member of the New York "Panther 21." As a result of this upbringing and public family history, there were always revolutionary undertones—and, in some cases, overtones—to his work. When Shakur expressed distrust of the police and the state, there was a wider meaning behind it that ran even deeper than personalized rage—his upbringing offered clear and spoken parameters for his understanding of the "thug life" as a chosen self-articulation. None of this can be captured in this new performance—a performance that happens without his permission and denial of his compliance. Instead, despite their efforts to leave his real, significant absence unacknowledged, the presence of this hologram either misconstrues Shakur's legacy for unfamiliar spectators or reiterates his absence for his former, intended audience. It is as Regina Arnold posits, "The use of Tupac's body in this manner falls directly into this paradigm, with its deadness combining with its blackness to reduce his artistic identity to the

FORBIDDING MOURNING

simplified signifier of black male body."[22] Indeed, it is this commodification of his mannerisms and physicality without any sense of autonomy or context that is so problematic—it is not an image of the living but a ghastly, simplified composite created after his death. It is disturbing because no aspect of the image is then ultimately *real* although it is coded as such. Indeed, making Shakur appear to move anew by replicating his past performances only enhances the grotesque aspect of this reincarnation.

This sense of grotesque unreality is heightened by Shakur's presence next to and interactions on stage with rapper Snoop Dogg—forty years old at the time of the Coachella performance.[23] As the artists would be the same age had Shakur lived—both were born in 1971—Shakur's presence as an eternal twenty-four- or twenty-five-year-old next to Snoop simultaneously reminds audiences of his own untimely death while still refusing to acknowledge it overtly. Similarly, it evokes the anticipatory loss connected with Black life—if the leading cause of death for Black men under the age of thirty is homicide, then Snoop himself as an aged gangster rapper may signal the seeming anomaly. And again, because this reality of Shakur's death remains self-consciously and insistently ignored, there is no implication that the audience is witnessing a touching reunion—Shakur is instead simply an uncanny anachronism. When the performance begins, Shakur introduces the two men and the song they perform by saying, "Two of America's most wanted in the same motherfuckin' place at the same motherfuckin' time." Yet, when viewed *in time*, this assertion is peculiar if the audience considers the trajectory of Snoop Dogg's career. Snoop has not articulated a threatening persona since the turn of the twenty-first century. Starting in the early 2000s, Snoop reinvented his gangsta persona and emerged as what can only be described as an "affable pimp" before shifting entirely into a family-friendly mode. In the twenty-first century, the former gangsta rapper has been decidedly mainstream, hosting his own sketch comedy show called *Doggy Fizzle Televizzle,* and making comedic turns on *Saturday Night Live.* He's starred in his own reality television show, *Snoop Dogg's Fatherhood*—a show chronicling his family life with his wife and children. He's performed at the Kennedy Center Honors in Herbie Hancock's honor and been featured in commercials for Old Navy. He's even coached a team in a youth football league. He's come a long way from being charged with and ultimately acquitted of murder—Snoop was actually faced with a charge of real violence, and it is this moment that may have served as impetus for his reinvention. It would be fruitless to speculate about whether or not Shakur might have reinvented himself in a cuddlier image, although the vast majority of his compatriots have as they entered their late thirties and early forties, but what is significant is that this resurrection disallows the possibility. Like James Dean, Marilyn Monroe, or the Notorious B.I.G.—his friend and later rival, a rapper who was gunned down under similarly mysterious circumstances in 1997—Shakur's image and persona are frozen in time. He is eternally young—the embodiment of the romanticized notion that it is better to "live fast, die young, and leave a beautiful corpse"—and eternally gangsta, but few of his contemporaries are either of those things anymore, and this evolution is significant.[24] Sean "P. Diddy" Combs is now a hype man turned rapper turned business mogul; Ice Cube, who got his start in the seminal rap group NWA, is now perhaps more famous in loveable film roles like *Barbershop* and the family-friendly *Are We There Yet?*; Ice-T is now recognized from TV's *Law and Order: SVU* and his own E! reality show, *Ice Loves Coco.* And these are just a few examples—there are a wide number of rappers who came to prominence in the early and mid-1990s and then reinvented themselves as actors, businessmen, and father figures as the years progressed. It is this strange evolution that makes the

appearance at Coachella so unnerving and couched so clearly in a desire to commodify memory of Shakur bereft of context. The rapper shouldn't still be on stage performing these same songs—and certainly not with the same dance moves and physical appearance as at the time of his death. He, like his compatriots, should have evolved into something else—and in his brief career, we see indications that Shakur was interested in continuing to change and advance. The visual presence and performance of Snoop Dogg offers implied validity of that which is already known to be impossible. While the performance tacitly denies Shakur's death for the purposes of commodification, it ultimately only highlights the fact that something inappropriate—something grotesque—is occurring here.

Indeed, although it isn't the first time a prominent Black male celebrity has been resurrected—one need only consider Nat King Cole's recurring presence, particularly as his daughter's duet partner—but the appearance of Shakur is substantively different from Natalie Cole's singing "Unforgettable" with her late father. Cole sings with recorded footage of her father performing, and her sadness at his loss is palpable. When Cole sings with her father, there is an overt acknowledgment of his physical absence, underscored by the distance implied by her presence with his prerecorded image. This moment is bittersweet and tender—at its heart, it is a daughter's tribute to her father.[25] But there is none of this emotionality to the moment between Shakur, Snoop Dogg, and Dr. Dre. The three men greet each other as they always have—there isn't even a flickering moment where Dr. Dre or Snoop acknowledges the apparent miracle of Shakur's reemergence or their pleasure upon seeing him again. Instead, they perform as though Shakur's presence is natural and to be expected, when it is decidedly unnatural. There is no implication of homage or compliment. It is as though it is only right that Shakur be on stage, not because his life was cut too short and he gets a chance to live again but because he is a performer and as such should continue to perform. Not only is Shakur here disallowed the opportunity to rest in peace as he is summoned to perform for voyeuristic entertainment, but it is never acknowledged that he is dead in the first place. It is as if his death is of less significance than the fact that a method has been created to bring him back. The uncanny and distasteful nature of this performance is further elucidated when Arnold argues,

> Shakur's 'live' performance was not the first of its type, it was just the lengthiest and the most surprising. Will.i.am appeared via hologram talking with Anderson Cooper on CNN on election night 2008. Al Gore appeared as a hologram at Live Earth Tokyo. Celine Dion even sang a duet with a hologram of Elvis Presley on an episode of *American Idol*. Shakur's performance at Coachella, however, was unique in that it didn't merely project a prerecorded message in a 3D manner to a mediated audience; rather, by presenting itself to a live audience, it passed off what was billed as a *new* performance by a dead man as a *current* one.[26]

It is the insistence of this performance as current—that its timeliness and relevance are offered up as proof of its usefulness—that further problematizes the performance of the hologram. The production company that orchestrated the production explained, "This is not found footage. This is not archival footage. This is an illusion."[27] Yet even here the meaning of the illusory is collapsed with realism—that because the hologram had the appearance of the actual, living Shakur while being wholly invented material implies some synonymity between that which is *real* and

FORBIDDING MOURNING

that which is the constructed to *appear* as or *emulate* the real. Ultimately, it is the lack of nuance and subtlety that further heightens this sense of unreality, of only appearing as real. The movements of the projection are either exactly what Shakur has done in the past—although they are expressly also *not* the archival imagery of Shakur's movements—or there is no template for the movement and so it does not exist in reality, only in *surreality*. In its strange insistence on the illusion as authentic and somehow original, the anachronistic nature of Shakur's appearance only underscores the uncanny feelings associated with the resurrection of the dead.

Shelley D. Brunt elucidates the peculiarities of this merger of the dead performer and the living counterpart in a broader conversation about the posthumous duet. She writes, "Despite the realism, these relationships could never have existed outside an editing suite. The power of the producers of this video is undeniable, as is the lack of agency of the dead, the malleability of the star image, and how it can be manipulated after the star has died. . . . These questions are about the producer's intent, but they are also about a perceived positive response from fans."[28] Indeed, while the intent in many of these hologram resurrections seems to be either a sort of unfocused homage or technological braggadocio, it is what Brunt describes here as the "power of the producers" and "perceived positive response from fans" that merit further inquiry. The ending of the performance, in this sense, offers a useful framework. In the second half of this spectacle, Snoop Dogg reemerges on stage and the two perform "2 of Amerikas Most Wanted," dancing next to each other on stage. When the song ends, Snoop leaves the stage hurriedly and without any signal that the performance itself is coming to a close. Tupac is left alone onstage, head bowed. A seeming technical glitch or inadequacy of the venue—perhaps the limitations of the form itself—results in his sliding back and forth in this moment of representative stillness. Suddenly, Shakur's image explodes into a burst of light and disappears. That Shakur disappears without audiences' anticipating the hologram's dissolution—recollecting Shakur's actual death in its suddenness and its destruction of Shakur's physical form—troubles the potential of this performance as homage and renders it instead sheer spectacle. Even if it were intended as tribute, the implicit violence of Shakur's murder, echoed through this concluding disruptive image, refuses the potential of audience catharsis.

Shakur at Coachella is an illusion of light, and this is violently underscored by his conversion into the overwhelming light of a starburst at the performance's end. In both the performance and its jarring conclusion, he becomes the embodiment of optic Blackness as it is problematically reframed in popular and consumerist scenarios. W. T. Lhamon, Jr., offers an incisive analysis of these stakes, arguing that "[Optic Blackness] struggles to lever into view a particular Blackness that disaffected peoples of every ethnicity in the United States evoke to signal their dissatisfied relation to American and Atlantic history. Optic Blackness is a contrapuntal cultural style that opposes whiteness, is available to participants who include, but certainly are not limited to, blacks, and embodies a persistent countermemory of historical opposition."[29] If optic Blackness is a counterpoint, a turn away from the predominant cultural accoutrements of the mainstream, Shakur's positioning here is a dangerous reification of the subversive mode. By essentializing Shakur through his most reproducible optics, his commodified version becomes the stand-in for what he actually represented—a shorthand way to demonstrate his value and his valuation. He becomes, in this sense, bling personified.

Krista Thompson traces the trajectory of "bling" as a term by writing, "Coined in 1998 by the rapper B.G. (Baby Gangsta) of the New Orleans-based group Cash Money Millionaires, the term

131

DANIELLE FUENTES MORGAN

bling originally referred to expensive jewelry. 'Bling' quickly entered common parlance and by 2003, the *Oxford English Dictionary* defined it not only as a 'piece of ostentatious jewellery' but also as any 'flashy' accoutrement that 'glorifies conspicuous consumption.'"[30] This second definition is of special significance to an understanding of the hologram within the frame of consumable Blackness. Bling, in this manner, is not to elevate the object, although it is often used as a nearly onomatopoetic description of the shine associated with decadence. Instead, when viewed as the accoutrements of consumption, and this consumption must be *conspicuous*, then the object's utility may experience a *reduction* as it is seen as too calculated. Thompson rightly continues her argument:

> Bling calls attention to the moment when the commodity displays its opulence in the visual field, when it reflects a shimmering light from its luminous surface. It captures the moment, so central in contemporary hip-hop, when consumption becomes conspicuous. Even as bling denotes an investment in the light of visibility, the concept may also be seen to pinpoint the limits of the visible world: the instant that reflected light bounces off a shiny object, it denies and obliterates vision. It saturates the visual plane, ultimately blinding the viewer. . . . Bling, then, conveys a state between hyper visibility and blinding invisibility, between visual surplus and disappearance. It signals a state of the sublime, the physiological—even painful—limits of vision. Bling, in short, illuminates an approach to visibility in which optical and even blinding visual effect has its own representational value.[31]

If bling manifests itself in the tension of the visible and invisible—it both enhances and destroys the visual plane in a moment—what does it mean if the object itself is destroyed? In the case of this hologram, it may demonstrate to audiences not only the vicissitude of life but their lack of control in it by ultimately taming the seeming ferocity of Shakur. For a figure iconized for his autonomy, this is particularly troubling. Shakur's image is conjured without his consent and then destroyed in the same sudden manner, an especially damning prospect when the representationality of the image and the reality of the individual are collapsed. What ultimately is the utility of having Shakur appear posthumously, and in this venue? If it forbids mourning, what does it require of spectators in its place? In reference to the violent persona of many of these popular Black male figures, Ellis argues, "While the destructive element of these practices is readily apparent, what can be said about the emancipatory, triumphant sense of power many of these men claim to experience? How can we understand the paradoxical (and counterintuitive) assertion that death and defiance (especially in the face of death) are humanizing, a proclamation of one's ability to have some 'say' in confronting what many black men see as their inevitable and imminent fates?"[32]

Although Shakur raps in "Hail Mary," "I'm a ghost in these killing fields," at Coachella he is not even a ghost; at least a ghost is presumed to have autonomy in deciding where and whom to haunt. Quite troublingly, this resurrection is a mimicry of his form and most iconic mannerisms, thus turning the fiercely independent rapper into a mere facsimile. It takes on a life of its own and even serves to replace him. By forbidding mourning, this performance leaves Tupac's reality unspoken and instead highlights the inherent performativity couched in the Black masculine. It implies that, like celebrity, the Black masculine is easily reproduced. However, unlike celebrity, which seems to place value on the originality of the celebrity—which is why we concern

ourselves with the use of original footage or actors transforming into their interpretations—the Tupac hologram makes the original something quantifiable, thus demonstrating simultaneously its worth and worthlessness. The worth is shown in the seeming value of his representation, but this representation is ultimately worthless because it can be created and replicated so seamlessly. Shakur is valuable in performance, but even when his physical presence is removed, he can still be recreated. If Shakur's sheer physicality can be so easily reproduced and reperformed, then what was ever so unique about him in the first place? He is instead a specter. His movements and mannerisms are thus quantified and calculated for profit. Certainly, the argument could be made that he was already a willing participant in his own commodification and that he embraced a particular performance of the Black masculine for his own gain. Perhaps this is true. But it is important to remember that Shakur was also well known for his efforts at self-determination. Whatever portrayal of the Black masculine he utilized, its most significant aspect was that he chose it, created it himself, and occupied it as a space for play within the realm of Black identity formation. The disruption of this autonomy by demonstrating how easily its appearance can be replicated is a particularly disturbing effect of the commodification of this performance of Blackness and of Black celebrity more broadly, and, even if unintentional, speaks directly to the consistent refusal of Black subjectivity.

NOTES

1. Although Tupac Shakur's image here is not, technically speaking, a hologram—it is, instead, a reflection of an image using light, smoke, and mirrors—I refer to it throughout this chapter as a hologram as shorthand in consideration of the original press release and the popular discourse surrounding this image. Further, I have chosen not to include a reproduction of the hologram in order not to participate in the commodification and co-optation of Tupac Shakur's image. I am inclined to reserve a space for mourning by allowing Tupac Shakur to rest in power, free from spectacularization.
2. Coco Fusco, "Better Yet When Dead," *Coco Fusco*, accessed December 5, 2015, http://www.thing.net/~cocofusco /subpages/performances/performancepage/subpages/betteryetwhendead/betteryetwhendead.html.
3. Regina Arnold, "There's a Spectre Haunting Hip-hop: Tupac Shakur, Holograms in Concert and the Future of Live Performance," in *Death and the Rock Star*, ed. Catherine Strong and Barbara LeBrun (New York: Routledge, 2015), 178.
4. This may be one possible way to think about the prominence of the cult of personality in relation to the broadening reach of celebrity and reality television stardom—the idea of celebrity has become discrete from the traditional supposition of physical, artistic, performance, or aesthetic "exceptionality" and instead often contemporarily is found in the willingness of the celebrity to capitalize on their own image and persona. The popularity of the Kardashians, for example, may speak to this new framing of celebrity—they may or may not be "exceptional," but they are exceptionally willing to participate in their own commodification while living.
5. Dagmawi Woubshet, *The Calendar of Loss: Race, Sexuality, and Mourning in the Early Era of AIDS* (Baltimore, MD: Johns Hopkins University Press, 2015), 18.
6. The first two quotations are taken from the Negro spirituals "Balm in Gilead" and "Swing Low, Sweet Chariot." The final quotation is from Bone Thugs-n-Harmony's 1996 song, "Tha Crossroads," from the album *E. 1999 Eternal* produced by Ruthless Records.
7. Woubshet, *The Calendar of Loss*, 19.
8. Both "I Ain't Mad at Cha" and "Open Fire" were released after Shakur's murder—"I Ain't Mad at Cha" was released on the album *All Eyez on Me*, produced by Death Row and Interscope a mere two days after his death; "Open Fire" was released in 1997 on *R U Still Down? (Remember Me)* by Amaru, Jive, and Interscope and was

the first of his posthumous albums to be released without his creative control. Importantly, while the video for "I Ain't Mad at Cha" does resurrect the figures of deceased African American performers (silently played by actors), this usage does not conjure the same concerns as the hologram as the images are structured intentionally to convey the peaceful afterlife of these performers and reify their legacies postmortem.

9. Robert van Krieken, *Celebrity Society* (London: Routledge, 2012), 24.

10. Karl Marx, *Capital: A Critique of Political Economy*, ed. Frederic Engels (Chicago: C. H. Kerr, 1909), 83.

11. Michele Wallace, "Afterword: 'Why Are There No Great Black Artists?' The Problem of Visuality in African-American Culture," in *Black Popular Culture*, ed. Michele Wallace (New York: The New Press, 1998), 335.

12. I specifically mention "de jure equality" with quotation marks here in consideration of the fact that where laws are usually written in such a way that disallow discrimination in theory, the practice still demonstrates enormous disparities based on race and class.

13. Jermaine Singleton, *Cultural Melancholy: Readings of Race, Impossible Mourning, and African American Ritual* (Champaign: University of Illinois Press, 2015), 9.

14. Justin A. Williams, "Post-Mortem Sampling in Hip-hop Recordings and the Rap Lament," in *Death and the Rock Star*, ed. Catherine Strong and Barbara LeBrun (New York: Routledge, 2015), 190.

15. Marx, *Capital*, 81–82.

16. Marx, *Capital*, 95.

17. van Krieken, *Celebrity Society*, 7.

18. Aimé J. Ellis, *If We Must Die: From Bigger Thomas to Biggie Smalls* (Detroit, MI: Wayne State University Press, 2011), 93.

19. Shakur's most recent complete posthumous album was released in 2007, a full eleven years after his death. The prevalence of these albums contributed to a belief that Shakur was still alive and still creating new music, perhaps best underscored comically in a 2006 *Chappelle's Show* sketch in which a Shakur record playing at a club makes uncanny references to current events the rapper could not have witnessed or anticipated.

20. Nicole Fleetwood, *On Racial Icons: Blackness and the Public Imagination* (New Brunswick, NJ: Rutgers University Press, 2015), 7.

21. As of September 2023, an arrest and indictment was finally made in the case of the 1996 murder of Shakur.

22. Regina Arnold, "There's a Spectre Haunting Hip-hop," 182.

23. This performance was a mere three months before Snoop Dogg reemerged as Snoop Lion, a name he said he was given by a Rastafarian priest during a trip to Jamaica.

24. This quotation is usually attributed to actor James Dean—another figure of virile masculinity who died tragically in his mid-20s—but the popularization may instead stem from the 1949 movie, *Knock on Any Door*, adapted from African American author Willard Motley's 1947 novel of the same name, in which a character says his motto is, "Live fast, die young and have a good-looking corpse!"

25. Indeed, when Natalie Cole herself passed away in 2016, this footage was recirculated as tribute to both.

26. Arnold, "There's a Spectre Haunting Hip-hop," 177.

27. "Tupac Hologram May Go on Tour," *Rolling Stone*, April 17, 2012, http://www.rollingstone.com/music/news/tupac-hologram-may-go-on-tour-20120417.

28. Shelley D. Brunt, "Performing Beyond the Grave: The Posthumous Duet," in *Death and the Rock Star*, ed. Catherine Strong and Barbara LeBrun (New York: Routledge, 2015), 170.

29. W. T. Lhamon, Jr., "Optic Black: Naturalizing the Refusal to Fit," in *Black Cultural Traffic: Crossroads in Global Performance and Popular Culture*, ed. Harry J. Elam, Jr., and Kennell Jackson (Ann Arbor: The University of Michigan Press, 2005), 111.

30. Krista Thompson, "The Sound of Light: Reflections on Art History in the Visual Culture of Hip-Hop," *The Art Bulletin* 91, no. 4 (2009): 483.

31. Thompson, "The Sound of Light," 483.

32. Ellis, *If We Must Die*, 93.

PART III

SPECTRAL TECHNOLOGIES OF HIP-HOP

SEVEN

THE AFTERLIFE IN AUDIO, APPAREL, AND ART

Hip-Hop, Mourning, and the Posthumous

SHAMIKA ANN MITCHELL

COCHISE: This is for the brothers who ain't here.
TYRONE: Forget them, man. If they ain't here, they don't get none.
COCHISE: There's a lot of brothers who's dead or in jail, and we just got to give them a little
bit of respect. Understand?

—*Cooley High*

This classic scene from *Cooley High* (1975), a film that highlights the transition of boyhood to manhood in 1960s Chicago, is one in which the main characters are pouring wine to pay respect for their brethren who are not with them. The motif of memorializing fallen comrades is not unique to hip-hop, but this libation takes on new meaning in this context. Because *Cooley High* was immensely popular, this scene inspired many rappers' verses and remained within the consciousness of the upcoming generation. Perhaps because hip-hop is a culture that was borne out of institutional oppression, socioeconomic struggle, and systemic violence, it is not unusual to have hip-hop artists talk about death and dying. Because hip-hop is both a product and part of the African Diaspora, the act of remembering the departed has ritual significance that links it to the afterlives of slavery and the traditions of African spiritualism. Throughout its existence, hip-hop has experienced losses great and small; whether the deceased is a person of international fame or someone of local notoriety, mourners among the hip-hop community honor and remember those who have died in myriad ways. Whether the deaths are due to state violence, street violence, natural causes, or accidents, the music that is created out of this grief is bittersweet; the mourning inspires creation of music and is imbued with a sense of loss that is deep and sometimes overwhelming. The music, in turn, becomes a form of memorial that evokes and invokes the legacies of hip-hop artists whose physical existence has faded. In essence, the music becomes an aural libation.

MUSICAL MOURNING

Musical mourning in hip-hop takes on death and dying in a variety of contexts. Rapper Nas's music is inspired by the untimely murder of his friend Ill Will. KRS ONE soldiers on with Boogie Down Productions after DJ Scott La Rock is killed while trying to mediate a conflict. Wu-Tang Clan member Ol' Dirty Bastard (ODB) accidentally overdoses and leaves an unfillable void. Notorious B.I.G. fixates on death and dying in his two albums *Ready to Die* and *Life After Death*, and is later murdered. Tupac Shakur's murder continues to be devastating to the hip-hop community, and his holographic resurrection brings new hope to audiences. Harlem's Big L also continues to be remembered in lyrics by his Diggin In The Crates (DITC) crew. NWA founder Eazy E's sobering death from AIDS-induced pneumonia still saddens. Pro Era's Capital STEEZ's suicide still stuns fans. Chinx was murdered in what appears to be a targeted killing, and fellow Coke Boy rapper French Montana works to keep his memory alive. Big Pun's weight loss efforts could not deter his massive heart attack, and his partner in rhyme, Fat Joe, still feels the sting of his absence many years later. A Tribe Called Quest continues to mourn the loss of Phife, who struggled with diabetes and eventual kidney failure. Boot Camp Clik member Sean Price dies suddenly in his sleep, weeks before his album *Songs in the Key of Price* is scheduled for release. To celebrate his life and promote ending street violence, Nipsey Hussle's fans continue to circulate his music on social media. Juice WRLD dies of an accidental overdose, and years later, fans still post memorial messages on social media. Young Dolph is murdered, and mourning fans continue to flood his social media with words of sadness and appreciation. In these and many other instances, the afterlife is most commonly represented in the music and merchandise associated with the artist. The music that artists recorded prior to their deaths is released posthumously and can usually be a financial boon to the label and the artist's family. It is uncanny to hear music from people who have died, especially when the lyrics either proclaim their demise, or perhaps proclaim their will to live and thrive. Due to systemic racism and state-sanctioned violence, hip-hop artists and their communities are constantly bombarded with images of death, such as anti-Black police brutality, and they are forced to contemplate their own mortality daily. Their music, then, becomes a sonic testimony to lost lives, an audio obituary.

An obituary is a public account of a lived life. It is often filled with details about professional and personal milestones, as well as the cause of death. Of course, some obituaries will give extensive information and some will be vague; however, an artist's catalogue and body of work can become the most reliable archive. In many instances, the artist's work functions in a manner similar to a journal or diary. The audience learns about the artist's hopes, fears, struggles, vulnerabilities, and sources of happiness. When an artist dies before the release of a project, the work created takes on additional meaning. People listen for clues to understand what was happening in the artist's life. When the artist has a social media account, those posts will be heavily scrutinized for meaning. For example, moments after Capital STEEZ posted this Twitter message, "The end,"[1] he flung himself off the roof of a building and plummeted to his death.[2] Fans immediately scoured his lyrics for hints of distress but only pieced together moments of lyrical brilliance that still have many wondering what happened and why.

THE AFTERLIFE IN AUDIO, APPAREL, AND ART

LIBATION

"One of the most important means by which deceased elders [in Ghanian culture] are summoned to participate in the world of the living," scholar Boatema Boateng argues, "is through the offering of libations."[3] This ritual of pouring libations finds its place in the practices of mourning in contemporary hip-hop. As in the scene in *Cooley High*, one such way to remember those who have died is to pour liquid libation consisting of any combination of alcohol or liquor, blessed or sacred oils, juices or sap, or simply water. The ritual pouring of libation is an act of cultural memory, one that has been brought to US hip-hop culture through diasporic circuits. According to Kimani S. K. Nehusi, "The origins of the ritual of libation are so ancient that even to the people of the ancient Afrikan state of Kemet they were obscure, lost in the mists of time, and therefore accounted for in legend and myth."[4]

Tupac Shakur's "Pour Out a Little Liquor" specifically echoes the libation scene from *Cooley High*. During his lifetime and career, the late Tupac Shakur, also known as 2Pac, released several songs that focused on death, dying, and memorializing those who have died. The main message in this song is that the speaker misses his friend, and that other people should pour libation to remember their loved ones. "Drinkin' on gin, smokin' on blunts, and it's on. / Reminiscing 'bout my niggas, that's dead and gone. / And now they buried. Sometimes my eyes still get blurry, / Cause I'm losin' all my homies and I worry."[5] The pain of this loss is expressed in the lyrics through drinking in excess. Libation can also mean pouring liquor into oneself via consumption, and not just pouring liquid onto the ground or into an empty glass.

The libation thus becomes not only a ceremonial tribute, but also a means of numbing and escaping trauma. Inebriation often accompanies bereavement; that is to say, mourners are inclined to consume alcohol to alleviate their sadness or to quell their nerves. As stated in the Book of Proverbs:

> Give strong drink to one who is perishing,
> and wine to those in distress;
> let them drink and forget their poverty,
> and remember their misery no more.[6]

Drinking to forget, or as a sign of remembrance, are both acts of mourning. In some instances, the altered state of consciousness induced by alcohol may be experienced as a means for spiritual or metaphysical communication with the dead. In his song, "Voices," Blaq Poet discusses having inebriated interactions with 2Pac, Notorious B.I.G., ODB, Big L, Eazy-E, and Big Pun, all of whom have died: "Damn. I'm hearing voices. Gotta' stop drinking that Henny. I know that shit's poison. Damn. I hear voices in my head. Niggas that's live, niggas that's dead."[7] This lyrical communion/communication is not only a form of necromancy or conjuring, but also a form of spiritual affinity and attachment.

SHAMIKA ANN MITCHELL

ELEGY AND DIRGE

Elegy, from the Greek *elegos* or "song of mourning," is a classical literary form of lamentation for the dead, traditionally composed in couplets, that has a unique iteration in hip-hop. The hip-hop elegy employs the literary device of apostrophe, in which the speaker addresses the present absence of the deceased, and most frequently does so in the form of song:

> Readers and writers of the later Middle Ages and the Renaissance seem to understand that elegy is a kind of poetry in which metrical, psychic, and fictional elements converge around the problem of addressing something not present in or to the poem. Towards the end of the seventeenth century, the problem is made regular in a modern generic disposition: elegy as a lament for the dead.[8]

Hip-hop elegy, however, can take on a variety of forms of lamentation that are not present in the classic poetic tradition. When Wu Tang Clan member ODB died in 2004 from an accidental drug overdose, friends and fans were devastated.[9] Coincidentally, members of Wu Tang were in the process of recording a few projects, in which ODB was to be featured. The song "O.D.B. Tribute" by DJ Noize was included on the 2005 album *Think Differently Music: Wu-Tang Meets Indie Culture*. Noize craftily resurrects OBD by piecing together various audio snippets from interviews, songs, and original material. Some of the lyrics are hauntingly portentious: "It's time for me to move on. It's time for Ol' Dirty Bastard to not exist no more."[10] DJ Noize uses the snippets and audio clips to draw full attention to ODB's voice, and thus allows ODB to give his own elegy, a remarkable shift from the traditional literary form. In the more classic elegiac style, Wu Tang member Raekwon raps about his friendship with ODB in the song "Ason Jones" (ODB's legal name was Russell Jones, but he also went by the name Ason) from the *Only Built 4 Cuban Linx, Pt. 2*. Raekwon openly mourns and laments his late friend, offering libation while sharing fond memories: "He had a heart of gold. Intelligent soul from day one."[11] Through this process of mourning, Raekwon identifies the complexity of ODB's multilayered and multifaceted life via sonic expression. Raekwon also references OBD's intense spirituality and faith, thus offering some comfort and solace for mourners: "The lover. The father. The hustler. The rap professor. Now he's with Allah. That's a blessing."[12] Regardless of the causes of his death, it is evident that ODB is still loved and missed by his friends, family, and fans.

In his song "Do the Math," rapper Torae muses about existential moments of loss in hip-hop and Black culture, positing alternative outcomes and imagining brighter futures. He does so by posing hypothetical questions about rappers who have died too soon, and he speculates about what the music and culture would sound like if these artists were still living:

> Imagine if 2Pac would have had kids
> And left another soldier for the revolution
> And what if them cowards would have never shot B.I.G.?
> I bet he'd still spit
> I bet it'd be sick.[13]

THE AFTERLIFE IN AUDIO, APPAREL, AND ART

Torae projects his own hopes throughout this song and envisions a different outcome, while realizing that the circumstances remain foregone conclusions. Listening to these lyrics is humbling, and perhaps troubling, as we are asked to think about how today's reality is dependent on yesterday's tragedy—and how we are shaped by change and crisis. Torae raises listeners' awareness about our perception of conditions of tragedy by asking, "Could you marvel at things if it wasn't what it was?"[14] 2Pac's and B.I.G.'s deaths did have the tragic effect of opening up commercial space for younger rappers. Their deaths inspired a whole new generation of youths to rap and fill their void. According to Torae, "the song 'Do the Math' was a way to lament the people who died and honor them. I also wanted to spark the question how things would be different if certain things/people weren't in place."[15]

According to Patrick Cheney and Philip Hardie, "Of the Renaissance genres that show themselves as survivors across diverse contexts, elegy is one of the hardiest."[16] Historically, professional poets would have been commissioned to write an elegy for someone prominent who died, such as an aristocrat or a royal. Poets also wrote elegies to honor close personal relations. The elegy is also an opportunity to atone and share remorse for one's actions or perceived misdeeds toward the deceased. For example, rapper Jean Grae, born in South Africa and raised in Brooklyn, elegizes experiences of pregnancy, abortion, and miscarriage in "My Story (Please Forgive Me)." Presented from a personal point of view, similar to a diary or journal entry, the song offers Grae a space in which to lament the losses associated with abortion and miscarriage:

> If I could swim a thousand lakes to bring your life back,
> I write that, but infinity can't rewind facts.
> You are divinity.
> My primitive mind was struggling
> Just to understand the meaning of life, forgive me.[17]

The begging of forgiveness in the elegy serves two purposes: it puts to rest the ethereal spiritual presences of the children who died, and it gives the speaker a kind of closure. Grae considers the children's spirits to be divine, pure, and a blessing, and regrets that she was unable to see the pregnancies to term. Her subsequent suicidal depression arose in response to these losses: "Years past, the guilt's worse and it builds till your heart's smashed."[18] The lost children are incapable of providing absolution, but until she is forgiven, the guilt will remain. Because she is speaking into a void created by the absence of these children, her use of apostrophe is significant. Abortions and miscarriages have taken a physical and emotional toll, and this elegy offers a form of catharsis. Throughout this elegy, then, Grae seeks expiation; however, it is unclear whether she will be able to achieve true self-forgiveness, despite her solemn contrition.

These sonic elegies can be seen as dirges, or performances of mournful funereal music, which, in some African traditions, as Laurenti Magesa argues, have specific significance:

> The dirge is in actual fact a three-way conversation, between the living, the newly deceased, and the ancestors, with the mourners as the visible actors. But the deceased and the ancestors are very much present in the situation and are often addressed by name and asked to grant the petitions in the dirges or to accept praise expressed there.[19]

141

SHAMIKA ANN MITCHELL

I argue that Jean Grae's "My Story" should be understood as a hip-hop dirge with diasporic roots. Grae's elegy becomes a plea between mourners, ancestors, and the deceased for forgiveness and clemency. She speaks about the unborn in order to solicit their energies. Her elegy invokes the names and memories of those who have died (or were never born) in order to make their presences felt.

THE INVOCATION

Invocation, a vocative appeal to the deceased, is often a ritual part of mourning practices. For example, Nas often mentions the name of his murdered friend, Ill Will, in his verses: "To my man Ill Will, God bless your life."[20] By keeping Ill Will's name visible and accessible, Nas is keeping his friend's legacy alive. During the release of the documentary *Time Is Illmatic*, which commemorated the twenty-year anniversary of *Illmatic*, Nas posted an archival photo of himself with his friend, along with the caption, "To my man Ill Will, god bless your life. Your memory and soul live in the story of Illmatic."[21] In this act of invocation, Nas calls the name of the deceased in order to solicit his now ancestral presence, thereby forging communion and communication with the afterlife. Chapter XXV of *The Egyptian Book of the Dead* discusses the significance of one's name, especially in the afterlife:

> The soul without a name was in a terrible plight in the Other World, for its name was an integral part of its being, and if it had forgotten its name, and there was no one there to remind it what it was, it could not be presented to the Great God. No greater harm could be done to the deceased than the erasing of his name from his monuments, for the destruction of his name was equivalent to the destruction of his individuality.[22]

Invocation is a critical component of remembrance. Speaking a person's name acts as a guidepost in the afterlife. This person is alive in the metaphysical realm, and, thus, as long as the person is invoked and remembered, his or her presence remains intact. The "shout-out," in which the speaker verbally acknowledges a loved one or significant other, can be seen as an example of invocation.

Starting in the 1980s, rap radio programs such as DJ Red Alert of KISS FM and Mister Magic of WBLS, would allow listeners to call the station and make an on-the-air dedication, or shout-out, to people in their social networks.[23] People would regularly call the Request Line to give recognition to their friends and family; whether it was an "I love you" or "happy birthday" or "just because" salutation, the shout-out became a unique opportunity to share and send public praise and affection. "Shout-out" segments became an essential practice in hip-hop culture, and similar to a testimonial during a worship service, listeners would use the shout-out as a moment to give praise, thanks, and acknowledgment. The liner notes of hip-hop albums would also contain shout-out messages of appreciation and recognition. In addition, the shout-out often became an opportunity to send loving thoughts to people in prison, who were also listening, and to people who have died. In this way, the shout-out became a public display of affection, a greeting that all listeners could hear. Frontman KRS ONE was known to

THE AFTERLIFE IN AUDIO, APPAREL, AND ART

shout-out his friend and partner DJ Scott La Rock after he was murdered. KRS ONE would constantly invoke Scott La Rock in songs and pay tribute in his music videos. In the 1987 song "Going Way Back," KRS ONE asserts, "Rest in peace to my brother Scott La Rock. He's in here!"[24] In KRS ONE's 1988 music video "My Philosophy," the opening scene displays a family portrait of a smiling Scott La Rock holding his two children, and KRS ONE invokes Scott La Rock's name throughout the song. There is a scene in which someone spray paints Scott La Rock's name on a wall, a visual reminder of his physical absence and an invocation of his continued spiritual presence.[25]

In some instances, the DJs would have shout-out segments dedicated only to people who were either in prison or deceased. DJ Kay Slay would often encourage people to call the station during his show and send love to those people who were "locked up" in the prison system. In this manner, the invocation becomes a form of testifying—the reclamation of a person's life and emotional value, which is proclaimed for all to hear. Sean Price's sudden death, for example, devastated friends and fans alike. On his birthday, many of those who loved him posted tributes on their social media. Tek of Smif-n-Wessun, a longtime friend of Price's, commented on his Instagram page: "SALLAMS START YA DAY WITTA SMILE AS BRIGHT & WATCH THE EFFECTS IT HAS ON YOU ASWELL AS OTHERS! #S4MN #DOUKNOWOT2DAYIS #HAPPYBORNDAY #IMISSUAHK #TILLWEMEETAGAIN #RIPSEANP!"[26] Both Price and Tek are Muslims and their texts are in English and Arabic. The hashtag "till we meet again" reinforces the notion of an afterlife, in which kindred spirits will be reunited in paradise. Speaking someone into existence who has died here serves as a declaration of love and loyalty. This social media invocation might also be seen as continuing Yoruba religious tradition, which adheres to the belief of continued existence.

> For the Yoruba, life does not really end; the person changes from one state of existence to another. Their belief in reincarnation and life continuing in heaven, much as it does on earth, means that for them there is a cycle of existence in which the living become the ancestors = the unborn who are born again in their descendants. Death does not break relationships.[27]

During their 2016 appearance at the Governor's Ball Music Festival, De La Soul played songs from their catalogue that had been produced by the late and exceptionally talented J Dilla.[28] Throughout, they instructed people to acknowledge Dilla, either by raising their hands or shouting his name. Fans also wore memorial t-shirts.

Invocations are plentiful in hip-hop, especially in reference to someone who has died. The last song on Gang Starr's final album *The Ownerz*, called "Eulogy," is a dedication to those who have died. In the song, they express how they miss their be/loved ones and, after calling their names, say "rest in peace."[29] Similarly, in the introduction to the song "Full Clip," DJ Premier raps, "Big L, rest in peace."[30] During his performances, DJ Premier will instruct the crowd to put an L sign up when he plays Big L's music.[31] After his partner GURU died from illness, DJ Premier paid tribute to him during his shows. In his social media posts, DJ Premier invokes Big L, GURU, and others on their birthdays or the anniversaries of their deaths.[32] On the sixth anniversary of GURU's passing, for example, DJ Premier posted this caption, along with GURU's photo:

143

6 years ago today your soul left us . . .

There's not a day that goes by that I don't think of you and what we've done together to change so many lives with our music . . .

I will keep Saluting the journey and the team will keep the name alive.

I LOVE YOU! Salute the Elam and Clark Families . . . YOUR SON KC, Lana, Trish, Jay, Jocie, Justin, Denzel, Nile, Miss Barbara & R.I.P. Judge Harry Elam. . . . @triciabreathing @justinnelamruff #RipGuru #OneOfTheBestYet #GiftedUnlimitedRhymesUniversal #GangStarr[33]

As he states, invoking his friend's name keeps GURU's spirit and presence vital. The act of remembrance is as much about sentiment as it is about tangible mementos. Despite the many negative stereotypes about aggressive masculinity of Black and Latino men and within hip-hop culture, when someone is being memorialized, we see the sentimental masculinity inherent to hip-hop culture. This hip-hop space of memorialization is one of the notable instances in which Black and Latino men give public expression to emotions of vulnerability and grief.

After Grandmaster Roc Raida of the X-ecutioners died in 2009 due to injuries sustained from an accident, the hip-hop and DJ worlds were in deep mourning. Weeks after Roc Raida's passing, childhood friend DJ Boogie Blind performed at the tribute show in B. B. King's, New York City. Boogie Blind performed one of Roc Raida's trademark turntable routines and received a resounding ovation. At the end of his performance, Boogie Blind openly wept and was comforted with embraces from other performers who were there to mourn and celebrate Roc Raida's musical legacy.[34] Boogie Blind, often a champion for keeping Roc Raida's name in the spotlight, shared this perspective about their relationship:

Roc Raida was my friend before spinning any records. I will continue to keep his name alive, just as well as all of the members of the X-men/X-ecutioners. His legacy means everything to me because I watched him grow into a mentor and loving father, and of course, he was a beast on the set (turntables).[35]

Roc Raida's musical legacy was widely heralded, and his DJ routines are classic and, at the time of their inception, were quite innovative. Because his technique and style were so unique, some people considered Roc Raida to be one of the best DJs ever (hence the "Grandmaster" title). There are many turntablist DJs from later generations whom he has inspired, and who admire him still. More recently, on Roc Raida's birthday, Boogie Blind posted: "I know you watching over us and so many people in the world.. Miss u bro.."[36] Playing their music is only part of the invocation. Chanting their names, wishing for their peaceful transition, and sharing love for them with other people are also parts of these invocations. The people who have died leave aspects of themselves with us, and through these invocations, we are able to reconnect with them.

Invocations often work in concert with memorialization. Anniversaries and commemorative events become alternative forms of invocation, where people gather to celebrate the person's passing. These acts of memorialization are part of a global and diasporic practice. In *Funerals in Africa: Explorations of a Social Phenomenon*, Michael Jindra and Joel Noret explore African funerary practices: "The funeral service and burial may be only a small part of such funerary events. From mourning practices to dancing, drumming, drinking, and eating, the events may, in some

THE AFTERLIFE IN AUDIO, APPAREL, AND ART

regions, involve planning post-funerary activities over many months or years."[37] Similarly, in hip-hop culture, these memorial practices use the shout-out, the invocation, the elegy, and the dirge as forms of remembrance over the span of years. DJs will curate special music sets in honor of the deceased. After the death of Phife from A Tribe Called Quest, DJ Spinna created a tribute show in honor of his late friend and colleague. As justification for making his set, Spinna declares in his caption, "I had to do it."[38] The compulsion is motivated by the underlying spiritual and cultural need to declare affection for and pay tribute to someone close who has died. These festive events are Homegoing celebrations, in which mourners come together and honor the person's life and memory. A Homegoing is a festive, bittersweet occasion. Drawing on the work of Tanzanian theologian Laurenti Magesa, Allan Anderson writes:

[F]uneral rites simultaneously mourn for the dead and celebrate life in all its abundance. Funerals are a time for the community to be in solidarity and to regain its identity. In some communities this may include dancing and merriment for all but the immediate family, thus limiting or even denying the destructive powers of death and providing the deceased with "light feet" for the journey to the other world.[39]

The "light feet" are represented through dancing during a musical tribute. There is painful sadness at the loss of life, but there is also joy that the person's soul is returning to the Divine and reuniting with the ancestors. Uplifting people's spirits is a unique task, especially when the attendees are grieving and struggling with a loss. A foundation or other collective group will often host a memorial tribute party, which may also be a fundraiser.[40] In such instances, people will attend to provide monetary support for the family left behind. For DJ Spinna, the Phife musical tribute had significant meaning because he was both fan and friend:

I definitely wanted to create a musical home going through the mix I created. I also paid homage to Phife in the form of a tribute event and donated the proceeds to his foundation. It's important to honor our luminaries while they exist on Earth and also once they've entered the ancestral world. Their contributions should be celebrated and never forgotten. We generally are spiritual people. The reason why we make the music we make and impact the world so effectively is because of our natural spiritual connection. Rhythmic vibrations have always been how we communicate. I embrace that spirit every time I play or make music. Phife was as sincere as it gets. You felt his entire spirit in the music. Malik Taylor and Phife Dawg the MC were the same people. No filter.[41]

DJ Spinna felt it was necessary to create the tribute because "[t]heir music impacted my life and [I] consider it part of my DNA."[42] Phife's death, then, means part of DJ Spinna died, too. Because Phife was such a sincere person, DJ Spinna was compelled to create a lasting musical tribute that expressed his own sincerity toward Phife. Furthermore, DJ Spinna wanted to create a tribute that Phife would have enjoyed if he were alive to hear it. What the listener hears, when playing the tribute, is the absolutely unfiltered love and admiration that DJ Spinna had—and still has—for Phife.

The spiritual aspect of death and dying is significant in the diasporic African narrative. Once the spirits arrive in the other world and join the ancestral line, it is expected that they will watch

145

over those who remain in the physical realm. The spirits of the deceased are constantly invoked, so that their legacy is not forgotten. In hip-hop, special memorial concerts, including fundraisers, will be planned, in which the deceased is honored by peers.[43] The other forms of invocation that are less popular, but still meaningful, are the "shout-out" segments at the end of a song, and recognition in the rolling credits of music videos. Wu Tang Clan duo Raekwon and Ghostface list deceased loved ones at the end of their music video "Heaven & Hell," from *Only Built 4 Cuban Linx.* The final screen reads, "IN MEMORY OF" and then the names of twenty-eight people scroll until the video ends.[44] The song itself contemplates our earthly existence, with the chorus, "What do you believe in, heaven or hell? You don't believe in heaven 'cause we're living in hell."[45] For the album version, near the end of the song, Raekwon and Ghostface send shout-outs to their friends and invoke the name of a friend who has died. In fact, one of the people listed in the memorial was Ghostface's daughter, Destiny, who died in infancy. During an interview, he discusses how he perceived her passing:

> She had to return back to the essence five days after she was born. That's [my son's twin] sister, right there. When things like that happen it usually be on what things you did in your life—like what bad things I ever did for something like that to happen. The things you do that's real bad don't necessarily come back to you. Sometimes they come back to someone you love.[46]

In addition, the song is used as an allegorical cautionary tale to avoid street life and make better decisions. In one verse, Ghostface says, "You ain't even promised tomorrow," and Raekwon follows, saying, "Niggas don't understand how life can be so short. Come so fast."[47] The fragility of life is plainly stated in the song, and the numerous memorial dedications in the music video are a clear and poignant reminder of the fragility of life. Still, despite her brief earthly life, Ghostface invokes his daughter's memory and carries her loss within.

VISUAL MOURNING

The elegiac culture of hip-hop, with its sonic forms of mourning, is accompanied by a rich tradition of visual art. For the mourner, visual art—such as tattoos, clothing design, graffiti, murals, and monuments—provide an opportunity to produce afterlives through ephemeral and persistent public tributes to the deceased. Graffiti, an ancient art tradition, is one of the key elements of hip-hop culture and is often used as a platform to share public sentiments.[48] In hip-hop, three of the most common visual art practices of mourning are tattoos, clothing designs, and murals. The afterlife is an intangible space, and the physicality of memorializing makes tangible the loss and the person's absence. Similar to landmarks, the physical markings of graffiti are reminders of loss, love, and the celebration of life. For the artist-survivor, graffiti is part of the bereavement process, an act of love memorializing the person who has died. The creative attention to detail and the intentionality of the process allows for a cathartic experience, in which grief is transformed into an act of public art and communal mourning.

For some, the self-infliction of physical pain becomes a means of working through the emotional pain of personal loss. In psychoanalytic terms, the physical pain can function to displace

THE AFTERLIFE IN AUDIO, APPAREL, AND ART

the emotional pain and, at the same time, to creatively refashion the body as a site of memorialization. Put simply, just as some people turn to drink *to forget* their woes, still others get tattooed *to remember* their losses. Tattooing is often painful, and quality studios are pricey and time-consuming; however, memorial tattoos have a specific emotional motivation that transcends the inconveniences of pain, cost, and time. As frequently noted in the tattoo community, "Memorial tattoos in recent years have become an increasing trend in the world of tattooing and it is now not uncommon to see people sporting a piece of ink dedicated to someone they have lost."[49] A memorial tattoo might be an inscription, such as a quotation for which the deceased was known; a likeness or portrait image of the deceased; or sometimes merely an imprint of the deceased's name or signature.

In *The A–Z of Death and Dying: Social, Medical, and Cultural Aspects*, John Troyer reflects on memorial tattoos:

> Within the broader history of memorialization for the dead, the memorial tattoo represents an ancient form of body marking merged with a popular, contemporary form of artwork. As tattooing has become more socially accepted, so too has the choice to permanently remember a deceased individual with a memorial tattoo.[50]

The late rapper DMX had more than one memorial portrait tattoo of his beloved canine companions. Across his entire back, for example, DMX had a tattoo that proclaims "ONE LOVE BOOMER" with a depiction of his beloved pit bull that died after being hit by a car.[51] Because tattoos are permanent, they offer an enduring physical reminder of the beloved. Indeed, some memorial tattoos will even use cremains mixed with the ink, endowing them with both material and symbolic meaning. At his memorial service, fans memorialized DMX through tattoos and clothing bearing his likeness.[52]

After the murder of his longtime friend and mentor, Jam Master Jay of RUN DMC, DJ Scratch tattooed the initials JMJ on his hand, so that Jam Master Jay remains physically and musically with him when he deejays.[53] When asked about his tattoo, DJ Scratch explained its significance:

> My JMJ tattoo signifies the last verse on "Peter Piper" that says "You'll see Jay again my friend." I salute like a soldier when I greet people & when I'm on stage. My JMJ tattoo is on the side of my right hand so when I salute, you see JMJ. So when you see me, you see JMJ again. His legacy means everything to me. JMJ is one of the greatest DJ's of all time. He is the first artist that became a music mogul by having his own record label & Onyx selling millions of records. Mentoring me, Michael Bivins, discovering 50 Cent & creating the Scratch DJ Academy are also part of that. His legacy continues to grow & now two of his sons are touring DJs as well. If the dictionary had faces to symbolize words & phrases, JMJ's face would be the image of the following: Hip Hop, DJ, mogul, pure heart.[54]

Thus, memorial tattoos can also function cathartically. Not only does the mourner endure pain to ease the emotional loss of a loved one, but the bleeding that occurs during the process symbolizes a physical sacrifice in honor of that person. Conducting a study in which he interviewed people with memorial tattoos, Andrew McCarthy concluded that "[t]hese tattoos keep the spirit of the loved one alive" and become "a way of honoring" the deceased.[55]

Another popular (and perhaps less physically painful) way to honor the dead is through clothing designs. Not long after J Dilla succumbed to illness, t-shirts with the caption "Dilla changed my life" began to circulate and soon gained popularity. The act of commemorating someone's life on a t-shirt is commonplace within hip-hop culture, but it is unclear where the traditions began and by whom they were started. What is known is that there is now a rich archive of memorial shirt designs, including, for example, garments depicting DMX's "ONE LOVE BOOMER" tattoo. This fashion statement has diasporic resonances with the designs in Kente cloth, which have woven into them patterns of ancestral significance. Sometimes the weavers will create patterns so unique that they are tantamount to a signature. According to Boateng, "Deceased elders are both pioneers and coauthors with living cloth makers, and death does not lessen the importance of those roles. Thus, the living not only recognize individual acts of creativity but continue to do so even after the individuals concerned have died."[56] The t-shirt market is very similar, in that someone can release a popular shirt design, making them coauthors with the dead, albeit not necessarily authorized coauthors. With his mother assuming control of such fashion merchandising, J Dilla's estate will be better able to orchestrate the transmission of the popular archive of his legacy.

The James Dewitt Yancey Foundation, created and named for Dilla, also vends merchandise bearing Dilla's likeness and name on their J Dilla Merch store. Items are also sold at memorial events, such as Donuts Are Forever, where people don clothing and other memorabilia in tribute to the rapper's legacy. The J Dilla "Maestro" t-shirt with an image of him sitting at his beat machine echoes the famous Charles Schultz *Peanuts* comics and the iconic image of the character Schroeder sitting at his piano (see figure 7.1). Schroeder's adoration of the classical composer Beethoven, and his relentless celebration of the composer's catalogue, is what makes this J Dilla rendition politically and artistically powerful. The comparison renders J Dilla as a maestro, immediately ascribing iconic status to him.

J Dilla was a brilliant and talented musician, and his catalogue is full of now classic material. In essence, the t-shirt design is quite provocative and produces association on different registers, linking J Dilla to both Schroeder and, by association, to Beethoven's brilliance. The archive of commemorative t-shirt designs includes those in the "Invisible Bully" line. This trademark derives from Notorious B.I.G.'s verse on the classic "Flava in Ya Ear Remix."[57] In its marketing materials, the company explain their mission: "We're representing 'BK to the fullest' in tribute to the legacy of late, great Christopher Wallace AKA the Notorious BIG."[58] Their shirt designs reflect this goal by featuring images, captions, and verses from the late rapper.

After the (commercial) success of the 1986 hit song "My Adidas," iconic rappers RUN DMC received an endorsement with Adidas.[59] What is more, after Jam Master Jay was murdered in 2002, Adidas released a variety of sneaker designs to commemorate his life and his contributions to music and fashion. Adidas released a t-shirt and sneaker bearing the Adidas logo and Jam Master Jay's name.[60] Although wearing clothing with a deceased person's likeness and name on it can be perceived as macabre, this branding of memorialization is also a way of honoring that person and mourning their absence. While these items are intended for commercial purposes, the means by which they commemorate these artists is also a unique cultural practice in hip-hop that hearkens back to textile memorialization within the African Diaspora.

THE AFTERLIFE IN AUDIO, APPAREL, AND ART

Figure 7.1. "Maestro" t-shirt. Photograph by Ann M. Kakaliouras.

Another unique practice for memorializing in hip-hop culture is the use of paintings and graffiti art. Like the apparel designs, such public visual images honor and preserve the memory of the deceased. Unlike t-shirts, which have a wider commercial circulation, the murals are often grounded in the community where the person resided. As Insanul Ahmed observes, "Dead rappers don't *just* get better promotion, but they're often the subject of some of the best rap murals around. . . . What better way to honor the memory of a community hero than larger-than-life street art?"[61] When a member of the community dies, especially under tragic circumstances, the community comes together to grieve and mourn collectively and publicly. Hip-hop memorials are resonant with diasporic practices. As Anderson notes, "African funerals are community affairs in which the whole community feels the grief of the bereaved and shares in it."[62] In the hip-hop community, other public practices of grieving include memorial parties and social events featuring the unveiling of commemorative community murals. For example, following the untimely passing of Brooklyn rapper Boot Camp Clik / Random Axe / Heltah Skeltah member Sean Price in August 2015, the 5 Pointz graffiti notable Meres One painted a memorial mural in Crown

Figure 7.2. Sean Price mural created by Meres One. Photograph by Mark Abramson.

Heights (see figure 7.2). His loss is still felt by family, friends, and fans. In an interview with *The Source Magazine*, Meres One explained his inspiration for the mural:

> It's about paying homage to him, 'cause he gave me years of enjoyment. . . . I did it just out of support. That's what I like about Hip Hop. It's that one element can support the other, and vice versa. And I think, at times even though they're all separate elements, when something sad or tragic or emotional, something happens all the elements come together. And I think that what's um, what's great about Hip Hop.[63]

For mourners, the mural became a place to grieve and show respect to someone they cared for. In addition to leaving flowers and lit candles, people also left notes, cards, tribute items, and bottles of liquor and poured libation.

The power of remembrance through murals is pivotal for people and communities who are mourning. To remember someone is to keep the person forever extant. For instance, the murals catalogued in the *Complex Magazine* article "40 Dope Rap Murals" feature work that honors both the deceased and the living. A mural for GURU modified the meaning of RIP, which normally is an acronym for "rest in peace," but instead, has the inscription "Remembrance is Power." In the same manner in which GURU's music will be played long after his death, the memory of him also endures in material culture. In an ironic twist, by their memorializing, the deceased are made immortal.

THE AFTERLIFE IN AUDIO, APPAREL, AND ART

Memorial murals can be found in a variety of places. Often, the person's neighborhood will be the first site of memorialization, but because hip-hop fanbases are often widespread, memorial murals may appear both locally and globally. The mural of GURU, for example, is in Trnava, Slovakia, speaking to his global influence as an artist.[64] Italian designer and illustrator, Gradoner Graphics, created *Tribute to the Kings*, a photo portrait collection in memoriam of several hip-hop artists, such as Nate Dogg and Heavy D, among others. The photo portraits were modified with personal details. In the portrait of South Bronx DJ Scott La Rock of Boogie Down Productions, who was tragically killed, the photo remains lifelike, depicting a youthful artist in his prime. Each photo in the Gradoner collection includes the subject's legal name, dates of birth and death, and a symbol that best represents that person's legacy. For Scott La Rock, the symbol is a red and white seal that is inscribed with "South Bronx," his hometown and one of the rapper's most recognized songs.

An ancient Egyptian proverb states: "To speak the name of the dead is to make him live again."[65] In the same way, murals (and hip-hop fashion apparel and body tattoos) symbolically resurrect the artists and keep their legacy alive. The visual details are sometimes so realistic that it appears the subject is alive or reborn, as in Gradoner Graphics's photo memorials. Notably, memorial murals can be painted not only for hip-hop icons but for any member of the community who is lost. Murals thus function as local shrines, where it is not uncommon for mourners to place flowers, candles, and other memorabilia in commemoration of birthdays or dates of death.

Increasingly, street artists have painted murals on vehicles, creating mobile memorials. Because the trains in New York City are now increasingly graffiti-proofed, there are far fewer moving canvases than there once were. Out of necessity and ingenuity, artists are finding alternative mobile canvases on which to display their talents.[66] For example, Canadian artist DEF3 painted a memorial mural of Jam Master Jay and Grandmaster Roc Raida on a truck that operates as a mobile DJ lab for enthusiasts. The truck travels to various cities, and anyone who takes lessons at the lab becomes part of the ongoing legacies of both Jam Master Jay and Grandmaster Roc Raida. Students will learn DJ history and techniques, while developing their own unique talents. The work of these community-based mobile labs—an afterlife of these two iconic DJs—transmits the possibility of productive, creative futures to a younger generation.

THE BEAT GOES ON

Artists have taken steps toward promoting appreciation for others while they are still living, instead of only commemorating them after death. For example, Boot Camp Clik members Smif-n-Wessun send this message using their song "Roses" from the 2011 *Monumental* album. Part of the chorus states, "If I could, I'd part waters like Moses, and give you dozens while you can still smell the roses."[67] The music video of the song features an array of memorial murals, and the main setting is a cemetery in which the rappers, Steele and Tek, are sitting among tombstones.[68] In a text message to me, DJ Scratch reflected, "Every DJ in the world has the obligation to keep JMJ's legacy alive. Our culture only mentions fallen greats on their birthday & the day that they passed away. We, as a culture, need to do better."[69] His point is that, as a society, we all need to be more attentive to nurturing our living communities, as well as the dead, and hip-hop is no exception. While African traditions of honoring the ancestors remain intact within

151

hip-hop, so do those rituals of celebrating everyday community life. Despite allegations of hip-hop's fixation on the macabre, it is important to acknowledge the ways in which the art and music directly reflect life experiences. The music can function as a form of therapy or meditation in which these artists share their grief and their joys in the recording booth, while inviting listeners to engage with the music as a healing process.

Boateng writes, "The Akan proverb 'The tongue does not rot,' in pointing to the endurance of words—and creative acts—underscores the view that a person's words and actions are not curtailed by their physical death."[70] J Dilla's mother, Maureen "Ma Dukes" Yancey, has said that her son expressed to her how he wanted to be remembered. Therefore, she became committed to celebrating her son's legacy rather than merely mourning it and shared that commitment with his friends and fans. She has said: "I haven't mourned. I'm not mourning, I'm celebrating, because I'm just so excited about him getting the credit he worked for and deserves; [we're] letting the world know just how great he was with what he did."[71] As long as this memorial work continues, J Dilla's legacy will not be forgotten. As Joseph Healey and Donald Sybertz observe:

> In traditional African society remembrance and respect for the living dead are intimately connected with ancestor veneration. Everything in life is linked to the ancestors, who do not take the place of the "Supreme God," but are mediators. There is a live communion with the dead, an interdependence between the living and the dead.[72]

Although J Dilla died in 2006, the efforts of his mother and other people to keep his memory alive will allow generations born after his passing to know and appreciate his music. And despite the fact that Scott La Rock died many years ago, KRS ONE still shouts out his fallen friend and invokes his memory in songs and during live shows. In these and countless other examples, the legacy of these artists lives on through the sonic and visual invocation of their names and repertoires.

It is crucial to remember that the majority of hip-hop artists are young urban Black and Latino males, who disproportionately experience forms of institutional violence, oppression, and marginalization. The lives they lead are deeply entwined with these realities. When the hip-hop community experiences the loss of friends and family to police and street violence or illness or accidents, or poverty, they turn to music for respite. But that music is part of a larger set of practices of memorialization and celebration that can become manifest in libations, tattoos, t-shirts, murals, and community-based projects like mobile deejaying. Taken together, this archive of ritual elements in hip-hop culture ensures that the community is not mired in mourning but pursues the promise of life in the face of social death. Hip-hop culture thus mourns deaths, celebrates lives, and creates futures through communal, public, and popular everyday rituals of remembrance.

NOTES

1. Capital STEEZ, "The End," December 23, 2013, https://web.archive.org/web/20130101062759/https://twitter.com/CapitalSTEEZ_
2. Eli Rosenberg, "Capital STEEZ: King Capital," *The FADER Magazine*, January 2014, http://www.thefader.com/2013/11/26/capital-steez-king-capital.

3. Boatema Boateng, *The Copyright Thing Doesn't Work Here: Adinkra and Kente Cloth and Intellectual Property in Ghana* (Minneapolis: University of Minnesota Press), 40.

4. Kimani S. K. Nehusi. *Libation: An Afrikan Ritual of Heritage in the Circle of Life* (Lanham, MD: University Press of America, 2016), 43.

5. 2Pac, *Thug Life Vol. 1*, iTunes.

6. Proverbs 31:6–7 (New Revised Standard Version).

7. Blaq Poet, *The Blaqprint*, iTunes.

8. Patrick Cheney and Philip Hardie, *The Oxford History of Classical Reception in English Literature, 1558–1660*, vol. 2 (Oxford: Oxford University Press, 2015), 315.

9. Associated Press, "Autopsy: ODB Died of Accidental Overdose," last modified December 15, 2004, http://www.billboard.com/articles/news/65284/autopsy-odb-died-of-accidental-overdose.

10. Think Differently, *Think Differently Music: Wu-Tang Meets Indie Culture*, iTunes.

11. Raekwon, *Only Built 4 Cuban Linx, Pt. 2*, iTunes.

12. Raekwon, *Only Built 4 Cuban Linx, Pt. 2*.

13. Torae, *For the Record*, iTunes.

14. Torae, *For the Record*.

15. Torae, *For the Record*.

16. Cheney and Hardie, *The Oxford History of Classical Reception in English Literature*, 2:314.

17. Jean Grae, "My Story (Please Forgive Me)," *Jeanius*, 2008, compact disc.

18. Jean Grae, "My Story (Please Forgive Me)."

19. Laurenti Magesa, *What Is Not Sacred?: African Spirituality* (New York: Orbis Books, 2013).

20. Nas, *Illmatic*, iTunes.

21. Nas, Facebook post, September 21, 2014, https://www.facebook.com/Nas/photos/a.260508870659066.63306.113591595350795/830439460332668/?type=1&theater.

22. John Romer and E. A. Wallis Budge, *The Egyptian Book of the Dead* (London: Penguin, 2008), 132.

23. DJ Mikec22, "Kool DJ Red Alert 98.7 KISS FM 1991," August 31, 1991, https://archive.org/details/DJRedAlert-Spring1991.

24. Just-Ice and KRS ONE, *Cool and Deadly*, iTunes.

25. BoogieDwnProdVEVO, "My Philosophy," June 20, 2013, https://www.youtube.com/watch?v=h1vKOchATXs.

26. Tek, "Sean P," March 17, 2016, https://www.instagram.com/p/BC-lNlpMdYB.

27. Mary Cuthrell Curry, *Making the Gods in New York: The Yoruba Religion in the African American Community* (New York: Garland Publishing, 1997), 62.

28. Governors Ball, "Lineup," last modified 2016, http://governorsballmusicfestival.com/lineup.

29. Gang Starr, *The Ownerz*, iTunes.

30. Gang Starr, *Full Clip: A Decade of Gang Starr*, iTunes.

31. GlenJamn3, "DJ Premier—Big L and BIG R.I.P.," March 11, 2016, https://www.youtube.com/watch?v=X7Pa9dRs4uM.

32. DJ Premier, Instagram posts, https://www.instagram.com/p/BBz6EeqGh8i, https://www.instagram.com/p/BCu4hEnmh-7, https://www.instagram.com/p/BEYmR5uGh98.

33. DJ Premier, Instagram post, April 16, 2016, https://www.instagram.com/p/BEYmR5uGh98/.

34. Grandgood, "Boogie Blind Plays Tribute to Roc Raida," October 22, 2009, https://www.youtube.com/watch?v=7xIEOEVPSdA.

35. Shamika Ann Mitchell, e-mail with DJ Boogie Blind, June 19, 2016.

36. Boogie Blind, "Roc Raida," May 17, 2016, https://www.instagram.com/p/7z8dRXkpCy.

37. Michael Jindra and Joel Noret, *Funerals in Africa: Explorations of a Social Phenomenon* (New York: Berghahn, 2011), 1.

38. DJ Spinna, "Tribute to Phife Dawg on Deviation with Benji B," DJSpinna's Podcast, last modified April 2, 2016, https://www.podomatic.com/podcasts/djspinna/episodes/2016-04-02T07_32_22-07_00.

39. Allan Anderson, "African Religions," *Encyclopedia of Death and Dying*, last modified 2016, http://www.deathreference.com/A-Bi/African-Religions.html#ixzz4Bvc1fnZd.

40. DJ Eclipse, "DJ Eclipse & DJ Premier—September 21, 2009—Roc Raida Tribute," last modified 2016, https://www.mixcloud.com/itsdjeclipse/dj-eclipse-dj-premier-apt-92114-roc-raida-tribute.
41. Shamika Ann Mitchell, e-mail with DJ Spinna, June 18, 2016.
42. Mitchell, e-mail with DJ Spinna.
43. Donuts Are Forever, "Thank You," February 19, 2015, https://www.facebook.com/donutsareforever/photos/a.138586072863539.49234.132990833423063/934248986630573; and Donuts Are Forever 10, flyer, last modified February 12, 2016, https://www.brooklynvegan.com/j-dilla-tribute/.
44. Brooklyn Zoo, "Raekwon—Heaven & Hell," April 28, 2012, https://www.youtube.com/watch?v=Iq7Wm8sz4Ec.
45. Raekwon and Ghostface, *Only Built 4 Cuban Linx*, iTunes.
46. Chairman Mao, "The Iron Man Cometh: Wu-Tang Clan's Ghostface Killah Unmasked," *Ego Trip Magazine*, April 6, 2010, https://www.egotripland.com/the-iron-man-cometh-wu-tang-clan's-ghostface-killah-unmasked. Accessed August 20, 2018.
47. Chairman Mao, "The Iron Man Cometh."
48. Shamika Ann Mitchell, "Hip Hop," in *Encyclopedia of African American History* (Santa Barbara, CA: ABC CLIO), 801–806.
49. Nadia Vella, "Tattooing a Dead Loved Ones Ashes on Your Body Is the Ultimate Tribute," HMB: Horror Movies Blog, last modified February 18, 2017, https://paranormalhorror.com/2017/02/18/tattooing-dead-loved-ones-ashes-body-ultimate-tribute/. See also Jennifer R. Donnelly, "Memorial Tattoos: Ashes in the Ink!," last modified March 30, 2015, https://www.tattoodo.com/a/2015/03/memorial-tattoos-ashes-in-the-ink.
50. John Troyer, "Memorial Tattoos," in *The A–Z of Death and Dying: Social, Medical, and Cultural Aspects*, ed. Michael John Brennan (Santa Barbara, CA: Greenwood, 2014), 312.
51. Ruff Ryders, Twitter, last modified November 26, 2018, https://twitter.com/itsruffryders/status/1067044380685398016; https://www.usatoday.com/story/entertainment/music/2021/05/17/rapper-dmx-last-interview-tv-one-uncensored-docuseries-final-revelations/5092446001.
52. Brittainy Newman, "Fans Gather to Mourn, Celebrate Rapper DMX at New York City Memorial Service," *USA Today*, last modified April 24, 2021, https://www.usatoday.com/picture-gallery/entertainment/music/2021/04/25/dmx-memorial-draws-fan-mourn-celebrate-his-life-new-york-city/7372496002.
53. Jason Newman, "Jam Master Jay Remembered by Protégé DJ Scratch," Fuse TV, last modified October 30, 2013, http://www.fuse.tv/videos/2013/10/dj-scratch-jam-master-jay.
54. Shamika Ann Mitchell, text message with DJ Scratch, June 19, 2016.
55. Quoted in Phyllis Hanlon, "The Deeper Meaning of Tattoos," last modified April 2011, https://spiritualityhealth.com/articles/deeper-meaning-tattoos. See also Andrew McCarthy, "The Ink Is Flowing: A Study of Religious Meaning in Tattoo Culture," *Imaginatio et Ratio: A Journal of Theology and the Arts* 1, no. 1 (2012).
56. Boateng, *The Copyright Thing Doesn't Work Here*, 41.
57. Craig Mack (featuring Notorious B.I.G., L.L. Cool J, Busta Rhymes, & Rampage), "Flava in Ya Ear Remix," iTunes.
58. Invisible Bully, STORY, last modified 2016, http://invisiblebully.com/pages/heritage. Accessed August 20, 2018.
59. Robin Mellery-Pratt, "Run-D.M.C.'s 'My Adidas' and the Birth of Hip Hop Sneaker Culture," *The Business of Fashion*, last modified on July 18, 2014.
60. Patrick Johnson, "Jam Master Jay Honored by Adidas with this Incredible Sneaker," last modified August 19, 2015, http://sneakernews.com/2015/08/19/jam-master-jay-honored-by-adidas-with-this-incredible-sneaker.
61. Insanul Ahmed, "40 Dope Rap Murals," *Complex Magazine*, April 21, 2013, http://www.complex.com/music/2013/04/40-dope-rap-murals2.
62. Anderson, "African Religions," http://www.deathreference.com/A-Bi/African-Religions.html#ixzz4Bvc1fnZd.
63. Pologod / Sha Be Allah, "Exlcusive [sic] Interview with Creator of Sean Price Mural MERES One," *The Source Magazine*, September 8, 2015, http://thesource.com/2015/09/08/thesource-com-exlcusive-interview-with-creator-of-sean-price-mural-meres-one.
64. "GURU Memorial," *Molotow Magazine*, April 29, 2010, http://www.molotow.com/magazine/blog/blog/2010/04/29/guru-memorial. Accessed August 20, 2018.
65. Pat Remler, *Egyptian Mythology, A to Z*, 3rd ed. (New York: Chelsea House, 2010), 93.

66. "Box Trucks as Rolling Graffiti Marquees," *BSA: Brooklyn Street Art*, last modified January 22, 2014, http://www.brooklynstreetart.com/theblog/2014/01/22/box-trucks-as-rolling-graffiti-marquees.
67. Smif-n-Wessun, *Monumental*, iTunes.
68. Duck Down Music, "Pete Rock & Smif N Wessun—Roses," September 2, 2011, https://www.youtube.com/watch?v=xy0z8OZ00Iw.
69. Shamika Ann Mitchell, text message with DJ Scratch, June 19, 2016.
70. Boateng, *The Copyright Thing Doesn't Work Here*, 41.
71. Ronnie Reese, "Biography," j-dilla.com, last modified 2016, http://www.j-dilla.com/biography. Accessed August 20, 2018.
72. Joseph Healey and Donald Sybertz, "Importance of the Living Dead," in *Towards an African Narrative Theology* (New York: Orbis Books, 1996), 214.

EIGHT

DREAMING OF *LIFE AFTER DEATH* WHEN YOU'RE *READY TO DIE*

Notorious B.I.G. and the Sonic Potentialities of Black Afterlife

ANDREW R. BELTON

One can be, indeed one must strive to become, tough and philosophical concerning destruction and death . . .

—James Baldwin, *The Fire Next Time*

In the wake of Christopher Wallace's shooting death on March 9, 1997, *The Source* magazine released its May issue in memory of the recently deceased emcee,[1] who had presciently elegized his own demise: "I spit phrases that'll thrill you | You're nobody till somebody kills you."[2] The cover features a simple black and white photograph of Biggie Smalls, in medium close-up, staring head-on into the unseen camera. His face appears both menacing and revealing, as he revels in a "mean mug."[3] Appropriately, the photographic perspective is oversized—BIG—stretching the emcee's image over and beyond the cover page's strictly delineated material border. In a stylized mugshot-cum-headshot, Wallace's image is cropped at mid-chest, with aspects of his face and head edged out of the frame. Catty-corner from his face, at the bottom left of the page in gold lettering, is the embossed epitaph of one of his most popular emcee monikers, "Notorious B.I.G." And above his given name, "Christopher Wallace," in black lettering, are inscribed the dates of his birth and death, "1972–1997."[4] Perhaps as menacing as his expression are the words appearing directly opposite his face in large gold print lettering, "Now What?" held-up by the orienting sub-header, "The Tragic Marriage of Hip Hop and Violence," positioned in smaller black print as under-signage. It is a cover designed in call-up to the art and aesthetic of Biggie's debut studio album, *Ready to Die* (1994). From this creative invocation ensues an appeal to reflect on the cultural history and the performative production of Black destruction and death within hip-hop culture and within the constraints of an anti-Black world.

This essay heeds the call issued by *The Source*'s commemorative cover by thinking through the biological death of Christopher Wallace in relation to the production of an aesthetics of Black death by The Notorious B.I.G., particularly as dramatized and immortalized in "Suicidal Thoughts," the final track of his debut studio album.[5] The aesthetics of Black death are evidenced in the lingering presence of Biggie's voice within the culture, long after his biological death, and materialized in the posthumous release of the preponderance of his oeuvre, including the albums

Life After Death (1997), *Born Again* (1999), and *Duets: The Final Chapter* (2005). Further, this essay seeks to pay homage to what James Baldwin might have described as the "tough and philosophical [conceptualization of black] destruction and death" in Biggie's work. Indeed, by practicing what Fred Moten has articulated as a pleasure taken in "incessant listening,"[6] the final track of *Ready to Die* provides a meditation on suicide as a radical (or otherwise revolutionary) reaction to the perpetual terror of living in a world conditioned upon anti-Blackness.[7]

I aim to listen and attend to Biggie's "Suicidal Thoughts" and its prefiguring of the sound space of the (telephonic) call, which functions on the album as a recording of Biggie's voice calling out for help (in this case, to his producer, Sean "P. Diddy" Combs). This telephonic sound space becomes the terrain for voicing desires for Black ontological escape—or as the always already figured escape of Blackness from Western ontological thinking that gets illuminated (or, rather, sounded) within the racial encounter.[8] With incessant listening, the album's recordings make audible both the emcee's aesthetic production of Black destruction and death (which culminates in B.I.G.'s fantasy of suicidal escape at album's end), and the anticipatory "fugitive planning"[9] expressed by the concept of being "ready to die." The aesthetics of Black destruction and death are also given voice in Biggie's lyrical performances and registered repeatedly as the emcee's inevitable questioning of the "terror of antiblackness."[10]

Further, this essay seeks to bear sonic *ear* witness[11] to just how the final performance/production of Biggie's debut album positions the sonic realm as a terrain rife with possibilities for Black life beyond the bareness of any fixed humanist conceptualization of being.[12] Through the sonic performance of an aesthetics of Black death, this album registers the potential for Blackness after and beyond death, an afterlife of Blackness surviving in excess of the biological necessities (and even precarities) of embodied, or material, being. There exists, then—in our incessant listening to Biggie's "readiness to die," in the form of his sonic performance of suicidal death, and in our invited cohabitation with his posthumously released prerecorded albums—something of an understanding of how the sonic realm establishes a broader and more profound access to Blackness and its afterlives.

Throughout his repertoire, The Notorious B.I.G. seeks to neutralize the terror of anti-Blackness by performing through it. Indeed, the aestheticizing of Black death works to extend a radical legacy of Black fugitive planning—in this case, by way of lyrical movements through narratives of Black destruction. The repertoire, then, possesses a seeming perpetuity, illustrating the necessity of thinking a horizon of escape through sound. Further, the repertoire offers the potential of a life of Blackness after and beyond the limits of being human, particularly when that humanity is predicated on the "insatiable" terror of (extra-)state violence in its pursuit of Black life.[13] Speaking to this incongruity between Blackness and being, Calvin Warren notes that "the terror of inhabiting existence outside the precincts of humanity and its humanism" requires Black thinking to address some fundamental ontological questions: "[C]an blacks have life? What would such life *mean* within an antiblack world. . . . [I]s the black, in fact, a human *being*? Or can black(ness) ground itself in the *being* of the human?"[14]

As a "notorious" example of and lyrical stand-in for the anti-Black world's Black *persona* (*non grata*), Biggie inevitably calls into question the perpetuity of such terror. The recorded production of his death (situated within the systemic violence of the anti-Black world that surrounds a world of violence of the emcee's own making) reveals what remains unthought in thinking "ontological terror." How might we otherwise imagine the potentiality of thinking the existence of

ANDREW R. BELTON

Blackness beyond the metaphysical infrastructure of anti-Blackness, even after its de-anchoring from the ontological ground that bonds *Black* being (or Black *being*, as Warren dictates) to the violence of the human and its humanism.[15] *Ready to Die*, I argue, reproduces the narratives of Black destruction and death not as a form of resistance to anti-Blackness but rather to produce Biggie's performative presence, which explores the potentiality of Black life after death. The album is pursuant not of new ontological ground to unburden the terror of anti-Blackness, but of a horizon to think and sound Blackness beyond being and death. That is to say, in incessant listening to the continuous return of Biggie's voice to hip-hop's *airwaves*,[16] long after his biological death, we hear the haunting potentiality of Blackness in an escape from anti-Black ontology, perhaps suggesting a *Black hauntology* that is most often and most easily accessible only through sound— the sonic potentiality of Black afterlife.[17]

THE ONTOLOGICAL TERROR OF BEING *READY TO DIE*

The skit that functions as Biggie's official "Intro" (the title of the track) to the hip-hop scene opens *Ready to Die* by dramatizing several details of the emcee's early autobiography. Born in 1972 in St. Mary's hospital in Brooklyn, New York, Christopher Wallace, the second-generation son of Jamaican immigrants, was just twenty-four years old when he was killed in a drive-by shooting in 1997. That his inevitable and premature death is retrofitted into the opening sketch of his album signals an approach that defines and distinguishes the aesthetic method and style of Biggie's production. The track thus begins at the moment of the Notorious B.I.G's birth into sound by audio-producing the soundtrack of Christopher Wallace's nativity scene. Beneath the ominous opening chords of the track's synthesized digital organ, which are initially faint and then amplified, is the beating sound of a human heart, along with a mother's moans and a father's urgent pleas to "Come on. Push."[18] It is not without a sense of existential irony that an album engaged with themes of Black death and destruction is here instigated by the sonic mimesis of B.I.G's birth. The album's opening track, then, foregrounds the motif of mortality as prelude to the inevitable ontological terror of violence that haunts the artist throughout *Ready to Die*.

Running three minutes and twenty-three seconds, the introductory track is produced as a sound montage of early events in the life of Christopher Wallace, from his birth to the beginnings of a criminal career in 1979, to his release from prison in 1991 and his emergence as an underground emcee in the early 1990s. Throughout, the brief autobiographical sketches (represented as dialogue) record Wallace's maturation, weaving in and out of an ongoing soundtrack. The soundscape moves through the docudrama of his birth (scored to Curtis Mayfield's "Super Fly") into a moment of domestic strife between an adolescent Wallace's parents in 1979 (scored to The Sugarhill Gang's "Rapper's Delight"). In addition to Curtis Mayfield's "Super Fly" and The Sugarhill Gang's "Rapper's Delight," the soundtrack of songs in the key of Wallace's life includes Audio Two's "Top Billin'" (1987) and Snoop Dogg's "tha shiznitt" (1993). Other details specific to the track's chronological progression include a premeditative exchange between the fifteen-year-old Wallace and his friend (and criminal accomplice) just before staging a robbery on a New York City subway car; the moment of Wallace's prison release, after serving a nine-month sentence for drug trafficking; and, finally, the brief exchange, upon his exit, with a prison guard.[19]

DREAMING OF *LIFE AFTER DEATH* WHEN YOU'RE *READY TO DIE*

The particulars used in the sonic reproduction of Wallace's story in the album offer the listener what Roland Barthes describes as the incorporation of "luxurious detail" to manifest "the reality effect."[20] From what we know of Wallace's biography, the sketch presents a man exchanging a litany of curses and threats with Wallace's mother, Voletta (voiced by Lil' Kim). The voice, however, would seem to be different from that representing Wallace's father at the start of the song (voiced by P. Diddy). Our ears do not deceive in noting this change. Nor is the modification a result of careless production. Instead, I want to suggest that the switch is distinct and one of many examples of attention to detail in sound production throughout the album. As we know from Wallace's biography, his biological father, Selwyn Latore, abandons the family when Christopher is only two years old.[21] It follows, then, that by 1979 (as signaled by the shift to The Sugarhill Gang's "Rapper's Delight"), the man we hear "arguing" with Biggie's mother would not have been his biological father, as evidenced by the sonic distinctions between voices.

The evolving narrative of Wallace's fugitive status, as played out in the introductory track's fragmentary biographical sketches, curated sound, and sampling in the soundtrack, briefly maps his life from hospital delivery to disaffected adolescent to unapologetic career criminal to surveilled inmate, extending the ambit of anti-Black violence from the US prison-industrial complex retrospectively back to his infancy. Yet, Wallace's lifelong flirtation with escape, figured in the album, is neither solely a response to social conditions nor to institutional racism, but a result of the complex entanglement underlying the cultural notions of being, Blackness, and the precarity of Black life, which, as we later learn, begins *perinatally*.[22] More than a decade after the release of his debut album, the song "1970 Somethin'" emerges as the lyrical accompaniment to *Ready to Die*'s introductory track (as a posthumous remix to *Ready to Die*'s "Respect"), appending Wallace's prefatory montage with the emcee's *antenatal* thoughts of death from the greenroom to the world. As Biggie anxiously awaits the start to his mother's belated labor, his lyrics mark the violence of that space and time: "my moms was late | So I had to plan my escape. . . . | The doctor looked and said | "He's going to be bad boy."[23] Rereleased in 2005, this prerecorded verse resumes Biggie's introduction to the hip-hop world many years after both his lyrical debut and his biological death, by dispensing "crib" notes detailing prenatal fugitivity. The mother's womb figures, inimically, as the child's primal obstruction to freedom, autonomy, and life. The heavy drinking causing the mother to regurgitate, suggested in the unborn Biggie's reference to "Tanqueray and Hennessey" that "call Earl" (1990s slang for vomiting), makes the space unpropitious to prenatal health and development. Portentous visions of premature death supersede even the most basic life endeavors—such as taking his "first step." The "umbilical cords wrapped around his neck" prefigure the racialized iconography of American lynching. Taken together, these details call into question the mother's womb as a space (in)hospitable to Black being. Analogous to the world-in-waiting, the threat of premature death permeates Biggie's lyrical representation of the antenatal space, where the violence that pursues Black life infiltrates the womb, conjuring prenatal anxieties over becoming, along with fantasies of violence and plots of escape.[24]

It would seem, then, that even before life begins, Black being operates under the threat of nonbeing. The perpetuity of that violence translates into a readiness to die that defines ontological terror and precedes embodiment. Biggie's lyrical innovation, displayed in the verse quoted previously, demonstrates a mature consciousness, attached to and directed by the narrative persona of an unborn self, and provides the emcee a uniquely postmodern literary framework for

ANDREW R. BELTON

sounding the complex entanglement of Blackness, being, and the violence that preexists and encloses the Black body in a form of primeval terror that predicates Black existence. If not disembodied, the voice here cannot be understood as fully constituted in the flesh. Thus, the representation of this paradoxical disjuncture—the fugitive (pre-)consciousness that seeks escape from the Black body as harbinger of violence and death—prefigures the fugitive desire for escape (demonstrated throughout the album) that comes when encountering a world conditioned upon anti-Blackness.

From the initial sound production of *Ready to Die*, then, the listener is meant to sonically experience the impulse to escape being as a metaphysical aspiration predating Black life, the Black body, and the violence of an anti-Black world. In fact, the power of this fugitive message in the face of Black death and destruction is made manifest in the packaging of the product. In the haunting portrait used for its cover art, we find the sepia-toned photographic image of a Black male infant, seated at an angle (yet also floating) within luminously white space. His legs are crossed, and surrounding his face is an afro, a crown or nimbus of hair nostalgically reminiscent of 1970s Black Power aesthetics. Slightly tense, his left arm and leg create a fleshy barrier of prematurely developed musculature, closing off from view most of his abdomen. His loosely pursed, non-smiling mouth is neither mean mug nor grimace. His head, tilted upward and turned diagonally to his body, features eyes that stare off at something outside of the frame.[25]

As hip-hop album covers go, this image of Black infancy would seem to be quite innocent. The tiny brown boy at the center of the frame neither invokes danger nor invites menace. Instead, the first impression given is archetypal, evocative of the infant-soul waiting to be born into a graphic design version of a cosmic crib. The contrast between his body and the emanation of an all-encompassing white light invokes a certain cinematic method of dissolve and fade that allegorizes the transition between the antenatal spirit/soul and being. Yet, under more critical scrutiny, *Ready to Die*'s cover would seem to reverberate with the larger themes in the album it encases. Viewed chromatically, the uncompromising whiteness begins to place the Blackness of the antenatal infant under erasure.[26] Thus, I argue that, in the moment of his infancy, the boy on the cover stands as a surrogate for the man that Biggie is to become, while, at the same time, anticipating his future sense of loss and dislocation in the fading outer edges of the image.

This album's iconographic framing of the imminent ontological terror associated with Blackness coming-into-being is itself framed by descriptors above and below the photographic scene. Identifying the emcee, the font above the image of the infant moves from black to red in color, with the initial lowercase print spelling out "the notorious" in all-black lettering, giving way to the eye-catching and larger, upper-cased bold red print spelling out "BIG" (highlighted in a black block). Likewise, below the image of the infant boy is font that moves from black to red lettering that signals the album title: *Ready to Die*—where *ready*, in bold black print slightly larger than "the notorious" directly above, gives way to a fainter "to" in black lettering, which itself gives way to "die" in equally faint red print. The infringement of human language into the design of this antenatal scene creates a context for interpreting the image of the otherworldly child within a framework that interpellates the Black condition as always already "ready to die." Juxtaposed against the pervasive white space, the image of the Black boy as infant, labeled provocatively as "notorious," "big," and professedly "ready to die," provides the album's optical materialization. The cover thus anticipates the sounds of entanglement on the album, expressing the violence of Blackness coming-into-being and the inevitability of premature death as

160

SOUNDING DEAD, OR THE BLACK RADICAL AESTHETICS OF SOUND REPRODUCTION

The graphic and aural meditations on Black birth and antenatal being serving as the sonic introduction to The Notorious B.I.G. raise questions regarding the function of Black death and Black afterlife in Biggie's thinking and performance. For this reason, I want to shift the focus onto how twentieth-century sound recording and reproduction technologies figure prominently in B.I.G.'s afterlife and legacy, enacting in his albums a sonorous desire to overcome the ontological terror grounding Blackness to the graphic, material, and embodied worlds of anti-Blackness. Warren's onto-metaphysical space is explored in this prerecorded and reproduced sounding of the world in what Ashon Crawley describes as an air "vibration [and] sonic event," situating in Black thought "the gift, the concept, the inhabitation of and living into [of] *otherwise possibilities*" for Blackness.[27] Alexander Weheliye, furthermore, writes of "the spatialities resulting from the juxtaposition of *consuming* sonic technologies and *being consumed* by them suggest[ing] specifically modern ways of be(com)ing in the world."[28] If we consider, then, the potentiality of pursuing Black life as it adheres to novel forms of existence in technologies of sound and sound reproduction—and in an ontological state beyond the being of the human and its humanism—we might begin to register what is truly transformative and transcendent in Biggie's attachment to sound, and technologies of sound recording, as a method for searching out Black life after death.

Throughout the production of *Ready to Die*, Biggie's team of sound mixers and track producers adopts a strategy analogous to certain cinematic deployments of diegetic and non-diegetic sound. Distinctions between sounds that find their source in actions that occur on-screen and sounds that emerge from outside of the narrative frame compel a new conceptual language. In concept albums like The Notorious B.I.G.'s *Ready to Die*, the relationship between narrative and musical elements of sound requires similar distinguishing categories. In establishing these distinctions, it is important to remember not only that hip-hop's primary mode of sound deployment is nonmimetic but also that the incorporation of mimetic sound is often what allows for narrative coherence between tracks, creating the "concept album" as a distinct subgenre within hip-hop. We might, then, designate these soundscapes occurring within this album as part of its musical composition as nonmimetic and those occurring outside of the musical frame as mimetic. Therefore, it is possible to think through the distinction in sounding practices on *Ready to Die* as the deployment of sounds that register what Roland Barthes calls "the effect of the real" in the world the album creates, or presumes to record and reproduce. These sounds enlarge and augment the "real" world through the musical arrangements of rhythmic sound, samples, and other such hip-hop sounding practices. Among these mimetic sounds on B.I.G.'s album are those symbolically reproductive of cycles in the creation of life, from the squeaking of a noisy bedframe and the accompanying moans of a couple's raucous sex to the nascent beats of an infant heart and the ceaseless cries of a newborn child. Among these sounds are also those symbolically

ANDREW R. BELTON

foreboding of Black death, including guns being loaded, cocked, and shot; guard dogs barking threateningly; (subway) train wheels screeching to a halt; people choking from smoke inhalation; sirens wailing from police cars and emergency vehicles; and prison bars slamming shut.

All these mimetic sounds trouble the coherence of the album as a strictly aesthetic or nonmimetic composition, filling the digital spaces in between the musical interpolations, sampling, and instrumentations with a "realness" that disrupts the primary nonmimetic musical elements of the album's tracks.[29] Yet, more meaningful than the ways this mélange of mimetic and nonmimetic sounds augments, interrupts, and disrupts throughout the album are the ways in which certain mimetic sounds merge with and become part of the album's nonmimetic sounding strategy. Most notable, perhaps, are the moments reproducing the sonic resonances of modern telecommunication technologies, especially those associated with life in the 1990s—including the sounding alert of the wireless pager, the automated voice greeting and beep tone of an answering machine voicemail recorder, and the dial and ringing tones and dual-tone multifrequency signaling of the push-button keypad of the touch-tone telephone. The dramatic incorporation of these mimetic elements produces the reality effect, as well as a spectral quality, through technological portals of sound transmission, transportation, and transformation for Black voices. I argue that, taken together, these elements produce soundings of Black fugitivity.[30] Indeed, the album's reproductive sounding of these technologies, as twentieth- and twenty-first-century modes of air and airwave disruption, as recording journeys and flights of sound, dramatizes the spectral potentiality of the sonic terrain as a space for realizing new ontological fantasies and constituting a new terrain of Black fugitive life—specifically, in apposition to the Western conceptions of the human. This emergent technological account of Black life rivals and rests beyond any recourse to the limiting, Western discourses of the human, based, as they are, in a (post-meta-)physical world, and the attendant philosophical constructions of ontological terror that precondition that world as anti-Black.

The album partakes in a kind of metaphysical rupture, which Alexander Weheliye has described as defining a "sonic Afro-modernity" in which a "(dis)juncture between sound and source" is made possible by the advent and wide circulation of new sound technologies.[31] Consequently, the "split" between sounds and the "sources that (re)produced them" creates "differently pitched technological oralities and musicalities in twentieth[-]century black culture"—oralities and musicalities that, Weheliye notes, render sound recording ephemeral and the "immediate presence of the human subject" as nonessential in its production.[32] Tracks like "Warning" and "One More Chance" exploit the metaphysical ruptures created by the prerecorded sound of modern telecommunication technologies to reveal a prosthetic function in all recorded sound at the end of the twentieth century. The wireless pager, voicemail answering machine, or touch-tone telephone, and the integration of reproductive sound technologies as signs of the real offer listeners incessant pleasure in their access to and surveillance of Black life and death within *Ready to Die*'s sonic production.[33]

Sound recording and sound reproduction, then, proliferate previously unimagined possibilities for Black life in forms of listening and sounding pleasure. The first form of pleasure comes in the persistent access to Black culture and Black cultural products without the obligatory and necessarily tendentious racial encounter. The Black body, as the originary source of vocalizations of sound, is made nonessential by sonic (re)production, thus forfeiting the potential for staging the racial encounter in sound reproduction technologies. Because of the many ways that the consumption of Black culture and Black cultural products, particularly recorded sound,

DREAMING OF *LIFE AFTER DEATH* WHEN YOU'RE *READY TO DIE*

affords its audiences the luxury of ignoring anti-Black violence, perhaps as a function of the structuring logic of that cultural production (e.g., in the process of receiving the audio recordings of Black artists, their lives become nonessential to the reproduction of their sounds), I like to think of the pleasure found in the loss of the racial encounter during this process as a kind of forfeiture of possibility (for remorse, for reparation, for social transformation, and so forth). The second form of pleasure is the listener's sonic voyeurism in *overhearing*—both the overhearing of Biggie's narratives of Black destruction and death, and the overhearing of his suicidal fantasy of sonic escape. Reinforced, then, within the structure of *Ready to Die*'s sounding practices is the pervasiveness of the ontological terror that pursues Black life and its ongoing production. At the advent of a new era of technological ubiquity, Blackness is once again distinguished from the subjectivity of the human through the creation of a transactional relationship between Black life and sound reproduction. This arrangement in the twentieth- and twenty-first centuries between Black life and sound technologies instrumentalizes the voice of the Black emcee (and other Black artists) in order to (re)deploy Blackness as a spectral presence in sound.

Nowhere is this sonic hauntology clearer than in the track that serves as finale to The Notorious B.I.G.'s debut. The first sounds that we hear as the final track begins are the now roughly recognizable seven punch dialing tones of a 1990s-era touch-tone telephone's push-button keypad.[34] The dual-tone multifrequency signaling of the touch-tone telephone quickly gives way to its high-pitch ringing tones and the receiver click of a suddenly live telephone line. Barely audible beneath an airy and eerie sample from Miles Davis's "Lonely Fire"[35] is the voice of Biggie's sleepy interlocutor answering questioningly. The mimetic reproduction of the sounds of the touch-tone telephone's call-in-progress, here, positions B.I.G.'s listeners as silent sonic voyeurs on the line, eavesdropping as his voice emerges within the dramatic context of a late-night emergency telephone call to his producer, Sean "Puff Daddy" Combs, expressing "Suicidal Thoughts." As part of the call, we also overhear—throughout the track—Biggie's justifications for wanting to take his own life, disregarding his producer's petitions not to do so. To an audience of muted interlocutors, Biggie's voice floats hauntingly across the airwaves (of the telephone and the audio recording), indicting us as silent sonic voyeurs to the catalogue of Black death and destruction featured across the album, and culminating in the emcee's own suicidal death at album's end: "slit my wrists and end this bullshit | . . . | I feel like death is fucking calling me | . . . | I'm sick of talking [sound of gunshot] | (A yo, Big . . . A yo, Big . . .)."[36] In the transmission of B.I.G.'s and Combs's overlapping voices, the listener is simultaneously haunted by the telephonic echo repeatedly capturing the distance between each of the speakers' words and the telephone receiver and by the interplay between the emcee's explicitly stated desire for suicidal escape and his friend and producer's responsive gestures. A sign of the extended life of sound, the telephonic echo, ultimately, registers each speaker's transmitted voice as a sonic presence in and against the violence that threatens to render all forms of Black life and afterlife inaudible or otherwise illegible. Thus, eavesdropping on the voices and sounds gives a sense of the precarity of Black life (and afterlife) symbolized in the suicide call received in the early hours of the morning.

Moving away from the production on tracks like "Machine Gun Funk" and "Gimme the Loot," where the sound of gunfire is heard or directed elsewhere at Biggie's assailants, "Suicidal Thoughts" reproduces the particular sound of a single close-range gunshot hitting the emcee directly. As the lyrics come to a close, we overhear the forensically reverberating "pop" of the close-range shot, the subsequently abrupt crashing of a large body to the floor, and the cacophonous echo of

ANDREW R. BELTON

Combs's voice calling after Biggie. The heartbeat from the album's opening track returns—the only remaining sound, as all others flatline. The album thus concludes with a dying heartbeat and the prerecorded message of the telephone operator, alerting whoever remains on the line to "[p]lease hang up and try your call again," repeating for emphasis, "Please hang up. This is a recording." The self-conscious interplay between the track's mimetic incorporation of the sounds of modern telecommunication technologies—including the telephone's dial and ringing tones, the dual-tone multifrequency signaling of the telephone's push-button keypad, and the prerecorded prompting at the end to hang up because the line is dead—all contribute to what Tricia Rose might call the *noisy* build up to Christopher Wallace's sonic death. In this recording, created from sounds rendering for the listener a "reality effect," Biggie's final moment leaves the earwitness traumatized and haunted by what turns out to be a sonic simulation of suicide. His performance of suicide at the album's end, thus, is the beginning of an aesthetic desire to affix to the sound of his voice a mode of being that, for Blackness, exists beyond the historical precarity of the Black body (even in sound recording)—as the sonic echoes of Black lives after death or as the sonic potentiality of Black afterlives.

THE SONIC POTENTIALITY OF BLACK AFTERLIVES

The story of The Notorious B.I.G., of course, does not end here—with his suicidal death at album's end. How could it? If *Ready to Die* comes to its close by staging Biggie's death, then his follow-up album, *Life After Death* (1997), along with several of his subsequent releases, allow Biggie to revel in a full Black sonic afterlife. Thus, a few short weeks after Christopher Wallace's biological death and three short days after his Brooklyn funeral procession—in the wake of his wake—the posthumous release of *Life after Death* returns to the themes introduced in his debut album. The sonic afterlives of Biggie's voice on *Life after Death* have now become a means for audiences to begin to register the full impact of his suicidal death at the close of *Ready to Die*, where we move into that horizon of Black thought inaugurated by the emcee's dream of the possibility of a sonic escape into sound.

As such, it is in Biggie's follow-up album (and all his subsequent releases) that the terms of his afterlife in hip-hop are established. The emcee's embrace of technologies of sound recording and reproduction fashions for him a Black afterlife as sonic/spectral presence in the reproduction of his prerecorded voice long after his death. Thus, the posthumous release of Biggie's second album, *Life after Death*, following the fabricated moment of suicide at the close of *Ready to Die*, and following, too, Wallace's actual murder three years later, enacts a fear and desire for sonic escape from social (and biological) death.[37] In this expansive imagining of the possibilities of bare (Black) life beyond its biological operations, Biggie abandons the unattainable desire for persistence associated with the Black body and defines an alternative mode of Black being made possible by and in sound (re)production. Within the sonically captured voice of Biggie, there exists a metaphysical rupturing of the events of Christopher Wallace's life, making of those accumulated experiences a prerecorded archive for sounding Biggie's afterlife.

Thus, posthumous verse after posthumous verse, wavelength after wavelength, in the wake of his death, Biggie's lingering presence in hip-hop helps us to recognize the full innovation of modern technologies of sound—the capacity to effect spatiotemporal disruptions that extend Black life and existence beyond social and biological death and across space and time. If, as

DREAMING OF *LIFE AFTER DEATH* WHEN YOU'RE *READY TO DIE*

Calvin Warren observes, there is no resistance that will eradicate the anti-Black violence that pursues Black life to its premature and untimely death, then how does Biggie's album expose the violent rupture necessary to create a space outside of the reach of the anti-Black world? The Brooklyn emcee's lingering presence in hip-hop (lingering because prematurely departed, but nevertheless persistent and hauntingly extant) tests the limits of imagining Black being beyond discourses of the human. As the subject of Black thought maintained and persevering through various forms and permutations of historical violence, Biggie's voice—in its otherwise perpetually available prerecorded form—draws our attention to how practices of emceeing use technologies of sound to advance new forms of Black fugitivity. Emceeing, thus, offers a mode of escape from the ontological terror of anti-Blackness through fugitive, spectral transmissions and technological transformations in sound.

Biggie's mode, then, of premillennial representation anticipates later formulations of Black radical thought. The emcee's particular intervention attunes us to the necessity of an incessant listening after Black life, allowing us to bear earwitness in *Ready to Die* to that spectrally haunting horizon of sound that finds Black being beyond the human. At a time when Black people might become otherwise overwhelmed by what anti-Blackness forces us to see and keep a watchful eye out for, Biggie begs us to hear the sonic potentiality of Black life in all the fullness of its living, soundly, after death, inhabiting an existence within, and in union with, the sonic potentiality of so many already extant Black afterlives. What, otherwise, are the possibilities for Black life after death? In other words, what are the potentialities of imagining Black life as afterlife?

Biggie will continue sounding himself into oblivion, aestheticizing the embrace of suicidal death as a method of escape from ontological terror, and performing Black fugitivity—all augmented by technological innovations in the recording and reproduction of sound. What remains of his life remains in the sound and haunting echo of his prerecorded voice. These recordings, as the emcee's final personal effects, sustain his presence in hip-hop; and, through our incessant listening, he is suspended between life and death, producing a contemporary sonic afterlife in Black fugitivity.

NOTES

1. As hip-hop's longest running periodical, *The Source* (founded in 1988 as a bimonthly Boston newsletter) has documented many of hip-hop's most important cultural moments and transitions, but also, through the editorial feature dubbed "Unsigned Hype," has exposed the hip-hop community to the efforts of several underground emcees. The March 1992 issue, for example, highlighted a little-known Brooklyn-based emcee calling himself "The Notorious B-I-G" with rhyme skills "fatter than he is." It's fitting, then, that *The Source* would commemorate the emcee's death only five short years after introducing Biggie to the world.

2. The Notorious B.I.G., "You're Nobody (Til Somebody Kills You)," *Life After Death* (Bad Boy/Arista Records, 1997).

3. As a performative gesture, Biggie's mean mug subverts the interpellative power of the viewer's gaze. Miles White suggests that "[t]he act of mean mugging in the performance of the hard masculine ideal in contemporary hip-hop adopts a privileged subjectivity . . . a posture of confident masculinity in which one must project power[ful emotions] if one is to gain respect" and, I would add, resists what Fanon, and later Althusser, describes elsewhere as the power in looking that hails the racialized subject. See Miles White, *From Jim Crow to Jay-Z: Race, Rap, and the Performance of Masculinity* (Chicago: University of Illinois Press, 2011), 18. See also Frantz Fanon, *Black Skin, White Masks* (New York: Grove Press, 1967).

ANDREW R. BELTON

4. Wallace's seemingly endless list of interchangeable pseudonyms, which include "The Notorious B.I.G.," "Frank White," "Biggie Smalls," "Biggie," "Big Poppa," and "B.I.G.," reinvigorates the African American literary trope of naming as a thematic substructure of the emcee's performance of Black afterlife in ways peripherally bound to certain interests of this chapter. Some of Wallace's aliases include appropriations from cinema ("Biggie Smalls" from Sydney Poitier's 1975 *Let's Do It Again* and "Frank White" from Abel Ferrara's 1990 *King of New York*, starring Christopher Walken as the central character) that meditate deeply on the relationship between the perpetual threat of death and the possibilities for eluding fatal ends inherent to Black performance. For a brilliant reading on the trope of naming in African American narrative practices, see Kimberly Benston's "'I Yam what I Am': Naming and Unnaming in Afro-American Literature," *Black American Literature Forum* 16, no. 1 (1982): 3–11.

5. See The Notorious B.I.G., *Ready to Die* (Bad Boy/Arista Records, 1994).

6. See Fred Moten's "Interpolation and Interpellation," in *Black and Blur* (Durham, NC: Duke University Press, 2017), 28–33.

7. Several scholars have contributed significantly to discussions of anti-Blackness, although I primarily want to engage with analyses that converge within the intellectual arena contained by the term Afro-pessimism. I am interested particularly in Calvin Warren's recent work, *Ontological Terror: Blackness, Nihilism, and Emancipation* (Durham, NC: Duke University Press, 2018), as it works to identify the "metaphysical infrastructure" of antiBlackness, and the terrifying ways in which it conditions our world and the ways we think about our world. For more on the relationship between anti-Blackness and Afro-Pessimism, see also Frank Wilderson's *Red, White & Black: Cinema and the Structure of U. S. Antagonisms* (Durham, NC: Duke University Press, 2010). See also Jared Sexton's "Afro-Pessimism: The Unclear Word," *Rhizomes*, Issue 29 (2016), and his (alongside Huey Copeland's) special issue of the journal *Qui Parle*, especially their editors' introduction, "Raw Life: An Introduction," *Qui Parle* 13, no. 2 (2003): 53–62.

8. Nahum Chandler engages this notion of an always already resistant pressure in the escape of Blackness from the philosophical concepts, methods, and logics of any ontology structured in anti-Blackness (or white supremacy) through his deployment of the terms *paraontology* or *paraontological discourse*. Through a deep reading and analysis of the writings and thought of W. E. B. Du Bois, Chandler charts the mission and terrain of Black thought in the exclusion from or exteriority of Blackness in Western ontological thinking. See Nahum Chandler, *X: The Problem of the Negro as a Problem for Thought* (New York: Fordham University Press, 2014).

9. See Stefano Harney and Fred Moten, *The Undercommons: Fugitive Planning and Black Study* (Wivenhoe, NY: Minor Compositions, 2013).

10. See the introduction to Warren's *Ontological Terror*, 1–25.

11. Mae G. Henderson, "Black Women Writers Speaking, Listening, and Witnessing," in *Speaking in Tongues and Dancing Diaspora: Black Women Writing and Performing* (New York: Oxford University Press, 2014), 11.

12. My use of "bareness" as a remarkable declension of being is meant in call up to Giorgio Agamben's writing about the politicization of "bare life." Unlike Agamben, and following Afro-pessimism, my concern here is for the relationship between arguing the politicization of life and thinking the politics of (metaphysical) Being. These discourses ultimately converge to establish anti-Blackness as global phenomenon, with metaphysical and political infrastructures. See Agamben's "The Politicization of Life" and "Biopolitics and the Rights of Man," in *Biopolitics: A Reader*, ed. Timothy Campbell and Adam Sitze (Durham, NC: Duke University Press, 2013), 145–160.

13. Warren, *Ontological Terror*, 1–25.

14. Warren, *Ontological Terror*, 1–2.

15. In *Ontological Terror*, Warren defines ontological terror in pressing the question of being, particularly as that pressure is mounted by Black subjects seeking the claims of humanism to address the world's anti-Blackness and the incompatibility of Blackness with forms of being predicated upon the human. He describes this as "the (non)relation between blackness and Being" (5). He provides a critique of the romance between Black humanism and metaphysics and of post-metaphysics and its supposed ability to solve the problem of anti-Blackness. For example, he writes, "the function of black(ness) is to give form to a terrifying formlessness (nothing)." In addition, Warren writes, "*Ontological Terror* challenges the claim that blacks are human and can ground existence in the same being of the human" (6). He continues, "What is black existence without Being? This is the question black thought orbits, the question that emerges through urgency, devastation, or the declaration 'black

DREAMING OF *LIFE AFTER DEATH* WHEN YOU'RE *READY TO DIE*

lives matter.' It is a question that, perhaps, cannot be answered adequately—or any answer resides outside the world, in an unimaginable time/space horizon" (14). In fact, this is precisely what Biggie imagines.

16. My particular use of the term hip-hop's "airwaves" invites a complimentary reading in dialogue with Christina Sharpe's beautiful and multitudinous conceptualization of "the orthography of the wake," where contemporary Black life is haunted by the specter of the slave ship hold and animated by the afterlives of enslavement. Imagining what possibilities of planning and escape might also exist in that wake, I offer "airwaves," as a conceptual equivalent to the inevitable fugitivity preconditioned by any thinking of the afterlives of enslavement. Emcees like The Notorious B.I.G., then, might be said to examine Black sound as a disturbance and displacement of air, or of the "airways," as an inquiry into the possibilities of Black life after or beyond "the wake" of slavery's material afterlives. This seems, at least to me, a fruitful, if not too "optimistic," enterprise for Black thought. See Christina Sharpe, *In the Wake: On Blackness and Being* (Durham, NC: Duke University Press, 2016). See also Daphne Brooks, *Bodies in Dissent: Spectacular Performances of Race and Freedom, 1850–1910* (Durham, NC: Duke University Press, 2006).

17. The idea of *Black hauntology* I express here pivots on Derrida's treatment in *Specters of Marx: The State of the Debt, the Work of Mourning, and the New International* (New York: Routledge, 1994), on the legacy of Marx, after the supposed death of communism, at the moment of a declared "end of the history" that inaugurates a new international allegiance against the onslaught of global capitalism. Black hauntology puts Derrida's analysis of the international order that follows in the spirit of Marx in conversation with what Denise Ferreira da Silva has eloquently articulated as the "productive role the racial" has played in "instituting the global as an ontoepistemological context—a productive and violent gesture" (*Toward a Global Idea of Race* [Minneapolis: University of Minnesota Press, 2007], xxvi).

18. The Notorious B.I.G., "Intro," *Ready to Die.*

19. The Notorious B.I.G., "Intro," *Ready to Die.*

20. See Roland Barthes, "The Reality Effect," in *The Rustle of Language*, trans. Richard Howard (Berkeley: University of California Press, 1989), 141–148.

21. See Cheo Hodari Coker, *Unbelievable: The Life, Death, and Afterlife of the Notorious B.I.G.* (New York: Three Rivers Press, 2003).

22. See Fred Moten's "Resistance of the Object: Aunt Hester's Scream," in his *In the Break: The Aesthetics of the Black Radical Tradition* (Minneapolis: University of Minnesota Press, 2003), 1–24.

23. See both The Notorious B.I.G., "1970 Somethin'," *Duets: The Final Chapter* (Bad Boy Records, 2005); and The Notorious B.I.G., "Respect," *Ready to Die.*

24. In the same year of Biggie's debut release, Queensbridge emcee, Nasir Jones (Nas), similarly rapped about the prenatal space as a environ hostile to Black being and fertile for fugitive planning. On the track, "One Time 4 Your Mind," Nas memorably declares, "I'm prepared to bomb troops | ya'll niggas was born | I shot my way out my mom dukes . . . ," as a glib reminder that the violence that pursues black life, even prenatally, must be met with a kind of fugitive violence that paradoxically extends the threat to becoming. See Nas, "One Time 4 Your Mind," *Illmatic* (Columbia Records, 1994).

25. The Notorious B.I.G., Cover Art, *Ready to Die.*

26. Although her treatment runs somewhat counter to my reading of *Ready to Die*'s cover art, I am indebted to Krista Thompson's brilliant analysis of the relationship between photographic practice, portraiture, light, and visibility in hip-hop. See Krista A. Thompson, *Shine: The Visual Economy of Light in African Diasporic Aesthetic Practice* (Durham, NC: Duke University Press, 2015).

27. Again, I am interested in the many ways that Black sound, as a "property" of air disruption, bears the afterlife of fugitive planning and legacies of Black escape, as creating "airways" on "airwaves." In attending to the Black (pentecostal) breath, as perhaps the minimalist increment of this legacy of fugitivity (it is, as it where, in the maintenance of the breath's escape from the body that contemporary Black life is simultaneously lost and perpetuated, measured and meted out of existence), Crawley offers an intervention into Black Study that begins to engage the contemporary remnants of anti-enslavement fugitivity. See Ashon T. Crawley, *Blackpentecostal Breath: The Aesthetics of Possibility* (New York: Fordham University Press, 2017), 4.

28. See Alexander G. Weheliye, *Phonographies: Grooves in Sonic Afro-Modernity* (Durham, NC: Duke University Press, 2005), 107.

ANDREW R. BELTON

29. See Joseph Schloss, *Making Beats: The Art of Sample-Based Hip-Hop* (Middletown, CT: Wesleyan University Press, 2014).

30. Ashon Crawley writes: "the necessity of the breath, of breathing itself, as performative act, as performative gesture . . . is constitutive for flight, for movement, for performance." While his reading of the disruption of air (and breath) as an aesthetic practice in the mode of fugitive planning and escape conflates the obstruction of breath/air or the need to "keep breathing," in the here and now, with fugitivity, I am interested instead in the relationship between airwave disruption and the transmission of breaths through another realm as the mark of Black fugitivity. The capacity for modern sound recording and reproduction technologies to disrupt airwaves and transport black breath into another (sonic) realm, then, is the sign of Black fugitivity and its afterlife in Black sound reproduction. See Crawley, *Blackpentecostal Breath*, 33.

31. See Alexander Weheliye. *Phonographies*, 1–17.

32. Additionally, Weheliye notes that, with the advent of technological sound recording, sound "[gains] its materiality in [these] technological apparatuses" and the "black voice performs and constructs its corporeality" (*Phonographies*, 54). The interplay between the materiality of audio recording (or its technologies and apparatuses) and the accessed corporality of the Black voice (with the sublimation of its connection to the human subject as the original source of sound, as both disembodied and ephemeral musical presence) locates "the tension at the core of sonic Afro-modernity" for Weheliye (*Phonographies*, 7).

33. For more on the relationship between Blackness and the history of surveillance, see Simone Browne's *Dark Matters: On the Surveillance of Blackness* (Durham, NC: Duke University Press, 2015).

34. The Notorious B.I.G., "Suicidal Thoughts," *Ready to Die*.

35. The sample is taken from Miles Davis's "electric" period, from a track that incorporates Southeast Asian instruments, such as the sitar and tambura, to create a slowed down, meditative, and capaciousness experimental jazz sound. See Miles Davis, "Lonely Fire," *Big Fun* (Columbia Records, 1974).

36. The Notorious B.I.G., "Suicidal Thoughts," *Ready to Die*.

37. The Notorious B.I.G., "Intro," *Ready to Die*.

NINE

"WE AIN'T EVEN REALLY RAPPIN', WE JUST LETTING OUR DEAD HOMIES TELL STORIES FOR US"

Kendrick Lamar, Radical Popular Hip-Hop, and the Specters of Slavery and Its Afterlife

KIM WHITE

One cannot speak of the arts of the African Diaspora without summoning the specters of slavery and colonialism. As Frank Wilderson suggests, every colloquy concerning "the intersection of performance and subjectivity" in the lives of the African Diaspora is saturated with "a palpable structure of feeling, a shared sense that violence and captivity are the grammar and ghosts" of every Afrodiasporic expression.[1] To speak of how the Afrodiasporic subject constitutes herself in illocutionary speech or performative gesture is to speak either of a self that attunes itself to the ghostly echoes of the Middle Passage, the plantation, and the ghetto, or a self that instead finds its voice and its gestures in repressing Black history's traumatic legacy. In the context of the United States, what is at stake in this distinction is whether African American art challenges or leaves unexamined what Jared Sexton calls "the originating metaphors of captivity and mutilation" of white racist discourses that "continue to adapt and mutate to meet the exigencies of the now."[2] Among the rich artistic conjugations of these ghostly grammars, perhaps no African American art better embodies the tension between grounding the self in attunement to the specters of slavery and founding subjectivity on their repression than hip-hop. The shift in critical attitude of one of hip-hop's first academic champions from qualified celebration of its radical potential to profound ambivalence concerning its recent state neatly illustrates the issue.

In her 1994 classic *Black Noise*, Tricia Rose waxed Gramscian on hip-hop as a "polyvocal black cultural discourse engaged in discursive 'wars of position' within and against dominant discourses."[3] In her later work, however, the civil society of twenty-first-century American capitalism has become territory far less favorable to such struggles. Instead, the market has funneled insurgent creativity into a choke point where "the underdevelopment of appreciation for hip hop" in the public sphere engenders rappers who "capitulate to this market substandard and thus contribute to the reduction of market value of more complex rhymes, creative risks, and unexpected collaborations."[4] On this analysis, one might say that the interwoven dynamics of capitalism and the mutating discourses of white supremacy have proven efficacious in deafening hip-hop artists to the sounds of the specters of Black history that inspired a range of earlier radical insurgencies into the pop mainstream. Gone, it would seem, is the late 1980s and early 1990s Black revolutionary aesthetic of Public Enemy "speaking directly to the poor, using indirection and symbolic reference";[5] gone, too, the contemporaneous "lumpenprole rebellion of 'Fuck Tha

169

Police'"[6] that made NWA the embodiment of gangsta rap's articulation of the angst of an "increasingly nonpoliticized generation, which has seen traditional forms of protest lose much of their resonance";[7] gone, finally, the artist in whose oeuvre these opposed forms of protest enter into volatile confluence, Tupac Shakur, "a blistering mixture of 'black power' past and 'thug life' present" whose "residual political commitment" made his "perceived changes all the more palpable and poignant."[8]

The critical and commercial successes of the rapper Kendrick Lamar would seem to constitute a challenge to this exorcism of the specters of resistant Black life from hip-hop. The coronation of Lamar as the voice of a new generation of Black social struggle has coalesced around the politicized aesthetics and political adoption of songs from his 2015 album *To Pimp a Butterfly*. A juxtaposition of Greg Tate's reflections on the paucity of twenty-first-century political rap and his review of Lamar's third album represents a broad critical consensus: "While the first 15 years of millennial rap (and rock) will be remembered for many things, good, bad, and ugly, a surfeit of ditties decrying the status quo of systematic racism won't be one of them";[9] however, for Tate, with the release of "Kendrick Lamar's *To Pimp a Butterfly*, 2015 will be remembered as the year radical black politics and for-real black music resurged in tandem."[10] If, as Tryon P. Woods has suggested, the state of contemporary hip-hop is one in which "the black revolution—and all meaningful assertions of black resistance—must be killed off in order that the colorblind nation, with its enormous market and cultural interest in hip hop, may live," then the aesthetic politics of *To Pimp a Butterfly* are radical indeed.[11] Hua Hsu provides a succinct account of the album's insurgent qualities when he describes it as an "art that imagines an 'unmitigated blackness,' art that rejects the possibility of a single, liberal 'we.'"[12] Moreover, this evocation of Black selves irreducible and resistant to the subject-positions of a color-blind liberal sovereignty would seem to have resonated with, and become part of the praxis of, the #BlackLivesMatter movement. When footage of #BlackLivesMatter protestors chanting Lamar's song "Alright" surfaced in late 2015, Aisha Harris declared herself "surprised it took this long for it to be used during a protest," especially given that Lamar's performance of the song at the 2015 BET awards "seemed to be making a kind of argument for the role the song might play in black communities and black protests."[13] *The Guardian* would go on to assert at the end of 2015 that "[t]he sound of Kendrick Lamar's Alright rang out like a clarion call this year, from clubs, cars and house parties to political harassment protests."[14] To be sure, one must guard against the temptation to regard "art as the very essence of, rather than an accompaniment to, structural change."[15] Yet, at the same time, in its admixture of "unmitigated blackness" and intractable public sphere presence, *To Pimp a Butterfly* resists and contests those forces that Sexton, Rose, and Woods hold to be inimical to a militant Black poetics.

It is the contention of this essay that Kendrick Lamar's success in once again fighting something like (but ultimately distinct from) a Gramscian "war of position" in a hip-hop media terrain bleached of Blackness in all its love, pride, and torment is inseparable from the centrality of the specter—as both explicit artistic theme and critical analytical concept—to his mature work. From his "Visions of Martin Luther staring at me" in "HiiiPoWeR," the single to his indie-label debut *Section.80*, to his conversation with the technologically resurrected voice of Tupac Shakur in the coda of *To Pimp a Butterfly*'s twelve-minute final song, "Mortal Man," Lamar recurrently summons himself before the exacting words and gazes of icons of Black resistance, be they universally respected progressives like King or tragically ambiguous figures of the Black militant

turned gangsta martyr like Shakur. But Lamar's every word, and the rhythms, melodies, and harmonies of the music over which he rhymes, can also be read as a form of communion with and conduit for the lost voices of the anonymous specters of those murdered and marginalized by centuries of structural violence against Black life.

This is a reading suggested by the concluding exchange of the ghostly conversation between Tupac Shakur and Lamar that the latter stages in "Mortal Man." In a move that risks becoming kitsch, but ultimately functions as an example of Fouché's concept of "black vernacular technological creativity,"[16] Lamar interpolates excerpts of a 1994 Swedish radio interview of Tupac Shakur with his own questions and thoughts about the nature of hip-hop expression and Black selfhood in 2015. Free jazz improvisation oscillates between pensive elegy and exuberant hope in the background of the conversation, reflecting and commenting on the manner in which the interpolation of the voice of a decades-dead rapper (Tupac Shakur was murdered in 1996) into conversation with living Black artists marks the manner in which Black thought draws on the sounds and specters of past suffering to fight the battles of the present. In the final exchange of the discussion, after suggesting that the "only hope that we kinda have left is music and vibrations," a disingenuously naïve Lamar expresses puzzlement about the aleatory but exigent force of Afrodiasporic performance.[17] The recording of Tupac Shakur's voice utters a response that reaches not only forward in time from his past towards our present but also refers back to centuries of Afrodiasporic suffering that finds expression in the specters of victims of anti-Black violence: "Because the spirits, we ain't even really rappin', we just letting our dead homies tell stories for us."[18] The words of Tupac Shakur's interview, and Lamar's choice in excerpting them, suggest a confrontation with something like the logic of mutating tropes of racist oppression that Sexton theorizes. When Lamar reflects that "there's nothing but turmoil goin' on" and asks Tupac, "what you think is the future for me and my generation today?," he samples Tupac's assertion in 1994 that "it's gonna be like Nat Turner, 1831, up in this muthafucka."[19] For Lamar, to be a Black person in America is to live among the specters of structural violence against Black life and, moreover, to become the vessel that gives voice to them so that the conditions that make their hauntings necessary might be brought to an end, be it in blood or in peace. Indeed, the different stagings Lamar has performed over his career with the voices of the Black dead entails a constant meditation on whether emancipation is best achieved through violent means, such as Turner's 1831 rebellion, or nonviolent means, such as the Civil Rights protests embodied in the figure of Martin Luther King.

"Mortal Man" lodges the generative vibrations of Black poetry and musicality, the metaphor of Frantz Fanon's "*yes* that vibrates to cosmic harmonies"[20] made concrete, in the matrix of the ongoing history of discursively and institutionally entrenched Black suffering and the ghosts it engenders. If this brings to mind Gayle Wald's analysis of Sun Ra's mystical aesthetics in which the self "existed on a continuum with other entities, living and nonliving, which simultaneously emit, decipher, and absorb musical vibrations,"[21] it also directs one towards Moten's reflections on "mysticism in the flesh," where "[w]hat the biopolitical continuum (the trajectory of sovereignty's illegitimate, speculative dissemination) attempts to regulate, suppress, and consume is the social poetics, the aesthetic sociality of this generativity."[22] If we wish to concur with Wald that "atmospheres are sonically saturated and that the history of twentieth-century black musical performance" is one of making American "places/spaces more hospitable, 'making room' for black presence,"[23] then Lamar's music, and the history of African American subjugation with

which it communes, suggests that it is not adequate to understand radical Black aesthetics as simply clearing space or mollifying hostility. Rather, we must understand Black music, and the vibrations through which it communes with the living and the dead, to be insisting on what Hsu described as "unmitigated blackness," an affective atmosphere that unchains those attuned to it from discourses of conservative white supremacy and liberal color-blindness. In "Mortal Man," Lamar's theorization of Black aesthetics concurs with Moten's formulation in which "blackness is the name that has been given to the social field and social life of an illicit alternative capacity to desire."[24] By identifying itself in the "illicit" terms that sovereignty, in its attempt to continue its biopolitical subjugation and mutilation of the Black body and Black subject, gives it, Black selfhood transvaluates these terms of opprobrium and repudiates the normative position from which such judgments are dispensed in order to assert that Black life is irreducible to the terms by which it is traduced, those metaphors of captivity and mutilation that constitute what Darieck Scott calls the "crèche of racialization" in the Americas.[25]

Conceiving of Black aesthetic politics in this manner requires not only the radicalization of a poetics that confines itself to making room for Black people in a political structure founded on their dehumanization; it also requires that the relationship between Black art and the cultural industries that seek to mold it toward more complaisant postures of Black life be understood within a biopolitical framework that locates the origins of capitalism not in the labor theory of value but rather in the historical event of the Atlantic slave trade. If, as Wilderson suggests in his analysis of Gramsci's colorblindness, Marxism is unable to "cope with the possibility that the generative subject of capitalism, the black body of the fifteenth and sixteenth centuries, and the generative subject that resolves late-capital's over accumulation crisis, the black (incarcerated) body of the twentieth and twenty-first centuries" are irreducible to "the categories of work, production, exploitation, historical-awareness and, above all, hegemony,"[26] then perhaps the Gramscian paradigm needs to be replaced, or at least challenged, by something like the experiments in affect theory and biopolitics that one finds in the works of Moten and Sexton. When the Afrofuturist jazz of Sun Ra or the hip-hop of Kendrick Lamar vibrates with an intensity that responds to and makes palpable the specters of slavery, they do so with the sorrow and the fury of centuries of Black dead, and they make us, be we Black or white, feel this sorrow and fury in such a way that we cease to be satisfied with the structures of government and commerce that have, in their injustices, made this sorrow and fury into a music that cannot be abjured and whose demand on us is that we, white and Black, seek forms of life beyond white racialist sovereignty.

Jared Sexton has written that "[t]he question of the possibility of racial slavery is, we might say, the question of global modernity itself, including the development of historical capitalism" and that consequently "slavery cannot be addressed fully if it is only addressed as a matter of *black* experience, rather than [as] the epochal transformation it inaugurates on a global scale: 'a tear in the world' is not something that happens solely to Africans; it is something that happens to *everyone*, and with radically incommensurate effects."[27] Slavery's inextricable relation to capitalism is both the condition of possibility for and the spectral warrant of the Black hauntings that confront people of all races with the injustices on which modernity is founded. The "incommensurate effects," a phrase of withering understatement, of this rupture refers to the unique inheritance borne by the descendants of slaves of "the singularity of racial slavery and its afterlife, the lasting paradox of a sentient and sapient being 'sealed into crushing objecthood.'"[28] Whatever myriad other injustices might have been visited upon other peoples, they

"WE AIN'T EVEN REALLY RAPPIN'"

are not ever quite this experience of finding the foundation of their selfhood in the juridical and ontological repudiation of their capacity to give expression to themselves as subjects of any desires other than those of the overseer, the plantation owner, the distant market for cotton, or, as it happens, rap audiences. While no longer subject to the intimately violent regimes of the antebellum plantation, rappers, and Black people whom they are held to represent, remain subject to, among others, one particular strain of the "originating metaphors of captivity and mutilation" that "mutate to meet the exigencies of the now": the apparatus of white desire for certain figures of the Black rapper that obfuscate and seal up the rupture in history on which modernity and capitalism are based and from within which the ghosts of the diaspora resonate, in furious harmony or dull distortion, in the sounds of Black music.

In what follows I will seek to trace the ways in which the rap music of Kendrick Lamar has wrestled with and resisted metaphors of captivity and manipulation both explicitly and implicitly in the work that spans his first three albums: *Section.80* (2011), *good kid, m.A.A.d city* (2012), and *To Pimp a Butterfly* (2015). I will argue that Lamar's Black radical voice did not coalesce solely in *To Pimp a Butterfly*, but rather finds its most strident and programmatic utterance in his debut, and sole indie-label album, *Section.80.* Named for Compton slang for welfare entitlements, the album reflects on what Imani Perry has called "the post-Moynihan blues"—juridical structures that immiserate, segregate, and ruthlessly police Black populations discursively inscribed under a rubric that figures "black women as welfare queens and black men as violent offenders."[29] Against the twin violences of racist policy and racist discourse Lamar posits the figure of "HiiiPoWeR," a kind of vague neo-civil rights community organization of which he anoints himself the leader. As he puts it at the beginning of the song of the same name, in which he likens himself to a pantheon of Civil Rights and Black Power icons, "The sky is falling, the wind is calling / stand for something or die in the morning."[30] Such explicit theorization of the urgent necessity of developing a radical Black aesthetic to resist structural violence is absent, however, from his major-label debut, *good kid, m.A.A.d city.* Indeed, one way of reading the complex politics of Lamar's short but much-feted career thus far might be to trace the way in which the HiiiPoWeR motif, which he has yet to take up again even in the polemical *To Pimp a Butterfly*, comes to find modulated expression on the lower frequencies of his music, as in *good kid, m.A.A.d city*, or in a profound anxiety about the possibilities of mixing pop success with political significance, as in *To Pimp a Butterfly*. While icons of Black resistance struggles of the past return to Lamar's lyrics in *To Pimp a Butterfly*, they are, with one significant, yet obliquely referenced, exception, absent from *good kid, m.A.A.d city*. Rather than reading this as capitulation to the metaphors of the self-mutilation of radical Black aesthetics that seem to purge so much commercially successful hip-hop of its radical valences, I want to suggest that Lamar's second, and to-date best-selling, album performs a kind of passive resistance, a radically melancholic refusal of violence, within the choke-hold of neo-minstrelsy in order to map the affective and discursive co-ordinates of the genealogy of anti-Black violence that George Lipsitz has traced from the Supreme Court's decision in *Plessy v. Ferguson* to Michael Brown's shooting in Ferguson, Missouri.[31] Lastly, in analyzing *To Pimp a Butterfly* I will look to its meditation on the relationship between the imperatives toward neo-minstrelsy in the recording industry and the possibilities of producing Black militancy for a popular audience amid the rising mainstream awareness of long-standing systemic violence against Black lives. I further argue that throughout Lamar's oeuvre it is possible to discern profound reflections on whether revolutionary

173

violence or something perhaps closer to a kind of post-industrial marronage is the proper form of Black communal resistance. What is ultimately at stake in these reflections is whether Lamar's summoning of the specters of anti-Black violence makes possible the reclamation for Black life of what Joy James has called "the dead zone": that asymptotic (non)relation between the success of Black elites that is cited as evidence of the end of structural racism and the persistent immiseration of the Black masses who languish in a structural violence unacknowledged by political elites or mainstream media.[32] If Lamar's considerable cultural prestige and financial riches can be said to depend on his art's ability to speak for the specters of systemic racial oppression, then his career might suggest hope for the possibility of a less colorblind and historically myopic political culture.

According to Jacques Derrida, "[o]ne never inherits without coming to terms with [s'expliquer avec] some specter, and therefore with more than one specter."[33] Such "being-with-specters" is, he holds, "a politics of memory, of inheritance, and of generations."[34] For Derrida, this spectral politics involves listening for the "trajectory of a *precipitation* towards which trembles, vibrates, at once orients and disorients itself the question that is here addressed to us under the name or in the name of *justice*."[35] Lamar's "HiiiPower," built around the loop of a reedy, quavering, synth sample that rises from a diffuse hum to something like the tolling of a high-pitched bell of judgment, only to be joined at its apex by wordless psalmodies that give way to Lamar's gravelly enunciation of the titular rallying cry, floods its soundscape with a tide of ghostly voices intimating the necessity of arriving at some sense of what justice demands; moreover, as will become clearer in the analysis of its lyrics to come, it does so in a way that attends to the difficult issues that arise when one considers African American inheritance. If, as Sharon P. Holland has suggested, post–civil rights America is one where "[c]ollectively, blackness mourns the loss of the Father,"[36] then one might say that the distinctively Black problem raised by "HiiiPoWeR" is one born of the historical exclusion of Black subjects from citizenship: if the white attunement to spectral demands for justice is secured by a sense of unbroken descent from the white fathers of the American Revolution (think Walt Whitman's "A Boston Ballad"), then the Black person who attunes herself to the demands of past injustices finds herself without ancestors in the white patriarchal space of the American public sphere. Black convocations with specters require, then, not only hearkening to the problem of dealing with historical injustices but also responding to the particular injustice whereby the grand tradition of Black social resistance is deracinated through either the gentrification of nonviolent radicals like Martin Luther King or the demonization of gun-bearing radicals like Huey P. Newton. The Black revolution, in other words, remains to be refought and rethought through the formulation of new counterpublics.

The spectral work of "HiiiPoWeR" is to convoke a gathering that might populate and enliven this "dead zone" in the heart of American popular political discourse. It is a song that seems to aspire to return hip-hop to its glory years where, in Richard Iton's words, it "rearranged the geography of black life in the late 1980s and 1990s much in the same way that the energies unleashed by Ella Baker's launching of the SNCC impacted black politics in the 1960s."[37] Lamar opens with a sense of angst before the ghosts of leaders of the past (Martin Luther King, Jr., and Malcolm X) before transmuting this uncanny energy into a polemical fervor.[38] Invoking the desert that functions as a synecdoche for Afrodiasporic identity in juxtaposition with the names of the two best-known icons of Black struggle in the 1960s situates the song firmly within the tradition of a poetics seeking to assert a vital political place for a people, African Americans, whose very

home is in homelessness. The "backstabbers" whom he wishes to lay flat on their backs are those in the hip-hop and wider American communities who have betrayed those who fought for justice by attesting to this fundamental uncanniness at the heart of Afrodiasporic experience. The primary epistemological component of this betrayal is the obfuscation of slavery as a rupture in history constitutive of modernity and the uncanny heart of Black experience. It is through this obfuscation that the "dead zone" is perpetuated. Rather than maintain this epistemology, Lamar, to use the terms of Fred Moten, valorizes "an irremediable homelessness common to the colonized, the enslaved, and the enclosed" such that "what is claimed in the name of blackness is an undercommon disorder that has always been there, that is retrospectively and retroactively *located* there, that is embraced by the ones who stay there while living somewhere else."[39] Moten's figure of the "undercommons" provides a way of thinking about discourses of affiliation founded in elucidation of the shared African American inheritance of slavery that might infiltrate the no-man's-land of the "dead zone" separating the immiserated masses from the avatars of Black respectability. It asserts that both those African Americans who have found a semblance of home in American civil society and those who remain in the carceral margins have had to, and continue to, exist in the gap between Africa and white America, at home in being at home in neither.

If Martin Luther King's countenance is the first of the lost Black fathers that "HiiiPoWeR" invokes, his is not the example to which the Lamar of *Section.80* turns for inspiration. Instead, in "HiiiPoWeR," Lamar takes up metaphors of violent resistance to structural violence that King would have abjured. In the first verse Lamar, letting his voice become hoarse with anger, exclaims, "I got my finger on the mothafuckin' pistol / Aiming it at a pig, Charlotte's web is going to miss you."[40] There is more at work here than simply the anti-police anger that resonates in Lamar's snarled intonation of "pig." He conceives of structural violence as part of a wider apparatus of repression, a metaphorical "web" that exposes as a children's story, analogous to that on which he puns (*Charlotte's Web*), any attempt to reduce the policing of Black neighborhoods to a matter of cops and robbers. This simplification of the problem of "criminogenic"[41] Black neighborhoods, to use Lipsitz's term, is, Lamar's lyrics assert, a quandary that receives little media attention, an "issue" that "isn't televised." The notion that existing elites living apart from the ghetto are incapable of understanding or representing Lamar's urban constituency finds expression in the way in which the rhyming of "wise" with "televised" displaces the referent of the "wise" from its anticipated correspondence with technocrats taking in the televised spectacle of ghetto poverty and violence to, instead, the people who endure this injustice everyday who already know "how to stay on beat." The wise are not those who need to be alerted to the problems of the ghetto; the wise are those who already vibrate with an undercommons rage and indignation against their oppression because their life is itself "an instrumental." For the Lamar of "HiiiPoWeR," whatever ghetto life has to attest about (in)justice in America needs to be felt with the visceral and poignant intensities of Black vernacular aesthetic performance if it is to have any impact on politics waged from below.

"HiiiPoWeR" is suffused with what Aida Hussen describes as "black rage" understood as an affect that "attempts to fill the generative and hopeful space that has been evacuated by the lost leader," although in Lamar's song it would be better to speak of leaders, plural.[42] Lamar begins the second verse by making explicit the renunciation of nonviolence implicit in the first verse's pun on *Charlotte's Web*.[43] If there is a sense of generational distance here, then it is perhaps surprising that Lamar's own nominated exemplars of Black struggle come from King's era. The song's

175

chorus, sung three times as a rallying cry to Black militant thought, begins on each occasion with an injunction that invokes "HiiiPoWeR," the title of the song, before on each occasion identifying the ethos of the song with a different Black Panther: "Huey Newton" in the first chorus; "Bobby Seale" in the second; and "Fred Hampton" in the last.[44] Neo-Garveyism, even the metaphorical sort practiced by hip-hop group Black Star, is disavowed, each verse concluding with a common refrain that keeps the injustices of the *longue durée* of post-slavery in firm view while cultivating a sort of Afrodiasporic pride in the historical testaments to the creativity of a people whose history is repudiated.[45] The song suggests implicitly that some remain discursively enslaved and that Lamar's music aspires to contest their oppression, if also seeking to shame them into seeking to emancipate themselves. In the final verse the refrain shifts to suggest that the repository of Black American cultural expression is to be found in the epoch of post-slavery and not a mythological return to pre-slavery civilization.[46]

Of the several dead icons referred to in "HiiiPoWeR" the one most significant to Lamar's project is perhaps the one who is not called by name. In a song that seeks to articulate a new radical hip-hop aesthetic, the final words are ceded to the enunciation of the leitmotif of hip-hop's most politically ambiguous figure, Tupac Shakur. After he incants the chorus for the third time, Lamar allows the beat to breathe a little before twice intoning, first in puzzlement, then in something like desperation, the phrase "THUG LIFE," which, on its second utterance brings the music to an abrupt close, leaving Tupac's words to dwindle in their own reverberation. As Holland explains, Tupac's phrase is an acronym for "The Hate U Give Lil Infants Fuck[s] Everybody."[47] As with everything in Tupac's work, it possesses both radical and reactionary significations. If it, as in Holland's reading, illuminates and resists libidinal economies of racial hatred and carceralization, such that "THUG LIFE represents a coming back from the dead, as black youth recognize not just their relative invisibility in the culture at large, but also perceive an active hatred of them that is systematic,"[48] then it also corresponds just as closely with the ethos of Tupac's later, most popular, oeuvre where, in the words of Michael P. Jeffries, "[t]huggish hip-hop authenticity is not merely about claiming the capacity to commit criminal acts and dominate others; it is about claiming this capacity with full knowledge of the consequences of such behavior."[49] On the one hand, THUG LIFE signifies an attempt to elucidate and contest anti-Black structural violence; on the other hand, it seems to signify defining authenticity in terms of a kind of supernumerary complicity in that violence, an instance of what Joy James calls "autogenocide."[50]

Tupac Shakur's invocation in a song whose chorus extols the Black Panthers is, of course, no accident. The literal inheritor of the traditions of the Black Panthers, son of Afeni Shakur, stepson of Mtulu Shakur, and godson of Geronimo Pratt,[51] Tupac is the embodiment of the intersection of Black radicalism and gangsta aesthetics. For Michael Eric Dyson, Tupac has become "a religious figure with special power—a ghetto saint."[52] For the imprisoned militant Mumia Abu-Jamal, Tupac's career is cause for lament: "[f]rom revolutionary to thug—regression in the extreme, in one generation."[53] For Lamar, Tupac seems to represent the tragic difficulty of inhabiting the "dead zone" and building the discursive undercommons in which Black life unites to honor the specters of the lost and secede from the ontological structures of white sovereignty. Speaking for the ghetto without succumbing to or becoming complicit in the structural violence that subjugates it, the lyrics of "HiiiPoWeR" invoke Lauryn Hill's musical silence.[54] Implicit in the comparison between the unimpeachable *négritude* of Lauryn Hill and the ambiguous political legacy of Shakur lies the assertion that, had Hill persisted in her career beyond the iconic

Miseducation of Lauryn Hill, she too might have found her poetics contorted and deformed by the mutating metaphors of captivity and mutilation that oppress Black artistic expression, especially that which threatens to become a counterpublic.

If *Section.80* constitutes an overtly political aesthetics that attempts to formulate what Jeff Weiss calls "a generational manifesto for Reagan babies,"[55] then *good kid, m.A.A.d city* represents a surprising departure. Gone are explicit invocations of Black icons of the past and gone is the phrase HiiiPoWeR. Gone, too, any direct invocation of THUG LIFE. Instead Lamar's second album takes the form of a *bildungsroman* tracing a tenth-grade Lamar's traumatic navigation of the perils of millennial ghetto life. If the renunciation of explicitly political material constitutes some measure of negotiation with those discourses of colorblind desire for figures of Black masculinity that reaffirm rather than challenge existing juridical structures, it is also the case that Lamar finds oblique ways of building an undercommons counterpublic within the folds of the desires of colorblind liberal sovereignty that would otherwise foreclose the enunciation of explicitly radical positions. The key to this subversive strategy is the shift in the dominant affective key of Lamar's poetics from Black rage to racial melancholia. According to José Esteban Muñoz, racial melancholia is "a melancholia that individual subjects and different communities in crisis can use to map ambivalences of identification and conditions of (im)possibility that shape the minority identities" that are excised from American civil society. This radical melancholia is not confined to crafting an affective cartography of spaces of racial oppression but also offers the possibility of constructing "a productive space of hybridization that uniquely exists between a necessary militancy and an indispensable mourning."[56] As such, this melancholia suggests itself as a covert counterpart to the overt affect of rage in binding together and animating the resistant form-of-life of Black being-with-specters. The diffuseness of these performances in *good kid, m.A.A.d city* necessitates an explication of its enunciation that looks to at least two of its songs, rather than the single representative credo that was possible in the preceding analysis of "HiiiPoWeR," as a synecdoche for *Section.80*.

I begin with "Backseat Freestyle," which I read as an obliquely expressed melancholic reflection on the difficulty of affirming the militant intimations of THUG LIFE, which strive to liberate "lil infants" from the "hate" discourses of anti-Black ontology, over and against its reactionary valences that devolve into a potentially anti-Black lust for power. This reflection is organized around the juxtaposition and mutual penetration of a discourse that subtly mourns the failure of American history to fulfill the dreams of Martin Luther King and a discourse that expertly replicates and broadly parodies the idioms and cadences of the reactionary aspects of THUG LIFE. That which plays host to and makes possible the mutual resonance of these two discourses is a musical foundation constituted entirely by an accumulation of percussive tracks (*inter alia*, muffled vocals, bells, drums, handclaps, exhortations, something approximating the diminuendo of a falling bomb, and what sounds like sonar blips) that pile one upon the other in a rhythmic cacophony that represents something like an aural correlate to the vision of Walter Benjamin's Angel of History: "one single catastrophe, which keeps piling wreckage upon wreckage";[57] however, here, as in David Marriott's reflections on Benjamin, the performative invocation of the catastrophe is a matter of "looking rearward" in order "to sense the light about to break somewhere above the ruins of incomprehension."[58]

"Backseat Freestyle" opens with a distorted vocal recording of a male voice chanting "R-Ring-King-King" in a tone somewhere between that of a muezzin and a war cry. The phrase is joined

by minatory drum-breaks and harsh static buzzes over which it repeats itself eight times before giving way to bells over which Lamar intones, in the dull menacing accents of an adolescent seeking to sound tough, the following comparison: "Martin had a dream; Martin had a dream; Kendrick have a dream!"[59] At each utterance of the word "dream" his voice strains for exaggerated gravitas in a kind of strangled and failed approximation of the solemnity of Dr. King. As soon as he begins to give expression to the dream of his adolescent self, the beat brings in a cluster of still more violent sounds interspersed with vocal scratches that sound somewhat like the distant cries of someone under a hail of gunfire. The lyrics eschew any further direct engagement with the name or legacy of Dr. King, instead focusing on a deliberately hyperbolic expression of gangsta aspirations. It is sufficient to record the parodic chorus that constitutes the phallogocentric "dream" of his adolescent self that Lamar presents: "Respect my mind or die from lead shower / I pray my dick get big as the Eiffel Tower / So I can fuck the world for seventy-two hours."[60] The song proceeds in much the same way over its three minutes before closing with a reiteration of the juxtaposed dreams and fading into silence.

I consider "Backseat Freestyle" to be an example of Muñoz's notion of radical creative melancholia because it maps not only the difficulty later generations of Black communities have had in appropriating King's radical legacy but also the manner in which American civil society reduces all but the most anodyne aspects of his legacy to little more than background noise. In the war cry-cum-call to prayer of "R-Ring-King-King" that drifts through the song, and the intricacies of suggestive onomatopoeia in the percussion (King's body, and the Black bodies of the anonymous masses falling to a hail of fire much like that "lead shower" that the Thug-infatuated narrator fetishizes), Lamar stages the return of the (psychologically and physically) repressed spirit of the radical King who, as Singh asserts, held that "black freedom dreams had a habit of exceeding the sanctioned boundaries and brokered compromises of the established political order."[61] In starkly juxtaposing the aspirations of Black youth infatuated with gangsta chic against the vague promises of the deracinated King peddled by the public culture, he maps the figures through which colorblind discourse seeks to confine ghetto youth to discourses of either self-demonization or polite accommodationism, while also suggesting that the hope of a return to militant affect persists in the complexities of the music itself, inviting us, as Alexander G. Weheliye says in his study of R&B, to "turn the critical dial on our radio to those lower frequencies"[62] where the possibilities of an idiom of radical freedom continue to reverberate.

If "Backseat Freestyle" maps the contribution of colorblind public culture to the carceralization of ghetto life, then the later song "good kid" maps the affective experience, and suggests the possibility of a redemptive suffering, inherent to this carceralization from the perspective of an adolescent whose every journey outside the door is striated by the rigid grids of police and gang oppression of ghetto "civilians." It confirms the opinion of Ta-Nehisi Coates regarding the album more broadly, namely that "[h]ip-hop is obsessed with soldiers" and *good kid, m.A.A.d city* "may be the first great record" composed "by someone obsessed with speaking as a civilian."[63] Here, I take "civilian" to mean not accomodationist, but rather nonviolent, for there is much that militates against capitulation to existing power structures in "good kid," although this resistance takes the form of something closer to the "soul force" of Martin Luther King than the "revolutionary suicide" of Huey P. Newton. In "I Have a Dream" King exhorted those gathered in the National Mall to "rise to the majestic heights of meeting physical force with soul force," a form of resistance he judged to be consistent with the "marvelous new militancy which has engulfed the Negro

community."[64] He would go on to praise the crowd as "veterans of creative suffering" and exhorted them to "work with the faith that unearned suffering is redemptive."[65] "HiiiPoWeR" had invoked passive resistance to repudiate it; but "good kid" seeks to organize its aesthetic impact around the possibility of redemptive suffering.

A darkly mellow, yet hauntingly urgent, synthetic orchestral arrangement swells and swoons across the soundscape of "good kid," augmenting Pharrell Williams's chorus and its promise of the possibility of redeeming hope from the affective dissonance of despair and marginalization."[66] Lamar reveals the "mass hallucination" and "ill education" to be maladies shared by the police force (and implicitly the government and citizens that support it) and murderously territorial ghetto gangsters. The central motif linking the two opposed groups together in a wider ontology of structural violence against Black life is that of the inseparable dyad of red and blue: colors that refer both to the blinking of police car lights and to the visual shibboleths of Bloods/Pirus (red) and Crips (blue). As a choir begins to chant urgently as though in appeal to divine justice, Lamar asks, "what am I 'posed to do when the topic is red or blue?" and he is not.[67] When Lamar's attempt to eschew gang-affiliation gives rise to gang violence, he puts his faith in something like King's "creative suffering," challenging gangbangers and foretelling their future respect."[68]

After figuring himself as a martyr in the cause of eluding complicity in the "autogenocide" of Black communities, Lamar extends the figure of militant redemptive suffering under the shadow of "red and blue" violence to an encounter with the police.[69] Recalling photos of Bull Connor's dogs in Birmingham, a metaphor, indeed a concrete phenomenon, of captivity and mutilation that is yet to fade from quotidian Black American experience, Lamar on this occasion presents someone else's Black martyrdom from the perspective of a Black witness eavesdropping on the racist assumptions of the policemen: "Step on his neck as hard as your bullet proof vest / He don't mind, he know we'll never respect, the good kid."[70] A question arises as to whether this form of resistance can truly be said to be militant if it offers passivity in the face of a police oppression that it also holds will "never respect" those who oppose it in this way. Rather than regarding the putative impossibility of persuading the police as a capitulation to existing social structures, I want to suggest that the implicit form of social organization asserted in "good kid" is neither open rebellion nor accommodation but rather a kind of anarchist undercommons association that lives apart from and refuses to participate in the operative violences of sovereignty, whether they be those of the official legal order or its criminal obverse, the warring Blood/Piru and Crip gangs. If the founding metaphors of captivity and mutilation recur in new forms in the era of post-slavery, then perhaps "good kid" could be said to mobilize against them a metaphor of antebellum slave resistance that eschewed the choice between capitulation and open rebellion: marronage. It has been the achievement of Stefano Harney and Fred Moten to take up the figure of the agent of marronage, the maroon, as a paradigm of "prophetic organization" whose refusal of the existing order is a constant struggle for new possibilities of social organization, the soul-force and soul-vibrations that coalesce in the paradigm of a "contrapuntal island, where we are marooned in search of marronage, where we linger in stateless emergency."[71]

The achievement of *good kid, m.A.A.d* city is to have mapped a search for marronage that moves from a contrapuntal field where the ethos of militant nonviolence is a barely audible ostinato beneath the rhythms of the dominant discourses of gangsta chic and accomodationism to

a form of counterpoint in which these roles are utterly reversed. If Lamar maintains some relation to the aesthetics of gangsta it is not in order to valorize it but rather because he has lived the experience of one for whom such discourses seem to offer the only forms of dignified identity for impoverished Black life. To seek to replace them utterly with pan-Africanism or unimpeachable *négritude* would be to misrepresent the discursive terrain through which contemporary marronage moves.

The movement from the revolutionary Black rage of *Section.80* to the Black melancholia of passive resistance in *good kid, m.A.A.d city* represents an evolving and feverishly imaginative political aesthetics at the heart of Kendrick Lamar's mature work. If 2015's *To Pimp a Butterfly* is conventionally regarded as his first overtly political work, it is perhaps because it is in that album that the two possibilities of Black militant aesthetics with which his earlier work experiments first come into explicit contrast within a single volume. While "Alright" has justly won the admiration of protestors and critics alike, the most complex expression of the possibilities of Black militancy in *To Pimp a Butterfly* is perhaps to be found in "The Blacker the Berry." To be sure, the chorus to "Alright" offers an eminently intelligible expression of uplift in the face of oppression that implicitly refers to the nonviolence of Dr. King: "Nigga, I'm at the preacher's door / My knees gettin' weak, and my gun might blow / But we gon' be alright."[72] The juxtaposition of the temptation to engage in violence against the resolve to find redemption in the creative suffering implicit in refusing to return evil with evil reasserts the movement of marronage traced in "good kid." Indeed, one finds in "Alright," with its looped sample of an a cappella vocal harmony undergirded by Terrace Martin's exuberant alto saxophone riffs, an unabashedly aureate spiritual successor to the admixture of gloomy and golden tones of "good kid." But the most profound moments of *To Pimp a Butterfly* are those that wring radical insight from the torment of what Hsu describes as Lamar's self-recriminations about being "guilty of making music prized by an establishment that he would prefer to destroy," and no song is more suffused with this conflict than "The Blacker the Berry."

"The Blacker the Berry" was released as a single prior to *To Pimp a Butterfly*, the day after Lamar won a Grammy for the radio-friendly "I," another early-release single from the same album. It was released through the Twitter account of Taraji P. Henson, an actor in the popular televisual melodrama *Empire*, a show devoted to exploring the fortunes of a drug dealer turned hip-hop mogul whose business success is founded on precisely those aesthetics that Rose and Woods attack. The timing and venue chosen for Lamar's release of "The Blacker the Berry," when measured against its own polemical fervor, suggest that it is a protest song directed not only at the dehumanization of Blackness in America but also at an industry that has grounded the success of a few Black people on complicity with discourses that augment the oppression of many more. The song opens over hazy, distorted piano keys that persist throughout with the insistence of tocsins signaling some emergency. They are swiftly joined by two African American voices, one high and distant, and the other low, nearer, and flattened with static. The former laments in mellifluous phrases that are enunciated over the lower voice's muttered words of racial ambivalence.[73] These interlaced voices give expression to a crisis of Blackness that seems to find no immediate comfort in the god behind the "preacher's door" of "Alright," a Blackness seemingly without attributes but also irreducible to a hypostasis in which Blackness is some timeless essence. What is clear is that some "they," the discourses of colorblind sovereignty, wishes to make Blackness bow and what remains to be determined are the forms in which Blackness

claims itself as that "illicit alternative capacity to desire," to return to Moten's phrase, that contests the authority that would have Blackness humble itself before oppressive power.

With the alarm sounded and the problem stated, the music is joined by grittily violent drums and the rise to crescendo of a distorted synthesizer that reflects the bridge's dreams of suburbs razed to the ground.[74] If the opening moments seem to suggest that Blackness is to be defined solely in terms of armed uprising, then the refrain with which each of the three verses opens quells any such certainty. At the conclusion of the bridge Lamar tells us, "I'm the biggest hypocrite of 2015 / Once I finish this, witnesses will convey just what I mean."[75] If it is the song that is to bear witness to this claim, then it does indeed defer its confirmation of the assertion of hypocrisy until after the first verse, which is a defiant repudiation of the discourses of colorblind liberalism.[76] Lamar explicitly invokes metaphors of racist discourse to challenge white America's failed appropriations. The Black aesthetic he offers is one that transvaluates the terms of opprobrium of white supremacy from dehumanizing pseudo-facts to discursive battle scars worn with pride.[77] The final lines of the first verse seem to shift the target from the more conspicuous forms of racist discourses to the more insidious commercial exploitation of racist discourse by the media industries: Where, then, is the hypocrisy? Is it the pride of the rap star in verse two who accuses other Black people of jealousy? Is it the gangbanger persona of verse three who asks: "Why did I weep when Trayvon Martin was in the street / when gang banging make me kill a nigga blacker than me?"

I want to suggest that the hypocrisy of which Lamar accuses himself has something to do with the forcefield of what Moten calls Black life's "normative striving against the grain of the very radicalism from which the desire for norms is derived."[78] It is a profound anxiety about one's fidelity to the demands of justice made by the specters of slavery that is itself generative of every attempt to enter into the marronage that eludes the snares of sovereignty and its norms. To accuse oneself of hypocrisy is to put oneself on guard against joining the former side in the "strife between normativity and the deconstruction of norms [that] is essential not only to contemporary black academic discourse but also to the discourses of the barbershop, the beauty shop, and the bookstore,"[79] and, one must add, hip-hop. Twenty-two years ago, Ronald A. T. Judy wrote that "at those moments in which rap's appropriation by the transnational economy appears to signal its comprehension and diluting, hard core is reclaimed as the source"[80] of resistance. In the work of Kendrick Lamar, one finds a reminder that resistance to such dilution by contemporary markets serving white racialist or colorblind liberal desires entails convoking the specters of the transnational economy formative of capitalism: slavery and its afterlife. In doing so, he suggests the possibility of constructing an undercommons counterpublic in the dead zone between the narrative of Black success and the tragedy of Black genocide and offers words and music whose vibrations might move people of all races to take up the struggle of creating a just response to anti-Black structural violence, even if his music cannot win that struggle by itself.

NOTES

Due to copyright restrictions, the editors have had to significantly limit the number of direct quotations from the lyrics of Kendrick Lamar's songs, but citations remain where omissions have been made.

1. Frank B. Wilderson III, "Grammar & Ghosts: The Performative Limits of African Freedom," *Theatre Survey* 50, no. 1 (2009): 119.
2. Jared Sexton, "Unbearable Blackness," *Cultural Critique* 90, no. 1 (2015): 168.

3. Tricia Rose, *Black Noise: Rap Music and Black Culture in Contemporary America* (Middletown: Wesleyan University Press, 1994), 102.
4. Tricia Rose, *The Hip-Hop Wars: What We Talk About When We Talk About Hip-Hop and Why It Matters* (Washington: Basic Books, 2008), 220.
5. Rose, *Black Noise*, 99.
6. Jeff Chang, *Can't Stop Won't Stop: A History of the Hip-Hop Generation* (New York: St. Martin's Press, 2005), 326.
7. Eithne Quinn, *Nuthin' but a "G" Thang: The Culture and Commerce of Gangsta Rap* (New York: Columbia University Press, 2013), 15.
8. Quinn, *Nuthin' but a "G" Thang*, 178.
9. Greg Tate, "How #BlackLivesMatter Changed Hip-hop and R&B in 2015," *Rolling Stone*, December 16, 2015, http://www.rollingstone.com/music/news/how-blacklivesmatter-changed-hip-hop-and-r-b-in-2015 -20151216.
10. Greg Tate, "Album review: *To Pimp a Butterfly*," *Rolling Stone*, March 19, 2015, http://www.rollingstone.com /music/albumreviews/kendrick-lamar-to-pimp-a-butterfly-20150319.
11. Tryon P. Woods, "'Beat it like a Cop': The Erotic Cultural Politics of Punishment in the Era of Postracialism," *Social Text* 31, no. 1, 114 (2013): 28–29.
12. Hua Hsu, "No Compromises," *The New Yorker*, March 31, 2015, http://www.newyorker.com/culture/cultural -comment/no-compromises.
13. Aisha Harris, "Has Kendrick Lamar Recorded the New Black National Anthem?" *Slate*, August 3, 2015, http:// www.slate.com/articles/arts/culturebox/2015/08/black_lives_matter_protesters_chant_kendrick_lamar_s _alright_what_makes.html.
14. Kieran Yates, "When Rap Raged against Racism—2015 and the Black Protest Anthem," *The Guardian*, December 30, 2015, https://www.theguardian.com/music/2015/dec/29/rap-racism-race-issues-america-black-protest -anthem-kendrick-lamar-janelle-monae-asap-rocky-prince.
15. Wilderson, "Grammar & Ghosts," 121.
16. Rayvon Fouché, "Say It Loud, I'm Black and I'm Proud: African Americans, American Artifactual Culture, and Black Vernacular Technological Creativity," *American Quarterly* 58, no. 3 (2006): 657–658.
17. Kendrick Lamar, "Mortal Man," *To Pimp a Butterfly* (Aftermath/Interscope, 2015), compact disc.
18. Lamar, "Mortal Man."
19. Lamar, "Mortal Man."
20. Frantz Fanon, *Black Skin, White Masks*, trans. Charles Lam Markham (London: Pluto, 2008), 2.
21. Gayle Wald, "Soul Vibrations: Black Music and Black Freedom in Sound and Space," *American Quarterly* 63, no. 3 (2011): 673.
22. Fred Moten, "Blackness and Nothingness (Mysticism in the Flesh)," *South Atlantic Quarterly* 112, no. 4 (2013): 775.
23. Wald, "Soul Vibrations," 691.
24. Moten, "Blackness and Nothingness," 778.
25. Darieck Scott, *Extravagant Abjection: Blackness, Power, and Sexuality in the African American Literary Imagination* (New York: New York University Press, 2010), 129.
26. Frank B. Wilderson III, "Gramsci's Black Marx: Whither the Slave in Civil Society?" *Social Identities* 9, no. 2 (2003): 230.
27. Sexton, "Unbearable Blackness," 165–166.
28. Jared Sexton, "People-of-Color-Blindness: Notes on the Afterlife of Slavery," *Social Text* 28, no. 2 (103) (2010): 44.
29. Imani Perry, *Prophets of the Hood: Politics and Poetics in Hip Hop* (Durham, NC: Duke University Press, 2004), 112.
30. Kendrick Lamar, "HiiiPoWeR," *Section.80* (Top Dawg Entertainment, 2011), digital download.
31. George Lipsitz, "From *Plessy* to Ferguson," *Cultural Critique* 90, no. 1 (2015): 129–130.
32. Joy James, "The Dead Zone: Stumbling at the Crossroads of Party Politics, Genocide, and Postracial Racism," *South Atlantic Quarterly* 108, no. 3 (2009): 460.

33. Jacques Derrida, *Specters of Marx: The State of the Debt, the Work of Mourning and the New International*, trans. Peggy Kamuf (New York: Routledge, 1994), 24.
34. Derrida, *Specters of Marx*, xviii.
35. Derrida, *Specters of Marx*, 27.
36. Sharon P. Holland, "Bill T. Jones, Tupac Shakur and the (Queer) Art of Death," *Callaloo* 23, no. 1 (2000): 390.
37. Richard Iton, *In Search of the Black Fantastic: Politics and Popular Culture in the Post-Civil Rights Era* (New York: Oxford University Press, 2008), 129.
38. Lamar, "HiiiPoWeR."
39. Fred Moten, "The Case of Blackness," *Criticism* 50, no. 2 (2008): 187.
40. Lamar, "HiiiPoWeR."
41. Lipsitz, "From Plessy to Ferguson," 119.
42. Aida Hussen, "'Black Rage' and 'Useless Pain': Affect, Ambivalence, and Identity after King," *South Atlantic Quarterly* 112, no. 2 (2013): 307.
43. Lamar, "HiiiPoWeR."
44. Lamar, "HiiiPoWeR."
45. Lamar, "HiiiPoWeR."
46. Lamar, "HiiiPoWeR."
47. Holland, "Bill T. Jones, Tupac Shakur and the (Queer) Art of Death," 392.
48. Holland, "Bill T. Jones, Tupac Shakur and the (Queer) Art of Death," 392.
49. Michael P. Jeffries, *Thug Life: Race, Gender, and the Meaning of Hip-Hop* (Chicago: University of Chicago Press, 2011), 92.
50. James, "The Dead Zone," 460.
51. Michael Eric Dyson, *Holler If You Hear Me: Searching for Tupac Shakur* (New York: Basic Civitas Books, 2001), 53–58.
52. Dyson, *Holler If You Hear Me*, 267.
53. Quoted in Quinn, *Nuthin' but a "G" Thang*, 178.
54. Lamar, "HiiiPoWeR."
55. Jeff Weiss, "Pazz and Jop: Kendrick Lamar, Finally Compton's Most Wanted," *The Village Voice*, January 16, 2013, http://www.villagevoice.com/music/pazz-and-jop-kendrick-lamar-finally-comptons-most-wanted-6437250.
56. José Esteban Muñoz, *Disidentifications: Queers of Color and the Performance of Politics* (Minneapolis: University of Minnesota Press, 1999), 74.
57. Walter Benjamin, "On the Concept of History," trans. Harry Zohn, in *Walter Benjamin, Selected Writings Volume 4: 1938–1940*, ed. Howard Eiland and Michael W. Jennings (Cambridge, MA: The Belknap Press, 2004), 392.
58. David Marriott, *Haunted Life: Visual Culture and Black Modernity* (New Brunswick, NJ: Rutgers University Press, 2007), 227.
59. Kendrick Lamar, "Backseat Freestyle," *good kid, m.A.A.d city: A Short Film by Kendrick Lamar (deluxe edition)* (Aftermath/Interscope, 2012), compact disc.
60. Lamar, "Backseat Freestyle."
61. Nikhil Pal Singh, *Black Is a Country: Race and the Unfinished Struggle for Democracy* (Cambridge, MA: Harvard University Press, 2004), 4.
62. Alexander G. Weheliye, "'Feenin': Posthuman Voices in Contemporary Black Popular Music," *Social Text* 20, no. 2 (2002): 39–40.
63. Ta-Nehisi Coates, "I Can Feel the Changes," *The Atlantic*, January 8, 2013, http://www.theatlantic.com/entertainment/archive/2013/01/i-can-feel-the-changes/266933/.
64. Martin Luther King, Jr., "I Have a Dream: Address Delivered at the March on Washington for Jobs and Freedom, August 28, 1963," in *The Landmark Speeches of Dr. Martin Luther King, Jr.*, ed. Claybourne Carson and Kris Shepard (Boston: Little, Brown, and Company, 2001), 83.
65. King, "I Have a Dream," 84.
66. Kendrick Lamar, "good kid," *good kid, m.A.A.d city*.
67. Lamar, "good kid."

KIM WHITE

68. Lamar, "good kid."
69. Lamar, "good kid."
70. Lamar, "good kid."
71. Stefano Harney and Fred Moten, *The Undercommons: Fugitive Planning & Black Study* (New York: Autonomedia, 2013), 35, 94.
72. Kendrick Lamar, "Alright," *To Pimp a Butterfly*.
73. Kendrick Lamar, "The Blacker the Berry," *To Pimp a Butterfly*.
74. Lamar, "The Blacker the Berry."
75. Lamar, "The Blacker the Berry."
76. Lamar, "The Blacker the Berry."
77. Lamar, "The Blacker the Berry."
78. Moten, "The Case of Blackness," 177.
79. Moten, "The Case of Blackness," 178.
80. Ronald A. T. Judy, "On the Question of Nigga Authenticity," *boundary 2* 21, no. 3 (1994): 229.

PART IV

THE POSTHUMOUS AND THE POSTHUMAN

TEN

DNA AS CULTURAL MEMORY

Posthumanism in Octavia Butler's Fledgling
and Nnedi Okorafor's The Book of Phoenix

SHEILA SMITH McKOY

Justice and humanity have coupled uncomfortably in the Western response to the challenges of race and difference, particularly when the humans in question are African or of African descent. In the West, the dominant modes of thinking about bodies of difference are structurally embedded in the practice of biopower on and over Black bodies, in particular at the site of scientific research and medical experimentation. It is strikingly evident that modern medical research continues to bear the legacy of "colonial pathologies" as these relate to the racialized science and practice of medicine. And despite the well-known benefits of biodiversity to the human ecosystem, the medical infrastructure still operates as if race were a scientifically based fact. Confronting the complex intersections of racial and gendered difference and the practice of biopower, Black women writers have sought to push beyond the limits of narrowly defined ways to be "human" into the possibilities and potentialities of posthumanity. Increasingly, Black women Afrofuturist and Africanfuturist writers have turned their attention to Black female bodies as sites of collision between biopower and white supremacist medical practices.[1] In their respective novels, *Fledgling* (2005)[2] and *The Book of Phoenix* (2015),[3] Octavia Butler and Nnedi Okorafor seek to construct the conditions for biological and cultural belonging, even as they advance powerful arguments on the dangerous interplay between race, medical exploration, and biopower. Focusing on Black, female posthumans, their projects consider the injustices that engender and endanger Black life, while simultaneously creating alternative lenses through which to critique racial and biological (in)justice. These texts also consider the long history of what Harriet Washington describes as medical apartheid.[4] Because these literary texts take up medical experimentation, my methodology in this essay is necessarily interdisciplinary, approaching the larger questions posed by these novels through the discourses of science: bioethics, eugenics, genetics, and evolutionary biology, along with legal discourses regarding the use of human subjects.

Specifically, I argue that Octavia Butler's *Fledgling* and Nnedi Okorafor's *The Book of Phoenix* envision contemporary medical experimentation as the living legacy—the afterlife, if you will—of the Western eugenics movement. In exploring the transgenerational cultural realities their protagonists navigate, these authors create worlds in which the germ seed of humanity—African DNA—enables individual, human, and cultural survival. These novels position the reader in the midst of two powerful, contingent intersections: life/death and memory/history. Both Butler and Okorafor

SHEILA SMITH McKOY

seek to unravel the complexities of DNA, the self-replicating molecule that transmits genetic information from generation to generation, and, more precisely, the intricate linkages between DNA and cultural memory. Their protagonists struggle to access memories, supplanted by official histories—or "received truths"—that belie both the destructive impact of white privilege and the salvic potential offered by their own cultural origins. Both novelists focus on the importance of understanding that the linkages between DNA and culture are dependent on mnemogenic reactions. With each memory they recover, the protagonists in these novels recenter their being in DNA. Butler and Okorafor thus suggest that the impact of white supremacy and its concomitant biases can be overcome by deploying cultural and genetic memory as a means of survival.

BODIES THAT MATTER: GENUS, EUGENICS, AND MEDICAL EXPERIMENTATION

Combining elements of ancient African tradition and modern technoculture, science fiction and historical fiction, myth and magical realism, Afrofuturist literature, from its inception, has focused on reimagining or re-envisioning the multiple and potential guises of Black identity in the African Diaspora. At the heart of Butler's *Fledgling* and Okorafor's *The Book of Phoenix* are questions grounded in the fear and anticipation of the unknown: How do we define posthumanity given its fictive manifestations and potential future formations as promised by biomedical research, genetic engineering, and DNA manipulation? What is the endgame of the genetics of race, particularly in reference to shared African identities? And, bluntly put, given the ability to alter and manipulate human DNA, what, one might ask (along with Chinwezu), is the intention of the "West" regarding the "Rest" of us?[5] We might turn to evolutionary biology for answers to these queries since, at its core, this branch of science is concerned with human origins and evolution. And although what precisely constitutes "race" has never been definitively established, the idea of race remains one of the oldest constructs in human evolutionary biology. Quayshawn Spencer argues that there is no evidence that race has a biological origin and embraces "race" as akin to "endorsing 'pseudoscience' or adopting 'pseudophilosophy.'"[6] In the context of posthumanism, however, the categorization of humans has almost always been dominated by the notion of race and race difference.

In their orphic texts, Butler and Okorafor create a framework through which the constructs of humanity and posthumanity connect biological, cultural, and esoteric ways of being. At the same time, these authors interrogate notions of normativity informing Western assumptions about race and difference as such ideas shape the practice of biopower on and over Black bodies. The history of Sara (Saartjie) Baartman is by now a familiar and well-documented tale of white male exploitation and pathologization of Black women's sexuality through the objectification and commodification of the body under the alibis of science, "education," and biomedical research. Baartman—the so-called Venus Hottentot, taken from her South African homeland to London in 1810—lost her fight to protect her body from the incursions and curiosities of modern science. Even after she died at the age of twenty-six in France, Georges Cuvier—the so-called "father of physiology"—performed surgical explorations of her genitalia, notwithstanding her refusal to submit to his scientific fantasies while she was alive.

In *Intimate Justice*, Shatema Threadcraft links the coercive reproduction practices of the past and present from Black women who were subjected to sterilization abuse during slavery to the

188

DNA AS CULTURAL MEMORY

modern-day "Mississippi Appendectomy" in the 1930s to practices of sterilization under carceral conditions in the contemporary era.[7] And, nearly a century earlier, in the antebellum southern United States, Dr. James Marion Sims, known as the "father of gynecology," performed multiple operations on the enslaved women known as Anarcha, Lucy, and Betsey (as well as others whose names are unrecorded in history). These medical experimentations not only raise serious issues of medical ethics but, more recently, have given rise to a study of what is described as "the medical plantation," defined as a space or locality in which slave women's pathologized bodies became "test subjects" or "raw material" for medical research and experimentation in the emergent field of gynecology.[8] Undertaken in the 1840s, Sims's surgeries, aimed at correcting vesicovaginal fistulas for white women, were, perhaps not surprisingly, performed on enslaved women without the use of anesthesia, though it was widely and cheaply available.[9]

The legacy of the medical plantation and its subjection of the Black female body to experimentation became a model for later eugenics projects that rendered Black subjects guinea pigs in biomedical research and clinical practice, including the infamous Tuskegee Syphilis Study, which began in 1932, when there was no known treatment for syphilis. Black southern sharecroppers were recruited by the US Public Health Department to participate in an experiment to monitor the effects of syphilis throughout the life span of the subjects. The study continued until 1972, well after the 1947 discovery of the efficacy of penicillin in the treatment of a disease that led not only to the blindness, insanity, and death of the untreated subjects but also to the transmission of the disease to their spouses and children.[10]

Such practices and experiments on Black bodies have occurred repeatedly even once laws were established to protect human subjects regardless of racial or national origins. This kind of problematic clinical practice, in relation to medical research, has historically been conducted without informed consent and in violation of protocols established to protect human subjects issued by the 1947 Nuremberg Code and later the 2013 Declaration of Helsinki, which addresses the impact of medical research on vulnerable populations in the so-called developing world. These codes and regulations have failed to stop unethical and commercially driven medical experimentation on Africans, however. One need only consider the history and impact of the Navrongo Experiment in Ghana, 1994–2006, funded by the USAID, the Population Council, the Bill and Melinda Gates Foundation, the Rockefeller Foundation, and the Andrew W. Mellon Foundation, in which women in rural, Northern Ghana, completely unprotected by informed consent laws, were given Depo-Provera as a part of routine medical care.[11] And, though responsible for the fertility loss of many of the women in this study, the principal investigator for the project, James Phillips, a professor at Columbia University, has never faced civil or criminal charges and has, moreover, benefited professionally from publishing this research. As Harriet Washington reminds us, rather than being held accountable for their actions, these researchers often gain financially and, in many instances, earn recognition for their work.[12] In more recent encounters with biomedical racism, protocols were also ignored in the clinical trials of AZT (an antiviral used to treat HIV) on human subjects in Africa, Asia, and the Caribbean. Adam Laughton has rightly noted that—given the medical risks of the study—even the placebo component of the study would not have been legal in the United States.[13] These examples aside, in 2015, the world watched the unfolding of clinical trials of the Ebola vaccine in Liberia and Guinea, where pharmaceutical companies with vaccines available for testing had a ready source of African human test subjects who were wholly unprotected by the safeguards established for human trials.

Race and difference have, in effect, constrained our ideas about human biology, biomedical research, and human interactions. And despite the abundance of research demonstrating that race is a social construction, race continues to dominate discourses on health, illness, and disease prevention and acquisition. The obsession with racial difference gave rise to the pseudoscience of eugenics, a term coined by Sir Francis Galton in *Inquiries into Human Faculty and Its Development*, which he published in 1883.[14] In formulating the hypothesis of eugenics, Galton focused principally on what he termed "the cultivation of race."[15] Galton based his flawed assumptions on the phenotypical characteristics of race, and thus used scientific racism to promote whiteness at the expense of other so-called "unfit" populations. As a practice, eugenics is an example of Michel Foucault's formulation of biopower, focusing on blood as a locus of differentiation. As Foucault notes in *The History of Sexuality*, this focus on blood created conditions under which governing bodies defined what blood should be valued and what blood devalued.[16] Though unsubstantiated by the very scientific processes from which its foundational beliefs arose, the eugenics movement has sought to eradicate unwanted "racial characteristics" on the micro level in reference to individuals and on the macro level in reference to entire populations. In its nascent form, eugenics was a pseudoscience based on eradication as the only and "final" solution. Attributes that fell outside of the norms of the white, nuclear family unit fell into categories that were then deemed heritable differences that could be subject to extermination: criminality, poor vision, poverty, mental health, and promiscuity. All were at risk for removal from the human genome. Yet, the goals of eugenics were as flawed as the choice of markers for the differences it sought to eradicate. After all, there is considerable scientific and cultural disagreement about whether criminality, promiscuity, and poverty are attributes that are genetically inherited. Even if genetic predispositions do indeed exist, that is not a guarantor that those genes will manifest.

Such deterministic thinking is costly. Conservative estimates suggest that over 64,000 vulnerable Americans were sterilized during the American version of the eugenics movement. In North Carolina alone, the eugenics project was responsible for over 7,500 sterilizations between 1929 and 1974. The reach of this movement cannot be underestimated; indeed, similar projects worked to eradicate the "unwanted" throughout the United States and worldwide. The project of the eugenics movement was one of many shaped by what Jesse Williams rightly termed "this invention called whiteness."[17] It is thus not surprising to find that most of the bodies targeted by the eugenics movement were Black. In the portraits of their posthuman protagonists, Butler and Okorafor focus on the aftermath and legacy of eugenics. The cultural work that these writers call us to do in their novels is, therefore, grounded in the intersectional and differential experiences attributed to African ancestry and phenotypical Blackness. Moreover, they ask readers to consider the terms of Black survival on the planet. The larger question, however, is whether or not humanity can survive without the germline written into its African DNA.

GERMLINES AND FOREMOTHERS: A NOTE ABOUT ANCESTRY

The pseudoscience of eugenics, of course, exists at the site of origins. And, not coincidentally, questions of origins and ancestry define the discourse of Afrofuturist, Africanfuturist, and speculative fiction. We can trace the narrative arc of Afrofuturism in Black women's writing back to Octavia Butler, whose ancestral presence shapes the practice of Black speculative or

Afrofuturist fiction. In *Fledgling*, published shortly before her death, Butler tells the story of Shori, ostensibly a pubescent Black girl, found wandering and naked by Wright, a young white man, who takes the waif under his protection. They develop an intimacy despite Shori's amnesia and youthful appearance (we later discover that she is fifty-six years old). She is gradually revealed to belong to a race of vampires, the Ina, who have evolved through the centuries alongside humans. And although she traces her ancestry to European forebears, Shori turns out to be a genetically modified organism. She has been genetically altered by her Black foremothers, who used a virus vector to protect her from daylight by increasing her melanin production. Butler thus appropriates contemporary genetic research into a tale that reverses the historical pattern of eugenics by remapping the human genome in such a way that the betterment of the Ina is embodied in the creation of a Black female who is physically superior to her "white" forebearers. At the time Butler wrote *Fledgling*, gene transfer science was focused on viral vector systems that could be programmed to alter human DNA in significant ways.[18] We learn something of the process by which this genetic engineering was achieved when Stefan, Shori's brother, incorporates the history of virus vector science into the story he tells of her origins:

> Our mothers were three sisters . . . and one human woman who donated her DNA. Also, there were two eldermothers—our mothers' surviving mothers. The two eldermothers were the ones that made it possible for us—you in particular—to be born with better-than-usual protection from the sun and more daytime alertness. . . . They understood more about the use of viruses in genetic engineering than anyone I've ever heard of, and they understood it well before humans did.[19]

Notably, mitochondrial DNA is a maternal inheritance, so it is significant that Shori's genetic heritage is passed down matrilineally.

Shori survives the head injury sustained when an ethnocentric European family of Ina execute a plot to kill her entire family line because they had created a "black mongrel bitch."[20] It is not without some irony that it is precisely due to her "life-saving" African DNA that Shori manages to survive the vicious attack from the "white" Silk family.[21] The novel concludes with the conviction of several members of the Silk family and their advocate, Katherine Dahlman, by the Council of Judgment, notably an Ina—and not human—"legal system" that is "ancient and very strong" and focused not on the rule of law but on the pursuit of truth in dispensing justice.[22] And, appropriately, the sentence meted out to the Silk family is the eradication of the Silk genetic line. Though sentenced to a lesser fate, Dahlman refuses to accept the final judgment of the Council, a rejection that culminates in her death as a consequence of her physical attack on Shori in the courtroom; thus, her lineage, too, ends with her death. However, Butler imbues her protagonist with immortality. She is defined and protected by her DNA. Her survival ensures that her genetic line, her African DNA, will continue to be in the Ina gene pool for generations to come. Butler thus provides Shori with an afterlife inextricably linked to social justice and African bio-cultural survival.

Nnedi Okorafor also constructs a universe shaped by the cultural experiences and biopolitics of Africans and diasporic Africans. Like most women of African descent writing in the field, Okorafor was influenced by Butler's work; she took "strength" from reading Butler's *Wild Seed*, a novel that spans centuries and details the intricate connections that link African and diasporic

African histories and cultural memories.[23] In *The Book of Phoenix*, published in 2015 as the prequel to her earlier *Who Fears Death* (2010), Nigerian-American Okorafor draws on contemporary Black science fiction and magical realism, along with the myth and folklore of her African heritage, to produce an Africanfuturist narrative presented as a tale within a tale. In the frame story, an old man, Sunuteel, camping in the desert, discovers in an underground cave a cache of old computers from the Apocalyptic "Black Days" from which he downloads a large audio file. What follows is "the book of the Phoenix," a story of communal origins dating back two hundred years. At the center of the tale is the titular character of the Phoenix, a genetically modified organism, one of thousands of so-called "speciMen," all products of multiple experiments conducted by a large biotech company, LifeGen, known as the Big Eye by its human subjects, who are subjected to constant observation. LifeGen represents a conglomeration of Big Pharma, the military-industrial complex, and a cadre of university graduates working off their "academic indenture." Scientifically engineered to become a destructive biological weapon, Phoenix, along with other speciMen, are human subjects genetically altered, monitored, controlled, and confined in a series of facilities throughout the United States and its territories. Upon the supposed death of her beloved Saeed, a fellow speciMen, Phoenix begins to recognize that the only home she has ever known, Tower 7 in Manhattan, is, in fact, her prison. With the emergence of a new consciousness ("We're so colonized that we build our own shackles"[24]) and with the assistance of her friend, Mmuo, Phoenix plots a daring escape—despite the obstructions of doctors, lab technicians, guards, and paramilitary—from an existence that she realizes to be "an abomination."[25]

Phoenix emerges from this dystopia as the literal embodiment of the African Diaspora, demonstrated by her fondness for Ethiopian food, attachment to Ghana, and her adoption of African spiritual traditions and beliefs. The daughter of an African American woman, she is symbolically "fathered" by Seven, a flying African who is released when Phoenix escapes her captivity in Tower 7. Like Seven, Phoenix can fly. And true to her name, Phoenix possesses the capacity to self-annihilate and self-recreate time and again. Importantly, like Butler's Shori, Okorafor's Phoenix is principally defined by a sense of justice, along with a profound insight into the abiding reach of racism. Thus, she seeks to free and to find justice for the speciMen whose lives are determined by scientific experimentation. And, as we shall see, Okorafor makes it difficult to ignore the fact that the presence of African genes in her DNA is the key to her cultural and physical survival.

It is in response to the sustained history of unethical medical research and experimentation on African and diasporic African bodies that Butler and Okorafor explore the potential benefits and hazards of biological engineering. In *Fledgling*, however, Butler also underscores white privilege as one of the central questions driving Shori's narrative. Her family members, including her Ina and human foremothers, have been killed because the solution to the problem of Ina survival resides in racialized Blackness. As noted by Wright, Shori's lover and symbiot (defined in the novel as a human who forms a symbiotic relationship with the host, to whom the symbiot supplies life-saving blood), the Ina racists "don't like the idea that a good part of the answer to your daytime problem is melanin."[26] In *Fledgling*, Butler departs from the historical narratives about medical experimentation on Black bodies since Shori's value resides precisely in the fact that her African DNA is deliberately bred into, rather than out of, her gene pool.

Okorafor's *The Book of Phoenix* provides a fictional examination on the extreme use of Black bodies in medical experimentation aimed at preserving white racial dominance. All of the speciMen, including Phoenix, are created to shore up white wealth and privilege. The speciMen provide human organs for transplant and blood for those seeking immortality—as is the case with the Jawara woman named HeLa (for the immortal cell-line produced from the body of Henrietta Lacks in the 1950s[27]). Phoenix and Saeed are engineered to be humanoid weapons to support the military interests of the government. And, as Phoenix discovers after she escapes from Tower 7, the monetary value of these posthuman creations is almost incalculable: "Billions and billions of dollars, euros and yuan were poured into the towers each year. But here was the twist: even more money was earned through patents, research results, and other things that were called names like 'Project X' and 'Experiment 626'.... There was also a large portion accredited to 'harvests.'"[28] Throughout the text, however, Okorafor also reminds her readers of the significance and exploitation of the Black body as a site of biological and cultural memory.

This dual inheritance is literally embodied in her brief portrait of Lucy, a speciMen who possesses the ability to remember every moment of her life. Lucy, "the complete Great Book of Humanity," is named in tribute to the East African *Australopithecus afarensis*—widely regarded as the female ancestral forebear of all humans—whose fossil remains were discovered in Ethiopia by Donald C. Johanson in 1974.[29] In *The Book of Phoenix*, Lucy, who is cloned and genetically reprogrammed to arrest the aging process, provides the financial model deployed by Big Pharma (LifeGen) to support its medical experimentation and DNA manipulation on Black bodies. In her depiction of the attempt to immortalize and commercialize the reproduction of Lucy, Okorafor reminds us that eugenics is "always always always corrupt, driven by a lusty greed."[30]

It is all the more important, then, that Butler and Okorafor give us protagonists whose Blackness is positively marked by the darkness of their skin, and whose African genetic heritage enables their survival. In *Fledgling*, in particular, Butler addresses the phenomenon of skin color as the product of a single genetic variation whose presence becomes the justification for racism and racist praxis. Phoenix is created from a "slurry of African DNA and cells," a weapon whose humanity and posthuman characteristics surprised even her creators. Phoenix explains her complex genetic inheritance, noting that:

> They constructed the sperm and the egg with materials of over ten Africans, all from the West African nations of Nigeria, Ghana, Senegal and Benin. Then they combined all of that with DNA from Lucy the Mitochondrial Eve, the ten-year-old Ethiopian girl who carried the complete genetic blueprint of the human race. The girl who remembered every part of her life; the girl whom they tried to make immortal.[31]

Her surrogate mother is an African American woman who was not even allowed to kiss the child forcibly taken from her. Phoenix embodies the existential threat to the African Diaspora even as she becomes the incarnate manifestation of the planetary potential for justice and biodiversity destined to emerge from the ashes of the world's destruction.

These matters are paramount in understanding modern medical science since experimentation and research are still haunted by the racial ideology of the 1920s eugenics movement and its belief in the betterment of the human species through the reproduction of whiteness. Paddy

SHEILA SMITH McKOY

Rawlinson and Vijay Kumar Yadavendu further contextualize the impact of such practices on the poor and marginalized:

> What is not in doubt, however, is the fact that, as in Nazi Germany, the most likely targets of unethical clinical practices have been, and continue to be, society's most vulnerable. In the current climate of commercialised medical research, an integral part of the global marketisation of health delivery, vulnerability is largely defined in economic terms, further qualified by marginalising factors such as race, ethnicity and gender.[32]

Yet, it is notable that these "marginalising factors" contribute to human survival by conferring species plasticity through biodiversity. In contrast, however, the medical infrastructure still operates as if race is a scientific certainty rather than a social construct. In *Fledgling* and *The Book of Phoenix*, the authors locate spaces through which the reader is able to interrogate this incongruity. And, as we shall see, Butler and Okorafor offer an alternative to these hierarchies in their focus on the linkages between DNA and memory.

EMMERE ASIESIE: DNA, NARRATIVE, AND MEMORY

> You asked me questions and you made me look into the mirror. Maybe now, with you to help me, I will remember more and more.
>
> —Octavia Butler, *Fledgling*

> Did DNA carry memory, too?
>
> —Nnedi Okorafor, *The Book of Phoenix*

Okorafor and Butler use these novels to explore the linkages between culture, memory, and history. Both authors manipulate and problematize the complex interplay between what is written, what is narrated in oral tradition, and the incongruities between the two. In effect, their novels suggest that accessing an ancestral culture through memory is a powerful way to disengage from the white supremacy that shapes the conditions against which their protagonists struggle. Here, I propose the Akan term *emmere asiesie* as a cultural pathway leading to the embrace of cross-generational ancestral memory.[33] At the core of the meaning of *emmere asiesie* is the capacity to transcend temporal and spatial constraints. Memory simultaneously transcends individual experiences—and, through genetic transmission, creates a cross-generational link to their ancestors. Taken together, the epigraphs above, then, encapsulate the ways in which we interpret genealogical narratives, the relationships between narrative and memory, and, most importantly, the ways in which narratives and their multiple audiences generate meaning within a culture.

Memory becomes the vehicle through which these writers, their protagonists, and their readers understand how to move beyond the hierarchies created by whiteness and expressed in the medical practices that are interrogated in these texts. In *Fledgling* and *The Book of Phoenix*, Butler and Okorafor offer memory as a means of cultural reproduction and reconnection, providing their readers with examples of *emmere asiesie*. Akin to, but not contextualized by, the Akan

concept of *sankofa*, *emmere asiesie* can be conceived of as a process, or movement, of reaching back to the past to define both present and future ontologies.

Emmere asiesie is concept that is also rooted in the scientific inquiry into the nature of being. Significantly, a growing body of contemporary scientific inquiry focuses on the role of mitochondrial DNA—the DNA inherited from the maternal family—in the processes of memory transmission. In fact, the health or the decline of mitochondrial DNA can impact a wide range of body functions, including cell memory and the development of complications associated with diabetes and other degenerative, inheritable diseases.[34] There is also nascent research suggesting that cultural memory exists in the DNA. A 2009 study of zebra finches found that finches raised in isolation will still, over generations, reproduce songs similar to those sung by species in the wild—thereby demonstrating the potential of DNA to reproduce cultural memory.[35]

In effect, as Shori and Phoenix strive to access their ancestral roots—particularly those of their matrilineal, or mitochondrial, line—they are able to erase the barriers that prevent them from understanding their cultures and, by extension, themselves. Mitochondrial memory provides the pathway through which individuals can map their belongingness despite personal or communal dislocation from spaces of cultural mooring. Perhaps Okorafor expresses this notion best in her construction of Phoenix's ability to "slip through time and space."[36] DNA, then, opens the portal to cultural memory.

In *The Book of Phoenix*, Okorafor creates a narrative that unfolds from the memories of Phoenix, whose consciousness lives in computer files that Sunuteel, our human witness, accidently encounters in the cave. Yet Okorafor also reminds us that in most African epistemologies, there is nothing that is truly "accidental." Sunuteel's encounter with the living memories of Phoenix were foreseen by his wife, Hussaina, who tells him that he will encounter an angel or a djinn on his journey. Moreover, she asks that he return with a good story, denoting the importance of the counter histories encoded into cultural narratives. Indeed, Sunuteel encounters these memory files two hundred years after the occurrence of the Apocalypse, calling into question the accuracy of events recorded in the "Good Book." It is also no coincidence that Phoenix's memories are recounted in English, a language that Sunuteel understands because he has been taught the language by Saeed, Phoenix's Arab lover, who never forgot that his Arab ancestry was also African. Okorafor thus presents a character whose life, personal memories, ancestral memories, and understanding of history are not only altered but also function to correct the official record. The memory files, then, are hybrids: part memory and part history. And, importantly, they are designed to rewrite the prevailing narrative that Africans caused the demise of civilization. Okorafor contextualizes this revisionary narrative of history when she writes, "Let that which had been written all be rewritten."[37] The living memories of Phoenix also complicate and layer Okorafor's focus on posthumanity. In the world that Okorafor creates, the immortality of Phoenix is contained in her memories, which remain tethered to her Black body. Okorafor's posthuman experience is centered on the body, its conjoined memories, and its correlative and corrective histories.

Like Okorafor, Butler observes that memories associated with the maternal line have the potential to provide redress for the historic rupture in cultural connectedness and belongingness in the lived experiences of diasporic Africans; however, the future she envisions is made possible only by the search for the missing matrilineal heritage, the source of the mitochondrial linkage across temporal and spatial divides. The image of the fragmented family is, of course, a persistent one in diasporic African history and literary expression. As the lyrics to the African

SHEILA SMITH McKOY

American spiritual suggest, a "motherless child" has no spatial referent for home or belonging. Thus, the absent mother figure has evolved into a symbol of displacement and cultural rupture in the African and diasporic African literary tradition.

Butler revises this maternal trope in *Fledgling*, a novel that begins and ends with the protagonist's search for the memories of her mothers and her eldermothers, whose generational narratives would have provided her with the knowledge she needs to be both Ina and human but whose murders prevent that transmission. The novel is something of a *bildungsroman*; however, Shori's search for wholeness is situated in her ability to access and recreate memories of her maternal ancestral past, the only thing that will ensure her survival in the future.

Promad Nayar reads *Fledgling* as an exploration of a biological citizenship in which the embrace of belongingness is "never restricted to one species."[38] However, Butler insists that there is an Ina hegemony at work in the novel, and that hegemony rests in the biases of the Ina families whose racism results in Shori's physical injuries, the loss of her memories, and the murder of her foremothers. In actuality, this hegemony is only mitigated by Shori's access to her memories and, by extension, to her foremothers. The brutal attack on Shori's home ensured that she would not have direct access to the knowledge base that her mothers would have provided. And, significantly, it is the mothering relationship, though absent, that defines the connections that open the possibility of understanding Ina culture, along with the protagonist's place within it, and the continuation of her maternal lineage. In Ina cultures, daughters live with their mothers in compounds separate from their male relatives. And, within the family unit, it is the mothers who are empowered to choose or refuse a mate for their daughters. Her amnesia forces Shori to discover, then recover, the place of her foremothers, and hence her own, within that cultural framework.

Butler suggests that the most significant rupture in diasporic African familial structures is the absence of the mother precisely because of the ensuing erosion of cultural access that is the result of maternal absence. Shori's mothers and foremothers not only birthed her, but passed down a genetic inheritance of melanin that will, in turn, be passed on to the next generation and down through the maternal lineage. Butler, in effect, rescues Shori in the promise that her memory might be restored through reunion with the maternal line. In the midst of seeking justice for her mothers' murders, Shori's father opines that "memories . . . sometime return."[39] As the novel closes, Butler suggests that, barring the return of her memory, the only other way that she might achieve something like *emmere asiesie* is to find connection among the females of her secondary families. While Shori remains motherless, Butler provides her with a pathway through which she can access the memories and maternal scripts—and through them, the cultural memories—of her foremothers.

TOWARD A CONCLUSION: MEMORY, CULTURE, AND CONSCIOUSNESS

The story was alive. . . . It was up to the reader to interpret what the story really was about.

—Nnedi Okorafor, *The Book of Phoenix*

The worlds of the elders do not lock all the doors; they leave the right door open.

—Zambian Proverb

The above proverbs suggest that it is shared cultural memories, the multiple and recurring inter-relationships derived from ancestral moorings, that enable survival. The mutable, fluid, and ambient boundaries between Africa and the Diaspora, Africans and diasporic Africans, and Africans and other continental Africans transcend time and space. Butler and Okorafor contribute to our understanding of belongingness and cultural reclamation through their novelistic explorations of these complex and interdependent relationships. Re-envisioning what it means to be human within the context of posthumanity, these texts refute the notion that Black humanity does not matter. Butler and Okorafor both link African cultural survival to DNA and propose that the power of memory—maternal or mitochondrial DNA memory—presents the path through which humanity may come to embrace the expansive genetic and cultural heritage of Mother Africa.

In traditional African cultures, there exists an enduring symbiosis between the living and their ancestors. The bridge uniting the living and the dead finds expression through spiritual observances and ritual practices that honor and celebrate the ancestors as presences who enable the survival of the living. It is the process of remembering that becomes a means to access cultural memory. As Jan Assman and John Czaplicka argue, a cultural group is defined by a structure of knowledge that enables "the concretion of identity" on which the group bases its "consciousness of unity and specificity." And, further, it is "the store of knowledge" preserved in "cultural memory" that "allows the group to reproduce its identity."[40] Significantly, at the conclusion of *Fledgling*, Butler's protagonist is poised, finally, to claim her culture and (genetically modified) identity through the reproduction of the family line by which survival is ensured through mitochondrial memory. Similarly, at the close of *The Book of Phoenix*, Sunuteel is summoned to create his version of alternative communal histories (what Phoenix refers to as "this shit spread far and wide"[41]); however, the narrator also promises that these narratives will be changed yet again into still other salvic stories.

What these two novels have in common, then, is their insistence on the importance of accessing the ancestral legacies through the process of memory, since it is precisely this connection that provides peoples of African descent with alternative and sustaining possibilities. The posthumans central to these texts are manifest responses to the call of the ancestors, ancestral presences that refuse to be quieted. They speak because, as Barbadian poet Edward Kamau Brathwaite observes, "African culture not only crossed the Atlantic, it crossed, survived, and creatively adapted itself to its new environment."[42] In the imaginary poly-temporal and poly-cultural worlds of these Afrofuturist texts, culture recreates itself. Remembering transforms Shori from victim of a racist attack into a new being—Ina and human—who values and is valued for her genetic Blackness. Remembering her racial legacy enables Phoenix to pass on her "turbulent accurate memory . . . [her] oral unfinished tale" because—as being and as story—she is immortal.[43] Thus, the posthumans in these texts represent the reclamation of wholeness through genetic and cultural memory in the African Diaspora.

Literature like Butler's *Fledgling* and Okorafor's *The Book of Phoenix*—texts written about Black women, whose bodies have most often been sites where biopower has intersected Western medicine—exposes the afterlife of the Western eugenics movement. Unlike many of her powerful female protagonists, Shori has no afterlife in Butler's oeuvre since it was the last novel that Butler published before her death. She leaves Shori in the midst of her cultural reclamation, hopeful that she might regain her memories that (dis)connect her from her maternal line. *The*

SHEILA SMITH McKOY

Book of Phoenix is a cautionary tale about the ethics of genetic engineering, especially at this point in the history of science, when genetic technologies—such as CRSPR–Cas 9—enable scientists to edit, or reprogram, human DNA, effectively allowing for the removal of selected genes and the addition of others. Although there are currently moratoria on certain technologies of human genetic engineering in the United States and Britain, scientists elsewhere are already employing CRSPR–Cas 9.[44] Therefore, it is now possible to imagine achieving through genetic engineering the goals of white supremacist eugenics by editing Blackness out of the human genome. As Okorafor reminds us, "Human beings make terrible gods."[45] *Fledgling* and *The Book of Phoenix*, finally, offer us narratives in which African genetic heritage enables the survival of humanity and provides a means through which Blackness can never be eradicated, even in the posthuman world.

NOTES

1. In a series of tweets on December 16, 2020, Nnedi Okorafor noted her vehement opposition to being called an Afrofuturist writer, defining herself instead as an Africanfuturist. The term Afrofuturist, however, has been embraced widely in the field, including by Octavia Butler.
2. Octavia Butler, *Fledgling* (New York: Seven Stories Press, 2005).
3. Nnedi Okorafor, *The Book of Phoenix* (New York: Daw Books, 2015).
4. Harriet Washington, *Medical Apartheid: The Dark History of Medical Experimentation on Black Americans from Colonial Times to the Present* (New York: Doubleday, 2007). These concerns have had a profound impact on Black speculative literature, which represents Black women's bodies as sites where biopower has met Western medicine, and are especially salient in texts written by Black women. Butler's *Fledgling* and Okorafor's *The Book of Phoenix* expose the biopower at work in human-based scientific research and reveal what the afterlife of the Western eugenics movement might look like. *Fledgling* and *The Book of Phoenix* offer us worlds in which our common African genetic heritage enables the survival of humanity and provides protection against the eradication of Blackness, even in posthuman experience.
5. See Chinwezu, *The West and the Rest of Us: White Predators, Black Slavers, and the African Elite* (New York: Random House, 1975).
6. Quayshawn Spencer, "Introduction to Is There Space for Race in Evolutionary Biology?" *Studies in History and Philosophy of Science: Part C: Studies in History and Philosophy of Biological and Biomedical Sciences* 44, no. 3 (2013): 247.
7. Shatema Threadcraft, *Intimate Justice: The Black Female Body and the Body Politic* (New York: Oxford University Press, 2016), 2.
8. See Petra Kuppers, "The Anarcha Project: Performing in the 'Medical Plantation,'" *Sustainable Feminisms* 11 (2007): 127–141; and C. Riley Snorton, *Black on Both Sides: A Racial History of Trans Identity* (Minneapolis: University of Minnesota Press, 2017). See also: Washington, *Medical Apartheid*, and Threadcraft, *Intimate Justice*.
9. For a fuller exploration of these issues, refer to Harriet Washington's *Medical Apartheid*.
10. For a fuller exploration of these issues, refer to Harriet Washington's *Medical Apartheid*.
11. See *The Rebecca Project for Human Rights: Health, Safety and Dignity for Vulnerable Families*, http://www.1037thebeat.com/wp-content/uploads/2013/06/DEPO-PROVERA-DEADLY-REPRODUCTIVE-VIOLENCE-Rebecca-Project-for-Human-Rights-June-2013-2.pdf.
12. Harriet Washington, interview by Amy Goodman and Juan Gonzalez, *Democracy Now!*, January 19, 2007.
13. Adam H. Laughton, "Somewhere to Run, Somewhere to Hide?: International Regulation of Human Subject Experimentation," *Duke Journal of Comparative & International Law* 18 (2007): 188.
14. Francis Galton, *Inquiries into Human Faculty and Its Development* (New York: Macmillian, 1883), accessed December 10, 2015, http://galton.org/books/human-faculty/.

15. Galton, *Inquiries into Human Faculty and Its Development*, 24.
16. Michel Foucault, *The History of Sexuality: An Introduction*, trans. Robert Hurley (New York: Vintage, 2012), 147–150.
17. Jesse Williams, "BET Humanitarian Award Speech," BET Network, June 26, 2016.
18. Howarth, Joanna, Youn Bok Lee, and James B. Uney, "Using Viral Vectors as Gene Transfer Tools," *Cell Biology and Toxicology Special Issue: ETCS-UK 1 Day Meeting on Genetic Manipulation of Cells* (2009): 1, accessed May 14, 2016.
19. Butler, *Fledgling*, 153.
20. Butler, *Fledgling*, 306.
21. Butler, *Fledgling*, 278.
22. Butler, *Fledgling*, 200.
23. Mensah Damery, "Interview with Speculative Fiction Writer Nnedi Okorafor," *Specter: A Curated Literary Website*, January 2, 2012, http://www.spectermagazine.com/five/okorafor/.
24. Okorafor, *The Book of Phoenix*, 118.
25. Okorafor, *The Book of Phoenix*, 7.
26. Butler, *Fledgling*, 153.
27. Rebecca Skloot, *The Immortal Life of Henrietta Lacks* (New York: Crown, 2010). See also "The Legacy of Henrietta Lacks," *Johns Hopkins Medicine*, https://www.hopkinsmedicine.org/henriettalacks/.
28. Okorafor, *The Book of Phoenix*, 148.
29. Donald C. Johanson and Maitland A. Edey, *Lucy: The Beginnings of Humankind* (New York: Simon and Schuster, 1981).
30. Okorafor, *The Book of Phoenix*, 98.
31. Okorafor, *The Book of Phoenix*, 147.
32. Paddy Rawlinson and Vijay Kumar Yadavendu, "Foreign Bodies: The New Victims of Unethical Experimentation," *The Howard Journal* 54, no. 1 (2015): 9.
33. *Emmere asiesie* translates from Twi as "to fix the times."
34. See, for example, Sally A. Madsen–Bouterse, Ghulam Mohammad, Mamta Kanwar, and Renu A. Kowluru, "Role of Mitochondrial DNA Damage in the Development of Diabetic Retinopathy, and the Metabolic Memory Phenomenon Associated with Its Progression," *Antioxidants & Redox Signaling* 13 (2010): 797–805.
35. Olga Fehér, Haibin Wang, Sigal Saar, Partha P. Mitra, and Ofer Tchernichovski, "*De Novo* Establishment of Wild-Type Song Culture in the Zebra Finch," *Nature* 459 (2009): 564.
36. Okorafor, *The Book of Phoenix*, 96.
37. Okorafor, *The Book of Phoenix*, 221.
38. Pramod K. Nayar, "A New Biological Citizenship: Posthumanism in Octavia Butler's *Fledgling*," *Modern Fiction Studies* 58, no. 4 (2012): 796–797.
39. Butler, *Fledgling*, 73.
40. Jan Assman and John Czaplicka, "Collective Memory and Cultural Identity," *New German Critique* 65 (1995): 130.
41. Okorafor, *The Book of Phoenix*, 232.
42. Edward Kamau Brathwaite, "The African Presence in Caribbean Literature," *Daedalus* 103, no. 2, Slavery, Colonialism, and Racism (1974): 73.
43. Okorafor, *The Book of Phoenix*, 93.
44. See Carolyn Brokowski and Mazhar Adli, "CRISPR Ethics: Moral Considerations for Applications of a Powerful Tool," *Journal of Molecular Biology* 431, no. 1 (2019): 88–91, as well as the following NIH sites: https://www.nih.gov/about-nih/what-we-do/nih-turning-discovery-into-health/crispr-revolution and https://www.nih.gov/news-events/gene-editing-digital-press-kit. Notably, the most widely used genome editor, CRISPR/Cas9 has been instrumental to the development of mRNA vaccines for COVID-19 (such as those produced by Moderna and Pfizer).
45. Okorafor, *The Book of Phoenix*, 162.

ELEVEN

GHOSTS OF TRAUMATIC CULTURAL MEMORY

Haunting, Posthumanism, and Animism in Daniel Black's The Sacred Place *and Bernice L. McFadden's* Gathering of Waters

PEKKA KILPELÄINEN

There are ghosts lurking in the narratives of contemporary African American fiction. Those who speak from the margins of society have stories—ghost stories—to tell. Their spectral voices, urgent and insistent in their appeal, compel our listening and attune our ears to the echoes of silenced histories, stories told but unheard—narratives submerged into the political unconscious of Western modernity.[1] The ghost, or specter—what Jacques Derrida describes as "this non-object, this non-present present, this being-there of an absent or departed one"[2]—constitutes one of the paradoxes of contemporary existence. As Derrida elaborates, in order to achieve *justice*, one must not only *speak* with ghosts but also *learn to live* with them.[3] These phantasmatic entities return to haunt us as a society, to remind us of something past that refuses to be buried, or, as Kathleen Brogan puts it, that "can neither be properly remembered nor entirely forgotten."[4] In *Ghosts of the African Diaspora*, Joanne Chassot argues that "African diaspora literature invites us to live with ghosts, rather than to exorcise them or lay them to rest."[5] As such, ghosts are not mere figments of imagination, something that can be written off as fundamentally unreal and, therefore, irrelevant. Rather, as Avery F. Gordon has argued in *Ghostly Matters*, the ghost is a social figure, "one form by which something lost, or barely visible, or seemingly not there to our supposedly well-trained eyes, makes itself known or apparent to us."[6] In a political reading, the ghost becomes a complex and equivocal site where social and historical contradictions are rendered visible, where past wrongs and their lingering wounds are once more made manifest, and where their haunting and grievous resonances can be subjected to critical scrutiny and potential redress.

As Jeffrey Weinstock notes in *Spectral America*, the specter "calls into question the linearity of history" and "suggests the complex relationship between the constitution of individual subjectivity and the larger social collective."[7] The existence of the specter, then, threatens to collapse the distinctions between the past and present and the individual and the collective. Individual histories and private memories become inscribed in collective memory and group identity based on directly experienced, and often mediated, cultural trauma. Underlying this mediation are histories of intersectional oppression—including, but not limited to, ideologies and practices of racism, (hetero)sexism, and classism—within the grand narrative of Western modernity.

This essay will examine two African American novels that engage with specters and ghosts in their fictive reconstruction of an event that turns on racial violence and traumatic memory.

In Daniel Black's *The Sacred Place* (2007) and Bernice L. McFadden's *Gathering of Waters* (2012), ghosts can be read as spectral representations of the past, carrying with them often traumatic individual memories generated by collective experiences. These traumatic memories, transmitted across time via cultural memory, may be read in terms of cultural trauma, which Ron Eyerman defines as "a dramatic loss of identity and meaning, a tear in the social fabric, affecting a group of people that has achieved some degree of cohesion."[8] In the context of these African American novels, traumatic cultural memory can be understood in terms of Paul Gilroy's theories of the Black Atlantic and the ways in which slavery continues to impact and shape Black identities and cultural production.[9] It is precisely rationality—as the fundamental premise of Western modernity on which the institution of transatlantic slavery was based—that is the history and ideology addressed by *The Sacred Place* and *Gathering of Waters*.

Arguing that "memory is the repository of trauma," Angelyn Mitchell, among others, observes that the "contemporary liberatory narrative functions to bear witness to the *memories* of slavery."[10] Slavery—its memory and its representation—has been the source of not only physical and psychic but also cultural trauma.[11] And it is Toni Morrison's iconic novel *Beloved* (1987) that has become emblematic of the representation of slavery, its intergenerational afterlives, and the ensuing individual and cultural trauma that is manifested in the presence of ghosts in contemporary African American fiction. According to Weinstock, "[t]he ubiquity of ghost stories in our particular cultural moment is connected to the recognition that history is always fragmented and perspectival and to contestations for control of the meaning of history as minority voices foreground the 'exclusions and invisibilities' of American history."[12] This recognition and the consequent endeavor to reassess history from the perspective of excluded and repressed narratives provide an explanation for the intensified presence of ghosts in African American literature. My fundamental argument here is that ghosts tend to occupy a central role in Black American literature because they originate in and articulate real sociohistorical contradictions—past wrongs that significantly impact the course of history and the structures and practices of society. By turning to the supernatural, the irrational, and the unreal, these narratives together construct a grand counternarrative to the ideal of rationality, one of the ideological cornerstones of Western modernity. In *Cultural Haunting*, Brogan argues, "[i]n contemporary haunted literature, ghost stories are offered as an alternative—or challenge—to 'official,' dominant history."[13] More specifically, Gilroy argues that the cultures of the African Diaspora constitute a distinctively Black counterculture to white, Western modernity that has systematically marginalized nonwhite experiences.[14]

This essay therefore will examine how *The Sacred Place* and *Gathering of Waters* reimagine and rearticulate the historical subtext of the racially motivated murder of a barely pubescent African American youth. On August 28, 1955, in Money, Mississippi, Emmett Till, a fourteen-year-old African American boy, was brutally tortured and murdered for allegedly whistling at a white woman. The murderers, J. W. Milam and Ron Bryant, two white men, were brought to trial but acquitted by an all-white, all-male jury. Till's murder is part of a long continuum of racial violence now referred to as the haunting afterlife of slavery. What makes the Emmett Till case crucial is that its wide and explicit media coverage struck a responsive chord and played a significant role in mobilizing the Civil Rights Movement. Emmett Till's story continues as a haunting presence in African American literature, as evident in the writings of authors such as Gwendolyn Brooks, James Baldwin, Audre Lorde, and Toni Morrison. The enduring afterlife of Till's

radically politicized ghost has become emblematic of the cultural trauma produced by the racially motivated violence that tragically persists in contemporary American culture.

Although both novels focus on the same historical subject, they differ in their use of the supernatural, their contestation of Western modernity, and their representation of cultural trauma. In *The Sacred Place*, ghosts appear to signify the spiritual presence of past generations. The ancestral spirits communicate with humans in a clearing in the forest, The Sacred Place, conceptualized as a posthumanist enclave where the boundaries between human beings, nonhuman animals, plants, and the supernatural collapse and dissolve. These spirits accompany the living in their public protest against the racist murder of Emmett Till by white supremacists in Money, Mississippi. This protest march, in effect, allegorizes the Civil Rights Movement, the rise of which was galvanized by the Emmett Till case and—due to the advocacy of Mamie Till-Mobley (Till's mother)—by the extensive media coverage of this event. In *Gathering of Waters*, both evil and benevolent spirits travel intergenerationally, moving from one host to the next, leading up to the inhabitation of one of the murderers of Emmett Till. The principle of animism—or "the idea that souls inhabit all objects, living things, and even phenomena"[15]—provides the narrative framework for spectral and otherworldly manifestations. These life-forms, including the "so-called inanimate objects,"[16] function to challenge the demystifying and rationalizing tenets of Western modernity. In both narratives, it is the role of spirits and ghosts to articulate and reassess the collective experience and memory of cultural trauma rooted in the primal scene of slavery and its afterlife.

HAUNTING AND POSTHUMANISM IN *THE SACRED PLACE*

Daniel Black's novel, *The Sacred Place*, narrates the story of the fictive Black Johnson family in Money, Mississippi, including the character of Clement, a renamed stand-in for Emmett Till, who is a victim of racial violence. The narrative is dominated by a climate of racial tension and the fear of violence and death deeply embedded in the intergenerational memory and experiences of the Black population of this southern town. Subjected to Jim Crow laws and strict, demeaning social codes, the Black people of Money live lives of subjugation and humiliation. Confronted with the harsh conditions of racial exclusion and the daily threat of violence, "colored folks . . . just bury the dead and move on."[17] It is thus hegemonic whiteness that keeps African Americans at bay, effectively eliminating the potential of organized acts of resistance. As a visitor from Chicago, Clement fails to adapt to the Jim Crow social codes of 1955 Mississippi. His young life is brutally struck down for what is perceived to be defiance of long-established codes of racial etiquette. His alleged familiarity with a white female store clerk is deemed to be a violation of white southern womanhood. The torture and murder of Till is motivated by the racist will to secure the interests of white supremacy and to keep the Black people of Money "in their place." However, in this instance—and with the support of the ancestors—Clement's grandfather, Jeremiah, mobilizes the Black community in a march to publicly confront and challenge the local sheriff, an embodiment and symbol of the ideologies and practices of white supremacy.

Underlying Black's challenge to the oppressive ideologies and practices based on such categories as race, sexuality, and gender is the larger goal of transcending the limitations of what we traditionally regard as *human*. In other words, his novel also addresses the issue of *speciesism*, defined by Cary Wolfe as a framework that "involves systematic discrimination against an other

based solely on a generic characteristic—in this case, species."[18] Wolfe contends that, "[i]n the light of developments in cognitive science, ethology, and other fields over the past twenty years . . . it seems clear that there is no longer any good reason to take it for granted that the theoretical, ethical, and political question of the subject is automatically coterminous with the species distinction between *Homo sapiens* and everything else."[19] These premises, often referred to as posthumanism, render a multifaceted concept that I will take up as a critique of humanism as a system that categorizes and constructs ideological boundaries that have elevated human beings to a position of privilege and excluded other life-forms, such as nonhuman animals and plants.[20]

Constructed as a site of both tragedy and triumph, of both sorrow and redemption, The Sacred Place—a location described in biblical terms as "the Kingdom of God"[21] and later as "a beautiful little oasis, almost like a Garden of Eden"[22]—is conspicuous as a place in which the ideologies and conventions of Western rationality are absent. The clearing is characterized by extraordinary natural beauty and the peaceful coexistence of nature and its various constituents, including humans, nonhuman animals, plants, and inanimate objects. Engaged in relationships of mutual respect and amity, the denizens populating such a scenario challenge conventional power hierarchies and, in particular, the position of privilege and power assigned to human beings in the context of humanism. These relations of harmony and felicity among different orders of being clearly stand in contrast to the racist white hegemony of Money, Mississippi—and, at the same time, offer a utopic vision of what society could look like with the achievement of social equality. The author, then, not only calls into question racist white rule and supremacy, but—in his evocation of an ideal order—seeks to map new modes of social coexistence.

The element of the supernatural is introduced as Jeremiah enters The Sacred Place following Clement's murder. There is an absence of fear between humans and nonhuman animals that challenges "the humanist belief that 'man is the measure of all things.'"[23] Anti-speciesism also becomes manifest in Jeremiah's encounter with a mother bird and her brood, in which "[t]he mother's eyes met his own and made him feel warm and welcome."[24] In this moment of boundary-crossing amity, Jeremiah experiences an interspecies bond of parenthood. And, significantly, here it is the similarities between species that are emphasized instead of the differences. In The Sacred Place, haunting (or the supernatural) would seem to be intertwined with posthumanism and anti-speciesism.

The events that lead to the discovery of the ghostly presence in The Sacred Place include both communal celebration and personal tragedy, as Jeremiah's son, Jerry, hangs himself in this consecrated space after killing the white men who raped his wife, Billie Faye. Yet, following Clement's murder, Jeremiah adopts the habit of going to The Sacred Place to find the will and strength to initiate collective Black resistance to white supremacy. During his sojourn in this garden of rest and contemplation, Jeremiah calls out to his son, without actually anticipating an answer, and is startled to hear Jerry's voice respond, encouraging him to confront the racist practices and social injustice that have, for generations, defined the daily existence of Blacks in Money. When Jeremiah hesitates, the spectral voice replies with a powerful injunction: "*Nothing is too much to ask for if you're willing to make it happen. That is the job of the living—to make the seemingly impossible come to pass. I'll be right next to you, Daddy, every step of the way.*"[25] It is thus ghostly communion with the deceased son that fortifies Jeremiah's determination to lead: "He left The Sacred Place surer than ever of what he was going to do. . . . Jerry's voice alone had reminded him of his unfinished business with whites in Money. Now he would bring it all to closure."[26] As Melanie

Anderson notes in a different context, "a liminal figure"—here the dead son—becomes "enmeshed in a specific social situation, catalyzing change in the lives of surrounding characters."[27]

What is important here is that the supernatural presences and otherworldly experiences are not demystified, dismissed, or rationalized away as individual hallucination or wish-fulfilment fantasy. Instead, the spectral is integrated into the material world of the novel; indeed, the realm of reality is neither displaced nor superseded by the transcendent world of the spiritual. Arguing that in "many non-Western (and marginal Western) traditions of the ghost . . . the ghost is not reduced to a metaphor," Esther Peeren further explains, "In such traditions, ghosts do not have to be learned, nor do they necessarily oppose or disturb the reigning ontology. Instead, they are simply there as part of everyday life."[28] Startled upon discovering the presence of his son's ghost, Jeremiah's reaction ("He stood quickly, searching to the right and left for the voice he was sure he had heard"[29]) suggests the influence of twentieth-century Western rationalism. During the course of the narrative, however, the supernatural assumes an unquestioned place in the everyday reality of the Black community. The Black community's embrace of the spiritual world and rejection of Western rationalism, in which slavery and racism are rooted, signify a pathway to freedom.

The cultural trauma of slavery and its aftermath finds its clearest expression in the text when Jeremiah witnesses Clement's mutilated body. Jeremiah has experienced personal, family, and communal losses to white violence, but his "[submission] to the ancestors [who] bore the pain of people he never knew and abuses he never witnessed"[30] constitute his testimony to the larger ancestral and intergenerational loss that has shaped the collective memory and cultural trauma of the African American community. As Eyerman argues, the historical trauma of slavery becomes a cultural trauma precisely because its memory is "mediated through recollection and reflection," rather than derived from direct first-hand experience.[31] Thus it is through not only his recent and personal loss but the collective sense of loss and cultural trauma associated with slavery and its aftermath that Jeremiah becomes a catalyst for Black resistance in Money.

Through barn meetings, Jeremiah summons the community and attempts to persuade them to challenge the white racist hegemony that has paralyzed their lives and contained any organized acts of collective resistance. What is emphasized during these sessions is the tension between the individual and the collective impulse to resist. Individual efforts to confront white supremacy always result in the death of the Black people who have dared to defy the status quo. Jerry's suicide after killing his wife's rapists is a case in point. Jeremiah's wife, Miss Mary, articulates the need for changing the frame of resistance: "We gotta start thinkin' collective instead o' individual. That's how they get us. When it com time fu us to stand together, we as separate as the fingers on a hand. . . . You can always destroy a person who stands alone, but a strong group o' people gon last a long time 'cause they gon take care o' one another. Dat's how we gotta be, y'all. We gotta stand together."[32]

Despite the aptness of Miss Mary's argument and its positive resonance, Jeremiah's "jealousy almost got the best of him when he thought of telling his wife to sit down and shut up, but she evoked from the crowd the enthusiasm needed to get his plan under way. . . ."[33] Although keenly aware of the impact of racist hierarchy, Jeremiah appears less attuned to the pitfalls of patriarchal thinking, and reprimands his wife for speaking on public matters. To his credit, however, Jeremiah manages to recognized the received patriarchal ideologies of southern society, as well as the larger Western traditions of gender oppression: "I know. I jes wanted to be de big dog, I guess. I'm sorry."[34] Daniel Black's anti-patriarchal critique is expressed even more directly when another

GHOSTS OF TRAUMATIC CULTURAL MEMORY

character, Miss Mary, passes on to her daughter, Ella Mae, the following maternal wisdom: "Girl, my momma told me dat a colored woman oughta stand wherever standin' need to happen, whether a man there or not . . . ! If you let him do all de fightin', he gon do all de rulin', too."[35]

Haunting and spectrality return to the text and community when the Black marchers confront the sheriff over Clement's murder. During this confrontation, Jeremiah, family, and friends find themselves surrounded by the protective presence of the invisible dead:

> With each step the people took, their numbers multiplied. Folks glanced around without seeing the presences they felt, but they knew others were among them. . . . It was funny, Jeremiah thought, that as soon as he gathered the strength to stand alone, others came. And not just human others but spirits who had the power and the authority to protect them from dangers seen and unseen.[36]

Although not everyone in the procession sees or feels the spectral presence of past generations, the collective sense of solidarity and unity is radically enhanced by ghostly presences mediated to the crowd.

Religion, both in concept and practice, is linked to the ideas of spectrality and afterlife in the novel. As the march grows, for example, the ghostly presences "strengthened the people and made them feel like the Hebrew army preparing to face the Philistines."[37] Fundamentally, the spiritual and the sacred are allied in both Christianity and many African diasporic belief systems. Not only is The Sacred Place referred to as "a space wherein God dwelled,"[38] but the spirits that accompany the living in their procession are depicted through biblical allusion and imagery. Such spirits demonstrate Brogan's observation that (1) "[I]n contemporary African-American ghost stories the individual's or family's haunting clearly reflects the crises of a larger social group" and (2) "The figure of the ghost itself emerges from the cultural history of that group: one of the key elements of African religious thought to survive in syncretic forms of new-world religious practice and in slave folklore is the belief in ancestor spirits."[39] In the novel, Jerry's ghost—which first appears only to his father in The Sacred Place—is later joined by the multitudinous spirits of past generations of African Americans. The spirits represent a syncretic form of African American Christianity in which the ancestors provide protection and guidance to the living.

Notably, in African American history, Christianity has functioned as a source of spiritual strength and resistance. The Black community claims the banner of religion combined with the spirits of ancestors as they prepare to confront the town's racist establishment: "Every colored citizen, buttressed by souls larger than themselves, borrowed strength from those Inexhaustible Ones and purposed in their hearts to tell their children and their children's children how, one dusty summer morning, God and the ancestors ushered them into victory."[40] Christianity, however, has also served as an ideological justification for white supremacy. Clement's murderers, for example, invoke Scripture to support their own sense of racial superiority: "God made white men to rule over everything and everybody, and sometimes it's a hard job, but it's our destiny."[41] Furthermore, Christianity's role as a containment strategy is exposed as Jeremiah cautions his followers: "White folks been laughin' for years, y'all! They been watchin' us pray and do nothin', and that's how they keep rulin' our lives. They know God don't do nothin' if you don't!"[42]

After the confrontation with the sheriff and other white supremacists, the Black community returns to The Sacred Place to pay homage to the ancestors. This special space, an embodiment

of Michel Foucault's concept of *heterotopia*, or "a place of otherness,"[43] is transformed into a Jamesonian *utopian enclave*,[44] a place where humans, ghosts, nonhuman animals, and plants achieve a posthumanist state of unity. In jubilant culmination of their nascent organized, collective resistance to longstanding southern traditions of white supremacy—a symbolic figuration of the origins of the Civil Rights Movement—the community returns to its sanctuary. Miss Mary

> moved throughout The Sacred Place, touching trees, flowers, butterflies, birds, deer, rabbits, and squirrels, all of whom accepted her anointing willingly, lovingly. . . . Others joined her, creating a collective voice that reverberated throughout The Sacred Place like the voice of God. . . . Together, they looked possessed, marching from tree to bush, singing to the animate and the inanimate about the power of sacrifice and giving.[45]

In this posthumanist, postcategorical moment of unity and amity, the specters of the past generations make an appearance: "[S]uddenly, those ancient beings, the once Invisible Ones, came again. Yet this time, they arrived in radiant splendor. Draped in flowing, snow-white garments with matching headwraps and accompanying staffs, they looked like gigantic African spirits on their way to a river baptism."[46] And it is here among the heavenly throng that the presence of Clement's ghost makes itself known as a guide and guardian spirit: "[S]uddenly Possum felt a small, familiar hand pat her shoulder, and she knew her child was safe among the angels."[47]

The joyous reunion in *The Sacred Place* encompasses a syncretism of indigenous African religion and Western Christianity, conjoins the dead and the living, and disrupts the hierarchy of power between human beings and the rest of nature.[48] This posthumanist state of being, along with a reconceptualization of the deity, is aptly summarized by one of the grandchildren of Jeremiah and Miss Mary: "Chop concluded that God must be everybody and everything that ever lived all combined, working to teach earth folks how to love existence—not just physical life."[49] This blurring of the boundaries between human beings, deity, and spirits, and between physical and spiritual forms of subjectivity redefines the symbolic terrain of The Sacred Place in the world of the novel and models the state of being toward which it aspires.

HAUNTING AND ANIMISM IN *GATHERING OF WATERS*

Both Black's *The Sacred Place* and McFadden's *Gathering of Waters* resonate with the voices of the repressed and the histories of the marginalized—those excluded from the grand narrative of Western modernity—by emphasizing the supernatural and resurrecting the historical ghost of Emmett Till. The renarrativizations of this historical subtext, however, differ in significant ways. Whereas Black emphasizes the political meanings of Till's murder for the Black community of Money, Mississippi, by highlighting a profoundly collective dimension, McFadden focuses primarily on the personal consequences of this event, leaving the larger social and political conclusions to the reader. In addition, the latter text depicts a larger historical timeframe, spanning the early twentieth to the early twenty-first centuries, emphasizing the *longue durée* of racial injustice. *Gathering of Waters* also intertwines natural disasters, such as the Great Mississippi Flood of 1927 and the Hurricane Katrina tropical cyclone of 2005, dramatizing how natural disasters become human-made social catastrophes due to historical structures of racial inequality.

GHOSTS OF TRAUMATIC CULTURAL MEMORY

McFadden's *Gathering of Waters* deploys an animistic narrative voice that identifies itself not as a *person* but rather as a *place* ("I am Money. Money Mississippi"[50]). In its nonhuman guise, then, the narrator positions this story, at the outset, within the larger Black counternarrative of modernity. Significantly, Caroline Rooney observes that animism,[51] "as an anthropological term," has traditionally carried rather negative connotations in Western thought and science in that it "designate[s] a non-monotheistic primitive religion of spirits," belonging "to the repertoire of terms that have aimed to distinguish between primitive and modern thought."[52] Further, according to Istvan Praet, animism has frequently been based on an exaggerated attribution of "life and/or humanity to this, that, and the other in a remarkably generous manner" and, as a result, especially in the nineteenth century, "ethnographers tended to characterize animists as primitive, childish, and irrational."[53] It is by now common knowledge that animism is a characteristic feature in African philosophies and religions, although, as Rooney notes, "African thought . . . is by no means reducible to animism."[54] In the context of African American culture, then, animism is often viewed as a continuum of these traditions that survives the Middle Passage and continues to exist in Black communities in the Americas. The derogatory connotations that the ideologies of Western modernity have attached to animism are a part of the Othering of non-Western modes of thinking. Embracing animism, therefore, can be read as a counternarrative to Western modernity and its rationalizing tendencies. In *Gathering of Waters*, animism works in conjunction with concepts such as haunting and silenced histories to disrupt the power of grand narratives.

Assuming a narrative position that strategically stages a nonhuman speaker as part of the Black counternarrative of modernity, *Gathering of Waters* opens with the town of Money, Mississippi, introducing itself as omniscient narrative voice and witness to the events to follow:

I am Money. Money Mississippi.

I have had many selves and have been many things. My beginning was not a conception, but the result of a growing, stretching, and expanding, which took place over thousands of years.

I have been figments of imaginations, shadows and sudden movements seen out of the corner of your eye. I have been dewdrops, falling stars, silence, flowers, and snails.

For a time I lived as a beating heart, another life found me swimming upstream toward a home nestled in my memory. Once I was a language that died. I have been sunlight, snowdrifts, and sweet babies' breath. But today, however, for you and for this story, I am Money. Money Mississippi.[55]

The town is thus not only inhabited but personified by a traveling spirit that has assumed various other forms and guises, as it moves from one host to another through time and space. By endowing inanimate or inert entities with spirituality, the text supports what Rooney defines as an "African perception of the dynamic or vital nature of matter in which nature and spirit are not opposed."[56] In its explicit introduction to the concept of animism, the narrative contests and transcends the typically western opposition between the material and the spiritual:

But what you may not know and what the colonists, genociders, and slave owners certainly did not know is this: Both the Native man and the African believed in animism, which is

207

the idea that souls inhabit all objects, living things, and even phenomena. When objects are destroyed and bodies perish, the souls flit off in search of a new home. Some souls bring along memories, baggage if you will, that they are unwilling or unable to relive [sic] themselves of.[57]

Writing against traditional Western worldviews based on rationality and the exclusion of the supernatural, McFadden deploys animism and a nonhuman narrator to construct a counternarrative. Establishing the novel as a forcefield where the supernatural is intertwined with mundane social reality, the author seeks to construct a more inclusive worldview in which the ideology of rationality no longer functions as an instrument of domination and repression. Thus, the memories that these animistic souls carry—the "baggage" to which the text refers—may be read as fragments of the traumatic memory of slavery.

If the narrative is told by an inanimate spirit assuming the voice of the town, it is the vengeful and evil spirit of Esther Gold who, like a succubus, haunts the novel and travels from one host to another, carrying memories of earlier lives and generations. It is, in fact, this tormented spirit that precipitates the murder of Emmett Till and, ultimately, becomes manifest in Hurricane Katrina. Esther, a beautiful and passionate Black woman, is rendered victim to the insecurity and self-doubts of the men who question her devotion. Eventually, she turns to sex work:

Too pretty for any woman to want as a friend. So beautiful, men didn't think about loving her; they only fantasized about melting away between her creamy thighs.
Poor Esther.
The men she welcomed into her heart and into her bed should have worshipped the ground she walked on—and they did for a while—but eventually her beauty felt like a hot spotlight and their confidence faded away beneath the luminous beam. They questioned her loyalty and themselves.
Why she want me?
The answers always fell short of what they needed, which was a scaffold of assuredness sturdy enough to bear their egos. Esther replied, "I love you, ain't that enough?"
They said it was, but it wasn't and they didn't know why. So the men beat her for loving them.
They beat the goodness and the sweetness out of her. They beat her into the streets, into back alleys, down into the dirt, into the gutter, onto her knees, her back, and then they climbed on top and emptied their miseries inside her.[58]

Under the demeaning brutality of slavery in the Americas, Black identity became profoundly contested, and in this case, the traces of the cultural trauma of slavery surface in the degradation of Black women and the demoralization of Black men who believe themselves unworthy of love and esteem. The Black man's diminished sense of self-worth is then transformed into violence toward women such as Esther, who is, consequently, subjected to the traumatic memory of slavery both as a cultural trauma and, in an individual sense, as a victim of abuse at the hands of Black men. In her account of African American womanhood as "the ultimate 'other,'" Patricia Hill Collins articulates oppression as intersectional.[59] As an intersectional figure, Esther is rather complex. Unlike the noble and courageous biblical (Queen) Esther, who saved the Jews from King Ahasuerus,

Esther Gold vindictively leads her family and followers to intergenerational death and destruction. As an agent of possession, her evil spirit travels from one host to another, carrying sorrow and creating havoc. The reappearance of her spiritual habitations through generations of hosts would seem, as Brogan might argue, to "[mark] a continuity with the past over which one has little control: history lodges within, swollen bodies (a recurring image in this literature) give birth not to the future but to a nightmarish repetition of the past."[60] Esther's spirit, then, may be read as a representation of the traumatic memory of slavery that keeps moving on, traveling through history, possessing and then moving on again, thereby repeating the past and continuing the succession of catastrophes and tragedies. As we shall see, this representation is compelling, but vexing, because it seemingly shifts the responsibility for Till's murder onto Black womanhood. As "ultimate other," a victim of white and Black men, Esther's spirit also becomes proxy and proximate cause of white male violence as she takes on cross-racial and cross-gender guises and manifestations.

Emmett Till's story becomes intertwined with the traumatic cultural memory of slavery, represented by Esther's spirit, as the latter finds a new host during the Great Mississippi Flood of 1927. Her spirit enters into J. W. Milam, a young white boy, who dies in the flood and is resurrected. Commenting on this event, the narrator invites the reader to reflect on resurrection narratives: "[Y]ou may doubt that this actually happened. But I have no reason to lie to you. People coming back from the dead is a phenomenon that can be traced all the way back to the Old Testament of the Bible."[61] And citing more recent examples from the United States and Nigeria, the narrator offers different explanations, ranging from human misdiagnosis to the metaphysical: "Medical officials blame the occurrence on human error. They even have a term for it: Lazarus syndrome. The religious, of course, give the glory to God."[62] The narrator, however, attributes the phenomenon to the character haunting the narrative: "[T]he culprit in the resurrection of J. W. Milam was none other than Esther."[63] After coming back from the dead, Milam transforms from a "sweet child" into a monster, who repeatedly resorts to violence toward human beings and nonhuman animals alike. Eventually, Emmett Till becomes one of his victims in a brutal racist slaying. Thus, the fates of Esther and Milam not only become interwined in an act of demonic inhabitation, but in an ironic and unfortunate twist of fate, both are transformed from humane and caring individuals into monstrous and inhuman(e) creatures responsible for the death and destruction of others.

McFadden, like Black, combines elements of historical fiction and magical realism in a narrative that gives a ghostly afterlife to Emmett Till, although in the two novels the circumstances of his spectral return are vastly different. Till's ghost remains a presence in the life of Tass Hilson, a Black girl, who develops a crush on the young boy visiting from Chicago. When Tass gets married and moves to Detroit years later, she takes a flowerpot of dandelions with her, thereby transporting a bit of the soil from Money, which enables Money to accompany her and continue narrating Tass's story. When she returns to Money for her mother's funeral, Tass senses a supernatural presence for the first time: "She was swiping at her face when she felt the unmistakable tickle of a feather in her ear, followed by a gentle breath of air against her cheek. Little did she know that the lines of communication between the here-and-now and the beyond were now open."[64] Till's ghost has followed Tass to Detroit, but does not really appear to her, except though little gestures that make her life somewhat more tolerable: "[H]e would send a butterfly or bloom a flower to make her happy," along with "hundreds of cardinals feathered in the most vibrant red she had ever seen."[65]

PEKKA KILPELÄINEN

Till's spectrality, visible to some and invisible to others, calls into question a notion of being that denies the spiritual dimension of existence and, in so doing, counters the rationalizing and demystifying ideologies of modernity. As the narrator reflects, "When you are young, you are open to all things; that's why the babies were able to see Emmett following Tass from room to room, and hunched in the corners watching her. . . . But as the babies grew into toddlers and beyond, that window known as spiritual consciousness slipped closed and Emmett became as invisible to them as air."[66] Implied in this passage is the idea that the supernatural world is accessible until the child becomes conditioned by the Western tenets of rationality. Further, at the other end of earthly life, this process is reversed. Thus, continues the narrator, "when a soul begins to slip from the binds of the physical world, the consciousness reverts to its natural state and once again it becomes open and receptive to the spirits that live amongst the host body."[67] Before he dies, Tass's husband, Fish, suffers a serious stroke, becomes aware of Till's ghostly presence, and, consequently, (falsely) accuses Tass of infidelity. Not only humans but also non-human animals can be "extremely sensitive to the spirits that live amongst you."[68] Fish gets rid of a cocker spaniel "who found Emmett's presence so disturbing that he barked himself hoarse," and, sadly, a pet hamster "mounted his exercise wheel and ran until his heart gave out."[69] And, finally, when Sonny, Tass's son, brings his Ghanaian girlfriend, Aida, to meet his parents, it becomes clear that she is able to see Till's ghost as well: "Before turning to leave, she looked right at Emmett and offered a soft, knowing smile."[70] The fact that Aida is African excludes her from the grand narrative of Western modernity and its demystifying tendencies, which, arguably, enables her to see the ghost.

Toward the end of the novel, the supernatural and mundane worlds become intertwined in increasingly tangible ways. In her reading of Nigerian ghost novels, Peeren contends that in various non-Western cultures "[g]hosts . . . do not tend to be confined to a completely separate world."[71] Rather, the ghostly becomes part of the everyday world and vice versa, as the boundaries that Western rationality has established between these two realms inevitably dissolve.[72]

Returning to Money, in the wake of the deaths of both husband and mother, Tass has a dream in which she encounters a stranger standing outside her home. The following morning, the grass outside her home is flattened precisely in the place where the stranger had been standing in the dreamscape. The next day, she meets the stranger, revealed as the young boy of her dreams. She is once more a girl of fifteen, and the boy, who introduces himself as Bobo (Till's nickname), joins her as they begin walking down the road toward Bryant's grocery store. The dreams become a narrative prequel to the ensuing heinous and savage murder of Emmett Till by Roy Bryant and his half-brother J. W. Milam. In this imaginary scenario that combines elements of the everyday and the supernatural, the author is able to capture an instance that memorializes two young lives full of love and hope for the future. As Padagonia hears the radio announcement of an approaching hurricane and comes to warn her slumbering friend, Padagonia sees two young people on the road, the girl wearing an oversized nightgown. It is Tass and Till returning from Bryant's store, licking ice pops—in effect, enacting Tass's prophetic dream and, once more, emphasizing the coexistence of the mundane and the supernatural, of human beings and ghosts in an animistic worldview. As the reader knows, what the author renders in this phantasmatic image is a liminal moment betwixt and between the real-life fatal encounter in Bryant's grocery and the (extratextual) recovery, days later, of Till's decomposing and disfigured corpse found in the Tallahatchie River.

210

While McFadden's narrative focuses on the imagined personal afterlife of Emmett Till rather than the political significance of his murder, *Gathering of Waters* closes with the image of the surviving remains of Bryant's grocery store, abandoned and decrepit, where fifty years earlier Till's alleged violation of southern racial codes led to the birth of the modern Civil Rights Movement:

> Vacant and ghostly, it [Bryant's store] had survived high winds and treacherous storms, holding onto a life that no longer wanted it—it slouched there, plastered with advertisements and riddled with racial epithets, Bible verses, and swastikas. It stood as a reminder of the then and the now; refusing to die, it clung stubbornly to this world always, loudly insisting upon itself. . . .
>
> Virulently racist whites wanted it to remain as a reminder to black folk that what had happened here could happen again. And black people wanted it to remain for the very same reason.[73]

In the close of McFadden's text, then, the abandoned store, the site of a historic and tragic encounter, stands as a faltering monument, a kind of Bakhtinian *chronotope*,[74] in which the spatiotemporal history of institutionalized racism—the legacy of American slavery—is juxtaposed to the fictionally memorialized image of Emmett Till and his young love, Tass Hilson.

CONCLUSION

The Sacred Place and *Gathering of Waters* join the African American literary tradition of "haunted texts" populated by what Anderson describes as "figures of spectrality mediating personal and cultural history."[75] Like Morrison's *Beloved*, these two novels may be read through the concept of "rememory," which Marisa Parham defines as "how memory circulates, how it crosses boundaries between people, how it haunts."[76] Both novels challenge and displace Eurocentric ways of seeing reality by invoking ghosts and the supernatural as inseparable from everyday life and mundane experience. Representing marginalized histories and narratives, repressed by the grand narrative of Western modernity, ghosts in African American texts often function to bring to the surface the traumatic cultural memory of slavery. According to Anderson, however, "[g]hosts create spaces that indicate issues of dispossession and trauma, and they can create places for memorializing and healing."[77] Further, as Brogan observes, cultural haunting "potentially leads to a valuable awareness of how the group's past continues to inhabit and inform the living."[78] These fictional reconstructions of Emmett Till demonstrate Brogan's contention that it is precisely the narrativization of the ghostly presences of past wrongs that enables a process of mediation whereby traumatic memory is transformed into "'narrative memory,' which reshapes and gives meaning to past experience by adapting it to present circumstances."[79] Throughout the process of renarrativization, both *The Sacred Place* and *Gathering of Waters* seek to resurrect the significance of Emmett Till's murder, thereby providing Till with an afterlife in the early twenty-first century, a period still marked by racial tension and racially motivated violence.

Seeking to transform traumatic memory into narrative memory—to map possibilities of negotiation, of revision, of healing—these texts employ different strategies in order to account for and reckon with the traumatic memory of slavery. In *The Sacred Place*, the spectral presence of

past generations, their suffering and hopes for a better future for successive generations, becomes a source of courage and inspiration. Clement's death is reclaimed and transformed into an act of empowerment for the Black community of Money, Mississippi. The march to the white part of the town becomes an allegory of the Civil Rights Movement, which began to grow in strength and scope as a response to the widely publicized murder of Emmett Till and the widely publicized trial that failed to convict his murderers. The way in which Black rewrites the event clearly resonates with Till's historical role in galvanizing the Civil Rights Movement. Ultimately, Black writes against the grain of the Western ideologies of rationalism and demystification by creating a distinctively posthumanist enclave where the boundaries between ghosts, human beings, non-human animals, and plants seem to dissolve in unison with the growing Black resistance against southern racism. In *Gathering of Waters*, there is no direct indication of the significance of Till's murder in galvanizing Black resistance and civil rights activism in the real world. Instead, the narrative functions on a more allegorical or metonymical level by depicting the redemptive effects of spectrality on one individual's life, while simultaneously dramatizing the longevity of traumatic cultural memory and its effects on the present. In some respects, the novel's central thematic is summarized in the hauntingly resonant injunction that concludes the narrative: "As you go about your lives, keep in mind that an evil act can ruin generations, and gestures of love and kindness will survive and thrive forever."[80]

In taking up theories of animism and posthumanism, Black and McFadden seek to construct a model for Black life in the face of social death. The posthuman and interspecies model disrupts white supremacist versions of the "human" as exclusive of Black life and other sentient beings and life-forms. *The Sacred Place* and *Gathering of Waters* take both a "posthumanist turn" and a "spectral turn" and, through their deployment of animism and the supernatural, participate in the contemporary move toward posthumanist Black countermodernity. In their renarrativization and reassessment of Emmet Till's murder, these authors, in effect, expand the critical afterlife of this tragic and politically charged event. These narratives, thus, not only contest a worldview of Western modernity based on rationality and demystification but also give embodiment to the specters of racial violence and the ghosts of traumatic memory that bear testimony to a sometimes shadowy and frequently under-recorded history of racial terrorism and subjugation in the United States.

NOTES

1. See Fredric Jameson, *The Political Unconscious* (Ithaca, NY: Cornell University Press, 1981), 98.
2. Jacques Derrida, *Specters of Marx: The State of the Debt, the Work of Mourning, and the New International*, trans. Peggy Kamuf (New York: Routledge, 1994), 6.
3. See Derrida, *Specters of Marx*, xvii-xviii. In the original French, Derrida's phrasing is "s'entretenir de quelque fantôme."
4. Kathleen Brogan, *Cultural Haunting: Ghosts and Ethnicity in Recent American Literature* (Charlottesville: University Press of Virginia, 1998), 63.
5. Joanne Chassot, *Ghosts of the African Diaspora: Re-Visioning History, Memory, and Identity* (Chicago: University of Chicago Press, 2018), 32–33.
6. Avery F. Gordon, *Ghostly Matters: Haunting and the Sociological Imagination* (Minneapolis: University of Minnesota Press, 2008), 8.

GHOSTS OF TRAUMATIC CULTURAL MEMORY

7. Jeffrey Andrew Weinstock, "Introduction: The Spectral Turn," in *Spectral America: Phantoms and the National Imagination*, ed. Jeffrey Andrew Weinstock (Madison: University of Wisconsin Press, 2004), 4.
8. Ron Eyerman, *Cultural Trauma: Slavery and the Formation of African American Identity* (Cambridge: Cambridge University Press, 2001), 2.
9. Paul Gilroy, *The Black Atlantic: Modernity and Double Consciousness* (London: Verso, 1993), 39.
10. Angelyn Mitchell, *The Freedom to Remember: Narrative, Slavery, and Gender in Contemporary Black Women's Fiction* (New Brunswick, NJ: Rutgers University Press, 2002), 147; italics original.
11. Eyerman, *Cultural Trauma*, 4.
12. Weinstock, "Introduction: The Spectral Turn," in *Spectral America*, 5–6.
13. Brogan, *Cultural Haunting*, 17.
14. Gilroy, *The Black Atlantic*, 36–38.
15. Bernice L. McFadden, *Gathering of Waters* (New York: Akashic, 2012), 16.
16. McFadden, *Gathering of Waters*, 16.
17. Daniel Black, *The Sacred Place* (New York: St. Martin's Griffin, 2007), 100.
18. Cary Wolfe, *Animal Rites: American Culture, the Discourse of Species, and Posthumanist Theory* (Chicago: University of Chicago Press, 2003), 1.
19. Wolfe, *Animal Rites*, 1; italics original.
20. For discussions on posthumanism, see, for example, Cary Wolfe, *What Is Posthumanism?* (Minneapolis: University of Minneapolis Press, 2010); Donna J. Haraway, *When Species Meet* (Minneapolis: University of Minneapolis Press, 2008); and David Roden, *Posthuman Life: Philosophy at the Edge of the Human* (London: Routledge, 2015).
21. Black, *The Sacred Place*, 12.
22. Black, *The Sacred Place*, 151.
23. Robert Ranisch and Stefan Lorenz Sorgner, "Introducing Post- and Transhumanism," in *Post- and Transhumanism: An Introduction*, ed. Robert Ranisch and Stefan Lorenz Sorgner (Frankfurt am Mein: Peter Lang, 2014), 16.
24. Black, *The Sacred Place*, 105.
25. Black, *The Sacred Place*, 107; italics original.
26. Black, *The Sacred Place*, 108.
27. Melanie R. Anderson, *Spectrality in the Novels of Toni Morrison* (Knoxville: University of Tennessee Press, 2013), 14.
28. Esther Peeren, "Everyday Ghosts and the Ghostly Everyday in Amos Tutuola, Ben Okri, and Achille Mbembe," in *Popular Ghosts*, ed. Esther Peeren and Maria del Pilar Blanco (New York: Continuum, 2014), 109.
29. Black, *The Sacred Place*, 106.
30. Black, *The Sacred Place*, 245.
31. Eyerman, *Cultural Trauma*, 2–3.
32. Black, *The Sacred Place*, 139.
33. Black, *The Sacred Place*, 139.
34. Black, *The Sacred Place*, 157.
35. Black, *The Sacred Place*, 268.
36. Black, *The Sacred Place*, 275–276.
37. Black, *The Sacred Place*, 275.
38. Black, *The Sacred Place*, 104.
39. Brogan, *Cultural Haunting*, 2.
40. Black, *The Sacred Place*, 278.
41. Black, *The Sacred Place*, 121–122.
42. Black, *The Sacred Place*, 256.
43. According to Foucault, heterotopia refers to "real places . . . which are something like counter-sites, a kind of effectively enacted utopia in which the real sites, all the other real sites that can be found within the culture, are simultaneously represented, contested, and inverted" ("Of Other Spaces," *Diacritics* 16, no. 1 [1986]: 24).
44. Jameson defines the utopian enclave as a space "momentarily beyond the reach of the social," where "new wish images of the social can be elaborated and experimented on" (*Archaeologies of the Future: The Desire Called Utopia and Other Science Fictions* [London: Verso, 2005], 16).

45. Black, *The Sacred Place*, 291.
46. Black, *The Sacred Place*, 294.
47. Black, *The Sacred Place*, 296.
48. Although this essay references only specific aspects of African religions and cultures, a fuller treatment of this rich, complex history can be found in *Encyclopedia of African Religions and Philosophy*, edited by V. Y. Mudimbe and Kasereka Kavwahirehi (Dordrecht, The Netherlands: Springer, 2021). For earlier explorations of this important topic, outside the scope of this essay, see: Jainheinz Jahn, *Muntu: African Culture and the Western World*, trans. Marjorie Grene (New York: Grove Press, 1994); John S. Mbiti, *Introduction to African Religions* (London: Heinemann, 1975); and Robert Farris Thompson, *Flash of the Spirit: African and Afro-American Art and Philosophy* (New York: Random House/Vintage, 1984).
49. Black, *The Sacred Place*, 277.
50. McFadden, *Gathering of Waters*, 15.
51. For further discussion on the concept of animism, see, for example, Graham Harvey, *Animism: Respecting the Living World* (London: Hurst & Company, 2005); Caroline Rooney, *African Literature, Animism and Politics* (London: Routledge, 2000); and Istvan Praet, *Animism and the Question of Life* (New York: Routledge, 2014).
52. Rooney, *African Literature*, 8.
53. Praet, *Animism*, 3.
54. Rooney, *African Literature*, 12.
55. McFadden, *Gathering of Waters*, 15.
56. Rooney, *African Literature*, 19.
57. McFadden, *Gathering of Waters*, 16.
58. McFadden, *Gathering of Waters*, 23–24; italics original.
59. Patricia Hill Collins, *Black Sexual Politics: African Americans, Gender, and the New Racism* (New York: Routledge, 2005), 188.
60. Brogan, *Cultural Haunting*, 9.
61. McFadden, *Gathering of Waters*, 131.
62. McFadden, *Gathering of Waters*, 131.
63. McFadden, *Gathering of Waters*, 131–132.
64. McFadden, *Gathering of Waters*, 207.
65. McFadden, *Gathering of Waters*, 211–212.
66. McFadden, *Gathering of Waters*, 212.
67. McFadden, *Gathering of Waters*, 219.
68. McFadden, *Gathering of Waters*, 212.
69. McFadden, *Gathering of Waters*, 212–213.
70. McFadden, *Gathering of Waters*, 213.
71. Peeren, "Everyday Ghosts," in *Popular Ghosts*, 109.
72. Peeren, "Everyday Ghosts," in *Popular Ghosts*, 108–109.
73. McFadden, *Gathering of Waters*, 237.
74. M. M. Bakhtin, *The Dialogic Imagination*, ed. Michael Holquist, trans. Caryl Emerson and Michael Holquist (Austin: University of Texas Press, 1981), 425–426.
75. Anderson, *Spectrality in the Novels of Toni Morrison*, 1.
76. Marisa Parham, *Haunting and Displacement in African American Literature and Culture* (New York: Routledge, 2009), 7.
77. Anderson, *Spectrality in the Novels of Toni Morrison*, 2.
78. Brogan, *Cultural Haunting*, 8.
79. Brogan, *Cultural Haunting*, 79.
80. McFadden, *Gathering of Waters*, 252.

TWELVE

AFRICA IN HORROR CINEMA

A Critical Survey

FERNANDO GABRIEL PAGNONI BERNS, EMILIANO AGUILAR,
AND JUAN IGNACIO JUVÉ

THE IMAGE OF AFRICA IN HORROR CINEMA

In his classic essay "An Introduction to the American Horror Film," Robin Wood argues that horror films operate on the Freudian principle that sexuality is subject to punishment if not properly channeled into (hetero)normative behavior. Wood frames this idea within a larger political premise, namely, that Western capitalism must punish that part of the libido not alienated from labor in order to protect itself and its values. Continuing, Wood notes that, if an individual escapes this punishment, then *repression* is converted into *oppression*.[1] If internal, or psychological, repression fails, then, external, or political, oppression takes its place and the subject, in the prevailing social order, is ostracized and classified as a disruptive, and often monstrous, Other.[2] For Wood, American horror cinema, as a genre, allegorically exemplifies what is repressed within a particular spatialized social context at any given historical moment.

Drawing on Wood's fundamental premise here, we may ask the following twofold question: (1) Which social anxieties are figured into a monstrous Other in the horror films that deploy African landscapes as backdrop? and (2) In which ways are Africa and its inhabitants (mis)represented within the genre and tradition of Western horror cinema? There are no easy answers to these questions, since—despite the recurring and conventionalized "Africanist" tropes—the image of Africa in horror cinema is far from univocal. We will argue that Africa, even when codified through the filter of horror, is subject to misrepresentation as a symbolic and physical landscape within Western horror film. Contrary to what one might think, images of Africa in horror cinema—like monsters in general within the genre—are not static, but rather dialectical, and run the gamut from progressive to regressive in terms of ideological valence.[3] Some films are regressive and some ambiguous, while others contain both regressive and progressive elements.

The introduction of Africa into horror cinema took place during the classical era of Hollywood cinema. These appearances were an extension of the stereotypical images of Africa as a continent homogeneously populated by inferior, superstitious, irrational natives. Films such as *West of Zanzibar* (Tod Browning, 1928) and its remake, *Kongo* (William Cowen, 1932), or *Son of Ingagi* (Richard Kahn, 1940) depict an Africa dominated by ignorance, superstition, and savagery. In those years, argues one historian, "Africa became the 'beloved outcast'; an extreme manifestation

of all that other societies feared and rejected about themselves."[4] Through negative identification, Africa is rendered the dark mirror of the enlightened, rational, and civilized world.

The turning point is an all-but-forgotten film: *The Vampire's Ghost* (Lesley Selander, 1945), in which a white creature of the night preys on South African villages. Even if it is true that legends of vampires exist in Africa, the film's main vampire answers to the European prototype that gained wide circulation in Hollywood. Nevertheless, *The Vampire's Ghost* represents a critical turn in horror cinema's depiction of Africa since here the Africans possess agency and exercise an active role in the film's plot: they are superstitious—and completely right regarding their assumptions about the Europeans. Similarly, African coproductions, like the American *The Stick* (Darrell Roodt, 1988) and the British *Dust Devil* (Richard Stanley, 1992), brought an end to decades of cinematic neglect of the continent. In contemporary horror, the return of the repressed signals the ways in which the First World engages the loss of its hold on colonial Africa.

MONSTROUS AFRICA IN CLASSIC HORROR

Examining how competing notions of "Africa" operate in classical Hollywood film, we will argue that while the films' constructions of the region in which they are set manifest a neocolonialist point of view, these films by no means do so uniformly and without internal contradictions. For example, the sense of geographical space is sometimes shattered in order to privilege stereotypical "Africa-ness" rather than render a material and historical continent. However, we find that there is some register of resistance to the pejorative excess typical of racist prejudice, especially when African natives prove intuitive and willful rather than contentedly colonized subjects. We also suggest that the decision to deploy Africa as the backdrop in foregrounding fundamentally American stories creates textual ruptures and tensions that menace the binary model of colonizers/colonized.

Early Hollywood films featuring an African background were mostly cheap B-grade productions that drew on an African landscape to create a mysterious ambience and exotic backdrop. However, there are notable differences in the contexts of production and circulation. *West of Zanzibar* was an A-grade film with a star director (Browning, who, in 1931, would helm Dracula) with an A-grade star, Lon Chaney. Arguably, *West of Zanzibar* was not so much a horror film as it was a melodrama. Strictly speaking, however, before the advent of the first cycle of horror in Hollywood with films made by Universal studios such as *Dracula* or *Frankenstein* (James Whale, 1931), there was no proper "horror film." Rather, it was the silent productions that actually prefigured the development of the genre. According to Louise Fenton, "[t]he silent era provided the foundation for the horror genre to build upon,"[5] and film stars and directors, like Chaney and Browning, were heavily linked to macabre cinema. It was not by chance that a major and risky event like *Dracula* was commissioned to Browning—with Chaney scheduled to be the main star, until cancer claimed him and the production replaced him with Bela Lugosi. *Kongo*, on the other hand, was a remake that recycled exterior shots lifted from the original film as a means to economize resources. In contrast, *Son of Ingagi*, together with films such as *Louisiana* (aka *Drums O' Voodoo*, and *She Devil*, Arthur Hoerl, 1934), *Chloe, Love Is Calling You* (Marshall Neilan, 1934), and *The Devil's Daughter* (aka *Pocomania*, Arthur H. Leonard, 1939), was part of a series of horror films that featured all-Black casts of actors and actresses to "make the genre relevant" to

216

AFRICA IN HORROR CINEMA

African American communities.[6] As niche films that circulated only in limited venues, these "horror-noire"[7] have been mostly lost since there has been little interest in preserving them. While films such as the ultra-racist *Chloe, Love Is Calling You* can hardly be seen as progressive,[8] *Son of Ingagi* at least presents African Americans as heroes, while displacing Africa as a politically complex geographical space with the idea of Africa as monstrous birthplace of humankind embodied by the figure of N'Gina. *The Vampire's Ghost*, made during the second round of classic horror films, with a tiny budget and no recognizable stars, became simply another B-grade product to fulfill double programs in the theaters. This film, along with a whole new cycle of horror, sought to capitalize on well-known tropes, such as the vampire and voodoo, popularized by studios like Universal. While none of these films is what academics would consider "classic," they offer the potential of rich readings of celluloid "Otherness." And, despite their relative obscurity, these films provide productive interpretive terrain for understanding the encoded valences and meanings of Africa in the horror genre.

The plots of the silent film classic *West of Zanzibar* and the "talkie" remake *Kongo* are parallel: the story opens with a magician—Phroso (Chaney) in the former and Flint Rutledge (Walter Huston) in the latter—who is assisted by his wife with his magic tricks (see figures 12.1 and 12.2).

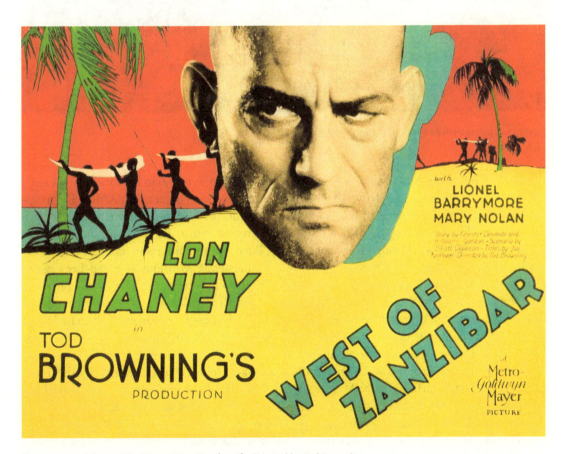

Figure 12.1. Lobby card for *West of Zanzibar* (1928), directed by Tod Browning.

217

Figure 12.2. Scene from *Kongo* (1932), directed by William Cowen.

The wife abandons her husband for a lover—Crane (Lionel Barrymore) in the former and Gregg Whitehall (C. Henry Gordon) in the latter—and together they plan to escape to Africa. The magician and the wife's lover come to blows and, by accident, the husband takes a tumble from a high altitude, breaking his spine. When the wife apparently returns from Africa, she dies, leaving behind a baby girl. Although now a paraplegic, Phroso/Flint, bitter and hateful, sets out for Africa to exact revenge on Crane/Gregg. Eighteen years later, Phroso/Flint—"Dead-Legs," as he is known—tricks the Black natives with voodoo magic so that he can gain spiritual authority over the tribe and plot the theft of elephant tusks from Crane/Gregg, now a trader in Africa. Meanwhile, as part of his nefarious scheme, he sends for the daughter to live with him in Africa. Maizie (Mary Nolan) is raised in a Zanzibar brothel in the original, and in the remake, Ann (Virginia Bruce) grows up in an orphanage run by nuns. Phroso/Flint seeks to dishonor and degrade his enemy's daughter and turn her into a drug-addicted prostitute. Eventually, the magician will learn the startling truth: Maizie/Anna is his child. The magician has engineered the ruin and destruction of his own daughter, and the revelation will shatter his life.

Both *West of Zanzibar* and *Kongo* carefully avoid references to actual spatialized geographies (with the exception of Zanzibar, which is just a name occasionally dropped). Thus, Africa is misrepresented as an undivided nation made up of undifferentiated states. Such a misconstruction

ignores the fact that Africa is a continent made of independent countries, which are in turn inhabited by diverse peoples, customs, beliefs, and languages. Amid this stereotypical scenario concealing difference and diversity between the many cultural and geographical landscapes of Africa lies a confirmation of African natives as homogeneous Others. In both films, the figuration of the natives oscillates between their total trivialization—as "dumbs"—and their sophisticated skepticism about the magician's "miracles." The overriding image, however, is one of subservience, superstition, and ignorance exaggerated to the point of the ridiculous, epitomized in the gullibility of the tribal chief who cheerfully enjoys the kerosene he is duped into believing is gin.

It would appear that the image and conceptualization of Africa in American cinema remained relatively unchanged between 1928 and 1932. There are, for example, few differences between *West of Zanzibar* and its reboot *Kongo*, and the fact that the latter lifts whole scenes from the former only heightens this blurring of distinctions. Among these shared scenes is the replication of the stock footage of the African landscape, legitimizing the wild and savage pseudo-anthropological images circulating during the period: menacing crocodiles, cavorting reptiles, and other creepy nocturnal critters slithering along the edges of the swampy terrain. If these images complemented the travelogues of silent cinema, the Jazz Age thrilled to the allure of exotic African imagery. William Beinart and Peter Coates observe that "[a] series of African films released in the late 1920s and early 1930s which interspersed 'thrills and spills' with careful conservationist observation were a major economic success, attracting audiences of hundreds of thousands. Southern and eastern African themes also enjoyed a high profile in American sports hunting periodicals at this time."[9] Further, in the 1920s, feature-length documentaries about African people and geography became popular in the West. As Stephen Zacks argues, "Africa as an entity is an ideological product," its unity and identity "constructed rather than having a priori historical or material existence"[10] in Western eyes. Writing of the cultural influence of films featuring Africa in the 1930s, Kevin Dunn contends that "[w]hat these celluloid images suggest is that, consciously or not, the filmmakers were acting as cultural colonialists by reinforcing and legitimizing Western political practices in Africa." Such images, he concludes, "contributed to the viewing audiences' misperception of Africa and Africans and helped to perpetuate and strengthen racist and colonialist modes of thinking."[11]

In *West of Zanzibar* and *Kongo*, the fundamentally colonial narrative of Africa conveyed by these familiar stereotypes is both enhanced and reinforced within the frame of the horror film. The "monstrosity" associated with Africa is embodied in two figures: one is Phroso/Flint, and the other, the natives themselves. The latter are dominated by superstition and by the hard rule of white Phroso/Flint. However, within the stranglehold of this oppressive relationship lies a persistent fear of the eruption of latent and untamed desires within the ostensibly compliant natives. In pursuit of the natives' friendship and trust (which cover over domination), Phroso/Flint performs magic tricks in an effort to convince tribal leaders that the white man possesses supernatural powers. The arrival of Crane to Phroso's place explicitly establishes a relationship of dominance and submission between America and Africa. Upon reaching the outskirts of the remote village, the foreign newcomer pauses at the border of a swamp, and to avoid getting mud splashed on his clothes, Crane demands to be physically transported by the natives in a scene that has no further relevance to the story. Nevertheless, it is precisely these small moments that mark and reinforce a hierarchical difference between the "dominant" white man and "submissive" African native. Such hegemonic relations function to naturalize and legitimize colonial

FERNANDO GABRIEL PAGNONI BERNS, EMILIANO AGUILAR, AND JUAN IGNACIO JUVÉ

rule.[12] With this goal in mind, the magician uses "religious" figures—his own henchmen dressed as native bogeymen—to keep the natives at bay.

In both these films, then, natives are double-coded—as *fearful* creatures and creatures *to be feared*. Purposefully, the link between the natives and the monstrous is enhanced through the use of the horror aesthetics and narrative: natives are figured most often as nocturnal, dangerous, bloodthirsty, and cannibalistic. And in both *West of Zanzibar* and *Kongo*, Vodun (largely recognized as one of two official religions of Haiti) functions as a demonized and reductive trope of evil and abomination.

One striking difference between these films lies in their depiction of African bodies. In Browning's film, the natives are formidable figures, featuring sleek, oiled bodies that glisten in the dark. With this simple artifice, the natives are both masculinized and rendered into objects of awe and fear. In contrast, it is the white women who possess oiled bodies in *Kongo*, thereby depriving the Black natives of their power to induce terror. This crisis in masculinity, manifested in very different ways in each film, has everything to do with the political context of "[t]he Great Depression and the rise of Fascism [that] created a climate that made some question the long-term viability of Africa-America."[13] Indeed, as Dunn notes, the Great Depression was a blow to American masculinity and jobs were scarce. The films, made in this context of exacerbated class and race conflict, thus reinforce negative images of Black people, who were perceived as competing for jobs with white people. Therefore, these films constructing images of inept Africans dependent on a dominant white masculinity "[reflect] and reinforc[e] the white, middle class male viewer's attitudes."[14]

Hedging the logic of history and geography, both films compound a "horror" mixture by fusing and confusing hearsay about voodoo with stories of human sacrifice, or murder, as a ritual part of native funereal practices. When a male dies in these films, it is customary for his wife to be sacrificed so that she can accompany her husband into the afterlife. In Browning's film, when Maizie observes the ritual, her reaction is one of pure madness: she screams in horror and laughs hysterically (in *Kongo*, she is similarly mortified). Tiny (Roscoe Ward), one of Phroso's assistants, sums up this bizarre ritual when he tells Maizie, "That's the law of the Congo . . . and nothin' can change it." Such an appeal to what is, in effect, "jungle law" locates the Africans in a world of savagery, while reinforcing, by contrast, the civilization of the West. Thus, the authors of the films function, according to Kevin Dunn, as "cultural colonialists"[15] legitimizing, through their representation of the relationship between Africa and the West, certain repressive and exploitative political practices with regard to the African continent.

The combination of violence and exoticism associated with African locations remained enticing for Hollywood's horror film industry. Appearing at the time of colonial enterprise, the films' productions coincided with the political mobilization of African Americans returning from the war with new demands for equality and inclusion during the era of the New Negro and Harlem Renaissance Movements, when African American artists, poets, writers, thinkers, and musicians flourished.[16] Yet, African Americans, like the natives in cinematic Africa, remained positioned as Others, subject to the control of whites in power. While angry white mobs confronted Blacks with violence and intimidation during the postwar years, whites in Hollywood film performed celluloid magic to sustain the illusion of superiority.[17] Moreover, representations of African submission in horror film continued beyond *West of Zanzibar* and *Kongo*. For example, the B-grade *Son of Ingagi* closely follows formulaic horror fare, including popular notions of Africa.

Figure 12.3. Scene from *Son of Ingagi* (1940), directed by Richard Kahn.

Son of Ingagi enjoys the distinction of being billed as the first African American horror film. And while its director, Richard C. Kahn, was white, its cast was all-Black, including the main characters and heroes of the film (see figure 12.3).

The screenplay itself was written by Black actor, writer, and later film director Spencer Williams, who based the plot on his own short story, "House of Horror." The story begins with the marriage between Bob (Alfred Grant) and Eleanor (Daisy Bufford). On the night of the couple's honeymoon, a great fire erupts at the foundry where Bob works, leaving the newlywed without a job and means to support his bride. At the same time, there appears a mysterious woman, Dr. Helen Jackson (Laura Bowman), feared by most people in the community as a practitioner of voodoo. Dr. Jackson has spent a lot of time in Africa and keeps ornaments and ancient artifacts like gongs and human skulls in her office. And, ominously, the doctor has imported from Africa a monstrous "ape-man" named N'Gina (Zack Williams), who remains hidden in her basement, subject to her summons by the ringing of a loud gong. Notably, N'Gina, like Mary Shelley's half-human creature created by Victor Frankenstein, is a character who evokes pathos and sympathy, although his ascribed status of "missing link" reinforces his Otherness.

FERNANDO GABRIEL PAGNONI BERNS, EMILIANO AGUILAR, AND JUAN IGNACIO JUVÉ

When the doctor is accidentally killed by her monstrous charge (not yet revealed to the community and thus unknown to the detective played by Spencer Williams), Bob and Eleanor are unexpectedly designated in Dr. Jackson's will as heirs to her estate. When other dead bodies start to appear in their new home (formerly belonging to Dr. Jackson), police take up residence in an attempt to solve the mystery behind a series of unexplained deaths. Soon enough, N'Gina is discovered and perishes in a fire that devours the mansion. Husband and wife subsequently receive the news that abundant riches, in the form of gold from Africa, have been discovered lying in the ashes beneath the fire-consumed house. The newlyweds can now live happily ever after.

Son of Ingagi follows the formula of 1930s horror films: spooky mansion, monster in the basement, and a distressed couple. And although it falls within the "horror noire" cycle, this film betrays no real deviation from the "white" formula for horror. The main detective is a classic buffoon figure, providing comic relief amid the tensions of the story. Arguably, such a character type, not unfamiliar in the horror genre, would seem to conflate social stereotype and racial cliché. However, less ambiguously racialized is the image of Africa—represented in the film only referentially—as a geography that gives birth to monsters. The half-man/half-ape creature, construed as the missing link between apes and humans, resists easy evaluation and/or categorization. Indeed, the perception of Africans as apes dates from the period of initial contact of the English with the Africans, giving rise to the notion of copulation between "beasts and Negroes."[18] The alignment of Africans with monkeys continues to circulate in American culture and in many American films. For example, Tula (Lupe Velez), a character in *Kongo*, pejoratively calls the tribe's chief "old monkey." And the lead character, Flint, wields a whip to discipline insubordinates, keeps a pet chimpanzee as a favored companion, and tells his friend, the doctor, "you're my kind of animal," all gestures that would seem to conflate the animal and human on the scale of evolution. It is with some irony, however, that despite the Euro-American relegation of the African to the lower rungs of the Great Chain of Being,[19] modern anthropology has complicated the notion of the missing link suggested in *Son of Ingagi*.

In 1924, a pit worker blasting limestone in an ancient cave at Taung, South Africa, unearthed a skull entrenched in rock. The skull was brought to Raymond Dart, Australian professor of anatomy at the University of the Witwatersrand, who reached the conclusion—which was controversial at the time—that the skull belonged to a humanlike creature. His findings helped to launch theories that human life emerged in the African savannahs.[20] N'Gina, then, is an embodiment both of prevailing stereotypes of the African as subhuman and of popular notions deriving from contemporaneous anthropological research and discovery.

Both the creature and his owner in *Son of Ingagi* are complex figures rather than unidimensional beings. The identity of the "mad scientist" (Dr. Jackson), is overlaid with that of a voodoo woman ostensibly due to her previous sojourn in Africa. The film foregrounds the fear and dislike she typically evokes in the community, even though she is revealed to be an intelligent and sensitive woman who is seeking a cure for multiple diseases. Unlike the more familiar trope of the mad scientists of the era, Dr. Jackson neither engages in cruel and sadistic experiments nor does she assume god-like powers of creation. She is not a Frankenstein but an academic. And the unfortunate mysterious creature that Dr. Jackson conceals is not a tool for murder and revenge, but rather a protective helper and "friend."

It would appear that the mere association with Africa renders one susceptible to the transmission of disease or contagion. It is thus the encounter with the "Dark Continent" that proves

AFRICA IN HORROR CINEMA

corrupting and degrading to the main characters in *West of Zanzibar* and *Kongo*, all of whom are subject to vile behavior, dipsomania, illness, or death. White Americans, in particular, appear to lose their morality and essential humanity when confronted with the "heart of darkness."

In these early horror films of the late 1920s and 1930s, Africa represents the embodiment of colonial fears around race difference and Otherness. To Western eyes, Africa's diversity in geography, peoples, and settings is swallowed into an undifferentiated jungle mass defined by savagery and exoticism. Abubakar Abdullahi argues that the negative images of Africa promulgated by missionaries and explorers depicted the continent as a "human zoo full of pagans, animists, [and] cannibals," which "gave impetus to one of the most puissant moral justifications for colonialism."[21] And even if the requisite monster takes the form of a white male in these films, Africa remains a moral morass and site of savagery where humanity is debased and returned to a mean and brutal state subject to some putative "lawless essence" intrinsically linked to the Dark Continent.

Yet, it is, finally, Africa itself that is cast as super monster in classical Hollywood horror film. In fact, *The Vampire's Ghost* opens with a voiceover establishing Africa as the "Dark Continent dominated by voodoo drums," even when this religious practice remains only marginally significant within the context of the narrative. And, notably, in *The Vampire's Ghost*, it is the presence of an African drummer, made ominous—rather than the titular white vampire—who dominates the title sequence, and visually codes, or prefigures, things to come (see figure 12.4).

Figure 12.4. Scene from *The Vampire's Ghost* (1945), directed by Lesley Selander.

223

FERNANDO GABRIEL PAGNONI BERNS, EMILIANO AGUILAR, AND JUAN IGNACIO JUVÉ

It is, thus, Africa, through the ubiquitous trope of the native Black drummer, that codes "horror" in this classic horror film.

However, *The Vampire's Ghost* has more in common with subsequent productions such as *Dust Devil* and *The Stick* in its depiction of Africa. In these three films, what is repressed and comes to the surface to haunt the Western mind is not so much the notion of Africa as Other but, rather, the fear that the so-called First World would lose its hold on the continent in the wake of decolonization following the end of the Second World War.

LOSING HOLD ON AFRICA

As several countries began to achieve independence from Western colonial powers during the post–World War II era, Africa as a site of horror began to appear less frequently in horror cinema. From the late 1980s onward, questions concerning negative imagery and the "proper" representations of foreignness are raised as Africa becomes a growing power in the global arena.[22] At the same time, we note that Africa and African Americans remained, for the most part, excluded or limited in the roles available—especially those deemed heroic—in postwar mainstream cinema. Within this negative scenario, *The Vampire's Ghost* works as a linchpin holding together the conventional colonized gaze on Africa and an emergent politics resisting Otherness.

Set amid voodoo drums and restless native tribes in a remote African village, *The Vampire's Ghost* features Webb Fallon (John Abbott), a club owner who possesses not only an uncanny ability to win at cards but also a need for human blood to sustain eternal life. Beset by fear, the surrounding countryside is mobilized to find the motive for and source of a series of seemingly vampiric killings. In the meantime, Vampire Fallon has designs on beautiful Julie (Peggy Stewart), whom he seeks to lure from the protection of boyfriend Roy (Charles Gordon) and priest Father Gilchrist (Grant Withers).

Not only are vampires displaced from their European origins in this film but, as Luise White argues, African specificity is lost when speaking of vampires in an African context. The meaning of the European term "vampire" functions to obscure any national specificity, and, in so doing, submerges regional and local history within "a vision of African vampires congruent with that of European lore."[23] In fact, White demonstrates, African languages contain no words for blood-drinkers. The extant terms that translate as "vampire" are themselves translations for terms designating firemen, game rangers, or animal slaughterers that have already undergone semantic shifts to signal European employees whose job it was to capture Africans and use their blood to make medicines.[24] In *Speaking with Vampires*, White notes that "[i]t had been a widespread belief in late nineteenth-century India, especially among plague victims on the west coast that hospitals were torture chambers designed to extract *momiai*, a medicine based on blood." Continuing, she observes that "[t]he Indian Ocean trade, with African sailors coming and going between Zanzibar and India, could easily have carried the idea, as well as medicines supposedly made from blood, to East African markets."[25]

The vampire in Selander's film is, however, of European origin. And, significantly, the film hints that Fallon had come to Africa as early as 1588, at the height of early colonial adventurism. Like magicians in earlier films, Fallon is an embodiment of colonialism, draining the natives

224

of money and lifeblood. Fallon follows Phroso and Flint as white men living in Africa, and as a vampire, he has long survived on natives' blood. Rather than practicing dominion through force, white men such as these exercise hegemony through practices like trickery (magic), appropriation (of native religion), and vampirism (theft of vital fluids and goods).

However, unlike the natives of traditional colonialism, these more contemporary natives astutely recognize what white Americans living in Africa lack the ability to comprehend: the vampire who threatens them. Only the natives can discern Fallon's true identity, evident in the *absence* of a mirror reflection (notoriously, vampires lack a reflection since light travels through them). The natives also suspect Fallon's "luck" when he survives a bullet passing through his body, and it is due to the intervention of the natives that Roy, the film's hero, discovers Fallon's true identity. It appears, in fact, that the Africans communicate their suspicions of Fallon through the drums long before Roy's revelation that the "drums [are] telling the truth." And contrary to earlier cinematic representations, the drums are not signs of savagery but, rather, precise and effective instruments for communicating the European threat to the safety of the tribe. Fallon's true opponents, then, are the natives, who seek to control and contain the vampire, rather than the powerless Roy, who moves through much of the film helplessly hypnotized by the vampire. Thus, while the hero remains passive and under the control of Fallon, it is the Africans who are left to battle a formidable and otherworldly antagonist. In the film's climax, Roy discovers the vampire's lair, by way of the African drums, where the latter lies in hiding with the kidnapped Julie. Father Gilchrist manages to stop the vampire with the crucifix, and Roy, the hero, slays the vampire by penetrating him with a silver lance. Finally, the natives burn to ashes both the vampire's corpse and his lair. Americans and Africans act in concert to destroy the supernatural menace. Still, the natives emerge heroically since it is they who both recognize and confront the film's powerful and monstrous antagonist.

Kevin Dunn's admonition is instructive: "It is important to realize that images of 'otherness' are constantly in flux. The images of Africa and Africans in the 1990s, for instance, are different from the images presented in the 1930s. Such changes in imagery have more to do with changes of the 'self' than of the 'other.'"[26] From this perspective, in the late 1980s and early 1990s, we can conclude that horror films deploying Africa as *mise-en-scène* betray the effects of decolonization. New elements integrated within the stereotypical narrative evoke a symptomatic loss of the imperialist grasp upon Africa. Both *The Stick* and *Dust Devil* engage with the colonial past, even if in oblique ways. In both films, the decolonized gaze is undoubtedly due, in large part, to the fact that both films are African coproductions, a step toward cinematic decolonization that accords Africa a voice in its own representation. Conspicuously absent are the tropes of jungle, drums, and voodoo. Instead, Africa is framed within the sociohistorical context of decolonization. Thus, it is not unexpected that, in both these latter films, the Western intruders find themselves lost amid an unimagined and unfamiliar African landscape. In these two films, displaced and invading American/British characters can only watch passively as Africa asserts its sovereignty, undermining the dreams and ambitions of European colonialism and American imperialism.

In *The Stick*, the voiceover opens the film explaining the presence of Western men in Africa: the continent is colonized under the pretext of halting communism, the purported reason for foreign intervention after World War II. The film focuses on a group of Western soldiers who are deployed to Africa on a mission to search and destroy a rebel group that killed an earlier patrol. When they encounter a small village comprised almost exclusively of women and children,

FERNANDO GABRIEL PAGNONI BERNS, EMILIANO AGUILAR, AND JUAN IGNACIO JUVÉ

the soldiers panic and slaughter the villagers, including an old witch doctor. As the platoon tries to make its way back to camp, they encounter strange and menacing events that threaten their survival and retreat to the base.

The mission in *The Stick* is ultimately all but aborted as the troops gradually lose their way amid a labyrinthine African landscape and are killed off or disappear one at a time. It is revealing, however, that their trials are due less to external threats than to the troop's incapacity to act in concert against a common enemy. The fatal errors and deadly calculations begin at the outset, as members of the platoon take a child hostage and interrogate him. Directed by the platoon's commander to release him when they cannot obtain answers, a rogue trooper, O'Grady (Sean Taylor), acts on impulse and shoots the youth in the back, killing him instantly. Only then does the lieutenant (Frantz Dobrowsky) explain that he intended to release the child so that they could follow him, and thus discover the whereabouts of his village. An onslaught of unnecessary killings and bloodshed follows, foreclosing any possibility of the mission's success. In a pivotal scene, Mkhonto (Dixon Malele), an African American translator in the platoon, is killed by another rogue trooper when the former refuses to shoot a native. The remaining members of the platoon are left further isolated and stranded since there no longer exists the possibility of communication between Africans and Americans. Predictably, the survivors wander aimlessly through the African landscape, undermined more by their own misdeeds and mistakes than by the African ghosts haunting and hunting them.

In *Dust Devil*, the titular spirit (Robert John Burke) emerges from the desert in search of victims. This malevolent spirit preys on the solitary, the unloved, and the hapless who have lost interest in life. Wendy (Chelsea Field) has broken up with her abusive husband and is driving about aimlessly. She picks up the stranger and, soon enough, becomes a target for the spirit in search of lost souls. The dust devil in Stanley's film does not stalk Africans but the Westerners living under African skies—white men and women who become victims of their own self-destruction. As the demon makes clear, he only kills those who want to be killed, namely, those lost in Africa—or the "doomed" ones. *Dust Devil* takes place in Namibia, during the last years of that country's War of Independence from apartheid South Africa (1966–1990). Just after Namibian independence, apartheid, the state politics and policy of segregation, was slowly coming to an end as F. W. de Klerk and Nelson Mandela began to negotiate a transition, culminating in the 1994 election of Mandela as president of South Africa. Not coincidentally, this shift in politics is mirrored in the film when the (white) head of the police department is compelled to quit his position so that Mukurob (Zakes Mokae), a local native, can replace him. In one minor but significant scene, Africans retire the ping-ball machine from the "bar of white people" to relocate it in the "bar of black people." And in a pivotal scene, an African is brutally tortured during an interrogation concerning the ritual killings taking place in the region. One of the two white guards exercising violence is reading a comic book; a close shot of one of the comic book panels depicts a group of semi-naked "savages" wearing clay masks while engaging in what is represented as indecipherable babbling. Another panel depicts a white muscular hero battling and defeating the "primitive" menace. The comic depictions amount to a display of white hyper-masculinity juxtaposed against tropical savagery, grotesquely evoking the white colonial violence exerted upon Black Africa through decades of imperialism and paralleled in the cinematic torture scene. Further, the victim in the jail scene will later savagely beat Wendy's abusive husband, in a moment that represents the shifting in powers.

Lastly, the uncanny monsters in *The Stick* and *Dust Devil* claim victims who fulfill a role within the order of things. In the latter, the dust devil, who rejects Manichean dichotomies such as good and evil, states that those killed by the spirit are "attracted to him." In its climax, the film suggests that Wendy, who has just destroyed the demon, will replace the dust devil and begin to fulfill that very same role. Her fate, like his, will be to travel the desert eternally looking for victims. In contrast, the natives in *The Stick* are depicted as speakers without interlocutors, and the ghosts following the platoon may well exist only in the shattered minds of the lost men.

CONTEMPORARY CONFIGURATIONS

What Ken Gelder described as the uses of "the Gothic" in the Australian colonial past is arguably true of the attitude of the Western colonials in their encounter with the African landscape, namely, that "occupation is replaced by *preoccupation*, by a bothersome sense of something that is already there before them."[27] Unlike the depictions of Africa as monstrous in the earlier films considered here, more recent films tend to modify this fundamentally fictional image while retaining a psychological sense of alien dread that continues to be associated with the Dark Continent. The Africa of *The Stick* is a geographical loop: the platoon always returns to the same places. *Dust Devil*, on the other hand, displays an Africa tinted in saturated red, a Martian landscape. These more contemporary constructions of an alien Africa do not emanate from a particular monster but rather from the sense of loss of white control over an Africa that is no longer subjected to Euro-American colonialist and imperialist designs.

In their depiction of Africa, films such as *West of Zanzibar*, *Kongo*, and *Son of Ingagi* follow the traditional colonial patterns of representation so common in the 1920s and 1930s. The modern use of stereotypical stock footage of jungle landscapes, voodoo ceremonies, and African drumming rituals aims to retain a sense of Otherness and racial difference associated with "African-ness" in horror film, while invoking the "reality effect" of documentary. Borrowing from the travelogues of earlier eras, these "indexical representations of patterns of culture"[28] are too often passed off as an unmediated record of an alien "Africa-ness" that complements and enhances the horror story. For a Western audience, however, the real threat and source of terror in these films resides in the risk that the white protagonists might become victims of a pagan nation. Even *Son of Ingagi* cannot escape the representation of Africa as a cradle for creatures of monstrosity, a land that continues to cast its long and dark shadow across a vast ocean.

The Vampire's Ghost, on the other hand, bridges two eras. Here, Africa continues to be the land of junglescapes and drumming ritual, but the white characters can no longer navigate its mysterious terrain; they wander aimlessly and lose their way within a self-created enigma. Today, Africa now has embarked on its own production of horror films,[29] and it will take a while to see the ways in which native filmmakers engage with this particular genre. We await with interest and curiosity to discover where monstrosity resides in African horror cinema in the new globalized millennium.

In the meantime, Black horror film in the United States is experiencing its own renaissance of *horror noire*, epitomized in the cinema by Jordan Peele's award-winning *Get Out* (2017) and *Us* (2019), *Little Monsters* (2019), *Antebellum* (2020), the *Tales from the Hood* anthology (1995–2020), and on streaming by *The Twilight Zone* (2019), *Lovecraft Country* (2020), and *Them* (2021).

Populated by "everything from intellectual exterminators, to (helpful) conjure women, to cannibal rappers," these films renegotiate racial relations, explore new configurations of Black identity, and critically disrupt the present with evocations of a brutal and brutalizing past.[30] This genre moves away from "*fin-de-siècle* minstrelsy"[31] and reworks past imaginaries of the *bête noire*,[32] variously representing visions of vengeance, reparation, and justice as a diasporic cinematic afterlife in dialogue with the turn in African horror to a critical reckoning with the meaning of monstrosity.

NOTES

1. Robin Wood, "An Introduction to the American Horror Film," in *Planks of Reason: Essays on the Horror Film*, ed. Barry Keith Grant and Christopher Sharrett (Lanham, MD: Scarecrow Press, 2004), 108.
2. Wood, "An Introduction," 111.
3. Angela M. Smith, *Hideous Progeny: Disability, Eugenics, and Classic Horror Cinema* (New York: Columbia University Press, 2011), 118.
4. Michael Crowder, ed. *The Cambridge History of Africa. Volume 8, from c. 1940 to c. 1975* (Cambridge: Cambridge University Press, 1984), 330.
5. Louise Fenton, "The Demise of the Cinematic Zombie: From the Golden Age of Hollywood to the 1940s," in *Recovering 1940s Horror Cinema: Traces of a Lost Decade*, ed. Mario DeGiglio-Bellemare, Charlie Ellbé, and Kristopher Woofter (Lanham, MD: Lexington Books, 2015), 178.
6. Ian Olney, *Euro Horror: Classic European Horror Cinema in Contemporary American Culture* (Indianapolis: Indiana University Press, 2013), 184.
7. Robin R. Means Coleman, *Horror Noire: Blacks in American Horror Films from the 1890s to Present* (New York: Routledge, 2011), 72.
8. For a close reading of the horror/melodrama film *Chloe, Love Is Calling You*, see Fernando Gabriel Pagnoni Berns, Mariana Zárate, and Patricia Vazquez, "Return of the Repressed Slaveholding Past in Three Horror Films: *Chloe, Love Is Calling You*, *Poor Pretty Eddie*, and *White Dog*," in *Gothic and Racism*, ed. Christine Artenie (Ontario: University Press, 2015), 106–117.
9. William Beinart and Peter Coates, *Environment and History: The Taming of Nature in the USA and South Africa* (New York: Routledge, 1995), 81.
10. Stephen Zacks, "The Theoretical Construction of African Cinema," in *African Cinema: Postcolonial and Feminist Readings*, ed. Kenneth Harrow (Trenton, NJ: Africa World Press, 1999), 5.
11. Kevin Dunn, "Lights . . . Camera . . . Africa: Images of Africa and Africans in Western Popular Films of the 1930," *African Studies Review* 39, no. 1 (1996): 149.
12. Dagmar Engels and Shula Marks, "Introduction: Hegemoy in a Colonial Context," in *Contesting Colonial Hegemony: State and Society in Africa and India*, ed. Dagmar Engels and Shula Marks (London: British Academic Press, 1994), 3.
13. Ibrahim Sundiata, "The Garvey Aftermath," in *The United States and West Africa: Interactions and Relations*, ed. Alusine Jalloh and Toyin Falola (Rochester, NY: University of Rochester Press, 2008), 84.
14. Dunn, "Lights . . . Camera . . . Africa," 151–152.
15. Dunn, "Lights . . . Camera . . . Africa," 149.
16. Reiland Rabaka, *The Negritude Movement: W.E.B. Du Bois, Leon Damas, Aimé Césaire, Leopold Senghor, Frantz Fanon, and the Evolution of an Insurgent Idea* (Lanham, MD: Lexington Books, 2015), 43.
17. Darron T. Smith, *When Race, Religion, and Sport Collide: Black Athletes at BYU and Beyond* (Lanham, MD: Rowman & Littlefield, 2016), 37.
18. Eric Greene, *Planet of the Apes as American Myth: Race, Politics, and Popular Culture* (Middletown, CT: Wesleyan University Press, 1996), 6.

AFRICA IN HORROR CINEMA

19. Margo DeMello, *Animals and Society: An Introduction to Human-Animal Studies* (New York: Columbia University Press, 2012), 265.
20. Iris Berger, *South Africa in World History* (New York: Oxford University Press, 2009), 2–4.
21. Abubakar Abdullahi, "Noble Savages, Communists and Terrorists: Hegemonic Imperatives in Mediated Images of Africa from Mungo Park to Gaddafi," *Africa Media Review* 5, no. 2 (1991): 4.
22. Graham Harrison, *The African Presence: Representations of Africa in the Construction of Britishness* (New York: Manchester University Press, 2013), 104.
23. Luise White, *Speaking with Vampires: Rumor and History in Colonial Africa* (Berkeley: University of California Press, 2000), 10.
24. White, *Speaking with Vampires*, 10.
25. White, *Speaking with Vampires*, 11.
26. Dunn, "Lights . . . Camera . . . Africa," 150.
27. Ken Gelder, "Australian Gothic," in *The Routledge Companion to Gothic*, ed. Catherine Spooner and Emma McEvoy (London: Routledge, 2007), 119; italics in the original.
28. Christian Hansen, Catherine Needham, and Bill Nichols, "Pornography, Ethnography and the Discourses of Power," in *Representing Reality: Issues and Concepts in Documentary*, ed. Bill Nichols (Bloomington: Indiana University Press, 1991), 201.
29. See: http://www.fangoria.com/new/qa-south-african-horrorfest-celebrates-10-years-of-terror/. Accessed August 20, 2018.
30. Coleman, *Horror Noire*, 215.
31. Mark Winokur, "Technologies of Race: Special Effects, Fetish, Film and the Fifteenth Century," *Genders OnLine Journal* 40 (2004), https://www.colorado.edu/gendersarchive1998-2013/2004/08/01/technologies-race-special-effects-fetish-film-and-fifteenth-century.
32. Coleman, *Horror Noire*, 10.

PART V

"IN THE WAKE"

Racial Mourning and Memorialization

THIRTEEN

MAPPING LOSS AS PERFORMATIVE RESEARCH IN RALPH LEMON'S *COME HOME CHARLEY PATTON*

KAJSA K. HENRY

In 2004, Ralph Lemon presented *Come home Charley Patton*, the last of his three-part project titled *The Geography Trilogy*. The performance marked the end of a ten-year journey for Lemon, during which he struggled to define his relationship to contemporary modes of dance.[1] The genesis of the project connected with his desire to find new interactions with the stage and to participate in what he calls "collaborative conversations," but, as his research reveals, the project became much more expansive. In the published narrative accounts for each of the three parts, Lemon documents how his aesthetic sensibility grew beyond the stage, and how he attempted to transfer the embodied, performative research he conducted to the familiar space of the stage.[2] The three performances and texts that make up *The Geography Trilogy* show evidence of his play with form as he integrates literary, ethnographic, and visual studies with both the stage and modern dance forms. *The Geography Trilogy*, especially *Come home Charley Patton* because of Lemon's contentious relationship with the racialized South, reveals not only Lemon's extensive effort to develop a narrative form but also how he understands the Black dancing body as a multilayered site of memory. At the onset of his project, Lemon admits that he saw it as an "anthropological collaboration about being American, African, brown, black, blue black, male, and artist."[3] By placing the Black male body as foundational to his research in *Come home Charley Patton*, Lemon creates and animates a complex archive of pain and loss that relies on his interaction with sites of loss using his dancing body, which is also, importantly, a "Black" and male body.[4] His intent: to uncover the physical and symbolic remains of a genealogy of violence and memory embedded in the Southern landscape and negotiate his relationship to this space and its history.

As the name of the series suggests, place is central to Lemon's efforts to understand each of these descriptors that comprise his identity. In the first performance, *Geography*, Lemon travels to the Ivory Coast and Ghana in hopes that the sense of relation he felt, or should feel, with Africa would help him develop a new relationship to the stage. Ann Daly describes the performance as being "about the space that marks identity and that is marked by journeys, and in particular by the African diaspora. And it's about ritually transforming stage space from the secular to the sacred.[5] In the second installment, *Tree*, Lemon heads to China, India, Japan, and Bali in search of a sense of spirituality accessible through dance. In this performance, he continues his focus on the space of the stage as being the place where he can "go beyond" limiting structures of time and space. While both performances allowed Lemon to have conversations that crossed cultural and spatial boundaries, ultimately, he felt unfulfilled and dissatisfied because he did not find a

sense of relationship between the audience and the performers as he had hoped. In *Come home Charley Patton*, however, Lemon's search for a new experience with the stage comes full circle when he travels to the South or what he calls the "ground zero of black American experience."[6]

MAPPING LOSS THROUGH PERFORMATIVE RESEARCH

For four years before the 2004 production of *Come home Charley Patton*, Lemon created what was essentially an archive of loss that maps his travels from the streets of St. Louis, Missouri, his hometown, to the dusty back roads of Mississippi. With his daughter, Lemon traveled the route that the Freedom Riders, a group of African Americans and whites determined to integrate the continental bus system, took in 1961. He also visited emotionally charged spaces where lynchings or events associated with the Civil Rights Movement took place, such as Medgar Evers's driveway and the Edmund Pettus Bridge that was the site of the march from Selma to Montgomery, Alabama. At the majority of the sites along the route of the Freedom Riders and other places associated with the movement, Lemon performs a series of what can best be understood as mourning rituals or, as he describes them in the program notes for *Come home Charley Patton*, counter-memorials.[7] Since he names the acts counter-memorials, Lemon locates his project as a part of the tradition of memorializing efforts that take on a decidedly nontraditional and anti-redemptive form. He focuses on narratives that run counter to "official" histories of the Civil Rights Movement, but he does so with an acknowledgment of his disconnection to this history.

Despite heeding the impulse to end *The Geography Project* by coming "home" to the South, Lemon does not describe or enact the return in nostalgic terms, but as one defined by disconnection, absence, and loss. He says:

> It seemed to me to be important to deal with this idea of home as memory, or home as remembering, because when you leave home . . . returning is about what's not there anymore. So I really just sort of amplified that, and I took in my whole personal history as an African American and my more personal remembrance of the civil rights movement. It was a remarkably charged time for me growing up, so I just kind of used that as a map.[8]

Lemon positions home as a physical place, but also as a metaphor for the process of embodying, gathering, remembering, and using a set of memories that includes what remains both absent and present. Intentionally not capitalizing the "h" in "home" in *Come home Charley Patton* reflects Lemon's efforts to de-center the traditional definition of home to see the South as a space that shifts in meaning for a collective body and for his own sense of relation to this history as memory.

Lemon's travels to emotionally charged places in the South show him returning to familiar motifs in African American cultural production, the violence of the Jim Crow South and the South as a homespace, through his representation of histories of loss that permeate those landscapes. However, *Come home Charley Patton* departs from other considerations of the Black body in pain because, as I suggest, Lemon approaches the Black male lynched body and the South from what Marianne Hirsch defines as a "postmemory" perspective.[9] The term identifies a relationship between generations who survived and witnessed historical or collective trauma and

MAPPING LOSS AS PERFORMATIVE RESEARCH

those who came after and remember, from a removed position, the events through stories, images, and other experiences.[10] Lemon's relationship to the events that he seeks to remember falls more into the affiliative realm as a type of inter- or transgenerational (mediated) memory that recalls the structure and function of memory, particularly in its affective force. A postmemory perspective reflects an often-challenging relationship to the past because of generational distance, and, in Lemon's case, he also lacks an immediate connection to the events of the Civil Rights Movement because of location, interest, and a history of aesthetic distance from the world of "black dance." Through this perspective, Lemon attempts to develop a sense of relation to the visual poetics of the Black body in pain that also shows him questioning his relationship to this history of loss. The sense of being connected to, but removed from, the moments of loss he mourns becomes one of the central motifs of the entire project. Since the lynched Black male body and the places where racialized violent acts took place remain charged sites of pain, Lemon must search for ways to access the memories embedded within them—for him personally, and as a part of a collective.[11]

The tone that Lemon takes in the narrative exposes an ambiguity in his sense of relation that he feels, and does not feel, with this violent history. For instance, he admits the lack he feels during aesthetic attempts at the recovery of this sense of connection while talking with a group of recovering drug addicts. He acknowledges that the only thing left for him and them is "recovery" because they had lost "what was mean, violent, and resistant."[12] Although able to think and say what they want, Lemon notes that it was all a performance:

Fake questions, a coded message, an affirmation really, for full-blown racial injustice or integration as I see it, and my confusion with what to do with this modern-past inequality and faux freedom, what I witness, right here, better to create Africa with wings, real ones, that sprout from the shoulder blades.[13]

Lemon questions the depth of freedom in the face of the continued impact of the racial history of the US. Instead of facing this realization, Lemon desires to retreat from, and invent an even further past—to invent that to which he does not have access. Lemon's characterization of the dilemma he faces reflects a desire to mourn or maintain a sense of relation, but perhaps he has lost the deep emotional impact of racial injustice needed to really cement the relationship. While Lemon desires to, in some way, mark what had happened at each of the places he visited, he acknowledges confusion regarding how exactly to do it in places that showed no evidence of the past pain and violence that took place there. He says: "I found confused and fleeting ways to make my presence known in these highly charged spaces that are not the same space of forty years ago. That have elusive memories. But the Civil Rights Movement did happen."[14] Lemon's assurance, to himself and the reader, that the Civil Rights Movement did happen, is telling. He recognizes that the lack of physical remains may place the event in the realm of the forgotten. His desire to mourn and acknowledge what has been lost shapes his actions.

As a way of accessing these memories and histories, Lemon embodies and materializes absence and the dead to bring the events into a present cycle of memory. For instance, he visits Selma's famous Edmund Pettus Bridge, the site of "Bloody Sunday, 1965," where state and local police officers attacked Civil Rights protesters as they attempted to march from Selma to Montgomery. Here, Lemon decides to create an act of remembrance for the event. He chooses not to dance

but to dress up in ancient overalls and drop albums, like Elton John's *Madman across the Water*, Harry Belafonte's *Day-O*, and a Scottish bagpipe version of *Amazing Grace*, down the length of the bridge. He calls this act an "art prayer." Lemon offers his actions as a prayer of remembrance of the loss that took place there and the important role that music played in the protests. He honors the event in ways that draw on the spirit of the march, while attempting to embody the experience of the marchers by wearing overalls and walking the bridge. In this same section, Lemon juxtaposes this story with his visit to Medgar Evers's house, where Evers was shot and killed in his driveway. Here, Lemon bows in the driveway. His bow shows honor but also serves as an act of remembrance. Lemon's actions on the bridge and at Evers's house are examples of the form that his counter-memorials at these various sites take: he questions, draws on physical and symbolic remains, and performs an embodied memorial act.

In one of his more dance-based counter-memorials, we begin to see how these moments helped to structure the performance aspects of *Come home Charley Patton* and his effort to represent his struggle in producing a sense of relation to this history. To honor and remember Willie Minnifield, a man burned at the stake in Yazoo City, Mississippi, after being falsely accused of killing a white woman, Lemon dances on an abandoned outdoor stage in Yazoo City to John Hurt's 1928 recording of "Louis Collins." Hurt, a blues guitarist from Avalon, Mississippi, mournfully recounts the death and burial of Collins as he sings:

Oh, kind friends, oh, ain't it hard?,
to see poor Louis in a new graveyard
The angels laid him away
The angels laid him away,
they laid him six feet under the clay
The angels laid him away[15]

Lemon admits that, although Hurt was not from Yazoo City, the "song seems appropriate, somebody mourning somebody else, its simple and hypnotic tone a sublime activation."[16] Lemon's recognition of Hurt's linkage of his art with mourning mirrors Lemon's own efforts to connect dance and mourning as he attempts to remember the life and death of Minnifield. Additionally, Lemon's choice of an abandoned stage to complete his dance shows his continued interest in spaces that seem devoid of memory. His choice shows a privileging of more affective remains and his attempt to activate and engage with those remains through dance. Lemon considers a number of alternative ways of completing the work of mourning so that he may find a way to share with a larger audience the knowledge he gains through his engagement with landscapes of violence. Although Lemon gains affective knowledge from his experiences visiting these landscapes, when it came time to transfer this knowledge to the stage, his archival research, particularly that involving the buck dance, provided the motivation and key elements of the form that the performance took.

AFFECTIVE KNOWLEDGE, THE "BUCK DANCE," AND THE PERFORMANCE OF LOSS

Lemon's interest in the buck dance comes long before we see it in its modified form in *Come home Charley Patton*. Katherine Profeta traces his almost obsessive engagement in her article

MAPPING LOSS AS PERFORMATIVE RESEARCH

"Ralph Lemon and the Buck Dance." Profeta, a longtime friend of Lemon, is in a unique position to follow the various incarnations of the buck dance from Lemon's early dances to what she calls its "death" in *Come home Charley Patton*. She labels this as Lemon's journey from a "largely schematic Buck Dance towards a more stylistic reinvention."[17] The original movements of the buck dance remain unknown, but it has been linked to dances performed by enslaved Africans on the plantations in the South and during post-Reconstruction. Profeta also notes that, culturally, the buck dance symbolizes a key ingredient in the painful tradition of minstrelsy and physically serves as an ancestor of modern-day tap dancing.[18] Others have suggested that the buck dance was often used as way to distract slave owners and overseers from plans of resistance. Lemon's first interaction with the buck dance came in 1991 in a piece entitled *Solo*. He later performed it again ten years later in *The buck dance in Tree*. It would appear again during Lemon's research sessions for *Come home Charley Patton* where the dance, in its modified form, serves as the basis for the movement throughout the performance. Looking at the various shifts in how Lemon uses the dance reveals the role that the dance plays in helping him to work through feelings of loss to finally arrive at a conflicted understanding of what the dance had meant to him as a dancer and as an African American. Lemon's engagement with the buck dance in *Come home Charley Patton* shows his attempt to use the dancing body to tell a narrative of a long history of racialized subjection and spectacle.

The role of memory in his engagement with the buck dance begins in the first part of *The Geography Trilogy*. In *Tree*, he juxtaposes a Chinese folk musician in blackface playing the *san xian*, a traditional instrument reminiscent of the American banjo, with the buck dance.[19] This differs from the more traditional style Lemon performs in *Solo*. These changes reveal the process through which Lemon develops a more personal relationship with the dance. He also grapples with the technical elements of the dance as he breaks them down and incorporates the interpretations of others in order to rebuild it for his purposes. He embraces the tortured history of the buck dance to create something from the remains of this history and the memory of subjection that is reflected in his Black male body. It appears that for Lemon, the buck dance embodies or symbolizes a psychological conflict between freedom and objectification. The conflict illustrates the common space occupied by African Americans as they deal with the remains of a history of loss.

It is this history of loss that Lemon contends with during a research endeavor for *Come home Charley Patton*, where he visited the homes of the relatives of early twentieth-century blues musicians. During these visits, he performed a series of "living room" dances where he usually danced to songs of whatever blues musician he was in search of that day. He would dance his version of the buck dance and ask for feedback from his often-captive audience. Sometimes they would offer to perform their own version, provide suggestions, or participate by clapping and patting their feet. For instance, in the home of Mrs. Mitchell, the cousin of the wife of Fred MacDowell, a famous Mississippi blues artist, Lemon performs for her while she shows her enjoyment by tapping her feet and exclaiming that yes, that was how they used to dance. However, Lemon is aware that the dance is *not* really how these people performed it in the past. Despite the fact that Lemon does not perform the traditional buck dance, his body acts as a medium of memory and movement in the hope that the boundaries of time and space can be crossed. Lemon's encounter with Otha Turner, a 101-year-old Black man living in Senotobia, Missisippi, offers insight into the types of questions Lemon poses and the conclusions that he

237

KAJSA K. HENRY

draws from the living room dances. During his visit, Lemon asks Turner to dance. During an interview, Lemon explains that although Turner was probably *not* performing the buck dance, "it was a dance that was very, very much about a Black body in the South and all the history and culture that that holds doing this dance that he probably did a long, long time ago and that his body still remembers. So that was enough truth for me."[20] Lemon sees Turner's dance as a form of collective memory that is linked to a cultural identity and heritage. Since the larger frame of reference for Turner's dance is the South and what that space has meant on a collective and personal level, the significance of the dance goes beyond aesthetic properties and instead becomes a space of contestation and resistance.

For Lemon, Turner embodies the history of a Black body being in the South and surviving, which allows Lemon, by embracing this embodied trace of memory, to challenge the parameters of what constitutes an archive. This trace, even in the absence of definable movements linked to the buck dance, has enough knowledge through which he can create his own ritualized form of memory through his representation of this absence in *Come home Charley Patton*. Although the acts of mourning and the living room dances occur in different spaces, Lemon's process and purpose for doing both draw on his desire to create a connection between the space and an embodied cultural memory. He finds in the living room dances the perfect relationship between the audience and the performer. The buck dance provides a form and conceptual framework of how the body can embody and transfer cultural memory as a way of mourning.

He uses this form and, more importantly, the questioning sense of relation that it affords him, to bring his research for *Come home Charley Patton* to the stage. His research travels influenced his understanding of the dance and changed the way he viewed his interaction with the stage and the audience. The translation of this onto the stage shows the effect of these histories of loss on the movement and the thematic choices Lemon would later choreograph. However, despite this experience with the buck dance, Lemon does not return to it until almost ten years later after the disbandment of his dance company and his search for a new project. The question arises as to why Lemon returned to the buck dance, which has no identifiable origins or definitive movements, during a project in which he searched for a relationship to a recent past of the Civil Rights Movement and incidents of lynchings? What connections does he find between the bodily movement and performance of the dance and that of the counter-memorials and travels that he does as he embodies these various spaces and moments of pain?

Lemon positions the buck dance as a way of creating counter-memories during his research travels throughout the South and as a form through which he can express his experiences with loss.[21] As Lemon attempts to move away from the usual forms of remembrance, he presents an alternative to the current memorialization efforts surrounding the Civil Rights Movement. He not only uses history and memory as key to his performances, but he questions his relationship to both and even his representation of it. Lemon uses a socially produced dance with no known origins and multiple influences and uses it in a performance that is about temporally and spatially specific events—but also about his and the audience's relationship to this past. The buck dance allows him to make sense of his travels and put it into a form that he found creates a reciprocal relationship between Lemon and his audience. The knowledge that Lemon collects during the living room dances becomes a part of the archive that helps to structure the movements found in *Come home Charley Patton*. Lemon would repeatedly study Turner's dance, which he captures on videotape, in his attempt to translate the buck dance, and the larger theoretical implications of the

MAPPING LOSS AS PERFORMATIVE RESEARCH

encounter with Turner, to the stage. Through the artistic connection that he forges with the buck dance during these living room dances and his mapping of memory and loss, Lemon finds that performance can incorporate personal and collective history and speak through a language of loss. So, while the buck dance illustrates Lemon's attempt to use bodily memory as a means of accessing the past, it also becomes the medium through which Lemon explores the ways in which embodied memory can transcend the spatial and temporal boundaries enforced by the stage.

The creative process through which Lemon combines the affective knowledge he gains through the buck dance and his counter-memorials is most evident in his visit to a site in Duluth, Minnesota, where the lynching of three Black circus employees of the John Robinson Show Circus, Elias Clayton, Elmer Jackson, and Issac McGhie, took place on June 15, 1920. The men were hanged from a streetlight after being falsely accused of raping a white woman. Instead of finding a marker indicating the horror that took place there, Lemon finds a traffic light marking this space of death. In an effort to complete some type of ritual of mourning, we see Lemon in a videotaped recording of the visit contemplating the best way in which to commemorate the men's murders. Lemon's first act involves embodying what he thinks Elias's last trip down Second Avenue was like: he bumps into walls and parked cars and falls when appropriate. At the site of the lynching, he leans against the wall of an old Shriners' building, picks up a pebble, tosses it in the air, sits down, looks up, and then stands. Finally, Lemon finds that simply lying down, arms by his side in a posture of death, commemorates the moment the best. He recalls: "I lie down on my back on the sidewalk for a long time . . . lying on the ground I could have been any of them, Issac or Elmer or Elias. Hard to tell from the old blurry photograph; three bodies in dungarees and overalls, with white shirts torn off, tied and twisted around their waists."[22]

By lying on the sidewalk in the Duluth scene, Lemon articulates the relationship between the event he is remembering and the position his body occupies. Lemon's description of the photograph of the lynching, an image that later was printed on postcards, focuses on the position of the bodies. In the scene, two men were hung from the streetlight with stretched necks. The murderous crowd bound the first man's hands in front of him, and the second man had his bound behind his back. The third man lies on the ground. In his various reenactments at the actual scene, Lemon moves from being Elias to being any one of them. Two of his other dancers, David and Djedje, along for the research expedition, also take turns stepping into the pain of others, which allows them to reenact the pain of violence and to give it language. Afterwards, Djedje tells the drunks watching that "there's nothing you can do to change what happened, so in my mind I reached out to them . . . memorials are about healing."[23] Djedje's statement shows that he recognizes the inaccessibility of the pain that the men felt, but that memorials are also about reactivating memory—a memory the story needs because the story of the three men at the time of Lemon's visit did not seem as if it had been "passed on."[24] It was only in 2003, after Lemon's visit, that the community erected the Clayton Jackson McGhie Memorial using the images of three local-area Black men because no pictures of those killed exist, except the one that documents them in death. Again, the "standing in" that occurs in the memorial and Lemon's and the other dancers' performance of counter-memorials bridges the gap between what one can feel personally and collectively. Lemon takes knowledge that he learns through this affective and performative research to the stage of *Come home Charley Patton*, which serves as a supplement to the archive and not a replacement, as he attempts to transmit his knowledge gathered through his attempts to "come home."

KAJSA K. HENRY

Lemon explores the relationship between his own experience, that of the performers, and the audience—and of all those, dead and alive, that were a part of Lemon's research. In the repetition of the themes of space, violence, and embodied memory within this five-minute period, we see the poetics of the performance of loss Lemon attempts to create. He transferred what he has learned from his research onto the stage but relies on the creation of meaning through multiple points of juxtaposition. His goal was to find a form, movement, and narrative structure that creates this understanding between Lemon, his archive, and the audience.

In performance, Lemon attempts to draw a connective thread between the physical landscapes, but most importantly the symbolic and emotional landscapes, of loss. James Baldwin, one of the twentieth century's most astute scholars of "race," provides parts of the structuring form of the performance. On the stage opposite of the screen, but slightly elevated, a video-mediated image of Baldwin "watches" both the actions on the stage and the audience. After an awkward pause, Baldwin eventually speaks. His voice is the first we hear: "Um, I recognize this landscape. The interior and exterior landscape. The tortured and noble and suffering and loving . . . it illuminates the people all around me."[25] The themes of torture, resilience, and suffering best describe the movements of the dancers and the stories of the people that Lemon encounters.

Toward the end of this opening scene, Lemon intertwines Arna Bontemps's short story, "A Summer Tragedy," with the multiple stories that intersect with it. First, he asks Baldwin: "Where is the center . . . or some focal point?"[26] Baldwin responds by telling him to make everything be seen through John. After Lemon expresses displeasure with the name choice, a voice from off-stage asks, "How 'bout Elias?" Lemon responds with, "Yeah, Elias. And what was that you said? If he moves here, he'll—I mean I'll—jump there, and then if I move here—I mean me! And I do this, he'll go—I'll—jump? Uh to do that. And when I make my next move, he'll—then I got him. Or something. And it always worked. Sorta."[27] Then Lemon introduces the real and fictionalized character of Elias, who serves as the focal point of the performance. Elias is the name of one of the men lynched in Duluth and the fictional son Lemon gives Jennie and Jeff in "A Summer Tragedy." The movement of the dancers replicates the theory of reaction from the reenactments during the research session: if one moves there, then another moves here. The story is not just Lemon's or Elias's, but that of all Black men who were lynched by angry mobs.. In his performance of a version of the buck dance, then, Lemon creates a somatic synecdoche for generations of Black men and their stories.

Lemon frames and performs the experience of this counter-memorial in Duluth in two ways that reveal how mourning shapes the rhythm and posture of the movement of the dancers, and the juxtaposition that occurs between the dance and the layered environment of the stage. Lemon explains the process that he and the other dancers took in an attempt to translate his research experience into a language with spatial and bodily properties. After returning to the workshop space, Lemon and the dancers drew on words associated with the counter-memorial at the site in Duluth to create a dance scene of the same title. The keywords included:

Walk
Press a button
Make circle
Back against a wall
Look up

MAPPING LOSS AS PERFORMATIVE RESEARCH

Pick up a coin lying on the ground
Toss it in the air
Lie on your back
Reorder as you wish.[28]

If we turn to the performance, the movements of the dancers in the second scene titled "Mississippi/Duluth," a five-minute sequence, draw on the posture, balance, bearing, and positioning of the body associated with the actions of these words and phrases. They are then joined by the other dancers in a straight line across the stage. In his attempt to understand the two places together, Lemon uses various performative techniques to portray this connective thread. In the opening of the scene, the two women dancers emerge from opposite sides of the stage, but cross and finally connect in a straight line with the other three dancers at the back of the stage. The other dancers take the stage, and they all stand in a straight horizontal line across the stage. A lazy, rhythmic tune begins, and, almost as if they are attached by an invisible string, each performer builds off of the movements of the others to perform a slowed-down and deconstructed buck dance. The movement continues to be punctuated by a slow but swinging beat that gives their dance a ghostly appearance and feel. Each dancer's personal iteration of Lemon's research and the buck dance combine to reflect Okwui Okpokwasili's admonition in a later scene to "respect the experience." Lemon gave the dancers the opportunity to interpret his research through their own context. The result was each doing the buck dance slightly different.

Lemon's juxtaposition of the two places, Mississippi and Duluth, highlights that the two places project similar feelings of danger, pain, and loss that he experienced in both places. The movements of the dancers suggest the nearness of danger.[29] This translates into the movement on the stage. The dancers seem almost possessed with the need to move, as they throw their bodies to the floor and from side to side with abandon. After the syncopated buck dance, the dancers break into a series of dances that build off of the energies and actions of each other. The dancers either run as if being chased or they fall to the floor as if flung. Other dancers hit their bodies repeatedly and violently. Okpokwasili's breathing sounds like the labored breathing of Lemon in the video clip played at the opening performance: Lemon reading in the waters of the Mississippi River. A high-pitched whistle and stomping also break the silence of the dance. Throughout, the dancers simulate the words listed above by throwing their bodies in the air, picking items off ground, and hurling themselves to the floor. When one falls to the floor, another falls, sometimes with all of them falling into positions very similar to that of those who were lynched in Duluth. During the five-minute scene, dancers repeat these movements, and they also appear again later in the performance. Lemon returns to this Duluth counter-memorial in one of the last scenes as a way of connecting all of the parts of the story he has been telling about himself and Elias. As he talks about his journey to Duluth, Lemon links his story to the time that Elias went to Duluth and got in trouble. He shows a clip of one of his memorial sessions at the site of the lynching. In these parts of the performance, Lemon makes a statement about the function of sharing and representing memory. The positioning and movement of the bodies tell a story of memory and violence that connects the two places and the affective knowledge Lemon gained from them.

The merging of the buck dance with the specificity of the water hose scene is where the present, the past, and individual and collective history collide. In a memorable and striking scene,

241

Lemon combines all of the questions he raises about his form, purpose, and research travels again through the buck dance and his and Elias's stories. During the ending of "A Summer Tragedy," where Jennie and Jeff kill themselves by driving off a cliff into water, Lemon adds their fictional son to the story as a witness to their deaths. It is Elias who takes the stage with the memories of that day, and the days of his arrest in Duluth. Lemon/Elias takes to the stage on an elevated platform standing in a spotlight. This stage within a stage highlights the connectedness of this scene with the rest of the performance, but also emphasizes that Lemon wants to draw attention to the performativity and importance of the moment. Lemon begins to dance to the same music that plays when the dancers perform the modified buck dance. His movement, recalling the same movements, represents his interpretation of the buck dance, which he also shows in the opening of *Come home Charley Patton*. As Lemon performs, one of the other dancers violently sprays him with a water hose. The scene is reminiscent of the attacks on the marchers at a number of civil rights demonstrations. The water batters his dancing body; he flails, falls down, but continues to dance. His tenacity reminds us of the actions of the civil rights marchers, and it reminds us of why Elias performs this dance after his wrongful arrest. The bodies of the lynched males in Duluth, Lemon, and Elias become one. As he dances, the other dancers return to the stage in their own wild versions of the buck dance. The music and bodies become increasingly frenzied in the glare of spotlights. The dancers draw on each other's movements to further illustrate the merging of history and its embodied remembrance. The aesthetic and philosophical arrangement of *Come home Charley Patton* suggests that a performance of loss involves the reconfiguration of Lemon's connection with the past, creative forms of substitution, and a discursive form that incorporates and recognizes those or what has been lost.

In particular, Lemon's use of the buck dance throughout the performance, especially in moments where he attempts to map points of intersection between various events, affords him the central means through which he performs loss. It is the buck dance that allows Lemon to question the ways in which embodied memory can transcend spatial and temporal boundaries enforced by the stage. The appearance of the buck dance in *The Geography Trilogy* seems appropriate given that the tensions he explores in the project between history/memory, subjection/agency, along with his play with form, also exists in his engagement with the buck dance. In his research on the buck dance, Lemon found a similar set of questions, but more importantly he recognizes the dance as denoting the experience of a Black body in the South. In *Come home Charley Patton*, he attempts to capture this same experience through the dancers that attempt to portray what he felt as a Black, male, and dancing body as he locates himself within a long narrative filled with a history of subjection and spectacle. Through his research of the buck dance, Lemon finds a performative language that helps him to structure the piece. He finds commonality between what he learned while researching the buck dance and following the trail of the Freedom Riders. Looking at the various shifts in Lemon's relationship with the buck dance reveals his conflicted understanding of what the dance means to him as a dancer and as an African American, along with the dance's role in helping him to develop an intricate understanding of loss and performance. As a result, Lemon's project also reveals his struggles to find a performative language of mourning capable of representing the various losses he uncovers on his journey. Lemon stretches the physical and generic parameters of dance in his contemplation of how the body can be a source for exploring the memory of histories of loss that have defined Black American experiences.

MAPPING LOSS AS PERFORMATIVE RESEARCH

Lemon's entire *Come home Charley Patton* project attempts to both mourn and access a legacy of racialized violence. His travels throughout the South highlight the absence and complicated nature of memorializing efforts in regard to events associated with racialized violence. However, his project also exposes the difficulties in developing a sense of relation to this past as he navigates between collective and personal memories. The structural and thematic arrangement of the performance reflects Lemon's efforts to negotiate the limits of representing a history of loss associated with racialized violence. In positioning the body as key in accessing the past, Lemon later employs the buck dance as the conceptual and physical framework to show how embodied memory can transcend the spatial and temporal boundaries enforced by the stage. By examining Lemon's own efforts to find an affective and aesthetic language as he maps loss across a number of sites, I have suggested that viewing Lemon's performative research through the theoretical framework of mourning and melancholia reveals that he engages with a social and aesthetic understanding of loss that he then uses to construct the movements on the stage.

NOTES

This essay has appeared, in somewhat different form, in Kajsa Henry, "Mapping Loss as Performative Research in Ralph Lemon's *Come home Charley Patton*," *PARTake: The Journal of Performance Research*, vol. 3, no.1 (2020). Republished by permission of the copyright holder and the Publisher (www.partakejournal.org).

1. In an interview with Ann Daly, Lemon admits that *The Geography Trilogy* is "about how [his] particular modern sensibility relates and/or clashes with the evolving act of refined order [he] find(s) in so-called traditional forms" (*Tree: Belief/Culture/Balance* [Middletown, CT: Wesleyan University Press, 2004], 256). See also Ann Daly, "Conversations about Race in the Language of Dance," *The New York Times*, December 6, 1997.

2. Lemon was one of only a few Black postmodern dancers who were a part of the downtown, avant-garde, or postmodern dance scene in New York City that began in the early 1960s with the Judson Church Theatre Group. Since all of the dancers in his company were white, which changed toward the end of the company, and he did not discuss "Black" themes, others, and even Lemon himself, describes his work during that time as "Eurocentric."

3. Lemon, *Tree: Belief/Culture/Balance*, 8.

4. A few considerations of Lemon's work have picked up on the dimension of loss, ritualization, and the importance of the buck dance to *Come home Charley Patton*. Mainly focusing on Lemon's most recent project, *How Can You Stay in the House All Day and Not Go Anywhere?*, which extends many of the themes found in *Come home Charley Patton*, Ryan Platt reads the performance as deeply connected to issues of mourning since it came after the death of Lemon's longtime partner, Asako Takami, and Lemon's interactions with Walter Carter, a man in his nineties whom Lemon met while researching throughout the South. He believes that Lemon was in search of "representational forms that could communicate his personal grief and the cultural dislocation at the root of African-American identity." Platt concludes that Lemon's efforts in *How Can You Stay in the House All Day and Not Go Anywhere?* shows the possibility of movement to "perceive traces of historical events and experiences in everyday movement such as vernacular dance and gesture, whose performance kinesthetically awakened dormant memories" ("Ralph Lemon and the Language of Loss," *PAJ: A Journal of Performance and Art* 34, no. 3 [2012], 71–82; quotation from 81). In "Ritualization of the Past: Ralph Lemon's Counter-Memorials," Nicholas Birns observes that Lemon "uses body movement in a way that internalizes the unseen journey that led to the performance. The body serves as a distilled history, a vehicle to communicate historical information" (*PAJ: A Journal of Performance and Art* 27, no. 3 [2005], 19). In her discussions of *Come home Charley Patton*, Katherine Profeta notes the importance of the "paratexts" that comprise Lemon's archive, and she valuably traces his extended interest in the buck dance ("The Geography of Inspiration," *PAJ: A Journal of*

243

Performance and Art 27, no. 3 [2005], 23–28). Profeta also includes a chapter on Lemon in *Dramaturgy in Motion: At Work on Dance and Movement Performance* (Madison: University of Wisconsin Press, 2015). Another work that offers criticism on Lemon is André Lepecki, *Exhausting Dance: Performance and the Politics of Movement* (New York: Routledge, 2006). More recently, Doria E. Charlson examines the body and memory connection in "'My Body is a Memory Map': Embodied History in Ralph Lemon's *Come home Charley Patton*," *Shift: Graduate Journal of Visual and Material Culture* 8, Space, Alterity, Memory (2015), 78–88. In 2016, MOMA published the first monograph on Lemon's work: Thomas J. Lax, ed., *Ralph Lemon: Modern Dance Series* (New York: MOMA, 2019).

5. Ann Daly, "Afterword," in *Tree: Belief/Culture/Balance*, 201.
6. Lemon uses this term in the program notes for *Come home Charley Patton*.
7. During his assessment of Holocaust memorials and art about the Holocaust, James Young highlights the politics of counter-monuments or counter-memorials in the remembrance of an event or the person. According to Young, artists who are drawn to the poetics of counter-memory, consider it their task "to jar viewers from complacency, to challenge and denaturalize the viewers' assumptions. . . . [These] artists renegotiate the tenets of their memory work" (*The Art of Memory: Holocaust Memorials in History* [New York: Prestel, 1994], 28).
8. Ralph Lemon, "Art + Invention Speaker Series (1): The Artist as Researcher: An Evening with Ralph Lemon," interview by Mark Gonnerman, Aurora Forum at Stanford University, December 3, 2007, https://podcasts.apple.com/us/podcast/the-artist-as-researcher-an-evening-with-ralph-lemon/id385780135?i=1000085476585.
9. Marianne Hirsch first proposed the term in "Family Pictures: *Maus*, Mourning, and Post-Memory," *Discourse* 15, no. 2 (1992–1993): 3–29. She continued to develop the concept in her later work, particularly in *Family Frames: Photography, Narrative, and Postmemory* (Cambridge, MA: Harvard University Press, 2006) and *The Generation of Postmemory: Visual Culture after the Holocaust* (New York: Columbia University Press, 2012).
10. In her later work, Hirsch makes the distinction between "familial" and "affiliative" postmemory.
11. "Collective memory" designates the shared knowledge of past experience held by the members of a select group. Developed by the French sociologist Maurice Halbwachs in the first half of the twentieth century, the concept stresses the relation between memory and its social context.
12. Ralph Lemon, *Come home Charley Patton* (Middletown, CT: Wesleyan University Press, 2013), 34.
13. Lemon, *Come home Charley Patton*, 34.
14. Lemon, *Come home Charley Patton*, 27
15. I found a transcription of this song at http://www.elyrics.net.
16. Lemon, *Come home Charley Patton*, 113.
17. Katherine Profeta, "Ralph Lemon and the Buck Dance," *Movement Research Performance Journal* 33 (2008). Profeta reads Lemon's reinvention of the buck dance through Joseph Roach's assertion that "[l]ike performance, memory operates as both quotation and invention, an improvisation on borrowed themes, with claims on the future as well as the past." See Roach, *Cities of the Dead: Circum-Atlantic Performance* (New York: Columbia University Press, 1996), 33. See also Profeta, "The Geography of Inspiration," 23–28.
18. Profeta, "Ralph Lemon and the Buck Dance."
19. Since performances of Lemon's earlier *Solo* performance were not available, it is difficult for me to trace the technical changes that he makes in this new reincarnation, but Profeta notes that, in the *Tree* version, the "dance is a little off center, a little wobbly, almost drunken" ("Ralph Lemon and the Buck Dance," 134).
20. Ralph Lemon, "Art + Invention Speaker Series."
21. Michel Foucault defines counter-memory as the use of history in a way that subverts nation-related, ceremonial, and disciplinary orders of memory. See Michel Foucault, *Language, Counter-Memory, Practice: Selected Essays and Interviews*, ed. and trans. Donald F. Bouchard and Sherry Simon (Ithaca, NY: Cornell University Press, 1977).
22. Lemon, *Come home Charley Patton*, 158.
23. Lemon, *Come home Charley Patton*, 158.
24. Karla F. C. Holloway theorizes about "cultural narratives that are 'passed on' in both senses of the expression—they are stories about death, and they are shared within the culture and from generation to generation [. . .] to perform perversely both a descriptive and prescriptive ritual" ("Cultural Narrative Passed On: African American Mourning Stories," *College English* 59, no. 1 [1997], 32, 34).

MAPPING LOSS AS PERFORMATIVE RESEARCH

25. Lemon, *Come home Charley Patton*, 219.
26. Lemon, *Come home Charley Patton*, 220.
27. Lemon, *Come home Charley Patton*, 221.
28. Lemon, *Come home Charley Patton*, 159.
29. "The Duluth scene serves as a point of concentration for the sense of the body as existing amidst danger, which suffuses Charley Patton" (Birns, "Ritualizing the Past," 21).

FOURTEEN

REMEMBERING AND RESURRECTING BAD N-----S AND DARK VILLAINS

Walking with the Ghosts That Ain't Gone

McKINLEY E. MELTON

We become poets in an attempt to tether words to righteousness,
Our notebooks to social consciousness

—Dominique Christina, "Karma"

When African American poets seek to memorialize the fallen through the use of poetic eulogy, they offer far more than metaphoric meditations on the rituals and practices of mourning. When the loss results from all-too-frequent acts of racialized violence, the creative response that emerges often endeavors to address the circumstances surrounding death, culminating in an effort to transform the society in which the deceased were deprived of the right to live. The contemporary moment—during which the declaration that "Black Lives Matter" has grown from a rallying cry of enraged exhaustion into a political movement with organization and purpose—produces seemingly endless catalysts for modern-day Black poets to eulogize those who are killed, often in an attempt to reverse the course of criminalization and demonization to which the slain are subjected in popular narratives and in the media. In so doing, contemporary Black poets create work that not only honors significant cultural and artistic legacies but also firmly positions them within the Black Radical Tradition of poetry for social justice.

As a means of exploring this tradition, this essay will focus on several poets, each of whom reflects on key figures from the twentieth-century civil rights era, ensuring that those figures continue to speak to the contemporary moment. In his collection *Turn Me Loose: The Unghosting of Medgar Evers* (2013), Frank X Walker utilizes historical poetry that meditates on the 1963 assassination of the civil rights leader and serves as a tribute to Evers and to the sacrifices made to bring change to Mississippi. Yet Walker's decision to incorporate the antagonistic voice of Evers's murderer, avowed and unrepentant white supremacist Byron De La Beckwith, suggests that any attempt to reckon with the loss of Evers also requires confronting the lethal logics of the man who took the civil rights leader's life. Similarly, Gwendolyn Brooks's "A Bronzeville Mother Loiters in Mississippi. Meanwhile, a Mississippi Mother Burns Bacon," published in *The Bean Eaters* (1960), offers a thoughtful meditation on the 1955 murder of Emmett Till, focusing on themes of guilt, innocence, and justice. The perspective that Brooks employs likewise urges

readers to examine not only the importance of whose memory is privileged but also how the psychology of race shapes both remembrance and reality. The legacy of Emmett Till's murder is also taken up by Dominique Christina, who draws urgent connections between Till and the contemporary epidemic of racialized state violence that threatens the survival of young African Americans. Put into conversation, the works of these poets reveal important continuities and structures of systemic violence in the social and political climate that threaten Black (after)lives. The poems engage with both the lives lost and the cost to the communities that claimed them as their own.

Pivotal to the ability of these poets to engage complex histories of social (in)justice is their multilayered approach to the act of remembrance, which firmly situates them within Black diasporic conceptions of life and death. Rather than simply mourning individual absence, Walker, Brooks, and Christina seek, in their poetry, to sustain life by maintaining the ongoing presence of the deceased. This approach to remembrance suggests an important connection between the contexts in which each poet writes and the cultural legacies with which they engage. In order to combat narratives that render these figures one-dimensional, these poets not only ensure that the spirits of the slain are preserved through memory, but they focus on *how* the fallen are remembered. By consistently incorporating a multiplicity of perspectives on these civil rights leaders, Walker, Brooks, and Christina reassert the complex humanity of Evers and Till while combatting cultural attitudes that conspired with racist violence to claim the lives of these poetically eulogized martyrs.

REMEMBRANCE AS CULTURAL AND SPIRITUAL RESISTANCE

The poetry of Walker, Brooks, and Christina emphasizes the act of remembrance within the cultural context of diasporic African thought, particularly beliefs regarding life, death, and the afterlife. In reflecting on the deaths of Emmett Till, Medgar Evers, and the many contemporary figures who follow, these poets each recognize that the fundamental purpose of racialized violence is about more than the destruction of individual Black bodies. It is also fueled by an anti-Blackness that seeks to dampen the spirit and weaken the will of the community. It is critical, then, to understand the ways in which Black poets engage with diasporic spirituality and notions of the afterlife. Indeed, the relationship between Black poetry and spiritual and cultural belief is articulated by Nigerian novelist and essayist Chinua Achebe, who writes, "[S]ince the Igbo did not construct a rigid and closely argued system of thought to explain the universe and the place of man in it, *preferring the metaphor of myth and poetry*, anyone seeking an insight into their world must seek it along their own way."[1] The legacy inhabited by these poets can, therefore, be understood as one wherein "metaphor of myth and poetry" serve as a conduit for giving voice to spiritual and cultural beliefs. In the assertion of such beliefs through poetic responses to racial violence, Walker, Brooks, and Christina perform nuanced and pointed acts of resistance through remembrance.

The relationship between remembrance and resistance is fundamentally rooted in diasporic sensibilities regarding life and death, which can be traced back to the West African cultural contexts discussed by Achebe and explored by scholars who wished to understand more fully the belief systems of traditional West African cultures.[2] Central to these conceptions of life and death is the framework through which time is articulated. Within West African cosmologies, time does

not follow the linear model of Western cultures. Rather, time is understood to operate in a cyclical manner, where the past, present, and future are not compartmentalized but instead defined fluidly and thus interconnected with one another. The moments of birth and death are also defined through a cyclical model, altering the view of human life. In an interview with J. O. J. Nwachurwu-Agbada, Achebe explains that

> the cyclic idea, the cyclic metaphor in Igbo thought is never very far from one's mind if one is reared in the Igbo culture. The cyclic thought is that if something happened before it will happen again; if one dies, one will return. If there's reincarnation and the grandfather comes back in the grandson, then you're likely to have certain events also, certain tendencies happening again and again. The world is not linear in the sense of wandering away in a straight trajectory; it is cyclic.[3]

Using the Igbo as an example, Achebe reflects on the cyclical nature of the world as made evident through the rituals and behaviors of the members of traditional West African societies. Recognition of the cyclical nature of reality inevitably and necessarily finds its way into the creative expression of the culture as well, particularly within "the metaphor of myth and poetry."

Central to Achebe's understanding of the modality of time as cyclical is the notion of holding onto the sense of the past as a continuing presence. Within a traditional West African spiritual worldview, the past is an active force shaping the activities of the present. Just as the past is kept alive in the present through the process of remembrance, those who—within a Western conception—would be considered to have lived in the past are instead kept very much alive in the present. As Ogbu U. Kalu explains in "Ancestral Spirituality and Society in Africa," "Death is a mere passage from the human world to the spirit world. The passage enhances the spiritual powers so that one could now operate in the human environment and especially in the human family as a guardian, protective spirit/power/influence."[4] In this way, a clear continuum is constructed between the "living" and the "deceased." Kalu refers to this continuum as "the vibrant reality of the spiritual world or 'an alive universe,' the continuity of life and human relationship beyond death, the unbroken bond of obligations and the seamless web of community."[5] Moreover, the relationships between the "living" and the "deceased" are continually reinforced through cultural practices designed to protect the spiritual integrity of traditional West African communities.

The veneration of the ancestors is a common observance in traditional West African religious practice, something that scholars often refer to as "ancestor worship." However, John Mbiti argues that

> it is wrong to interpret traditional religions simply in terms of 'worshipping the ancestors' . . . the departed, whether parents, brothers, sisters or children, form part of the family, and must therefore be kept in touch with their surviving relatives . . . it is blasphemous, therefore, to describe these acts of family relationships as 'worship' . . . Remembering them . . . is not worshipping them.[6]

As Mbiti points out, it is not only the position held by the ancestors but their relationship to the living that makes the presence of the ancestors all the more significant. Indeed, the way that the

living conceptualize the ancestors and the afterlife has tremendous bearing on how the living conceive of their own existence.

The term "ancestor worship" is also problematic because the designation of "worship" comes perilously close to placing ancestors on the same plane as gods. People honor one another for their achievements and accomplishments, and they do reverence unto one another in accordance with the respect that they have earned from the other members of their community. In much the same way, ancestors are honored for their contributions to the ongoing strength and success of their descendants. Because of the ancestors' role in shaping the past, those who secure health, wealth, and happiness in the present recognize a debt that must be paid, hence the rituals and commemorative practices that honor the ancestors. One dishonors the ancestors by failing to remember that what the ancestors have done has made contemporary existence possible. Rather than employ the term "worship," the following discussion is concerned with the concept of "remembrance" of the recent as well as distant past. The act of *remembrance* is intricately connected to the recognition of humanity in a way that *worship* is not; this distinction is imperative, given the efforts of poets to humanize the slain and complicate one-dimensional portrayals in an effort to acknowledge and respect the fullness of the humanity of the deceased.

The very act of remembrance often provides a central designation between life and death. Mbiti argues that, "while the departed person is remembered by name, he is not really dead: he is alive, and such a person I would call the *living-dead*." Mbiti further elaborates on his definition of the "living-dead" as one "who is physically dead but alive in the memory of those who knew him in his life as well as being alive in the world of the spirits. So long as the living-dead is thus remembered, he is in the state of *personal immortality*."[7] Once the deceased are no longer remembered by name by any living descendants, or by anyone who knew them in the flesh, "the process of death is now complete as far as [any] particular living-dead is concerned." Mbiti goes on to explain that the deceased is "no longer a 'human being', but a spirit, a thing, an IT . . . those who have 'moved on' to the stage of full spirits, merged into the company of spirits."[8] Therefore, descendants who honor the ancestors are keenly aware that the ways in which they practice remembrance are central to defining identity in life and in the afterlife.

Consequently, the fear of being forgotten pervades West African spiritual philosophy, and, thus, in order to be ushered into a state of "collective immortality," humankind must be remembered and honored after leaving the earthly plane. As Mbiti cautions, "[U]nless a person has close relatives to remember him when he has physically died, then he is nobody and simply vanishes out of human existence like a flame when it is extinguished."[9] This fear of being forgotten results in what Ogbu Kalu refers to as "the sincere desire of each person" to be remembered, captured by the colloquial expression "May my name never be lost"—a sentiment described by the Igbo of southern Nigeria as "*ahamefula*."[10] The act of remembrance protects against the finality of death, repudiating any effort to extinguish a life by slaying both the flesh and the spirit. When Mamie Till Mobley adamantly refuses to let her son be forgotten or dismissed as just another Black boy disappeared in a Mississippi midnight, she enacts a form of resistance that resonates with these West African practices of remembrance. In choosing to display her son Emmett's disfigured and mutilated body in an open casket for all the world to witness, she performs personal and political resistance by ensuring that her son's name would not be lost to future history. This essay also considers how Myrlie Evers Williams's tireless efforts to bring her husband's killer to justice were driven by the same desire: a refusal for Medgar Evers to have been murdered,

McKINLEY E. MELTON

buried, and forgotten without acknowledgment of the man he was, the community work he had done, and the legacy he bequeathed to the struggle for civil rights.

REMEMBERING MEDGAR EVERS AND MISSISSIPPI

In *Turn Me Loose*, Walker highlights the importance of remembrance by speaking through the historical actors central to the murder of Medgar Evers. Myrlie Evers Williams is one of the collection's primary poetic voices. Quite deliberately, Walker links the concepts of remembrance and voice, beginning with his introduction to the collection:

> Much of Mississippi's and the South's past is characterized by increased resistance to white supremacy in the face of overt and subtle racism that resulted in a multitude of crimes. These include crimes against the body, crimes against property, the collusion of public and private institutions in preventing access and opportunity to all people, and conspiracies of silence that continue today. This collection of poems seeks to interrupt that silence and shine a light on the important legacy of a civil rights icon all too often omitted from summaries of the era, by giving voice to a particular chapter in this history from multiple and often divergent points of view.[11]

Walker's choice of phrasing is purposeful in emphasizing the tension between silence and memory. Indeed, the entire collection challenges a complicity of silence, which seeks to will away the racially motivated traumas of the past by a refusal to acknowledge them. Walker's collection is largely dedicated to reclaiming a forgotten history and invoking vanished presences and unsung voices, thereby ensuring that those who have been sacrificed will not be killed again through historical erasure. Walker discusses this aesthetic strategy in a 2013 *Crisis Magazine* interview with Jabari Asim:

> First, I love history. And I think my activist instincts and my interest in reconciling what generally passes for history and what is actually true is at the core of my Historical Poetry. I've learned to appreciate how much the teller can shape and influence the story and how important it is for muted or marginalized voices to tell their own stories. I've also learned that the more participants in the story that share their often contrasting points of view, the closer we get to the truth.[12]

Walker articulates a purposeful and powerful link between the preservation of history and his "activist instincts," asserting that the truth of history requires a multiplicity of perspectives, voices, and stories deploying individual memory to disrupt the forgeries of history. This thread runs throughout Walker's collection and is perhaps most artfully expressed in his poem, "A Final Accounting." Walker's Mississippi chorus acknowledges the power that comes with narratively owning a thing or a place, while remaining adamant in its refusal to allow the power of narrativity to define reality or to maintain control and authority over the "truth." Walker offers a final accounting by closing the poem with the assertion that "[y]ou can fill all the libraries

250

with your version / of facts, call it history, and still not own the truth."[13] Walker's collection demonstrates how disruptive memory constitutes an act of profound resistance.

Central to Walker's project of political resistance through poetic memory is the construction of a dialogic constellation of "multiple and often divergent" voices within *Turn Me Loose*. In describing his approach and selection of speakers—Evers's widow, Myrlie; brother, Charles; murderer, Byron De La Beckwith, along with Beckwith's two wives, Willie and Thelma; as well as a voice that functions as a kind of Greek chorus—Walker explains that, in the collection, "Medgar Evers's voice is silent beyond lifting his final words, '. . . turn me loose,' for the title, but his presence, like a ghost, speaks loudly throughout the poems."[14] The relationship between silence and presence is significant here. Walker clearly establishes that Evers is kept ever-present through the voices—indeed, the remembrances—of others, despite being ostensibly silenced by his murder. In her foreword to *Turn Me Loose*, Michelle Hite notes that Evers's voice lingers throughout the collection, inviting readers to engage in an "act of remembrance much like the act necessary to answer the call of Medgar Evers."[15] The mandate for readers, as Hite argues, is forthright: "[I]f we are to finally lay him to rest, to satisfy his request to *turn him loose*, we must remember."[16] However, I would argue that the goal is not to lay Evers to rest, in an effort to bring closure to his life. Rather, what is accomplished through Walker's collection is a revival of Medgar Evers, a more complete resistance through a *refusal* to let Evers rest. To truly "turn him loose," then, is to release him from the grip of death, to allow him the sustained freedom for which he had been fighting all of his life. This freedom, through the preservation of life, can only be accomplished through a collective remembrance and a resistance to a historical narrative that would rather see Evers relegated to the finality of the past.

The necessity for a collective remembrance is further illuminated within "What Kills Me," the first poem in Walker's collection, which is delivered in the voice of Myrlie Evers. The poem's title blurs murderous rhetoric with a colloquialism that suggests the presence of something that is more bothersome than life-threatening. In so doing, Walker immediately confronts his readers with an unsettling turn of phrase, particularly given the traumatic and violent history that he is preparing to engage. In this case, what "kills" Myrlie is the idea that important contributions to the Civil Rights Movement are forgotten by those who "talk about the movement / as if it started in '64."[17] The mis-remembering of the Movement, then, "erases every / body who vanished on the way home," "erases the pile of recovered / bodies," and "mutes every unsung voice in Mississippi / that dared to speak up—fully understanding / the consequences."[18] Walker's emphasis on erasure, vanishing, and disappearance is as critical as his multilayered engagement with voice and voicelessness. The innumerable deaths that marked the struggle for civil rights are losses made more acute and profound by their consignment to historical oblivion and the failure to properly memorialize the lost, thereby solidifying the absences created in the wake of anti-Movement violence.

Walker subverts his audience's expectations regarding Myrlie's response to her husband's 1963 assassination. Instead of showing her simply mourning Medgar's death, Walker gives voice to Myrlie's dismay over the erasure of her husband's legacy by those who date the Movement as originating in 1964, a year later. Myrlie mourns the loss of the collective voices of the many who fought, died, and were disappeared alongside her husband. Even the poem's title, "What Kills Me," suggests that the cost of forgetting is also borne by Myrlie, as one of those left behind, and

McKINLEY E. MELTON

that her life is diminished by the cultural obliteration of those who have gone before. Only after she has acknowledged the collective damage done by their omission from the archive establishing the narrative of the Civil Rights Movement does she directly address her husband, saying, "[I]t erases his entire life's work." She then closes the poem's fourth stanza with the resonant declaration, "It means he lived and died for nothing. / And that's worse than killing him again."[19] In this final claim, Walker's Myrlie clearly echoes the diasporic sensibility that being forgotten and erased from the archive is indeed a more devastating prospect than even physical death. Death—in this case, violent murder—brings one's life to its earthly and physical conclusion, whereas being forgotten does more than rob one of a state of "personal immortality"—it negates the entirety of one's existence altogether and robs the community of its rightful legacy.

As an alternative vision to the forgetting of Medgar, Walker provides readers with a later poem in the collection, "Arlington," which suggests preservation through remembrance. Again, through the narrative perspective of Myrlie Evers Williams, Walker details Medgar's burial service in Arlington National Cemetery. A symbol of honor and pride, where fallen soldiers are accorded the respect that they have earned through valor and sacrifice in service to their country, Arlington reminds readers that Medgar Evers was, indeed, a World War II veteran and also a warrior in the Civil Rights Movement, who fought on both fronts, at home and abroad, for the fulfillment of American freedoms, even when the national leadership failed to champion those ideals. Similarly, the flag ceremony, during which "soldiers folded, creased, tucked, / smoothed, and then folded [the flag] again / with such precision and care" reinforces for readers the necessity of remembering Medgar's efforts to secure the freedom that the flag represents.[20] The link between the flag and Medgar is further suggested through Myrlie's recollection that she "imagined they were wrapping / a body / a red, white, and blue mummy" and is then made explicit when she reflects on "the time they placed that triangle / of husband in my arms."[21] At this moment, holding the triangular, folded flag, Myrlie is left with "no doubt" that she "was holding his future / and what we were burying / was only his past."[22] The pomp and circumstance of burial merely lays to rest Medgar's remains, leaving his widow to carry him into the future. Thus, in this poem, Walker works to bear witness to the significance and memory of Medgar, just as Myrlie and the community work to sustain his legacy and leadership as an afterlife.

Myrlie Evers Williams's efforts, like Mamie Till Mobley's before her, are best understood as forms of resistance against death itself, forms rooted in diasporic cultural traditions that deploy rituals of memory to ensure a viable afterlife for the deceased. This cultural legacy, however, is merged with the "activist instincts" of poets like Walker, who are not content to simply keep the past alive through mere remembrance. Rather, the ultimate goal of preserving life continues the work left undone in the struggle for justice and freedom. Walker's work not only embraces the cultural legacies of cyclical time and the power of memory to disrupt traditional conceptions of life and death but also advances Black radical resistance to oppressive violence that seeks to extinguish the life and memory of the Movement.

FALSE BALLADS AND MIS-REMEMBERING THE FALLEN

Poets like Walker, however, endeavor to do much more than ensure that we remember the names of Black men and women whose lives have been lost to racist violence. The difficulty of the task

these poets have undertaken often lies in shaping *how* we remember them. As we have seen in Mbiti's articulation of West African rituals of remembrance, what is important is that the "living-dead" are kept alive by *those who knew them*, with sufficiently established intimacy—often through familial bonds—to ensure that remembrance is sustained and also accurate. In the absence of intimate remembrance, the slain are reimagined by those who were strangers at best, and enemies at worst. For his part, Walker explores this dynamic with the inclusion of Byron De La Beckwith and his first and second wives, Willie and Thelma. When speaking of his penchant for historical poetry as opposed to forms such as biography, Walker reflects, "I like the under-the-skin-closeness of poetry. I like getting so deep inside a character's head and heart that you start to imagine what they dream about."[23] Ironically, by excavating the imagination of Medgar Evers's murderer, Walker reveals the danger of granting De La Beckwith, or his wives, the opportunity and privilege of shaping how Evers is remembered and preserved in the official historical archive.

Through a series of direct quotations as well as the voice that is created for him by Walker, De La Beckwith's words permeate the collection. *Turn Me Loose* opens with two epigraphs. The first epigraph, from Medgar Evers, declares, "If I die, it will be in a good cause. I've been fighting for America just as much as the soldiers in Vietnam," and foregrounds the representation that Walker will later provide in poems like "Arlington." The second epigraph, from De La Beckwith, exposes him as an unrepentant racist convinced that he is fighting a just cause: "[W]hen I go to Hades, I'm going to raise hell all over Hades till I get to the white section. For the next 15 years we here in Mississippi are going to have to do a lot of shooting to protect our wives and children from a lot of bad [n-----s]."[24] While this quotation does, indeed, provide a gateway into De La Beckwith's thoughts, it also suggests the danger in allowing his viewpoint to become the determinative one where Medgar's legacy is concerned, lest he be remembered only as a "bad n-----r."

Walker continues to pursue a poetic understanding of De La Beckwith's motivations, perhaps nowhere more powerfully than in his poem, "After Birth." Walker opens the poem with another epigraph from De La Beckwith: "[K]illing that [n-----r] gave me no more inner discomfort than our wives endure when they give birth to our children."[25] Drawing parallels to pregnancy, Evers's assassin, as the narrator of the poem, then goes on to describe his plot to kill Evers as a conception that gestates inside of him. At the appointed time for execution—or, *delivery*—De La Beckwith reflects, "[W]hen it was finally time, it was painless. / it was the most natural thing I'd ever done. / I just closed my eyes and squeezed."[26] Within this framework, Evers's death and extinction is conceived as necessary and natural for the birth and preservation of white life. Ultimately, Walker demonstrates the necessity, in the white imaginary, of Black death to the conceit of white life and afterlife.

While Walker's rendering of De La Beckwith is brilliant yet disturbing, it is not without precedent. Indeed, it echoes the work of Gwendolyn Brooks, who explores a related racist psychology in her 1960 poem, "A Bronzeville Mother Loiters in Mississippi. Meanwhile, a Mississippi Mother Burns Bacon," written in response to the 1955 death of Emmett Till. Brooks makes the strategic decision to reflect on the death of Emmett Till through the eyes, and memory, of Carolyn Bryant, the white woman at whom Till was accused of whistling. The poem follows Bryant as she attempts to make breakfast for her family on the morning after her husband's acquittal. Scholar Barbara Jean Bolden asserts that Brooks is offering commentary "upon the equally pervasive sexism evident in the unempowered status of the Southern white woman," thereby

McKINLEY E. MELTON

simultaneously critiquing what she calls America's "dissonant tones of blatant racism and sexism."[27] Bolden attributes value to Brooks's approach by describing Bryant as "an otherwise silenced white female" who "did not tell her husband of the event and apparently did not encourage retaliation against the youth for his alleged advances," suggesting that she "was overridden and discounted by her husband."[28] Finally, in what could be construed as an apologist reading, Bolden concludes that Brooks's poem offers necessary reflection on "the protected status of white women whose intellectual confinement made them victims to the very gender and racial stereotypes which held them captive."[29] Black poets, including Brooks, have used themes of silence and voice to examine the limitations of freedom and the correspondent denial of full humanity. Recentering gender to the exclusion of race, Bolden foregoes an intersectional analysis in order to produce a reading of silence under the sign of sexism in Brooks's poem that becomes, in effect, an apologia for white femininity.

The consideration of Carolyn Bryant as another victim of the racially motivated murder of Emmett Till, however, is not uncontested. Molly McKibbin, for example, argues that "Brooks is insisting that white women shoulder some responsibility for the violence carried out in their names."[30] Regarding Bryant's silence and passivity, McKibbin further argues that

> Carolyn Bryant's apparent initial reluctance either to accuse Emmett Till of wrongdoing or report her exchange with him to her husband, suggests her own hesitancy to become the reason for violence—but her support of her husband during her testimony in court . . . reveals that she chose not to condemn the lynching. While her behavior might have been the result of her submission to her husband, it nonetheless demonstrates that she made a decision to support him and secure her own comfort, rather than use the opportunity to expose black suffering to a wide audience.[31]

McKibbin continues: "[T]hough she is certainly a victim of Southern patriarchy and its accompanying gender norms, the woman is not consequently blameless." McKibbin then suggests that "Brooks' depiction of the woman must be considered not with a dichotomous understanding of guilt and innocence, but in a way that recognizes degrees of both."[32] What we now know, of course, is that Bryant has since recanted her original court testimony to historian Timothy Tyson.[33] McKibbin's reading returns a necessary level of complexity to analysis of the figure of Carolyn Bryant in the poem. Yet I would argue that Brooks's ultimate goal, through the use of Carolyn Bryant, is to extend the consideration of complexity to the young Emmett Till, who had been alternatively portrayed as villain or victim, without the multidimensionality that attends full humanity.

Indeed, Brooks's poem is not *about* Carolyn Bryant but is instead told through her perspective. Brooks's use of this point of view focuses attention more on Bryant's psychology than on her physical presence, her guilt, or her innocence. While Bolden similarly points to Brooks's emphasis on Bryant's "psychological dilemma," she focuses principally on "the mental juggling which would be necessary to empower the Southern white women, who are controlled by a white patriarchal order."[34] Even as Bolden emphasizes that this mental process must be examined not only to challenge the ways that white women "define themselves, but to redefine the people around them according to human, not merely racial, standards,"[35] she continues to center the figure of the white woman in her analysis. In order to fully explore Brooks's poem, and the tradition out

254

of which she writes, it is absolutely necessary to move beyond an undue emphasis on the individual figure of Carolyn Bryant and examine the collective ideology that she represents.

Bryant could be considered a more sympathetic figure than De La Beckwith, compelling an effort to engage with her in more nuanced ways. However, an examination of the attitudes Bryant embodies—reinforced by her complicity or submission—invites readers to engage in a more complicated analysis of white femininity and its imbrication in structures of racial violence, including lynching. Thus, in much the same way that Walker enlists De La Beckwith's voice to reckon with racist ideological constructions in the process of memorializing Evers, so Brooks's interpellation of Bryant's perspective is put in the service of her memorialization of Emmett Till. As Brooks acknowledges in a 1967 interview, "I wrote about the Emmett Till murder because it got to me. I was appalled like every civilized being was appalled. I was especially touched because my son was fourteen at the time, and I couldn't help but think that it could have been him down there if I'd sent him to Mississippi. That was a very personal expression."[36] In the same interview, Brooks explains that she "tried to imagine how the young woman, the one who was whistled at, felt after the murder and after the trial."[37] Gladys Williams notes that this poem "is the only one of Brooks' ballads in which the poet assumes the persona of a white person. In her other ballads, a black persona, in typical ballad tradition, has written out of a community consciousness from which the social norms and attitudes of personae and actors have come."[38] It is not without some irony that, in "Bronzeville Mother," Brooks scrutinizes Carolyn Bryant and her self-appointed standard-bearers for how they converge around the consolidation of whiteness and examines their perceived need to defend white womanhood by means of false accusation.

Brooks explores the "community consciousness" of the white community of Money, Mississippi—which had all but endorsed Till's murder in the local press and in the eventual jury acquittal—by framing it as steeped in those deceptively innocuous fairy tales and associated with the traditions and conventions of the ballad, populated with white knights and dark villains. Brooks invites readers into Bryant's kitchen and into her consciousness: "From the first it had been like a / Ballad. It had the beat inevitable. It had the blood . . . Like the four-line stanzas of the ballads she had never quite / understood—the ballads they had set her to, in school."[39] Despite never having "quite understood" the ubiquitous ballads that had constituted the cultural mythos of Bryant's southern white childhood, she received them as uncontested reality. This fairytale version of reality inevitably shaped her encounter with Emmett Till "from the first." Brooks shows how the chivalric values attached to ballad conventions were at play long before Till and Bryant crossed paths. Although she depicts Bryant's "feminine" passivity (as these were "the ballads they had set her to"), Brooks suggests that Bryant is not only comfortable with her gendered role but exhilarated by it: "It was good to be a 'maid mild.' / That made the breath go fast."[40]

Bryant, however, is quickly jarred into reality at the start of the poem's third stanza, when she realizes that the bacon has burned, reminding her of the mundane reality of her domestic duties, which she had absentmindedly neglected in the midst of her daydreams. Through the remainder of the poem, Brooks highlights the unraveling of the ballad, as Bryant comes to realize that its attendant construction of "normal" has always been far more fantasy than fact. Bryant is confronted with the reality of what her husband has done in the name of chivalry and the protection of her honor. While preparing a meal for her own children, she cannot help but see the parallels between their "infant softness" and that of the fourteen-year-old Till, to whom she refers

McKINLEY E. MELTON

in her mind as "the Dark Villain."[41] Her own positioning as mother demands a maturity that can no longer allow her to indulge in a child's fantasy.

As Bryant begins to recognize more fully the innocence of the "Dark Villain," she then also begins to reflect much differently on the guilt of the "Fine Prince." When her "prince" arrives to the breakfast table, gloating over his acquittal and muttering resentments over the inconvenience of the trial and the press, he disciplines their younger child for throwing molasses at his brother. Brooks then draws the clearest parallel in the mother's eyes between her own child and the supposedly villainous Till who had been struck down by her husband, as she describes the manner by which "The Fine Prince leaned across the table and slapped / The small and smiling criminal."[42] Bryant imagines his hands dripping with blood, quickly morphing between the imagined bloodstains on her own child's cheek and the bloodied remains of Till, which produced "a lengthening red, a red that had no end."[43] When the "Fine Prince" touches her, she too feels tainted by the blood, which in the poem is described as "a red ooze . . . seeping, spreading darkly, thickly, slowly / Over her white shoulders, her own shoulders, / And over all of Earth and Mars."[44] In one of the poem's most chilling lines, Brooks captures the moment where Bryant's entire vision of her idyllic life shatters, in the midst of the sweet nothings that her husband speaks into her ear: "He whispered something to her, did the Fine Prince, something about love and night and intention. / She heard no hoof-beat of the horse and saw no flash of the shining steel."[45] In this moment, Bryant loses any lingering sense of herself as portraying the part of the "milk-white maid," as she fights, silently, to struggle under the weight of the sickening new reality that she must face.

More important than simply depicting Bryant's epiphany, however, Brooks confronts readers with the power and impact of received cultural narratives that establish who is allowed to be a hero, and who must always be cast as a villain. Shattering the gendered and raced presumptions of the fairytale conceit, Brooks nevertheless emphasizes how pervasive and dangerous are the conventions of the ballads, with their clearly defined roles of "maid mild," "Fine Prince," and "Dark Villain." As scholar Christopher Metress argues, Brooks's "Bronzeville Mother" falls squarely within a literary tradition through which "Till's image has emerged as one of the most powerful and haunting reminders of racial injustice in America."[46] Brooks embraces "the task of configuring Till as something other than a sacrificial lamb" in order to acknowledge Till as what Metress describes as "a figure of disturbance and disruption who unsettles the peace of those who victimized him and then refused to grant him justice."[47] And, in so doing, Brooks herself disturbs and disrupts the white "community consciousness" that so thoroughly embraces the dichotomy of "Fair Prince" and "Dark Villain" central to the justification and perpetuation of white supremacy and southern racist ideology.

Further, Brooks utilizes remembrance as both a form of resistance and the means by which the Black community can restore Emmett Till to his youthful innocence and full humanity. She projects an image whereby Till can be honored and memorialized and symbolically kept alive in the minds of those who continue to mourn the fourteen-year-old boy. Moreover, by telling the Till narrative from the perspective of Carolyn Bryant, Brooks subverts the authority and distortions of the white community's collective memory. Highlighting the crumbling of Bryant's investments in the ideologies and fantasies of the ballad and their influence on her memory of the events that led to Till's death, Brooks exposes the fragility of the false narratives that seek to

REMEMBERING AND RESURRECTING

define Till within the white collective consciousness, and most certainly in the historical record, as a "Dark Villain."

RAGE AND MOURNING IN THE CONTEMPORARY MOMENT

Walker's and Brooks's powerful poetic meditations on Medgar Evers and Emmett Till, key figures from the Civil Rights Movement era, correct the historical record and restore to the archives the full humanity and political impact of their lives. Situated within a diasporic tradition in which it is necessary to remember the names of the ancestors to ensure the life and afterlife of the community, these works deliberately write the past with an eye to the future. To succeeding generations of young Black children and activists who might, like Evers and Till, become victim to a racial mythology that always already casts them as "Dark Villains," these poets thus offer valuable insight into racial (il)logics, along with the tools to dismantle their supporting ideologies. Walker and Brooks interrogate the psychological and mythological underpinnings of racism and racial violence that, years after the murders of Evers and Till, continue to structure race relations in contemporary US society and threaten Black lives.

This labor is continually necessary, when young Black children are forever cast in the role of the "Dark Villain." Brooks's acknowledgment that even Bryant "had never quite understood— the ballads that they had set her to, in school" makes their prevalence and prominence within US schools all the more disturbing. The fear of the "Dark Villain"—which incensed segregationists after the 1954 *Brown v. Board of Education* decision integrated schools and which contributed to the heightened atmosphere of racial animus that cost Till his life a year later in that fateful summer of 1955—has morphed into what we now recognize as the preschool to prison pipeline.[48] The inability to see the innocence of Black children likewise persists, and contemporary activists, as well as contemporary poets, argue that this racial distortion is the same mentality that cost twelve-year-old Tamir Rice his life, when officers rushed into a Cleveland park—as Brooks wrote of Till, to "hack down (unhorsed) / that little foe,"[49]—and then reported to dispatch that they imagined the suspect was approximately twenty years old.[50] Brooks explores how traumatic it is for Bryant to find her entire sense of reality irreparably shattered and herself unable to fit the pieces of her fantasy back together. Yet, "Bronzeville Mother" ultimately suggests that the unraveling of this ballad and the way its conventions have shaped the cultural imaginary is vital if Black children are ever to be afforded their humanity.

The discord between the ideologies of the "ballad" tradition and present reality has been taken up by a number of contemporary poets, many of whom seek to remind Black children that not everyone sees them as "the Dark Villain" or a threatening thug. Dominique Christina, for one example, directly engages the narrative of Emmett Till in order to impart a lesson to her son. Significantly, Christina's work allows for the complex humanity of Black children. Often, the politics of respectability is deployed to overwrite the "Dark Villain" narrative with reminders of the innocence of children who have a right to life and do not "deserve to die."

In her poem, "For Emmett Till,"[51] Christina engages in an ekphrastic response to the famous photograph of Till wearing his iconic brown hat. Christina paints a word-picture for her audience: "[I]n this photo he's laughing, and there is no cotton gin tied around him yet . . . and the

257

world did not know him because he had not been murdered yet . . . he's still slipping into the kitchen to eat another piece of cornbread, and when he goes to school he'll do a silly little dance and his friends will laugh."[52] Christina describes Till in a way that feels present and alive, not just frozen in time, within the still representation of a photograph. In creating this lively imagery of Till, she participates in the diasporic cultural tradition of giving new (after)life to the deceased through the act of remembrance, as evidenced by her vivid description of Till engaging in dance and other movements that are prospective, taking the past into the future. Noting that the photo was taken less than a year before his murder, Christina continues,

> . . . in those months, he is his mother's child. The smug and overfed manchild all Southern ladies love to cook for, 'cause he licks the plate clean. And ain't no men dressed like midnight with sunless unlaughing eyes, snatching him out the door and changing everything when neither he nor his momma asked to be anything other than laughing in the kitchen with the greens still simmering in the pot.[53]

Christina's emphasis on food and nourishment, along with her focus on the kitchen and homespace, draw powerful parallels to Brooks's "Bronzeville Mother," offering an alternative view of the kitchen space as revelatory even as its sanctity is similarly disturbed by the violent actions that claimed Till's life. After crafting a narrative in which Till is sweet, funny, and caring, complete with a mischievous glint in his hazel eyes, Christina says, "[T]his last photo of Emmett Till is a Holocaust" and confesses that "it is an image I shoved at my own 14 year old son, frenetic in my attempt to tell him that 'this is Black history.'"[54] This self-conscious effort—to commemorate "Black history"—is a necessary one for Christina, who needs her son to know that "if he relegates these stories to cliffnotes, well he bleeds out and dies in the epilogue."[55] In this assertion, Christina positions the act of remembrance, again, as the ultimate resistance; not only in the refutation of the racist violence that claimed Till's life but also in the assurance that her son's own life will be at stake should he ever disregard the importance of remembrance.

In the ensuing conversation, moreover, Christina is intentional in using the photograph of Till not to suggest that her own son mind his manners and his place, nor as a means of teaching resignation, but to instill in him the unfettered right to the joys of childhood:

> I tell my son, to remember Emmett Till when his head was high, when his eyes were still hazel . . . your head held so high is still a cautionary tale, but go on and do it anyway son, go on and do it anyway, and laugh, and dance, and clap and dance . . . and be grateful that when you and your boys say some slick shit about the pretty blond girl in the front row of algebra, you're permitted that levity! After 400 years of midnights, necks decorated in nooses, plantations that dressed up terrorism in white lace gloves and mint juleps.[56]

While aware that she cannot fully protect her son from the brutal realities of the way that the world perceives him, Christina urges him to stand tall, with a hero's stance. She tells him "that I will be his momma all the days of my life, that I will celebrate his beautiful brown boy buoyance" and ends the poem with the declaration that "We will be strong, and unapologetically Black, for as long as we can be."[57] Despite the surety of her convictions, and the empowerment that she bequeaths her son as legacy, the phrasing of "as long as we can be," lingering in the poem's final

moments, shadows hope with a sense that Mamie Till's and Myrlie Evers's mourning is not yet a thing of the past.

Like Frank X Walker and Gwendolyn Brooks before her, Dominique Christina resists despondency and explores the meditative power of mourning. In so doing, she galvanizes the strength of the community and bolsters their spirits in order to complete the necessary work of ensuring racial justice that has been left undone, in part, because of the systematic, state-sanctioned murders of key figures in the Civil Rights Movement. By remembering those who lived in the past, and reflecting on the implications of their deaths, Black poets endeavor not only to extend the life of those figures who are being remembered but to advance their work in the Movements of which they are a part. Thus, Black poets offer spiritual and material resistance, not only in the commemoration of those who have gone before but in the sustenance of those who remain behind. Drawing necessary links between the Civil Rights Movement and the ongoing struggles for racial justice—most recently embodied in the #BlackLivesMatter movement—these poets carry forward an important cultural legacy that not only insists that Black names must never be forgotten but also declares that Black Lives (and Afterlives) Matter.

NOTES

Quotations from Frank X Walker's Turn Me Loose: The Unghosting of Medgar Evars (University of Georgia Press, 2013) are reprinted by permission of Frank X Walker and The University of Georgia. Walker's "Arlington" was originally published in Black Magnolias, vol. 2, no. 4, December-February 2008–2009. Quotations from Gwendolyn Brooks's "A Bronzeville Mother Loiters in Mississippi. Meanwhile a Mississippi Mother Burns Bacon" are reprinted by consent of Brooks Permissions.

Quotations from Dominique Christina's poems "For Emmett Till" and "Karma" are reprinted by permission of Dominique Christina.

1. Chinua Achebe, "Chi in Igbo Cosmology," in *Morning Yet on Creation Day: Essays* (London: Heinemann, 1975), 94; emphasis added.
2. The terminology "traditional West African cultures" does not suggest a monolithic view of the region or of the history but is utilized to refer to cultural ideals and traditions that resonate across a diversity of cultural contexts composing this geopolitical region. The tenets and beliefs being presented in this discussion represent what Achebe describes in "Chi in Igbo Cosmology" as the "dominant and persistent concepts" that represent the foundation of diasporan cultural thought (167).
3. J. O. J. Nwachurwu-Agbada, "An Interview with Chinua Achebe," *The Massachusetts Review* 28, no. 2 (1987): 280.
4. Ogbu Kalu, "Ancestral Spirituality and Society in Africa," in *African Spirituality: Forms, Meanings, and Expressions*, ed. Jacob Olupona (New York: Crossroad, 2000), 54.
5. Kalu, "Ancestral Spirituality and Society in Africa," 55.
6. John S. Mbiti, *African Religions and Philosophy*. 2nd ed. (London: Heinemann, 1990), 8–9.
7. Mbiti, *African Religions and Philosophy*, 25.
8. Mbiti, *African Religions and Philosophy*, 83.
9. Mbiti, *African Religions and Philosophy*, 25.
10. Kalu, "Ancestral Spirituality and Society in Africa," 55.
11. Frank X Walker, "Introduction," in *Turn Me Loose: The Unghosting of Medgar Evers* (Athens: University of Georgia Press, 2013), xxiii.
12. Jabari Asim, "An Interview with Frank X Walker," *The Crisis Magazine* 120, no. 3 (2013): 32–33.
13. Frank X Walker, "A Final Accounting," in *Turn Me Loose*, 58.
14. Walker, "Introduction," xxiii–xxiv.

McKINLEY E. MELTON

15. Michelle S. Hite, "How Do We Comply?: Answering the Call of Medgar Evers," in *Turn Me Loose*, xviii.
16. Hite, "How Do We Comply?," xviii.
17. Frank X Walker, "What Kills Me," in *Turn Me Loose*, 3.
18. Walker, "What Kills Me," 3.
19. Walker, "What Kills Me," 3.
20. Frank X Walker, "Arlington," in *Turn Me Loose*, 48.
21. Walker, "Arlington," 48.
22. Walker, "Arlington," 48.
23. JoAnn LoVerde-Dropp, "Conscious Narratives: Exploring Historical Poetry with Frank X Walker," *Poetry Matters*, June 30, 2014, http://readwritepoetry.blogspot.com/2014/06/an-interview-with-frank-x-walker.html.
24. Walker, "Introduction," vii.
25. Frank X Walker, "After Birth," in *Turn Me Loose*, 44.
26. Walker, "After Birth," 44.
27. Barbara Jean Bolden, *Urban Rage in Bronzeville: Social Commentary in the Poetry of Gwendolyn Brooks, 1945–1960* (Chicago: Third World Press, 1999), 111.
28. Bolden, *Urban Rage in Bronzeville*, 142.
29. Bolden, *Urban Rage in Bronzeville*, 145.
30. Molly Littlewood McKibbin, "Southern Patriarchy and the Figure of the White Woman in Gwendolyn Brooks's 'A Bronzeville Mother Loiters in Mississippi. Meanwhile, a Mississippi Mother Burns Bacon,'" *African American Review* 44, no. 4 (2011): 667.
31. McKibbin, "Southern Patriarchy and the Figure of the White Woman," 671.
32. McKibbin, "Southern Patriarchy and the Figure of the White Woman," 669–670.
33. See Timothy Tyson, *The Blood of Emmett Till* (New York: Simon and Schuster, 2017), and Richard Pérez-Peña, "Woman Linked to 1955 Emmett Till Murder Tells Historian Her Claims Were False," *New York Times*, January 27, 2017, https://www.nytimes.com/2017/01/27/us/emmett-till-lynching-carolyn-bryant-donham.html. Despite this earlier recantation, the recent discovery in the Leflore County, Mississippi, Courthouse of the original August 29, 1955, arrest warrant suggests that Carolyn Bryant Donham, now eighty-eight years old, was present at the scene of the torture and death of Emmett Till. See Nick Judin, "Unserved Arrest Warrant for 'Mrs. Roy Bryant' in Till Case Uncovered in Leflore County," *Mississippi Free Press*, June 29, 2022, https://www.mississippifreepress.org/25296/unserved-arrest-warrant-for-mrs-roy-bryant-in-till-case-uncovered-in-leflore-county.
34. Bolden, *Urban Rage in Bronzeville*, 145.
35. Bolden, *Urban Rage in Bronzeville*, 145.
36. Roy Newquist, "Gwendolyn Brooks Interview," in *Conversations with Gwendolyn Brooks*, ed. Gloria Wade Gayles (Jackson: University Press of Mississippi, 2003), 35–36.
37. Newquist, "Gwendolyn Brooks Interview," 36.
38. Gladys Williams, "The Ballads of Gwendolyn Brooks," in *A Life Distilled: Gwendolyn Brooks, Her Poetry and Fiction*, ed. Maria K. Mootry and Gary Smith (Urbana: University of Illinois Press, 1987), 220.
39. Gwendolyn Brooks, "A Bronzeville Mother Loiters in Mississippi. Meanwhile a Mississippi Mother Burns Bacon," in *The Essential Gwendolyn Brooks*, ed. Elizabeth Alexander (New York: Library of America, 2005), 61.
40. Brooks, "Bronzeville Mother," 62.
41. Brooks, "Bronzeville Mother," 62.
42. Brooks, "Bronzeville Mother," 65.
43. Brooks, "Bronzeville Mother," 65.
44. Brooks, "Bronzeville Mother," 66.
45. Brooks, "Bronzeville Mother," 66–67.
46. Christopher Metress, "'No Justice, No Peace:' The Figure of Emmett Till in African American Literature," *MELUS* 28, no. 1. (2003): 89.
47. Metress, "'No Justice, No Peace,'" 90–91.
48. American Civil Liberties Union, "Locating the School-To-Prison Pipeline," American Civil Liberties Union, https://www.aclu.org/fact-sheet/locating-school-prison-pipeline.

REMEMBERING AND RESURRECTING

49. Brooks, "Bronzeville Mother," 63.
50. Wesley Lowery and Afi Scruggs, "Cleveland Officers Say Tamir Rice Reached into Waistband and Pulled Toy Gun before One of Them Shot Him," *Washington Post*, December 2, 2015, https://www.washingtonpost.com /news/post-nation/wp/2015/12/01/cleveland-officers-say-tamir-rice-reached-into-waistband-and-pulled-toy -gun-before-one-of-them-shot-him.
51. Button Poetry, "Dominique Christina—'For Emmett Till' (WoWPS 2014)," *YouTube*, https://www.youtube.com /watch?v=A9DhsymA9tQ.
52. Button Poetry, "Dominique Christina—'For Emmett Till' (WoWPS 2014)."
53. Button Poetry, "Dominique Christina—'For Emmett Till' (WoWPS 2014)."
54. Button Poetry, "Dominique Christina—'For Emmett Till' (WoWPS 2014)."
55. Button Poetry, "Dominique Christina—'For Emmett Till' (WoWPS 2014)."
56. Button Poetry, "Dominique Christina—'For Emmett Till' (WoWPS 2014)."
57. Button Poetry, "Dominique Christina—'For Emmett Till' (WoWPS 2014)."

FIFTEEN

MOURNING TRAYVON MARTIN

Elegiac Responsibility in Claudia Rankine's
Citizen: An American Lyric

EMILY RUTH RUTTER

The cover of Claudia Rankine's award-winning collection *Citizen: An American Lyric* (2014) features the haunting image of a black hoodie, headless and ghostly against the slick white background. While the image immediately recalls Trayvon Martin, it actually reproduces David Hammons's 1993 art installation *In the Hood*, evincing the long-standing racial injustices that unfold on the pages that follow. In the many glowing essays and reviews attending *Citizen's* publication, considerable attention has been drawn to Rankine's innovative formal strategies. David Mason quips, for example, "Is it poetry?" and then adds, "Provocatively subtitled 'An American Lyric,' the book is much more than conceptual art—genre bending at the very least."[1] Dan Chiasson likewise notes that *Citizen* challenges "our sense of the lyric's natural territory as the exclusively personal, outside the scope of politics."[2] Moreover, the poet and critic Evie Shockley contends, "Rankine's relational lyric-*You* may challenge us, as well, to retheorize the lyric genre."[3] Pressuring assumptions about the lyric "I" and its autonomy, Rankine's poetics are crucial to understanding the sociocultural work *Citizen* performs as a whole. What is equally significant, however, is her contribution to an African American elegy tradition and specifically to what I term here the "Trayvon Martin poem."

"Trayvon Martin's death," George Yancy and Janine Jones note, "has led to thousands of Americans (across race) rallying throughout the nation to bring attention to what so many see as an act of racial profiling, racial injustice, murder, and police incompetence."[4] Indeed, Martin's death on February 26, 2012, and George Zimmerman's subsequent exoneration for his killing set the stage for the Black Lives Matter movement and the newly charged conversation about systemic racism currently underway[5]—conversations in which artists have played key roles. As the Preface to *A Gathering of Words: Poetry and Commentary for Trayvon Martin* (2012) avers, "Trayvon will forever be a part of our lives as an unsuspecting catalyst, catapulted to change the universe during his brief journey in this world. He will forever be mourned, martyred, and memorialized but he will never again be trivialized."[6] High-profile musicians such as Beyoncé and Kendrick Lamar have also telegraphed their outrage over Martin's death and their resistance to institutionalized racism more generally.[7] The group Black Poets Speak Out (#BlackPoetsSpeakOut) has created, among other initiatives, an online platform for writers to lodge their poetic protests; each video begins with the declaration, "I am a Black poet who will not remain silent while this nation murders Black people. I have a right to be angry."[8] In response

to Martin's killing, Shockley likewise revised her 2011 poem "improper(ty) behavior" to address the fatal consequences of racial profiling: "like so many young men, trayvon martin was given a real mission impossible: / to buy candy at the corner store without getting caught surviving while black."[9] Shockley's ironic tone underscores the disjuncture between Martin's actions and Zimmerman's response, as well as her dismay with the ongoing persecution of citizens of African descent.

With *Citizen*, Rankine joins these writers, the acclaimed poet Danez Smith, and the former Poet Laureate Rita Dove, among many others,[10] who have used the printed page to ruminate on Martin's death, as well as the scores of unarmed African American men, women, and children who have died in state-sanctioned violence in the intervening years up to the present. Within this elegiac economy, Martin's death continues to be not only an occasion for lamentation and consolation, but also the catalyst for rethinking the current sociopolitical landscape in which many of the ideologies that justified *de jure* segregation remain entrenched, even while overt displays of racism are ostensibly no longer socially condoned. Briefly considering elegies for Martin by Dove and Smith but centralizing Rankine's *Citizen*, this essay explores the ways in which these poets marked a new era in the long marriage of poetic and sociopolitical protest, one in which Black bodies and the rights of citizenship remain at risk.

In particular, I consider *Citizen*'s multimodal, dialogic reconfiguration of the elegy, which Rankine uses to transform the loss of an individual into a collective (and interracial) mourning for the ways in which American society has failed its citizens of color. Drawing on the elegy's traditional movement between private and public grief, Rankine grapples with the emotional landscape of both white privilege and racial microaggressions that culminated in Zimmerman's shooting down the unarmed Martin with impunity. Making prolific use of a second-person, present-tense "you" speaker, whose race and gender are often strategically withheld, Rankine forecloses the possibility for readers distancing themselves from the encounters that she stages. Readers are made to *feel*, for example, what it is like "when the woman with the multiple degrees says, I didn't know black women could get cancer," or when a man says incredulously after breaking in line, "Oh my God, I didn't see you," and then "No, no, no, I really didn't see you." Rankine likewise provides readers of color with the emotional validation so often denied in a society that cleaves to its democratic ideals of citizenship while eliding the tiered access to these ideals: "Hold up, did you just hear, did you just say, did you just see, did you just do that?"[11] Yes, Rankine seems to answer, to all of these questions and more. Whether we are the citizens traditionally labeled "other" or the ones implicated in the "othering," Rankine emphasizes the ways in which we are always already bound up in the emotional lives of others. Ultimately, then, she uses the elegiac mode not only to grieve but also to enjoin readers to make the afterlives of Martin and the scores of other victims of racialized violence meaningful, to restore to them what they were not granted in life: the full rights of citizenship.

POEMS FOR TRAYVON

Before exploring poetic responses to Martin's death, it is instructive to briefly consider the elegiac tradition in which Rankine, Dove, and Smith, among other poets, are working. Identifying the conventional tropes of elegy, Mark Strand and Eavan Boland write, "An elegy is a lament.

EMILY RUTH RUTTER

It sets out the circumstances and character of a loss. It mourns for a dead person, lists his or her virtues, and seeks consolation beyond the momentary event. . . . Because of its public role, the elegy is also one of the forms that can be said to be coauthored by its community."[12] Traditionally, therefore, elegies affirm the shared values that allow a given community to honor the dead on the one hand and move toward closure on the other—dual aims that Rankine and her contemporaries both adopt and reconfigure. Moreover, in *Poetry of Mourning: The Modern Elegy from Hardy to Heaney* (1994), Jahan Ramazani observes, "Modern poets reanimate the elegy not by slavishly adopting its conventions; instead they violate its norms and transgress its limits"; in particular, he argues that "[Langston] Hughes and other African-American poets have altered the elegy to address issues traditionally excluded from its repertoire, such as racial strife, lynching, and urban poverty."[13] Perhaps no genre is better equipped to express the history of the African American experience than the elegy, with its concomitant investment in testifying to both personal and public grief. That is, to be of African descent in America has nearly always required that the lyric "I" also speak to the concerns of the "we," and these collective concerns have often been traumatic: from slavery, to Jim Crow and lynching, to political assassinations, and to our own era of widespread police harassment and violence against Black bodies.

One of the most recognizable elegies in African American poetry is what Kimberly Benston has termed the "[John] Coltrane Poem,"[14] and I take a cue from Benston here in considering the subgenre of poems dedicated to Martin. Yet while poets harness the power of the word to overcome the loss of creativity that Coltrane's death from liver cancer exemplifies, a different kind of elegiac mode is called for when the dead are victims of white supremacy. For example, numerous poets, including Langston Hughes, Gwendolyn Brooks, James A. Emanuel, Audre Lorde, Jerry W. Ward, Jr., Wanda Coleman, Sterling Plumpp, Al Young, and Marilyn Nelson, have penned elegies marking the 1955 murder of Emmett Till—the fourteen-year-old Chicago native who was pistol-whipped, shot, his neck tied to a cotton gin, and then drowned in the Tallahatchie River in Money, Mississippi.[15] As Kristen Boudreau notes, writers "who sought justice in the Till lynching believed that they must reach the widest possible audience, and they did not shy away from angry and impassioned attempts to awaken the world to the crimes of Mississippi."[16] Just as poets invoked Till in order to elucidate the gruesome consequences of racial apartheid, elegies for Martin expose and often trenchantly resist the power structures and sociopolitical injustices that led to his killing.

Accordingly, Rita Dove's "Trayvon, Redux" (2013) reimagines the circumstances of Martin's death, demonstrating that even a teenager cannot be inoculated from the pathology of criminality projected onto Black males in particular. Inhabiting a Zimmerman persona, she illuminates the ingrained racism and white privilege that led him to consider the unarmed Martin a threat to the well-being of himself and his neighbors. Dove writes, "*Hey!* It tastes good, shoving your voice / down a throat thinking only of sweetness. / *Go on, choke on that.*" Reversing the paradigmatic script in which whites are vulnerable to the predatory nature of Black men, Dove stages a scene in which Zimmerman stalks Martin, relishing his ability to wield his dominance: "*Do you do hear me talking to you? Boy.*"[17] The term "Boy" collapses the decades that have transpired from the Jim Crow era, when it was commonplace to openly belittle Black men by calling them boys, to our own supposedly "post-racial" moment. At the same time, Dove implies that Martin was not yet, at least by the metrics of American law, a man: he was not old enough to serve in the military, to vote, or to buy alcohol. This reminder of his youthfulness and innocence

264

MOURNING TRAYVON MARTIN

makes Zimmerman's fear and anger over Martin's presence within his predominantly white gated community all the more disturbing.

Dove's final stanza then raises epistemological questions about the narrative of Martin's death:

If a mouth shoots off and no one's around
to hear it, who can say which came first—
push or shove, bang or whimper?
Which is news fit to write home about?[18]

These queries remind us that we have only been allowed one side (Zimmerman's) of this story; moreover, Dove raises concerns both about the racial subtext of what is deemed newsworthy and the ways in which these "bangs" and "whimpers" are reported. Thus, Dove's "Trayvon Martin poem" not only expresses outrage over Martin's death but also elucidates what Zimmerman's exoneration signifies, particularly in terms of the continuation of racism within the criminal justice system, the media, and the nation at large.

Danez Smith's "Short Film" (2015) begins by asserting that the poem is "*not an elegy for Trayvon Martin*," announcing its resistance to providing consolation, as well as to viewing Martin's death as a singular crime. In fact, all of the poem's section titles include this statement of elegiac negation in reference to the African American victims of state-sanctioned violence that Smith invokes: Michael Brown, Renisha McBride, John Crawford, and Brandon Zachary. And, as Smith puts it in the poem's second section, "I am sick of writing this poem / but bring the boy. his new name. // his same old body. ordinary, black."[19] The title "Short Film" likewise alludes to these lives cut painfully short. More obliquely, this title refers to the recordings and videos capturing snippets of fatal encounters between white officials and African American men and women that have gone viral across the internet—these "short films," in other words, have made it indisputable that Black lives are still systematically devalued. Furthermore, this poem title, like Smith's admission of fatigue ("I am sick of writing this poem"), implies the montaged nature of these deaths in which the names and bodies begin to lose their individuality as they become part of a relentless pattern of loss and mourning.

Smith thus follows Dove in refusing the elegiac closure that would allow American society to move on without confronting systemic forces of oppression. Specifically, Smith reminds us of the traces of the Jim Crow past made legible in these recent tragedies, yoking together the haunting similarities between Till's and Martin's deaths:

ask the rain
 what it was
like to be the river
then ask
 who it drowned.[20]

Akin to the hydrologic cycle, the killing of Black men is a *naturalized* pattern, a feature of the landscape like the Tallahatchie River in which Till's body was submerged. In other words, the script for Martin's death and its aftermath were in many ways already written and just waiting to be enacted. Charting this history of white supremacist violence and Black suffering, "Short Film"

EMILY RUTH RUTTER

echoes "Trayvon, Redux" in subverting a teleological view of race in America, encouraging readers, instead, to question how and why Black lives are cut so short.

CITIZEN'S EMOTIONAL CALL TO ACTION

As with Dove, Smith, and the many poets who have penned "Trayvon Martin poems," Rankine's *Citizen* resists closure, but she also encourages an emotional shift in the way readers process the deaths of Martin and other unarmed Black men, women, and children. "What *feels* more than feeling?," Rankine queries, indicating her affective, dialogic rendering of the elegy.[21] In an interview with Saskia Hamilton about *Citizen,* Rankine explained, "I've been thinking about what it means to have grief be an ambient feeling, a feeling that is just out there like air, it just stays. So, then I thought that in a sense what we want (and I'm using this 'we' loosely) is to turn that feeling into a national feeling." In other words, "How do we get that grief to become a national grief and not one that is held only within the Black body?"[22] Using a wide range of media and moving between macroaggressions such as Martin's death to more ephemeral microaggressions, Rankine facilitates this national mourning, encouraging readers to bear emotional witness to the experience of second-class citizenship. Rankine writes, for example, "You're not sick, not crazy, / not angry, not sad—/ It's just this, you're injured,"[23] both validating the suffering caused by the accretion of racialized insults perpetrated against people of color *and* challenging white interlocutors (the other "you"), too quick to dismiss racial injury as mental and/or emotional instability in order to relieve themselves of blame or culpability.

Marshaling grief to these socially productive ends, Rankine's work is consonant with that of Judith Butler, one of several theorists she cites in *Citizen.*[24] In *Undoing Gender* (2004), Butler advocates "tarrying with grief" as a means of recognizing "our collective responsibility for the physical lives of one another." She further notes, "To grieve, and to make grief itself into a resource for politics, is not to be resigned to a simple passivity or powerlessness. It is, rather, to allow oneself to extrapolate from this experience of vulnerability to the vulnerability that others suffer through military incursions, occupations, suddenly declared wars, and police brutality."[25] Similarly, Rankine utilizes grief as a tool for enabling empathy and, ultimately, for moving individuals toward a collective emotional consciousness. Rankine's use of the second-person pronoun "you" is especially effective in this regard, as it implicates without racializing, removing an escape hatch for white readers and staging encounters in which all citizens are made to confront the everyday realities of systemic discrimination.

According to the *Oxford English Dictionary*, a citizen is, firstly, "an inhabitant of a city or (often) of a town, especially one possessing civic rights and privileges" and, secondly, "a member of a state, an enfranchised inhabitant of a country, as opposed to an alien."[26] Yet, in the elegiac economy in which *Citizen* works, there are consistent reminders that these privileges are doled out unevenly and that there are serious emotional ramifications to such inequities. In *An Archive of Feelings: Trauma, Sexuality, and Lesbian Public Cultures* (2003), Ann Cvetkovich notes, "It is important to incorporate affective life into our conceptions of citizenship and to recognize that these affective forms of citizenship may fall outside the institutional practices that we customarily associate with the concept of citizen."[27] Cvetkovich centralizes lesbian culture and traumas incurred therein, but her archival hermeneutics accord with Rankine's similar investment in

266

MOURNING TRAYVON MARTIN

testifying to the affective and somatic experience of being denied the privileges of first-class citizenship.

In *Citizen*'s opening chapter, for example, Rankine draws readers into moments of rupture between colleagues and friends that, while not directly related to Martin's death, are part of a society—a citizenry—in which African Americans are rendered alternately invisible and hyper-visible, but denied the right to express pain and outrage without risking social marginalization. In one scenario, for example, a colleague "tells you his dean is making him hire a person of color when there are so many great writers out there." The listener wonders, "Why do you feel comfortable saying this to me?"[28] Nevertheless, he or she is unable to respond to such a problematic and insensitive comment:

> As usual you drive straight through the moment with the expected backing off of what was previously said. It is not only that confrontation is headache-producing; it is also that you have a destination that doesn't include acting like this moment isn't inhabitable, hasn't happened before, and the before isn't part of the now as the night darkens and the time shortens between where we are and where we are going.[29]

Through the lyric "you," Rankine situates readers in this powerless position of listening to the glibly racist comments of a white colleague without making one's dissent known, lest one is willing to incur "headache-producing" physical and psychological pain (as well as the professional costs of not reaching the obligatory "destination"). The word "inhabitable" is also especially telling here, since it circles back to the definition of a citizen as an enfranchised inhabitant of a city or country. Making the situation confrontational or "uninhabitable," in other words, risks the precarious rights of citizenship that the person of color must grip ever firmly.

On the page that follows, Rankine then contemplates the emotional costs of silence: "Sitting there staring at the closed garage door you are reminded that a friend once told you there exists the medical term—John Henryism—for people exposed to stresses stemming from racism. They achieve themselves to death trying to dodge the buildup of erasure. Sherman James, the researcher, who came up with the term, claimed the physiological costs were high."[30] In both of these speechless moments—the microaggression with the colleague in the car and, later, alone in the garage—Rankine's "you" places readers in an empathetic stance. We are asked to feel what it would be like to wish that an arrest or something as violent as a car accident would suddenly disrupt this racialized encounter and attenuate "the buildup of erasure." The "we" statement that concludes the previous passage—"Where we are and where we are going"—also reminds us that, just as our emotional stability depends on the validation of others, so, too, private grief may find its most potent expression in public elegy. Indeed, this statement, which could easily be reframed as a series of questions ("Where are we?" and "Where are we going?") reminds us all of the high stakes of these seemingly quotidian encounters.

In *Citizen*'s emotionally gripping chapter VI, Rankine then invokes Martin using a prototypical elegiac phrase "In Memory of"; yet she also revises that phrasing by adding a time stamp as well as a gesture toward the multimodal process of mourning that she activates: "February 26, 2012 / In Memory of Trayvon Martin // Script for Situation video created in collaboration with / John Lucas."[31] These two lines inscribed on the white background resemble a poetic gravestone, marking the date of Martin's death and anticipating the elegiac rumination that will guide the

EMILY RUTH RUTTER

prose-poetry that follows. At the same time, Rankine indicates the multimedia significance of these lines, as they are also part of a script performed in collaboration with her husband, the experimental filmmaker John Lucas. Rankine thus signals that this elegy for Martin is part of a larger project of documentation and resistance—a "situation" in which readers are participants, both bearing witness to and acting out the script she unfolds.

The corresponding page does not identify Martin's name and, unlike Dove's poem, omits the details of his death. Moreover, instead of the second-person "you," here Rankine transitions between first, second, and third person, instantiating a collective mourning not only of Martin but also of a history of violence perpetrated against Black bodies. Implicitly, Rankine links Martin's death, sanctioned under Florida's "Stand Your Ground" law, to lynching, racial profiling, and the mass incarceration of Black men, implying that grieving for Martin necessarily involves confronting institutionalized racism and the emotional trauma it has produced. Highlighting the ways in which Black men have been pathologized in America's racial imagination, Rankine writes, "My brothers are notorious. They have not been to prison. They have been imprisoned. The prison is not a place you enter. It is no place. My brothers are notorious."[32] As Mark Anthony Neal similarly notes,

> Black male bodies continue to function as tried and tested props, whether justifying the lynching of black male bodies after emancipation or the maintenance of antimiscegenation laws and Black Codes (well into the twentieth century) to discourage so-called race mixing and limit black mobility. In the contemporary moment we witness the prison industrial complex (where privatization looms large), which warehouses black (and brown) male bodies for nonviolent offenses as part of some preemptive attack on the presumed criminality of those bodies.[33]

Bringing the specter of this history to bear on Martin's memory, Rankine suggests that he is yet another victim in a long line of criminalized figures, whose "notoriety" has foreclosed the possibility of their humanity in the culture at large. Whether jailed physically or psychologically (often both), Black men in American society continue to be subjugated, as Rankine's clarification reinforces: "prison is not a place you enter."

Exploring the emotional costs of this systematic dehumanization, Rankine also establishes an empathetic connection between victims of this persecution and readers: "Your hearts are broken. This is not a secret though there are secrets. And as yet I do not understand how my own sorrow has turned into my brothers' hearts. The hearts of my brothers are broken. If I knew another way to be, I would call up a brother, I would hear myself saying, my brother, dear brother, my dearest brothers, dear heart—."[34] Moving between the "you" and "I" perspective here, Rankine both exposes the consequences of racism—the "broken" hearts (perhaps no better image for describing the physical *and* emotional costs)—and implicates readers ("you") in this commiseration. "Your brother," in other words, works colloquially in the sense of Black people referring to one another in solidarity, while Rankine's movement between these pronouns enacts the fellowship (or enfranchised citizenry) that she implies is necessary in order to prevent the loss of these "brothers" in the first place.

Not unlike Rita Dove and Danez Smith, Rankine then traces the racial oppression and violence that preceded Martin's death, refusing the notion that it was an isolated tragedy. She writes

of "years of passage, plantation, migration, of Jim Crow segregation, of poverty, inner cities, profiling, of one in three, two jobs, boy, hey boy, each a felony, accumulate into the hours inside our lives where we are all caught hanging, the rope inside us, the tree inside us."[35] The collective pronoun "us" works to link all African Americans (past and present) in this racial schema in which the lynching tree and rope are internalized, functioning as a kind of psychological weapon threatening erasure; moreover, she describes the silence meted out by white supremacy: "a throat sliced through when we open our mouth to speak, blossoms, o blossoms, no place coming out, brother, dear brother, that kind of blue."[36] Giving voice to those who have been rendered mute, Rankine uses the elegiac form as much to grieve as to prevent historical amnesia about the circumstances—both sociopolitical and emotional—surrounding the loss of Martin and others.

Her reference to Miles Davis's legendary 1959 album *Kind of Blue* ("dear brother, that kind of blue") also places *Citizen* within an artistic history of resistance, inclusive of blues, jazz, hip-hop, Emmett Till elegies, contemporary "Trayvon Martin poems," and numerous other forms of African American cultural production. Expanding the terms of the elegy to accommodate this extra-textual media, Rankine unsettles the notion that there is ever *one* way of grieving or resisting injustice. In the aforementioned video *Situation 5*, for example, Rankine reads a version of "In Memory of Trayvon Martin" over *Kind of Blue*'s first track "So What"—the spare, plaintive notes on Bill Evans's piano and Paul Chambers's bass enhancing the elegiac tone.[37] Meanwhile, Lucas's camera zooms in on the profile of a young African American man looking pensively out of a car window. Not the teenage Martin, of course, this figure nonetheless embodies the experiences of a Black man living in a white-dominated society.

As the film progresses, Lucas splits the screen between the close-up shot of this man's face and images of southern landscapes (signifying America's slaveholding past); next, the close-up of the man parallels footage of Los Angeles police bludgeoning Rodney King. As the film concludes, Lucas juxtaposes the man's profile with images of the thousands of New Orleanians (the majority of whom were African American) stranded at the Superdome in the wake of Hurricane Katrina.[38] In fact, the section that precedes this elegiac tribute to Martin is titled "August 29, 2005 / Hurricane Katrina // Script for Situation video compromised of quotes collected, from CNN, created in collaboration with John Lucas."[39] Arranging these sections in succession, Rankine analogizes the government's lack of response to rescuing New Orleanians from Katrina and the racial biases within the justice system that made it possible for Martin's death to occur with impunity for his killer. Moreover, indicating that these sonic and imagistic materials be experienced in conjunction with her prose-poetry, Rankine subverts the traditionally monomodal elegy; at the same time, her inclusion of other artists and voices formally realizes the communal ethos necessary in order to prevent further violation of Black bodies.

As the text of the "In Memory of Trayvon Martin" section concludes, Rankine issues a series of imperatives, emphasizing the importance of keeping the memory of Martin and others alive: "I say good-bye before anyone can hang up, don't hang up. Wait with me. Wait with me though the waiting might be the call of good-byes."[40] Crucially, the speaker says "good-bye" before the abrupt severance of the "hang up"—a reference to both telephonic dialogue and lynching—modeling the fellowship that she advocates between readers and these "brothers" on the other end. The commands to "Wait" further place the onus on readers to prevent the "hang up," as well as to participate in the act of solidarity signified in waiting "with me." As such, Rankine refuses to offer either consolation or a sense of closure for this history of brutality and erasure

EMILY RUTH RUTTER

that Martin's death signifies. Instead, she encourages an empathetic form of identification in which readers are asked to see each other as part of a grieving collective charged with preventing future elegies "In Memory of."

According to Marcellus Blount, "In African American elegies, race often stands for community, and that sense of community is often structured through a figurative glimpse of the past."[41] Rankine both extends and evolves these frameworks to accommodate a contemporary American landscape in which *de jure* segregation has been nullified, but the white privilege that it protected has not. While she does not deny the communal bonds that Blackness forges, she strives to facilitate an interracial community in which white citizens in particular take responsibility for the emotional lives of others, including the dead and the bereaved. Moreover, Rankine's "glimpse[s] of the past" are not only figurative but also starkly literal. To this end, Rankine juxtaposes her lyrical response to Martin's death with perhaps the most haunting image in this viscerally emotive collection: a reproduction of the infamous photograph of the 1930 lynching of Thomas Shipp and Abram Smith. In this rendering, however, the gruesomely maimed bodies have been removed, and the spectacle is now the white mob. Given that this image is paired with Rankine's mourning of Martin, she invites readers to consider their complicity in contemporary versions of lynching. Confronting the white smiling faces in this lynch mob—faces that range in age, gender, and seemingly class—Rankine enjoins readers to see the threat that this mob poses, and because the Black bodies have been erased, to recognize that lynching (along with other forms of racialized scapegoating) was never about Black criminal behavior or pathology. The bodies of Shipp and Smith were sacrificed to maintain white domination—a ritualistic act that Rankine suggests is co-terminus with Zimmerman killing Martin purportedly to preserve the "safety" of his neighborhood.

As with Danez Smith, Rankine also expands the traditional elegiac scope to encompass a range of racially charged deaths. For example, the page that follows this lynching photograph reads, "June 26, 2011 / In Memory of James Craig Anderson / Script for Situation video in collaboration with John Lucas."[42] Anderson died in a hate crime in 2011, when a group of young white men robbed and beat him and then ran him over with a pickup truck.[43] Like a filmic reenactment, Rankine's words describe the scene of the crime and the ways in which Anderson, like Martin after him, was seen not as a human being but rather as an objectified threat: "In the next frame the pickup is in motion. Its motion activates its darkness. The pickup truck is a condition of darkness in motion. It makes a dark subject. You mean a black subject. No, a black object."[44] Momentarily taking the perspective of eighteen-year-old white supremacist Deryl Dedmon, Rankine changes the discourse from one focused on the loss of Martin, Anderson, and others to one that centralizes the pathology of white supremacy. "The pickup," she writes, "returns us to live cruelty, like sunrise, red streaks falling from dawn to asphalt—then again this pickup is not about beauty. It's a pure product."[45] Recalling William Carlos Williams's famous opening lines of "To Elsie" (1923), "The pure products of America / go crazy—,"[46] Rankine suggests that Dedmon and his pickup emblematize a history of genocide, imperialism, and oppression that continues to be reenacted. Anderson's death, like Martin's, are America's "pure products," in other words.

Rankine's scopic approach to the elegy continues in the sections that follow, which memorialize other victims of racialized violence while calling attention to the systemic practices that sanction them. For example, she writes of Mark Duggan, the London man of African descent gunned down by police ("August 4, 2011 / In Memory of Mark Duggan"), whose death sparked

mass protests and looting that, as Rankine writes, the British government and media labeled "'opportunism' and 'sheer criminality.'"[47] As with her elegiac remembrances of Martin and Anderson, however, Rankine's interest is less in recounting the circumstances of Duggan's death and more in the racialized ideologies that make it possible for whites to absolve themselves of responsibility for Black lives and afterlives. She describes, for example, a conversation with "A man, a novelist with the face of the English sky": "Will you write about Duggan? the man wants to know. / Why don't you? you ask. Me? he asks, looking slightly / irritated."[48] While the novelist expects "you" (presumably here a thinly veiled Rankine) to use her art to mourn Duggan, he feels "irritated" by the suggestion that he should. As Stephanie M. Wildman and Adrienne D. Davis put it, "Members of privileged groups can opt out of struggles against oppression if they choose. Often this privilege may be exercised by silence."[49] Indeed, one of the benefits of white privilege is freedom from what Rankine described in a 2015 essay, "The Condition of Black Life is One of Mourning": "For African-American families, this living in a state of mourning and fear remains commonplace."[50] Throughout *Citizen*, and in this exchange about Duggan's death in particular, Rankine exposes this undue burden in which inequities in grief become further evidence of systemic racism.

Her elegiac strategies also work to expand the parameters of this grieving public, facilitating an interracial sense of mourning. For instance, in the preceding section, entitled "Stop-and-Frisk," Rankine makes use of the "you" perspective to place readers in the position of being, like Martin, Anderson, Duggan, among many others, rendered both invisible and hypervisible by the dominant white power structure. Four times in five pages, she repeats the lines, "And you are not the guy and still you fit the description because there is only one guy who is always the guy fitting the description."[51] Reinforcing the frequency of the insult, Rankine echoes Danez Smith—"bring the boy. his new name / his same old body. ordinary, black"—with her emphasis on the endemic nature of racial erasure.[52] Additionally, moving between these high-profile deaths and these recurring instances of racial profiling, Rankine encourages readers both to bear witness to the daily instances in which Black citizens are denied their rights and privileges and to recognize the often fatal consequences of complying with tiered systems of citizenship.

Chapter VI then concludes with a particularly stark elegiac gesture—a list of victims of police brutality that have occurred since Martin's death. And, in what is surely an unprecedented move, Rankine has periodically revised this list to account for new victims. In the first 2014 printing, page 134 marked one death: "November 23, 2012 / In Memory of Jordan Russell Davis"; the adjacent page then read "February 15, 2014 / The Justice System," indicating the date that Davis's murderer, Michael David Dunn, was released after a mistrial. Dunn was subsequently convicted of first-degree murder on October 1, 2014.[53] Later, Rankine added "August 9, 2014 / In Memory of Michael Brown," mourning the death of the teenager killed in Ferguson, Missouri, by white police officer Darren Wilson. A subsequent printing included more victims, reading: "In Memory of Jordan Russell Davis, Eric Garner, John Crawford, Michael Brown," not to mention the individuals Rankine both mourns and anticipates in the repeated phrase "In Memory" inscribed on the white glossy page that bears these names. Rankine then added Akai Gurley, Tamir Rice, Walter Scott, and Freddie Gray to that list, and in the 2016 printing, Sharonda Coleman-Singleton, Cynthia Hurd, Susie Jackson, Ethel Lee Lance, DePayne Middleton Doctor, Clementa Pinckney, Tywanza Sanders, Daniel L. Simmons, Sr., Myra Thompson, Sandra Bland,

EMILY RUTH RUTTER

and Jamar Clark are also named. The repeated phrase "In Memory"—now shortened by the longer list of names—occupies the remaining space on the page, reminding us of the inevitable.[54]

It is not only Rankine's phrase but also the ink itself that haunts. The words fade to a mere trace by the page's end, indicating both the "not yet" deaths of African Americans and the scores that precede them, which have been effectively effaced from public memory. This gravestone-esque page, therefore, serves as a marker of endemic racism, just as the white background signifies the pernicious social force that constantly threatens Black lives. On the adjacent page, revised after Brown's death, Rankine announces unequivocally: "because white men can't / police their imagination / black men are dying."[55] This brief haiku puts the lie to any notion that these deaths were the result of individualized circumstances. Moreover, while not all readers will be aware of the dynamic process the text has undergone, Rankine's insistence that these pages are applicable to the present moment as well as to the history of racially motivated violence reflects her nuanced approach to the elegy. The grief she documents is not temporally bound; it is unfolding as we are reading, and Rankine facilitates the process of "tarrying in grief," as Butler put it earlier, which is necessary in order for this mourning to become a shared experience.

In the collection's final seventh section, Rankine then circles back to Martin, reiterating the ways in which his death and Zimmerman's subsequent exoneration affirm the existence of tiered levels of citizenship. Akin to the structure of the "In Memory of Trayvon Martin" section, Rankine places the marker "July 13, 2013"—the date that a Florida jury handed down a not-guilty verdict on all counts against Zimmerman—against the stark white background of the page.[56] In fact, the date is nearly subsumed by the whiteness that envelops it, a visual analogue to the institutionalized privileging of whiteness that made it possible for Zimmerman to be set free. As Michelle Alexander puts it in *The New Jim Crow: Mass Incarceration in the Age of Colorblindness* (2010), "Rather than rely on race, we use our criminal justice system to label people of color 'criminals' and then engage in all the practices we supposedly left behind. . . . We have not ended racial caste in America; we have merely redesigned it."[57] Instead of exploring these injustices on a macroscale, Rankine's prose-poetry segues into the privacy of domestic life in order to demonstrate the affective consequences of these implicit forms of racial stratification. As the speaker rides in the car with a partner and considers the "numbing effects of humming," they then catch a snippet from the radio that seems to announce another victim: "Just this morning another, What did he say?"[58] Whatever the details, the specter of anti-Black racism hovers over the encounter, threatening to evacuate the speaker's sense of safety and security.

Moreover, as with the conventional elegiac negotiation between private and public, Rankine illuminates both the grief and fear that Zimmerman's exoneration engenders within this otherwise intimate setting:

Trayvon Martin's name sounds from the car radio a dozen times each half hour. You pull your love back into the seat because though no one seems to be chasing you, the justice system has other plans.

Yes, and this is how you are a citizen: Come on. Let it go. Move on.

Despite the air-conditioning you pull the button back and the window slides down into its door-sleeve. A breeze touches your cheek. As something should.[59]

272

In this fleeting moment, the "you" becomes aware of the tenuous rights of citizenship, as well as the profound need for the love and security that institutionalized racism threatens to deny. As George Yancy explains, the logic of white supremacy has long deemed that "Black people are not really fit to be part of the white body politic. Hence, their status as 'citizens' is always already racialized and thus precarious, contestable, or simply nonexistent. In fact, Black people have been deemed 'anti-citizens.'"[60] Demonstrating a yearning for fellowship ("You pull your love") alongside the social reality of its absence ("the justice system has other plans"), Rankine elucidates the emotional response to social subordination and exclusion.

The imperatives ("Come on. Let it go. Move on.") likewise indicate the cultural devaluation of feelings caused by racism. The expectation is, in other words, that the "you" persona will persevere in spite of the sense of fear, alienation, and frustration that Martin's death and Zimmerman's exoneration have caused. There is no public allowance, Rankine suggests, for Black rage or grief; African Americans are always told to move swiftly past these racialized incidents. As she puts it earlier in the collection in an episode involving discrimination against the tennis superstar Serena Williams, the message is "Feel good. Feel better. Move forward. Let it go. Come on. Come on. Come on. . . . Move on. Let it go. Come on."[61] This refrain, threaded as it is through these diverse episodes, underscores the ways in which people of color are not only more vulnerable within the justice system but are also prohibited from expressing the pain of that vulnerability. Drawing on the lyric and the elegy—the poetic forms perhaps most associated with emotive expression—Rankine militates against such dehumanizing expectations. More implicitly, she redirects these imperatives toward an American citizenry that needs to "move on" and "let go" of the racialized stereotypes and expectations that quite literally endanger Black lives.

In the collection's final section, Rankine moves away from the capacious "you" perspective, invoking the lyric (or elegiac) "I" and at times collapsing a range of possible pronouns so that they read in succession "I they he she we you."[62] These shifting pronouns thus become the means of suturing the wounds of dissociation—reclaiming an "I" voice that has been disenfranchised and denigrated—and affirming that the concept of citizenry is predicated on an enfranchised community as much as it is on individual rights and privileges. Indeed, this string of pronouns (thrice repeated in *Citizen*'s seventh and final section) refuses the separation between the individual and the collective.[63] In so doing, Rankine returns us to the elegy's traditionally public role in which lamenting the dead is as much about negotiating the poet's private grief as it is about guiding the community toward a future of possibilities. As Rankine writes on *Citizen*'s final page of text, "I want to interrupt to tell him her us you me I don't know how to end what doesn't have an ending."[64] Rankine cannot provide closure when the onus remains on us all.

According to Ramazani, "We need elegies that, while imbued with grief, can hold up to the acid suspicions of our moment."[65] Adapting the ancient poetic genre of elegy to address the contemporary circumstances surrounding Martin's death, Smith, Dove, and Rankine, among many others, respond to such a call. Charting a long history of white supremacist violence, these poets refuse to offer closure for the deaths that continue to haunt our racial landscape, as well as our notion of citizenry. Rankine's "Trayvon Martin poem" is especially groundbreaking, for she not only reconfigures the conventional scope of the elegy, she also pressures its traditional monomodality, engendering instead a polyvocal, communal grieving process. Just as *Citizen* implicates readers in the discourse on race staged throughout its pages, Rankine emphasizes our shared responsibility for the emotional lives (and afterlives) of all citizens. As she announces via a

EMILY RUTH RUTTER

tennis metaphor in the collection's closing lines, "It wasn't a match, I say. It was a lesson."[66] In other words, this collection is not meant to reverse engineer a racial hierarchy by beating her opponents; rather, Rankine's aim is pedagogical, enjoining readers/citizens to grieve for Martin as we would our own "dearest brothers, dear heart—."[67]

NOTES

Claudia Rankine, excerpts from *Citizen: An American Lyric* Copyright © 2014 by Claudia Rankine. Reprinted with the permission of The Permissions Company, LLC on behalf of Graywolf Press, www.graywolfpress.org (non-UK rights). From *Citizen* by Claudia Rankine published by Penguin. Copyright © Claudia Rankine, 2014. Reprinted by permission of Penguin Books Limited (UK rights).

1. David Mason, "Against Identity," review of *Citizen: An American Lyric*, by Claudia Rankine, *The Hudson Review* 68, no. 4 (2016): 669.
2. Dan Chiasson, "Color Codes," *The New Yorker*, October 27, 2014, http://www.newyorker.com/magazine/2014/10/27/color-codes.
3. Evie Shockley, Roderick A. Ferguson, Maria A. Windell, and Daniel Worden, "Reconsidering Claudia Rankine's *Citizen: An American Lyric*. A Symposium, Part I," *Los Angeles Review of Books*, January 16, 2016, https://lareviewofbooks.org/essay/reconsidering-claudia-rankines-citizen-an-american-lyric-a-symposium-part-i. For more critical commentary about *Citizen*, see essays by Maureen Gallagher and Anne Rashid in *Revisiting the Elegy in the Black Lives Matter Era*, ed. Tiffany Austin, Sequoia Maner, darlene anita scott, and Emily Ruth Rutter (New York: Routledge, 2020).
4. George Yancy and Janine Jones, "Introduction," in *Pursuing Trayvon Martin: Historical Contexts and Contemporary Manifestations of Racial Dynamics*, ed. George Yancy and Janine Jones (Lanham, MD: Lexington Books, 2013), 18.
5. As Alicia Garza notes on the "Herstory" page of the Black Lives Matter website, "I created #BlackLivesMatter with Patrisse Cullors and Opal Tometi, two of my sisters, as a call to action for Black people after 17-year-old Trayvon Martin was post-humously placed on trial for his own murder and the killer, George Zimmerman, was not held accountable for the crime he committed." Accessed January 20, 2016, http://blacklivesmatter.com/about/.
6. Cheryl Sublime Poetess Faison, "Preface," in *A Gathering of Words: Poetry and Commentary for Trayvon Martin*, ed. The Poets and Writers of Consciousness (Philadelphia: Inner Child Press, 2012), xiv.
7. Among other messages of support for Black Lives Matter, Beyoncé's visual album, *Lemonade* (2016), features Sybrina Fulton, Trayvon's Martin's mother, Lesley McSpadden, Michael Brown's mother, and Gwen Carr, Eric Garner's mother, holding photographs of their slain sons. See Beyoncé, *Lemonade*, Tidal, 1:05, April 23, 2016, http://listen.tidal.com/.

 The track "Alright" on Kendrick Lamar's 2015 album *To Pimp a Butterfly* has become a consistent rallying cry among Black Lives Matter supporters. During his 2016 Grammy performance, Lamar lodged a more explicit protest of systemic racism when he referenced February 26, 2012, the day Martin was shot and lamented, "This is modern-day slavery." See James West, "Watch Kendrick Lamar's Incredible Grammy Performance," *Mother Jones* video, 5:50, February 15, 2016, http://www.motherjones.com/mixed-media/2016/02/kendrick-lamar-grammy-performance.
8. "About Us," #BlackPoetsSpeakOut, accessed May 10, 2016, http://blackpoetsspeakout.tumblr.com/About.
9. Evie Shockley's "improper(ty) behavior" originally appeared in her collection *The New Black* (Middletown, CT: Wesleyan University Press, 2011). She reposted the poem with the additional lines about Martin on March 23, 2012, on the website Red Room under the title "Trayvon Martin's Murder Is Not an Anomaly."
10. See the "Appendix for Further Reading" in *Revisiting the Elegy in the Black Lives Matter Era* for a list of other Trayvon Martin elegies.
11. Claudia Rankine, *Citizen: An American Lyric* (Minneapolis, MN: Graywolf Press, 2014), 45, 77, 55.
12. Mark Strand and Eavan Boland, *The Making of a Poem: A Norton Anthology of Poetic Forms* (New York: Norton, 2000), 168; ellipses added.

MOURNING TRAYVON MARTIN

13. Jahan Ramazani, *Poetry of Mourning: The Modern Elegy from Hardy to Heaney* (Chicago: University of Chicago Press, 1994), 1, 135.

14. See chapter 4, "Renovating Blackness: Remembrance and Revolution in the Coltrane Poem," in Kimberly Benston's *Performing Blackness: Enactments of African-American Modernism* (New York: Routledge, 2000).

15. The following represent only a few of the many elegiac remembrances of Till: Langston Hughes's "Mississippi—1955" (1955); Gwendolyn Brooks's "A Bronzeville Mother Loiters in Mississippi. Meanwhile a Mississippi Mother Burns Bacon" and "The Last Quatrain of the Ballad of Emmett Till" (both 1960); James A. Emanuel's "Emmett Till" (1963); Audre Lorde's "Afterimages" (1981); Jerry W. Ward, Jr., "Don't Be Fourteen (In Mississippi)" (1982); Wanda Coleman's "Emmett Till" (1986); Sterling Plumpp, "Unremembered" (1997); Al Young's "The Emmett Till Blues" (2008); and Marilyn Nelson's *A Wreath for Emmett Till* (2005). See *Revisiting the Elegy in the Black Lives Matter Era; Words of Protest, Words of Freedom: Poetry of the American Civil Rights Movement and Era*, ed. Jeffrey Lamar Coleman (Durham, NC: Duke University Press, 2012); and *Emmett Till in Literary Memory and Imagination*, ed. Harriett Pollack and Christopher Metress (Baton Rouge: Louisiana State University Press, 2008), for further references to and examinations of elegies for Till. See also Stephen J. Whitfield, *A Death in the Delta: The Story of Emmett Till* (New York: The Free Press, 1998), for a full description of the gruesome murder of Till.

16. Kristin Boudreau, *The Spectacle Death: Populist Literary Responses to American Capital Cases* (New York: Prometheus Books, 2006), 136.

17. Ritz Dove, "Trayvon, Redux" (2013), *The Root*, July 16, 2013, https://www.theroot.com/trayvon-redux-by-rita-dove-1790897314.

18. Dove, "Trayvon Redux."

19. Danez Smith, "Short Film," in *Black Movie* (Minneapolis, MN: Button Poetry, 2015), 20, 21.

20. Smith, "Short Film," 20.

21. Rankine, *Citizen*, 152.

22. Rankine, "Conversation with Saskia Hamilton," *Lannan*, May 6, 2015, http://podcast.lannan.org/2015/05/11/claudia-rankine-with-saskia-hamilton-conversation-6-may-2015-video/.

23. Rankine, *Citizen*, 145.

24. Rankine cites Butler on page 49 of *Citizen*.

25. Judith Butler, *Undoing Gender* (New York: Routledge, 2004), 23.

26. "Citizen," *The Compact Oxford English Dictionary* (New York: Oxford University Press, 1971), 442.

27. Ann Cvetkovich, *An Archive of Feelings: Trauma, Sexuality, and Lesbian Public Cultures* (Durham, NC: Duke University Press, 2003), 11.

28. Rankine, *Citizen*, 10.

29. Rankine, *Citizen*, 10.

30. Rankine, *Citizen*, 11.

31. Rankine, *Citizen*, 88.

32. Rankine, *Citizen*, 89.

33. Mark Anthony Neal, *Looking for Leroy: Illegible Black Masculinities* (New York: New York University Press, 2013), 4.

34. Rankine, *Citizen*, 89.

35. Rankine, *Citizen*, 89–90.

36. Rankine, *Citizen*, 90.

37. Claudia Rankine and John Lucas, *Situation 5, Claudiarankine.com*, January 15, 2016, http://claudiarankine.com/situations/.

38. Rankine and Lucas, *Situation 5.*

39. Rankine, *Citizen*, 82.

40. Rankine, *Citizen*, 90.

41. Marcellus Blount, "Paul Laurence Dunbar and the African American Elegy," *African American Review* 41, no. 2 (2007): 241.

42. Rankine, *Citizen*, 92.

43. Kim Severson, "Weighing Race and Hate in a Mississippi Killing," *The New York Times*, August 22, 2011, http://www.nytimes.com/2011/08/23/us/23jackson.html?_r=0.

EMILY RUTH RUTTER

44. Rankine, *Citizen*, 93.

45. Rankine, *Citizen*, 94.

46. William Carlos Williams, "To Elsie," in *The Norton Anthology of American Literature*, Volume D, 8th edition, ed. Nina Baym and Robert S. Levine (New York: Norton, 2012), 307.

47. Rankine, *Citizen*, 114, 116. See Stephen Castle's "Police Cleared in 2011 Death That Incited British Riots," *The New York Times*, January 8, 2014, http://www.nytimes.com/2014/01/09/world/europe/officer-cleared -in-shooting-that-caused-riots-in-england.html.

48. Rankine, *Citizen*, 115, 116.

49. Stephanie M. Wildman and Adrienne D. Davis, "Making Systems of Privilege Visible," in *White Privilege: Essential Readings on the Other Side of Racism*, ed. Paula S. Rothenberg (New York: Worth Publishers, 2012), 111.

50. Claudia Rankine, "The Condition of Black Life Is One of Mourning," *The New York Times*, June 22, 2015, http://www.nytimes.com/2015/06/22/magazine/the-condition-of-black-life-is-one-of-mourning.html?_r=0.

51. Rankine, *Citizen*, 105, 106, 108, 109. In the final iteration of this passage, Rankine inserts the word "still" so that it reads, "And still you are not the guy and still you fit the description because there is only one guy who is always the guy fitting the description."

52. Smith, "Short Film," 21.

53. "Florida's Stand Your Ground Law," *Tampa Bay Times*, October 1, 2014. Accessed August 20, 2018.

54. Rankine, *Citizen*, 134.

55. Rankine, *Citizen*, 135.

56. Rankine, *Citizen*, 150.

57. Michelle Alexander, *The New Jim Crow: Mass Incarceration in the Age of Colorblindness* (2010; New York: The New Press, 2012), 2; ellipses added.

58. Rankine, *Citizen*, 151.

59. Rankine, *Citizen*, 151.

60. George Yancy, "Trayvon Martin: When Effortless Grace Is Sacrificed on the Altar of the Image," in *Pursuing Trayvon Martin*, 244.

61. Rankine, *Citizen*, 66; ellipses added.

62. Rankine, *Citizen*, 140.

63. Rankine, *Citizen*, 140, 146, 159. In the final iteration, the pronouns read "him her us you me," whereas the previous two unfold as "I they he she we you."

64. Rankine, *Citizen*, 159.

65. Ramazani, *Poetry of Mourning*, x.

66. Rankine, *Citizen*, 159.

67. Rankine, *Citizen*, 89.

CODA

Post Vitam Amicitiae, *or The Afterlife of a Friendship*

MAE G. HENDERSON

Cheryl A. Wall

1948–2020
Sister, Colleague, Educator, Scholar, Literary Critic, Teacher, Friend

Of all the women I have known, my friend Cheryl Wall—during the course of a personal and professional friendship that spanned nearly a half century—embodied, for me, the deep compassion, profound humanity, and strong principles expressed in Wollstonecraft's notion of friendship as "the most sublime of all affections."

The submission of this volume to press marks the third year since the passing of my friend and colleague, Cheryl Ann Wall. And it is my honor to dedicate this work to a pioneering scholar and devoted mentor who touched so many lives through her writing, speaking, and teaching, as well as through the generosity of her intellect. As Cora Kaplan's admirable collection of essays from her colleagues and former students attests, Cheryl Wall gave of herself—her time, her insight, her guidance—in order to pass on the legacy to which her work so profoundly contributed and to help others to fulfill their academic quests and potentials.

The Afterword, or Coda, to a volume, itself predicated upon words, makes it no less difficult to find the language to capture the sense of sorrow that I feel as a colleague, the sense of privation I feel as a sister scholar, and the sense of bereavement I feel at the loss of one who envisioned future plans and projects. I feel an acute sense of the limitations of language, the futility of words, when confronted with the bewildering reality of the sudden and unexpected death of my friend. My heart, as the Chinese proverb says, speaks in many tongues, but my lips seek to maintain their silence, bound perhaps by the belief that meaningful silence is better than meaningless words—an injunction that itself threatens to collapse into commonplace.

The ephemerality of life and the finality of death has challenged poets and prophets, preachers and philosophers. And as I desperately seek a language beyond the palliative platitudes and timeworn tropes that we necessarily turn to at such times to express our sense of loss and grief, I find myself entrapped by the boundaries of language and convention—and perhaps, too, a failure of imagination—upon engaging the discourse of mortality.

Cheryl Wall's personification of principle (she was a loyal friend and devoted church woman), her embrace of family (she was a doting mother and loving sister), her historical race

MAE G. HENDERSON

Figure C.1. Personal inscription from Cheryl Wall to Mae Henderson on the title page of Wall (ed.), *Zora Neale Hurston: Novels and Stories* (Library of America, 1995). From the collection of Mae Henderson.

Figure C.2. Cheryl Wall, 2019 Black Women Writers at Work Symposium, Duke University. Photograph by Les Todd.

consciousness and contemporary feminist sensibility—all these combined to produce a courageous spirit, a formidable intellect, and that increasingly rarest of qualities: high moral integrity. She was indeed what Henry James might have called a *rara avis*—an accomplished pianist, a meticulous and prolific scholar, a world traveler and self-acknowledged Francophile, a voracious reader (she eagerly anticipated the *New York Times* each Sunday morning and *Time Magazine* during the week), a drama enthusiast and charter member of Crossroads Theatre (a local Black repertory company), and so, so much more. She enjoyed her teaching and writing, and savored the salt of life. She adored daughter Camara (her "sweet inspiration"), and she was generous with friends. And it was my sheer good fortune to be counted among them. For my part, she was among the closest of few friends—a friend whom, as the Bard wrote, one sought to "grapple . . . unto [one's] soul with hoops of steel."

I knew from the moment of her passing that writing, or speaking, about the loss of my friend—a loss mourned by so many—would not be easy. Profound grief robs one of speech. And the morning I received Claudine Raynaud's group email informing me and others of Cheryl's shocking and unexpected death, I could think only of her projected conference keynote that she had discussed during our last conversation and of her forthcoming retirement celebration and how she had wanted to make sure that I'd received an invitation. As I reflected on this last phone conversation, it occurred to me that we know not our final words with friends. Nor do we know when fate will call upon us to say final words about friends.

CODA

From that moment until now, I have been unable to speak of my friend's passing. And though it is most certainly a cliché, I can only say that words failed me. Any words I could summon seemed shallow and totally incommensurate with the depth of feeling I experienced. Like Zora Neale Hurston's Janie in *Their Eyes Were Watching God*, I think now that I was too busy feeling grief to publicly form an expression or show of grief.

But I now seek to find words to express my sense of profound loss and deep appreciation for the best woman I ever knew—a sentiment that, thankfully, I sometimes shared with her. As Scipio Africanus reportedly said to Gaius Laelius, his faithful and devoted friend, "[N]othing is more difficult than for friendship to last through life." I know that I was not Cheryl Wall's *best* friend, but I was privileged to call her friend for the greater part of my life.

And now, it is not easy for me to speak *about* my friend; I'd so much rather be speaking *with* her. I wish that we could be "changing words," as we did for so many years (before the advent of email, Facebook, Instagram, and texting). In later years, we would lament the absence of a record or recording of these very conversations that, or so we thought, would have given a unique perspective on the events resulting in the paradigmatic shift that changed the ways of reading Black women's writing. Nevertheless, the voice that I now hear, the image that now confronts me of my friend, are as bright and ebullient as our late-night soulful phone conversations—at times accompanied by a glass or two of red or white (*in vino veritas!*)—that erased time and closed distance, engaging us in and with an interpretive community of writers and critics who were building and defining a field of study.

Cheryl and I first met at a summer seminar on minority literature at Yale University where I was then completing my graduate studies. It was during the late seventies and early eighties—a turbulent and politically fraught period characterized by the Anti-Apartheid Movement, the Black Power and Black Arts Movements, the emergence of second wave feminism, and the gay rights movements. It was also a moment that saw the introduction of African American literature and women's writing into the Modern Language Association, the US academy, and popular culture.

As young scholars and burgeoning critics of Black and women's literature, we were tooling up to explore the riches of a literary tradition bequeathed to us by earlier generations of African American women. It was an exciting and heady time! I remember my delight in discovering someone else who was reading and thinking and writing about Zora Neale Hurston, Paule Marshall, Toni Cade Bambara, Toni Morrison, and Alice Walker. It seems, in retrospect, that Cheryl and I at once formed an intellectual affinity, motivated by a mutual passion for reclaiming a legacy—a legacy that had been lost or obscured. We two began a dialogue—changing words— that quickly became a journey. It was a promising moment in the profession, but the journey on which we embarked proved at times uphill, rocky, and perilous, while at other times the open road beckoned, gratifying and rewarding. The fruit borne of that journey is evidenced in the corpus of work left by Cheryl Wall for generations of scholars.

Sometime afterward, Cheryl began planning for her now historic symposium, Changing Our Own Words, which she brought to fruition at Rutgers University in October 1987. It was a brilliant gathering of students and scholars whose work would define and shape the field for generations to come. I recall this occasion, in particular, for two reasons: The first is that Cheryl wished to introduce me to a sister scholar whom she described as remarkable. It was at this

conference where I first made the acquaintance of my friend and colleague, Hortense Spillers. And, secondly, it was a deeply meaningful moment, for me, since it was at this event that I debuted my signature essay, "Speaking in Tongues." Two years later, Rutgers University Press published the critical volume based on this symposium, and Cheryl Wall's *Changing Our Own Words: Essays on Criticism, Theory, and Writing by Black Women* became a foundational text in feminist criticism. But what is not generally known are the obstacles Cheryl confronted in launching this project. Time and again, she was discouraged by the Press, which envisioned no audience or interest for such a volume. But Cheryl was not one easily to give up once she'd made up her mind. Undaunted, she persevered until the book became a reality—and generations of scholars are forever grateful!

There were doubtlessly many sessions, symposia, and conferences that Cheryl and I shared, but snapshots associated with two stand out in retrospect. The first is a conference on Black writers hosted by Claudine Raynaud at the University of Tours in 1991. The conference itself was a brilliant and elegant international gathering of scholars sharing their work in the stimulating and convivial ambience of the French academy. Before the conference actually began, however, Cheryl and I had what I eerily recall as a kind of Baldwinian moment in this beautiful, quaint university town located in the historic Loire Valley (see figures C.3 and C.4). And though the circumstances were far different from the *drap de lit* incident that James Baldwin

Figure C.3. Cheryl Wall, 1991, photographed by Mae Henderson, Tours, France. From the collection of Mae Henderson.

Figure C.4. Mae Henderson, 1991, photographed by Cheryl Wall, Tours, France. From the collection of Mae Henderson.

CODA

describes in "Equal in Paris" (in fact, our situation was the reverse of Baldwin's), it is fair to say that our experience with the French legal system gave us a similarly startling insight. Cheryl and I had taken the TGV from Paris and arrived at the *Gare de Tours* on what I recollect as an overcast and rainy day. We were attempting to hail a cab from the station to the University when Cheryl felt a light tug on her handbag, but, alas, too late to prevent the flight of the *voleur*. We reported the theft (her passport and travel funds had been taken) to a local gendarme, and were instructed to return to the *Préfecture de police* the next day. What followed was a revealing, if unsettling, experience. After filling out reams of paperwork, Cheryl was presented with a large and weighty volume by the French police. The sheer size of the book in question was daunting, even to a seasoned reader of texts, as Cheryl surely was. It proved to be a picture book—photos and sketches of racial and ethnic types, including French-speaking peoples from Black, Arab, and other minority backgrounds. Cheryl was asked to identify the *phenotype* of the culprit based on the pictures presented to her. After a perusal of the volume, Cheryl informed the book bearer that she was unable to make any identification based on racial/ethnic classifications. What we had borne witness to (and what Baldwin surely understood during his years of exile in France) was something uncannily familiar. Afterward, Cheryl whispered to me that she had indeed caught a glimpse of the young man who had run off with the contents of her handbag and that he had been visibly Arab in appearance. We were, of course, well aware of France's settler history with Algeria, the second-class treatment of French-born Algerians, and the appalling condition of Algerian immigrants in France. When Cheryl and I left the *commissariat*, we spoke of the incident, but said little to our conferees about our experience with the French police. Thinking about the incident much later, I hoped that, under similar circumstances, I too would have had the courage that day to choose illiteracy, rather than literacy!

The second snapshot comes from a symposium that Cheryl and I were invited to attend while I was on fellowship leave in New Brunswick, New Jersey, at the Women's Institute at Rutgers in 1988–1989. The conference was hosted by a prominent colleague, and focused on the status of African American literature in the 1990s. As younger scholars in the field, Cheryl and I were honored to be invited to participate, and proud of the work and accomplishments of the conference conveners. We drove from New Brunswick to the one-day symposium, which took place just outside of Philadelphia. Excited to be chosen as respondents to the primary presenters at this invitational symposium, all along the way, we sang the praises of the conference host, an Esteemed Scholar who had recently published a well-received and much talked-about monograph. In fact, the Esteemed Scholar's book had been the topic of a small reading group of interested Black women scholars at Rutgers, including Abena Busia, Cheryl Clarke, Cheryl Wall, and myself. Expressing our pride and admiration of the Esteemed Scholar for his academic achievements, along with his future in the profession, we happily concluded that we "wanted one just like him." Yes, we were young and starstruck, and in awe of his considerable accomplishments in a field of study that was rapidly changing as scholars confronted the nexus of Black literature, theory, and the project of literary recovery. I do not remember precisely why—whether we had gotten off to a late start, encountered unexpected traffic on the Jersey Turnpike, or had car trouble—but for some now forgotten reason, our arrival was delayed. In any event, what I do remember is that we were present for most, if not all, of the presentations and we ourselves were able to formally

281

MAE G. HENDERSON

respond to papers we had received in advance. What I most recall, however, in the electrified (and rarified) air of this gathering, were two incidents. The first is that the participants were given a coded injunction by the Esteemed Scholar, one which we well understood, that we must never allow another "Reconstruction of Instruction" to take place! We were admonished that, as guardians of a tradition and legacy, those of us present—the chosen, as it were—were entrusted with the sacred mission of defining the future direction of Black literary studies.

The second incident involved not high literary injunctions, but the practical and conceptual way in which a rather vigorous exchange among conferees would be represented in a forthcoming symposium-based volume. As editor, the Esteemed Scholar wished to incorporate the presumably secondary, critical responses from the presumably secondary scholars into the primary presentations *before* publication. However, there were present in the postmortem following the symposium those who voiced objections to what seemed an appropriation of their work, insisting on preserving the integrity of their critiques. As a consequence, it was decided to restructure the volume as a dialogue between presenters and responders. I, for one, was delighted with what I deemed to be a dialogic (rather than monologic) approach to the project. Nevertheless, it seemed a long drive back to New Brunswick—but Cheryl and I remained, on the whole, in elevated spirits, looking forward to the forthcoming volume, with the inclusion of our work.

Imagine, then, months later, when we heard through the Black academic grapevine (the precursor to Black Twitter) that the Esteemed Scholar who had convened the conference had bruited about that Cheryl and I had deliberately staged a late entry to the symposium in order to—we could not believe it!—*sabotage* (that was the word that I remember) the event! We were staggered! Apparently, the Esteemed Scholar had misconstrued our tardiness as a subversive (Black) feminist ploy! We were duly chastened by the Esteemed Scholar's misreading of our inadvertent tardiness. And, for my part at least, these events, and the rather startling aftermath of the conference, became something of a cautionary tale. Not only did they suggest the dangers in promulgating notions of exclusion and exclusivity on the one hand, and the practice of appropriation on the other, but the very real consequences of intentional or unintentional misreading. For it is precisely these very notions and practices that have led to the exclusion and marginalization of Black and women's literature—and, by extension, Black women's literature! The chastisement of the "dutiful daughters" by the "founding fathers" pointed to the pressing need to oppose the replication of dominant (race and gender) ideologies and practices, and suggested the need for a kind of un-mapping of traditional genealogies governing the construction of "traditions" or legacies. Despite the paternalistic and misguided assumptions of the Esteemed Scholar, this moment provided a beacon lighting the future direction of the (Black) feminist project that was to shape both our careers.

As I note above, my reticence, until now, has been borne of a sense of shock and grief, and beyond this, it is a consequence of my sense of unease resulting from something of a lapse in our friendship. Rarely did my friend and I disagree, but we had our moments, and during the latter years our personal encounters were few and the phone calls, fewer. Yet, though we spoke less and saw each other less, a genuine affinity remained, and we shared life events. I attended the wedding of Cheryl's daughter Camara, and Cheryl was present for a lifetime achievement

CODA

award I received from my high school alma mater. In my mind, I continued to cherish the notion that, years from now, in the still distant future, undistracted by schedules and deadlines, term papers and theses, my friend and I would recollect, amidst laughter and tears, the small triumphs and defeats of years gone by, that we would nostalgize—perhaps even memorialize—those moments and finally settle into the dreaded but preordained roles that students would inevitably bestow on our generation: *foremothers.*

We began as hopeful and aspiring graduate students, matured into professional and seasoned scholars and critics, and, finally, not without some reluctance, began to embark on that inevitable Sankofa journey of looking back while looking forward. And now I recall conversations long past rehearsed about a rising star in the field, a recently published biography that appeared in the *New York Review of Books*, the announcement of the next national *poet laureate*, a new novel that must surely find its place on the fall syllabus—and, of course, our favorite pastime: quoting from the Book of Morrison!

As Morrison's Paul D said of Sethe, Cheryl was indeed "a friend of my mind." As the Ancient Greeks and modern psychologists might say, our friendship was a cultivation of mind. But as a "sister in the spirit," she was also someone you could call, day or night, and who would inevitably respond, "Girl, I was just thinking 'bout you!" At other times, one might be just on the verge of dialing when the phone rings with the familiar greeting, the knowing whisper, "Hey Girl, did you hear . . . ?" such-and-such-a-one is leaving Harvard or Princeton due to "Hush Girl, don't even say it!" And too often the stunned, quiet calls, "I'm sorry to be the one to tell you," followed by the solemn invocation of a brilliant scholar or famous artist who has transitioned at the height of his or her productivity or creativity.

Thinking back on my relationship with Cheryl, whose wise counsel, intellectual courage, and critical independence I realize now that I had begun already to miss during the latter years, for reasons that neither of us ever discussed nor, indeed, ever fully acknowledged, I experience regret that I should have allowed anything to deprive me of even moments to be shared in a radiant and remarkable friendship with one whom Harriet Jacobs might have described as a "whole-souled" woman.

There are those who have scores of friends—so many that friendship seems commonplace, and friends seem rather like the collectibles one picks up in a bargain basement or thrift shop. Some have described these relationships as transactional—with "deal" rather than "real" friends. Others refer to such practices as networking, a social custom now technologized and greatly facilitated by platforms such as X (formerly Twitter), Instagram, Facebook, TikTok, and other social media. More recently, however, I have learned to embrace the sacred and profoundly existential significance of friends and friendship. For me, as someone in possession of few friends, real friendship is the highest and most perfect manifestation of love, or as Mary Wollstonecraft described friendship in her *Vindication of the Rights of Woman*, "the most sublime of all affections . . . founded on principle, and cemented by time."

I have often thought that what Toni Morrison says of love and the lover can be said of friendship and the friend. From this point of view, then, one might say that friendship is never any better than the friend herself. Wicked people "friend" wickedly, violent people "friend" violently, and stupid people "friend" stupidly. What Morrison implies, but does not say, is that real love can exist only between good and true lovers—and I would add that real friendship can exist

only between good and true friends. One recognizes that in order to have a good friend, one must be a good friend. And here I speak of true friendship—not friendships that are a matter of calculating returns and deficits, but friendships that share the rewards of good times, and, in bad times, take consolation from the rewards of a friendship that lessens the loss. Such friendships are neither "timely" nor "seasonable"; they are life friendships.

I have had both friends and lovers—and friends who were also lovers. I have had female and male friends—in fact, on the whole, more men than women friends. But I can say unequivocally that when I did not have a girlfriend, a real girlfriend, whom I could call at any time—day or night—my life was not only lonely, but impoverished, spiritually and emotionally, and I might go so far as to say, at peril.

Once I had a girlfriend (sometimes real friends reveal themselves to be seasonable friends) who was, shall we say, marvelously "multiloquent." She happened to reside in a different state, and sometimes opined on the thousands of dollars she was able to save by calling her friends instead of going to a therapist (and this when AT&T still had a virtual monopoly and charged by the minute for long-distance calls). Her point, however, is well taken: When we are feeling lonely, lost, isolated, misunderstood, outraged, or just plain crazy, these are the times when a "holler," a talk, a primal scream, or even a good cry to a real friend—someone who has shared life and love and even grief—can become a lifeline to hope and promise. With the simple words, "Girl, girl," one can call a real friend at the midnight hour, and she knows just what you're talking about before you say anything more. And if that friend were wise, empathetic, and true, like my friend Cheryl, she would know just what to say—and *not* to say!

In this season of my life, the loss of a real friend is acute. And the sense of loss of a sister scholar and life friend with whom one has labored in the proverbial academic vineyard is, for me, poignant and bruising. The absence of an interlocutor, a visionary, a compassionate critic, remains like the phantom limb after an amputation; it haunts one, it hurts one; it is a wounding that does not heal, an ache that does not go away, the rent in a fabric that cannot be mended. To experience such a loss, especially as one becomes a veteran of life and its assorted battles—and I speak here of adversity as well as age—is without recovery. Without my friend I am bereft of a part of myself. I am incomplete since I exist in part because I am recognized by my friend—a friend who sees me as I am and who I can potentially become. Cheryl was such a friend!

Cheryl and I shared in an intellectual adventure; we exchanged thoughts and ideas that have been essential to my life and learning and growth. What we shared was a rare and inexpressibly gratifying—one might call it *sublime*—friendship.

I have lived on after the death of my friend. I am a survivor. To "survive" literally means to "live beyond." It comes from two Latin words: *super*, which means "above, over, or beyond" and *vivere*, which means "to live." And as a survivor, one can never forget; one must bear witness; leave a record; pay tribute—whatever the place, whatever the time. That is the unwritten, perhaps unstated, pact of what the philosopher Cicero described as "perfect and true" friendship—and what the Greeks described as *philia*. To my mind, Cheryl and I had such a friendship—and here is my attempt to archive for posterity something of that friendship, and its afterlife.

Chapel Hill, North Carolina
December 2023

CODA

SELECTED BIBLIOGRAPHY OF WORKS BY CHERYL A. WALL

Changing Our Own Words: Criticism, Theory, and Writing by Black Women (editor, 1989)
Women of the Harlem Renaissance (1995)
Zora Neale Hurston: Novels and Stories (editor, 1995)
Zora Neale Hurston: Folklore, Memoirs, and Other Writings (editor, 1995)
"Sweat": Texts and Contexts (editor, 1997)
Their Eyes Were Watching God: A Casebook (editor, 2000)
Worrying the Line: Black Women Writers, Lineage, and Literary Tradition (2005)
Savoring the Salt: The Legacy of Toni Cade Bambara (editor, 2007)
The Harlem Renaissance: A Very Short Introduction (2016)
On Freedom and the Will to Adorn: The Art of the African American Essay (2019)

ACKNOWLEDGMENTS

The editors gratefully acknowledge the Humanities Center at the University of California, Irvine, for publication grants to offset the cost of images and permissions.

Stella Setka's essay, "Yoruba Visions of the Afterlife in Phyllis Alesia Perry's *Stigmata*," first appeared, in slightly different form, as "'The Circle Stands before You': Reincarnation and Traumatic Memory in Phyllis Alesia Perry's Stigmata" in *MFS: Modern Fiction Studies*, volume 68, no. 3, Fall 2022, pp. 482–505. Published by Johns Hopkins University Press. Copyright © 2022 Purdue University.

Meina Yates-Richard's essay, "The Sonic Afterlives of Hester's Scream: The Reverberating Aesthetic of Black Women's Pain in the Black Nationalist Imagination from Slavery to Black Lives Matter," has appeared, in somewhat different form, as "'WHAT IS YOUR MOTHER'S NAME?': Maternal Disavowal and the Reverberating Aesthetic of Black Women's Pain in Black Nationalist Literature," *American Literature* 88, no. 3 (2016), 477–507. Copyright © 2016, Duke University Press. All rights reserved. Republished by permission of the copyright holder and the Publisher (www.dukeupress.edu).

Kajsa K. Henry's essay, "Mapping Loss as Performative Research in Ralph Lemon's *Come home Charley Patton*," has appeared, in somewhat different form, as Kajsa Henry, "Mapping Loss as Performative Research in Ralph Lemon's *Come home Charley Patton*," *PARTake: The Journal of Performance Research*, vol. 3, no.1 (2020). Republished by permission of the copyright holder and the Publisher (www.partakejournal.org).

Quotations from M. NourbeSe Philip's *Zong!*, first published by Wesleyan University Press, 2008, Middleton, CT, are reprinted by permission of M. NourbeSe Philip.

Quotations from Frank X Walker's *Turn Me Loose: The Unghosting of Medgar Evers* (University of Georgia Press, 2013) are reprinted by permission of Frank X Walker and The University of Georgia. Walker's "Arlington" was originally published in *Black Magnolias*, vol. 2, no. 4, December–February 2008–2009.

Quotations from Gwendolyn Brooks's "A Bronzeville Mother Loiters in Mississippi. Meanwhile a Mississippi Mother Burns Bacon" are reprinted by consent of Brooks Permissions.

Quotations from Dominique Christina's poems "For Emmet Till" and "Karma" are reprinted by permission of Dominique Christina.

Claudia Rankine, excerpts from *Citizen: An American Lyric* Copyright © 2014 by Claudia Rankine. Reprinted with the permission of The Permissions Company, LLC on behalf of Graywolf

ACKNOWLEDGMENTS

Press, www.graywolfpress.org (non-UK rights). From *Citizen* by Claudia Rankine published by Penguin. Copyright © Claudia Rankine, 2014. Reprinted by permission of Penguin Books Limited (UK rights).

SELECTED BIBLIOGRAPHY

Abdullahi, Abubakar. "Noble Savages, Communists and Terrorists: Hegemonic Imperatives in Mediated Images of Africa from Mungo Park to Gaddafi." *Africa Media Review* 5, no. 2 (1991): 1–15.

Abraham, Nicolas, and Maria Torok. *The Shell and the Kernel: Renewals of Psychoanalysis*. Translated by Nicholas T. Rand. Chicago: University of Chicago Press, 1994.

Abu-Jamal, Mumia. *All Things Censored*. Edited by Noelle Hanrahan. New York: Seven Stories Press, 2000.

———. *Death Blossoms: Reflections from a Prisoner of Conscience*. Cambridge, MA: South End Press, 1996.

Achebe, Chinua. "Chi in Igbo Cosmology." In *Morning Yet on Creation Day: Essays*, by Chinua Achebe, 159–175. London: Heinemann, 1975.

Agamben, Giorgio. "Biopolitics and the Rights of Man." In *Biopolitics: A Reader*, edited by Timothy Campbell and Adam Sitze, 152–160. Durham, NC: Duke University Press, 2013.

———. "The Politicization of Life." In *Biopolitics: A Reader*, edited by Timothy Campbell and Adam Sitze, 145–151. Durham, NC: Duke University Press, 2013.

———. *Remnants of Auschwitz: The Witness and the Archive*. Translated by Daniel Heller-Roazen. New York: Zone Books, 2000.

Alexander, M. Jacqui. *Pedagogies of Crossing: Meditations on Feminism, Sexual Politics, Memory, and the Sacred*. Durham, NC: Duke University Press, 2005.

Alexander, Michelle. *The New Jim Crow: Mass Incarceration in the Age of Colorblindness*. New York: New Press, 2011.

Anderson, Allan. "African Religions." *Encyclopedia of Death and Dying*. Last modified 2016, http://www.deathreference.com/A-Bi/African-Religions.html#ixzz4Bvc1fnZd.

Anderson, Melanie R. *Spectrality in the Novels of Toni Morrison*. Knoxville: University of Tennessee Press, 2013.

Andrews, William L. *To Tell a Free Story: The First Century of Afro-American Autobiography, 1760–1865*. Chicago: University of Chicago Press, 1986.

Anzaldúa, Gloria. *Borderlands/La Frontera: The New Mestiza*. San Francisco: Aunt Lute Books, 1987.

Arnold, Regina. "There's a Spectre Haunting Hip-hop: Tupac Shakur, Holograms in Concert and the Future of Live Performance." In *Death and the Rock Star*, edited by Catherine Strong and Barbara LeBrun, 177–188. New York: Routledge, 2015.

Asim, Jabari. "An Interview with Frank X Walker." *The Crisis Magazine* 120, no. 3 (2013): 32–33.

Assman, Jan, and John Czaplicka. "Collective Memory and Cultural Identity." *New German Critique* 65 (1995): 125–133.

Austen, Veronica J. "*Zong!*'s 'Should We?': Questioning the Ethical Representation of Trauma." *ESC: English Studies in Canada* 37, nos. 3–4 (2011): 61–81.

Austin, Tiffany, Sequoia Maner, darlene anita scott, and Emily Ruth Rutter, eds. *Revisiting the Elegy in the Black Lives Matter Era*. New York: Routledge, 2020.

Bakhtin, M. M. *The Dialogic Imagination*. Edited by Michael Holquist. Translated by Caryl Emerson and Michael Holquist. Austin: University of Texas Press, 1981.

Baldwin, James. *The Fire Next Time*. 1962. Reprint, New York: Vintage, 1993.

SELECTED BIBLIOGRAPHY

Baraka, Amiri. *Slave Ship: A Historical Pageant.* In *The Motion of History and Other Plays*, 129–150. New York: William Morrow, 1978.

Barthes, Roland. *The Rustle of Language.* Translated by Richard Howard. Berkeley: University of California Press, 1989.

Bascom, William Russell. *Sixteen Cowries: Yoruba Divination from Africa to the New World.* Bloomington: Indiana University Press, 1980.

Baucom, Ian. *Specters of the Atlantic: Finance Capital, Slavery, and the Philosophy of History.* Durham, NC: Duke University Press, 2005.

Baum, Robert Craig. "Tree: Belief/Culture/Balance (Book Review)." *Theatre Journal* 57, no. 4 (2005): 772–774.

Beinart, William, and Peter Coates. *Environment and History: The Taming of Nature in the USA and South Africa.* New York: Routledge, 1995.

Benjamin, Ruha. "Black Afterlives Matter: Cultivating Kinfulness as Reproductive Justice." In *Making Kin Not Population: Reconceiving Generations*, edited by Adele E. Clarke and Donna Haraway, 41–65. Chicago: Prickly Paradigm Press, 2018.

Benjamin, Walter. *Illuminations.* Translated by Harry Zohn. New York: Harcourt, Brace & World, 1968.

———. "On the Concept of History," translated by Harry Zohn. In *Walter Benjamin, Selected Writings Volume 4: 1938–1940*, edited by Howard Eiland and Michael W. Jennings, 389–400. Cambridge, MA: The Belknap Press, 2004.

Benston, Kimberly W. "'I Yam what I Am': Naming and Unnaming in Afro-American Literature." *Black American Literature Forum* 16, no. 1 (1982): 3–11.

———. *Performing Blackness: Enactments of African-American Modernism.* New York: Routledge, 2000.

Berger, Iris. *South Africa in World History.* New York: Oxford University Press, 2009.

Berlant, Lauren. "The Female Woman: Fanny Fern and the Form of Sentiment." *American Literary History* 3, no. 3 (1991): 429–454.

Birns, Nicholas. "Ritualizing the Past: Ralph Lemon's Counter-Memorials." *PAJ: A Journal of Performance and Art* 27, no. 3 (2005): 18–22.

Blount, Marcellus. "Paul Laurence Dunbar and the African American Elegy." *African American Review* 41, no. 2 (2007): 239–246.

Boateng, Boatema. *The Copyright Thing Doesn't Work Here: Adinkra and Kente Cloth and Intellectual Property in Ghana.* Minneapolis: University of Minnesota Press.

Bolden, Barbara Jean. *Urban Rage in Bronzeville: Social Commentary in the Poetry of Gwendolyn Brooks, 1945–1960.* Chicago: Third World Press, 1999.

Boudreau, Kristin. *The Spectacle Death: Populist Literary Responses to American Capital Cases.* New York: Prometheus Books, 2006.

Brand, Dionne. *A Map to the Door of No Return: Notes to Belonging.* Toronto: Doubleday Canada, 2001.

Brathwaite, Edward Kamau. "The African Presence in Caribbean Literature." *Daedalus* 103, no. 2, Slavery, Colonialism, and Racism (1974): 73–109.

Brathwaite, Kamau. *The Development of Creole Society in Jamaica, 1770–1820.* Kingston, Jamaica: Ian Randle, 2005.

Brecht, Bertolt. *Brecht on Theatre: The Development of an Aesthetic.* Edited and Translated by John Willett. New York: Hill and Wang, 1964.

Brogan, Kathleen. *Cultural Haunting: Ghosts and Ethnicity in Recent American Literature.* Charlottesville: University of Virginia Press, 1998.

Brokowski, Carolyn, and Mazhar Adli. "CRISPR Ethics: Moral Considerations for Applications of a Powerful Tool." *Journal of Molecular Biology* 431, no. 1 (2019): 88–91.

Brooks, Daphne. *Bodies in Dissent: Spectacular Performances of Race and Freedom, 1850–1910.* Durham, NC: Duke University Press, 2006.

Brooks, Kinitra. "Maternal Inheritances: Trinity Formations and Constructing Self-Identities in *Stigmata* and *Louisiana.*" *FEMSPEC* 12, no. 2 (2012): 17–46.

Browne, Simone. *Dark Matters: On the Surveillance of Blackness.* Durham, NC: Duke University Press, 2015.

Brunt, Shelley D. "Performing beyond the Grave: The Posthumous Duet." In *Death and the Rock Star*, edited by Catherine Strong and Barbara LeBrun, 165–176. New York: Routledge, 2015.

SELECTED BIBLIOGRAPHY

Burnham, Michelle. *Captivity and Sentiment: Cultural Exchange in American Literature, 1682–1861*. Hanover, NH: University Press of New England, 1997.

Butler, Judith. *Undoing Gender*. New York: Routledge, 2004.

Butler, Octavia. *Fledgling*. New York: Seven Stories Press, 2005.

Caruth, Cathy. "Introduction to Part II: 'Recapturing the Past.'" In *Trauma: Explorations in Memory*, edited by Cathy Caruth, 151–157. Baltimore, MD: Johns Hopkins University Press, 1995.

———. *Unclaimed Experience: Trauma, Narrative, and History*. Baltimore, MD: Johns Hopkins University Press, 1996.

Castronovo, Russ. *Necro Citizenship: Death, Eroticism, and the Public Sphere in the Nineteenth-Century United States*. Durham, NC: Duke University Press, 2001.

Césaire, Aimé. *Discourse on Colonialism*. Translated by Joan Pinkham. 1955; New York: Monthly Review Press, 2001.

Chandler, Nahum. *X: The Problem of the Negro as a Problem for Thought*. New York: Fordham University Press, 2014.

Chang, Jeff. *Can't Stop Won't Stop: A History of the Hip-Hop Generation*. New York: St. Martin's Press, 2005.

Charlson, Doria E. "'My Body is a Memory Map': Embodied History in Ralph Lemon's *Come home Charley Patton*." *Shift: Graduate Journal of Visual and Material Culture* 8, Space, Alterity, Memory (2015), 78–88.

Chassot, Joanne. *Ghosts of the African Diaspora: Re-Visioning History, Memory, and Identity*. Chicago: University of Chicago Press, 2018.

Chatelain, Marcia, and Kaavya Asoka, "Women and Black Lives Matter: An Interview with Marcia Chatelain." *Dissent* 63, no. 3 (2015): 54–61.

Cheney, Patrick, and Philip Hardie. *The Oxford History of Classical Reception in English Literature, 1558–1660*. Vol. 2. Oxford: Oxford University Press, 2015.

Chinwezu. *The West and the Rest of Us: White Predators, Black Slavers, and the African Elite*. New York: Random House, 1975.

Cho, Grace M. *Haunting the Korean Diaspora: Shame, Secrecy, and the Forgotten War*. Minneapolis: University of Minnesota Press, 2008.

Clifford, James. *Routes: Travel and Translation in the Late Twentieth Century*. Cambridge, MA: Harvard University Press, 1997.

Cloutier, Jean Christophe. *Shadow Archives: The Lifecycles of African American Literature*. New York: Columbia University Press, 2019.

Coker, Cheo Hodari. *Unbelievable: The Life, Death, and Afterlife of the Notorious B.I.G*. New York: Three Rivers Press, 2003.

Coleman, Jeffrey Lamar, ed. *Words of Protest, Words of Freedom: Poetry of the American Civil Rights Movement and Era*. Durham, NC: Duke University Press, 2012.

Coleman, Robin R. Means. *Horror Noire: Blacks in American Horror Films from the 1890s to Present*. New York: Routledge, 2011.

Collins, Patricia Hill. *Black Sexual Politics: African Americans, Gender, and the New Racism*. New York: Routledge, 2005.

Crais, Clifton, and Pamela Scully. *Sara Baartman and the Hottentot Venus: A Ghost Story and a Biography*. Princeton, NJ: Princeton University Press, 2009.

Craps, Stef. *Postcolonial Witnessing: Trauma Out of Bounds*. New York: Palgrave Macmillan, 2013.

Crawley, Ashon. *Blackpentecostal Breath: The Aesthetics of Possibility*. New York: Fordham University Press, 2017.

Crowder, Michael, ed. *The Cambridge History of Africa. Volume 8, from c. 1940 to c. 1975*. Cambridge: Cambridge University Press, 1984.

Cugoano, Quobna Ottobah. *Thoughts and Sentiments on the Evil of Slavery and Other Writings*. Edited by Vincent Carretta. New York: Penguin Books, 1999.

Curry, Mary Cuthrell. *Making the Gods in New York: The Yoruba Religion in the African American Community*. New York: Garland Publishing, 1997.

Cvetkovich, Ann. *An Archive of Feelings: Trauma, Sexuality, and Lesbian Public Cultures*. Durham, NC: Duke University Press, 2003.

SELECTED BIBLIOGRAPHY

D'Aguiar, Fred. *Feeding the Ghosts*. Hopewell, NJ: Ecco Press, 1999.

Da Silva, Denise Ferreira. *Toward a Global Idea of Race*. Minneapolis: University of Minnesota Press, 2007.

Deloria, Vine, Jr. *God Is Red: A Native View of Religion*. 1973. New York: Putnam, 2003.

DeMello, Margo. *Animals and Society: An Introduction to Human-Animal Studies*. New York: Columbia University Press, 2012.

Derrida, Jacques. *Archive Fever: A Freudian Impression*. Translated by Eric Prenowitz. Chicago: University of Chicago Press, 1996.

———. "'A Self-Unsealing Poetic Text': Poetics and Politics of Witnessing." Translated by Rachel Bowlby. In *Revenge of the Aesthetic: The Place of Literature in Theory Today*, edited by Michael P. Clark, 180–207. Berkeley: University of California Press, 2000.

———. *Specters of Marx: The State of the Debt, the Work of Mourning, and the New International*. Translated by Peggy Kamf. New York: Routledge, 1994.

Diedrich, Maria, Henry Louis Gates, Jr., and Carl Pedersen, eds. *Black Imagination and the Middle Passage*. New York: Oxford University Press, 1999.

Domby, Adam H. *The False Cause: Fraud, Fabrication, and White Supremacy in Confederate Memory*. Charlottesville: University of Virginia Press, 2020.

Dubey, Madhu, and Elizabeth Swanson Goldberg. "New Frontiers, Cross-Currents and Convergences: Emerging Cultural Paradigms." In *The Cambridge History of African American Literature*, edited by Maryemma Graham and Jerry W. Ward, Jr., 566–617. Cambridge: Cambridge University Press, 2011.

Duboin, Corinne. "Confronting the Specters of the Past, Writing the Legacy of Pain: An Interview with Phyllis Alesia Perry." *The Mississippi Quarterly* 63, nos. 3/4 (2009): 633–653.

Dunn, Kevin. "Lights . . . Camera . . . Africa: Images of Africa and Africans in Western Popular Films of the 1930." *African Studies Review* 39, no. 1 (1996): 149–175.

Dunton, Chris. "Sara Baartman and the Ethics of Representation." *Research in African Literatures* 46, no. 2 (2015): 32–51.

Dyson, Michael Eric. *Holler If You Hear Me: Searching for Tupac Shakur*. New York: Basic Civitas Books, 2006.

Eaton, Kalenda. *Womanism, Literature and the Transformation of the Black Community 1965–1980*. New York: Routledge, 2007.

Edkins, Jenny. *Trauma and the Memory of Politics*. Cambridge: Cambridge University Press, 2003.

Eichorn, Katie. "Multiple Registers of Silence in M. NourbeSe Philip's *Zong!*" *Xcp: Cross-Cultural Poetics* 23 (2010): 33–39.

———. "Notes on Trauma and Community." In *Trauma: Explorations in Memory*, edited by Cathy Caruth, 183–199. Baltimore, MD: Johns Hopkins University Press, 1995.

Ekwunife, Anthony Nwoye Okechukwu. *Meaning and Function of the "Ino Uwa" (Reincarnation) in Igbo Traditional Religious Culture*. Onitsha, Nigeria: Spiritan Publications, 1999.

Ellis, Aimé J. *If We Must Die: From Bigger Thomas to Biggie Smalls*. Detroit, MI: Wayne State University Press, 2011.

Engels, Dagmar, and Shula Marks. "Introduction: Hegemoy in a Colonial Context." In *Contesting Colonial Hegemony: State and Society in Africa and India*, edited by Dagmar Engels and Shula Marks, 1–8. London: British Academic Press, 1994.

Erikson, Kai T. *A New Species of Trouble: Explorations in Disaster, Trauma, and Community*. New York: Norton, 1994.

Eyerman, Ron. *Cultural Trauma: Slavery and the Formation of African American Identity*. Cambridge: Cambridge University Press, 2001.

Faison, Cheryl. "Preface." In *A Gathering of Words: Poetry and Commentary for Trayvon Martin*, edited by The Poets and Writers of Consciousness, xiii–xiv. Philadelphia: Inner Child Press, 2012.

Fanon, Frantz. *Black Skin, White Masks*. New York: Grove Press, 1967.

———. *Black Skin, White Masks*. Trans. Charles Lam Markham. London: Pluto, 2008.

Farmer, Paul. "On Suffering and Structural Violence: A View from Below." In *Violence in War and Peace: An Anthology*, edited by Nancy Scheper-Hughes and Philippe Bourgois, 281–289. Malden, MA: Blackwell Publishing, 2004.

Farrell, Kirby. *Post-traumatic Culture: Injury and Interpretation in the Nineties*. Baltimore, MD: Johns Hopkins University Press, 1998.

SELECTED BIBLIOGRAPHY

Fausto-Sterling, Anna. "Gender, Race, and Nation: The Comparative Anatomy of 'Hottentot' Women in Europe, 1815–1817." In *Deviant Bodies: Critical Perspectives on Difference in Science and Popular Culture*, edited by Jennifer Terry and Jacqueline Urla, 19–48. Bloomington: Indiana University Press, 1995.

Fehér, Olga, Haibin Wang, Sigal Saar, Partha P. Mitra, and Ofer Tchernichovski. "*De Novo* Establishment of Wild-Type Song Culture in the Zebra Finch." *Nature* 459 (2009): 564–568.

Fehskens, Erin M. "Accounts Unpaid, Accounts Untold: M. NourbeSe Philip's *Zong!* and the Catalogue." *Callaloo* 35, no. 2 (2012): 407–424.

Felman, Shoshana. "From 'The Return of the Voice: Claude Lanzmann's *Shoah*.'" In *The Claims of Literature: A Shosana Felman Reader*, edited by Emily Sun, Eyal Peretz, and Ulrich Baer, 295–314. New York: Fordham University Press, 2007.

Felman, Shoshana, and Dori Laub. *Testimony: Crises of Witnessing in Literature, Psychoanalysis, and History*. New York: Routledge, 1991.

Fenton, Louise. "The Demise of the Cinematic Zombie: From the Golden Age of Hollywood to the 1940s." In *Recovering 1940s Horror Cinema: Traces of a Lost Decade*, edited by Mario DeGiglio-Bellemare, Charlie Ellbé, and Kristopher Woofter, 177–186. Lanham, MD: Lexington Books, 2015.

Fleetwood, Nicole. *On Racial Icons: Blackness and the Public Imagination*. New Brunswick, NJ: Rutgers University Press, 2015.

Foster, Frances Smith. "'In Respect to Females . . .': Differences in the Depiction of Women by Male and Female Narrators." *Black American Literature Forum* 15, no. 2 (1981): 66–70.

Foucault, Michel. *The History of Sexuality: An Introduction*. Translated by Robert Hurley. New York: Vintage, 2012.

———. *Language, Counter-Memory, Practice: Selected Essays and Interviews*, edited and translated by Donald F. Bouchard and Sherry Simon. Ithaca, NY: Cornell University Press, 1977.

———. "Of Other Spaces." *Diacritics* 16, no. 1 (1986): 22–27.

Fouché, Rayvon. "Say It Loud, I'm Black and I'm Proud: African Americans, American Artifactual Culture, and Black Vernacular Technological Creativity." *American Quarterly* 58, no. 3 (2006): 639–661.

Galton, Francis. *Inquiries into Human Faculty and Its Development*. New York: Macmillan, 1883.

Gates, Henry Louis, Jr. *The Signifying Monkey: A Theory of African American Literary Criticism*. 1988. New York: Oxford University Press, 2014.

Gelder, Ken. "Australian Gothic." In *The Routledge Companion to Gothic*, edited by Catherine Spooner and Emma McEvoy, 115–123. London: Routledge, 2007.

Gilroy, Paul. *The Black Atlantic: Modernity and Double Consciousness*. Cambridge, MA: Harvard University Press, 1993.

———. *The Black Atlantic: Modernity and Double Consciousness*. London: Verso, 1993.

Glissant, Édouard. *Caribbean Discourse: Selected Essays*. Translated by J. Michael Dash. Charlottesville: University of Virginia Press, 1989.

———. *Poetics of Relation*. Translated by Betsy Wing. Ann Arbor: University of Michigan Press, 1997.

Gordon, Avery F. *Ghostly Matters: Haunting and the Sociological Imagination*. Minneapolis: University of Minnesota Press, 1997.

———. *Ghostly Matters: Haunting and the Sociological Imagination*. 1997. Reprint, Minneapolis: University of Minnesota Press, 2008.

Green, Percy, II, Robin D. G. Kelley, Tef Poe, George Lipsitz, Jamala Rogers, and Elizabeth Hinton. "Generations of Struggle: St. Louis from Civil Rights to Black Lives Matter." *Transitions* 119 (2016): 9–16.

Greene, Eric. *Planet of the Apes as American Myth: Race, Politics, and Popular Culture*. Middletown, CT: Wesleyan University Press, 1996.

Hansen, Christian, Catherine Needham, and Bill Nichols. "Pornography, Ethnography and the Discourses of Power." In *Representing Reality: Issues and Concepts in Documentary*, edited by Bill Nichols, 201–228. Bloomington: Indiana University Press, 1991.

Haraway, Donna J. *When Species Meet*. Minneapolis: University of Minnesota Press, 2008.

Harney, Stefano, and Fred Moten. *The Undercommons: Fugitive Planning & Black Study*. New York: Autonomedia, 2013.

SELECTED BIBLIOGRAPHY

Harrison, Graham. *The African Presence: Representations of Africa in the Construction of Britishness*. New York: Manchester University Press, 2013.

Hartman, Saidiya. "The Belly of the World: A Note on Black Women's Labors." *Souls* 18, no. 1 (2016): 166–173.

———. *Lose Your Mother: A Journey Along the Atlantic Slave Route*. New York: Farrar, Straus and Giroux, 2007.

———. *Scenes of Subjection: Terror, Slavery, and Self-Making in Nineteenth-Century America*. New York: Oxford University Press, 1997.

———. "Venus in Two Acts." *Small Axe: A Caribbean Journal of Criticism* 26 (2008): 1–14.

Harvey, Graham. *Animism: Respecting the Living World*. London: Hurst, 2005.

Healey, Joseph, and Donald Sybertz. *Towards an African Narrative Theology*. New York: Orbis Books, 1996.

Henderson, Carol E. "Writing from No Man's Land: The Black Man's Quest for Freedom from Behind the Walls." In *From the Plantation to the Prison: African-American Confinement Literature*, edited by Tara T. Green, 11–31. Macon, GA: Mercer University Press, 2008.

Henderson, Mae G. *Speaking in Tongues and Dancing Diaspora: Black Women Writing and Performing*. Oxford: Oxford University Press, 2014.

Herman, Judith Lewis. *Trauma and Recovery*. New York: Basic Books, 1997.

Hirsch, Marianne. *Family Frames: Photography, Narrative, and Postmemory*. Cambridge, MA: Harvard University Press, 2006.

———. "Family Pictures: *Maus*, Mourning, and Post-Memory." *Discourse* 15, no. 2 (1992–1993): 3–29.

———. *The Generation of Postmemory: Visual Culture after the Holocaust*. New York: Columbia University Press, 2012.

Hite, Michelle S. "How Do We Comply?: Answering the Call of Medgar Evers." In *Turn Me Loose: The Unghosting of Medgar Evers*, by Frank X Walker, xiii–xix. Athens: University of Georgia Press, 2013.

Holder, Heidi J. "Strange Legacy: The History." In *Suzan-Lori Parks: A Casebook*, edited by Kevin J. Wetmore, Jr., and Alycia Smith Howard, 18–28. New York: Routledge, 2007.

Holland, Sharon Patricia. "Bill T. Jones, Tupac Shakur and the (Queer) Art of Death," *Callaloo* 23, no. 1 (2000): 384–393.

———. *Raising the Dead: Readings of Death and (Black) Subjectivity*. Durham, NC: Duke University Press, 2000.

Holloway, Karla F. C. "Cultural Narrative Passed On: African American Mourning Stories." *College English* 59, no. 1 (1997): 32–40.

Holmes, Rachel. *The Hottentot Venus: The Life and Death of Saartjie Baartman: Born 1789–Buried 2002*. London: Bloomsbury, 2007.

hooks, bell. "Postmodern Blackness." In *Postmodern American Fiction: A Norton Anthology*, edited by Paula Geyh, Fred G. Leebron, and Andrew Levy, 624–631. New York and London: Norton, 1998.

Howarth, Joanna, Youn Bok Lee, and James B. Uney. "Using Viral Vectors as Gene Transfer Tools." *Cell Biology and Toxicology Special Issue: ETCS-UK 1 Day Meeting on Genetic Manipulation of Cells* (2009): 1–20.

Hudson, Nicholas. "The 'Hottentot Venus,' Sexuality, and the Changing Aesthetics of Race, 1650–1850." *Mosaic* 40, no. 1 (2008): 19–41.

Hussen, Aida. "'Black Rage' and 'Useless Pain': Affect, Ambivalence, and Identity after King." *South Atlantic Quarterly* 112, no. 2 (2013): 303–318.

Iton, Richard. *In Search of the Black Fantastic: Politics and Popular Culture in the Post-Civil Rights Era*. New York: Oxford University Press, 2008.

Jackson-Opoku, Sandra. "Out Beyond Our Borders: Literary Travelers of the TransDiaspora." In *The New African Diaspora*, edited by Isidore Okepwho and Nikiru Nzegqu, 476–482. Bloomington: Indiana University Press, 2009.

Jahn, Jainheinz. *Muntu: African Culture and the Western World*, trans. Marjorie Grene. New York: Grove Press, 1994.

James, Joy. "The Dead Zone: Stumbling at the Crossroads of Party Politics, Genocide, and Postracial Racism." *South Atlantic Quarterly* 108, no. 3 (2009): 459–481.

Jameson, Fredric. *Archaeologies of the Future: The Desire Called Utopia and Other Science Fictions*. London: Verso, 2005.

———. *The Political Unconscious: Narrative as a Socially Symbolic Act*. 1981; Ithaca, NY: Cornell University Press, 1982.

———. *The Prison-House of Language: A Critical Account of Structuralism and Russian Formalism*. Princeton, NJ: Princeton University Press, 1975.

SELECTED BIBLIOGRAPHY

Jeffries, Michael P. *Thug Life: Race, Gender, and the Meaning of Hip-Hop*. Chicago: University of Chicago Press, 2011.

Jindra, Michael, and Jöel Noret. *Funerals in Africa: Explorations of a Social Phenomenon*. New York: Berghahn, 2011.

Johanson, Donald C., and Maitland A. Edey. *Lucy: The Beginnings of Humankind*. New York: Simon and Schuster, 1981.

Judy, Ronald A. T. "On the Question of Nigga Authenticity." *boundary 2* 21, no. 3 (1994): 211–230.

Kalu, Ogbu. "Ancestral Spirituality and Society in Africa." In *African Spirituality: Forms, Meanings, and Expressions*, edited by Jacob Olupona, 54–81. New York: Crossroad, 2000.

Keating, AnaLouise. *New Perspectives on Gloria E. Anzaldúa*. New York: Palgrave Macmillan, 2005.

Kenan, Randall. "Letter from North Carolina: Learning from Ghosts of the Civil War," *Literary Hub*, August 18, 2020, https://lithub.com/letter-from-north-carolina-learning-from-ghosts-of-the-civil-war/.

Keizer, Arlene R. *Black Subjects: Identity Formation in the Contemporary Narrative of Slavery*. Ithaca, NY: Cornell University Press, 2004.

Kirmayer, Lawrence J. "Landscapes of Memory: Trauma, Narrative, and Dissociation." In *Tense Past: Cultural Essays in Trauma and Memory*, edited by Paul Antze and Michael Lambek, 173–198. New York: Routledge, 1996.

Kolin, Philip C. "Puck's Magic Mojo: The Achievements of Suzan-Lori Parks." In *Suzan-Lori Parks: Essays on the Plays and Other Works*, edited by Philip C. Kolin, 7–19. Jefferson, NC: McFarland, 2010.

Kuppers, Petra. "The Anarcha Project: Performing in the 'Medical Plantation.'" *Sustainable Feminisms* 11 (2007): 127–141.

LaCapra, Dominick. *Writing Trauma, Writing History*. Baltimore, MD: Johns Hopkins University Press, 2001.

Lambek, Michael. "The Past Imperfect: Remembering as Moral Practice." In *Tense Past: Cultural Essays in Trauma and Memory*, edited by Paul Antze and Michael Lambeck, 235–254. New York: Routledge, 1996.

Larson, Jennifer. *Understanding Suzan-Lori Parks*. Columbia: University of South Carolina Press, 2012.

Laub, Dori. "The Empty Circle: Children of Survivors and the Limits of Reconstruction." *Journal of the American Psychoanalytic Association* 46, no. 2 (1998): 507–529.

Laub, Dori, and Nanette C. Auerhahn. "Knowing and Not Knowing Massive Psychic Trauma." *The International Journal of Psychoanalysis* 74, no. 2 (1993): 287–302.

Laughton, Adam H. "Somewhere to Run, Somewhere to Hide?: International Regulation of Human Subject Experimentation." *Duke Journal of Comparative and International Law* 18 (2007): 181–212.

Lavie, Smadar, and Ted Swedenburg. "Introduction: Displacement, Diaspora, and Geographies of Identity." In *Displacement, Diaspora, and Geographies of Identity*, edited by Smadar Lavie and Ted Swedenburg, 1–26. Durham, NC: Duke University Press, 1996.

Lawal, Babatunde. "The Living Dead: Art and Immortality among the Yoruba of Nigeria." *Africa: Journal of the International African Institute* 47, no. 1 (1977): 50–61.

Lax, Thomas J., ed. *Ralph Lemon: Modern Dance Series*. New York: MOMA, 2019.

Leong, Diana. "The Salt Bones: *Zong!* and an Ecology of Thirst." *Interdisciplinary Studies in Literature and Environment* 23, no. 4 (2016): 798–820.

Lepecki, André. *Exhausting Dance: Performance and the Politics of Movement*. New York: Routledge, 2006.

Levinas, Emmanuel. *Entre Nous: On Thinking-of-the-Other*, trans. Michael B. Smith and Barbara Harshav. New York: Columbia University Press, 1998.

Levine, Robert S. "The Slave Narrative and the Revolutionary Tradition of American Autobiography." In *The Cambridge Companion to the African American Slave Narrative*, edited by Audrey Fisch, 99–114. Cambridge: Cambridge University Press, 2007.

Leys, Ruth. *Trauma: A Genealogy*. Chicago: University of Chicago Press, 2000.

Lhamon, W. T., Jr. "Optic Black: Naturalizing the Refusal to Fit." In *Black Cultural Traffic: Crossroads in Global Performance and Popular Culture*, edited by Harry J. Elam, Jr., and Kennell Jackson, 111–140. Ann Arbor: The University of Michigan Press, 2005.

Lippit, Akira Mizuta. *Atomic Light (Shadow Optics)*. Minneapolis: University of Minnesota Press, 2005.

Lipsitz, George. "From *Plessy* to Ferguson." *Cultural Critique* 90, no. 1 (2015): 119–139.

Lloyd, Sheila. "Sara Baartman and the 'Inclusive Exclusions' of Neoliberalism." *Meridians* 11, no. 2 (2013): 212–237.

SELECTED BIBLIOGRAPHY

Long, Lisa A. "A Relative Pain: The Rape of History in Octavia Butler's *Kindred* and Phyllis Alesia Perry's *Stigmata*." *College English* 64, no. 4 (2009): 459–483.

Lucasi, Stephen. "Saartjie's Speech and the Sounds of National Identification." *Mosaic* 42, no. 2 (2009): 171–189.

Lundy Martin, Dawn, and Lisa Sewell. "The Language of Trauma: Faith and Atheism in M. NourbeSe Philip's Poetry." In *Eleven More American Women Poets in the 21st Century: Poetics Across North America*, Vol. 3 of *American Poets in the 21st Century*, edited by Claudia Rankine and Lisa Sewell, 283–307. Middletown, CT: Wesleyan University Press, 2012.

Madsen–Bouterse, Sally A., Ghulam Mohammad, Mamta Kanwar, and Renu A. Kowluru. "Role of Mitochondrial DNA Damage in the Development of Diabetic Retinopathy, and the Metabolic Memory Phenomenon Associated with Its Progression." *Antioxidants & Redox Signaling* 13 (2010): 797–805.

Magesa, Laurenti. *What Is Not Sacred?: African Spirituality*. New York: Orbis Books, 2013.

Mahlis, Kristen. "A Poet of Place: An Interview with M. NourbeSe Philip." *Callaloo* 27, no. 3 (2004): 682–697.

Marriott, David. *Haunted Life: Visual Culture and Black Modernity*. New Brunswick, NJ: Rutgers University Press, 2007.

Marx, Karl. *Capital*. Oxford: Oxford University Press, 2008.

———. *Capital; A Critique of Political Economy*. Edited by Frederic Engels. Chicago: C. H. Kerr, 1909.

Mason, David. "Against Identity." Review of *Citizen: An American Lyric*, by Claudia Rankine. *The Hudson Review* 68, no. 4 (2016): 669–679.

Mbiti, John S. *Introduction to African Religion*. 2nd ed. New York: Waveland Press, 2015.

———. *African Religions and Philosophy*. New York: Praeger, 1969.

———. *African Religions and Philosophy*. 2nd ed. London: Heinemann, 1990.

McCarren, Felicia. "The Use-Value of 'Josephine Baker.'" *S & F Online* 6, nos. 1–2 (2007/2008), accessed November 18, 2020, http://sfonline.barnard.edu/baker/mccarren_01.htm.

McCormick, Stacie. "Witnessing and Wounding in Suzan-Lori Parks's *Venus*." *MELUS* 39, no. 2 (2014): 188–207.

McKibbin, Molly Littlewood. "Southern Patriarchy and the Figure of the White Woman in Gwendolyn Brooks's 'A Bronzeville Mother Loiters in Mississippi. Meanwhile, a Mississippi Mother Burns Bacon.'" *African American Review* 44, no. 4 (2011): 667–685.

McNally, Richard J. *Remembering Trauma*. Cambridge, MA: Belknap Press, 2005.

Metress, Christopher. "'No Justice, No Peace:' The Figure of Emmett Till in African American Literature." *MELUS* 28, no. 1. (2003): 87–103.

Miles, Tiya. *Tales from the Haunted South: Dark Tourism and Memories of Slavery from the Civil War Era*. Chapel Hill: University of North Carolina Press, 2015.

Miller, Nancy K., and Jason Tougaw. "Introduction: Extremities." *Extremities: Trauma, Testimony, and Community*, edited by Nancy K. Miller and Jason Tougaw, 1–22. Chicago: University of Chicago Press, 2002.

Mitchell, Angelyn. *The Freedom to Remember: Narrative, Slavery, and Gender in Contemporary Black Women's Fiction*. New Brunswick, NJ: Rutgers University Press, 2002.

Mitchell, Robin. "Another Means of Understanding the Gaze: Sarah Bartmann in the Development of Nineteenth-Century French National Identity." In *Black Venus 2010: They Called Her "Hottentot*," edited by Deborah Willis, 32–46. Philadelphia: Temple University Press, 2010.

Mitchell, Shamika Ann. "Hip Hop." In *Encyclopedia of African American History*. Vol. 3. Santa Barbara, CA: ABC CLIO, 2010.

Morton, Nelle. *The Journey Is Home*. Boston: Beacon Press, 1985.

Moten, Fred. *Black and Blur*. Durham, NC: Duke University Press, 2017.

———. "Blackness and Nothingness (Mysticism in the Flesh)." *South Atlantic Quarterly* 112, no. 4 (2013): 737–780.

———. "The Case of Blackness." *Criticism* 50, no. 2 (2008): 177–218.

———. *In the Break: The Aesthetics of the Black Radical Tradition*. Minneapolis: University of Minnesota Press, 2003.

Mudimbe, V. Y., and Kasereka Kavwahirehi, eds. *Encyclopedia of African Religions and Philosophy*. Dordrecht, The Netherlands: Springer, 2021.

Muñoz, José Esteban. *Disidentifications: Queers of Color and the Performance of Politics*. Minneapolis: University of Minnesota Press, 1999.

SELECTED BIBLIOGRAPHY

Nayar, Pramod K. "A New Biological Citizenship: Posthumanism in Octavia Butler's Fledgling." *Modern Fiction Studies* 58, no. 4 (2012): 796–817.

Neal, Larry. *Visions of a Liberated Future: Black Arts Movement Writings.* New York: Basic Books, 1989.

Neal, Mark Anthony. *Looking for Leroy: Illegible Black Masculinities.* New York: New York University Press, 2013.

Nehusi, Kimani S. K. *Libation: An Afrikan Ritual of Heritage in the Circle of Life.* Lanham, MD: University Press of America, 2016.

Newquist, Roy. "Gwendolyn Brooks Interview." In *Conversations with Gwendolyn Brooks*, edited by Gloria Wade Gayles, 26–36. Jackson: University Press of Mississippi, 2003.

Nobles, Wade W. "Consciousness." In *Encyclopedia of Black Studies*, edited by Molefi Kete Asante and Ama Mazama, 197–200. Thousand Oaks, CA: Sage, 2005.

Nwachurwu-Agbada, J. O. J. "An Interview with Chinua Achebe." *The Massachusetts Review* 28, no. 2 (1987): 273–285.

Okorafor, Nnedi. *The Book of Phoenix.* New York: Daw Books, 2015.

Olney, Ian. *Euro Horror: Classic European Horror Cinema in Contemporary American Culture.* Indianapolis: Indiana University Press, 2013.

Ostriker, Alice. "Beyond Confession: The Poetics of Postmodern Witness." In *After Confession: Poetry as Autobiography*, edited by K. Sontag, 317–331. Saint Paul, MN: Graywolf Press, 2001.

Pagnoni Berns, Fernando Gabriel, Mariana Zárate, and Patricia Vazquez. "Racism and Gothic in Three Horror Films: *Chloe, Love Is Calling You, Poor Pretty Eddie* and *White Dog*." In *Gothic and Racism*, edited by Christine Artenie, 106–117. Ontario: Universitas Press, 2015.

Parham, Marisa. *Haunting and Displacement in African American Literature and Culture.* New York: Routledge, 2009.

Passalacqua, Camille. "Witnessing to Heal the Self in Gayl Jones's *Corregidora* and Phyllis Alesia Perry's *Stigmata*." *MELUS* 35, no. 4 (2010): 139–163.

Patterson, Tiffany Ruby, and Robin D. G. Kelley. "Unfinished Migrations: Reflections on the African Diaspora and the Making of the Modern World." *African Studies Review* 43, no. 1 (2000): 11–45.

Patton, Venetria. *The Grasp That Reaches beyond the Grave: The Ancestral Call in Black Women's Texts.* Albany, NY: SUNY Press, 2013.

Peeren, Esther. "Everyday Ghosts and the Ghostly Everyday in Amos Tutuola, Ben Okri, and Achille Mbembe." In *Popular Ghosts*, edited by Esther Peeren and Maria del Pilar Blanco, 106–117. New York: Continuum, 2014.

Perry, Imani. *Prophets of the Hood: Politics and Poetics in Hip Hop.* Durham, NC: Duke University Press, 2004.

Perry, Phyllis Alesia. *Stigmata.* New York: Anchor, 1998.

Philip, M. NourbeSe. *Bla_K: Essays and Interviews.* Toronto: Book*Hug, 2017.

———. *A Genealogy of Resistance: And Other Essays.* Toronto: Mercury Press, 1997.

Platt, Ryan. "Ralph Lemon and the Language of Loss." *PAJ: A Journal of Performance and Art* 34, no. 3 (2012): 71–82.

Pollack, Harriett, and Christopher Metress, eds. *Emmett Till in Literary Memory and Imagination.* Baton Rouge: Louisiana State University Press, 2008.

Praet, Istvan. *Animism and the Question of Life.* New York: Routledge, 2014.

Profeta, Katherine. *Dramaturgy in Motion: At Work on Dance and Movement Performance.* Madison: University of Wisconsin Press, 2015.

———. "The Geography of Inspiration." *PAJ: A Journal of Performance and Art* 27, no. 3 (2005): 23–28.

———. "Ralph Lemon and the Buck Dance." *Movement Research Performance Journal* 33 (2008): n.p.

Quéma, Anne. "M. NourbeSe Philip's *Zong!*: Metaphors, Laws, and Fugues of Justice." *Journal of Law and Society* 43, no. 1 (2016): 85–104.

Quinn, Eithne. *Nuthin' but a "G" Thang: The Culture and Commerce of Gangsta Rap.* New York: Columbia University Press, 2013.

Rabaka, Reiland. *The Negritude Movement: W. E. B. Du Bois, Leon Damas, Aimé Césaire, Leopold Senghor, Frantz Fanon, and the Evolution of an Insurgent Idea.* Lanham, MD: Lexington Books, 2015.

Ramazani, Jahan. *Poetry and Its Others: News, Prayer, Song, and the Dialogue of Genres.* Chicago: University of Chicago Press, 2013.

———. *Poetry of Mourning: The Modern Elegy from Hardy to Heaney.* Chicago: University of Chicago Press, 1994.

Ranger, T. O., and Isaria Kimambo. *The Historical Study of African Religion.* Berkeley: University of California Press, 1972.

SELECTED BIBLIOGRAPHY

Ranisch, Robert, and Stefan Lorenz Sorgner. "Introducing Post- and Transhumanism." *Post- and Transhumanism: An Introduction*, edited by Robert Ranisch and Stefan Lorenz Sorgner, 7–27. Frankfurt am Mein, Germany: Peter Lang, 2014.

Rawlinson, Paddy, and Vijay Kumar Yadavendu. "Foreign Bodies: The New Victims of Unethical Experimentation." *The Howard Journal of Criminal Justice* 54, no. 1 (2015): 8–24.

Remler, Pat. *Egyptian Mythology, A to Z.* 3rd ed. New York: Chelsea House, 2010.

Roach, Joseph R. *Cities of the Dead: Circum-Atlantic Performance.* New York: Columbia University Press, 1996.

Robinson, Cedric J. *Forgeries of Memory and Meaning: Blacks and the Regimes of Race in American Theater and Film before World War II.* Chapel Hill: University of North Carolina Press, 2007.

Roden, David. *Posthuman Life: Philosophy at the Edge of the Human.* London: Routledge, 2015.

Romer, John, and E. A. Wallis Budge. *The Egyptian Book of the Dead.* London: Penguin, 2008.

Romero, Channette. *Activism and the American Novel: Religion and Resistance in Fiction by Women of Color.* Charlottesville: University of Virigina Press, 2012.

Rooney, Caroline. *African Literature, Animism and Politics.* London: Routledge, 2000.

Rose, Tricia. *Black Noise: Rap Music and Black Culture in Contemporary America.* Middletown, CT: Wesleyan University Press, 1994.

———. *The Hip-Hop Wars: What We Talk about when We Talk about Hip-Hop and Why It Matters.* Washington: Basic Books, 2008.

Rushdy, Ashraf. *Neo-Slave Narratives: Studies in the Social Logic of a Literary Form.* New York and Oxford: Oxford University Press, 1999.

Safran, William. "Diasporas in Modern Societies: Myths of Homeland and Return." *Diaspora* 1, no. 1 (1991): 83–99.

Saunders, Patricia. "Defending the Dead, Confronting the Archive: A Conversation with M. NourbeSe Philip." *Small Axe: A Caribbean Journal of Criticism* 26 (2008): 63–79.

———. "Fugitive Dreams of Diaspora: Conversations with Saidiya Hartman." *Anthurium: A Caribbean Studies Journal* 6, no. 1 (2008): article 17.

Scheper, Jeanne. *Moving Performances: Divas, Iconicity, and Remembering the Modern Stage.* New Brunswick, NJ: Rutgers University Press, 2016.

Schloss, Joseph. *Making Beats: The Art of Sample-Based Hip-Hop.* Middletown, CT: Wesleyan University Press, 2014.

Schultz, Michael, dir. *Cooley High.* 1975. Los Angeles, CA: MGM Studios, 2000. DVD.

Scott, Darieck. *Extravagant Abjection: Blackness, Power, and Sexuality in the African American Literary Imagination.* New York: New York University Press, 2010.

Sears, Laurie Jo. *Situated Testimonies: Dread and Enchantment in an Indonesian Literary Archive.* Honolulu: University of Hawai'i Press, 20013.

Sexton, Jared. "Afro-Pessimism: The Unclear Word." *Rhizomes,* no. 29 (2016), https://doi.org/10.20415/rhiz/029.e02.

———. "People-of-Color-Blindness: Notes on the Afterlife of Slavery." *Social Text* 28, no. 2 (2010): 31–56.

———. "Unbearable Blackness." *Cultural Critique* 90, no. 1 (2015): 159–178.

Sexton, Jared, and Huey Copeland. "Raw Life: An Introduction." *Qui Parle* 13, no. 2: 53–62.

Sharpe, Christina. *In the Wake: On Blackness and Being.* Durham, NC: Duke University Press, 2016.

Sharpe, Jenny. "The Archive and Affective Memory in M. Nourbese [sic] Philip's *Zong!*" *Interventions* 16, no. 4 (2013): 465–482.

Sharpley-Whiting, T. Denean. *Black Venus: Sexualized Savages, Primal Fears, and Primitive Narratives in French.* Durham, NC: Duke University Press, 1999.

Shockley, Evie. "Going Overboard: African American Poetic Innovation and the Middle Passage." *Contemporary Literature* 52, no. 4 (2011): 791–817.

———. *The New Black.* Middletown, CT: Wesleyan University Press, 2011.

Sievers, Stefanie. "Embodied Memories—Sharable Stories? The Legacies of Slavery as a Problem of Representation in Phyllis Alesia Perry's *Stigmata*." In *Monuments of the Black Atlantic: Slavery and Memory*, edited by Joanne M. Braxton and Maria I. Diedrich, 131–140. Münster: LIT Verlag, 2004.

Singh, Nikhil Pal. *Black Is a Country: Race and the Unfinished Struggle for Democracy.* Cambridge, MA: Harvard University Press, 2004.

Singleton, Jermaine. *Cultural Melancholy: Readings of Race, Impossible Mourning, and African American Ritual.* Champaign: University of Illinois Press, 2015.

SELECTED BIBLIOGRAPHY

Smallwood, Stephanie E. *Saltwater Slavery: A Middle Passage from Africa to American Diaspora*. Cambridge, MA: Harvard University Press, 2009.

Smith, Angela. *Hideous Progeny: Disability, Eugenics, and Classic Horror Cinema*. New York: Columbia University Press, 2011.

Smith, Darron T. *When Race, Religion, and Sport Collide: Black Athletes at BYU and Beyond*. Lanham, MD: Rowman & Littlefield, 2016.

Snorton, C. Riley. *Black on Both Sides: A Racial History of Trans Identity*. Minneapolis: University of Minnesota Press, 2017.

Spaulding, A. Timothy. *Re-Forming the Past: History, the Fantastic, and the Postmodern Slave Narrative*. Columbus: The Ohio State University Press, 2005.

Spencer, Quayshawn. "Introduction to Is There Space for Race in Evolutionary Biology?" *Studies in History and Philosophy of Science: Part C: Studies in History and Philosophy of Biological and Biomedical Sciences* 44, no. 3 (2013): 247–249.

Spillers, Hortense J. "Mama's Baby, Papa's Maybe: An American Grammar Book." *Diacritics* 17, no. 2 (1987): 64–81.

———. "Mama's Baby, Papa's Maybe: An American Grammar Book." In *Black, White and In Color: Essays on American Literature and Culture*, by Hortense Spillers, 203–229. Chicago: University of Chicago Press, 2003.

Strand, Mark, and Eavan Boland. *The Making of a Poem: A Norton Anthology of Poetic Forms*. New York: Norton, 2000.

Strejilevich, Nora. "Testimony: Beyond the Language of Truth." *Human Rights Quarterly* 28, no. 3 (2006): 701–713.

Sundermeier, Theo. "Soul, Self—Reincarnation: African Perspecives." In *Self, Soul, and Body in Religious Experience*, edited by Albert I. Baumgarten, Jan Assmann, and Guy G. Stroumsa, 10–26. Leiden, The Netherlands: Brill, 1998.

Sundiata, Ibrahim. "The Garvey Aftermath." In *The United States and West Africa: Interactions and Relations*, edited by Alusine Jalloh and Toyin Falola, 75–89. Rochester, NY: University of Rochester Press, 2008.

Taylor, Diana. *The Archive and the Repertoire: Performing Cultural Memory in the Americas*. Durham, NC: Duke University Press, 2003.

Taylor, Keeanga-Yahmatta. *From #BlackLivesMatter to Black Liberation*. Chicago: Haymarket Books, 2016.

Tettenborn, Éva. "Africana Concepts of the Ancestor and Time in Phyllis Alesia Perry's *Stigmata* and *A Sunday in June*." *Obsidian* 12, no. 1 (2011): 94–109.

Théaulon, Marie-Emmanuel-Guillaume-Marguerite, Armand Dartois, and Nicolas Brasier. *La Vénus hottentote, ou haine aux Françaises*. In *Black Venus: Sexualized Savages, Primal Fears, and Primitive Narratives in French*, edited by T. Denean Sharpley-Whiting, 127–164. Durham, NC: Duke University Press, 1999.

Thompson, Krista A. *Shine: The Visual Economy of Light in African Diasporic Aesthetic Practice*. Durham, NC: Duke University Press, 2015.

———. "The Sound of Light: Reflections on Art History in the Visual Culture of Hip-Hop." *The Art Bulletin* 91, no. 4 (2009): 481–505.

Thompson, Robert Farris. *Flash of the Spirit: African and Afro-American Art and Philosophy*. New York: Random House/Vintage, 1984.

Threadcraft, Shatema. *Intimate Justice: The Black Female Body and the Body Politic*. New York: Oxford University Press, 2016.

Troyer, John. "Memorial Tattoos." In *The A–Z of Death and Dying: Social, Medical, and Cultural Aspects*, edited by Michael John Brennan, 312. Santa Barbara, CA: Greenwood, 2014.

Van Kriekan, Robert. *Celebrity Society*. London: Routledge, 2012.

Vickroy, Laurie. *Trauma and Survival in Contemporary Fiction*. Charlottesville: University of Virginia Press, 2002.

Wald, Gayle. "Soul Vibrations: Black Music and Black Freedom in Sound and Space." *American Quarterly* 63, no. 3 (2011): 673–696.

Waligora-Davis, Nicole. "Riotous Discontent: Ralph Ellison's 'Birth of a Nation.'" *Modern Fiction Studies* 50, no. 2 (2004): 385–410.

Wall, Cheryl. "Resounding *Souls*: Du Bois and the African American Literary Tradition." *Public Culture* 17, no. 2 (2005): 217–234.

Wallace, Michele. "Afterword: 'Why Are There No Great Black Artists?' The Problem of Visuality in African-American Culture." In *Black Popular Culture*, edited by Michele Wallace, 333–346. New York: The New Press, 1998.

SELECTED BIBLIOGRAPHY

Walvin, James. *Black Ivory: A History of British Slavery*. London: HarperCollins, 1992.

———. *The* Zong: *A Massacre, the Law and the End of Slavery*. New Haven, CT: Yale University Press, 2011.

Warren, Calvin. *Ontological Terror: Blackness, Nihilism, and Emancipation*. Durham, NC: Duke University Press, 2018.

Washington, Harriet A. *Medical Apartheid: The Dark History of Medical Experimentation on Black Americans from Colonial Times to the Present*. New York: Doubleday, 2007.

Weheliye, Alexander G. "'Feenin': Posthuman Voices in Contemporary Black Popular Music." *Social Text* 20, no. 2 (2002): 21–47.

———. *Phonographies: Grooves in Sonic Afro-Modernity*. Durham, NC: Duke University Press, 2005.

Weinstock, Jeffrey Andrew. "Introduction: The Spectral Turn." In *Spectral America: Phantoms and the National Imagination*, edited by Jeffrey Andrew Weinstock, 3–17. Madison: University of Wisconsin Press, 2004.

White, Luise. *Speaking with Vampires: Rumor and History in Colonial Africa*. Berkeley: University of California Press, 2000.

White, Miles. *From Jim Crow to Jay-Z: Race, Rap, and the Performance of Masculinity*. Chicago: University of Illinois Press, 2011.

Whitfield, Stephen J. *A Death in the Delta: The Story of Emmett Till*. New York: The Free Press, 1998.

Wilderson, Frank B., III. "Grammar & Ghosts: The Performative Limits of African Freedom." Theatre Survey 50, no. 1 (2009): 119–125.

———. "Gramsci's Black Marx: Whither the Slave in Civil Society?" Social Identities 9, no. 2 (2003): 225–240.

———. Red, White & Black: Cinema and the Structure of U. S. Antagonisms. Durham, NC: Duke University Press, 2010.

Wildman, Stephanie M., and Adrienne D. Davis. "Making Systems of Privilege Visible." In *White Privilege: Essential Readings on the Other Side of Racism*, edited by Paula S. Rothenberg, 137–144. New York: Worth Publishers, 2012.

Wilentz, Gay. "Civilizations Underneath: African Heritage as Cultural Discourse in Toni Morrison's *Song of Solomon*." *African American Review* 26, no. 1 (1992): 61–76.

Williams, Gladys. "The Ballads of Gwendolyn Brooks." In *A Life Distilled: Gwendolyn Brooks, Her Poetry and Fiction*, edited by Maria K. Mootry and Gary Smith, 205–223. Urbana: University of Illinois Press, 1987.

Williams, Justin A. "Post-Mortem Sampling in Hip-hop Recordings and the Rap Lament." In *Death and the Rock Star*, edited by Catherine Strong and Barbara LeBrun, 189–200. New York: Routledge, 2015.

Wilson, Fred, Leslie King-Hammond, and Ira Berlin. *Mining the Museum: An Installation*. Baltimore, MD: Contemporary Museum of Art, 1994.

Winokur, Mark. "Technologies of Race: Special Effects, Fetish, Film and the Fifteenth Century." *Genders OnLine Journal* 40 (2004), https://www.colorado.edu/gendersarchive1998-2013/2004/08/01/technologies-race-special-effects-fetish-film-and-fifteenth-century.

Wolfe, Cary. *Animal Rites: American Culture, the Discourse of Species, and Posthumanist Theory*. Chicago: University of Chicago Press, 2003.

———. *What Is Posthumanism?* Minneapolis: University of Minnesota Press, 2010.

Wood, Robin. "An Introduction to the American Horror Film." In *Planks of Reason: Essays on the Horror Film*, edited by Barry Keith Grant and Christopher Sharrett, 107–141. Lanham, MD: Scarecrow Press, 2004.

Woods, Tryon P. "'Beat it like a Cop': The Erotic Cultural Politics of Punishment in the Era of Postracialism." *Social Text* 31, no. 1 (2013): 21–41.

Woodworth, Christine. "Parks and the Traumas of Childhood." In *Suzan-Lori Parks: Essays on the Plays and Other Works*, edited by Philip C. Kolin, 140–155. Jefferson, NC: McFarland, 2010.

Woolfork, Lisa. *Embodying American Slavery in Contemporary Culture*. Urbana: University of Illinois Press, 2009.

Woubshet, Dagmawi. *The Calendar of Loss: Race, Sexuality, and Mourning in the Early Era of AIDS*. Baltimore, MD: Johns Hopkins University Press, 2015.

Yancy, George. "Trayvon Martin: When Effortless Grace Is Sacrificed on the Altar of the Image." In *Pursuing Trayvon Martin: Historical Contexts and Contemporary Manifestations of Racial Dynamics*, edited by George Yancy and Janine Jones, 237–250. Lanham, MD: Lexington Books, 2013.

Yancy, George, and Janine Jones. "Introduction." In *Pursuing Trayvon Martin: Historical Contexts and Contemporary Manifestations of Racial Dynamics*, edited by George Yancy and Janine Jones, 1–23. Lanham, MD: Lexington Books, 2013.

SELECTED BIBLIOGRAPHY

Yellin, Jean Fagan. "Introduction." In *Incidents in the Life of a Slave Girl Written by Herself*, edited by Jean Fagan Yellin, xix–liv. Cambridge, MA: The Belknap Press of Harvard University Press, 2009.

Young, Harvey. "Choral Compassion: In the Blood and Venus." In *Suzan-Lori Parks: A Casebook*, edited by Kevin J. Wetmore, Jr., and Alycia Smith-Howard, 29–47. New York: Routledge, 2007.

Young, James Edward. *The Art of Memory: Holocaust Memorials in History*. New York: Prestel, 1994.

Young, Jean. "The Re-Objectification and Re-Commodification of Saartjie Baartman in Suzan-Lori Parks's *Venus*." *African American Review* 31, no. 4 (1997): 699–708.

Zacks, Stephen. "The Theoretical Construction of African Cinema." In *African Cinema: Postcolonial and Feminist Readings*, edited by Kenneth Harrow, 3–20. Trenton, NJ: Africa World Press, 1999.

NOTES ON CONTRIBUTORS

Emiliano Aguilar is an independent scholar who has published on science fiction in journals such as *Revista Lindes* and *Letraceluloide*. He has also contributed chapters to scholarly collections, including *New Heart and New Spirit: Perspectives on the Modern Biblical Epic* (ed. Wickham Clayton), *"Orphan Black" and Philosophy: Grand Theft DNA* (eds. Richard Greene and Rachel Robison-Greene), *"The Man in the High Castle" and Philosophy: Subversive Reports from Another Reality* (eds. Bruce Krajewski and Joshua Heter), *Giant Creatures in Our World: Essays on Kaiju and American Popular Culture* (eds. Camille D. G. Mustachio and Jason Barr), and *Arthur Machen: Critical Essays* (ed. Antonio Sanna).

Diana Arterian teaches literature and creative writing at Merrimack College in Massachusetts. Her dissertation, "Migratory Wounds: Relayed Trauma in Contemporary Poetics," interrogates the intersection of trauma, identity, and creative production. Arterian's criticism has appeared in *The New York Times Book Review*, *Literary Hub*, and *Los Angeles Review of Books*. Her collection of poetry, *Playing Monster:: Seiche*, received a starred review in *Publishers Weekly*. Arterian has held residencies and scholarships from Caldera Arts Center, Millay Arts, Vermont Studio Center, and Yaddo.

Andrew R. Belton is an assistant professor of African diasporic literature and culture in the English department at Oklahoma State University. His writing has appeared in *PMLA* and *Southern Cultures*. He has received support for his research from the John W. Kluge Presidential Scholarship, the Royster Society of Fellows, and the Center for American Literary Studies' First Book Institute. Belton is currently working on a monograph titled "Hip Hop Illiterate: Being toward New Meanings in Literature and Black Life."

Luis Omar Ceniceros is an independent scholar who teaches courses in English and philosophy. His research is on twentieth-century African American literature, postcolonial studies, Marxist theory and literary criticism, and popular culture, with a focus on comics and music. A freelance writer, editor, and activist, his writing has appeared in *The St. John's University Humanities Review*.

Christopher Giroux is a professor of English specializing in twentieth-century American literature and drama at Saginaw Valley State University, where he coedits *Writing@SVSU*. He

NOTES ON CONTRIBUTORS

received his doctorate from Wayne State University; his most recent poetry chapbook is *Sheltered in Place*.

Mae G. Henderson is a professor emerita of English and Comparative Literature at the University of North Carolina, Chapel Hill. She is author of *Speaking in Tongues and Dancing Diaspora: Black Women Writing and Performing*, a feminist cultural studies volume that collects a number of her groundbreaking essays on ways of reading Black women's writing and culture. Author of critical introductions to Nella Larsen's *Passing* and Gayl Jones's *White Rat*, Henderson has also edited or coedited field-defining anthologies and readers, including *Borders, Boundaries, and Frames: Essays in Cultural Criticism and Cultural Studies*, *The Josephine Baker Critical Reader: Selected Writings on the Entertainer and Activist*, *Black Queer Studies: A Critical Anthology*, and *Antislavery Newspapers and Periodicals: An Annotated Index of Letters, 1817–1871, Volumes I–V*. In addition, Henderson is coeditor of the forthcoming and much anticipated "'Don't Say Goodbye to the Porkpie Hat': The Larry Neal Critical Reader."

Kajsa K. Henry is an assistant professor of English at Florida A&M University. She is currently working on a monograph titled "From What Remains: The Politics of Mourning and the Praxis of Loss in Contemporary African American Culture," examining the interactions between racialized spaces, memory practices, and aesthetic forms in contemporary African American culture.

Juan Ignacio Juvé lectures in sociology, horror cinema, and popular culture. He has published in the journals *Revista Lindes* and *Vita e Pensiero* and contributed essays to the volumes *Science Fiction and the Abolition of Man: Finding C. S. Lewis in Sci-Fi Film and Television* (eds. Mark J. Boone et al.), *Bad Mothers: Regulations, Representations, and Resistance* (eds. Michelle Hughes Miller et al.), *Requiem for a Nation: Religion and Politics in Post War Italian Cinema* (ed. Roberto Cavallini), *The Rwandan Genocide on Film: Critical Essays and Interviews* (ed. Matthew Edwards), and *"Twilight Zone" and Philosophy: A Dangerous Dimension to Visit* (eds. Heather L. Rivera and Alexander E. Hooke).

Pekka Kilpeläinen is a university lecturer in English language and culture at the University of Eastern Finland in Joensuu. He is author of *Postcategorical Utopia: James Baldwin and the Political Unconscious of Imagined Futures*. Kilpeläinen has also published in *Atlantic Studies, Amerikastudien/American Studies*, and the *European Journal of American Studies*. His research interests include the African diaspora, utopian studies, transculturation and mobility, and gender studies.

Gene Melton II is a senior lecturer in the English department at North Carolina State University. His scholarship appears in *Contested Boundaries: New Critical Essays on the Fiction of Toni Morrison* (ed. Maxine L. Montgomery). Melton is currently coediting "Silenced Masculinities," a collection of cultural studies essays exploring the politics of manhood in contemporary film, literature, and popular culture.

McKinley E. Melton is the Inaugural Kermit and Renee Paxton Endowed Teaching Chair and Associate Professor of English at Gettysburg College. He has published in *The James Baldwin Review* and *The Langston Hughes Review* and contributed to the volume *James Baldwin:*

304

NOTES ON CONTRIBUTORS

Challenging Authors (eds. A. Scott Henderson and P. L. Thomas). He is currently working on a monograph titled "Claiming All the World as Our Stage: Contemporary Black Poetry, Performance, and Resistance." In his research and teaching, Melton focuses primarily on twentieth- and twenty-first-century Africana literatures; the intersections of social, political, and cultural movements; and the relationship between the rituals and traditions of Africana cultures and Black diasporan creative expression.

Shamika Ann Mitchell is an associate professor of English at Rockland Community College, State University of New York. She is the creator of #SalaamFandom, an initiative to celebrate and uplift Muslims in all aspects of fandom, and a board member of Women in Comics (WinC) NYC Collective International. Her writing has appeared in *College English Notes* and in the collections *Unstable Masks: Whiteness and American Superhero Comics* (eds. Sean Guynes and Martin Lund), *Black Muslim Reads* (eds. Layla Abdullah-Poulos, Fatimah Abdulmalik, and Umm Juwayriyah), *Gloria Naylor's Fiction: Contemporary Explorations of Class and Capitalism* (eds. Sharon A. Lewis and Ama S. Wattley), *Icons of Hip Hop* (ed. Mickey Hess), and *Women on Women: Indian Women Writers' Perspectives on Women* (ed. Asha Choubey). Mitchell has served as editor and creative guide for Unstoppable Comics and is currently editor-in-chief of *WinC Magazine* and lead editor for RAE Comics.

Danielle Fuentes Morgan is an associate professor in the Departments of English and Ethnic Studies at Santa Clara University. She is author of *Laughing to Keep from Dying: African American Satire in the Twenty-First Century*. Her scholarship has appeared in *Biography: An Interdisciplinary Quarterly*, *Pre/Text: A Journal of Rhetorical Theory*, *Journal of Science Fiction*, *Humanities*, and *College Literature*, as well as in a variety of edited collections on African American literature and culture. Morgan has also contributed to *Vulture*, *Racialicious*, and *Al Jazeera*.

Fernando Gabriel Pagnoni Berns is on the Facultad de Filosofía y Letras at the Universidad de Buenos Aires, Argentina, where he teaches courses on international horror film and is director of "Grite," a research group on horror cinema. He is author of *Alegorías televisivas del franquismo: Narciso Ibáñez Serrador y las "Historias para no Dormir,"* a volume on the Spanish horror TV series. Pagnoni Berns has also edited *Frankenstein, celebración de un bicentenario: ensayos críticos sobre transposiciones* and coedited *The Cinema of James Wan: Critical Essays* and *Bloodstained Narratives: The Giallo Film in Italy and Abroad*.

Emily Ruth Rutter is a professor of English and associate dean of the Honors College at Ball State University. She is author of *Invisible Ball of Dreams: Literary Representations of Baseball behind the Color Line*, *The Blues Muse: Race, Gender, and Musical Celebrity in American Poetry*, *Black Celebrity: Contemporary Representations of Postbellum Athletes and Artists*, and most recently *White Lies and Allies in Contemporary Black Media*. She is coeditor of *Revisiting the Elegy in the Black Lives Matter Era*. Rutter's scholarship appears in *African American Review*, *MELUS*, and *Tulsa Studies in Women's Literature*.

Jeanne Scheper is an associate professor and chair of the Department of Gender and Sexuality Studies at the University of California, Irvine. She is the author of *Moving Performances: Divas,*

NOTES ON CONTRIBUTORS

Iconicity, and Remembering the Modern Stage. Her scholarship appears in *Feminist Media Studies, Radical Teacher, African American Review, Duke Journal of Gender Law and Policy, Feminist Studies, Camera Obscura,* and *Women & Performance,* as well as in the collections *The Josephine Baker Critical Reader: Selected Writings on the Entertainer and Activist* (eds. Mae G. Henderson and Charlene B. Regester) and *Sasinda Futhi Siselapha: Black Feminist Approaches to Cultural Studies in South Africa's Twenty-Five Years Since 1994* (eds. Derilene Dee Marco et al.). Scheper is currently completing a monograph titled "Policytainment: 'Don't Ask, Don't Tell,' Transgender Military Service, and Popular Culture."

Stella Setka is a professor of English at West Los Angeles College. She is the author of *Empathy and the Phantasmic in Ethnic American Trauma Narratives.* Her scholarship has appeared in *Modern Fiction Studies, MELUS, Mosaic, American Periodicals,* and *Jewish Film & New Media.* She has contributed to *Re-visioning Terrorism: A Humanistic Perspective* (eds. Elena Coda and Ben Lawton) and coedited the textbook *Literature of Exile and Displacement: American Identity in a Time of Crisis.* Setka is currently working on a book project titled "Going Home: Reverse Migrations in African American Literature."

Sheila Smith McKoy serves as vice provost of Equity, Inclusion and Faculty Excellence at the University of San Francisco. She is author of *When Whites Riot: Writing Race and Violence in American and South African Cultures* and editor of *The Elizabeth Keckley Reader: Writing Self, Writing Nation* and *The Elizabeth Keckley Reader: Artistry, Culture and Commerce.* Smith McKoy is coeditor of *Recovering the African Feminine Divine in Literature, the Arts, and Practice: Yemonja Awakening* and *Teaching Literature and Writing in Prisons.* Smith McKoy is also a prize-winning poet, a short fiction writer, and a screenwriter and producer.

Kim White is a doctoral candidate in the School of the Arts and Media at the University of New South Wales in Sydney, Australia, where she has written a dissertation titled "Postsecular Pilgrimages: Civil Religion and Mystical Anarchism in the American Novel after the 1960s." White's research interests include postsecular theory, the twentieth-century American novel, popular music, and radical democratic movements.

Meina Yates-Richard is an assistant professor of African American studies and English at Emory University. She is currently completing a monograph titled "Sonorous Passages: Black Maternal Soundings and the Liberation Imaginary," for which she was named a First Book Institute Fellow at Penn State's Center for American Literary Studies. Yates-Richard was also awarded the 2016 Norman Foerster Prize for Best Essay published in *American Literature* and a 2018 Ford Foundation Postdoctoral Fellowship. Her scholarship appears in the *Journal of West Indian Literature, American Studies, Post45 Contemporaries,* and *Feminist Review,* as well as in the collection *Ralph Ellison in Context* (ed. Paul Devlin).

INDEX

Page numbers in italics indicate an illustration.

abandonment, 5, 88–89, 94–97, 159, 164, 211, 218, 236, 241
Abbott, John, 224
Abdullahi, Abubakar, 223
abolition, 11, 24, 46n34, 49n111, 57, 59
abortion, 54, 141
Above the Rim, 122. *See also* Shakur, Tupac
Abraham, Nicholas, 30, 40, 47n53, 47n55, 49n126
Abu-Jamal, Mumia, 11, 104–109, 111, 114, 116–117, 176. See also *Death Blossoms*; *Live from Death Row*; "Spider, The"
Achebe, Chinua, 247–248, 259n2
Adli, Mazhar, 199n44
aesthetic: of Black death, 156, 157; Black Power, 160; Black radical, 161, 169, 170, 172, 173, 176, 177, 181; Black vernacular, 175; of Black women's pain, 11, 87, 89, 93; dance, 233, 235, 238, 242–243; of dramatic mimesis, 58; gangsta, 176, 180; hip-hop, 137; horror, 220; methods, 43, 44, 58, 158, 168n30; militant, 13, 180; mystical, 171; postmodern, 105–108; spectral Black, 13. *See also* Black Aesthetic
Africa, 5, 55–56, 75, 79, 172, 187, 189, 197, 233, 263–264; and archive, 14; cinematic representations of, 14, 215–228; colonial, 216; cultural traditions of, 141, 151, 188, 192; family structures, 196; funerary practices of, 144, 149, 220; history of, 71, 195, 205; languages of, 224; literature tradition of, 196; and Middle Passage, 24, 27, 31–33, 37–38, 41–42, 45n12, 45n15, 110; precolonial, 23; proverbs of, 151, 152, 196, 197; spiritualism (religion) of, 5, 80–81, 82n9, 137, 188, 192, 195, 205, 214n48, 248; West, 23, 24, 27, 31–33, 37–38, 41–42, 45n12, 45n15, 237, 248–249, 253, 259n2. *See also* Ethiopia; Ghana; Guinea; Liberia; Namibia; Nigeria; Senegal; South Africa

African American Policy Forum, 100
African Americans, 16, 174–175, 208, 237, 242, 247, 267; and afterlife, 207; art of, 169; and communal trauma, 204; culture of, 71; heroic representation of, 217; and hip-hop, 134n8, 180; history of, 71, 83n10; literature of, 14, 15, 70–71, 81, 89, 166n4, 200–201, 211, 262, 264–265, 272–273, 281, 279, 281; political mobilization of, 220, 234; post-slavery, 10, 70; and resistance, 202, 205; and subjectivity, 125; as victims of state-sanctioned violence, 263, 265. *See also* slavery; subjugation
African Diaspora, 4, 51, 72, 87, 233; activism in, 97; afterlife of, 5, 7, 9–10, 52, 58, 65; archives of, 7, 10; arts of, 169; belief systems of, 205; and Black counter-culture, 201; and culture, 5, 87; and generational relay, 23, 50n153; and hip-hop, 137, 148; literature of, 70–71, 82n9, 192–193, 197; and Middle Passage, 50n153; and relayed trauma, 25; religious beliefs, 5; and social media, 17; and sounding, 87; specters of, 169; and trauma, 51–52; writers of, 23, 70–71
African futurism, 13, 187, 190, 192, 198n1
Africa(n)-ness, 261, 227
Afrofuturism, 13, 187–188, 190, 192, 197, 198n1; and jazz, 172; in literature, 13, 188, 191
Afropessimism, 13, 166n7, 166n12
afterlife, 5–9, 15, 17, 78, 134n8, 142–143, 191, 205, 212, 220, 253, 257, 273; as archives, 8; Black, 1, 10, 12–13, 16, 60, 157–158, 161, 163–165, 166n4, 259, 271; Black Antebellum, 5; of colonialism, 10; of Confederacy, 2, 4; diasporic, 5, 7, 9–10, 228, 247, 249; of Emmett Till's ghost, 201–202, 209, 211; of friendship, 284; intergenerational, 201; of Medgar Evers, 252; and public memorials, 146; of racialized violence, 15, 53;

of Sara (Saartjie) Baartman, 53, 55–56; of slavery, 4, 13, 39, 60–61, 63–65, 137, 167n16, 172, 181, 201–202; sonic, 12, 13, 97, 138, 151, 161, 163–165, 167n27; of Trayvon Martin, 263; of Western eugenics, 13, 187, 197, 198n4; and Yoruba, 11, 70–71, 73
Agamben, Giorgio, 49n115, 166n12
Ahmed, Insanul, 149. *See also* Price, Sean
AIDS, 123, 138
Akan (dialect), 152, 194
Alexander, Elizabeth, 52
Alexander, Michelle, 272
Alexander, M. Jacqui, 24, 39–40
All Eyes on Me (Tupac Shakur), 133n8
All Things Censored (Mumia Abu-Jamal), 104
Althusser, Louis, 165n3
America (United States), 55, 75–76, 79, 88, 90, 93–94, 124, 171, 219, 256; civil society in, 178; history of, 90, 128, 131, 177; post-racial, 99, 264; sports in, 219. *See also* United States
American Idol, 130
American Monument (lauren woods), 4
America Play, The (Suzan-Lori Parks), 66n20
Anarcha, 189. *See also* Sims, James Marion
Anarcha Project, The, 198n8
"anarchive," 30
ancestors, 18, 23, 72–76, 96, 141–142, 145, 202, 205, 257; absence of, 174; African diasporic, 71, 81, 151, 197, 205, 248–249; afterlife of, 70; culture of, 194; veneration of, 248; worship of, 249
Anderson, Allan, 145, 149
Anderson, James Craig, 270, 271
Anderson, Melanie, 203–204, 211
Anderson, Monica, 103n79
Andrews, William, 101n8–9
animism, 14, 200, 207–208, 212; principle of, 202
Antebellum (Gerard Bush and Christopher Renz), 227
antenatality, 159–161
Anti-Apartheid Movement, 279

307

INDEX

anti-Blackness, 166n8, 166n12, 247; and Afropessimism, 166n7; and hip-hop, 157, 158; metaphysics of, 158; ontology of, 158, 165, 166n8, 177; and police brutality, 138; and racism, 7, 272; and sound, 163, 176; and systemic violence, 157, 159, 176, 181; and violence, 13, 163, 165, 171–174. *See also* anti-Black world; lynching; ontological escape; ontological terror; ontology; racial terror; racial violence

anti-Black world, 156, 157, 160, 161–162, 165, 166n15

anxiety: about Black male subjectivity, 90; and maternal soundings, 90; about monstrous other, 215; prenatal, 159; about specters of slavery, 181; western social, 14

Anzaldúa, Gloria, 63–64

Apartheid, 7, 53, 187, 226, 264

apostrophe, 140–141

archive, 8, 9, 47n47, 47n51, 53, 56, 138, 142, 236, 252, 257, 266, 284; of African Diaspora, 7, 8, 10; colonial, 30; of Confederacy, 2, 3; critical practices of, 15; dancing body as, 233–234, 238; embodied, 15, 238–240, 243n4; haunted, 8; hegemonic, 37; law as, 27, 30, 31, 32–33, 38, 40, 42; normative, 38, 40; oceanic, 23–25, 30, 38, 44; official, 30, 32, 35, 38, 253; popular culture, 12, 14, 148, 152; public monuments as, 4; shadow, 10; of slavery, 2, 3, 24, 45n15; sonic, 11, 164; transtemporal, 12; of University of North Carolina at Chapel Hill, 3. *See also* "anarchive"; counter-archive

Are We There Yet?, 129. *See also* Ice Cube

Arlington National Cemetery, 252

Armstrong, Louis, 90

Arnold, Regina, 123, 128, 130

Asim, Jabari, 250

Asoka, Kaavya, 98

Assman, Jan, 197

Astaire, Fred, 123

audience, 109, 131, 163–164, 194, 240, 251, 264, 280; as consumer, 126; participation of, 10, 15, 43–44, 52–65, 121–123, 129, 234, 236–238; rap, 173; as witness, 129

"audio obituary," 12, 138

Audio Two, 158. *See also* Notorious B.I.G.

Aunt Hester's scream, 11, 87–91, 96–99. See also *Narrative of the Life of Frederick Douglass, The*

Australopithecus afarensis, 193. *See also* Lucy (the Mitochondrial Eve)

autogenocide (Joy James), 176, 179

AZT, clinical trials of, 189. *See also* AIDS

Baartman, Sara (Saartjie), 9–10, 51–56, 63, 188; historical illustrations of, 59. *See also* Venus Hottentot

Baby Gangsta, 131

"Backseat Freestyle" (Kendrick Lamar), 177–178, 183n59

Baker, Ella, 174

Bakhtin, Mikhail M., 214n74

Baldwin, James, 156–157, 201, 240, 280–281

Bambara, Toni Cade, 279

Baraka, Amiri (aka LeRoi Jones), 47n68. See also *Slave Ship: A Historical Pageant*

Barbershop, 129. *See also* Ice Cube

"bare life" (Giorgio Agamben), 166n12

Barrymore, Lionel, 218

Barthes, Roland, 159, 161

Bascom, William, 74

Basquiat, Jean-Michel, 108

Baucom, Ian, 27–28, 31, 45n12, 46n24

Bean Eaters, The (Gwendolyn Brooks), 246

Beinart, William, 219

Belafonte, Harry, 236

Beloved (Toni Morrison), 33, 201, 211

Benjamin, Ruha, 1, 16–17

Benjamin, Walter, 24, 32, 47n70, 177

Benston, Kimberly, 264

bête noire, 228

Betsey, 189. *See also* Sims, James Marion

Between, The (Tananarive Due), 71

Beyoncé, 262

Big Fun (Miles Davis), 168n35

Big L, 138–139, 143

Big Pharma, 192, 193

Big Pun, 138, 139

Bill and Melinda Gates Foundation, 189. *See also* Navrongo Experiment

biodiversity, 187, 193, 194

biopolitics, 171–172, 191

biopower, 13, 187, 188, 190, 197, 198n4; and Black body, 187–189

Birns, Nicholas, 243n4, 245n29

Bivins, Michael, 147

Black, Daniel, 14, 201–202, 204, 212. See also *Sacred Place, The*

Black Aesthetic, 13, 180, 181; postmodern, 105; radical, 172–173

Black Arts Movement, 18, 124, 279

Black Atlantic (Paul Gilroy), 9, 14, 52, 201

Black body, 12, 13, 15, 91, 93, 112, 118, 160, 162, 164, 172, 178, 187–189, 195, 242, 247, 263; African, 23, 192, 220; African Diasporic, 192; and biopower, 187–189; commodified, 12, 55, 112, 122; dancing, 9, 223, 237–238, 242, 243n4; discursive, 118, 125; female (women's), 3, 13, 114, 115, 187, 189, 193, 197, 198n4; incarcerated, 172; lynched male, 234, 235, 242, 270; male, 15, 93, 129, 160, 162, 164, 223, 237, 268; maternal, 91, 92; medical experimentation on, 192–193; in pain, 234–235; slave, 46n23, 111–112, 113, 114; violence against, 264, 268–269

Black experience, 10, 32, 66n21, 87, 172, 175

Black feminism, 97, 282

Black fugitivity, 157, 159, 160, 162, 165, 167n16, 167n27, 168n30

Black hauntology. *See* hauntology

Black Liberation, 95, 103n85, 103n93; activism, 97, 99–100, 101n4; communal, 90; corporeal, 113; and diaspora, 87; ideologies of, 87, 88, 98, 99;

masculinism in, 93; movements, 11, 97–100, 101n4, 103n94; praxis, 97; and slavery, 106, 113; and women, 93, 97–100

Black life, 7, 14, 100, 123–124, 129, 157, 160, 162, 164, 167n16, 167n27, 172, 174, 180, 187, 212; after death, 158, 161; as afterlife, 165; antenatal, 159; commodified, 128; disposability of, 97; in hip-hop, 13; and normativity, 181; and ontological terror, 163; perinatal, 159; precarity of, 159; prenatal, 159; resistant, 170; and sound technologies, 163, 165; thingification of, 91; and undercommons, 176; and violence, 167n24, 171, 179

Black Lives Matter, 246, 259; #BlackLivesMatter, 11, 93, 97–100, 103n79, 170, 259, 274n5; in Britain, 17–18; as movement, 11, 16, 103n79, 262, 274n5, 274n7

Black masculinity, 177; and Black liberation, 93; and Black nationalisms, 87–89, 95–97, 101n4; and celebrity, 122, 125, 127–128, 132; commodification of, 12, 122, 133; fetishization of, 124; in hip-hop, 122, 125, 144, 165n3; and Latino masculinity, 144; performance of, 125; sentimental, 144; stereotypes of aggressive, 144

Black maternal, 11, 70, 75, 79, 88, 92, 94–96, 98, 102n48, 112, 115, 193, 196, 209, 256, 277; and activism, 16, 98, 100, 128, 202; body, 87, 89, 90, 93, 159; foremothers, 73–74, 78, 80–81, 191–192, 196, 283; and loss, 99, 116, 117; as machine, 91, 93; and memory, 148, 152; and silencing, 97, 100, 101n4; and sonority, 97, 89, 90–92, 94, 96–97, 99, 101n14, 111, 158–159; and specter, 113, 117

Black men, 94, 117, 208; and archives, 239; and Black liberation, 99; and Black Lives Matter, 97–98, 103n81; and Black nationalism, 87, 95; and Black radical politics, 95; enslaved, 27, 92; and friendship, 284; and hip-hop, 129–130; and Latino men, 12, 144, 152; and leading causes of death, 129; and lynching, 239–240; and memorialization, 129–130; and personhood, 89; and racial violence, 93, 242, 264–265; as subjects of freedom, 99, 101n4; subjugation of, 268

Black militancy, 93, 170–171, 173, 176–180

Black Movie (Danez Smith), 275n19

Black nationalism, 87–88, 90, 96, 99–100, 102n48; Black maternal sonority and, 101n14, 103n94; discourses, 88; ideology of, 11, 87–88, 94–95, 97–98; masculinism in, 87–89, 95–97, 101n4; militant forms, 93; politics of, 93; tradition of, 89

Blackness, 159–161, 164, 174–175, 180–181, 270; afterlife of, 157; and being, 157, 160; and celebrity, 122; commodification of, 125–126, 131–133;

INDEX

genetic, 197–198; and masculinity, 122; and metaphysics, 158; objectification of, 123; and ontological terror, 161; optic, 131; performance of, 128; phenotypical, 190; in popular culture, 124, 131; racialized, 192; and surveillance, 168n33; and sound, 158, 163; unmitigated, 170, 172

Black Panther party, 122, 128, 176

Black poetics, 170, 172, 174, 177; visual, 235

Black Poets Speak Out, 262

Black Power Movement, 11, 88, 99, 170, 279

Black Radical Tradition, 12, 176, 181, 246

"Black rage," 13, 175, 177, 180, 273

Black revolutionary thought, 116, 157, 178; aesthetics of, 169; and hip-hop, 170, 173–174, 176, 180

Black Star, 176

Black subjectivity, 12, 70, 71, 99, 122, 133, 166, 172, 174, 189, 270

Black thought, 161, 164–165, 166n8, 166n15, 167n16, 171

Black women, 11, 96, 102n48, 241, 263, 265–266; and activism, 98; and Black liberation, 99; and Black Lives Matter, 16, 97, 100; enslaved, 55, 88–90, 101n9, 101n13, 102n32, 187, 190–191, 208; erasure of, 90; exclusion from Black nationalism, 98–99; material absence of, 92; maternal labor of, 93–95; and maternal sound, 87; and medical experimentation, 188–189, 198n4; and memory, 73–74, 77; and pain, 97; queer, 97, 100; and racist violence, 252, 266; representations of, 227; and #SayHerName, 16, 100; silencing of, 88, 101n4; and sonic labor, 87, 97; and sound, 87–93, 95, 97, 99–100, 101n14, 103n94; survival of, 93; writers, 13, 101n14, 187, 197, 198n4, 279–285; and *Zong* massacre, 27

Black Youth Project, 100

Bland, Sandra, 16, 271

Blaq Poet, 139

Blaqprint, The (Blaq Poet), 153n7

Bloods, 179

Bloody Sunday (Selma, Alabama), 235

Blount, Marcellus, 270

Blues, 95, 173, 236, 269, 275n15; musician, 237; singer, 90, 93, 94; woman, 94

Boateng, Boatema, 139, 148, 152

Boateng, Setaey Adamu, 24, 38–39

body, 23, 39, 40, 64, 74, 82n9, 109, 112, 241; apparition, 113; collective, 234; counter-discourse of, 118; crimes against, 250; deceased, 6, 23; depiction of, 220, 222; of Emmett Till, 249, 265; of Henrietta Lacks, 193; injuries of, 72, 270; instrumentalization of, 51; laboring, 91, 99, 111, 115; of Martin Luther King Jr., 178; as memorial, 147, 251–252; organic, 13, 65, 116; politic, Black, 99, 116; politic, white, 273; racialized, 118; of Sara (Saartjie) Baartman, 10, 51, 52, 54–56, 59; as site of memory, 73, 81,

233, 237, 238, 242, 243, 244n4; slave, 46n23, 111–112; tattoos, 151; of Tupac Shakur, 128. *See also* Black body; buck dance; dance; embodiment

Bogeyman, 220

Boland, Eavan, 263

Bolden, Barbara Jean, 253–254

bondage, 51, 52, 53, 56, 57, 63, 89, 91–92, 99. *See also* slavery

Bone Thugs-n-Harmony, 124

Bontemps, Arna, 240

Boogie Down Productions, 138, 151

Book of Phoenix, The (Nnedi Okorafor), 13, 187–188, 192–197, 198n4

Book of Proverbs, 139

Boot Camp Clik, 138, 149, 151. *See also* Price, Sean

Born Again (Notorious B.I.G.), 157

Bouchard, Donald F., 244n21

Boudreau, Kristen, 264

Bowman, Laura, 221

Boyd, Rekia, 98

Boyd, Zhaleh, 18

Bradbury, Ray, 114

Brand, Dionne, 23

Brathwaite, Kamau, 33, 197

Braxton, Joanne, 84n59

Brecht, Bertolt, 60–61

Brechtian alienation (Bertolt Brecht), 60–61

Britain, 17, 20, 26, 28, 41, 45n22, 51, 54–57, 65n2, 198; civil rights protestors, 17

British Courts, 28, 54, 57, 59

Brogan, Kathleen, 39, 40, 200–201, 205, 209, 211

Brokowski, Carolyn, 199n44

Brookes (ship), 26, 46n23. See also *Zong* (ship)

Brooks, Daphne, 167n16

Brooks, Gwendolyn, 15, 201, 246–247, 253, 254, 256–257, 259, 264

Brooks, Kinitra, 82n9

Brown, James, 87

Brown, Michael, 16, 98, 173, 265, 271–272, 274n7

Browne, Simone, 168n33

Browning, Tod, 215–216, 220

Brown v. Board of Education, 257

Bruce, Virginia, 218

Brunt, Shelley D., 131

Bryant, Carolyn, 15, 253–257, 260n33

Bryant, Ron, 201, 210–211

buck dance, 15, 236, 240–241; as archive, 239; as counter-memory, 238; as cultural memory, 238; as embodied memory, 242–243; living room dances, relation to, 15, 237, 238, 239; origins of, 237. See also *Come home Charley Patton*; *Geography Trilogy, The*; *Solo*

Budge, E.A. Wallis, 153n22

Bufford, Daisy, 221

Burke, Robert John, 226

Burnham, Michelle, 114

Busia, Abena, 281

Busta Rhymes, 154n57

Butler, Judith, 266, 272

Butler, Octavia, 13–14, 82n6, 191–193; African spiritual traditions, relation to, 70–71; and Afrofuturism, 198n1; and afterlife of medical experimentation (eugenics), 187, 190, 191, 198; and cultural memory and survival, 188, 194–195, 197; and kinship, 196; and maternal trope, 196; and traumatic history, 82n9. See also *Fledgling* (Octavia Butler); *Kindred*; *Wild Seed*

Campaign Zero, 103n81

Campbell, Timothy, 166n12

Cape Coast Castle (Ghana), 26–27

capital (capitalism), 94, 99, 104, 110, 114, 117, 123, 169, 173, 215; as afterlife of slavery, 181; and Atlantic slave trade, 172; corporate, 12; counter-narratives of, 116, 118; and enslavement, 107, 112; global, 107, 118, 167n17; ideology of, 106; and imperialism, 107; late, 11; Marxist critiques of, 126; and mysticism, 112; racial, 7, 42, 104, 105, 108, 172; and slaveocracy, 112; sociocultural and political logic of, 110–112; as system of oppression, 111

Capital STEEZ, 138, 152n1

captivity, 169, 172–173, 177, 179; carceral, 11; conditions of, 7; and enslavement, 45n15; posthumous (Sara [Saartjie] Baartman), 56; and Sara (Saartjie) Baartman, 55; space of, 18

carceralization, 175, 176, 178; state, 7. *See also* captivity; mass incarceration

Caribbean, 10, 24, 25, 26, 28, 31–32, 33, 189

Carr, Gwen, 274n7

Carr, Julian, 1–3

Carruthers, Charlene, 100

Carter, Walter, 243n4

Caruth, Cathy, 62–64, 82n9

Cash Money Millionaire, 131

Castronovo, Russ, 120n101

catharsis, 77, 112, 124, 131, 141, 146–147

Cattle Killing, The (John Edgar Wideman), 71, 82n6

celebrity, 11, 12, 103n81, 121–128, 130, 132, 133, 133n4; effect, 127

censorship, state, 104, 114

Center for Intersectionality and Social Policy Studies, 100

Césaire, Aimé, 102n31, 228n16

Chambers, Paul, 269

Chandler, Nahum, 166n8

Chaney, Lon, 216–217

Chang, Jeff, 182n6

Chappelle's Show, 134n19

Charlotte's Web, 175. *See also* Lamar, Kendrick

Charlson, Doria E., 244n4

Charras, Françoise, 45n13

Chase-Riboud, Barbara, 52

Chassot, Joanne, 200

Chatelain, Marcia, 98, 103n88

Cheney, Patrick, 141

Cheryl Sublime Poetess Faison, 274n6

309

INDEX

Chiasson, Dan, 274n2
Chinwezu, 188
Chinx, 138
Chloe, Love Is Calling You (Marshall Neilan), 216–217, 228n8
Christian, Alexia, 98
Christianity, 5, 11, 70, 71, 78, 205–206; evangelical, 77
Christina, Dominique, 15, 247, 257–259. *See also* "For Emmett Till"; "Karma"
chronotope (Mikhail M. Bakhtin), 211
Citizen: An American Lyric (Claudia Rankine), 15, 45n9, 262, 263, 266–267, 269, 271–273, 275n24
citizenship, 59, 96, 99, 179, 268, 270, 273, 274; biological, 196; Black bodies, in relation to, 15; construction of, 116; first-class, 267; historical exclusion of Black people from, 174; and othering, 263; second-class, 266, 281; tiered levels of, 271–272
civilization, 14, 24, 32, 47n70, 51, 71, 195, 216, 220; pre-slavery, 176
Civil Rights Movement, 99, 201–202, 206, 211, 257, 259; activism, 212; and death of Emmett Till, 201–202, 212, 257; demonstrations, 171, 242; era, 246, 257; historical sites of, 234–235; history of, 242; icons, 173, 250; leaders, 16, 173, 246, 247, 252, 257; marginalization of Black women in, 98; and memorialization, 238; murders of key figures in, 15, 246, 259; neo-, 173; and non-violence, 171; omissions from archive, 252; struggle, 250–251; and women, 98, 202, 249, 252, 259. *See also* Evers, Medgar; Post-Civil Rights; Till, Emmett; Till-Mobley, Mamie
Civil War, 1–2
Clark, Jamar, 271
Clarke, Cheryl, 281–282
class (classism), 56, 100, 125, 134n12, 200, 220, 266, 267, 270, 281; Black slave, 111; master, 111, 114; slave-owning, 45n6
Clayton, Elias, 239, 242
Clayton Jackson McGhie Memorial (Duluth, Minnesota), 239
Clifford, James, 67n42
Clifton, Todd, 93
Cloutier, Jean Christophe, 10
Coachella Valley Music and Arts Festival, The (Indio, California), 121–123, 126, 128–132
Coates, Peter, 219
Coates, Ta-Nehisi, 178
Cobb, Jelani, 103n79
Coke Boy, 138. *See also* Chinx; Montana, French
Coker, Cheo Hodari, 167n21
Cole, Natalie, 130, 134n25
Cole, Nat King, 130
Coleman, Robin R. Means, 228n7, 229n30, 229n32
Coleman, Wanda, 264

Coleman-Singleton, Sharonda, 271
Collingwood, Luke, 26, 28, 37, 46n24, 46n29. See also *Zong* (ship)
Collins, Patricia Hill, 208
colonialism, 7, 17, 38–39; and Africa, 216; afterlives of, 10, 61, 65; and depictions of Africa, 219–220, 223–227; and English language, 31, 33; and fragmentation of kinship and culture, 34; and historical trauma, 62, 64; and law, 33; legacies of, 58; and medicine, 187; past of, 225; pathologies of, 187; public history of, 61; and slavery, 52, 55, 56, 169; and South Africa, 55; trauma of, 10; violence of, 226
colorblind racial ideology, 170, 172, 174, 177–178, 180–181; liberal, 172, 181; of public culture, 178
Colston, Edward, 17–18
Combs, Sean (aka Sean P. Diddy, P. Diddy, Puff Daddy), 13, 129, 157, 159, 163–164
Come home Charley Patton (Ralph Lemon), 9, 14, 233–239, 241–243, 243–244n4
commemoration, 249, 259; of Emmett Till, 258; in fashion, 148; in hip-hop, 148, 156, 165n1; and lynching, 239; memorabilia as, 151; and memorialization, 144; in murals, 149, 151; statues as, 17, 18
commodification, 27, 124, 127, 133n4; of Black Antebellum afterlife, 5; of Black body, 12, 55, 122, 112, 122, 188; of Black life, 128; of Black maternal body, 91–92, 102n32; of Blackness, 126, 133; and fetish(ism), 122, 125; self-, 57; and slavery, 44n1, 110–114; of Tupac Shakur's posthumous celebrity, 12, 122–123, 125–131, 133, 133n1
commodity, 109, 124, 132; and abstracted corporeality, 110, 113–114; and conspicuous consumption, 132; as fungible, 23, 27; and slavery, 2, 12, 27, 31, 44n1, 110
commodity mysticism, 11, 111–112
community, 76–77, 239, 249, 259; African American, 81, 82, 204, 217, 270, 273; American, 175; Black, 87–88, 92, 94–100, 102n48, 103n79, 170, 178–179, 202, 204–207, 212, 256; and Black women, 98; Civil Rights Movement and, 252; commodification of, 125; of empathetic witnesses, 75; Harlem, 92; hip-hop, 137, 138, 149, 151–152, 165n1, 175; interpretive, 279; interracial, 270; post-slavery Black, 79; of public mourning, 149, 150; scientific, 57; tattoo, 147; West African, 248; white, 255–256, 265
Confederacy, 1–4, 17
Connor, Bull, 179
consciousness, 91, 139, 192; collective, 74; community, 255–256; historical, 277–278; integrated, 73–77, 79–81;

liminal, 75; multiple, 77; public, 98, 137; shared, 76–77, 81; spiritual, 210; white collective, 257
Cool and Deadly, 153n24. *See also* Just-Ice; KRS ONE
Cooley High, 137, 139
Cooper, Anderson, 130
Cooper, J. California, 70; African spiritual traditions, relation to, 70–71
Corregidora (Gayle Jones), 70, 82n6, 82n9
cosmology, 80, 82n4, 247
counter-archive, 9, 10, 15, 30, 35
counterculture, 14, 201
counter-discourse(s), 8, 118
counter-memorials, 234, 236, 238–241, 244n7
counter-memory, 244n7, 244n21; embodied, 15, 131
counternarrative, 8, 12, 201, 207, 208
COVID-19, 199n44
Cowen, William, 215, 218
Crais, Clifton, 65n4, 66n7, 67n36, 67n38
Crawford, John, 265, 271
Crawley, Ashon, 161, 167n27, 168n30
creolization, 36
Crips, 179
CRISPR-Cas, 9, 198, 199n44
Crossing the River (Caryl Phillips), 107, 120n98
Crowder, Michael, 228n4
Cugoano, Quobna Ottobah, 23, 105
Cullors, Patrice, 97, 103n79, 274n5. *See also* Black Lives Matter
cultural imaginary, 4, 14, 52, 257
culture: African, 214n48; African American, 207; American visual, 125; Black, 123–124, 140, 162, 169, 176; border, 64; Ghanaian, 139; hip-hop, 142, 144–146, 148–149, 152, 156, 164, 165n1; Igbo, 248–249; industries, 172; mainstream representations of, 52; Pan-African, 71, 180; popular, 121; West African, 259n2; Western, 248
Curry, Mary Cuthrell, 153n27
Cuvier, Georges, 51, 188
Cvetkovich, Ann, 266–267
Czaplicka, John, 197

D'Aguiar, Fred, 44
Daly, Ann, 243, 243n1
Damery, Mensah, 199n23
dance, 130, 233. *See also* buck dance
Dark Continent, 14, 222–224, 227
Dark Villain, 256–257
Dart, Raymond, 222
Dash, J. Michael, 44, 82
Dash, Julie, 71
da Silva, Denise Ferrira, 167n17
Daughters of the Confederacy, 1
Daughters of the Dust (Julie Dash), 71
Davis, Adrienne, 271
Davis, Jordan Russell, 271
Davis, Miles, 163, 168n35, 269
Day-O (Harry Belafonte), 236
"dead zone" (Joy James), 174
Dean, James, 129, 134n24

310

INDEX

death, 17–18, 78, 127, 165, 187, 189, 209–210, 248; and acts of remembrance, 249; aesthetics of Black, 157; and afterlife, 5–6, 16, 252; and archive, 252; Black, 127, 160–163, 253; Black life after, 156–158; in *Book of Phoenix* (Nnedi Okorafor), 192; of Breonna Taylor, 16; and Civil Rights Movement, 251; commodification of the Black body after, 10, 12, 125; and dance as counter-memorials, 236–243; of Deshawnda Sanchez, 16; of Emmett Till, 253, 256, 265; of Eric Garner, 16; and fetishization of Black, 128; in *Fledgling* (Octavia Butler), 191; of Freddie Gray, 16; and friendship, 277–284; of George Floyd, 16; and hip-hop, 137–152, 156; in horror film, 222–224; in *Incidents in the Life of a Slave Girl* (Harriet Jacobs), 111–112, 115; intergenerational, 209; of Medgar Evers, 251; of Michael Brown, 16; and Middle Passage, 23, 26, 28, 32, 38–39, 41–42; in *Narrative of the Life of Frederick Douglass, The* (Frederick Douglass), 89; premature, 158–159, 160; and racialized violence, 246, 270–272; and remory, 122; reminders of, 8; in *Sacred Place, The* (Daniel Black), 202, 212; of Sandra Bland, 16; and slavery, 79; in *Song of Solomon* (Toni Morrison), 96–97; sonic, 164; and specters, 40; of Tamir Rice, 16; of Tony McDade, 16; tourism, 5; traditional West African beliefs about, 23, 247; of Trayvon Martin, 15, 262–271, 273; of Tupac Shakur, 121, 123–124, 125, 127, 129–132; in *Venus* (Suzan-Lori Parks), 53–57, 60–61, 64–65; and white supremacy, 204; Yoruba spiritual practices about, 72–73, 80. *See also* memento mori; social death
Death Blossoms: Reflections from a Prisoner of Conscience (Mumia Abu-Jamal), 104, 106, 108–109, 114, 116–117
death row, 11, 104–109, 114, 116–117
Death Row Records, 133n8
Declaration of Helsinki (2013), 189
decolonization, 2, 224, 225
deejaying (DJ), 138, 140, 142–145, 147, 151
DEF3, 151
dehumanization, 7, 30, 125, 172, 180, 181, 268, 273; systemic, 268
de Klerk, F.W., 226
De La Beckworth, Byron, 15, 246, 251, 253, 255
De La Beckworth, Thelma, 251, 253. *See also* De La Beckwith, Byron
De La Beckworth, Willie, 251, 253. *See also* De La Beckwith, Byron
De La Soul, 143. *See also* J Dilla
Deloria, Vine, Jr., 76
dematerialization, 73, 112, 113, 114
dematerialized materialization, 117
DeMello, Margo, 229n19

democracy, 93, 99, 105, 111, 127, 263; anti-, 106
Depo-Provera, 189
Derrida, Jacques: and commodity, 110, 112; and concept of *arkeion*, 30; and concept of specter, 13, 109–110, 167n17, 174, 200; and witnessing, 39
Devil's Daughter, The (Arthur H. Leonard), 216
diaspora. *See* African Diaspora
diasporic relationality, 10
Dickison, Dan, 19n8
Diedrich, Maria, 45n8, 45n13, 84n59
Different World, A, 122. *See also* Shakur, Tupac
Diggin In The Crates, 138
Dion, Celine, 130
discrimination, 60, 273; institutional, 60; racial, 2; systematic, 202; systemic, 266
disembodiment, 114, 168n32; Black slave, 112
DJ Boogie Blind, 144
DJ Eclipse, 154n40
DJ Kay Slay, 143
DJ Mikec22, 153n23
DJ Noize, 140
DJ Premier, 143–144
DJ Red Alert, 142
DJ Scott La Rock, 138, 143, 151–152
DJ Scratch, 147, 151
DJ Spinna, 145
DMX, 147–148
DNA, 187–188, 190, 193–194, 197–198; African, 190–191; mitochondrial, 195
Dobrowsky, Frantz, 226
Doctor, DePayne Middleton, 271
Doggy Fizzle Televizzle (Snoop Dog), 129
Domby, Adam H., 2–3
Donuts Are Forever, 148. *See also* J Dilla
double-consciousness (W. E. B. Du Bois), 75
Douglass, Frederick, 11, 87–94, 96–99, 101n4, 101n9. *See also Narrative of the Life of Frederick Douglass, The*
Dove, Rita, 263–266, 268, 273
Dracula (Tod Browning), 216
drama, 9, 52, 58–60, 62, 65, 73, 180, 278
Dr. Dre, 121–122, 130
Dubey, Madhu, 82n7
Duboin, Corinne, 72
Du Bois, W.E.B., 166n8
Duck Down Music, 155n68
Due, Tananarive, 71, 82n6
Dunn, Kevin, 219–220, 225
Dunn, Michael David, 271
Dunton, Chris, 66n7
Dust Devil (Richard Stanley), 14, 216, 224, 225–227
Dyson, Michael Eric, 176
dystopia, 56, 107, 192

E. 1999 Eternal (Bone Thugs-n-Harmony), 133n6
earwitness, 157, 165, 166n11
Eastern Cape (South Africa), 51
Eaton, Kalenda, 102n62
Eazy E, 138–139
Ebola vaccine, 189
Edey, Maitland, 199n29

Edkins, Jenny, 31, 34, 38–39
Edmund Pettus Bridge (Selma, Alabama), 234, 235
Egyptian Book of the Dead, The, 142, 153n22
Eichorn, Katie, 35
Einstein, Albert, 117
Ekwunife, Anthony, 73
elite, 12, 104–105, 121, 174–175; Black, 174
Ellis, Aimé, 127, 132
Ellison, Ralph, 11, 89–94, 102n48. *See also Invisible Man*
Emanuel, James, 264
embodied research, 223. *See also* Lemon, Ralph
embodiment, 6, 7, 33, 131, 157, 159, 161, 192, 202, 205, 217, 219, 238; black body as, 93; of black slave, 112, 160; of colonial fears, 223; of colonialism, 224; of diaspora, 56; disembodied, 108, 112; symbolic, 18; of trauma, 82n9; of Tupac Shakur, 176. *See also* Black body; Black maternal; buck dance; dance; tattoos: memorial
Emerson, Caryl, 214n74
emmere asiesie, 194–196, 199n33
empathetic listening, 77, 103n94. *See also* Henderson, Mae G.
empathetic witness, 75, 77
empathic unsettlement, 51, 53, 60–61, 63. *See also* LaCapra, Dominick
empathy, 24, 25, 53, 56, 60, 266–268, 270, 284
Empire, 180. *See also* Henson, Taraji P.
Engels, Dagmar, 228n11
England. *See* Britain
Enlightenment rationality, 71, 216
ephemera, 8, 11, 146, 162, 168n32, 266, 277
Epps, Camara, 278, 282. *See also* Wall, Cheryl A.
Erikson, Kai T., 60, 63
Ethiopia, 123, 192, 193
eugenics, 13, 187, 188, 189–191, 193, 197–198
Eurocentrism, 31, 32, 211, 243n2
Europe, 10, 30, 32, 42, 48n101, 51, 54, 55, 76, 191, 216, 224, 225
Evans, Bill, 269
Evers, Charles, 251. *See also* Evers, Medgar
Evers, Medgar, 15, 236, 246–247, 249–253, 255
Evers Williams, Myrlie, 249–251, 259. *See also* Evers, Medgar
exorcism, 13, 170, 200
exploitation, 23; of Africa, 220; of Black body, 193; capitalist, 94, 104–106, 111, 118, 172; by commercial media, 181; of Sara (Saartjie) Baartman, 55, 57–58, 60, 188; sexual, 55, 57, 188
Eyerman, Ron, 201, 204

Fahrenheit 451 (Ray Bradbury), 114
Family (J. California Cooper), 71, 82n6
Fanon, Frantz, 165n3, 171
Farmer, Paul, 60
Farrell, Kirby, 67n46
fascism, 114, 220
Father Comes Home from the Wars Parts 1, 2 & 3 (Suzan-Lori Parks), 66n20
Fat Joe, 138
Fausto-Sterling, Anne, 59

311

INDEX

Feeding the Ghosts (Fred D'Aguiar), 44
Fehér, Olga, 199n35
Fehskens, Erin M., 35
Felman, Shoshana, 53, 62
feminism, 282; contemporary sensibility of, 278
feminist literary criticism, 95, 278, 280
feminist movement, 100, 279
Fenton, Louise, 216
Ferguson, Missouri, 173, 271
Ferguson, Roderick, 274n3
Ferrara, Abel, 166n4
Ferrus, Diana, 52
fetishization, 54, 112, 122, 124–125, 128, 178
Feuerback, Ludwig, 109
Field, Chelsea, 226
Fifty Cent (aka 50 Cent), 147
Fisch, Audrey, 118n6
"Flava in Ya Ear Remix" (Craig Mack), 148. *See also* Notorious B.I.G.
Fledgling (Octavia Butler), 187–188, 191–194, 196–197, 198n4
Fleetwood, Nicole, 127
flesh, 65, 66n29, 160, 171, 249; Black female, 3
Floating Harbor (Bristol, England), 17
Floyd, George, 16
"For Emmett Till" (Dominique Christina), 257–259
foremothers, 11, 70, 73, 74, 78, 80–81, 97, 190, 191–192, 196, 283
Foster, Frances Smith, 101n9
Foucault, Michel, 190, 206, 213n43, 244n21
Fouché, Rayvon, 182n16
fragmentation, 73, 80, 83n29, 146, 159, 208; and archives, 7, 8; and discourse, 31; of kinship by slavery and colonialism, 34, 195; of language, 33–35, 37, 43; of memory, 34; as method, 44, 68n81, 106; in poetry, 32, 35, 38, 42; and trauma, 38, 42, 74, 208. See also *Zong!*
Frankenstein (James Whale), 216
Frankenstein (Mary Shelley), 221, 222
freedom, 105–108, 112, 113, 159, 204, 235, 237, 251–252; Black, 93, 99, 178; and Black liberation, 100; Black male imaginaries of, 11, 87–91; and Black nationalist ideologies, 95, 101n4; Black women's sonic repertoire as, 11, 87–91, 96, 103n94; and "born free" generation, 7; limitations of, 254; post-Civil Rights and, 7; radical, 178; and Sara (Saartjie) Baartman, 54–55, 57; and white privilege, 271
Freedom Riders, 234, 242
French vaudeville, 52, 59, 61
Frey, Shelly, 98
friendship, 77–78, 81, 95, 111, 115–116, 129, 150, 192, 205, 208, 210, 236–237, 258, 267; afterlife of, 277–284; depictions of colonial, 219, 222–223; in hip-hop, 129, 138–140, 142–147, 152, 158, 163; intellectual, 277–284; between Mae G. Henderson and Cheryl A. Wall, 277–284. *See also* Wall, Cheryl A.
"From *Elements of Style*" (Suzan-Lori Parks), 61, 63, 67n60

Fulton, Sabrina, 98, 274n7
funerary practices, 116, 164, 209; African, 144–145, 149, 220; diasporic, 141
Fusco, Coco, 12, 52, 121

Gallagher, Maureen, 274n3
Galton, Sir Frances, 190
Gang Starr, 143
Garner, Eric, 16, 98, 271, 274n7
Garner, Esaw, 98
Garza, Alicia, 97, 103n79, 274n5. *See also* Black Lives Matter
Gates, Henry Louis, Jr., 71
Gathering of Waters (Bernice L. McFadden), 14, 200, 202, 206–207, 211–212
Gelder, Ken, 227
gender, 52, 71, 74, 194, 202, 204, 263, 270; and biopower, 187; Black nationalist ideology, 98, 103n94; commodification of, 125; and cross-dressing, 113, 209; and division of labor, 96; ideology of, 282; inequities of, 100; and police violence, 98; representation of, 20n34; roles (norms), 254–255; silencing (muting) of, 11, 87–88, 93–94, 101n4; stereotypes, 254, 256; systems of, 35
generation, 8, 72, 95, 196, 203, 212, 244n24; and African beliefs of afterlife, 70, 71, 74, 77; and afterlife of slavery, 11, 201; and Black Lives Matter, 16; and Black women, 99, 279; "born free," 7; and DNA, 187–188, 191, 195; and foremothers, 283; future, 137; and haunting, 23, 202, 205, 208–209; and hip-hop, 141, 144, 151–152, 170–171, 176; and memory, 79, 194, 202, 235; post-Civil Rights, 178; post-slavery, 71; and trauma, 25, 32, 56–57, 60, 234
genre: autobiography, 104, 106, 158; *bildungsroman*, 177, 196; Black poetry, 171, 247; dirge, 12, 140–142, 145; elegy, 8, 12, 15, 140–142, 145–146, 171, 262–274, 275n15; eulogy, 15, 24, 143, 246–247; ghost story, 1, 14, 200–201, 211; Gothic, 111, 227; historical poetry, 250; horror-noire, 217, 222, 227; invocation (shout-out), 12, 122, 142–143, 145, 146, 152; lyric, 15, 31, 32, 40, 262, 270, 273; meta-slave narrative, 106; neo-slave narrative, 10, 11, 70, 72, 105–109, 114, 117–118; Nigerian ghost novel, 210; poetic eulogy, 24; poetic meditation, 257; prose poetry, 272; slave narrative, 38, 72, 87–90, 92, 98–99, 101n9, 104–112, 114–115, 117; stream-of-consciousness, 106, 108
Geography Trilogy, The (Ralph Lemon), 237, 242, 243n1
Get Out (Jordan Peele), 227
Getting Mother's Body (Suzan-Lori Parks), 66n20
Geyh, Paula, 118n2
Ghana, 25–26, 189, 192–193, 233

Ghostface, 146; Destiny (daughter), 146
ghosts, 203; and African American literature, 14, 15, 200–201, 204, 209, 211, 251, 262; Afrodiasporic expressions of, 169, 173, 205, 210; and afterlife of slavery, 202; and anti-Black violence, 13, 15; commodification of, 12; of Confederacy, 1; and cultural memory, 202; dance and, 241; Derrida and, 109–110, 200; of Emmett Till in literature, 206, 209–211; and haunting, 5, 23–27, 112; and popular culture, 121, 132, 171, 174; and posthuman, 212; representations of Africa and, 226–227; stories, 1, 201, 205; tourism, 4; and trauma, 202, 212; of unidentified Black woman, 1; and *Zong* massacre, 23–27, 37–41, 43–44, 49. See also *Zong!*
Gilroy, Paul, 14, 52, 201
GlenJamn3, 153n31
Glissant, Édouard, 24, 32, 36–38, 43–44, 45n6–7, 50n153
Goldberg, Elizabeth Swanson, 82n7
Gomez-Peña, Guillermo, 52
Gonzalez, Juan, 198n12
Good kid, m.A.A.d city: A Short Film by Kendrick Lamar (Kendrick Lamar), 173, 177–180
Goodman, Amy, 198n12
Gordon, Avery, 39, 200
Gordon, Charles, 224
Gordon, C. Henry, 218
Gore, Al, 130
Governors Ball Music Festival (New York City), 143, 153n28
Gradoner Graphics, 151
Grae, Jean, 141–142
graffiti, 146, 149, 151
Graham, Maryemma, 82n7
Gramsci, Antonio, 169–170, 172
Grandmaster Roc Raida, 144, 151
Grant, Alfred, 221
Gray, Freddie, 16, 98, 271
Great Chain of Being, 222
Great Depression, 220
Great Mississippi Flood (1927), 206, 209
Green, Percy, II, 103n87
Green, Renée, 52
Green, Tara T., 120n99
Greene, Eric, 228n18
Gregson v. Gilbert, 10, 27–33, 35, 42–44, 46n32
Grene, Marjorie, 214n48
grief, 23, 243n4, 272; collective, 103n79, 126, 270; community, 149; diasporic, 149; and friendship, 277–284; and hip-hop, 12, 137, 144, 146, 149, 152; national, 266; private, 263, 267, 273; public, 122–123, 146, 263–264, 266, 273; and systemic racism, 271
grotesque, 26, 94, 105, 126, 128–130, 226
Guinea, 189
Gurley, Akai, 271
GURU, 143–144, 150–151

habeas corpus, 57
Haiti, 5, 60, 220

INDEX

Halbwachs, Maurice, 244n11
Hall, Mia, 98
Hamilton, Saskia, 266
Hampton, Fred, 176
Hancock, Herbie, 129
Hanlon, Phyllis, 154n55
Hansen, Christian, 229n28
Haraway, Donna J., 213n20
Hardie, Phillip, 141
Harlem Renaissance Movement, 220, 285
Harney, Stefano, 13, 179. *See also*
 "undercommons"
Harris, Aisha, 170
Harrison, Graham, 229n22
Hartman, Saidiya, 7–9, 18, 45n15, 102n32
Harvey, Graham, 214n51
haunting, 1, 3–5, 7, 13, 18, 30, 172, 207;
 absence as, 284; afterlife of slavery,
 201; cultural, 201, 211; by ghosts,
 23–24, 40, 112, 114–115, 132,
 167n16, 200, 208, 209, 226; memory
 as, 211; phantasmic, 111; presences,
 88; and relayed trauma, 25, 38–39;
 sociological, 193, 200, 273; sonic,
 164–165; and spectrality, 3, 14, 171,
 205, 211; as the supernatural, 203
hauntology, 7, 18, 40, 158, 163, 167n17;
 Black, 158, 163, 167n17; sonic, 160
Hawking, Stephen, 117
Healey, Joseph, 152
healing, 73, 159, 284; and afterlife, 5–6; and
 afterlives of slavery, 65; communal,
 96; and memorializing, 211, 239;
 music as, 152; quilting as, 79; story-
 telling as, 79; and trauma, 55–58, 64,
 72, 211
Heavy D, 151
hegemony, 30, 39, 40; and archive, 37; colo-
 nial, 33, 219, 225; and history, 38;
 institutional, 32; and literature, 196;
 and narrative, 38, 41; and prison-
 industrial complex, 116; white
 racist, 202–204
Heine, Heinrich, 114
Heltah Skeltah, 149. *See also* Price, Sean
Henderson, Carol E., 118
Henderson, Mae G., 101n14, 103n94, *280*
Henson, Taraji P., 180
heritage, 71, 192, 238; cultural, 95, 197; gene-
 tic, 193, 197, 198n4; matrilineal, 195
Herman, Judith, 59
heteronormativity, 116, 118, 200, 215
heterotopia (Michel Foucault), 206, 213n43
hierarchy, 194, 203, 206; colonial, 219; racial,
 274; racist, 204
"HiiiPoWeR" (Kendrick Lamar), 173–177, 179
Hill, Lauryn, 176
Hilson, Tass, 209, 211
Hinton, Elizabeth, 103n87
hip-hop, 13, 156, 158, 160–161, 167n16,
 167n26, 171–172, 174–175, 180–
 181; and African Diaspora, 137, 139,
 142; and afterlife, 164–165; becom-
 ing mainstream, 129; community,
 137–138, 165n1, 165n3; and elegy, 8,
 140, 146; and fashion, 148–149, 151;
 and graffiti, 146; and invocation

(shout-out), 143; and memorializa-
 tion, 137, 144, 151, 159; and memo-
 rial murals, 151; and mourning, 12,
 124, 138–139, 152; and radical Black
 aesthetics, 173, 176; and specters of
 Black history, 169; and specters of
 Black resistance, 170; and specters
 of slavery, 169
Hirsch, Marianne, 244n9–10
history: Black, 123, 258; collective, 239, 241;
 violent, 235
Hite, Michelle, 251
Hoerl, Arthur, 216
Holder, Heidi J., 66n20
Holland, Sharon, 11, 116, 174, 176
Holloway, Karla F.C., 124
Hollywood, 107, 215–216, 220, 223; horror
 film industry of, 220
Holmes, Rachel, 66n9
Holocaust, 53, 244n7, 258
hologram, 121–122, 125–126, 128, 130–132,
 133n1, 133n3, 134n8, 134n27. *See
 also* Shakur, Tupac
Holquist, Michael, 214n74
homegoing, 145
homeland, 10, 14, 51, 54, 56, 57, 64, 188, 258
Homo sapiens, 203
horror film, 215–216; Africa in, 228; African
 American, 221; American, 215
Hottentot Venus. *See* Baartman, Sara (Saartjie)
Hougland, Allen, 106
Howard, Alycia Smith, 66n20
Howarth, Joanna, 199n18
*How Can You Stay in the House All Day and
 Not Go Anywhere?* (Ralph Lemon),
 243n4
Hsu, Hua, 170, 172, 180, 182n12
Hudson, Nicholas, 52
Hughes, Langston, 264, 275n15
humanity, 15, 26, 55, 187–188, 197, 247, 249,
 254, 256–257
Hurd, Cynthia, 271
Hurley, Robert, 199n16
Hurricane Katrina, 206, 208, 269
Hurston, Zora Neale, 279
Hurt, John, 236, 240
Hussen, Aida, 175
Hussle, Nipsey, 138
Huston, Walter, 217
hypersexuality, 54, 113

Ice Cube, 129
Ice Loves Coco (Ice-T), 129
Ice-T, 129
iconicity, 176, 250; and *Beloved* (Toni Morri-
 son), 201; Black, 177; of Black
 resistance, 170, 173–174; of Emmett
 Till, 257; and hip-hop, 148, 151; and
 memorializing, 8; and racialization,
 127–128, 159; of Tupac Shakur, 132
identity, 44, 55, 74, 76, 90, 100, 123, 219, 222,
 225, 233; and Africa, 14; Afrodia-
 sporic, 174, 188; and afterlife, 249;
 and archive, 33; Black, 71, 99, 227,
 243n4, 83n10, 124–125, 128, 133,
 180, 188, 208, 227; Black Atlantic, 9,
 201; Black male, 92–93; in Black

nationalist ideologies, 87, 94;
 Caribbean postmodern, 32; cultural,
 238; Eurocentric, 32; genetically
 modified, 197; Jim Crow and Amer-
 ican national, 20n34; and Middle
 Passage, 23, 25, 55; post-slavery
 African American, 70, 82n9; racial,
 91, 103n81, 127; reincarnated, 81;
 relational, 37; root (Édouard Glis-
 sant), 37; and slavery, 2, 11, 28, 40,
 55, 70, 83n10, 201, 208; and trauma,
 40, 41, 52, 87, 200. *See also* trauma
If We Must Die (Aimé J. Ellis), 127, 134n18,
 134n32
Illmatic (Nas), 142, 153n20, 167n24
Ill Will, 138, 142. *See also* Jones, Nasir
immortality, 123, 150, 191, 193, 197; per-
 sonal, 249, 252
imperialism, 37, 107, 225–227, 270
incarceration. *See* captivity; carceralization;
 mass incarceration
"incessant listening" (Fred Moten), 157–158,
 165
Incidents in the Life of a Slave Girl (Harriet
 Jacobs), 105–106, 110, 112, 113–117
inequity: gendered, 94, 98, 100; racial, 52,
 206, 271; social, 52, 266, 271
inheritance: African American, 174–175; and
 African spirituality, 81; Black radi-
 calism and, 176; genetic, 190–191,
 193, 195–196; matrilineal (mater-
 nal), 72, 96, 100, 191, 195–196; of
 memories, 73, 76; patrilineal (pater-
 nal), 95, 96; and slavery, 172; and
 specter, 174; of trauma, 73, 75, 76
injury, 191; Black men's bodies as sites of
 traumatic, 93; Black women's testa-
 ments to, 103n94; historical sources
 of Black, 99; racial, 266; testimonies
 to Black male, 99
injustice, 175–176, 264, 269, 272; and Black
 life, 187; and diasporic subjects,
 63; historical, 174; and imprison-
 ment, 105; racial, 103n88, 187,
 203, 206, 235, 256, 262; social, 247;
 structural, 172
*Inquiries into Human Faculty and Its Devel-
 opment* (Sir Frances Galton), 190,
 198n14, 199n15
Instagram, 283
insurgency, 8, 12, 18, 169, 170
Interscope Records, 133n8
In the Blood (Suzan-Lori Parks), 66n20
"Invisible Bully," 148, 154n57. *See also*
 Notorious B.I.G.
Invisible Man (Ralph Ellison), 11, 88–90,
 92–95, 102n48
invocation, 2, 7, 156, 177, 283; of afterlife,
 5; public, 16; shout-out as, 12,
 142–146, 152; of Tupac Shakur, 176
Iton, Richard, 174

Jackson, Elmer, 239
Jackson, Susie, 271
Jacobs, Harriet, 11, 105, 106, 110–116, 283
Jahn, Jainheinz, 214n48
Jamaica, 5, 26–27, 46n24, 134n23, 158

313

INDEX

James, Henry, 278
James, Joy, 174, 176
James, Sherman, 267
James Dewitt Yancey Foundation, 148
Jameson, Fredric, 206, 213n44
Jam Master Jay, 147, 151
JanMohamed, Abdul, 124
Jazz, 123, 269; and Afrofuturism, 172; Age, 219; Esthetic, 57, 58; and history of resistance, 269; improvisation, 171; sound, 168n35
J Dilla, 143, 148, 152; and Merch, 148, *149*
Jeanius (Jean Grae), 153n17
Jeffries, Michael P., 176
Jim Crow, 20n34, 99, 264; afterlife of, 265, 269; laws and codes, 202; "The New" (Michelle Alexander), 7; and violence, 14, 234
Jindra, Michael, 144
Jive, 133n8
Johanson, Donald C., 193
John, Elton, 236
John Henryism, 267
John Robinson Show Circus, 239
Johns Hopkins Medicine, 199n27
Johnson, Patrick, 154n60
Jones, Gayle, 71, 82n6, 82n9. See also *Corregidora*
Jones, Janine, 274n4
Jones, LeRoi, 100n1. *See also* Baraka, Amiri
Jones, Nasir (aka Nas), 138, 142, 167n24
Judin, Nick, 260n33
Judson Church Theatre Group, 243n2
Judy, Ronald A., 184n80
Juice WRLD, 138
Just-Ice, 153n24
justice, 16, 100, 128, 174–175, 187, 193, 200, 228, 246, 252; racial, 98, 259
Justice, Poetic Justice, 122. *See also* Shakur, Tupac
justice system, 273

Kahn, Richard, 215, 221
Kalu, Ogbu, 248–249
Kamuf, Peggy, 212n2
Kanwar, Mamta, 199n34
Kaplan, Cora, 277
Kardashians, 133n4
"Karma" (Dominique Christina), 246
Kavwahirehi, Kasereka, 214n48
Keating, Ana Louise, 103n94
Kechiche, Abdellatif, 52
Keizer, Arlene, 70, 82
Kelley, Robin D. G., 56
Kelsall, James, 27, 46n24, 46n29. See also *Zong* (ship)
Kenan, Randall, 1
Kennedy, John F., 123
Kennedy Center Honors, 129
Kente cloth, 148
Khoi Khoi, 10, 51, 55
Kimbabo, Isaria, 83n29
Kind of Blue (Miles Davis), 269
Kindred (Octavia Butler), 71, 82n6, 82n9
King, B. B., 144
King, Martin Luther, Jr., 170, 171, 174–175, 177–179, 180

King, Rodney, 269
King, Shaun, 98, 103n81
King of New York (Abel Ferrara), 166n4. *See also* Notorious B.I.G.
KISS FM, 142
Knock on Any Door (Willard Motley), 134n24
knowledge, 10, 24, 77, 90; affective, 236, 239, 241; ancestral, 74; archiving of, 30; Black, 91; communal, 98; embodied, 7; historical, 72; intimate, 113; official, 30; production of, 8; relayed, 40; self-, 96; and slavery, 88–89; subjugated, 39; transmission of, 8, 30; traumatic, 27, 34, 38–39, 63–64; and traumatic memory, 34; Western conceptions of, 9
Kolin, Philip C., 66n12, 67n35
Kongo (William Cowen), 14, 215–217, *218*, 219–220, 222–223, 225, 227
Kowluru, Renu A., 199n34
Krieken, Robert, 124, 127
KRS ONE, 138, 142–143, 152, 153n23
Kuppers, Petra, 198n8

labor, 125
LaCapra, Dominick, 1, 51, 53, 56, 66n19
Lacks, Henrietta, 193
Laelius, Gaius, 279
Lamar, Kendrick, 13, 170–181, 274n7
Lance, Ethel Lee, 271
landscapes: African, 219, 225–227; American, 270; cultural, 219; emotional, 240, 263; geographical, 219; jungle, 227; racial, 273; symbolic, 240
language, 41, 61–62, 91, 160–161, 219, 240; African, 224, 82n9; Arabic, 143; colonial, 10, 31, 33; and diasporic relationality, 10, 23, 36; English, 31–32, 143, 195; fractured, 30, 34, 42–43; legal, 30; of loss, 239, 277; "(mis-)use" of, 34–35; performative, 15, 242–243; poetic use of, 38; "prison house of," 33; and relayed trauma, 24; visual art based on, 108
Language Poets (1970s), 31
Lanzmann, Claude, 62
Larson, Jennifer, 66n20
Las Vegas Police Department, 128
Latore, Selwyn, 159
Laub, Dori, 53, 63
Laughton, Adam, 189
Lawal, Babatunde, 73, 82n4, 83n20
Law and Order: SVU, 129. *See also* Ice-T
Lax, Thomas J., 244n4
Lazarus syndrome, 209
Lee, John, 28
Lee, Youn Bok, 199n18
Leebron, Fred, 118n2
Lemon, Ralph, 9, 14, 235–242, 243n1–2, 243n4, 244n6, 244n8, 244nn19–20, 245n29. See also *Come home Charley Patton*; *Geography Trilogy, The*; *How Can You Stay in the House All Day and Not Go Anywhere?*; *Solo*; "Summer Tragedy, A"; *Tree: Belief/ Culture/Balance*
Lemonade (Beyoncé), 274n7

Leonard, Arthur H., 216
Lepecki, André, 244n4
Let's Do It Again (Sidney Poitier), 166n4. *See also* Notorious B.I.G.
Levinas, Emmanuel, 26
Levine, Robert, 118n6
Levy, Andrew, 118n2
Leys, Ruth, 67n46, 67nn61–62
Lhamon, W.T., 131
libation: in African rituals of mourning, 12, 139; in hip-hop culture, 137, 139–140, 150, 152
Liberia, 189
Life after Death (Notorious B.I.G.), 157, 164
Lil' Kim, 159
liminality, 74–75, 83n29, 92
Lincoln, Abraham, 123
Lippit, Akira, 30, 47, 50
Lipsitz, George, 173, 175
Little Monsters (Abe Forsyth), 227
Live Earth Tokyo, 130. *See also* Gore, Al
Live from Death Row (Mumia Abu-Jamal), 106–108
Liverpool, England, 45n22
living-dead, 73, 105–106, 108, 112, 115–118, 152, 249
L. L. Cool J, 154n57
Lloyd, Sheila, 66n18
Long, Lisa, 72, 82n9
loophole of retreat, 114–116. See also *Incidents in the Life of a Slave Girl*
Lorde, Audre, 8, 201, 264, 275n15
loss, 56, 63, 130, 189, 196, 201, 268; ancestral, 204; of Black life, 15–16, 18, 23, 28, 45n15, 93, 129; Black maternal, 99; collective experiences of, 52, 263; diaspora as, 7; and friendship, 277–285; in hip-hop, 137–141, 145–147, 150, 152, 160; intergenerational, 174, 204; of kinship in slavery, 88; language of, 239, 277; of life due to AIDS, 123; of life during the Civil Rights Movement, 251, 269; and mourning, 124; performative language of, 14; as performative research, 233–245; racialized violence, in relation to, 246; theory of, 53, 264, 265; trauma of, 124; unremitting, 124
"Lost Cause," 2–4
"Louis Collins" (John Hurt), 236
Louisiana (aka *Drums O' Voodoo* and *She Devil*) (Arthur Hoerl), 216
Lovecraft Country, 227
Lowery, Wesley, 261n50
Lucas, John, 267–270
Lucy (the Mitochondrial Eve), 193. See also *Book of Phoenix, The*
Lucy, 189. *See also* Sims, James Marion
Lugosi, Bela, 216
lynching, 4, 99, 159, 235, 238–242, 254–255, 264, 268–270; postcards, 239

Mack, Craig, 154n57
Madman across the Water (Elton John), 236
Madsen-Bouterse, Sally A., 199n34
Magesa, Laurenti, 141, 145

INDEX

Magubane, Zine, 52

Mahlis, Kristen, 47n64, 48n74

mainstream, the, 81, 173; and cinema, 224; concepts of time in, 75; cultural representations in, 52, 128; and media, 174; and popular culture, 122, 128–129, 131, 169

Malele, Dixon, 226

Mama Day (Gloria Naylor), 71, 82n6

Mandela, Nelson, 52, 226

Manhattan (New York), 127, 192

marginalization, 104, 107, 116, 125–126; institutional, 152

Marks, Shula, 228n12

Marriott, David, 177

marronage, 179–181; post-industrial, 174

Marshall, Paule, 71, 82n6, 279. See also *Praisesong for the Widow*

Martin, Terrace, 180

Martin, Trayvon, 15, 97; Black Lives Matter, in relation to, 98, 274n5, 274n7; elegy about, 263, 267–274; subgenre of poetry about, 264–266, 274n9

martyr, 98, 171, 179, 247, 262

Marx, Karl, 109–110, 122, 124–126, 167n17

Marxism, 172

Maseko, Zola, 52

Mason, David, 274n1

mass incarceration, 104, 106, 117, 172, 268, 272. *See also* captivity; carceralization

matrilineal reincarnation, 70, 72, 81

Mayfield, Curtis, 158

Mbiti, John, 73, 80, 214n48, 248–249, 253

McBride, Renisha, 265

McCarren, Felicia, 5

McCarthy, Andrew, 147

McCormick, Stacie, 52

McDade, Tony, 16

McFadden, Bernice L., 14, 201, 206–208, 211–212. See also *Gathering of Waters*

McGhie, Issac, 239

McKesson, Deray, 98, 103n81

Mckibbin, Molly, 254

McSpadden, Lesley, 98

medical apartheid, 187

medical experimentation, 13, 54, 57, 187–194; and human subjects, 187, 189, 192

medical plantation, 13, 189. *See also* Anarcha; Betsey; Lucy; Sims, James Marion

melancholia (melancholy), 125, 126, 180; creative, 178; racial, 125, 177

Mellery-Pratt, Robin, 154n59

memento mori, 8

memorial: dance as counter-, 234, 236, 238–241; fashion as, 143, 148–149, 152; holographic, 128; mobile, 151; murals as, 149–152; music as, 137, 139, 145, 146, 148, 150, 152; photographs as, 151; social media, 16, 138; sound, 92, 95, 151; tattoos as, 147, 152; tribute party as, 145, 149

memorialization, 12, 15, 92, 117, 147–152, 210–211, 283; of Emmett Till,

256; in hip-hop, 144; of Medgar Evers, 255; of Trayvon Martin, 262; of Tupac Shakur, 122, 126, 128, 139

memory, 11, 12, 57, 70, 78, 80–81, 111, 113, 197, 247; ancestral, 194; biological, 193, 195; Black dancing body as site of, 233, 237–238, 241, 243–244n4; and Black radical resistance, 252; collective, 52, 200, 204, 238, 243, 244n11, 256; counter-, 131, 244n7; cultural, 13–14, 39, 63, 139, 188, 192–195, 197, 201, 209, 211–212, 238, 139; diasporic, 7, 9, 75; embodied, 9, 236, 239–240, 242–244; of Emmett Till, 253; "forgeries of" (Cedric Robinson), 18, 65; genetic, 188, 194; and ghosts, 40; and hip-hop, 138, 145–146, 152, 156; and history, 2–3, 9, 13, 71, 73, 111, 187, 234, 238, 242, 250; hologram as site of, 122, 126, 128, 130; individual, 250; institutional, 10; intergenerational, 79, 202; intrusive, 75; and loss, 239, 242; material culture as, 150; material, 197; of Medgar Evers, 252; mitochondrial, 195, 197; and monuments, 18; and oceanic archive, 30; personal, 243; poetic, 251; "post-," 234–235; public, 4, 149, 272; and slavery, 201, 208–209, 211; slavery as, 107; sound and, 92, 95; spaces devoid of, 236; transgenerational, 235; and trauma, 34, 39, 56, 58, 72, 202, 204; traumatic, 56, 200–201, 209, 211, 212; of Trayvon Martin, 268–269; and violence, 233

Meres One, 149, *150*

metaphysical rupture, 162, 164

metaphysics, 160, 166n12, 209; and afterlife, 6, 139, 142; and anti-Blackness, 159, 166n15; and sound, 161–162, 164; and space, 161

meta-slave narrative, 106

Metress, Christopher, 256

microaggressions, 263, 266

Middle Ages, 140

Middle Passage, 10, 23, 25–26, 38, 42, 44–45, 52, 55, 75–76, 78, 107, 169, 207

Milam, J.W., 201, 209

military-industrial complex, 192

Miller, Nancy, 84n41

mimesis, 58, 122, 161–164

Minnifield, Willie, 236

Mirani, Katherine, 103n93

Miseducation of Lauryn Hill (Lauryn Hill), 177

mise-en-scène, 225

Mississippi, 241, 246, 249–251, 255, 260n33

Mississippi River, 241

Mister Magic, 142

Mitchell, Angelyn, 201

Mitchell, Robin, 66n6

Mitra, Partha P., 199n35

modernity, 188; and anthropology, 222; Black counter-, 14, 207, 212; and camera technologies, 51; and capitalism, 173; counter-culture of, 14;

and dance, 233, 237; and eugenics, 193; global, 172; and medical research, 187–189; and recorded sound, 13, 164, 168n30; slavery as constitutive of, 175; sonic Afro-, 162; and telecommunication technologies, 162, 164; Western, 14, 200–202, 206–207, 210–212. *See also* postmodernism

Modern Language Association, 279

Mohammad, Ghulam, 199n34

Mokae, Zakes, 226

momiai, 224

Money, Mississippi, 201–204, 206–207, 209–210, 212, 255, 264

Monroe, Marilyn, 129

Montana, French, 138

Montgomery, Alabama, 235

Monumental (Smif-n-Wessun), 155n67

monuments, 4, 146; Confederate, 2, 3; counter-, 244n7; lynching, 4; removal of, 17, 18

Mootry, Maria, 260n38

Morrison, Toni, 11, 95–97, 100, 201, 211, 279, 283; African spiritual traditions, relation to, 70–71. See also *Beloved*; *Song of Solomon*

Morton, Nelle, 103n94

Moses, 151

Moten, Fred, 13, 157–158, 165, 171–172, 175; and Blackness and "capacity to desire," 180–181; and marronage, 179; normative striving, 181. *See also* "incessant listening"; "undercommons"

Motley, Willard, 134n24. See also *Knock on Any Door*

mourning, 12, 126, 235, 238, 240, 243n4, 247, 251, 256, 259, 265, 267, 270; and archives, 15; and Black Lives Matter, 15, 98, 262, 271; collective, 149, 263, 268, 272; communal, 146; denial of, 123–125, 133; and fan culture, 126, 132, 138; forbidding of, 122, 132, 133; and friendship, 278; in hip-hop culture, 139, 152; in hip-hop music, 137, 141–142; and homegoing, 145; interracial, 15, 263, 271; and memorialization, 15; and Middle Passage, 23; national, 266; and performative language, 242; public, 149, 150–152, 264; racial, 15; rituals of, 16, 139–140, 142, 144, 234, 239, 246. *See also* buck dance; murals; performative research; tattoos; t-shirts

mRNA vaccine, 199n44

Mudimbe, V. Y., 214n48

multifrequency, 162–164

Muñoz, José Esteban, 177–178

murals, 152; community, 149, 150; memorial, 151; mobile, 151; and mourning, 146, 149–*150*; rap, 149–151

Murray, Anna, 101n9

Musée de l'Homme, 10, 51–52, 54–56

Muséum de l'Histoire Naturel, 51

Museum of Ethnography, 55

315

INDEX

music, 5, 9, 90, 162, 220; and activism, 181, 236, 262; and dance, 242; and fashion, 148; funerary, 141; and healing, 152; hip-hop, 13, 121–124, 137, 140, 147, 152, 161, 170–171, 173, 176–178, 180; and invocation, 144; mainstream, 122, 169; and memorialization (tribute), 144–145, 150, 152, 172; and music videos, 143, 146, 151; and poetry, 50n156; and posthumous recording, 138. *See also* Blues; hip-hop

Namibia, 226
Namibian independence, 226
narrative, 13, 15, 24, 40, 71, 73, 81–82, 91, 159, 192, 197–198, 204, 207, 211, 250, 257–258, 265; African American practices of, 166n4; Afrofuturist, 190, 192; and afterlife, 9, 211; ancestral, 81; anti-, 10; and anti-Blackness, 158; and archive, 35, 41, 252; and Black fugitivity, 157, 159; and Black women's writing, 190; cinematic horror, 219–220, 223, 225; and colonialism, 52; contested, 4; controlling, 3; counter-, 12, 14, 18, 78, 99, 116, 195, 201, 207, 234; cultural, 256; and dance, 233, 235, 237, 240; diasporic African, 145; dominant, 10, 99, 207, 234; genealogical, 194; and ghosts, 200, 202, 208–209, 211; and hip-hop, 161, 163; "invented," 2, 256; media, 246; and memory, 194–195, 211; meta-slave, 106; neo-slave, 10, 11, 70, 72, 105–109, 114, 117–118; and public memory, 4, 233; "recombinant," 9; repressed, 201; salvific, 9; slave, 38, 72, 87–90, 92, 98–99, 101n9, 104–112, 114–115, 117; and slavery, 35, 40–43, 71, 87, 104–105; submerged, 39; and trauma, 53, 56–58, 65, 80; and Western modernity, 200, 206, 210–211; and white privilege, 192. *See also* genre
Narrative of the Life of Frederick Douglass, The (Frederick Douglass), 87–90, 98–99, 101n4
Nas. *See* Jones, Nasir
Nate Dogg, 151
National Memorial for Peace and Justice in Montgomery, Alabama, 4
National Museum of African American History and Culture in Washington, DC, 4
Navrongo Experiment, 189
Nayar, Promad, 196
Naylor, Gloria, 71, 82n6
Neal, Larry, 18, 87
Neal, Mark Anthony, 268
Needham, Catherine, 229n28
Négritude, 176, 180
Negro spirituals, 133n6
Nehusi, Kimani S.K., 139
Neilan, Marshall, 216
Nelson, Marilyn, 264, 275n15

neocolonialism, 216
neo-Garveyism, 176
neo-slave narrative, 10–11, 70, 72, 81, 105–109, 114, 117–118; postmodern, 11, 105–109, 114, 117–118
New German Critique, 199n40
New Jim Crow. *See* Jim Crow
Newman, Brittainy, 154n52
Newman, Jason, 154n53
New Negro Movement, 220
New Orleans, Louisiana, 131
Newquist, Roy, 260nn36–37
News and Observer (Raleigh, NC), 2
Newton, Huey P., 174, 176, 178
New York, 113, 115, 144, 151, 158, 243n2
New York Stock Exchange, 109
Nichols, Bill, 229n28
Nigeria, 82n4, 193, 209, 249
Nobles, Wade W., 83n22
Nolan, Mary, 218
nonviolence, 171, 174–175, 178–180, 268
Noret, Joel, 144, 153n37
North Carolina, 1–3, 190
nostalgia, 2, 9, 126, 160, 234, 283; and archives, 8; "insurgent," 18
Notorious B.I.G. (aka Christopher Wallace, aka Biggie Smalls), 12, 13, 129, 138–141, 148, 156–165, 166n4, 166–167n15, 167n16. See also *Life after Death*; *Ready to Die*
Nuremberg Code (1947), 189
NWA, 129, 138, 170
Nwachurwu-Agbada, J. O. J., 248

Obeah (Caribbean), 5
objectification, 89, 188, 220; of Black bodies, 23, 51, 55–57, 64, 67n50, 123–125, 132, 237, 270; commodification as, 123–128; of enslaved bodies, 28, 32, 89, 46n23, 172; racial, 126
ogbanje figure (Igbo), 71
Okorafor, Nnedi, 13, 187–188, 190–194, 196–197, 198n1, 198n4. See also *Book of Phoenix, The*; *Who Fears Death*
Okpokwasili, Okwui, 241
Ol' Dirty Bastard (ODB), 138–140
Old Testament, 209
Olney, Ian, 228n6
Olupona, Jacob, 259n4
Only Built 4 Cuban Linx, Pt. 2, 140, 146, 153nn11–12, 154n45. *See also* Raekwon; Wu-Tang Clan
onomatopoeia, 132, 178
ontological escape, 157
ontological terror, 158–163, 165, 166n15
ontology, 11, 70–71, 76, 78, 158, 173, 176, 195, 204; anti-Black, 158, 166n8, 177; non-Western, 75; of Yoruba, 72, 75, 81
oppression, 29, 61; capitalist, 111, 118; colonial, 31–33, 39; dominant narratives of, 99; Freudian ideas of, 14; gender, 204; institutional, 12, 31, 137, 152, 265, 270; intersectional, 200, 208; and power, 181; racial, 171, 174–180, 268; and repression,

215; in slave narratives, 106; and theology, 109
òrìṣà (Yoruba), 50n140, 71
Ostriker, Alice, 39
Other, 24, 30, 36, 54, 57, 58, 59, 63, 207–208, 215, 220, 223–225
Otherness, 14, 51, 58, 59, 63, 206, 217, 219, 221, 223, 225, 227
Other World, 142, 145, 160, 225
overhearing, 163. *See also* earwitness
Owens, Camille, 1
Ownerz, The (Gang Starr), 143

paranormal phenomena, 5, 111
paraontological discourse, 166n8. *See also* Chandler, Nahum
Paris International Exposition (1937), 51
Parker, Morgan, 40
Parks, Suzan-Lori, 9–10, 51–64, 66nn20–21, 67n50, 68n81. See also *America Play, The*; *Father Comes Home from the Wars Parts 1, 2 & 3*; "From Elements of Style"; *Getting Mother's Body*; *Topdog/Underdog*; *Venus* (Suzan-Lori Parks)
Passalacqua, Camille, 72, 78, 82n9
patriarchy, 39; critique of, 204; ideology of, 204; and phallogocentrism, 178; and privilege, 95; and slavery, 116; Southern, 254; and whiteness, 174, 254
Patterson, Tiffany Ruby, 56
Patton, Venetria, 82n9
Peanuts (Charles Schulz), 148
peculiar institution. *See* slavery
Pedersen, Carl, 45n8, 45n13
Peele, Jordan, 227
Peeren, Ester, 204, 210
penicillin, 189
Pennsylvania penitentiaries, 104
"Pepper's Ghost," 121. *See also* Shakur, Tupac
Pérez-Peña, Richard, 260n33
performative research, 15, 233, 243. *See also* Lemon, Ralph
performativity, 6, 15, 169, 177, 241–242; and archives, 8; and Black masculinity, 132; and celebrity consumption, 12; in hop-hop, 156, 158, 165n3
perinatality, 159
Perry, Imani, 173
Perry, Phyllis Alesia, 72–73, 75, 81, 82n9; Yoruba spiritual traditions, relation to, 70–71. See also *Stigmata*; *Sunday in June, A*
Pew Research Center, 103n79
phenotype, 281
Phife, 145
Philip, M. NourbeSe, 10, 32, 41, 46n39, 49nn133–134, 50n140; and colonial language, 31, 37; and fragmentation, 33–36, 43; and law, 26–31, 43, 49n130; and oceanic archive, 44; and relayed trauma, 24–26, 38–40, 42, 44, 48n89. See also *Zong!*
Phillips, Caryl, 107
Phillips, James, 189
Piano Lesson, The (August Wilson), 71, 82n6

316

INDEX

Piccolo, 122. See also *Different World, A*; Shakur, Tupac
Pinckney, Clementa, 271
plantation, 112, 169, 173, 269; life, 105; medical, 189
Platt, Ryan, 243n4
Plessy v. Ferguson, 173
Plumpp, Sterling, 264, 275n15
Poe, Tef, 103n87
Poet Laureate, 263, 283. See also Dove, Rita
Poets and Writers of Consciousness, The, 274n6
Poitier, Sydney, 166n4
Pologod/Sha Be Alla, 154n63
poltergeist, 112
polyvocality, 32, 44, 47n68, 169, 273
Population Council, 189
Post-Civil Rights, 7, 71, 125, 174. See also Civil Rights Movement
posthumanism, 14, 187–188, 190, 193, 195, 197, 198n4, 202–203, 206, 212
posthumous exhibition. See Baartman, Sara (Saartjie)
posthumous music, 12, 13, 124, 127–128, 131, 133, 134n8, 134n19, 156–157, 159, 164
posthumous performance, 8, 9, 123–124, 132
"postmemory" perspective (Marianne Hirsch), 234–235, 244nn9–10
postmodernism, 11, 13, 52, 110; Black aesthetics of, 105–109, 114, 117–118; Caribbean, 31–32; and dance, 243n2; and hip-hop, 159
post-slavery, 10, 70, 71, 79, 82, 176, 179
post-World War II era, 224
Powell, Dwayne, 2–3
Praet, Istvan, 207
Praisesong for the Widow (Paule Marshall), 71, 82n6
Pratt, Geronimo, 176
Presley, Elvis, 130
Price, Sean, 138, 143, 149–150
prison-industrial complex, 11, 104–105, 116, 159, 268
Profeta, Katherine, 236–237, 243–244n4, 244n17, 244n19
protest: Black, 15, 170; Black Lives Matter, 11, 93, 97–98, 170, 262; Civil Rights, 17, 171, 235; in hip-hop, 180, 274n7; music in, 236; poetry as, 262–263; against racial violence, 93, 271; repatriation of Sara (Saartjie) Baartman, related to, 10; songs as, 180; at University of North Carolina at Chapel Hill, 2; and women, 87
psychiatry, 72, 77, 80; Western, 75–76
public art. See graffiti; monuments; murals

Queen Esther, 208
queer, 8, 9, 97
Quéma, Anne, 42
quilt (quilting), 72, 74–75, 77, 79–80
Quinn, Eithne, 182n7–8, 183n53
Quinn, Marc, 17–18

Rabaka, Reiland, 228n16
racial profiling, 98, 262–263, 268, 271

racial terror, 4, 52, 212. See also lynching; racial violence
racial violence, 55, 56, 93, 200, 202, 212, 247, 255, 257
racism, 2, 13–14, 98, 192–193, 196, 200, 204, 254, 257, 263, 267–268, 273; anti-Black, 7, 272; biomedical, 189; endemic, 272; environmental, 7; institutional, 99, 159, 211, 262, 268, 273; and policy, 173; southern, 212; structural, 174; systemic, 17, 60, 63, 138, 170, 262, 265, 271, 274n7. See also scientific racism
Raekwon, 140, 146
raising the dead, 116–117
Ramazani, Jahan, 47n56, 264, 273
Random Axe, 149. See also Price, Sean
Ranger, T. O., 83n29
Ranisch, Robert, 213n23
Rankine, Claudia, 15, 24, 264, 266, 267–271, 273. See also *Citizen: An American Lyric*
Rashid, Anne, 274n3
Rawlinson, Paddy, 194
Raynaud, Claudine, 278, 280
Ready to Die (Notorious B.I.G.), 138, 156, 158, 160–163, 165, 167n23, 167nn25–26
Rebecca Project for Human Rights: Health, Safety and Dignity for Vulnerable Families, 198n11
Reed-Veal, Geneva, 16
Reese, Ronnie, 155n71
Reid, Jen, 17–18
reincarnation, 6, 75–76, 78–81, 121; matrilineal, 10, 70; pseudo-, 125, 127–129; Yoruba beliefs in, 71–74, 77, 82n4, 82n9
relationality (Édouard Glissant), 10, 36–38, 43
religion, 5, 220; African, 80, 83n29, 143, 205, 207, 214n48, 228; and afterlife, 205; and Black community, 205; and ideology, 76, 205; and popular culture, 176; representations of African, 223, 225; and syncretism, 205
religious beliefs, African, 5, 50n140, 70, 80, 205–207, 214n48, 248
remembrance, 15, 235, 236, 249–250, 271; African world views, related to, 248, 249; and afterlife, 258; collective, 251; embodied, 236, 238, 242; in hip-hop, 145, 152; and invocation, 142; and mourning, 139; murals as, 150; and resistance, 247
Remembrance is Power, 150
rememory, 64, 79, 122
Remler, Pat, 154n65
Renaissance, 140–141
repatriation, 10, 52. See also Baartman, Sara (Saartjie)
repetition and revision (Rep & Rev), 10, 57–58, 65. See also *Venus* (Suzan-Lori Parks)
repression, 215
resistance, 178–179, 251–252, 259, 268; Antebellum slave, 179; Black, 12–13,

170, 173–174, 204, 212, 252; collective, 204; passive, 173, 180; political, 251; violent, 175
resurrection, 122–123, 128, 130–132, 138, 206
revolution: American, 174; Black, 12, 13, 108, 114, 116, 128, 174; Black nationalism as, 95; and slavery, 112
rhizomes, 166n7
Rice, Tamir, 16, 257, 271
righteousness, 246
Roach, Joseph, 244
Robinson, Cedric, 14, 18
Rockefeller Foundation, 189
Roden, David, 213n20
Rogers, Jamala, 103n87
Romer, John, 153n22
Romero, Channette, 83nn38–39
Roodt, Darrell, 216
Rooney, Caroline, 207
Rose, Tracy, 52
Rose, Tricia, 164, 169–170
Rosenburg, Eli, 152n2
Ruff Ryders, 154n51
RUN DMC, 147. See also Jam Master Jay
Rushdy, Ashraf, 117
R U Still Down? (Remember Me) (Tupac Shakur), 133n8
Ruthless Records, 133n6

Saar, Sigal, 199n35
Sacred Place, The (Daniel Black), 14, 201–206, 211–212
Safran, William, 56
Saint-Dominique, 26
Sanchez, Deshwanda, 16
Sanders, Tywanza, 271
Sankofa, 195, 283
Saturday Night Live, 129
Saunders, Patricia, 35
Say Her Name, 100; #SayHerName, 16, 100
Scheper, Jeanne, 8
Schloss, Joseph, 168n29
Schultz, Charles, 148
science fiction, 192
scientific racism, 51, 181, 188, 190, 219. See also Anarcha; Betsey; *Book of Phoenix, The* (Nnedi Okorafor); *Fledgling* (Octavia Butler); Lucy; Sims, James Marion; *Venus* (Suzan-Lori Parks)
Scott, Darieck, 172
Scott, Walter, 271
Scratch DJ Academy, 147
Scruggs, Afi, 260n50
Scully, Pamela, 65n4, 66n7, 67n36, 67n38
Seale, Bobby, 176
Sears, Laurie Jo, 30, 47n51
Section.80 (Kendrick Lamar), 173, 175, 177, 182n30
segregation, 173, 226, 257; de jure, 15, 263, 270; Jim Crow, 269
Selander, Lesley, 216, 224
Selma, Alabama, 235
Senegal, 193
Senotobia, Mississippi, 237
"sensuous-non-sensuous" (Jacques Derrida), 109–110, 112, 114
Severson, Kim, 275n43

317

INDEX

sexism, 60, 100, 200, 253–254
Sexton, Jared, 166n7, 169–172
sexuality, 52, 100, 202, 215
Shakur, Afeni, 128, 176. *See also* Shakur, Tupac
Shakur, Mtulu, 176. *See also* Shakur, Tupac
Shakur, Tupac (aka 2Pac), 121, 123, 139, 170; afterlife of, 9, 12–13, 171; and audience as witness, 129; and Black radical politics, 170–171, 176; and celebrity, 122, 124, 126–127; commodification of, 12, 123, 125–126, 130; death of, 124, 127–131, 133n8, 134n19, 134n21, 138, 171; and mainstream, 122; memorialization of, 122; mourning of, 126; posthumous hologram of, 9, 12, 121–123, 125–126, 128–133, 133n1; posthumous shout-out to Coachella, 122; and racialized iconicity, 127
Sharpe, Christina, 7
Sharpe, Jenny, 42
Sharpley-Whiting, T. Denean, 51
Shelley, Mary, 221. See also *Frankenstein*
Shipp, Thomas, 270
Shoah (Claude Lanzmann), 62
Shockley, Evie, 35, 48n101, 262–263
shout-out. *See* invocation
Sievers, Stefanie, 78
silence (silencing), 176, 178, 241, 277; and archive, 35, 38; and audiences, 60; and Black women, 11, 32, 87–89, 94–95, 97–100, 101n4, 103n95; genealogy of, 24, 32; and haunting, 88; and history, 15, 35, 38, 72, 200, 207; and memory, 250–251; representation of, 75, 100, 254, 267; sonic social, 11, 87; and trauma, 250; and white supremacy, 269
Silent Sam, 1–3, 18
Simmons, Daniel L., 271
Simon, Sherry, 244n21
Sims, James Marion, 189
Singh, Nikhil Pal, 178
Singleton, Jermaine, 125
Siopis, Penny, 52
Sitze, Adam, 166n12
Skloot, Rebecca, 199n27
slave narrative, 38, 72, 87–90, 92, 98–99, 101n9, 104–112, 114–115, 117
slaveocracy, 111–112
slavery, 14, 55, 73, 76, 79, 87, 112; and African Diaspora, 169, 175; afterlife of, 4, 7, 18, 39, 52, 60–61, 63, 65, 71, 99, 137, 169, 172, 181, 202; archive of, 9, 11; Atlantic, 52, 109, 201; and Black women, 90, 94, 102n32, 115, 188; chattel, 26, 91, 93, 106; and commodification of Black body, 12, 91, 115, 122; institution of, 2, 52, 75, 110, 116; and memory, 81, 107, 208–209, 211; and negation of kinship, 88, 91, 95; post-, 10, 70–71, 79, 82n9, 105, 109, 118, 176, 179; public history of, 61; representation of, 201; and sexual violence, 3, 55, 90, 101n13, 113; and trauma, 55–56, 58, 60, 62, 64, 72, 75, 88, 115, 201,

204, 208–209, 211, 264. *See also* capital (capitalism); colonialism; subjugation
Slavery Abolition Act (1833), 65n2, 99
slave ship, 8, 10, 24, 25–27, 38, 41, 46n23, 78, 105, 167n16. See also *Brookes* (ship); *Zong* (ship)
Slave Ship: A Historical Pageant (Amiri Baraka), 47n68
slave trade (Atlantic), 8, 11, 25–26, 28–29, 34, 38, 40, 42, 49n111, 51–52, 55–56, 105, 109, 122, 172
Slovakia, 151
Smallwood, Stephanie, 23, 38, 44n1, 46n23
Smif-n-Wessun, 143, 151
Smith, Abram, 270
Smith, Angela M., 228n3
Smith, Danez, 263, 265–266, 268, 270–271, 273. See also *Black Movie*
Smith, Darron T., 228n17
Smith, Gary, 260n38
SNCC, 174. *See also* Baker, Ella
Snoop Dogg, 121–122, 129–131, 134n23, 158
Snoop Dogg's Fatherhood (Snoop Dogg), 129
Snorton, C. Riley, 198n8
social death, 7, 12, 13, 44n1, 152, 212
social justice, 98, 100, 191, 246–247
social media, 5, 16–17, 118, 138, 142, 265; Black Twitter, 282; Facebook, 103n79, 279, 283; Instagram, 143, 279, 283; X (formerly Twitter), 138, 180, 283
social relationality, 109, 112
Solo (Ralph Lemon), 237, 244n19
Song of Solomon (Toni Morrison), 11, 88, 95–97, 100
Songs in the Key of Price (Sean Price), 138
sonic, the, 12, 161, 163–165; and afromodernity, 162, 168n32; and afterlife, 13, 97, 157–158, 164–165, 168n30; and archive, 11; and Black body, 162; and black life, 165; and Black women, 11, 99, 159; Black women's sonority, 11, 87–88, 100; and death, 164; and earwitnessing, 157; and elegy, 141, 146, 269; and haunting, 114, 116–117; and hip-hop, 13, 140, 146, 152, 158–161; and memory, 7; and performance, 9, 157; and resistance, 11; and social silencing, 11; and spectral presence, 13, 164; technologies of, 8; and testimony, 12, 138
sonic hauntology, 163. *See also* hauntology
sonic voyeurism, 163
Son of Ingagi (Richard Kahn), 14, 215–217, 220, *221*, 222, 227
Sorgner, Stefan Lorenzo, 213n23
soul, 34, 65, 74, 178–179, 226, 283; and afterlife, 6, 73; and ancestors, 23, 145; animistic, 208; antenatal, 160; and Middle Passage, 23. See also ghosts; specter; spirits
sound: non-diegetic, 161; nonmimetic, 161–162; reproduction of, 163–164, 168n30
Source, The, 150, 154n63, 156, 165n1

South Africa, 2, 7, 54, 141, 188, 216, 222, 226
South Bronx, New York, 151
Southeast Asia, 168n35
sovereignty, 112, 171, 179, 180–181, 225; liberal, 170, 177; white, 172, 176
"space of death" (Michael Taussig), 127
Spaulding, A. Timothy, 83n10, 106
spectacle, 121, 123, 131; of Black female body, 59
spectator, 59–60, 62–63, 122–123, 128, 132
specter, 7, 8, 40, 74, 206; and anti-Black violence, 171, 174, 212, 268, 272; "being-with" (Jacques Derrida), 174, 177; of Black history, 169; celebrity, 12, 121–122, 133; and commodification, 12; Harriet Jacobs as, 11, 113–115; and hip-hop, 170–171, 176; and mothers, 113; "as non-present-present" (Jacques Derrida), 200; and postmodernism, 11; of slavery and colonialism, 169, 172, 181; of slaves, 112; of slave ship hold, 167n16; sonic, 13; speaking, 13, 54; of unnamed Black woman, 3
spectrality, 113, 202–204, 210; and afterlife, 205, 209; and archives, 10, 12; and Black Aesthetic, 13; embodied, 111, 212; and haunting, 3, 14, 38, 165, 172, 205; and hip-hop, 13, 174; and neo-slave narrative, 118; and past generations, 205, 212; and performance, 44; and representations of the past, 201; and slavery, 111–113, 172; and sound, 11, 13, 162–165, 174, 200; and trauma, 38–39
"spectral turn" (Jeffrey Weinstock), 14, 212
"Spider, The" (Mumia Abu-Jamal), 108–109, 117
Spillers, Hortense, 44n3, 280
spirits, 74, 81, 206, 210, 247; African American, 71, 205; and afterlife, 6, 143; ancestral, 71, 145, 178, 202, 205, 249; antenatal, 160; of children in hip-hop, 141; cinematic representations of African, 226–227; and collective memory of cultural trauma, 202; and diaspora, 71; evil, 208–209; ghosts as "incarnation of" (Jacques Derrida), 109; and hip-hop, 144, 146; intergenerational, 202, 205, 209; and public protest, 202, 205; and syncretism, 205; traveling, 207; underwater, 44, 48n101, 50n159. *See also* ghosts; soul; specter
spirituality, 8, 17, 180, 204, 206, 210, 284; African, 44, 48n101, 50n140, 70, 81, 137, 192, 197, 207, 248–249; African American, 18, 81; and afterlife, 73; ancestral, 202, 248; and Black community, 204; and Black poets, 259; cinematic representations of African, 218; diasporic, 81, 137, 144–145, 192, 205, 247; and hip-hop, 139–141, 143, 145; non-Western, 233
Stanley, Richard, 216

318

INDEX

Stanley-Jones, Ayana, 98
Steele, 151. *See also* Smif-n-Wessun
sterilization, 188–190
Stewart, Peggy, 224
Stick, The (Darrell Roodt), 14, 216, 224, 225–227
Stigmata (Phyllis Alesia Perry), 11, 72–81
stippling, 117. See also *Death Blossoms*
St. Mary's Hospital (Brooklyn, New York), 158, 159. *See also* Notorious B.I.G.
Strand, Mark, 263
subjectivity, 8, 44n1, 91, 106, 162, 168n32, 177, 203, 215; and afterlife, 101n14; Black, 12, 18, 70–71, 88, 105, 125, 163, 133, 166n15, 169–170, 172–174, 189, 270; Black male, 90, 93, 95–99; and Black women, 91; collective, 117; colonial, 52, 216; diasporic, 63, 169; of enslaved persons, 23, 28, 45, 71; and ethics, 26; Eurocentric, 31; exclusion of Black women from, 100, 101n4, 87–88, 93, 95, 98–99; forbidding Black, 122, 123; and gender, 71; and haunting, 40; inter-, 100; mourning, 125; racial, 125–126, 165n3; spiritual forms of, 206; and trauma, 75–76; Western African, 23
subjugation: in bondage, 63, 65; and enslavement, 23, 55; racial, 64, 171–172, 202; sexual, 55
sublime, 3, 236, 284
Sugarhill Gang, The, 158–159
suicide (suicidality), 26, 41–42, 72, 141, 157, 178, 204; representation in hip-hop of, 163–165
"Summer Tragedy, A" (Ralph Lemon), 242
Sunday in June, A (Phyllis Alesia Perry), 75–77
Sundermeier, Theo, 79
Sundiata, Ibrahim, 228n13
Sun Ra, 171–172
supernatural, 14, 111, 113, 127, 201–204, 206, 210–214, 219, 225; exclusion of, 208
Surge of Power (Marc Quinn), 17–18
Sybertz, Donald, 152

Takami, Asako, 243n4
Tallahatchie River (Mississippi), 264, 265
Tate, Greg, 170
tattoos, memorial, 146–148, 151–152
Taussig, Michael, 127
Taylor, Breonna, 16
Taylor, Diana, 8, 30, 38, 40, 47n47
Taylor, Keeanga-Yamahtta, 98
Taylor, Malik, 145
Taylor, Sean, 226
Tchernichovski, Ofer, 199n35
Tek, 143, 153n26. *See also* Smif-n-Wessun
temporality, 10, 11, 52, 108, 110, 114; African concepts, in relation to, 194; and Afrofuturism, 197; and afterlife, 5, 7; and archives, 12; and death, 118; and diaspora, 195; "empathic unsettlement" (Dominick LaCapra), in relation to, 51, 53; and grief, 272; slavery and colonialism, in relation to, 55,

70, 107; and sound, 164; and theater, 61, 63, 239, 242–243; and trauma, 25; and Yoruba traditions, 72
testimony, 1, 58, 62, 76; Black, 88–89, 100; and Black Lives Matter, 16, 99; Black maternal, 16, 79; and Black women's sonority, 11, 87–88, 100; and ghosts, 212; legal, 24, 27, 39, 46n28, 54, 254; and music, 12, 138, 142; and #SayHerName, 100; situated, 30; and slavery, 79, 89, 204
Tettenborn, Eva, 82n9
thanatourism, 4
Their Eyes Were Watching God (Zora Neale Hurston), 279
Them, 227
Think Differently Music: Wu-Tang Meets Indie Culture (Think Differently), 140. See also DJ Noize
Thompson, Krista, 131–132, 167n26
Thompson, Myra, 271
Thompson, Robert Farris, 214n48
Threadcraft, Shatema, 188
Thug Life, 121, 127–128, 170, 176–177
Thug Life Vol. 1 (Tupac Shakur), 153n5
TikTok, 283
Till, Emmett, 14, 201–202, 206, 208–209, 211–212, 246–247, 253, 255–256, 258, 264
Till-Mobley, Mamie, 202, 249, 252, 259
time, 129–130, 180, 192; African concepts of, 82n9, 197, 247–248; and amnesia, 76; and call-and-response, 105; as cyclical, 248, 252; and death, 129, 138, 149, 164–165; diasporic, 63, 70, 171, 197; disordered, 107; and disruption, 106; Euro-American notions of, 75; and friendship, 277–285; and ghosts, 39–40; and history, 65; linear concepts of, 76; and maternal song, 96, 100; and Middle Passage, 55; reversal of, 61; and theater, 62; and trauma, 58, 201
Time Is Illmatic (Nas), 142. *See also* Ill Will
time-space, 207, 233; distortion of, 114; future, 124; and relayed trauma, 24, 34; and violence, 159
Tometi, Opal, 97–98, 274n5. *See also* Black Lives Matter
Topdog/Underdog (Suzan-Lori Parks), 66n20
To Pimp a Butterfly (Kendrick Lamar), 170, 173, 180, 182n10, 274n7
Torae, 140–141
Torok, Maria, 30, 40
Tougaw, Jason, 84n41
transgeneration, 13–14; cultural realities of, 187
transtemporality, 110; and archive, 112
trauma, 51, 55–59, 77, 268; cultural, 75, 200–202, 204, 208; diasporic, 55–56, 58, 60–65, 67nn40–41, 67n64; experiences, 74–76, 100, 115, 179; foundational, 53; generational, 38, 56, 57, 60; historical, 52–53, 60–62, 66n19, 70, 204, 251; inherited, 75; and memory, 56, 73, 79, 200, 201,

208–209, 211–212; muted, 53; racialized, 53, 99, 250; relayed, 10, 24–25, 31–34, 37–38, 43; and rupture, 78; secondary, 10, 25, 52, 61; social, 52; "structural" (Dominick LaCapra), 53, 66; testimony and, 87; unresolved, 63
Tree: Belief/Culture/Balance (Ralph Lemon), 237, 243n1, 244n5, 244n19
Tribe Called Quest, A, 138, 145. *See also* Phife
tribute, 131, 193, 284; ceremonial, 139; music as, 126, 130, 134n25, 143–145, 148; poetry as, 246, 269; public, 150; visual, 146
Tribute to the Kings (Gradoner Graphics), 151
Troyer, John, 147
t-shirts, memorial, 143, 148–*149*, 152
Turner, Nat, 112, 171
Turner, Otha, 237–239
Turn Me Loose: The Unghosting of Medgar Evers (Frank X Walker), 246, 250–251, 253
Tuskegee Syphilis Study (1932–1972), 189
Tyson, Timothy, 254

"undercommons" (Fred Moten and Stefano Harney), 13, 175–177, 179, 181; anarchist, 179
Uney, James B., 199n18
unfreedom, 63, 65
United States, 5, 7, 17, 99, 104, 108, 111, 118, 123, 131, 192, 198, 209, 212; Antebellum South in, 2, 189–190; Black horror film in, 227; citizenship in, 116; Civil War period in, 2; lynching in, 4; prison-industrial complex in, 11, 104–105, 107; slavery in, 52, 55–56, 105, 107, 109, 110, 116, 169. *See also* America
Universal Studios, 217
University of North Carolina, Chapel Hill, 1–3, 18
University of the Witwatersrand, 222
University of Tours, France, 280
Us (Jordan Peele), 227
USAID, 189
U.S. Public Health Department, 189
utopia, 56, 105, 111, 112, 116, 203, 213n43
utopian enclave (Fredric Jameson), 206, 213n30, 213n44

vampire, 5, 14, 123, 191, 216–217, 223–225, 227
Vampire's Ghost, The (Lesley Selander), 14, 216–217, 223–225, *224*, 227
Vazquez, Patricia, 228n8
Velez, Lupe, 222
Vella, Nadia, 154n49
Venus (Suzan-Lori Parks), 9–10, 51–66, 66n10, 66n29
Venus Hottentot, 10, 52–54, 64, 188. *See also* Baartman, Sara (Saartjie)
Veronica, Austen, 42
Vickroy, Laurie, 61
Vindication of the Rights of Woman (Mary Wollstonecraft), 283

319

INDEX

violence, 13, 15, 34, 37–38, 45n15, 179, 180, 202, 241, 268; anti-Black, 13, 159–160, 163, 165, 171, 173–174, 176, 181, 264; anti-movement, 251; colonial, 226; fantasy of, 159; gang, 179; gendered, 58; historical, 165, 251; institutional, 152; intracommunal, 100; oppressive, 252; police, 4, 7, 16, 60, 98, 103n81, 138, 152, 264, 266, 271, 138; political, 34, 60; racial, 55–56, 98, 200–202, 211, 243, 246, 252, 255, 257–258, 263, 268, 272; revolutionary, 173–174; state-supported (state-sanctioned), 99, 138, 247, 263, 265; street, 138, 152; structural, 171, 173, 175–176, 179, 181; systemic, 137, 157, 173, 247; textual, 33; white male, 209; white supremacist, 265, 273

Vodun (Haiti), 5, 220

Voodoo, tropes of, 218, 220–225, 227

voyeurism: as entertainment, 130; role of, 59; sonic, 163

Wald, Gayle, 171

Waligora-Davis, Nicole, 102n54, 102n56

Walken, Christopher, 166n4

Walker, Alice, 279

Walker, Frank X, 246–247, 250–253, 255, 257

Wall, Cheryl A., 277, *278*, 279, *280*, 281, 283–284, 285

Wallace, Christopher. *See* Notorious B.I.G.

Wallace, Michele, 125

Wallace, Voletta, 159. *See also* Notorious B.I.G.

Walvin, James, 28, 44n4, 45n6, 45n13, 46n24

Wang, Haibin, 199n35

Warren, Calvin, 157, 158, 165, 166n15

Washington, Harriet, 187, 189, 198n12

WBLS, 142

Weheliye, Alexander, 161–162, 168n32, 178

Weinstock, Jeffrey, 200–201

Weiss, Jeff, 183n55

Western medicine, 197, 198n4

West Indian folklore, 108

West of Zanzibar (Tod Browning), 14, 215–216, *217*, 218–220, 223, 225, 227

Wetmore, Kevin J., Jr., 66n20

Whale, James, 216

White, Frank, 166n4. See also *King of New York*

White, Kim, 13

White, Luise, 224

White, Miles, 165n3

white men: as Confederate soldiers, 3; and racial violence, 270, 272; representations of, 55, 203, 225–226

whiteness, 1, 91–92, 131, 160, 256; and afterlife, 253; and America, 175, 223; cinematic representations of, 219–223, 225–227; and citizenship, 96; and collective conscious, 257; and collective memory, 256; and color-blind liberal desire, 181; and desire, 173; and Euro male voice, 37–38, 41; and exploitation, 188, 190; and

femininity, 254–255; and gender, 236, 239, 254–255; hegemonic, 202–204; and heteronormativity, 118, 190; invention of, 190; and masculinity, 220, 226; and patriarchy, 174, 254; and racial dominance, 193, 270–271; and racial hierarchies, 194; and racist discourses, 169; and readers, 42; reproduction of, 193; and southern childhood, 255; and southern womanhood, 202, 253–255; and sovereignty, 172, 176; and violence, 204. *See also* white privilege; white supremacy

white privilege, 188, 192, 193, 203, 263–264, 270–271

white supremacy, 15, 172, 181, 212, 270, 273; and biopower, 187; and capitalism, 169; Christianity as an ideological justification for, 205; fictional representation of, 14; and long history of violence, 273; as longstanding southern tradition, 206; and memories of Confederacy, 2; and ontology, 166; overcome by genetic memory, 188, 194, 198; and racist murder, 202, 246, 264–265, 269; representations of resistance to, 203–204; and southern racist ideology, 256

white women, 93, 189, 201, 236, 239, 253; representations of, 220, 225–226; southern, 254

Whitman, Walt, 174

Who Fears Death (Nnedi Okorafor), 192

Wideman, John Edgar, 71, 82n6, 106. See also *Cattle Killing, The*

Wilderson, Frank, 13, 166n7, 169, 172

Wildman, Stephanie, 271

Wild Seed (Octavia Butler), 71, 82n6, 191

Wilentz, Gay, 102n60

Will.i.am, 130

Williams, Carla, 52

Williams, Gladys, 255

Williams, Jesse, 199n17

Williams, Justin A., 126

Williams, Pharrell, 179

Williams, Serena, 273

Williams, Seth, 104

Williams, Spencer, 221–222

Williams, William Carlos, 270

Williams, Zack, 221

Willis, Deborah, 52

Willoughby-Herard, Tiffany, 19n14

Wilson, August, 71

Wilson, Darren, 271

Windell, Maria, 274n3

Wing, Betsy, 45

Winokur, Mark, 229n31

Withers, Grant, 224

witness, 87, 195, 204, 207, 242; audience as, 25, 59–62, 64; of commercial spectacle, 121; and memorialization, 126; poet as, 32; readers as, 73, 75, 266, 268, 271, 281, 284; secondary, 52; and slavery, 88–89; song as, 181; sonic, 157, 164, 165, 179; and trauma, 52; to trauma, 76–77; world

as, 249. *See also* earwitness; empathetic witness

witnessing (to bear witness), 4, 9, 252; and audience, 129; and critical distance, 53; ethical, 26, 58; lacunae of, 39; rituals of, 77, 79–80; and trauma, 38–39, 52, 57, 59, 234; uncanny, 134n19

Wolfe, Cary, 202–203, 213n20

Wollstonecraft, Mary, 283

womb, 96, 115, 159; appropriation of, 88, 90; approximation of, 89, 91; proxy, 87, 92; slavery and reproductive extraction from, 102n32

women. *See* Black women; white women

Wood, Robin, 215

Woods, Tryon, 170, 180

Woodworth, Christine, 52

Woolfork, Lisa, 72, 79, 82n9

Worden, Daniel, 274n3

wordless psalmodies, 174

World War II, 224–225, 252

Woubshet, Dadmawi, 123–124

wound(ing), 33, 52, 55–56, 62–64, 284. *See also* trauma

Wu-Tang Clan, 138, 140, 146

X (formerly Twitter), 283

X, Malcolm, 174

X-ecutioners, 144. *See also* Grandmaster Roc Raida

Yadavendu, Vijay Kumar, 194

Yancey, Maureen ("Ma Dukes"), 152. *See also* J Dilla

Yancy, George, 262, 273

Yates, Kieran, 182n14

Yazoo City, Mississippi, 236

Yellin, Jean Fagan, 106

Yetunde, 10–11, 72–73, 77, 82n4, 83n20

Yoruba, 10; and afterlife, 11, 70, 73, 82n9, 143; cosmology, 71, 82n4; diasporic traditions, 81; language, 41, 47n68, 48n101; ontology of, 72, 75; and reincarnation, 71, 82n9; world view of, 71, 76, 79–80. See also *Yetunde*

Young, Al, 264

Young, Harvey, 59

Young, James, 244n7

Young Dolph, 138

Zachary, Brandon, 265

Zacks, Stephen, 219

Zárate, Mariana, 228n8

Zimmerman, George, 97, 103n79, 263–265, 270, 272–273, 274n5

Zohn, Harry, 45

zombie, 5, 15

Zong! (M. NourbeSe Phillip), 10, 19n32, 24–44, 46n39, 47n56, 48n89, 48n101, 49nn133–135, 50n140, 50n156, 50n159

Zong (ship), 8, 10, 24–44, 45n12, 45n22, 46nn23–24, 46nn28–29, 46n32; massacre on, 24–44, 45n12, 46n28, 46n34, 48n101, 49n111

320